Contemporary Aesthetics

CONTEMPORARY AESTHETICS

MATTHEW LIPMAN

Montclair State College

Allyn and Bacon, Inc. Boston

Contents

v

Contents

Contents

Preface

A new anthology in contemporary aesthetics must offer more to justify its appearance than merely being new. The following considerations regarding the present volume may therefore be of interest to prospective readers:

1. The selection of materials for this anthology has been guided by two major concerns:
 (i) an interest in philosophical excellence, regardless of schools or movements;
 (ii) an empirical concern to reflect the leading issues and discussions which have animated aesthetics in the past quarter century.

2. In addition, I have sought to organize the materials in such a way as might give the reader a rough yet reasonably accurate outline of the ways in which the problems of aesthetics are distributed and being dealt with at the present time. The historical and contemporary surveys by Beardsley, Margolis and Tejera are particularly useful for the orientation of the reader who is unfamiliar with the history of modern aesthetics, or with its characteristic problems.

3. A balance has been sought between established works on the one hand, and fresh points of view on the other. Thus I have not hesitated to include a few items (such as the Hampshire and Kennick selections) which have already appeared in several anthologies. On the other hand, I have sought to include meritorious works by possibly less familiar writers (e.g., Yoos, Redpath, Ehrenzweig, etc.), or works by established writers that have not previously been anthologized (e.g., Valéry, Isenberg, Sibley, Ingarden, etc.).

4. In several cases, I have been fortunate enough to obtain previously unpublished materials, which are presented here for the first time. This category includes the supplement to Margolis' "Recent Work in Aesthetics," Dickie's "Defining Art II," and Tejera's "Contemporary Aesthetic Theory," as well as a new translation of Diderot's "Treatise on Beauty." The Heidegger selection is in a newly revised and recently published translation by Albert Hofstadter.

I am grateful to Joseph Margolis for his suggestion of several selections for inclusion in this anthology, and to Allen K. Workman and H. David Snook, of Allyn and Bacon, Inc., for their cooperation in getting it all together.

PROLOGUE

Prologue

Seen from this chair, by this light, across this room, the irregular range of shelves projects in perpendicular relief from the wall—shelves supporting clusters of books, some standing huddled together, others leaning, or stacked and lying down, with bookends like sentence-ending periods, followed by spaces of random size, in some instances large enough to accommodate a painting (here a dreamy watercolor, there an oil, another a cheery collage, still another a child's painting), and then some spaces that are narrower, although not so narrow as to be unable to accommodate an object (a bowl, for instance, or a vase, or a wooden egg, smooth and compact and grained and utterly mute). On the right, a large round brass tray stands flat against the wall, and, just in front of it, a small Egyptian figurine: a princess, probably, straight and tall and slender, the great mass of her hair falling in twin cascades behind her ears and down almost to her folded arms, her lovely face tapering to the chin, a fox face with a bronze enamel glaze, now chipped away on one side of the cheek, while half-obliterated hieroglyphics emerge obscurely on the lower part of her body, which descends from her waist virtually without articulation, like a column with a single foot.

I wonder how long she has been standing like this. Could it really be 3500 years?—for so I'm told: 3500 years in which the mastery of the sculptor who carved and painted her is still present and visible in the lines of her face and body, in which the mystery of her proud, tiny presence connects me as with a thread of gold to that awesome civilization in whose fading days she had her birth. And that Egyptian sculptor, as he carved and painted her, some 3500 years ago, did he occasionally glance across his room to a shelf on which stood a small Mesopotamian bronze which he treasured as, for 1500 years or so before him, men had treasured it? And that Mesopotamian sculptor in turn. . . .

2

Is it possible that, as generations upon generations of ancestors link me to an obscure mammalian past, so the timeless life-span of each work of art stretches like a generation across the years to link itself to the chain of generations of works of art whose forging began with the emergence of mankind, where perhaps some perceptive simian connoisseur treasured a textured and striated stone, combed like the hair of the princess, or a smooth bit of rock, like the treasured rock that rests on the child's dresser upstairs, a product of nature's seeming mastery, and brimful of nature's authentic mystery? The savage's stone and the rock of the child, though totally self-enclosed and inarticulate, are yet thought by their owners to possess magic powers, to be capable, like magnets or like talismen, of acting at a distance; similarly, the princess with the folded arms, poised descendant of Nefertiti, though her stance suggests self-enclosure, enigmatic reserve, is yet somehow as intelligible to us as one of our own thoughts, and as haunting as the remembrance of a long-past act of love. May it not be said that the princess too has magic powers, the power of acting at a distance, the power of haunting, of irrupting within one's mind like an entrancing melody, or like the dream which we cannot help suspecting was produced in us by the person or thing dreamed about, so that the little figurine on the shelf may be likewise conceived as having the power of conveying the thought of itself to me and of maintaining that thought persistently in my mind, whether on the outer fringes of my memory, or deep in its dark inner core?

Yet, I reflect, if the distinction between the art process and the art product has any validity, doesn't it do violence to that distinction to describe the product in terms of the process? Which is the work of art—the wooden object before me, or the experience in which that object occurs? As I am about to acknowledge my confusion, I pause to wonder if perhaps the process of art is unique in that it is an *event* which allows itself to be discussed and legitimately interpreted as though it were merely a *thing.* If this is so, should it not be assumed that the primary subject matter of aesthetics cannot be the art object or the perceiving subject, since these are only discriminated subsequently, but rather the *aesthetic event* itself? The notion of aesthetic event momentarily intrigues me, evoking as it does the dynamism of art, for what is a work of art if not power and presence, the power of a crouching thing to leap alive at us, to spring up out of the dark of its deceptively immobile physical posture so that for an instant the chameleon self takes on the hue and contour of the object of art? But have I not fallen into the same trap once again, confusing the process of art with the art product, confusing, in other words, the aesthetic event with what is merely a condition of that event? Surely, I reflect, our discussion of the nature of the work of art cannot proceed unless we can tell the listener from the music, the poet from the poetry, the singer from the song, the dancer from the dance, just as we seek epistemologically to distinguish the knower from the known. Yet I cannot help thinking that in the case of art we may be dealing with a radically different sort of situation, in that the aesthetic event is not fully

separable from its conditions and consequences; instead, what if it partially absorbs or incorporates them—with the result that any specification of the art object as an *isolated* entity cannot help being artificial, forced and unjustified?

How imperceptibly one's thoughts drift away from the directness of one's perceptions—the lightness of the wood from which the little statuette has been carved, the gravity of her expression—inference by inference, association upon association, until one finds oneself pondering what it is *to be* a work of art—its ontological status, its metaphysical mode of existence! But a little reflection suggests that from aesthetic perception to aesthetic theory is indeed no great distance, since each of our perceptions is already theory-laden, irreducibly theory-laden, with the consequence that to speculate about art is merely to make philosophically explicit what is perceptually implicit. On the other hand the art object is neither docile nor passive; it establishes certain experiential stipulations, and rejects as well as accepts, even as the pigment in the bronze complexion of the princess rejects one particular frequency of light vibration and accepts all others. Thus the work of art would seem to possess a relative degree of objectivity, inasmuch as we enter its territory as guests. While enjoying the purview our host provides, we must respect its stipulations and demands, and, while in its domain, must submit to its authority, acknowledging the sovereignty of the aesthetic order over the order of our wishes or our memories.

But now a swarm of questions descends upon me—beautiful questions, fascinating, provocative, bewildering questions, and I find it no easy task to keep them from becoming hopelessly entangled with one another. I wonder how art is to be defined, a question which prompts the still more fundamental question of whether it can be defined at all. I wonder about the meaning of art, about the truth it is alleged to possess, about the emotional content attributed to it. I am led to question the presuppositions customarily employed in discussions about art—that works of art inevitably possess unity, or uniqueness, or originality, or authenticity. Nor can I keep from entering my mind those questions which only a metaphysic of art can come to grips with—the place of art in nature and in human life, the status of art in relation to scientific inquiry and in relation to utility. I wonder about the nature of appreciation, the nature of creation (if there be such a thing), about the nature of critical judgment. . . . clearly, there is nothing to be done but readily confess my bewilderment and turn for possible answers to contemporary aestheticians—which is what I now proceed to do.

PART ONE

What Is Aesthetics?

Introduction

Students often want to know what the difference is between "aesthetics" and "the philosophy of art." There is considerable warrant for saying that the two terms are synonymous. But conventional usage suggests that inquiries as to the place of art in the entire panorama of human activities—for example, the relationships of art with politics, or religion, or civilization, or the self—fall properly into the domain of the philosophy of art. On the other hand, those inquiries into specific philosophical problems within the domain of art itself—for example, the nature of the work of art, and the ways we make and appreciate and judge works of art—constitute the field of aesthetics.

Often, of course, philosophers concern themselves less with art itself than with the ways we talk about art. While this may be referred to as "meta-aesthetics," it is probably preferable to see such activity as simply a concern with methodological aspects of aesthetics itself, and not as a separate discipline.

In recent years, logical and methodological aspects of aesthetics have been the subject of an increasing number of philosophical studies. The issues dealt with are frequently technical rather than speculative. The eulogistic tone of much of the work done a generation or two ago has been replaced by language that aims at rigor and precision. Often, the problems attacked appear to be manageable and limited in scope; however, they not infrequently turn out to be less manageable than they initially seemed.

Students who encounter aesthetics for the first time are often bewildered by a formidable array of readings that seem to overlap far more than they dovetail, and that propose solutions to problems that are thoroughly unfamiliar. In this section, we attempt to correct this inadequacy by identifying some of the major problems in the aesthetics of the present generation. Furthermore, to demonstrate the ways in which earlier philosophers sought to define, interpret and resolve the problems of art as they conceived them, we have provided several readings from classic philosophies of art. Thus, in this section, the reader should be able to obtain a sense of what aesthetics has been, and what it is.

Since this volume is concerned primarily with contemporary aesthetics, it can do no more than present a glimpse of classical writings on the subject. Space does not permit inclusion of selections from such major philosophies of art as those of Aristotle, Kant, Hegel and Nietzsche, and we shall pause only to consider two representative selections from the eighteenth century, and one from the nineteenth. These three selections—Diderot, Hume and Tolstoy—have been chosen because of their special relevance to contemporary aesthetics, and because they are in certain ways so characteristic of their centuries. (This is not to deny the great importance of Kantian aesthetics at the close of the eighteenth century, or the enormous significance of Hegel at the beginning of and Nietzsche at the end of the nineteenth.)

Undoubtedly one of the merits of the classic discussions of art is that they provide frames of reference—comprehensive philosophical contexts—for today's more specialized aesthetic analyses, thereby making the technical inquiries more comprehensible. Thus, contemporary discussions of aesthetic objectivity, for example, take on a new luster and significance when grasped against the backdrop of the classical dialogue. Seen in this fashion, Diderot's conception of the work of art as an ensemble of objective relationships or rapports strikingly anticipates contemporary structuralistic analyses. In contrast, Hume sketches for us the outlines of an empirical science of aesthetics winnowed from the weighty historical evidence of countless aesthetic perceptions, just as a scientific conception of the world is, for Hume, winnowed from a mass of evidence consisting of countless sensory observations of nature. While both Diderot and Hume are skeptical of any absolute aesthetic criteria, Diderot contends that aesthetic relationships are objective enough within specific contexts, while Hume leans to the view that the judgment of good taste is identical with the judgment of history. Hume's stress upon atomic sentiments gives his aesthetics a decidedly subjectivistic flavor.

The work of Tolstoy continues to be controversial and provocative. There is more than a hint of Kant in Tolstoy's proposal of three generic characteristics of art, and in his perception of a link between the univer-

sality of art and the shared experience of the human community. At the same time, while Tolstoy anticipates twentieth-century theories of "socialist realism," it is likely that his vehement insistence upon the principle that art is communication is what invites the equally vehement insistence by Collingwood that it is not.

The selection by Beardsley briskly reviews events in aesthetics in the first half of the twentieth century. For the student to acquire some grasp of the trends in more recent aesthetic theory, no single frame of reference or point of view was felt to be sufficient. Hence the report by Margolis concerns itself chiefly with developments within analytical aesthetics, while that by Tejera addresses itself primarily to recent work in aesthetics by non-analytical philosophers.

CHAPTER 2

Landmarks in Aesthetics

Denis Diderot

*Denis Diderot (1713–1784) was a French philosopher, editor of
the great* Encyclopedie, *and author of several novels. He wrote a number
of philosophical dialogues, as well as essays in perception, aesthetics,
and scientific method.*

Treatise on Beauty

We are born with the faculty to feel and to think; the first step in the
thought process is to examine perceptions, to link, compare and combine
them, to detect among them both inappropriate and appropriate rela-
tions, etc. We are born with needs which force us to resort to various
expedients; and our choice here has often been dictated by what we have
come to expect of them, by their effect upon us and by the fact that they
may be good or bad, ready or efficient, complete or incomplete, etc. Most

Translated for this volume by Anne W. Stern.

of these expedients involved using a tool, a machine or some other invention of this kind; but every machine presupposes the combining and arranging of parts directed toward a single purpose, etc. Here then are our needs, as well as the most immediate exercise of our faculties, which, from our birth, interact in order to provide us with notions of order, arrangement, symmetry, mechanism, proportion and unity; all these notions are derived from our senses and therefore are factitious; from the idea of a multitude of artificial and natural things, proportioned, combined and arranged symmetrically, we have proceeded to the negative and abstract one of disproportion, disorder and chaos.

These ideas, like all others, are based on experience; they too have come to us through the senses; we would not have had any idea of God at all without them: for they existed in us much before our own notion of His existence; they are as positive, distinct, clear and real as those of length, width, depth, quantity and number; as these ideas originate at the same time as our needs and the exercise of our faculties, and even if there existed somewhere on earth a people whose language contained no words for these ideas, they would nevertheless exist to some extent in the mind, and would be more or less developed, because they would have been based on a certain number of experiences, and applied to quite a number of things; for this is what differentiates one people from another, and one man from another. Whatever sublime expression we may use for the abstract ideal of order, proportion, relations and harmony, whether they be called *eternal, original, supreme, essential rules of the beautiful,* they have all had to pass through our senses in order to reach our understanding. In the same way as the most insignificant of notions, they are nothing more than abstractions of the mind.

But no sooner the exercise of our intellectual faculties and the necessity of providing for our needs with inventions, machines, etc., had given us a general idea of the notions of order, relation, proportion, connection, arrangement and symmetry, than we found ourselves surrounded by things which contained these same ideas, repeated, as it were, *ad infinitum;* we could not take a step anywhere without some product revealing them to us; they would enter our mind at any moment, from anywhere; everything that took place within us, everything that existed beyond us, everything that remained from centuries gone by, everything that industry, thought, and the discoveries of our contemporaries were producing before our eyes continued to inculcate in us the notions of order, relation, arrangement, symmetry, appropriateness and inappropriateness, etc.; now there is no other idea, except perhaps that of existence, that could have become quite so familiar to men.

If, then, there is nothing in the idea of the *beautiful,* whether it be *absolute, relative, general* or *specific,* except ideas of order, relation, proportion, arrangement, symmetry, appropriateness and inappropriateness; and provided these ideas be derived from no other source than those of existence, number, length, width, depth and an infinity of others which remain indisputable, it seems to me that we can use the first

11

notions to define the *beautiful,* without being accused of substituting one term for another, and arguing in a circle.

Beautiful [*beau*] is a term that we apply to a great number of things, but whatever differences exist among them, either we must be using the term *beautiful* incorrectly, or else these things must have a certain quality of which the word *beautiful* is the sign.

This quality cannot be found among those which constitute their specific difference; for either there would be only one *beautiful* thing, or at the very most, a single beautiful species of things.

But which quality, among those common to all *beautiful* things will be chosen to represent that for which the term *beautiful* is the sign? Which one? Obviously, it can only be that which renders all things *beautiful;* that quality, no matter how rare (if indeed that is the case) which makes them more or less *beautiful;* a quality, without which these things will cease to be *beautiful,* which cannot change its nature without changing the *beauty* of the species; a quality, the opposite of which renders the most *beautiful* things offensive and ugly; in a word, a quality, through which *beauty* begins, increases, varies to infinity, fades away, and disappears. Now only the idea of relations (rapports) can produce such effects.

I therefore call *beautiful,* outside myself, all that is capable of revealing to my understanding the idea of relations; and *beautiful* in relation to me, all that reveals this idea.

By *all,* I do not mean, however, qualities of taste and smell; although these qualities could give us the idea of relations, the term *beautiful* does not at all apply to objects which contain these qualities, when the former are considered only in relation to the latter. We say *an excellent dish,* or *a delightful aroma,* but not *a beautiful dish* or *a beautiful aroma.* And when we speak of *a beautiful turbot* or *a beautiful rose,* other qualities are being considered in the rose and the turbot than those related to the senses of smell and taste.

When I say, *all that is capable of revealing to my understanding the idea of relations* or *all that reveals this idea,* we must distinguish between the forms contained in these objects and the idea I have of them. My understanding of them neither adds nor subtracts anything from these things. Whether I think of the facade of the Louvre or not, its various parts have, nonetheless, some sort of form and design. Whether there are men to perceive it or not, it would be just as *beautiful,* but only for possible beings, constituted of mind and body like ourselves; because, for others, the facade could be neither *beautiful* nor *ugly,* or even just *ugly.* We may then conclude that, although there be no *absolute beauty,* there are two types of *beauty* in relation to us, *beauty that is objective,* and *beauty that is perceived.*

By *all that reveals this idea to us,* I am not saying that, in order for some thing to be *beautiful,* one must determine the kind of relations contained in the object; I do not require that a person who sees a piece of architecture be able to be sure of what even the architect himself could

not know: for example, that this part is related to another, like one number to another; or that a person hearing a concert should sometimes know more than the musician knows, or that the relation of two sounds is two to four, or four to five. It suffices that he perceive and feel that the elements of this piece of architecture, or the sounds of this piece of music are related, either among themselves or with other objects. It is when these relations remain undetermined, when they are so easily grasped and give us so much pleasure, that we are led to imagine that the *beautiful* is a matter of feeling rather than of reason. And I would even say that whenever a principle has been with us from earliest childhood, and out of habit we apply it easily and almost automatically to objects outside us, we think we are basing our judgment on feeling. But we will be forced to confess our error whenever, because of the complication of relations or the unfamiliarity of objects, the application of the principle would be suspended. Pleasure will occur only after our understanding has decided that the object is *beautiful.* Besides, in such cases, judgment is almost always of *relative beauty* and not of *objective beauty.*

If we consider relations of customs, then we speak of *moral beauty;* if we consider works of literature, then we have *literary beauty;* if we consider pieces of music, we have *musical beauty;* works of nature have *natural beauty,* mechanical works of men have *artificial beauty;* in representations of works of art and nature, there is a *beauty of imitation;* in each object, and from whatever angle we consider the relations in a single object, the *beautiful* will assume different names.

But any single object, whatever it may be, can be considered in isolation, or in relation to others. When I say that a flower or a fish is *beautiful,* what do I mean? In considering that flower or fish by itself, all I mean is that I perceive in that thing, among its constituent parts, a certain order, arrangement, symmetry and relations (for all these words are merely different ways of considering the relations themselves): in this sense, every flower and every fish is *beautiful;* But what kind of *beauty?* It is what I call *objective beauty.*

If I consider the flower and fish relative to other flowers and fishes, when I say they are *beautiful,* that means that among the things of this kind, that among these flowers and those fishes, these are the ones which awaken in me the greatest number of relationships and the greatest number of specific relationships; and I shall not hesitate to show that all relationships are not of the same kind and that they all contribute more or less to the idea of *beauty.* But I am sure, when considering objects in this new light, that there is a *beauty* and an *ugliness;* but what *beauty?* What *ugliness?* One we may describe as *relative.*

If, instead of considering a flower or a fish, we were to generalize, and we considered a plant or an animal; or if we were to particularize, as in the case of a rose or a turbot, we will always be able to distinguish between *relative beauty* and *objective beauty.*

Thus, we see that there are several *relative beauties,* that a tulip may be *beautiful* or *ugly* in comparison with tulips, *beautiful* or *ugly* in com-

13

parison with flowers, *beautiful* or *ugly* in comparison with plants, *beautiful* or *ugly* in comparison with the creations of nature.

But it is understood that we must have seen many roses and many turbots, before declaring that certain are *beautiful* or *ugly* in comparison with all roses and all turbots; many plants and many fish, before declaring that the rose and the turbot are *beautiful* or *ugly* in comparison with plants and fish; and we must be very well acquainted with nature, before declaring that they are *beautiful* or *ugly* in comparison with the creations of nature.

What do we mean, when we say to an artist: *Imitate the beauty of nature?* Either we do not know what we are asking or we tell him: If you have to paint a flower, and it really does not matter which one you paint, choose the most *beautiful* of all flowers; if you are going to depict a plant, and your subject could be either an oak or an elm, withered, broken, splintered and bare, take the most *beautiful* of all plants; if you have to paint an object of nature, any object, paint the most *beautiful* one.

Therefore it follows:

(1) that the principle of imitation of the beauty of nature requires the deepest and widest study of its creations of every kind;

(2) that once we have a very thorough knowledge of nature and the limits she has prescribed in the creation of each being or thing, it would be nonetheless true that the number of occasions when the most *beautiful* could be used in the arts of imitation, would be proportionate to those occasions when the least *beautiful* is preferred, as in the ratio of one to infinity;

(3) that although there exists a *maximum quantity* of *beauty* in each work of nature, considered in itself; or, for example, although the most *beautiful* rose produced by nature never attains either the height or the spread of an oak, yet there is neither *beauty* nor *ugliness* in nature's creations, when we consider how they might be used in the arts.

Depending on the nature of an object, on whether it arouses in us the perception of a greater number of relationships, and depending on the nature of the relationships it arouses, we designate a thing *pretty, beautiful, more beautiful, very beautiful,* or *ugly; inferior, small, great, elevated, sublime, extravagant, burlesque* or *agreeable;* to discuss all these details would mean writing a very long work and not an article for a dictionary: we are content to have set forth the principles. We will leave the results and their applications to the reader. But he can be assured that whether he takes his examples from nature, or borrows them from painting, morals, architecture, or music, he will always find that the term *objective beauty* refers to all those things which, in themselves, contain elements that awaken in us the idea of relations; and the name *relative beauty* is given to everything that calls forth appropriate relations with the things to which they are necessarily compared.

I shall confine myself to a single example taken from literature.

Everyone is familiar with the sublime words in Corneille's tragedy, *Horace: Qu'il mourût.* (Let him die.) Let us assume I were to ask someone who does not know Corneille's play, someone who could not have any idea of what the elder Horace's answer would be, how he would react to that line: *Qu'il mourût.* Obviously this person, not knowing what this *Qu'il mourût* means, unable to guess if this is a complete sentence or just a fragment, and hardly perceiving between the three words any grammatical relation, this person will answer that the line is neither *beautiful* nor *ugly.* Now if I told him that this is the answer of a man who was consulted with regard to what another man must do in battle, he would begin to perceive in the speaker a kind of courage which does not necessarily mean that it is always better to live than to die; and the line, *Qu'il mourût,* begins to interest him. If I add that the honor of a country is at stake in this contest, that the combatant is the son of the speaker, that he is his only surviving son, that the young man in question faces three enemies who have already killed two of his brothers, that the old man is speaking to his daughter, that he is a Roman, then the answer, *Qu'il mourût,* which is neither *beautiful* nor *ugly,* grows more beautiful as I gradually relate it to the circumstances, and it finally becomes sublime.

Change the circumstances and the relations and transport the scene to the Italian theatre, from the lips of the elder Horace to the mouth of the valet Scapin, and the *Qu'il mourût* becomes burlesque.

Change the circumstances once again and suppose that Scapin is in the service of a hard, miserly, and churlish master, and that they were attacked on the highway by three or four bandits. Scapin escapes, the master puts up a fight, but, outnumbered by his assailants, he is obliged to flee too. Now Scapin learns that his master has escaped from danger. What, says Scapin, somewhat disappointed, he ran away then? Oh! The coward! But, we could reply, *alone against three,* what else *could he have done? Qu'il mourût,* would be his reply; and in this particular situation, *Qu'il mourût* becomes *humorous.* Thus, it is invariably true that *beauty* begins, grows, changes, declines, and disappears according to relationships, as we have just seen.

"But what do you mean by a *relationship?*" it may be asked. Do we not alter the meaning when we designate as *beautiful* that which has never been regarded as such? In our language, it seems that the idea of the *beautiful* is always associated with the idea of greatness, and, in fact, we would not be defining the *beautiful* by locating its specific difference in a quality which is united to an infinity of things which have neither greatness nor sublimity. Crousaz was undoubtedly mistaken, for his definition of the *beautiful* contained so many characteristics that its usage was restricted to a very small number of things; but would it not be just as bad, however, to render the definition so general that it seems to include everything, even a pile of shapeless stones thrown at random at the edge of a quarry? It may be added that all objects very likely contain relations among themselves, among their parts, and with other things;

there are none which cannot be distributed, ordered and arranged symmetrically. Perfection is a quality befitting them all. But such is not the case of *beauty,* for it applies only to a small number of objects.

It seems to me that this indeed is the strongest objection, if not the only one, that can be made, and I shall try to reply to it.

The abstract notion of relationship, in general, depends upon the operation of our understanding, which addresses itself either to a thing or a quality, in so much as this thing or quality presupposes the existence of another thing or quality. For example, when I say that Peter is *a good father,* I consider in him a quality that presupposes the existence of another quality, that of a son; and the same thing applies to relationships, whatever their nature. From which it follows that, although the relationship exists only in our understanding, the perception originates nonetheless in things; so I will say that a thing contains in itself absolute relations whenever it assumes those qualities which a being constituted of mind and body like myself could not conceive of without presupposing the existence either of other beings or of other qualities, whether in the thing itself or outside it; and I will distinguish between those relations which are *objective* and those which are *perceived.* But there exists a third category of relations, *intellectual* or *fictive* relationships; those that our understanding seems to ascribe to things. A sculptor contemplates a block of marble, and as his imagination is quicker than his chisel, he removes from it all unnecessary parts, and he is able to make out a figure. But this figure is, by nature, imaginary and fictive. Within an area of space circumscribed by intellectual lines, he could do what he has just executed in his imagination in a formless block of marble. A philosopher looks upon a pile of stones thrown at random; in his mind, he eliminates all the irregular elements in this pile, and he manages to make out of it a globe, a cube, or a regular figure. What does this mean? That, although the artist's hand can only trace a design upon resistant surfaces, he can transfer by thought the image onto any object. What am I saying, onto any object! Why, in space and in the void as well. The image, whether transported by thought through the air, or extracted by imagination from the most formless objects, can be *beautiful* or *ugly,* but no longer can it be the ideal canvas upon which it was painted, nor the formless object from which it was brought forth.

When I say then that something is *beautiful* because of the relationships we perceive in it, I am not at all referring to the intellectual or fictive relationships conveyed by our imagination there, but to objective relationships which exist there, and which our understanding discerns with the help of our senses.

On the other hand, I claim that whatever the relationships may be, *they* will constitute *beauty,* and I do not mean in the narrow sense of the word, in which *pretty* is the opposite of *beautiful,* but, if I may say so, in a more philosophical sense, which is more consistent with the idea of the *beautiful* in general, and the nature of languages and things.

If someone has the patience to assemble all things which we call

beautiful, he will soon realize that in this number there is an infinity of them which have nothing to do with smallness or greatness; smallness and greatness are of no consequence whenever the object is isolated, or when it is considered in isolation by itself, as an individual thing, within a large species. When the very first clock or watch was judged *beautiful,* was attention being paid to anything other than its mechanism, or the relation of its parts to one another? Today, when we say that a watch is *beautiful,* are we referring to anything besides its use and mechanism? Therefore, the general definition of *beauty* must suit all things designated by this term, and we must exclude the idea of greatness. I have undertaken to separate from the notion of *beauty* the idea of greatness, because it seemed to me that it was precisely this one which was most often associated with it. In mathematics, by a *beautiful problem,* we mean a difficult problem to solve; by a *beautiful solution,* we mean the simple and easy solution to a difficult and complicated problem. The concepts of the *great,* the *elevated,* and the *sublime* are inappropriate on these occasions when one cannot help using the term *beautiful.* Let us review in the same way all the things that we call *beautiful:* one person will exclude greatness, another will exclude usefulness, a third, symmetry; some will exclude even the obvious semblance of order and symmetry: such would be the case of a painting of a storm, a tempest or a scene depicting chaos; and we would have to admit that the only common quality which all these things share is the notion of relationship.

But when we want the general idea of *beauty* to agree with all the things so designated, are we referring only to the language of the speaker or do we mean all languages? Must the definition fit only those things that we call *beautiful* in French, or all things that one would call *beautiful* in Hebrew, Syriac, Arabic, Chaldean, Greek, Latin, English, Italian and all other languages which have existed, exist, or will exist? In order to prove that the idea of relationship is the only one that would remain after we have imposed such a restrictive criterion, will not the philosopher be forced to learn all the languages? Is it not sufficient to have noted that every language uses the term *beautiful* differently, that it is applied in one place to one category of things and not in another, but that no matter what language used, it does not presuppose the perception of relationships? The English say *a fine flavor, a fine woman.* Where would an English philosopher stand if, having to discuss the *beautiful,* he wished to take note of this peculiarity in his language? It is the people who have created languages, and it is up to the philosopher to discover the origins of things; and it would be rather surprising to find that the principles of the one did not often contradict the applications of the other. But the principle of the perception of relationships, when applied to the nature of the *beautiful,* does not even here have this disadvantage; for it is so general that it is difficult for anything to escape it.

Among all peoples, everywhere on earth, and at all times, there has existed a term for color in general, and other words for specific colors and for different shades of color. What would a philosopher have to do

if he were required to explain what a *beautiful color* is, except to indicate the original application of the word *beautiful* to a color in general, whatever it might be, and then, to indicate the reasons for choosing one nuance rather than another? In the same way, it is the perception of relationships which has given rise to the term *beautiful,* and according to whether the relationships and the minds of men have changed, we have created the words *pretty, beautiful, charming, great, sublime, divine,* and an infinity of others, as physical as they are moral. These are the nuances of the *beautiful;* but I wish to develop this thought by saying this:

When we require that the general notion of the *beautiful* fit all *beautiful* things, are we speaking only of those things which bear this term here and now, or are we speaking of those termed *beautiful* since the beginning of time, those we have called *beautiful* 5000 years ago, 3000 leagues away, those which will be called *beautiful* in centuries to come, those which we have regarded as *beautiful* in childhood, in maturity and in old age, those things which have been admired by civilized and primitive men alike? Will the truth of this definition be found in the specific, the immediate and the fleeting? Or will it apply to all things, at all times, to all men and in all places? If one takes the last view, one will come very close to my principle, and there will be hardly any other way of reconciling the judgments of the child with those of the adult: of the child, who needs only a vestige of symmetry and imitation, to admire and be recreated; of the adult, who needs palaces and works of wide scope to be impressed. As for the judgments of civilized and primitive man, the latter will marvel at the sight of a glass pendant, a brass ring, or a flashy, jangling bracelet, while civilized man gives his attention only to the most perfect works. Primitive man generously lavishes such terms as *beautiful* and *magnificent* etc. on cabins, huts and barns; and contemporary man has restricted the use of these terms to the most recent efforts of human endeavor.

Ascribe beauty to the perception of relationships and you will have the history of its progress from the beginning of the world to the present moment. Choose as a differential characteristic of the *beautiful* in general any other quality that you will, and your notion will suddenly be focused at a point in space and time.

The perception of relationships is therefore the foundation of *beauty;* consequently, it is the perception of relations that has been designated in all languages by different names, and these names indicate only different kinds of *beauty.*

But in our language and in almost all others, the term *beautiful* is often contrasted with the word *pretty;* and according to this new interpretation, it seems that the question of the *beautiful* is nothing more than a matter of grammar, specifying exactly the ideas ascribed to this term.

After having attempted to set forth in what the origin of the *beautiful* consists, all that remains for us to do is to determine the origin of the different opinions that men hold of *beauty:* this inquiry will finally verify

our principles, for we shall demonstrate that all these differences result from the diversity of relations perceived or introduced as much as in the creation of nature as in those of the arts.

The *beautiful* which results from the perception of a single relationship is usually less than that which results from the perception of several relationships. The sight of a *beautiful* face or a *beautiful* painting affects us more than the sight of a single color, a starry sky more than an azure-colored curtain, a landscape more than the open countryside, an edifice more than a level piece of land, a piece of music more than a sound. However, one does not have to multiply infinitely the number of relationships and *beauty* does not follow this progression: we admit those relationships in *beautiful* things that can be seized clearly and easily by a good mind. But how do we define a good mind? Where, in works of art, is that dividing line, short of which, from lack of relations, they appear too even, and beyond which they appear excessively burdened with them? This is the first reason for the diversity of opinions. Here begin the arguments. Everyone agrees that there is a *beauty,* that it is the result of perceived relations: but depending on whether one has more or less knowledge, experience, and practice in judging and meditating, depending on one's breadth of mind, one claims that an object is poor or rich, confused or ordered, impoverished or pregnant with meaning.

But how many compositions are there in which an artist is forced to use more relationships than most men can grasp, and in which there are hardly any men except those practising the same art, that is to say those men the least disposed to be fair, who recognize the full merit of his work? What becomes then of the *beautiful?* Either it is presented to a herd of ignoramuses who are totally insensitive to it, or the work is "appreciated" by a few jealous souls who keep their mouths shut. This is only too often the entire reception given a great piece of music. D'Alembert has said, in his *Discours préliminaire* (to the *Dictionnaire encyclopédique*), a work that certainly should be mentioned in this article, that now that there is an art to teaching music, there should also be an art to listening to music; and I might add that now that poetry and painting are arts, it is a waste of time to create an art of reading and seeing, for there will always prevail in the judgment of certain works an obvious uniformity of opinion which, in truth, is less insulting to the artist than differences of opinion, but is also very distressing to him.

Among all relations one can distinguish an infinity of kinds: there are those which strengthen, weaken, and moderate one another. What a difference in our opinion of the *beauty* of an object, if we were able to grasp all of the relations, or if we were able to grasp only some of them! Now this is a second cause for the diversity of opinions. There are relations that can be indeterminate or determinate: we shall call the former *beautiful* whenever it is not the immediate and sole aim of a science or an art to determine their nature. But if this determination is the immediate and sole object of a science or an art, we require not only the relations but also their value: this is why we speak of a *beautiful* theorem, but not

19

of a *beautiful* axiom, although one cannot deny that the axiom expressing a relation has its *objective beauty* too. When I say, in mathematics, that the whole is greater than its parts, I state with assurance an infinite number of specific propositions about the included quantities; but I determine nothing about the exact amount by which the whole exceeds its parts. It is almost as if I were to say: "The cylinder is greater than the inscribed sphere, and the sphere is greater than the inscribed cone." But the specific and immediate aim of mathematics is to determine by how much one of these volumes is greater or smaller than the other; and he who demonstrates that the relations of one to another is always like the numbers, 3, 2, 1, will have expounded a remarkable theorem. The *beauty* always comprised by these relationships will, in this case, consist of the number of relations and the difficulty involved in perceiving them; and the theorem which will state that every line dropped from the apex of an isosceles triangle to the middle point of its base divides the angle into two equal angles, will not be remarkable: but a *beautiful* theorem will be one that states that asymptotes approach a curve endlessly without ever meeting it, and that the spaces formed by a portion of the axis, a portion of the curve, the asymptote and the prolongation of the ordinate, are to one another as one number to another. One particular circumstance, not unrelated to *beauty* (in this case and in many others), is one in which relationships and surprise are combined; this occurs whenever the theorem, the validity of which has just been demonstrated, was taken first for a false proposition.

There exist relations which we consider more or less essential, such as the one of greatness relative to man, woman and child; we can speak of a *beautiful* child even though he may be small; it is absolutely essential that a handsome man be tall; this quality is less important for a woman and there is a greater chance for a small woman to be *beautiful* than for a small man to be handsome. I think that here we are dealing with things not only in themselves, but also relative to the place they occupy in nature, in the "great design"; depending upon whether we are more or less familiar with this great design, the scale that we form of the size of things is more or less exact: but we never really know when the scale is accurate. A third reason for the diversity of tastes and judgments is found in the arts. Great masters preferred that their scale be rather a little large than too small, but not a single one of them has the same scale, nor perhaps that of nature.

Self-interest, passions, ignorance, prejudices, usages, mores, climate, customs, governments, cults and events will interfere with the things which surround us, or will render them capable of arousing or not arousing in us several ideas. They will destroy very natural relations in such things, and these natural relations will be replaced by capricious and fortuitous ones. Here is a fourth source for the diversity of opinions.

We relate everything to our capacities and to our knowledge. We all play to some extent the role of the critic of Apelles: although we know only the shoe, we also judge the leg; or although we know only the leg,

we go on to the shoe. But we do not merely carry either this rashness of judgment or our concern for detail into the judgment of works of art; even those in nature are not exempt. Among the tulips in a garden, the most *beautiful* one for a person who is interested, will be the one in which he notices a rareness of size, color and foliage; but the painter who is concerned with effects of light, tints, chiaroscuro, and forms relative to his art, will neglect all those characteristics admired by the florist. A fifth reason for the diversity of judgments is the diversity of talent and knowledge.

Our mind has the power to bring together ideas that it receives separately, to compare the objects with the ideas it has of them, to observe their inner relations, to extend or limit its ideas at will, to consider separately each of the simple ideas which can be joined in the sensation that it has received of them. This operation of the mind is called *abstraction.* The ideas of corporeal substances are composed of various simple ideas, which together have made their impressions, when the corporeal substances present themselves to our senses. It is only when we specify in detail these sensorial ideas that we are able to define the substances. Such definitions can call forth a rather clear idea of a substance in a man who had never immediately perceived it. This occurs when he has previously received, separately through the senses, all the simple ideas which enter into the composition of the complex idea of the defined substance. But should he lack the notion of any one of those simple ideas of which this substance is composed, and should he lack a sense necessary to perceive them, or if this sense is irremediably impaired, there is no definition that could arouse in him the idea of which he would not have had previously a sensorial perception. This is a sixth reason for the diversity of judgments that men will make about the *beauty* of a description. For how many false notions, how many half-notions do men have about the same object!

But they are by no means supposed to agree any more about intellectual matters. Such matters are all represented by signs, and there is hardly a single sign that might be rather exactly defined in order that its acceptance be all the wider or narrower for one man than for another. Logic and metaphysics would approach perfection, if the dictionary of the language was well-made: but it is a work still to be perfected. And since words are the colors used by poetry and eloquence, what conformity can we expect in judgments about a picture, as long as we do not even know what to believe about the colors and the nuances? Here is a seventh reason for the diversity of judgments.

Whatever the thing we are judging, whether what we like and what we dislike is aroused by instruction, education, prejudice or a certain factitious order in our ideas, all are founded on the opinion which states that these objects have some degree of perfection or some defect in their qualities for the perception of which we have senses and suitable faculties. This constitutes an eighth reason for the diversity of judgments.

We can state with some degree of certainty that simple ideas, aroused

in different people by a single object, are as different as their likes and dislikes. This is even true of feelings. For it is no more difficult to imagine several people disagreeing at precisely the same moment than the same man having disagreements with himself at different times. Our senses are continually fluctuating: one day, we do not see anything; the next, we have difficulty hearing; and from one day to the next, we see, hear and feel differently. This is the ninth reason for the diversity of judgments among men of the same age and in one man at different ages.

Unpleasant ideas are often quite accidently joined to the most *beautiful* objects: if one likes Spanish wine, all one has to do is to drink it with some emetic to hate it. We are not free to choose whether to feel nausea or not over it. Spanish wine is always good, but our condition is not always the same in relation to it. In the same way, this entrance hall is always magnificent, but my friend died here. This theater has not ceased to be *beautiful* because it was here that I was jeered. But I can no longer look at it, without hearing the sounds of jeering. All I see in this hall is my dying friend; no longer am I able to feel its *beauty*. This is a tenth reason for the diversity of judgments, brought on by this funereal procession of accidental ideas, that we are not free to separate from the main idea.

Post equitem sedet atra cura.[1]

On the subject of composed objects, which present at the same time both natural and artificial forms, such as we find in architecture, gardens, clothing etc., our taste is based upon another association of ideas, half reasonable, half capricious. A weak analogy with the stance, the cry, the form or the color of some horrible object, the opinion of one's country, the conventions of one's compatriots etc., all these things influence our judgments. Do these reasons tend to make us regard vivid and vibrant colors as the mark of vanity or some other bad disposition of heart or mind? Are certain forms found among peasants and people whose profession, business, or character are odious or loathsome? These auxiliary ideas will recur despite us, with those of color and form, and we will pass judgment on this color and those forms, even though we find nothing unpleasant in them. This is the eleventh reason for the diversity of judgments.

With regard to purely imaginary things, such as the sphinx, the siren, the faun, the minotaur and the ideal man, etc., about whose beauty we seem to be less divided, that is not surprising: these imaginary things are, in fact, formed according to the relations that we see observed in objects; but the model that they are supposed to resemble, scattered throughout the works of nature, is appropriately everywhere and nowhere.

In spite of all these causes for the diversity of judgments, there is no reason to infer that objective *beauty,* the one which consists in the perception of relations, is a chimera; the application of this principle may vary *ad infinitum,* and its accidental modifications may occasion literary

quarrels and dissertations: but the principle remains nevertheless constant. There are perhaps no two men on earth who would perceive precisely the same relationships in a single object, and who would consider it *beautiful* to the same degree. But were there a single one which would remain unaffected by relations of this kind, he would be a perfect example of an idiot; and if he were insensitive only in a few areas, this phenomenon would reveal in him a defect of animal economy; and we would always stand at a great distance from skepticism, because of the general state of the rest of the species.

The *beautiful* is not always the work of an intelligent cause: movement often gives us, either in a thing considered in isolation, or among several things compared one with another, a prodigious number of surprising relationships. Natural history collections can furnish us with a great many examples. In this case, relationships are the result of fortuitous combinations, at least in relation to us. Nature playfully imitates, on one hundred different occasions, the production of art; and it could be asked, when we see some figures of geometry, as did that philosopher who was thrown, during a storm, on the shores of an unknown island (but I am not sure if he was right): "Courage, my friends, for I see the footsteps of men"; but how many relations exist in a thing because we are certain that it is indeed the work of some artist? On what occasion would a single defect of symmetry prove more than a complete list of relationships? What is the relation between the time of the occurrence of a fortuitous cause, and the relationships observed in the effects produced? And finally we may ask, whether, with the exception of the works of the Almighty, there are cases in which the number of relationships can never be matched by the number of throws of the dice.

Note
1. "On his horse behind him sits black care." (Horace, *Odes,* III, i, verse 40).

David Hume

A major figure in British empiricism, David Hume (1711–1776) was born in Edinburgh. His Treatise of Human Nature *appeared in 1739, and was published in revised form in 1748 as the* Enquiry into Human Understanding. *Hume's* Dialogues Concerning Natural Religion *was published posthumously in 1779.*

Of the Standard of Taste

The great variety of Taste, as well as of opinion, which prevails in the world, is too obvious not to have fallen under every one's observation. Men of the most confined knowledge are able to remark a difference of taste in the narrow circle of their acquaintance, even where the persons have been educated under the same government, and have early imbibed the same prejudices. But those who can enlarge their view to contemplate distant nations and remote ages, are still more surprised at the great inconsistence and contrariety. We are apt to call *barbarous* whatever departs widely from our own taste and apprehension; but soon find the epithet of reproach retorted on us. And the highest arrogance and self-conceit is at last startled, on observing an equal assurance on all sides, and scruples, amidst such a contest of sentiment, to pronounce positively in its own favor.

As this variety of taste is obvious to the most careless inquirer, so will it be found, on examination, to be still greater in reality than in appearance. The sentiments of men often differ with regard to beauty and deformity of all kinds, even while their general discourse is the same. There are certain terms in every language which import blame, and others praise; and all men who use the same tongue must agree in their application of them. Every voice is united in applauding elegance, propriety, simplicity, spirit in writing; and in blaming fustian, affectation, coldness, and a false brilliancy. But when critics come to particulars, this seeming unanimity vanishes; and it is found, that they had affixed a very different meaning to their expressions. In all matters of opinion and science, the case is opposite; the difference among men is there oftener found to lie in generals than in particulars, and to be less in reality than in appearance. An explanation of the terms commonly ends the controversy: and the disputants are surprised to find that they had been quarrelling, while at bottom they agreed in their judgment.

Those who found morality on sentiment, more than on reason, are inclined to comprehend ethics under the former observation, and to maintain, that, in all questions which regard conduct and manners, the

24

difference among men is really greater than at first sight it appears. It is indeed obvious, that writers of all nations and all ages concur in applauding justice, humanity, magnanimity, prudence, veracity; and in blaming the opposite qualities. Even poets and other authors, whose compositions are chiefly calculated to please the imagination, are yet found, from Homer down to Fénelon, to inculcate the same moral precepts, and to bestow their applause and blame on the same virtues and vices. This great unanimity is usually ascribed to the influence of plain reason, which, in all these cases, maintains similar sentiments in all men, and prevents those controversies to which the abstract sciences are so much exposed. So far as the unanimity is real, this account may be admitted as satisfactory. But we must also allow, that some part of the seeming harmony in morals may be accounted for from the very nature of language. The word *virtue,* with its equivalent in every tongue, implies praise, as that of *vice* does blame; and no one, without the most obvious and grossest impropriety, could affix reproach to a term, which in general acceptation is understood in a good sense: or bestow applause, where the idiom requires disapprobation. Homer's general precepts, where he delivers any such, will never be controverted; but it is obvious, that, when he draws particular pictures of manners, and represents heroism in Achilles, and prudence in Ulysses, he intermixes a much greater degree of ferocity in the former, and of cunning and fraud in the latter, than Fenelon would admit of. The sage Ulysses, in the Greek poet, seems to delight in lies and fictions, and often employs them without any necessity, or even advantage. But his more scrupulous son, in the French epic writer, exposes himself to the most imminent perils, rather than depart from the most exact line of truth and veracity.

The admirers and followers of the Alcoran insist on the excellent moral precepts interspersed throughout that wild and absurd performance. But it is to be supposed, that the Arabic words, which correspond to the English, equity, justice, temperance, meekness, charity, were such as, from the constant use of that tongue, must always be taken in a good sense: and it would have argued the greatest ignorance, not of morals, but of language, to have mentioned them with any epithets, besides those of applause and approbation. But would we know, whether the pretended prophet had really attained a just sentiment of morals, let us attend to his narration, and we shall soon find, that he bestows praise on such instances of treachery, inhumanity, cruelty, revenge, bigotry, as are utterly incompatible with civilized society. No steady rule of right seems there to be attended to; and every action is blamed or praised, so far only as it is beneficial or hurtful to the true believers.

The merit of delivering true general precepts in ethics is indeed very small. Whoever recommends any moral virtues, really does no more than is implied in the terms themselves. That people who invented the word *charity,* and used it in a good sense, inculcated more clearly, and much more efficaciously, the precept, *Be charitable,* than any pretended legislator or prophet, who should insert such a *maxim* in his writings. Of all

expressions, those which, together with their other meaning, imply a degree either of blame or approbation, are the least liable to be perverted or mistaken.

It is natural for us to seek a *Standard of Taste;* a rule by which the various sentiments of men may be reconciled; at least a decision afforded confirming one sentiment, and condemning another.

There is a species of philosophy, which cuts off all hopes of success in such an attempt, and represents the impossibility of ever attaining any standard of taste. The difference, it is said, is very wide between judgment and sentiment. All sentiment is right; because sentiment has a reference to nothing beyond itself, and is always real, wherever a man is conscious of it. But all determinations of the understanding are not right; because they have a reference to something beyond themselves, to wit, real matter of fact; and are not always conformable to that standard. Among a thousand different opinions which different men may entertain of the same subject, there is one, and but one, that is just and true: and the only difficulty is to fix and ascertain it. On the contrary, a thousand different sentiments, excited by the same object, are all right; because no sentiment represents what is really in the object. It only marks a certain conformity or relation between the object and the organs or faculties of the mind; and if that conformity did not really exist, the sentiment could never possibly have being. Beauty is no quality in things themselves: it exists merely in the mind which contemplates them; and each mind perceives a different beauty. One person may even perceive deformity, where another is sensible of beauty; and every individual ought to acquiesce in his own sentiment, without pretending to regulate those of others. To seek the real beauty, or real deformity, is as fruitless an inquiry, as to pretend to ascertain the real sweet or real bitter. According to the disposition of the organs, the same object may be both sweet and bitter; and the proverb has justly determined it to be fruitless to dispute concerning tastes. It is very natural, and even quite necessary, to extend this axiom to mental, as well as bodily taste; and thus common sense, which is so often at variance with philosophy, especially with the sceptical kind, is found, in one instance at least, to agree in pronouncing the same decision.

But though this axiom, by passing into a proverb, seems to have attained the sanction of common sense; there is certainly a species of common sense, which opposes it, at least serves to modify and restrain it. Whoever would assert an equality of genius and elegance between Ogilby and Milton, or Bunyan and Addison, would be thought to defend no less an extravagance, than if he had maintained a mole-hill to be as high as Teneriffe, or a pond as extensive as the ocean. Though there may be found persons, who give the preference to the former authors; no one pays attention to such a taste; and we pronounce, with scruple, the sentiment of these pretended critics to be absurd and ridiculous. The principle of the natural equality of tastes is then totally forgot, and while we admit it on some occasions, where the objects seem near an equality, it

appears an extravagant paradox, or rather a palpable absurdity, where objects so disproportioned are compared together.

It is evident that none of the rules of composition are fixed by reasonings *à priori,* or can be esteemed abstract conclusions of the understanding, from comparing those habitudes and relations of ideas, which are eternal and immutable. Their foundation is the same with that of all the practical sciences, experience; nor are they any thing but general observations, concerning what has been universally found to please in all countries and in all ages. Many of the beauties of poetry, and even of eloquence, are founded on falsehood and fiction, on hyperboles, metaphors, and an abuse or perversion of terms from their natural meaning. To check the sallies of the imagination, and to reduce every expression to geometrical truth and exactness, would be the most contrary to the laws of criticism; because it would produce a work, which, by universal experience, has been found the most insipid and disagreeable. But though poetry can never submit to exact truth, it must be confined by rules of art, discovered to the author either by genius or observation. If some negligent or irregular writers have pleased, they have not pleased by their transgressions of rule or order, but in spite of these transgressions: they have possessed other beauties, which were conformable to just criticism; and the force of these beauties has been able to overpower censure, and give the mind a satisfaction superior to the disgust arising from the blemishes. Ariosto pleases; but not by his monstrous and improbable fictions, by his bizarre mixture of the serious and comic styles, by the want of coherence in his stories or by the continual interruptions of his narration. He charms by the force and clearness of his expression, by the readiness and variety of his inventions, and by his natural pictures of the passions, especially those of the gay and amorous kind: and, however his faults may diminish our satisfaction, they are not able entirely to destroy it. Did our pleasure really arise from those parts of his poem, which we denominate faults, this would be no objection to criticism in general: it would only be an objection to those particular rules of criticism, which would establish such circumstances to be faults, and would represent them as universally blamable. If they are found to please, they cannot be faults, let the pleasure which they produce be ever so unexpected and unaccountable.

But though all the general rules of art are founded only on experience, and on the observation of the common sentiments of human nature, we must not imagine, that, on every occasion, the feelings of men will be conformable to these rules. Those finer emotions of the mind are of a very tender and delicate nature, and require the concurrence of many favorable circumstances to make them play with facility and exactness, according to their general and established principles. The least exterior hinderance to such small springs, or the least internal disorder, disturbs their motion, and confounds the operations of the whole machine. When we would make an experiment of this nature, and would try the force of any beauty or deformity, we must choose with care a proper time and

place, and bring the fancy to a suitable situation and disposition. A perfect serenity of mind, a recollection of thought, a due attention to the object; if any of these circumstances be wanting, our experiment will be fallacious, and we shall be unable to judge of the catholic and universal beauty. The relation, which nature has placed between the form and the sentiment, will at least be more obscure; and it will require greater accuracy to trace and discern it. We shall be able to ascertain its influence, not so much from the operation of each particular beauty, as from the durable admiration which attends those works that have survived all the caprices of mode and fashion, all the mistakes of ignorance and envy.

The same Homer who pleased at Athens and Rome two thousand years ago, is still admired at Paris and at London. All the changes of climate, government, religion, and language, have not been able to obscure his glory. Authority or prejudice may give a temporary vogue to a bad poet or orator; but his reputation will never be durable or general. When his compositions are examined by posterity or by foreigners, the enchantment is dissipated, and his faults appear in their true colors. On the contrary, a real genius, the longer his works endure, and the more wide they are spread, the more sincere is the admiration which he meets with. Envy and jealousy have too much place in a narrow circle; and even familiar acquaintance with his person may dimish the applause due to his performances: but when these obstructions are removed, the beauties, which are naturally fitted to excite agreeable sentiments, immediately display their energy; and while the world endures, they maintain their authority over the minds of men.

It appears, then, that amidst all the variety and caprice of taste, there are certain general principles of approbation or blame, whose influence a careful eye may trace in all operations of the mind. Some particular forms or qualities, from the original structure of the internal fabric are calculated to please, and other to displease; and if they fail of their effect in any particular instance, it is from some apparent defect or imperfection in the organ. A man in a fever would not insist on his palate as able to decide concerning flavors; nor would one affected with the jaundice pretend to give a verdict with regard to colors. In each creature there is a sound and a defective state; and the former alone can be supposed to afford us a true standard of taste and sentiment. If, in the sound state of the organ, there be an entire or a considerable uniformity of sentiment among men, we may thence derive an idea of the perfect beauty; in like manner as the appearance of objects in daylight, to the eye of a man in health, is denominated their true and real color, even while color is allowed to be merely a phantasm of the senses.

Many and frequent are the defects in the internal organs, which prevent or weaken the influence of those general principles, on which depends our sentiment of beauty or deformity. Though some objects, by the structure of the mind, be naturally calculated to give pleasure, it is not to be expected that in every individual the pleasure will be equally felt. Particular incidents and situations occur, which either throw a false

light on the objects, or hinder the true from conveying to the imagination the proper sentiment and perception.

One obvious cause why many feel not the proper sentiment of beauty, is the want of that *delicacy* of imagination which is requisite to convey a sensibility of those finer emotions. This delicacy every one pretends to: every one talks of it; and would reduce every kind of taste or sentiment to its standard. But as our intention in this Essay is to mingle some light of the understanding with the feelings of sentiment, it will be proper to give a more accurate definition of delicacy than has hitherto been attempted. And not to draw our philosophy from too profound a source, we shall have recourse to a noted story in Don Quixote.

It is with good reason, says Sancho to the squire with the great nose, that I pretend to have a judgment in wine: this is a quality hereditary in our family. Two of my kinsmen were once called to give their opinion of a hogshead, which was supposed to be excellent, being old and of a good vintage. One of them tastes it, considers it; and, after mature reflection, pronounces the wine to be good, were it not for a small taste of leather which he perceived in it. The other, after using the same precautions, gives also his verdict in favor of the wine; but with the reserve of a taste of iron, which he could easily distinguish. You cannot imagine how much they were both ridiculed for their judgment. But who laughed in the end? On emptying the hogshead, there was found at the bottom an old key with a leathern thong tied to it.

The great resemblance between mental and bodily taste will easily teach us to apply this story. Though it be certain that beauty and deformity, more than sweet and bitter, are not qualities in objects, but belong entirely to the sentiment, internal or external, it must be allowed, that there are certain qualities in objects which are fitted by nature to produce those particular feelings. Now, as these qualities may be found in a small degree, or may be mixed and confounded with each other, it often happens that the taste is not affected with such minute qualities, or is not able to distinguish all the particular flavors, amidst the disorder in which they are presented. Where the organs are so fine as to allow nothing to escape them, and at the same time so exact as to perceive every ingredient in the composition, this we call delicacy of taste, whether we employ these terms in the literal or metaphorical sense. Here then the general rules of beauty are of use, being drawn from established models, and from the observation of what pleases or displeases, when presented singly and in a high degree; and if the same qualities, in a continued composition, and in a smaller degree, affect not the organs with a sensible delight or uneasiness, we exclude the person from all pretensions to this delicacy. To produce these general rules or avowed patterns of composition, is like finding the key with the leathern thong, which justified the verdict of Sancho's kinsmen, and confounded those pretended judges who had condemned them. Though the hogshead had never been emptied, the taste of the one was still equally delicate, and that of the other equally dull and languid; but it would have been more difficult to have

proved the superiority of the former, to the conviction of every bystander. In like manner, though the beauties of writing had never been methodized, or reduced to general principles; though no excellent models had ever been acknowledged, the different degrees of taste would still have subsisted, and the judgment of one man been preferable to that of another; but it would not have been so easy to silence the bad critic, who might always insist upon his particular sentiment, and refuse to submit to his antagonist. But when we show him an avowed principle of art; when we illustrate this principle by examples, whose operation, from his own particular taste, he acknowledges to be conformable to the principle; when we prove that the same principle may be applied to the present case, where he did not perceive or feel its influence: he must conclude, upon the whole, that the fault lies in himself, and that he wants the delicacy which is requisite to make him sensible of every beauty and every blemish in any composition or discourse.

It is acknowledged to be the perfection of every sense or faculty, to perceive with exactness its most minute objects, and allow nothing to escape its notice and observation. The smaller the objects are which become sensible to the eye, the finer is that organ, and the more elaborate its make and composition. A good palate is not tried by strong flavors, but by a mixture of small ingredients, where we are still sensible of each part, notwithstanding its minuteness and its confusion with the rest. In like manner, a quick and acute perception of beauty and deformity must be the perfection of our mental taste; nor can a man be satisfied with himself while he suspects that any excellence or blemish in a discourse has passed him unobserved. In this case, the perfection of the man, and the perfection of the sense of feeling, are found to be united. A very delicate palate, on many occasions, may be a great inconvenience both to a man himself and to his friends. But a delicate taste of wit or beauty must always be a desirable quality, because it is the source of all the finest and most innocent enjoyments of which human nature is susceptible. In this decision the sentiments of all mankind are agreed. Wherever you can ascertain a delicacy of taste, it is sure to meet with approbation; and the best way of ascertaining it is, to appeal to those models and principles which have been established by the uniform consent and experience of nations and ages.

But though there be naturally a wide difference, in point of delicacy, between one person and another, nothing tends further to increase and improve this talent, than *practice* in a particular art, and the frequent survey or contemplation of a particular species of beauty. When objects of any kind are first presented to the eye or imagination, the sentiment which attends them is obscure and confused; and the mind is, in a great measure, incapable of pronouncing concerning their merits or defects. The taste cannot perceive the several excellences of the performance, much less distinguish the particular character of each excellency, and ascertain its quality and degree. If it pronounce the whole in general to be beautiful or deformed, it is the utmost that can be expected; and even

this judgment, a person so unpractised will be apt to deliver with great hesitation and reserve. But allow him to acquire experience in those objects, his feeling becomes more exact and nice: he not only perceives the beauties and defects of each part, but marks the distinguishing species of each quality, and assigns it suitable praise or blame. A clear and distinct sentiment attends him through the whole survey of the objects; and he discerns that very degree and kind of approbation or displeasure which each part is naturally fitted to produce. The mist dissipates which seemed formerly to hang over the object; the organ acquires greater perfection in its operations, and can pronounce, without danger of mistake, concerning the merits of every performance. In a word, the same address and dexterity which practice gives to the execution of any work, is also acquired by the same means in the judging of it.

So advantageous is practice to the discernment of beauty, that, before we can give judgment on any work of importance, it will even be requisite that that very individual performance be more than once perused by us, and be surveyed in different lights with attention and deliberation. There is a flutter or hurry of thought which attends the first perusal of any piece, and which confounds the genuine sentiment of beauty. The relation of the parts is not discerned: the true characters of style are little distinguished. The several perfections and defects seem wrapped up in a species of confusion, and present themselves indistinctly to the imagination. Not to mention, that there is a species of beauty, which, as it is florid and superficial, pleases at first; but being found incompatible with a just expression either of reason or passion, soon palls upon the taste, and is then rejected with disdain, at least rated at a much lower value.

It is impossible to continue in the practice of contemplating any order of beauty, without being frequently obliged to form *comparisons* between the several species and degrees of excellence, and estimating their proportion to each other. A man who has had no opportunity of comparing the different kinds of beauty, is indeed totally unqualified to pronounce an opinion with regard to any object presented to him. By comparison alone we fix the epithets of praise or blame, and learn how to assign the due degree of each. The coarsest daubing contains a certain lustre of colors and exactness of imitation, which are so far beauties, and would affect the mind of a peasant or Indian with the highest admiration. The most vulgar ballads are not entirely destitute of harmony or nature; and none but a person familiarized to superior beauties would pronounce their members harsh, or narration uninteresting. A great inferiority of beauty gives pain to a person conversant in the highest excellence of the kind, and is for that reason pronounced a deformity; as the most finished object with which we are acquainted is naturally supposed to have reached the pinnacle of perfection, and to be entitled to the highest applause. One accustomed to see, and examine, and weigh the several performances, admired in different ages and nations, can alone rate the merits of a work exhibited to his view, and assign its proper rank among the productions of genius.

But to enable a critic the more fully to execute this undertaking, he must preserve his mind free from all *prejudice,* and allow nothing to enter into his consideration, but the very object which is submitted to his examination. We may observe, that every work of art, in order to produce its due effect on the mind, must be surveyed in a certain point of view, and cannot be fully relished by persons whose situation, real or imaginary, is not conformable to that which is required by the performance. An orator addresses himself to a particular audience, and must have a regard to their particular genius, interests, opinions, passions, and prejudices; otherwise he hopes in vain to govern their resolutions, and inflame their affections. Should they even have entertained some prepossessions against him, however unreasonable, he must not overlook this disadvantage; but, before he enters upon the subject, must endeavor to conciliate their affection, and acquire their good graces. A critic of a different age or nation, who should peruse this discourse, must have all these circumstances in his eye, and must place himself in the same situation as the audience, in order to form a true judgment of the oration. In like manner, when any work is addressed to the public, though I should have a friendship or enmity with the author, I must depart from this situation, and, considering myself as a man in general, forget, if possible, my individual being, and my peculiar circumstances. A person influenced by prejudice complies not with this condition, but obstinately maintains his natural position, without placing himself in that point of view which the performance supposes. If the work be addressed to persons of a different age or nation, he makes no allowance for their peculiar views and prejudices; but, full of the manners of his own age and country, rashly condemns what seemed admirable in the eyes of those for whom alone the discourse was calculated. If the work be executed for the public, he never sufficiently enlarges his comprehension, or forgets his interest as a friend or enemy, as a rival or commentator. By this means his sentiments are perverted; nor have the same beauties and blemishes the same influence upon him, as if he had imposed a proper violence on his imagination, and had forgotten himself for a moment. So far his taste evidently departs from the true standard, and of consequence loses all credit and authority.

It is well known, that, in all questions submitted to the understanding, prejudice is destructive of sound judgment, and perverts all operations of the intellectual faculties: it is no less contrary to good taste; nor has it less influence to corrupt our sentiment of beauty. It belongs to *good sense* to check its influence in both cases; and in this respect, as well as in many others, reason, if not an essential part of taste, is at least requisite to the operations of this latter faculty. In all the nobler productions of genius, there is a mutual relation and correspondence of parts; nor can either the beauties or blemishes be perceived by him whose thought is not capacious enough to comprehend all those parts, and compare them with each other, in order to perceive the consistence and uniformity of the whole. Every work of art has also a certain end or purpose for which it is calculated; and is to be deemed more or less perfect, as it is more

or less fitted to attain this end. The object of eloquence is to persuade, of history to instruct, of poetry to please, by means of the passions and the imagination. These ends we must carry constantly in our view when we peruse any performance; and we must be able to judge how far the means employed are adapted to their respective purposes. Besides, every kind of composition, even the most poetical, is nothing but a chain of propositions and reasonings; not always, indeed, the justest and most exact, but still plausible and specious, however disguised by the coloring of the imagination. The persons introduced in tragedy and epic poetry must be represented as reasoning, and thinking, and concluding, and acting, suitably to their character and circumstances; and without judgment, as well as taste and invention, a poet can never hope to succeed in so delicate an undertaking. Not to mention, that the same excellence of faculties which contributes to the improvement of reason, the same clearness of conception, the same exactness of distinction, the same vivacity of apprehension, are essential to the operations of true taste, and are its infallible concomitants. It seldom or never happens, that a man of sense, who has experience in any art, cannot judge of its beauty; and it is no less rare to meet with a man who has a just taste without a sound understanding.

Thus, though the principles of taste be universal, and nearly, if not entirely, the same in all men; yet few are qualified to give judgment on any work of art, or establish their own sentiment as the standard of beauty. The organs of internal sensation are seldom so perfect as to allow the general principles their full play, and produce a feeling correspondent to those principles. They either labor under some defect, or are vitiated by some disorder; and by that means excite a sentiment, which may be pronounced erroneous. When the critic has no delicacy, he judges without any distinction, and is only affected by the grosser and more palpable qualities of the object: the finer touches pass unnoticed and disregarded. Where he is not aided by practice, his verdict is attended with confusion and hesitation. Where no comparison has been employed, the most frivolous beauties, such as rather merit the name of defects, are the object of his admiration. Where he lies under the influence of prejudice, all his natural sentiments are perverted. Where good sense is wanting, he is not qualified to discern the beauties of design and reasoning, which are the highest and most excellent. Under some or other of these imperfections, the generality of men labor; and hence a true judge in the finer arts is observed, even during the most polished ages, to be so rare a character: strong sense, united to delicate sentiment, improved by practice, perfected by comparison, and cleared of all prejudice, can alone entitle critics to this valuable character; and the joint verdict of such, wherever they are to be found, is the true standard of taste and beauty.

But where are such critics to be found? By what marks are they to be known? How distinguish them from pretenders? These questions are embarrassing; and seem to throw us back into the same uncertainty from which, during the course of this Essay, we have endeavored to extricate ourselves.

But if we consider the matter aright, these are questions of fact, not of sentiment. Whether any particular person be endowed with good sense and a delicate imagination, free from prejudice, may often be the subject of dispute, and be liable to great discussion and inquiry: but that such a character is valuable and estimable, will be agreed in by all mankind. Where these doubts occur, men can do no more than in other disputable questions which are submitted to the understanding: they must produce the best arguments that their invention suggests to them; they must acknowledge a true and decisive standard to exist somewhere, to wit, real existence and matter of fact; and they must have indulgence to such as differ from them in their appeals to this standard. It is sufficient for our present purpose, if we have proved, that the taste of all individuals is not upon an equal footing, and that some men in general, however difficult to be particularly pitched upon, will be acknowledged by universal sentiment to have a preference above others.

But, in reality, the difficulty of finding, even in particulars, the standard of taste, is not so great as it is represented. Though in speculation we may readily avow a certain criterion in science, and deny it in sentiment, the matter is found in practice to be much more hard to ascertain in the former case than in the latter. Theories of abstract philosophy, systems of profound theology, have prevailed during one age: in a successive period these have been universally exploded: their absurdity has been detected: other theories and systems have supplied their place, which again gave place to their successors: and nothing has been experienced more liable to the revolutions of chance and fashion than these pretended decisions of science. The case is not the same with the beauties of eloquence and poetry. Just expressions of passion and nature are sure, after a little time, to gain public applause, which they maintain for ever. Aristotle, and Plato, and Epicurus, and Descartes, may successively yield to each other: but Terence and Virgil maintain an universal, undisputed empire over the minds of men. The abstract philosophy of Cicero has lost its credit: the vehemence of his oratory is still the object of our admiration.

Though men of delicate taste be rare, they are easily to be distinguished in society by the soundness of their understanding, and the superiority of their faculties above the rest of mankind. The ascendant, which they acquire, gives a prevalence to that lively approbation with which they receive any productions of genius, and renders it generally predominant. Many men, when left to themselves, have but a faint and dubious perception of beauty, who yet are capable of relishing any fine stroke which is pointed out to them. Every convert to the admiration of the real poet or orator, is the cause of some new conversion. And though prejudices may prevail for a time, they never unite in celebrating any rival to the true genius, but yield at last to the force of nature and just sentiment. Thus, though a civilized nation may easily be mistaken in the choice of their admired philosopher, they never have been found long to err, in their affection for a favorite epic or tragic author.

Leo Tolstoy

Leo Tolstoy (1828–1910) was a Russian novelist and reformer. His great novels, including War and Peace *(1863–69) and* Anna Karenina *(1873–77) were written in the earlier period of his creative life. During the later period, he was principally concerned with religious, ethical and aesthetic subjects.*

What is Art?

In order correctly to define art, it is necessary, first of all, to cease to consider it as a means to pleasure, and to consider it as one of the conditions of human life. Viewing it in this way, we cannot fail to observe that art is one of the means of intercourse between man and man.

Every work of art causes the receiver to enter into a certain kind of relationship both with him who produced, or is producing, the art, and with all those who, simultaneously, previously, or subsequently, receive the same artistic impression.

Speech, transmitting the thoughts and experiences of men, serves as a means of union among them, and art acts in a similar manner. The peculiarity of this latter means of intercourse, distinguishing it from intercourse by means of words, consists in this, that whereas by words a man transmits his thoughts to another, by means of art he transmits his feelings.

The activity of art is based on the fact that a man, receiving through his sense of hearing or sight another man's expression of feeling, is capable of experiencing the emotion which moved the man who expressed it. To take the simplest example: one man laughs, and another, who hears, becomes merry; or a man weeps, and another, who hears, feels sorrow. A man is excited or irritated, and another man, seeing him, comes to a similar state of mind. By his movements, or by the sounds of his voice, a man expresses courage and determination, or sadness and calmness, and this state of mind passes on to others. A man suffers, expressing his sufferings by groans and spasms, and this suffering transmits itself to other people; a man expresses his feeling of admiration, devotion, fear, respect, or love to certain objects, persons, or phenomena, and others are infected by the same feelings of admiration, devotion, fear, respect, or love to the same objects, persons, and phenomena.

And it is on this capacity of man to receive another man's expression of feeling, and experience those feelings himself, that the activity of art is based.

If a man infects another or others, directly, immediately, by his ap-

pearance, or by the sounds he gives vent to at the very time he experiences the feeling; if he causes another man to yawn when he himself cannot help yawning, or to laugh or cry when he himself is obliged to laugh or cry, or to suffer when he himself is suffering—that does not amount to art.

Art begins when one person, with the object of joining another or others to himself in one and the same feeling, expresses that feeling by certain external indications. To take the simplest example: a boy, having experienced, let us say, fear on encountering a wolf, relates that encounter; and, in order to evoke in others the feeling he has experienced, describes himself, his condition before the encounter, the surroundings, the wood, his own light-heartedness, and then the wolf's appearance, its movements, the distance between himself and the wolf, etc. All this, if only the boy, when telling the story, again experiences the feelings he had lived through and infects the hearers and compels them to feel what the narrator had experienced, is art. If even the boy had not seen a wolf but had frequently been afraid of one, and if, wishing to evoke in others the fear he had felt, he invented an encounter with a wolf, and recounted it so as to make his hearers share the feelings he experienced when he feared the wolf, that also would be art. And just in the same way it is art if a man, having experienced either the fear of suffering or the attraction of enjoyment (whether in reality or in imagination), expresses these feelings on canvas or in marble so that others are infected by them. And it is also art if a man feels or imagines to himself feelings of delight, gladness, sorrow, despair, courage, or despondency, and the transition from one to another of these feelings, and expresses these feelings by sounds, so that the hearers are infected by them, and experience them as they were experienced by the composer.

The feelings with which the artist infects others may be most various—very strong or very weak, very important or very insignificant, very bad or very good: feelings of love for native land, self-devotion and submission to fate or to God expressed in a drama, raptures of lovers described in a novel, feelings of voluptuousness expressed in a picture, courage expressed in a triumphal march, merriment evoked by a dance, humor evoked by a funny story, the feeling of quietness transmitted by an evening landscape or by a lullaby, or the feeling of admiration evoked by a beautiful arabesque—it is all art.

If only the spectators or auditors are infected by the feelings which the author has felt, it is art.

To evoke in oneself a feeling one has once experienced, and having evoked it in oneself, then, by means of movements, lines, colors, sounds, or forms expressed in words, so to transmit that feeling that others may experience the same feeling—this is the activity of art.

Art is a human activity, consisting in this, that one man consciously, by means of certain external signs, hands on to others feelings he has lived through, and that other people are infected by these feelings, and also experience them.

Art is not, as the metaphysicians say, the manifestation of some mysterious Idea of beauty, or God; it is not, as the aesthetical physiologists say, a game in which man lets off his excess of stored-up energy; it is not the expression of man's emotions by external signs; it is not the production of pleasing objects; and, above all, it is not pleasure; but it is a means of union among men, joining them together in the same feelings, and indispensable for the life and progress toward well-being of individuals and of humanity.

As, thanks to man's capacity to express thoughts by words, every man may know all that has been done for him in the realms of thought by all humanity before his day, and can, in the present, thanks to this capacity to understand the thoughts of others, become a sharer in their activity, and can himself hand on to his contemporaries and descendants the thoughts he has assimilated from others, as well as those which have arisen within himself; so, thanks to man's capacity to be infected with the feelings of others by means of art, all that is being lived through by his contemporaries is accessible to him, as well as the feelings experienced by men thousands of years ago, and he has also the possibility of transmitting his own feelings to others.

If people lacked this capacity to receive the thoughts conceived by the men who preceded them, and to pass on to others their own thoughts, men would be like wild beasts, or like Kaspar Hauser.[1]

And if men lacked this other capacity of being infected by art, people might be almost more savage still, and, above all, more separated from, and more hostile to, one another.

And therefore the activity of art is a most important one, as important as the activity of speech itself, and as generally diffused.

We are accustomed to understand art to be only what we hear and see in theaters, concerts, and exhibitions; together with buildings, statues, poems, novels. . . . But all this is but the smallest part of the art by which we communicate with each other in life. All human life is filled with works of art of every kind—from cradle-song, jest, mimicry, the ornamentation of houses, dress, and utensils, up to church services, buildings, monuments, and triumphal processions. It is all artistic activity. So that by art, in the limited sense of the word, we do not mean all human activity transmitting feelings, but only that part which we for some reason select from it and to which we attach special importance.

This special importance has always been given by all men to that part of this activity which transmits feelings flowing from their religious perception, and this small part of art they have specifically called art, attaching to it the full meaning of the word. . . .

Art, in our society, has been so perverted that not only has bad art come to be considered good, but even the very perception of what art really is has been lost. In order to be able to speak about the art of our

society, it is, therefore, first of all necessary to distinguish art from counterfeit art.

There is one indubitable indication distinguishing real art from its counterfeit, namely, the infectiousness of art. If a man, without exercising effort and without altering his standpoint, on reading, hearing, or seeing another man's work, experiences a mental condition which unites him with that man and with other people who also partake of that work of art, then the object evoking that condition is a work of art. And however poetical, realistic, effectful, or interesting a work may be, it is not a work of art if it does not evoke that feeling (quite distinct from all other feelings) of joy, and of spiritual union with another (the author) and with others (those who are also infected by it).

It is true that this indication is an *internal* one, and that there are people who have forgotten what the action of real art is, who expect something else from art (in our society the great majority are in this state), and that therefore such people may mistake for this aesthetic feeling the feeling of divertisement and a certain excitement which they receive from counterfeits of art. But though it is impossible to undeceive these people, just as it is impossible to convince a man suffering from "Daltonism" that green is not red, yet, for all that, this indication remains perfectly definite to those whose feeling for art is neither perverted nor atrophied, and it clearly distinguishes the feeling produced by art from all other feelings.

The chief peculiarity of this feeling is that the receiver of a true artistic impression is so united to the artist that he feels as if the work were his own and not some one else's—as if what it expresses were just what he had long been wishing to express. A real work of art destroys, in the consciousness of the receiver, the separation between himself and the artist; nor that alone, but also between himself and all whose minds receive this work of art. In this freeing of our personality from its separation and isolation, in this uniting of it with others, lies the chief characteristic and the great attractive force of art.

If a man is infected by the author's condition of soul, if he feels this emotion and this union with others, then the object which has effected this is art; but if there be no such infection, if there be not this union with the author and with others who are moved by the same work—then it is not art. And not only is infection a sure sign of art, but the degree of infectiousness is also the sole measure of excellence in art.

The stronger the infection the better is the art; as art, speaking now apart from its subject-matter, *i.e.* not considering the quality of the feelings it transmits.

And the degree of the infectiousness of art depends on three conditions:

(1) On the greater or lesser individuality of the feeling transmitted; (2) on the greater or lesser clearness with which the feeling is transmitted; (3) on the sincerity of the artist, *i.e.* on the greater or lesser force with which the artist himself feels the emotion he transmits.

The more individual the feeling transmitted the more strongly does it act on the receiver; the more individual the state of soul into which he is transferred the more pleasure does the receiver obtain, and therefore the more readily and strongly does he join in it.

The clearness of expression assists infection, because the receiver, who mingles in consciousness with the author, is the better satisfied the more clearly the feeling is transmitted, which, as it seems to him, he has long known and felt, and for which he has only now found expression.

But most of all is the degree of infectiousness of art increased by the degree of sincerity in the artist. As soon as the spectator, hearer, or reader feels that the artist is infected by his own production, and writes, sings, or plays for himself, and not merely to act on others, this mental condition of the artist infects the receiver; and, contrariwise, as soon as the spectator, reader, or hearer feels that the author is not writing, singing, or playing for his own satisfaction—does not himself feel what he wishes to express—but is doing it for him, the receiver, a resistance immediately springs up, and the most individual and the newest feelings and the cleverest technique not only fail to produce any infection, but actually repel.

I have mentioned three conditions of contagiousness in art, but they may be all summed up into one, the last, sincerity, *i.e.* that the artist should be impelled by an inner need to express his feeling. That condition includes the first; for if the artist is sincere he will express the feeling as he experienced it. And as each man is different from every one else, his feeling will be individual for every one else; and the more individual it is—the more the artist has drawn it from the depths of his nature—the more sympathetic and sincere will it be. And this same sincerity will impel the artist to find a clear expression of the feeling which he wishes to transmit.

Therefore this third condition—sincerity—is the most important of the three. It is always complied with in peasant art, and this explains why such art always acts so powerfully; but it is a condition almost entirely absent from our upper-class art, which is continually produced by artists actuated by personal aims of covetousness or vanity.

Such are the three conditions which divide art from its counterfeits, and which also decide the quality of every work of art apart from its subject-matter.

The absence of any one of these conditions excludes a work from the category of art and relegates it to that of art's counterfeits. If the work does not transmit the artist's peculiarity of feeling, and is therefore not individual, if it is unintelligibly expressed, or if it has not proceeded from the author's inner need for expression—it is not a work of art. If all these conditions are present, even in the smallest degree, then the work, even if a weak one, is yet a work of art.

The presence in various degrees of these three conditions—individuality, clearness, and sincerity—decides the merit of a work of art, as art, apart from subject-matter. All works of art take rank of merit according

to the degree in which they fulfil the first, the second, and the third of these conditions. In one the individuality of the feeling transmitted may predominate; in another, clearness of expression; in a third, sincerity; while a fourth may have sincerity and individuality, but be deficient in clearness; a fifth, individuality and clearness, but less sincerity; and so forth, in all possible degrees and combinations.

Thus is art divided from not art, and thus is the quality of art, as art, decided, independently of its subject-matter, *i.e.* apart from whether the feelings it transmits are good or bad.

But how are we to define good and bad art with reference to its subject-matter?

Art, like speech, is a means of communication, and therefore of progress, *i.e.* of the movement of humanity forward toward perfection. Speech renders accessible to men of the latest generations all the knowledge discovered by the experience and reflection, both of preceding generations and of the best and foremost men of their own times; art renders accessible to men of the latest generations all the feelings experienced by their predecessors, and those also which are being felt by their best and foremost contemporaries. And as the evolution of knowledge proceeds by truer and more necessary knowledge dislodging and replacing what is mistaken and unnecessary, so the evolution of feeling proceeds through art—feelings less kind and less needful for the well-being of mankind are replaced by others kinder and more needful for that end. That is the purpose of art. And, speaking now of its subject-matter, the more art fulfils that purpose the better the art, and the less it fulfils it the worse the art.

And the appraisement of feelings (*i.e.* the acknowledgment of these or those feelings as being more or less good, more or less necessary for the well-being of mankind) is made by the religious perception of the age.

In every period of history, and in every human society, there exists an understanding of the meaning of life which represents the highest level to which men of that society have attained—an understanding defining the highest good at which that society aims. And this understanding is the religious perception of the given time and society. And this religious perception is always clearly expressed by some advanced men, and more or less vividly perceived by all the members of the society. Such a religious perception and its corresponding expression exists always in every society. If it appears to us that in our society there is no religious perception, this is not because there really is none, but only because we do not want to see it. And we often wish not to see it because it exposes the fact that our life is inconsistent with that religious perception.

Religious perception in a society is like the direction of a flowing river. If the river flows at all, it must have a direction. If a society lives,

there must be a religious perception indicating the direction in which, more or less consciously, all its members tend.

And so there always has been, and there is, a religious perception in every society. And it is by the standard of this religious perception that the feelings transmitted by art have always been estimated. Only on the basis of this religious perception of their age have men always chosen from the endlessly varied spheres of art that art which transmitted feelings making religious perception operative in actual life. And such art has always been highly valued and encouraged; while art transmitting feelings already outlived, flowing from the antiquated religious perceptions of a former age, has always been condemned and despised. All the rest of art, transmitting those most diverse feelings by means of which people commune together, was not condemned, and was tolerated, if only it did not transmit feelings contrary to religious perception. Thus, for instance, among the Greeks, art transmitting the feeling of beauty, strength, and courage (Hesiod, Homer, Phidias) was chosen, approved, and encouraged; while art transmitting feelings of rude sensuality, despondency, and effeminacy was condemned and despised. Among the Jews, art transmitting feelings of devotion and submission to the God of the Hebrews and to His will (the epic of Genesis, the prophets, the Psalms) was chosen and encouraged, while art transmitting feelings of idolatry (the golden calf) was condemned and despised. All the rest of art—stories, songs, dances, ornamentation of houses, of utensils, and of clothes—which was not contrary to religious perception, was neither distinguished nor discussed. Thus, in regard to its subject-matter, has art been appraised always and everywhere, and thus it should be appraised; for this attitude toward art proceeds from the fundamental characteristics of human nature, and those characteristics do not change. . . .

The subject-matter of the art of the future, as I imagine it to myself, will be totally unlike that of to-day. It will consist, not in the expression of exclusive feelings: pride, spleen, satiety, and all possible forms of voluptuousness, available and interesting only to people who, by force, have freed themselves from the labor natural to human beings; but it will consist in the expression of feelings experienced by a man living the life natural to all men and flowing from the religious perception of our times, or of such feelings as are open to all men without exception.

To people of our circle who do not know and cannot or will not understand the feelings which will form the subject-matter of the art of the future, such subject-matter appears very poor in comparison with those subtleties of exclusive art with which they are now occupied. "What is there fresh to be said in the sphere of the Christian feeling of love of one's fellow-man? The feelings common to every one are so insignificant and monotonous," think they. And yet, in our time, the really fresh feelings can only be religious, Christian feelings, and such as are

open, accessible, to all. The feelings flowing from the religious perception of our times, Christian feelings, are infinitely new and varied, only not in the sense some people imagine—not that they can be evoked by the depiction of Christ and of gospel episodes, or by repeating in new forms the Christian truths of unity, brotherhood, equality, and love—but in that all the oldest, commonest, and most hackneyed phenomena of life evoke the newest, most unexpected, and touching emotions as soon as a man regards them from the Christian point of view.

What can be older than the relations between married couples, of parents to children, of children to parents; the relations of men to their fellow-countrymen and to foreigners, to an invasion, to defense, to property, to the land, or to animals? But as soon as a man regards these matters from the Christian point of view, endlessly varied, fresh, complex, and strong emotions immediately arise.

And, in the same way, that realm of subject-matter for the art of the future which relates to the simplest feelings of common life open to all will not be narrowed, but widened. In our former art only the expression of feelings natural to people of a certain exceptional position was considered worthy of being transmitted by art, and even then only on condition that these feelings were transmitted in a most refined manner, incomprehensible to the majority of men; all the immense realm of folk-art, and children's art—jests, proverbs, riddles, songs, dances, children's games, and mimicry—was not esteemed a domain worthy of art.

The artist of the future will understand that to compose a fairy-tale, a little song which will touch, a lullaby or a riddle which will entertain, a jest which will amuse, or to draw a sketch which will delight dozens of generations or millions of children and adults, is incomparably more important and more fruitful than to compose a novel or a symphony, or paint a picture which will divert some members of the wealthy classes for a short time, and then be forever forgotten. The region of this art of the simple feelings accessible to all is enormous, and it is as yet almost untouched.

The art of the future, therefore, will not be poorer, but infinitely richer in subject-matter. And the form of the art of the future will also not be inferior to the present forms of art, but infinitely superior to them. Superior, not in the sense of having a refined and complex technique, but in the sense of the capacity briefly, simply, and clearly to transmit, without any superfluities, the feeling which the artist has experienced and wishes to transmit.

I remember once speaking to a famous astronomer who had given public lectures on the spectrum analysis of the stars of the Milky Way, and saying it would be a good thing if, with his knowledge and masterly delivery, he would give a lecture merely on the formation and movements of the earth, for certainly there were many people at his lecture on the spectrum analysis of the stars of the Milky Way, especially among the women, who did not well know why night follows day and summer follows winter. The wise astronomer smiled as he answered, "Yes, it

would be a good thing, but it would be very difficult. To lecture on the spectrum analysis of the Milky Way is far easier."

And so it is in art. To write a rhymed poem dealing with the times of Cleopatra, or paint a picture of Nero burning Rome, or compose a symphony in the manner of Brahms or Richard Strauss, or an opera like Wagner's, is far easier than to tell a simple story without any unnecessary details, yet so that it should transmit the feelings of the narrator, or to draw a pencil-sketch which should touch or amuse the beholder, or to compose four bars of clear and simple melody, without any accompaniment, which should convey an impression and be remembered by those who hear it.

"It is impossible for us, with our culture, to return to a primitive state," say the artists of our time. "It is impossible for us now to write such stories as that of Joseph or the 'Odyssey,' to produce such statues as the Venus of Milo, or to compose such music as the folk-songs."

And indeed, for the artists of our society and day, it is impossible, but not for the future artist, who will be free from all the perversion of technical improvements hiding the absence of subject-matter, and who, not being a professional artist and receiving no payment for his activity, will only produce art when he feels impelled to do so by an irresistible inner impulse.

The art of the future will thus be completely distinct, both in subject-matter and in form, from what is now called art. The only subject-matter of the art of the future will be either feelings drawing men toward union, or such as already unite them; and the forms of art will be such as will be open to every one. And therefore, the ideal of excellence in the future will not be the exclusiveness of feeling, accessible only to some, but, on the contrary, its universality. And not bulkiness, obscurity, and complexity of form, as is now esteemed, but, on the contrary, brevity, clearness, and simplicity of expression. Only when art has attained to that, will art neither divert nor deprave men as it does now, calling on them to expend their best strength on it, but be what it should be—a vehicle wherewith to transmit religious, Christian perception from the realm of reason and intellect into that of feeling, and really drawing people in actual life nearer to that perfection and unity indicated to them by their religious perception.

Note
1. "The foundling of Nuremberg," found in the market-place of that town on 26th May, 1828, apparently some sixteen years old. He spoke little, and was almost totally ignorant even of common objects. He subsequently explained that he had been brought up in confinement underground, and visited by only one man, whom he saw but seldom.—Tr.

CHAPTER 3

Twentieth Century Aesthetics

Monroe C. Beardsley

*Presently Professor of Philosophy at Temple University in
Philadelphia, Monroe C. Beardsley is the author of* Aesthetics:
Problems in the Philosophy of Criticism *(1958) and* Aesthetics From
Classical Greece to the Present: A Short History *(1965).*

Twentieth Century Aesthetics

Aesthetics has never been so actively and diversely cultivated as in
the twentieth century. Certain major figures and certain lines of work
stand out.

METAPHYSICAL THEORIES. Though he later proposed two important
changes in his central doctrine of intuition, the early aesthetic theory of

Benedetto Croce has remained the most pervasively influential aesthetics of the twentieth century. The fullest exposition was given in the *Estetica come scienza dell' espressione e linguistica generale* ("Aesthetic as Science of Expression and General Linguistic," 1902), which is part of his *Filosofia dello spirito.* Aesthetics, in this context, is the "science" of images, or intuitive knowledge, as logic is knowledge of concepts—both being distinguished from "practical knowledge." At the lower limit of consciousness, says Croce, are raw sense data, or "impressions," which, when they clarify themselves, are intuitions, are also said to be "expressed." To express, in this subjective sense, apart from any external physical activity, is to create art. Hence, his celebrated formula, "intuition = expression," on which many principles of his aesthetics are based. For example, he argued that in artistic failure, or "unsuccessful expression," the trouble is not that a fully formed intuition has not been fully expressed but that an impression has not been fully intuited. R. G. Collingwood, in his *Principles of Art* (1938), has extended and clarified Croce's basic point of view.

The theory of intuition presented by Henri Bergson is quite different but has also been eagerly accepted by many aestheticians. In his view, it is intuition (or instinct become self-conscious) that enables us to penetrate to the *durée,* or *élan vital*—the ultimate reality which our "spatializing" intellects inevitably distort. The general view is explained in his "Introduction à la métaphysique" (1903) and in *L'évolution créatrice* (1907) and applied with great ingenuity and subtlety to the problem of the comic in *Le Rire* (1900).

NATURALISM. Philosophers working within the tradition of American naturalism, or contextualism, have emphasized the continuity of the aesthetic with the rest of life and culture. George Santayana, for example, in his *Reason in Art* (1903; Vol. IV of *The Life of Reason*), argues against a sharp separation of "fine" from "useful" arts and gives a strong justification of fine art as both a model and an essential constituent of the life of reason. His earlier book, *The Sense of Beauty* (1896), was an essay in introspective psychology that did much to restimulate an empirical approach to art through its famous doctrine that beauty is "objectified pleasure."

The fullest and most vigorous expression of naturalistic aesthetics is *Art as Experience* (1934), by John Dewey. In *Experience and Nature* (1925), Dewey had already begun to reflect upon the "consummatory" aspect of experience (as well as the instrumental aspects, which had previously occupied most of his attention) and had treated art as the "culmination of nature," to which scientific discovery is a handmaiden (see Ch. 9). *Art as Experience,* a book that has had incalculable influence on contemporary aesthetic thinking, develops this basic point of view. When experience rounds itself off into more or less complete and coherent strands of doing and undergoing, we have, he says, "*an* experience"; and such an experience is aesthetic to the degree in which attention is

fixed on pervasive quality. Art is expression, in the sense that in expressive objects there is a "fusion" of "meaning" in the present quality; ends and means, separated for practical purposes, are reunited, to produce not only experience enjoyable in itself but, at its best, a celebration and commemoration of qualities ideal to the culture or society in which the art plays its part.

A number of other writers have worked with valuable results along similar lines, for example, D. W. Prall, *Aesthetic Judgment* (1929) and *Aesthetic Analysis* (1936); C. I. Lewis, *An Analysis of Knowledge and Valuation* (1946, Chs. 14, 15); and Stephen C. Pepper, *Aesthetic Quality* (1937), *The Basis of Criticism in the Arts* (1945), *The Work of Art* (1955).

SEMIOTIC APPROACHES. Since semiotics in a broad sense has undoubtedly been one of the central preoccupations of contemporary philosophy, as well as many other fields of thought, it is to be expected that philosophers working along this line would consider applying their results to the problems of aesthetics. The pioneering work of C. K. Ogden and I. A. Richards, *The Meaning of Meaning* (1923), stressed the authors' distinction between the "referential" and the "emotive" function of language. And they suggested two aesthetic implications that were widely followed: first, that the long-sought distinction between poetic and scientific discourse was to be found here, poetry being considered essentially emotive language; second, that judgments of beauty and other judgments of aesthetic value could be construed as purely emotive. This work, and later books of Richards, have been joined by a number of aesthetic studies in the general theory of (artistic) interpretation, for example, John Hospers, *Meaning and Truth in the Arts* (1946); Charles L. Stevenson, "Interpretation and Evaluation in Aesthetics" (1950); Morris Weitz, *Philosophy of the Arts* (1950); and Isabel C. Hungerland, *Poetic Discourse* (1958).

Meanwhile, anthropological interest in classical and primitive mythology, which became scientific in the nineteenth century, led to another semiotical way of looking at art, particularly literature. Under the influence of Sir James G. Frazer's *The Golden Bough* (1890–1915), a group of British classical scholars developed new theories about the relations between Greek tragedy, Greek mythology, and religious rite. Jane Ellen Harrison's *Themis: A Study of the Social Origins of Greek Religion* (1912) argued that Greek myth and drama grew out of ritual. This field of inquiry was further opened up, or out, by C. G. Jung, in his paper "On the Relation of Analytical Psychology to Poetic Art" (1922; see *Contributions to Analytical Psychology,* 1928) and in other works. Jung suggested that the basic symbolic elements of all literature are "primordial images" or "archetypes" that emerge from the "collective unconscious" of man. In recent years the search for "archetypal patterns" in all literature, to help explain its power, has been carried on by many critics and has become an accepted part of literary criticism.

The most ambitious attempt to bring together these and other lines of inquiry to make a general theory of human culture ("philosophical

anthropology") is that of Ernst Cassirer. In his *Philosophie der Symbolischen Formen* (3 vols., 1923, 1925, 1929), the central doctrines of which are also explained in *Sprache und Mythos* (1925) and in *An Essay on Man* (1944), he put forward a neo-Kantian theory of the great "symbolic forms" of culture—language, myth, art, religion, and science. In this view, man's world is determined, in fundamental ways, by the very symbolic forms in which he represents it to himself; so, for example, the primitive world of myth is necessarily different from that of science or art. Cassirer's philosophy exerted a strong influence upon two American philosophers especially: Wilbur Marshall Urban (*Language and Reality,* 1939) argued that "aesthetic symbols" are "insight symbols" of a specially revelatory sort; and Susanne K. Langer has developed in detail a theory of art as a "presentational symbol," or "semblance." In *Philosophy in a New Key* (1942), she argued that music is not self-expression or evocation but symbolizes the morphology of human sentience and hence articulates the emotional life of man. In *Feeling and Form* (1953) and in various essays (*Problems of Art,* 1957), she applied the theory to various basic arts.

Charles W. Morris presented a closely parallel view in 1939, in two articles that (like Mrs. Langer's books) have been much discussed: "Esthetics and the Theory of Signs" (*Journal of Unified Science* [*Erkenntnis*], VIII, 1939–1940) and "Science, Art and Technology" (*Kenyon Review,* I, 1939; see also *Signs, Language and Behavior,* 1946). Taking a term from Charles Peirce, he treats works of art as "iconic signs" (i.e., signs that signify a property in virtue of exhibiting it) of "value properties" (e.g., regional properties like the menacing, the sublime, the gay).

MARXISM-LENINISM. The philosophy of dialectical materialism formulated by Karl Marx and Friedrich Engels contained, at the start, only the basic principle of an aesthetics, whose implications have been drawn out and developed by Marxist theoreticians over more than half a century. This principle is that art, like all higher activities, belongs to the cultural "superstructure" and is determined by sociohistorical conditions, especially economic conditions. From this it is argued that a connection can always be traced—and must be traced, for full understanding—between a work of art and its sociohistorical matrix. In some sense, art is a "reflection of social reality," but the exact nature and limits of this sense has remained one of the fundamental and persistent problems of Marxist aesthetics. Marx himself, in his *Contribution to the Critique of Political Economy* (1859), pointed out that there is no simple one-to-one correspondence between the character of a society and its art.

In the period before the October Revolution of 1917, Georgi V. Plekhanov (*Art and Social Life,* 1912) developed dialectical materialist aesthetics through attacks on the doctrine of art for art and the separation of artist from society, either in theory or in practice. After the Revolution, there ensued a period of vigorous and free debate in Russia among various groups of Marxists and others (e.g., the formalists, see below). It was

questioned whether art can be understood entirely in sociohistorical terms or has its own "peculiar laws" (as Trotsky remarked in *Literature and Revolution,* 1924) and whether art is primarily a weapon in the class struggle or a resultant whose reformation awaits the full realization of a socialist society. The debate was closed in Russia by official fiat, when the party established control over the arts at the First All-Union Congress of Soviet Writers (1934). Socialist realism, as a theory of what art ought to be and as a guide to practice, was given a stricter definition by Andrei Zhdanov, who along with Gorki became the official theoretician of art. But the central idea had already been stated by Engels (letter to Margaret Harkness, April 1888): the artist is to reveal the moving social forces and portray his characters as expressions of these forces (this is what the Marxist means by a "typical" character), and in so doing he is to forward the revolutionary developments themselves. (*See* also Ralph Fox, *The Novel and the People,* 1937; Christopher Caudwell, *Illusion and Reality,* 1937, and other works.)

Indications of recent growth in dialectical materialist aesthetics, and of a resumption of the dialogue with other systems, can be seen in the important work of the Hungarian Marxist Georg Lukács (see, for example, *The Meaning of Contemporary Realism,* translated, 1962, from *Wider den missverstandenen Realismus,* 1958) and in the writings of the Polish Marxist, Stefan Morawski (see "Vicissitudes in the Theory of Socialist Realism," *Diogenes,* 1962).

PHENOMENOLOGY AND EXISTENTIALISM. Among many critics and critical theorists, there has been, in the twentieth century, a strong emphasis on the autonomy of the work of art, its objective qualities as an object in itself, independent of both its creator and its perceivers. This attitude was forcefully stated by Eduard Hanslick in *The Beautiful in Music* (1854); it was reflected in the work of Clive Bell (*Art,* 1914) and Roger Fry (*Vision and Design,* 1920); and it appeared especially in two literary movements. The first, Russian "formalism" (also present in Poland and Czechoslovakia), flourished from 1915 until suppressed about 1930. Its leaders were Roman Jakobson, Victor Shklovsky, Boris Eichenbaum, and Boris Tomashevsky (*Theory of Literature,* 1925). The second, American and British "New Criticism," was inaugurated by I. A. Richards (*Practical Criticism,* 1929), William Empson (*Seven Types of Ambiguity,* 1930), and others (see René Wellek and Austin Warren, *Theory of Literature,* 1949).

This emphasis on the autonomy of the work of art has been supported by Gestalt psychology, with its emphasis on the phenomenal objectivity of Gestalt qualities, and also phenomenology, the philosophical movement first developed by Edmund Husserl. Two outstanding works in phenomenological aesthetics have appeared. Working on Husserl's foundations, Roman Ingarden (*Das Literarische Kunstwerk,* 1930) has studied the mode of existence of the literary work as an intentional object and has distinguished four "strata" in literature: sound, meaning, the

"world of the work," and its "schematized aspects," or implicit perspectives. Mikel Dufrenne (*Phenomenologie de l'expérience esthétique,* 2 vols., 1953), closer to the phenomenology of Maurice Merleau-Ponty and Jean-Paul Sartre, has analyzed the differences between aesthetic objects and other things in the world. He finds that the basic difference lies in the "expressed world" of each aesthetic object, its own personality, which combines the "being in itself" *(en-soi)* of a presentation with the "being for itself" *(pour-soi)* of consciousness and contains measureless depths that speak to the depths of ourselves as persons.

The "existential phenomenalism" of Heidegger and Sartre suggests possibilities for an existentialist philosophy of art, in the central concept of "authentic existence," which art might be said to further. These possibilities have only begun to be worked out, for example, in Heidegger's paper "Der Ursprung des Kunstwerkes" (in *Holzwege,* 1950) and in a recent book by Arturo B. Fallico, *Art and Existentialism* (1962).

EMPIRICISM. The contemporary empiricist makes a cardinal point of attacking the traditional problems of philosophy by resolving them into two distinct types of questions: questions about matters of fact, to be answered by empirical science (and, in the case of aesthetics, psychology in particular), and questions about concepts and methods, to be answered by philosophical analysis.

Some empiricists emphasize the first type of question and have called for a "scientific aesthetics" to state aesthetic problems in such a way that the results of psychological inquiry can be brought to bear upon them. Max Dessoir, Charles Lalo, Étienne Souriau, and (in America) Thomas Munro have formulated this program (see, especially, Munro's *Scientific Method in Philosophy,* 1928, and later essays). The actual results of work in psychology, over the period since Fechner inaugurated experimental aesthetics (*Vorschule der Ästhetik,* 1876) to replace "aesthetics from above" by an "aesthetics from below," are too varied to summarize easily. But two lines of inquiry have had an important effect on the way in which twentieth-century philosophers think about art. The first is Gestalt psychology, whose studies of perceptual phenomena and the laws of Gestalt perception have illuminated the nature and value of form in art (see, for example, Kurt Koffka's "Problems in the Psychology of Art," in *Art: A Bryn Mawr Symposium,* 1940; Rudolf Arnheim, *Art and Visual Perception,* 1954; Leonard Meyer, *Emotion and Meaning in Music,* 1956). The second is Freudian psychology, beginning with Freud's interpretation of Hamlet (*Interpretation of Dreams,* 1900) and his studies of Leonardo (1910) and Dostoyevsky (1928), which have illuminated the nature of art creation and appreciation. Description of aesthetic experience, in terms of concepts like "empathy" (Theodor Lipps), "psychical distance" (Edward Bullough), and "synaesthesis" (I. A. Richards), has also been investigated by introspective methods.

Analytical aesthetics, in both its "reconstructionist" and "ordinary language" forms, is more recent. This school considers the task of philo-

sophical aesthetics to consist in the analysis of the language and reasoning of critics (including all talk about art), to clarify language, to resolve puzzles due to misapprehensions about language, and to understand its special functions, methods, and justifications (see M. C. Beardsley, *Aesthetics: Problems in the Philosophy of Criticism,* 1958; Jerome Stolnitz, *Aesthetics and Philosophy of Art Criticism,* 1960; William Elton, ed., *Aesthetics and Language,* 1954; Joseph Margolis, ed., *Philosophy Looks at the Arts,* 1962).

Problems of Contemporary Aesthetics

Joseph Margolis

Joseph Margolis has taught in various universities in the United States and Canada, and is now Professor of Philosophy at Temple University. He has published a number of books, including The Language of Art and Art Criticism *(1965), and* Psychotherapy and Morality *(1966).*

Recent Work in Aesthetics

Recent contributions to the Anglo-American literature in aesthetics appear chiefly, though not exclusively, in the journals. And aesthetics itself concerns a very wide range of rather loosely related issues. It is

From *American Philosophical Quarterly*, Vol. 2, No. 3 (July 1965), pp. 182–190. Reprinted by permission. Revised by the author for inclusion in this book.

convenient, therefore, in canvassing the field, to bring together the most prominent or most instructive contributions on particular topics rather than to attempt to summarize systematically the work of particular authors.

An earlier vogue in aesthetics, of about the time of the appearance of Elton's anthology,[1] was distinctly concerned to oppose idealism and to exploit in a very general manner the new analytic currents informed principally by the inquiries of Wittgenstein. Since that time, idealism has somewhat declined as the inevitable opponent, with the withering away of the expression "theory of art," and analytic contributions have become more detailed in inquiries into critical language but have remained as eclectic as ever in their preference of philosophical models.

Of all the questions that fall within the range of aesthetics, those that concern the nature of criticism lend themselves to the most systematic ordering. Here, the principal topics include the description, interpretation, appreciation, and evaluation of works of art, the analysis of the characteristic predicates that are employed in critical remarks either by professionals or amateurs, and the very variety of functions that critical exchange is designed to serve—including for instance instruction and the exhibition of taste, the analysis and comparison of works of art. We may also include here questions regarding the relevance or lack of relevance of comments about perceivable properties of a work of art, or about the conditions of production of a given work, or biographical information about the artist, or about the sorts of responses of an aesthetic percipient. There is no way to organize the relevant discussion simply, but the issues themselves are clearly interrelated.

From the time of the appearance of Elton's collection, one may fairly say that the analysis of the language of criticism has been pursued against the background of Margaret Macdonald's [1954] and Arnold Isenberg's [1949] accounts. Both of these authors, each in his own way, have been intent on insisting that supporting evidence for a critical "verdict" about some work of art could not, in principle, be supplied so as to oblige another to accept that verdict. Neither wished to deny, in some sense, the relevance of supporting reasons for a judgment rendered, but Isenberg was inclined to argue that a critical judgment is at bottom a matter of taste or feeling and Macdonald argued that reasons supplied are rather more like the detailing or "presenting" of what it is one appreciates in a given work than the provision of decisive evidence. Both rather misleadingly speak of "verdicts," though it is clear that their accounts do not intend the term in its usual sense. The common tendency of their discussion is relatively widespread. For example, it has been reinforced, particularly where emotional or expressive qualities of works of art are in question, as by John Hospers [1959] and Henry Aiken [1945], so that it appears to infect the description of works of art. And, to the extent that the interpretation of works of art is construed in terms of preferences of taste, as in C. L. Stevenson's recent discussion [1962], critical judgments not overtly valuational in nature have been construed as not confirmable

in the usual way in which matters of fact are (following, in Stevenson's case, the well-known account of value judgments as inherently persuasive) [1944; 1950].

The tendency of discussions of these sorts (and they are by no means in agreement with one another) falls very nicely in accord with that first wave of reaction to G. E. Moore's account of good as a non-natural property, in the sense that valuationally significant predicates in the aesthetic setting are not admitted to designate the properties of any work of art. The Naturalistic Fallacy has gradually lost its fearsome aspect and theorists in aesthetics (as well as in ethics and allied fields) have found it possible to reconsider the ascription of these predicates as objectively confirmable. The traditional view of public canons for evaluation is upheld for example in Monroe Beardsley's *Aesthetics,* where it is maintained that criteria corresponding to such broad-gauge judgments as of "unity," "harmony," and "balance" may be explicitly formulated and employed; and even J. A. Passmore's critical paper shows that that author is prepared to support, contrary to the reader's first impression, objective valuational criteria, though not perhaps of the same gauge that Beardsley is confident may be provided. The analysis of relevant valuational usage in P. H. Nowell-Smith's *Ethics* marks more definitely the beginning of the recovery of objectively attributable predicates both in ethics and aesthetics, with a fuller appreciation of the variety of conditions on which these may be appropriately used. And the most sustained and distinctive account of narrowly aesthetic concepts has been supplied by Frank Sibley [1962]. Sibley maintains that characteristically aesthetic concepts, like "garish," "dainty," and the like, cannot be segregated into descriptive and valuational components and are in fact not condition-governed at all, as are, in a variety of ways which he details, other characterizing predicates. His account is original and challenging and has provoked an exchange [Schwyzer; Sibley, 1963] and comments. The puzzle remains that aesthetic qualities are taken to be perceivable, to be complex in the sense in which they depend on non-aesthetic qualities, but simple in the sense in which criteria for their occurrence cannot be specified. In this respect, Isabel Hungerland [1963] has relevantly argued that Sibley's principal specimen terms do not allow, in application, for a contrast between what only seems to be so and what is really so. The upshot is that the question remains whether (and in what sense) one may be said to perceive that an object may be characterized in the relevant ways as opposed to one's being entitled to attribute to an object a relevant predicate on the basis of one's own taste. Also, the question may be raised as to whether the so-called aesthetic concepts (in a reasonably generous sense of "aesthetic") do show a common (and this particular) logical pattern; Sibley himself concedes that there may be exceptions, and the analysis of important categories like the baroque and the tragic do not seem to be readily analyzable along the lines suggested. The baroque, in fact, has received considerable attention in recent years [Friedrich et al; Heyl, 1961]. Alternatively put, without a general theory of what is logi-

cally distinctive about aesthetic considerations as such and about what marks perceptual discriminations as such, there is no antecedently plausible reason why aesthetic concepts should, in general, behave as Sibley claims or why, for those that do so behave, they should be construed as perceptual distinctions. On the contrary, if what is of aesthetic interest is, more plausibly, of a logically mixed nature and if the "is"-"appears" contrast does not obtain (which holds for simple perceptual qualities, even where criteria of application—as distinct from criteria of having learned to apply perceptual terms—are lacking), there is every reason to construe the concepts in question as either not or not merely perceptual in nature.

The discussion of value judgments has, since Moore, increasingly turned away from an almost exclusive concern with the use of "good" to predicates that have significant descriptive force. That valuational terms are used in other than descriptive ways, for instance for commending purposes, is part of the permanent contribution of analysts like Nowell-Smith and R. M. Hare who have responded to Moore's challenge. But, more pointedly for aesthetics, the early confidence of a commentator like Helen Knight, who holds that there are formulable sets of criteria for all the characteristic uses of "good" in such phrases as "good showdog," "good novel," "good tennis racquet," "good landscape," does not seem to be readily supported. The objectivity of such judgments need not be in question in challenging the view that there are necessary and sufficient conditions on which these judgments rest that can be antecedently provided. Criticism characteristically does not, and as William Kennick [1958] argues, summarizing the accumulating evidence, need not work by applying rules to cases. A variety of analysts, chiefly in the ethical and legal spheres (for instance, Kurt Baier, Philippa Foot, H. L. A. Hart, have tried to recover the objectivity of particular valuational predicates.

It is clear, of course, that aesthetic judgments characteristically, though not exclusively, depend on one's taste in an intimate way. The Kantian division of aesthetic and moral values, recently revived in an ingenious form by Stuart Hampshire, may be shown to be untenable. Aesthetic and moral judgments may exhibit the same logical properties and, within each domain, there may well appear logically distinct types of judgment. The most general account showing that aesthetic and moral judgments cannot be viewed as merely separate genera of judgment may be found in J. O. Urmson's account. And Joseph Margolis [1965] has sought to show that value judgments are of at least two distinct logical types (ranging across both domains)—"findings," which logically behave the way factual judgments do, except that the categories employed are valuationally significant; and "appreciative judgments," which depend on our particular tastes (both are supportable and, though appreciative judgments are weaker than findings, they are not, for that reason, less objective). Generally speaking, the trend in value theory is very decidedly in favor of exploring the actual grounds, the relatively informal

grounds, on which relevant judgments are rendered. In a word, what has come to be called cognitivism in value theory has been revived compatibly with the positive contribution of Moore's early statements, though the issue may be viewed syntactically (that is, conditionally), by comparing the logical properties of value judgments and factual judgments, and epistemologically (that is, in terms of alleged cognitive faculties addressed to the discrimination of values) [Hirsch, 1971].

Special attention has been paid to so-called expressive qualities in a work of art. Traditionally, with the Idealists, these have been linked to an account of artistic creativity; alternatively, following the example of Santayana, they have been construed as a projection of the response of the aesthetic percipient. Varieties of these views may be found for example in Stephen Pepper [1938], and L. A. Reid [1931]. At the present time, along lines substantially in accord with Vincent Tomas' account [1962], expressive qualities are construed as confirmable in a public way and substantially freed from an account of creativity, even if (following Nowell-Smith) dispositions to affective response are relevant. The view has been somewhat opposed by Hospers [1959] and Aiken [1945], both of whom are inclined to view the relevant comments as personal and subjective; also by Beardsley, but (as in "The Affective Fallacy" [Wimsatt]) for the altogether different reason that aesthetic considerations are thought to preclude attention to affective responses. What may be said in general, conceding a variety of uses of expressive predicates, is that there is a substantial range of such predicates used in a genuinely characterizing way that do not behave in a manner significantly different from that of otherwise quite typical aesthetic concepts.

Another cluster of issues centers on the interpretive efforts of critics. Stevenson [1962], as already noted, conflates interpretive efforts with the expression of personal taste and the influence of others. He does not concern himself at all with the question of professional criteria relatively free of personal preference or with the distinction between evaluating a work of art and evaluating an interpretation of a work of art. The argument is, to this extent, unconvincing. A number of commentators have explored the issue of interpretation in ways that seem reasonably free of Stevenson's reductive view; and Stevenson himself, notably in *Ethics and Language* [1944], had been obliged to face a corresponding difficulty in construing technical criteria of truth and validity in science and logic as somehow not "normative." The weakness of the present argument corresponds with that symptomatic difficulty. Granting relatively clear-cut professional canons (admittedly somewhat informal), the discussion has moved along two distinct lines. Some theorists, notably Beardsley [1958] and Pepper [1955], have held that defensible interpretations of a work of art must all be ideally convergent, even if (as Beardsley would insist) that ideal interpretation cannot be supplied. Margolis has argued [1962], to the contrary, that, given a work of art whose describable properties are noted, it is possible in principle, though not always fruitful in practice, to provide defensibly plural, non-converg-

ing, even incompatible interpretations of a given work of art. Suggestions along this line may be found also in Macdonald [1952–53; 1954].

Finally, attention has been drawn, notably by Paul Ziff [1958], to the varieties of remarks, all bearing on the discriminable properties of a work of art, that may or may not in different ways be relevant to instructing another in what one may appreciate in a given work. Ziff introduces the useful concept of "aspection" and stresses the point that one cannot offer reasons to another for valuing a work that are avowedly personal, though such reasons will be personal. The thesis accords generally with the view that one's personal tastes are never, as such, reasons that weigh with another's judgment and appreciation. The confusion of taste and judgment (even appreciative judgment) may be found in Bernard C. Heyl [1943], [1946] and colors to a degree Isenberg's account [1949]. It may be useful to mention here that detailed analyses of appreciative exchange are comparatively rare, though there exists a tantalizing and inconclusive fragment of Ludwig Wittgenstein's lectures on aesthetics, largely focused on appreciation [1967].

There is, to consider a second run of issues, a cluster of classic questions about the literary arts, which, though they do not have any clear unity, are readily collected. The principal topics concern fiction and metaphor. Two symposia in the *Proceedings of the Aristotelian Society* [Braithwaite, et al; MacDonald and Scriven] have been particularly instructive about fiction. There we may see that an earlier concern had been the elimination of fictional entities from the real world, what may fairly be regarded as an extension of the attack on idealism launched by Moore and Bertrand Russell. The pivotal issue had been reference to characters in fiction; under the influence of linguistic analysis, discussion gradually settled on the fictional use of sentences. Discussants, therefore, all subscribe to the view, emphatically put by R. B. Braithwaite, that the required distinctions must be detailed within "one world," but there is considerable divergence about the logical properties of fictional sentences. Gilbert Ryle [Braithwaite et al.] had been strenuously criticized by Moore [ibid.] for thinking that fictional sentences might, by a fluke of chance, turn out to be true. But Ryle himself had held, correctly though perhaps not consistently, that fictional characterizations employ only "pseudo-predicates," and Moore's correction was itself decidedly ambiguous and even, in a way, a repetition of Ryle's mistake. For Moore uses locutions that cannot escape being construed as referring to fictional entities and he holds that what is given in the story is "false." Furthermore, Moore finds it necessary to cast the concept of a story as a set of statements that the author makes, and this leads him to speculate about authors' biographies in an altogether unnecessary way. The best account in these symposia is undoubtedly that of Margaret MacDonald [MacDonald and Scriven] who carefully distinguishes fiction from lies and falsehoods, construing it as an implicit conspiracy between reader and author in terms of which questions of truth and falsity are waived. A position very much like that of Ryle's, but stated even more positively,

is advanced by Beardsley who believes that a story may actually turn out to be true. But his account fails to distinguish, for instance, between the logical function of sentences used to tell a story and the reasons for which a court of law may choose to treat an account as a libel rather than as a fiction. The puzzles of reference in fiction may be resolved by distinguishing that use of sentences (which MacDonald discusses) by which we are to imagine a certain world to exist, from those uses, given the imaginary world, that correspond with all the uses eligible in the real world: the problem of reference is thereby reconciled with current discussions of the referring use of language. Still, there is no compelling reason to think, contrary to the insistence of Russell, Quine, Strawson, Searle, and others—however they disagree among themselves about the logic of reference—that we do not actually refer to fictional and imaginary entities (as in critical discourse). The issue opens on the large matter of replacing intentional discourse with extensional but non-intentional paraphrases.

But the problem of truth in fiction, and in literature in general, and even in art in general, has remained interesting. The most promising adjustment, in the setting of fiction, has involved an application of Moore's well-known account of a certain sort of implication. The concept has been explored, in a non-aesthetic context, most systematically by Isabel Hungerland [1960]. And, in the aesthetic context, it has been applied to fiction notably by Morris Weitz [1950] and John Hospers [1960] (who, in this respect, departs from his earlier views [1946]). The difficulties are of two sorts. For one, it is necessary to distinguish verisimilitude in a novel or fiction from the (so-called "contextually implied") truth of a fiction. Weitz's discussion shows the ease with which one may slide from a comparison of a fictional character or scene with elements of the real world (verisimilitude) to a detailing of propositions allegedly "implied" by the fiction itself. And for another, one must distinguish the view that a work of art is a clue to the artist's convictions from that which holds that the work of art somehow presents or "implies" statements that otherwise might have been asserted. Hospers' discussion shows the difficulty of distinguishing between our making inferences about the author's views from his fiction to discriminating those propositions that are "contextually implied" by the fiction itself. The real problem lying behind these discussions remains with the informality of the type of implication identified.

The principal questions regarding poetry concern metaphor and symbol, but symbol lends itself to a larger discussion involving all the arts. The two are confused as differences of degree rather than of kind by such literary theorists as Cleanth Brooks [Brooks and Warren]. Reasonable grounds for distinguishing the two are discussed in perhaps the most sustained account by Isabel Hungerland [1958]. The single most influential paper on metaphor is undoubtedly that of Max Black [1954–55]. Paraphrasability is generally regarded as the central issue. Beardsley, for instance, regards metaphor as a "significant attribution"

which, apart from its ornamental features, may be paraphrased by sing-
ling out the appropriate connotation and supplying attributions that may
be truly or falsely ascribed to the relevant object. Beardsley is inclined,
therefore, to associate metaphor with assertion and statement. Metaphor
thereby becomes more or less of a puzzle to be solved with ingenuity and,
in principle, paraphrasable. Paul Henle develops an iconic theory of
metaphor, which concerns both paraphrasability and the question of the
basis for a metaphoric invention. He is unable to distinguish metaphor
satisfactorily from catachresis (which at least Gustaf Stern, in his well-
known account, had warned about). Also, though he employs C. S. Peir-
ce's category of the iconic, Henle considerably strains Peirce's view of
the limits of iconic similarity. I. A. Richards [1936] had already consid-
ered grounds other than similarity as a basis for metaphor, and the
ubiquity of resemblances of all sorts suggests (the argument goes against
Andrew Ushenko as well) that mere resemblance can hardly explain
metaphor. Richards, incidentally, departing from Aristotle, had held
metaphor to be an essential feature of language. He has been followed
in this by a number of writers [Berggren; Foss], but most discussants treat
metaphor correctly as logically dependent on non-figurative uses of lan-
guage. In fact, the entire enterprise of paraphrase requires such a view.
Black adopts a moderate position, allowing for paraphrasability for cer-
tain sorts of metaphors but holding, in his most characteristic view—in
what he terms "the interaction view of metaphor"—that paraphrase
would involve a loss of "cognitive" content, that metaphor provides a new
insight into things. He views metaphor as a sort of "filter" through which
the world may be seen in a fresh light but which antecedent language
has not yet reached; "successful" metaphors will then decay in the man-
ner of catachresis. Margolis [1965] has argued that paraphrase is not so
much inadequate as irrelevant to metaphor, holding that metaphor is
primarily a "game" of language by which we deliberately deform things
and the use of characterizing terms so that we may play with things as
if they were the same or similar knowing that they are not; the purposes
of using metaphor and of paraphrasing language are at odds with one
another. This allows us to escape Black's view that metaphor has an
essentially cognitive function (associated with science) as well as the
puzzles of reference to non-existent entities.

About poetry in general, it may at least be said that I. A. Richards'
attempt [1935] to assign a distinctive logical or linguistic function to po-
etry has been largely abandoned. Some of the most inventive specula-
tions about alternative types of poetry (as well as of other types of
literature and of art) have been supplied by Susanne Langer [1953]. But
it seems, for instance, inappropriate to speak of poetry as contrasted with
fiction, if for no other reason than fictional tales are often told poetically.
This suggests considerations discouraging any simple generalization
upon the variety of things falling under the head of poetry. The key
distinction regarding symbols, as for instance discussed by Isabel Hun-
gerland [1958], concerns the need, in the setting of critical appreciation,

to construe actions, objects, remarks, and the like as symbolizing something not otherwise presented, whose recognition by the critic (or reader, viewer, listener—for symbols, unlike metaphors, are not peculiarly literary devices) permits the entire structure of the work to be grasped and formulated. In short, the appeal to symbols concerns the clarification of works of art whose explicit structure is otherwise puzzling and difficult to articulate. The question of the appropriateness of construing materials symbolically returns us once again to the procedures of critical interpretation and dramatizes the problem of identifying and neutrally describing works open to alternative interpretations [Margolis, 1965; Morgan].

There have appeared, also, in recent aesthetics, two quite strenuously debated but rather special issues. One concerns the so-called Intentional Fallacy; the other, the question of the definition of art. The first was prompted by the appearance of William Wimsatt and Monroe Beardsley's well-known paper [Wimsatt]; the second, by the appearance of Morris Weitz' discussion of the problem of definition [1956]. Regarding the first, Wimsatt and Beardsley had held that the artist's intentions were neither available nor aesthetically relevant (nor desirable) in the critical appreciation of literature (or, one is inclined to suppose, in the other arts). Their discussion is somewhat spoiled by altogether too mentalistic a view of intentions. The paper, for instance, has been interestingly criticized by Theodore Redpath [1957] who suggests reasonably that an artist's intention may be discovered without going outside the work itself. Also, the aesthetic relevance of an artist's intentions has been argued for by Hungerland [1955], Aiken [1955], and Eliseo Vivas [1955], among others. Furthermore, a careful reading of the original article will show that the artist's intentions are actually not taken to be necessarily unavailable or even irrelevant; what the authors insist on is that the artist's intention cannot be a privileged criterion by which to decide what a work means. The controversy is somewhat additionally complicated by the fact that Beardsley has since construed the problem as that of our being actually able to fix the artist's intention and of determining the extent to which a work produced falls short of such intention. But this appears to undermine very nearly the original thesis. On the other hand, the extreme thesis—associated with the hermaneutic tradition and perhaps best represented in the American literature by E. D. Hirsch [1967]—that the meaning of a literary piece may be uniquely fixed by authorial intent and that that intent may itself be reliably determined, is open to serious internal difficulties including a vicious circularity; for the author's intent is allegedly fixed by reference to the genre he employs and the genre is fixed by reference to his intent.

Weitz's discussion depends on his attempted application of Wittgenstein's well-known account of "family resemblances" to the concept of art. He argues that it is, in principle, not possible to define any "empirical" concept in terms of necessary and sufficient conditions. But there are difficulties with his view. For one thing, Wittgenstein in the passage in question does not preclude definition, but only shows that concepts

resting on "family resemblances" are readily usable. For another, Weitz finds that Aristotle's definition of tragedy is false, though not inappropriately formulated. And finally and most important, Weitz does not satisfactorily distinguish between the logical job of defining a concept and that of extending the use of a concept: he appears to foreclose on the possibility of the first by appealing to the implications of the second. He has, in these respects, been criticized by Margolis [1958]. But the appearance of his paper has undoubtedly drawn attention to ulterior uses of definition for the presentation of otherwise eligible aesthetic theories.

There are also several even more specialized controversies that are of some interest. For one, there is the matter of Susanne Langer's theory of symbolic forms. First formulated in *Philosophy in a New Key* [1942], it was decisively criticized by Ernest Nagel in a review. Langer had expanded her theory without satisfactorily meeting Nagel's objection, and in her most recent collections of essays [1957; 1962], she has more or less abandoned the designation "symbolic" for the distinction she has in mind. There has also been a lesser exchange regarding Stephen Pepper's concept of a work of art as a "nest of objects" [1952; 1955]. Pepper's principal critic in this regard has been Donald Henze. Criticism centers on the oddity of construing a work of art produced by an artist as a set of plural objects; the issue has implications for the objectivity and relevance of critical and appreciative remarks. There is a need to identify a work of art in order to fix the object of criticism and appreciation; and it is impossible to reduce a work of art to a physical object, on which identity depends [Hirsch, 1968]. But, as it happens, there is no need to fix the entire range of properties of works of art in order to determine identity and competing views about boundary properties correspond to views about converging and non-converging critical interpretations (already alluded to). Further distinctions about identifying works of art—largely concerning tokens, types, and classes have been recently and effectively canvassed by Richard Wollheim [1968]. Nelson Goodman has, in a recent and much-discussed book, *The Languages of Art* [1969], sought to distinguish between autographic and allographic art, that is, between works whose identity depends on the "history of production" and works whose identity depends on the provision of a "notational system" that does not permit "ambiguous characters or intersecting compliance-classes" (ambiguous reference, in short). But his argument founders if it is descriptive of actual practice; and all arts are to some extent autographic (which tolerate, without disadvantage, notational ambiguities); also, no natural languages and no notational scheme has been devised—or could, arguably, be devised—that would meet Goodman's severe requirements of "notationality"; again, identification (consistent with the transitivity of identity) does not require conformity with Goodman's demands.

Some of the most energetic controversies, in fact, have centered around some proposed definitions of a work of art. Mention may be made for example of Vivas' [1955; 1961] challenging the neo-Aristotelian definitions of the Chicago School [Crane] and of MacDonald's criticism [1951]

of Weitz's [1950] organismic theory of art (which he has acknowledged). Finally, the expression "theory of art" has been exploded, at least in the classic form in which Bernard Bosanquet had presented it—in the form in which one supposes that the artist's feelings have somehow gotten into the work of art itself. The continuing, but somewhat dwindling, criticism of this issue shows fairly clearly that it is something of a vestige. The best-known discussions of its weaknesses appear in Tomas [1962] and Hospers [1956; 1959]. The expression theory, of course, is simply the philosophically most interesting version of the various theories of artistic creativity. These latter are undoubtedly suggestive but are difficult to manage in more than an impressionistic manner, which may be readily seen by reviewing such authors as Benedetto Croce, John Dewey, C. J. Ducasse, and R. G. Collingwood, the latter of whom in many ways is the most explicit. Freudian and Marxist theories are very nearly useless—though they are obviously not irrelevant for criticism [Baier; Caudwell; Kris]—at least for the reason (almost explicitly conceded by Freud himself) that they are not focused on the artist's craft. Possibly the most sustained and suggestive (but surely curious and unmanageable) account is given by Jacques Maritain, who appears to combine Bergson and St. Thomas. There are also accounts of special aspects of the question of creativity in Milton Nahm, Paul Weiss, and Tomas, who has collected a small anthology of relevant papers [1964].

Interest has also centered on the nature of aesthetic experience and associated concepts. Earlier accounts had tended to draw attention to distinctive discriminations made possible by aesthetic orientation itself. L. A. Reid [1931], for instance, had argued that the expressive qualities of a work of art are simply projections of the response of an aesthetic percipient. Similar, though not entirely unequivocal, views have been put forward by Pepper [1938] who is inclined to hold that there are properties of a work of art not discriminable unless one takes an aesthetic attitude to the work in question; Ducasse also holds that there are distinctive qualities that can only be "ecpathized," that is, discriminated, if one adopts the aesthetic attitude. All such doctrines are closely akin to (though substantively distinct from) the views of such theorists as Edward Bullough and the empathists [Langefeld; Lee]. Bullough's thesis has been recently revived [Dawson] but the original difficulties of his doctrine have not been resolved—in particular, that the negative and positive scales of "distancing" have nothing in common, which upsets the "antinomy of distance," and that the doctrine is merely designed to favor certain special aesthetic values (as with the empathists as well). Tomas [1959] has attempted to hold that aesthetic discrimination attends only to "appearances," in an effort to assign a distinctive object to the aesthetic concern. His account has been criticized by Sibley [1959], for instance, who points to the anomalies to which this leads. Beardsley had committed himself to a view similar to Tomas'. Possibly the most ambitious effort to distinguish aesthetic perception from that sort of perception that obtains in science is offered by Virgil Aldrich [1958] who

contrasts "basic imagination" with "observation," which he takes to be fundamentally different aspects of perception. The problem remains that, admitting strikingly subtle perceptual discriminations in the aesthetic setting, it is difficult to see why these discriminations theoretically require a distinct "mode" of perception; Aldrich's illustrations [1963] do not seem to force us to hold the view he advances. Margolis [1960] has argued that there is no distinctive perceptual "mode" corresponding to aesthetic interest, though perception, imagination, memory, association, and the like play a number of distinct roles in the appreciation of a work of art. A similar view is advanced by George Dickie [1964]. Psychological explorations of aesthetic experience, it has been argued, both by Dickie [1962] and Morgan, have not been particularly productive. But the concept of the "perception" of a work of art is misleadingly unified and a whole host of special problems arise regarding all the conceivable "ingredients" of such perception. For instance, special questions arise even for visual perception, as in representational art—which have been discussed by Isenberg [1944], Ziff [1951], and Stevenson [1958]. The question of the appropriate sense in which one may be said to "perceive" literature had already been broached by David Prall, and has been more recently considered by Sidney Zink. And of course, as we have already seen, the discrimination of emotional and expressive qualities in a work of art has raised its own distinctive questions. The search for distinctive values, perceptions, and experiences in the aesthetic setting—instructively, for instance, in such different writers as Dewey and Vivas [1955; 1959] —may, not unreasonably, be regarded as vestigial remains of the original Kantian division between the aesthetic and the moral. One may say that, bit by bit, the basis for a clear and simple logical contrast between these two domains has been whittled away.

These, then, are the principal issues that have occupied the attention of aestheticians in recent years. They do not exhibit a ready unity, and very likely one cannot avoid in a survey of this sort favoring one set of issues rather than another. A selected bibliography is appended to offset, if possible, the inevitable incompleteness of the account.

Note
1. For references of this sort see the "List of Works Discussed" given at the end of the paper.

List of Works Discussed

Aiken, Henry
> 1945. Art as Expression and Surface. *Journal of Aesthetics and Art Criticism* 4.
> 1955. The Aesthetic Relevance of Artists' Intentions. *Journal of Philosophy* 52.

Aldrich, Virgil
> 1958. Picture Space. *Philosophical Review* 67.
> 1963. *Philosophy of Art.* Englewood Cliffs, N.J.

Arnheim, Rudolph
 1954. *Art and Visual Perception.* Berkeley and Los Angeles.
Baier, Kurt
 1958. *The Moral Point of View.* Ithaca.
Beardsley, Monroe
 1958. *Aesthetics.* New York.
Beardsley, Monroe and Herbert M. Schueller (eds.)
 1967. *Aesthetic Inquiry.* Encino, Cal.
Bedford, E.
 1966. Seeing Paintings. *Proceedings of the Aristotelian Society,* Sup-
 plementary Volume 50.
Berggren, Douglas
 1962–63. The Use and Abuse of Metaphor. *Review of Metaphysics* 16.
Berleant, Arnold
 1970. *The Aesthetic Field.* Springfield, Ill.
Black, Max
 1954–55. Metaphor. *Proceedings of the Aristotelian Society* 55.
Bosanquet, Bernard
 1915. *Three Lectures on Aesthetic.* London.
Braithwaite, R. B., Gilbert Ryle and G. E. Moore
 1933. Imaginary Objects. Symposium. *Proceedings of the Aris-
 totelian Society,* Supplementary Volume 12.
Brooks, Cleanth and Robert Penn Warren
 1949. *Modern Rhetoric.* New York.
Brown, Lee B.
 1969–70. Definitions and Art Theory. *Journal of Aesthetics and Art
 Criticism* 28.
Brunius, Teddy
 1969a. *David Hume on Criticism.* Uppsala, Pa.
 1969b. *Theory and Taste.* Uppsala, Pa.
Bullough, Edward
 1912–13. Psychical Distance as a Factor in Art and an Aesthetic Prin-
 ciple. *British Journal of Psychology* 5.
Caudwell, Christopher
 1937. *Illusion and Reality.* New York.
Charleton, W.
 1970. *Aesthetics.* London.
Collingwood, C. G.
 1938. *The Principles of Art.* London.
Crane, Ronald S. (ed.)
 1954. *Critics and Criticism, Ancient and Modern.* Chicago.
Croce, Benedetto
 1909. *Aesthetic.* New York.
Danto, Arthur C.
 1964. The Artworld. *Journal of Philosophy* 61.
Dawson, Sheila
 1961. Distancing as an Aesthetic Principle. *Australasian Journal of
 Philosophy* 39.

Dewey, John
 1934. *Art as Experience.* New York.
Dickie, George
 1962. Is Psychology Relevant to Aesthetics. *Philosophical Review* 71.
 1964. The Myth of the Aesthetic Attitude. *American Philosophical Quarterly* 1.
 1968. Art Narrowly and Broadly Speaking. *American Philosophical Quarterly* 5.
 1969. Defining Art. *American Philosophical Quarterly* 6.
Ducasse, C. J.
 1929. *The Philosophy of Art.* New York.
Elliott, R. K.
 1966–67. Aesthetic Theory and the Experience of Art. *Proceedings of the Aristotelian Society* 67.
Elton, William (ed.)
 1954. *Aesthetics and Language.* Oxford.
Foot, Philippa
 1958–59. Moral Beliefs. *Proceedings of the Aristotelian Society* 59.
Foss, Martin
 1942. *Symbol and Metaphor in Human Experience.* Princeton.
Freud, Sigmund
 1916. *Leonardo da Vinci.* New York.
Friedrich, Carl A., Bukofzer, Hatzfeld, Martin and Stechow
 1955. Articles on the Baroque. *Journal of Aesthetics and Art Criticism* 14.
Gombrich, E. H.
 1962. *Art and Illusion.* London.
Goodman, Nelson
 1969. *Languages of Art.* Indianapolis.
Grigg, Robert
 1970. The Constantinian Friezes: Inferring Intentions from the Work of Art. *British Journal of Aesthetics* 10.
Hampshire, Stuart
 1954. Logic and Appreciation. In Elton (ed.), op. cit.
Hare, R. M.
 1952. *The Language of Morals.* Oxford.
Harrison, Andrew
 1967–68. Works of Art and Other Cultural Objects. *Proceedings of the Aristotelian Society* 67.
Hart, H. L. A.
 1948–49. The Ascription of Responsibility and Rights. *Proceedings of the Aristotelian Society* 49.
Henle, Paul
 1958. Metaphor. In Paul Henle (ed.), *Language, Thought and Culture.* Ann Arbor.
Henze, Donald
 1955. Is the Work of Art a Construct? *Journal of Philosophy* 52.

Heyl, Bernard C.
 1943. New Bearings in Aesthetics and Art Criticism. New Haven.
 1945. Relativism Again. *Journal of Aesthetics and Art Criticism* 5.
 1961. Meanings of Baroque. *Journal of Aesthetics and Art Criticism* 19.
Hirsch, E. D.
 1967. *Validity in Interpretation.* New Haven and London.
 1968. On Disputes about the Ontological Status of Works of Art. *British Journal of Aesthetics* 8.
 1971. *Values and Conduct.* New York and Oxford.
Hobsbaum, P.
 1967. Current Aesthetic Fallacies. *British Journal of Aesthetics* 7.
Hofstadter, Albert
 1970. *Agony and Epitaph.* New York.
Hook, Sidney (ed.)
 1966. *Art and Philosophy.* New York.
Hospers, John
 1946. *Meaning and Truth in the Arts.* Chapel Hill.
 1956. The Croce-Collingwood Theory of Art. *Philosophy* 31.
 1959. The Concept of Artistic Expression (slightly revised). In Morris Weitz (ed.), *Problems in Aesthetics.* New York.
 1960. Implied Truths in Literature. *Journal of Aesthetics and Art Criticism* 19.
Hungerland, Isabel C.
 1955. The Concept of Intention in Art Criticism. *Journal of Philosophy* 52.
 1958. *Poetic Discourse.* Berkeley.
 1960. Contextual Implication. *Inquiry* 4.
 1962–63. The Logic of Aesthetic Concepts. *Proceedings and Addresses of the American Philosophical Association* 36.
Isenberg, Arnold
 1944. Perception, Meaning, and the Subject-matter of Art. *Journal of Philosophy* 41.
 1949. Critical Communication. *Philosophical Review* 58.
Kadish, Mortimer
 1968. *Reason and Controversy in the Arts.* Cleveland.
Kennick, William E.
 1958. Does Traditional Aesthetics Rest on a Mistake? *Mind* 67.
Kivy, Peter
 1968. Aesthetic Aspects and Aesthetic Qualities. *Journal of Philosophy* 65.
Knight, Helen
 1936. The Use of 'Good' in Aesthetic Judgments. *Proceedings of the Aristotelian Society* 36.
Kris, Ernst
 1952. *Psychoanalytic Explorations in Art.* New York.
Langer, Susanne
 1942. Philosophy in a New Key. Cambridge, Mass.
 1953. *Feeling and Form.* New York.

mini ✒ 1957. *Problems of Art.* New York.
 1962. On a New Definition of 'Symbol.' In Susanne Langer (ed.), *Philosophical Sketches.* Baltimore.
Langfeld, H. S.
 1920. *The Aesthetic Attitude.* New York.
Lee, Vernon
 1913. *The Beautiful.* Cambridge.
Lipman, Matthew
 1967. *What Happens in Art.* New York.
MacDonald, Margaret
 1951. Review of Weitz' 'The Role of Theory in Aesthetics.' *Mind* 60.
 1952–3. Art and Imagination. *Proceedings of the Aristotelian Society* 53.
 1954. Some Distinctive Features of Arguments Used in Criticism in the Arts (somewhat altered). In Elton (ed.), op. cit.
MacDonald, Margaret and Michael Scriven
 1954. The Language of Fiction. Symposium. *Proceedings of the Aristotelian Society,* Supplementary Volume 27.
Machamer, Peter K. and George W. Roberts
 1968–69. Art and Morality. *Journal of Aesthetics and Art Criticism* 26.
Maritain, Jacques
 1953. *Creative Intuition in Art and Poetry.* 1953.
Margolis, Joseph
 1958. Mr. Weitz and the Definition of Art. *Philosophical Studies* 9.
 1960. Aesthetic Perception. *Journal of Aesthetics and Art Criticism* 19.
 1962. The Logic of Interpretation. In Joseph Margolis (ed.), *Philosophy Looks at the Arts.* New York.
 1965. *The Language of Art and Art Criticism.* Detroit.
Meager, R.
 1966. Seeing Paintings. *Proceedings of the Aristotelian Society,* Supplementary Volume 40.
 1970. Aesthetic Concepts. *British Journal of Aesthetics* 10.
Mészáros, István
 1966–67. Metaphor and Simile. *Proceedings of the Aristotelian Society* 67.
Meyer, Leonard B.
 1956. Emotion and Meaning in Music. Chicago.
Mitchells, K.
 1966–67. Aesthetic Perception and Aesthetic Qualities. *Proceedings of the Aristotelian Society* 67.
Morgan, Douglas N.
 1950. Psychology and Art Today. *Journal of Aesthetics and Art Criticism* 9.
Nagel, Ernest
 1943. Review of Langer (1942) op. cit. *Journal of Philosophy* 40.
Nahm, Milton C.
 1956. *The Artist as Creator.* Baltimore.

66

Nowell-Smith, P. H.
 1954. *Ethics.* London.
Osborne, Harold
 1968a. *Aesthetics and Art Theory.* London.
 1968b. *Aesthetics in the Modern World.* London.
 1969a. Appreciation Considered as a Skill. *British Journal of Aesthetics* 9.
 1969b. On Artistic Illusion. *British Journal of Aesthetics* 9.
 1970. *The Art of Appreciation.* London.
Passmore, J. A.
 1951. The Dreariness of Aesthetics. *Mind* 60.
Patanker, R. B.
 1969. *Aesthetics and Literary Criticism.* Bombay.
Pepper, Stephen
 1938. *Aesthetic Quality.* New York.
 1952. Further Considerations of the Aesthetic Work of Art. *Journal of Philosophy* 49.
 1955. *The Work of Art.* Bloomington, Ind.
Pleydell-Pearce, A. G.
 1970. Objectivity and Value in the Judgments of Aesthetics. *British Journal of Aesthetics* 10.
Prall, David
 1936. *Aesthetic Analysis.* New York.
Redpath, Theodore
 1957. Some Problems of Modern Aesthetics. In C. A. Mace (ed.), *British Philosophy in the Mid-Century.* London.
Reid, L. A.
 1931. *A Study in Aesthetics.* London.
 1970. *Meaning in the Arts.* London.
Richards, I. A.
 1935. *Science and Poetry* (revised). London.
 1936. *The Philosophy of Rhetoric.* London.
Schaper, Eva
 1968. *Prelude to Aesthetics.* London.
Schwyzer, H. R. G.
 1963. Sibley's 'Aesthetic Concepts.' *Philosophical Review* 72.
Sibley, Frank
 1959. Aesthetics and the Looks of Things. *Journal of Philosophy* 56.
 1962. Aesthetic Concepts (with extensive minor corrections). In J. Margolis (ed.), *Philosophy Looks at the Arts.* New York.
 1963. Aesthetic Concepts: A Rejoinder. *Philosophical Review* 72.
 1967–68. Colors. *Proceedings of the Aristotelian Society* 68.
 1968. Objectivity and Aesthetics. *Proceedings of the Aristotelian Society,* Supplementary Volume 42.
Smith, Ralph A. (ed.)
 1970. *Aesthetic Concepts and Education.* Urbana, Ill.
Sparshott, F. E.
 1967. *The Concept of Criticism.* Oxford.

Stern, Gustaf
1932. Meaning and Change of Meaning. In *Gotesborgs Hogskolas Arsskrift* 38.

Stevenson, C. L.
1944. *Ethics and Language.* New Haven.
1950. Interpretation and Evaluation in Aesthetics. In Max Black (ed.), *Philosophical Analysis.* Ithaca.
1958. Symbolism in the Non-representative Arts. In Paul Henle (ed.), *Language, Thought, and Culture.* Ann Arbor.
1962. On the Reasons That Can be Given for the Interpretation of a Poem. In J. Margolis (ed.), *Philosophy Looks at the Arts.* New York.

Tanner, Michael
1968. Objectivity and Aesthetics. *Proceedings of the Aristotelian Society,* Supplementary Volume 42.

Tilghman, B. R.
1966. Aesthetic Perception and the Problem of the 'Aesthetic Object.' *Mind* 85.

Tomas, Vincent
1959. Aesthetic Vision. *Philosophical Review* 68.
1962. The Concept of Expression in Art (with minor corrections). In J. Margolis (ed.), *Philosophy Looks at the Arts.* New York.
1964. *Creativity in the Arts.* Englewood Cliffs, N.J.

Tormey, Alan
1971. *The Concept of Expression.* Princeton.

Urmson, J. O.
1957–58. What Makes a Situation Aesthetic? *Proceedings of the Aristotelian Society* 31.

Ushenko, Andrew
1955. Metaphor. *Thought* 30.

Vivas, Eliseo
1955. *Creation and Discovery.* New York.
1959. Contextualism Reconsidered. *Journal of Aesthetics and Art Criticism* 18.
1961. Animadversions on Imitation and Expression. *Journal of Aesthetics and Art Criticism* 19.

Wacker, Jeanne
1960. Particular Works of Art. *Mind* 69.

Walsh, Dorothy
1970. Aesthetic Concepts. *British Journal of Aesthetics* 10.

Weiss, Paul
1961. *The World of Art.* Carbondale, Ill.

Weitz, Morris
1950. *Philosophy of the Arts.* Cambridge, Mass.
1956. The Role of Theory in Aesthetics. *Journal of Aesthetics and Art Criticism* 15.

Wimsatt, W. K. Jr.
1954. *The Verbal Icon.* Lexington, Kentucky.

Wittgenstein, Ludwig
 1967. *Lectures and Conversations on Aesthetics, Psychology and Religious Belief,* edited by Cyril Barrett, Berkeley and Los Angeles.
Wollheim, Richard
 1963. Art and Illusion. *British Journal of Aesthetics* 3.
 1964. On Expression and Expressionism. *Revue Internationale de Philosophie* 18.
 1968. *Art and Its Objects.* New York.
 1970. Freud and the Understanding of Art. *British Journal of Aesthetics* 10.
Ziff, Paul
 1951. Art and the 'Object of Art.' *Mind* 60.
 1958. Reasons in Art Criticism. In I. Scheffler (ed.), *Philosophy and Education.* Boston.
 1966. *Philosophic Turnings.* Ithaca.
Zink, Sidney
 1945. The Poetic Organism. *Journal of Philosophy* 42.

Supplementary Bibliography

Aiken, Henry "A Pluralistic Analysis of Aesthetic Value," *Philosophical Review,* vol. 59 (1950).
——— "The Aesthetic Relevance of Belief," *Journal of Aesthetics and Art Criticism,* vol. 9 (1951).
——— "Some Notes Concerning the Aesthetic and the Cognitive," *Journal of Aesthetics and Art Criticism,* vol. 13 (1955).
Ames, Van Meter "John Dewey as Aesthetician," *Journal of Aesthetics and Art Criticism,* vol. 12 (1953).
Arnheim, Rudolph *Art and Visual Perception* (Berkeley and Los Angeles, 1954).
Aschenbrenner, Karl "Intention and Understanding," in *Meaning and Interpretation. University of California Publications in Philosophy,* vol. 25 (Berkeley, 1950).
——— "Aesthetic Theory—Conflict and Conciliation," *Journal of Aesthetics,* vol. 18 (1959).
——— "Critical Reasoning," *Journal of Philosophy,* vol. 57 (1960).
——— "Creative Receptivity," *Journal of Aesthetics and Art Criticism,* vol. 22 (1963).
——— and Isenberg, Arnold (eds.) *Aesthetic Theories: Studies in the Philosophy of Art* (Englewood Cliffs, N.J., 1965).
Beardsley, Monroe "Representation and Presentation: A Reply to Professor Dickie," *Journal of Philosophy,* vol. 58 (1961).
——— Morgan, Douglas N., and Mothersill, Mary "Symposium: On Arts and the Definition of Arts," *Journal of Aesthetics and Art Criticism,* vol. 20 (1961).
——— Schueller, Herbert M. (eds.) *Aesthetic Inquiry* (Belmont, 1969).
——— "The Metaphorical Twist," *Philosophy and Phenomenological Research,* vol. 22 (1962).

Berleant, Arnold *The Aesthetic Field* (Springfield, 1970).

Boas, George "The Problem of Meaning in the Arts," in *Meaning and Interpretation. University of California Publications in Philosophy,* vol. 25 (Berkeley, 1950).

───── *Wingless Pegasus* (Baltimore, 1960).

Brunius, Teddy *Theory and Taste* (Uppsala, 1969).

───── *David Hume on Criticism* (Uppsala, 1962).

Bullough, Edward *Aesthetics* (London, 1957).

Carver, G. A. *Aesthetics and the Problem of Meaning* (New Haven, 1952).

Cohen, Marshall "Appearance and the Aesthetic Attitude," *Journal of Philosophy,* vol. 56 (1959).

Crockett, Campbell "Psychoanalysis in Art Criticism," *Journal of Aesthetics and Art Criticism,* vol. 17 (1958).

Dickie, George "Design and Subject Matter: Fusion and Confusion," *Journal of Philosophy,* vol. 58 (1961).

Ducasse, C. J. "The Sources of the Emotional Import of an Aesthetic Object," *Philosophy and Phenomenological Import,* vol. 21 (1961).

Eveling, H. S. "Composition and Criticism," *Proceedings of the Aristotelian Society,* vol. 59 (1958–59).

Gallie, W. B. "Art as an Essentially Contested Concept," *Philosophical Quarterly,* vol. 6 (1956).

Garvin, Lucius "Emotivism, Expression, and Symbolic Meaning," *Journal of Philosophy,* vol. 55 (1958).

Gottshalk, D. W. "Aesthetic Expression," *Journal of Aesthetics and Art Criticism,* vol. 13 (1954).

Hampshire, Stuart *Feeling and Expression* (London, 1961).

Hannay, A. H., Holloway, John, and MacDonald, Margaret "What are the Distinctive Features of Arguments Used in Art Criticism?" (symposium), *Proceedings of the Aristotelian Society, Supplementary Volume XXIII* (1949).

Harré, R. "Quasi-Aesthetic Appraisals," *Philosophy,* vol. 33 (1958).

Harrison, Andrew "Poetic Ambiguity," *Analysis,* vol. 23 (1963).

Harrison, B. "Some Uses of 'Good' in Criticism," *Mind,* vol. 69 (1960).

Henderson, G. P. "An 'Orthodox' Use of the Term 'Beautiful'," *Philosophy,* vol. 35 (1960).

Henze, Donald "The Work of Art," *Journal of Philosophy,* vol. 54 (1957).

───── "The 'Look' of a Work of Art," *Philosophical Quarterly,* vol. 2 (1961).

Hepburn, Ronald W. "Literary and Logical Analysis," *Philosophical Quarterly,* vol. 8 (1958).

───── "Emotions and Emotional Qualities," *British Journal of Aesthetics,* vol. 1 (1961).

Heyl, Bernard C. "Artistic Truth Reconsidered," *Journal of Aesthetics and Art Criticism,* vol. 8 (1950).

Hoffman, Robert "Aesthetic Argument—Interpretive and Evaluative," *Philosophical Quarterly,* vol. 2 (1961).

Hofstadter, Albert "Art and Spiritual Validity," *Journal of Aesthetics and Art Criticism,* vol. 22 (1963).

—— and Kuhns, Richard (eds.) *Philosophies of Art and Beauty* (New York, 1964).

Hook, Sidney (ed.) *Art and Philosophy* (New York, 1966).

Hospers, John "Literature and Human Nature," *Journal of Aesthetics and Art Criticism,* vol. 17 (1958).

Hungerland, Helmut "The Aesthetic Response Re-considered," *Journal of Aesthetics and Art Criticism,* vol. 16 (1957).

Ingarden, Roman "Aesthetic Experience and Aesthetic Object," *Philosophy and Phenomenological Research,* vol. 12 (1961).

Isenberg, Arnold "The Esthetic Function of Language," *Journal of Philosophy,* vol. 46 (1949).

—— *Analytic Philosophy and the Study of Art* (privately circulated, 1950).

—— "The Problem of Belief," *Journal of Aesthetics and Art Criticism,* vol. 13 (1955).

Jenkins, Iredell "The Being and the Meaning of Art," *Review of Metaphysics,* vol. 14 (1961).

Jessup, Bertram "Taste and Judgment in Aesthetic Experience," *Journal of Aesthetics and Art Criticism,* vol. 19 (1960).

Kadish, Mortimer R. and Hofstadter, Albert "Symposium: The Evidence for Esthetic Judgment," *Journal of Philosophy,* vol. 54 (1957).

Kaplan, Abraham "Obscenity as an Esthetic Category," in Sidney Hook (ed.), *American Philosophers at Work* (New York, 1956).

—— and Kris, Ernst "Esthetic Ambiguity," *Philosophy and Phenomenological Research,* vol. 8 (1948).

—— "Referential Meaning in the Arts," *Journal of Aesthetics and Art Criticism,* vol. 12 (1954).

Kennick, William E. "Art and the Ineffable," *Journal of Philosophy,* vol. 58 (1961).

—— (ed.) *Art and Philosophy* (New York, 1964).

Khatchadourian, Haig "Works of Art and Physical Reality," *Ratio,* vol. 2 (1960).

—— "Art-names and Aesthetic Judgments," *Philosophy,* vol. 36 (1961).

Kristeller, Oscar "The Modern System of the Arts: A Study in the History of Aesthetics," *Journal of the History of Ideas,* vol. 12 (1951); vol. 13 (1952).

Kuhns, Richard "Criticism and the Problem of Intention," *Journal of Philosophy,* vol. 57 (1960).

—— "Art Structures," *Journal of Aesthetics and Art Criticism,* vol. 19 (1960).

Langer, Susanne K. (ed.) *Reflections on Art* (Baltimore, 1958).

Levich, Marvin (ed.) *Aesthetics and the Philosophy of Criticism* (New York, 1963).

Margolis, Joseph "The Identity of a Work of Art," *Mind,* vol. 67 (1959).

──── "Describing and Interpreting Works of Art," *Philosophy and Phenomenological Research,* vol. 22 (1961).

──── "Rejoinder to W. D. L. Scobie on 'The Identity of a Work of Art'," *Mind,* vol. 70 (1961).

──── (ed.) *Philosophy Looks at the Arts* (New York, 1962).

──── "Creativity, Expression, and Value Once Again," *Journal of Aesthetics and Art Criticism,* vol. 22 (1963).

Mayo, Bernard "Art, Language, and Philosophy in Croce," *Philosophical Quarterly,* vol. 5 (1955).

Morgan, Douglas "The Concept of Expression in Art," in *Science, Language, and Human Rights* (Philadelphia, 1952).

──── "Creativity Today," *Journal of Aesthetics and Art Criticism,* vol. 12 (1953).

──── "Icon, Index and Symbol in the Visual Arts," *Philosophical Studies,* vol. 6 (1955).

Mothersill, Mary " 'Unique' as an Aesthetic Predicate," *Journal of Philosophy,* vol. 57 (1961).

──── "Critical Reasons," *Philosophical Quarterly,* vol. 2 (1961).

Nahm, Milton C. "The Philosophy of Aesthetic Expression: The Crocean Hypothesis," *Journal of Aesthetics and Art Criticism,* vol. 13 (1955).

Osborne, Harold *Theory of Beauty* (London, 1952).

──── *Aesthetics and Criticism* (London, 1955).

Pepper, Stephen C., and Potter, Karl "The Criterion of Relevancy in Aesthetics: A Discussion," *Journal of Aesthetics and Art Criticism,* vol. 16 (1957).

Pole, David "Varieties of Aesthetic Experience," *Philosophy,* vol 30 (1955).

──── "Morality and the Assessment of Literature," *Philosophy,* no. 37 (1962).

Price, Kingsley B. "Is There Artistic Truth?" *Journal of Philosophy,* vol. 46 (1949).

Purser, J. W. R. *Art and Truth* (Glasgow, 1957).

Quinton, A. M. and Meager, Ruby "Tragedy" (symposium), *Proceedings of the Aristotelian Society, Supplementary Volume XXXIV* (1960).

Rader, Melvin (ed.) *A Modern Book of Esthetics* (New York, 1960, 3d ed.).

Rudner, Richard "The Ontological Status of the Esthetic Object," *Philosophy and Phenomenological Research* (1950).

──── "On Semiotic Aesthetic," *Journal of Aesthetics and Art Criticism,* vol. 10 (1951).

──── "Some Problems of Nonsemiotic Aesthetic Theories," *Journal of Aesthetics and Art Criticism,* vol. 15 (1957).

Saw, Ruth "Sense and Nonsense in Aesthetics," *British Journal of Aesthetics,* vol. 1 (1961).

──── "What Is a 'Work of Art'?" *Philosophy,* vol. 36 (1961).

──── and Osborne, Harold "Aesthetics as a Branch of Philosophy," *British Journal of Aesthetics,* vol. 1 (1960).

Scobie, W. D. L. "Margolis on 'The Identity of a Work of Art', " *Mind,* vol. 69 (1960).

Sesonske, Alexander "Truth in Art," *Journal of Philosophy,* vol. 53 (1956).

Sparshott, Francis "Mr. Ziff and the 'Artistic Illusion', " *Mind,* vol. 61 (1952).

—— *The Structure of Aesthetics* (Toronto, 1963).

Stevenson, C. L. "On 'What Is a Poem'?" *Philosophical Review,* vol. 66 (1957).

—— "On the 'Analysis' of a Work of Art," *Philosophical Review,* vol. 67 (1958).

Stolnitz, Jerome "Notes on Comedy and Tragedy," *Philosophy and Phenomenological Research,* vol. 16 (1955).

—— "On Objective Relativity on Aesthetics," *Journal of Philosophy,* Vol. 57 (1960).

—— *Aesthetics and Philosophy of Art Criticism* (Cambridge, Mass., 1960).

—— "Some Questions Concerning Aesthetic Perception," *Philosophy and Phenomenological Research'* vol. 22 (1961).

—— "On the Origins of 'Aesthetic Disinterestedness," *Journal of Aesthetics and Art Criticism,* vol. 20 (1961).

—— " 'Beauty': History of an Idea," *Journal of the History of Ideas,* vol. 23 (1961).

Tejera, V. "The Nature of Aesthetics," *British Journal of Aesthetics,* vol. 1 (1961).

Tomas, Vincent "Ducasse on Art and its Appreciation," *Philosophy and Phenomenological Research,* vol. 13 (1952).

—— "Creativity in Art," *Philosophical Review,* vol. 67 (1958).

Tsugawa, Albert "The Objectivity of Aesthetic Judgments," *Philosophical Review,* Vol. 70 (1961).

Ushenko, Andrew P. *Dynamics of Art* (Bloomington, Ind., 1953).

—— "Pictorial Movement," *British Journal of Aesthetics,* vol. 1 (1961).

Vivas, Eliseo and Krieger, Murray (eds.) *The Problems of Aesthetics* (New York, 1953).

—— *The Artistic Transaction and Essays on the Theory of Literature* (Columbus, Ohio, 1963).

Walsh, Dorothy "Critical Reasons," *Philosophical Review,* vol. 69 (1960).

Weiss, Paul *Nine Basic Arts* (Carbondale, Ill., 1961).

—— *Religion and Art* (Milwaukee, 1963).

Weitz, Morris (ed.) *Problems in Aesthetics* (New York, 1959).

—— *Philosophy in Literature* (Detroit, 1963).

—— "Symbolism and Art," *Review of Metaphysics,* vol. 7 (1964).

Welsh, Paul "Discursive and Presentational Symbols," *Mind,* vol. 64 (1955).

—— "On Explicating Metaphors," *Journal of Philosophy,* vol. 60 (1963).

Wheelwright, Philip *The Burning Fountain* (Bloomington, Ind., 1954).

Wollheim, Richard "Art and Illusion," *British Journal of Aesthetics,* vol. 3 (1963).

Zerby, Lewis K. "A Reconsideration of the Role of Theory in Aesthetics—A Reply to Morris Weitz," *Journal of Aesthetics and Art Criticism,* vol. 16 (1957).

Ziff, Paul "The Task of Defining a Work of Art," *Philosophical Review,* vol. 63 (1953).

——— "On What a Painting Represents," *Journal of Philosophy,* vol. 57 (1960).

——— *Philosophic Turnings* (Ithaca, 1966).

Zink, Sidney "Is the Music Really Sad?" *Journal of Aesthetics and Art Criticism,* vol. 19 (1960).

Victorino Tejera

Victorino Tejera is the author of Art and Human Intelligence. *He teaches philosophy at the State University of New York, Stony Brook.*

Contemporary Trends in Aesthetics: Some Underlying Issues

"Nous nous reconnaissons humblement plus près de l'esprit artisanal que de l'esprit scientifique."

G. Morpurgo-Tagliabue

One of the interesting claims with which the most doctrinally and methodologically diverse thinkers would probably all agree, today, is the view that "the basis for a clear and simple logical contrast between . . . the aesthetic and the moral . . . domains has been whittled away," as J. Margolis puts it.[1] But, while agreeing to the dissipation or modulation of the distinction, they would certainly not all agree to the modification in the sense intended by Margolis. For one thing, they have not all inherited the distinction as a question from Kant. This is because the division

This essay was written expressly for inclusion in the present volume.

is not original with Kant, as Margolis strangely says; Aristotle had already formulated it as a difference reflected in the arts (or sciences) of the practical and the sciences (or arts) of production. For another, the Analytic trends of which Margolis speaks mediate the distinction mentioned within a framework which on the whole not only preserves but emphasizes the distinction between the sciences (in the Neopositivist sense of science) and scientific discourse, on one hand, and the arts and discourse about them, on the other. But Dewey, for example, can concede the distinction between the aesthetic and the moral in some senses only because he has gone so far in showing how mistaken is the alleged distinction between theory and science, on the one hand, and practice and production on the other. Furthermore, even those of us more interested in agreement than disagreement will have to grant that there is a vast difference between assimilating the aesthetic and the moral to each other as a consequence of a conception which says that philosophy is applied logic, and as a consequence of the assumption that there are other valid and more powerful paradigms for philosophical activity than logical activity (in the deductivist sense of logical). Finally, many of the aesthetic philosophers not mentioned by Margolis who would agree to minimizing the moral-aesthetic distinction, continue to take art and the arts as their primary subject matter, while the trends Margolis is talking about minimize the distinction as a function of their practice of taking the language (i.e. English) in which art is discussed or criticized as their major concern or primary subject matter.

This difference in what contemporary aestheticians take to be their subject matter is, indeed, one of the great underlying divides in the current pursuit of aesthetics. But the conception of its subject matter is less constitutive, in this case, of the style of aesthetic philosophizing than the basic paradigms or models of discourse and inquiry which guide (or are operative in) the different philosophical styles. Thus, rather than taking their methodological cues from their particular subject matter (works of art, human creativity), some writers on aesthetics have continued to apply ready-made distinctions and unquestioned assumptions that have seemed to work for them in other fields of inquiry. Notable among these has been Wittgenstein [2] who believed that appreciation requires an explicit knowledge of the system of rules which the work of art can be seen to be following, and who conceived of criticism as the detection and correction of blemishes. The model here seems to have been the technologist's examination of a predesigned machine of mathematizable structure. Or perhaps it was the teacher's detection of a learner's mistakes in following the rules of perspective drawing or those of a system of musical harmony. But in the case of art, constructive corrections can be performed only by the artist himself [3] as he proceeds with the creation of his art work. Nor is this anything like what a critic of art or literature actually does when confronting a work of art. If a critic or appreciator *really could* instruct the artist how to do his job in the way a knowledgeable gentleman of fashion might instruct his tailor (Wittgenstein's anal-

ogy), then the knowledgeable art forger would seldom be detected.[4]

There is, however, a sense in which even aesthetics of this sort can be said to be following the leads of its subject matter, if this is granted to be language (rather than art). The only trouble is, again, that this sort of aesthetics is based on, or goes with, what I will call a propositional conception of language. This is the conception which takes scientific or "informational" discourse as the primary form, and as the model which (with the logical form it can be given) serves as a standard for all other forms of discourse; so much so that, in an earlier day, such other forms as poetic discourse and ethical discourse were sweepingly declared (really, stipulated) to be not statements at all, but pseudo-statements. Now, while the propositional model of language is no longer invoked with such naiveté, it has nonetheless continued to be operative in much contemporary aesthetics. Especially interesting areas in which this underlying model seems to have had a negative effect are (1) in the philosophical development and use of the concept of "expression," and (2) in making the fruitful analogy between "art" and "language" one that advances our understanding of both.

Remarkably enough, one can find in this connection (and in English language works alone) thinkers who represent the various possible positions. Thus Nelson Goodman (*Languages of Art,* Bobbs Merrill, N.Y. 1968) is implicitly using the analogy, though he is primarily interested in propositional discourse and in language as a notational system. But Arnold Berleant (*The Field of Aesthetics,* C. Thomas, Springfield 1970), who is mainly interested in the moral and literary forms of discourse, rejects the analogy between art and language propositionally conceived. E. H. Gombrich (*Art and Illusion,* Pantheon Books, N.Y. 1961) has systematically illuminated the history of styles by invoking the analogy between art and language expressively conceived, as an exercise in applied aesthetics. V. Tejera (*Art and Human Intelligence,* Appleton Century Crofts, N.Y. 1965) has given some development to the analogy as part of the foundations of aesthetics, and in the context of a philosophy of language which takes expressive action language as the matrix from which the more specialized forms are precipitates. The philosophical foundations of this view of language are developed by J. H. Randall in "The Art of Language and the Linguistic Situation: A Naturalistic Analysis," (*Journal of Philosophy LX,* 1963). Interestingly, Randall's anthropological and historical sense of the experiential and social rootedness of communicability convincingly overlaps with recent phenomenological inquiry into language and art (see below). Whitehead, whose claim that a work of art is a proposition has been much refuted, should perhaps be reexamined by those interested in this area, whether he meant it literally or not. Perhaps Whitehead's understanding of language is not as "propositional" as the propositional theorists think; perhaps he meant that the abstracting done by a work of art is in some respects like the abstracting performed by a proposition or that, like any verbal proposal, art works make a determination in reality—as Justus Buchler has put it.[5] In a word,

there seems to exist in our time a latent general agreement (in spite of all other differences) that the analogy is a bad one if language is thought of exclusively on the model of scientific discourse, but that it is a good one when the full range of man's linguistic powers and language activities is suitably ordered and selected from. As a relevant word, I will venture to put on record here the agreement elicited in conversation from the leading propositional theorist P. F. Strawson, that it is a confusion to identify the theory of propositions with the philosophy of language and that the two should, therefore, be explicitly distinguished.

It can, in fact, be said that the thing American aesthetics would in the end most benefit from is just this: a fully developed, unclosed, and responsive philosophy of language which takes into account the mass of evidence about language and its behavior to be found in poetry and the study of poetry, in literature and literary criticism, in rhetoric and politics, in prayer and purely oral traditions, in magic, ritual, folklore, and drama, in myth and the language of myth, in historical and comparative linguistics, in the study of semantic and iconological change, in structural linguistics, prosody, and stylistics. In the meantime, it is to the works in aesthetics which have sought a fuller experiential confrontation and involvement with art that we must turn, today, for light on such concepts as "expression," "dramaticity" and "metaphor," "technique" and "discovery," "form" and "formativity," "humanity" and "spirituality," "truth" and "being," and the uses which these concepts can have in clarifying the practice, the enjoyment, and the understanding of art. Here the work in this country of S. K. Langer, R. Arnheim, and V. Tejera, stemming respectively from Cassirer, Gestalt psychology, and Dewey, immediately comes to mind. But the very suggestive aesthetics of Heidegger, its development by Albert Hofstadter, and the rich vein of work by the Italians should emphatically be included.[6]

Very roughly (and from a historical point of view), S. K. Langer can be said to have taken Cassirer's system-embedded concept of the symbol and developed it (along lines which emphasize the continuity between feeling and thought) into a conception of symbolic action as dynamic form-realization in response to man's basic need for such things as ritual, rhythm, dramaticity, mutuality, play, inwardness, vital order, and adjustment. Of special value here is her work on the relation between emotion, abstraction, and expression. In his analysis of these concepts in Aristotle and Dewey, Tejera arrives at a dissolution of the dichotomies between thought and feeling, between cognitive construction and expressive construction, and between judgment and appreciation. Arnheim, meanwhile, can be seen to have given specific development to the ideas of Gestalt psychology and its philosophy of form (derived from Husserl), in the light of his careful attention to the details of the dianoetic and perceptual processes (mainly the visual ones) by which we accept and constitute our world and construct and respond to our art (see also his earlier *Art and Visual Perception,* 1964).

Thus, with little risk of overstatement, the situation in recent aes-

thetics can so far be characterized as one in which what philosophical writers have been giving us is either overwhelmingly a consequence of their previous philosophical style, or else it is a consequence of the depth of their openness to art in its ramified involvement with the human condition—or, of course, it is a combination of both. But these alternatives by no means constitute a truism, if it is also intended by advancing them that what matters most (at this juncture of our intellectual history) is how much the observer has been *induced to develop or reconstruct* his habitual formulations by *his experience of art* or by the perception of the human condition *which art has instigated* in him.

That it is not impossible to develop a substantive and persuasive aesthetic from a previously given philosophical approach is proved by the long (and strictly scholastic) discourse on the beautiful by Stephen Daedalus in James Joyce's *Portrait of the Artist as a Young Man.* But the condition of Joyce's success here was his own passionate involvement with art and literature (at the corresponding stage in his career). Thus we need not call on, or expect, philosophers passionately attached to a previous style of philosophizing to abandon that style as a condition of their contributing substantively to the understanding, practice, or enjoyment of art. We need only call on them to become more deeply involved with some of the arts and more willing, philosophically, to understand the arts from which they are generalizing in terms of the practitioners' productive premises and in terms of the whole history to date of those arts—rather than in the external terms of a rival discipline alien to the creators in the arts.

Likewise, we should not be too pessimistic if even the most useful of the aesthetics mentioned in this survey have not yet been fully responsive to all of the newest developments in the arts today. It is only a matter of time before they will be. Some are already working on such problems as the maximization of our consciousness of ugliness in modern art, on "contradiction," ambiguity, dissonance, chance, and "the point of view" in art. Others, starting from Camus and Sartre (who were both politically involved and artists in their own right), are extending our understanding of the role of art in society and of the pervasiveness of the aesthetic factor in the tragedy and venture which is the human condition. It is not always the aesthetics that are somewhere fashionable that are most relevant to the problems of creativity at a given time. But it is certainly the practice of the creative workers of a time which gives direction to the changes which aesthetic theories undergo. But it has not been beyond the capacity of some philosophers to give a better formulation than they at first received to such theoretical responses to real innovation in the arts.

In sum, and limiting ourselves to the recent past,[8] the aesthetics of the last twenty years which has addressed itself to the arts, to human ingenuity, or to the human condition has (as philosophy) been mainly influenced by Cassirer (and Croce), Dewey (and Santayana), Heidegger (and Husserl), Camus and Sartre; while those which have been an attempt to extend previously developed philosophical techniques to the

arts can be seen to stem at some removes from a Machian or Neopositivist conception of the sciences and the logistic formalization of logic. Here the recent ancestors have been Moore (and Russell), Carnap, Wittgenstein, Austin (and the early I. A. Richards), and Ryle. The art-oriented philosophers have yet to confront the sciences as they are actually and creatively practiced, and to assimilate this practice to some corrigible conception of art and human ingenuity. The self-styled "linguistic" philosophers still have a lot to learn about the nature of discourse outside of the deductive sciences; and perhaps they too could benefit from a deep look at the sciences as creative processes rather than sets of contextless theoretical claims. Perhaps the growing interest in the social sciences and in social and political philosophy will provide the stimulus for understanding even the natural sciences as time-bound cultural products and, hence, as instances of art or distinctively human and social ingenuity.

Notes

1. "Recent Work in Aesthetics," *American Philosophical Quarterly* 2 (July 1965): 182–190. See pp. 51–75 of this volume. The benign reader will not be perturbed to note that by "Anglo-American" Margolis really and exclusively means what is called "analytic" philosophy. There are a number of analytic philosophers who are neither English nor American, and many American philosophers (including Latin Americans) who are not analytic in Margolis' special sense.

2. C. Barrett, ed., *Lectures and Conversations on Aesthetics, Psychology, and Religious Belief* (Oxford: Blackwell, 1966).

3. And this is a job which the artist does on the basis of his own implicit or emergent aesthetic, i.e. of his implicit or developing working premises as they relate to his executive or exploratory powers.

4. See Harold Osborne, "Wittgenstein on Aesthetics," *British Journal of Aesthetics* 6 (1966) for a more detailed discussion of just these issues. Osborne's work in aesthetics, by the way, and what he has done for the field in the last twenty years, has yet to receive the recognition it deserves.

5. *Towards a General Theory of Human Judgment* (New York: Columbia University Press, 1951). For Whitehead, see D. Sherburne, *A Whiteheadian Aesthetic* (New Haven: Yale University Press, 1961).

6. *Philosophy in A New Key, Feeling and Form, Philosophical Sketches, Problems of Art*, by S. K. Langer; *Visual Thinking* (1969) by R. Arnheim; *Art and Human Intelligence* by V. Tejera; *Der Ursprung des Kunstwerkes* (1936, published 1951) by Martin Heidegger; *Truth and Art* by A. Hofstadter (1964); A. Banfi, *Vita dell'arte* (1946); E. Paci, *Esistenza e immagine* (1948), *La mia perspettiva estetica* (1953); D. Formaggio, *Fenomonologia della tecnica artistica* (1953); Cesare Brandi, *Carmine, ou de la peinture* (1947), *La fine dell'avanguardia e l'arte d'oggi* (1949); G. Morpurgo-Tagliabue, *Il concetto dello stile* (1951), *L'evoluzione della critica figurativa contemporanea* (1951); M. Campo, "La dialletica dei sentimenti e l'estetica," *Rivista d'Estetica*

(1957); Luigi Pareyson, *Esistenza e persona* (1950), *Esthétique, théorie de la formativité* (1954); N. Abbagnano, *Esistenzialismo positivo* (1948), "L'arte e il ritorno alla natura," *Introduzione all'esistenzialismo* (1942), "Arte, linguaggio, societa," *Comprendere,* no. 4 (1951). A good guide to the resources of Italian and European aesthetics is G. Morpurgo-Tagliabue's *L'Esthétique contemporaine* (Milan, Italy: Mazorati, 1960). M. Dufrenne's *Phenomenologie de l'experience esthétique* (1953) should be taken into account. His countryman E. Sourieau belongs perhaps with the older generation of socially conscious thinkers, like Sartre; see his "L'art est-il un langage?" *Rivista di Estetica,* no. 13 (1963). For J. P. Sartre and A. Camus, see my chapter on "Existentialism and Art," op. cit.

7. Kenneth Burke, the literary theorist, is very relevant here for his work on art as symbolic action in *The Philosophy of Literary Form* (1941), *A Grammar of Motives* (1945), and *Rhetoric of Motives* (1950). Ivor Winters has a good discussion (*In Defense of Reason,* 1947) of poetry as a process of adjustment between thought (the motive) and feeling (the emotion). The literary critic from whom philosophers should have learned more is not so much I. A. Richards as William Empson (*Seven Types of Ambiguity,* 1947, and *The Structure of Complex Words,* 1957).

8. Also excluding work in the Slavic languages.

PART TWO

What Is a Work of Art?

Introduction

A striking characteristic of recent aesthetics is its avoidance of weighty pronouncements about the more esoteric aspects of art in general in favor of an intensive effort to deal with the more delimited question of the nature of the work of art. The work of art has thus become the focal point of inquiries converging from a number of perspectives. Metaphysical, logical, phenomenological and linguistic analyses have addressed themselves to such questions as the work of art's ontological status, its identity, and its definition—at times with impressive results.

This is not to say that the questions which seemed so central to preceding generations in aesthetics have lost all currency. It is true that there is today comparatively little concern with such issues as form, style, representation, and other such notions which not so long ago agitated the ranks of aestheticians who were themselves in rebellion against earlier efforts to define the nature of "beauty." Yet it must be acknowledged that many notions of the aesthetics of the recent past still retain, to a considerable extent, their earlier appeal. Aesthetic meaning and aesthetic expression, for example, continue to command considerable attention.

Recent aesthetics has subjected to searching criticism certain of what had traditionally been considered indispensable criteria or even generic traits of art. The limitations of such postulates as the uniqueness of the work of art, its originality, authenticity, or unity, have been more and more explicitly set forth, so that while these postulates or presuppo-

sitions have not been rejected, it is now apparent that they must be employed much more guardedly than had previously been the case.

The work of art is the product generated by the process that is art itself. Art, in turn, is one dimension of that peculiar way of functioning in nature which we call human. To understand the work of art in its aesthetic and human contexts, we can turn to such philosophers as Dewey and Buchler. With his characteristic energy, Dewey traces for us the emergence of art out of the progressive organization of human experience. And Buchler, consistently with Dewey, seeks to show that, when functioning exhibitively (aesthetically), man is engaged in a mode of judgment which can be just as appraisive, just as intelligent, as the mode of strictly verbal utterance.

Contemporary aesthetics has been much preoccupied with the question of whether or not art can be defined. The position of Wittgenstein (as reported here by G. E. Moore) had raised doubts about the possibility of any usable definition of art, insofar as works of art can be said to bear merely family resemblances to one another. This position has been questioned by Sibley and (elsewhere in this volume) by Mandelbaum, as well as by numerous other writers. But Dickey, contending that the controversy is now entering a new and possibly much more productive phase, has been willing to offer and defend a definition of his own, in which neither the genus nor the differentia of art is a perceivable quality.

Among the foremost of the questions of aesthetic ontology is that of the objectivity of the work of art. Lewis's defense of aesthetic objectivity has perhaps been less than fully persuasive. But subjectivists have been unable to dispose decisively of Lewis's notion that the ontological status of the work of art, like that of a civil law, is not reducible to the interpretations made of it under varying circumstances. Here the objective relativism advocated by Buchler can be seen to lend Lewis's position a subtle reinforcement. Meanwhile, approaching the question from a quite different direction, the early essay by Sartre seeks to show the ontological status of the work of art as an imaginary object.

Another perplexing aspect of the work of art is that of its identity. It is hardly surprising that many of the same difficulties which attend the analysis of personal identity are to be found in the inquiry into the identity of the work of art. Nonetheless, it is instructive to compare the treatment of the problem of artistic identity by Randall, whose perspective is that of a neo-Aristotelian naturalism and who seeks to define identity in terms of the relationship between structure and function, with that by Margolis, who seeks to demonstrate, through an analytic approach, that a work of art is able to maintain its identity despite contradictory interpretations.

It has already been intimated that the philosophies of Dewey and Buchler construe art as a form of intelligence, and the work of art as

having a cognitive dimension. While the notion of artistic truth is no longer as provocative as it was formerly (except for Heidegger and his followers), there remains a continuing interest in the problem of artistic meaning. Here, the subtly tempered analysis of Isenberg is supplemented by a more formal approach (quite Kantian in character) by Beck.

So long as Romanticism is part of the present scene and its ideology, the notion that art is preeminently expressive will have its advocates. But versions of the theory differ widely, ranging from the neo-Idealism of Collingwood to the analytic presentation by Wollheim of Gombrich's notion of expression (see Part IV of this volume), and to the naturalism of Dewey, who is strongly critical of attempts to link expression with the fatuousness of "self-expression."

The controversy over the notion of aesthetic unity continues to show signs of life, if not always of illumination. As a presupposition, possessing heuristic value, the notion is generally acknowledged to be useful, although some works of art seem to have a considerably higher tolerance of disunity than do others. Not so many years ago, proponents of Gestalt theory were in the forefront of those stressing the importance of aesthetic unity (see Koffka, in this anthology). Schapiro, while sensitively illustrating the limitations of the postulate of aesthetic unity, concedes that the notion is not one that is readily dispensed with or dismissed.

The question of artistic uniqueness has much in common with the question of artistic definability. For, it is contended, works of art can be defined only if they belong to classes about which generalizations can be made. But if they are quite unique, then the quest for definition is a hopeless one. Hampshire contrasts the alleged induplicability of works of art with what he conceives to be the duplicability of moral acts, and Kennick, adopting Wittgenstein's position referred to earlier, supports Hampshire's contention that works of art are irreducibly unique. Mandelbaum, however, urges that generalization in aesthetics is quite feasible.

It is customarily supposed that works of art *must* be both original and authentic. Such presuppositions are brought sharply into question by the problem of artistic forgeries, for if forgeries were totally lacking in aesthetic merit, it is doubtful that anyone would ever be deceived by them. On the other hand, must the merit of an original work, as over against a forgery, lie in some ultimately perceivable quality, or can it be that its merit—and the fault of the forgery—may be non-perceivable aspects of the works in question? These are among the issues touched upon by Goodman and Lessing.

Such are some of the dominant themes in the treatment of the work of art in contemporary aesthetics. It will not have escaped the reader that there is a curious oscillation here between discussions of the work of art itself and discussions of the *concept* of the work of art. Yet, from these two alternative approaches, there can be seen emerging a lively and fruitful interchange which is one of the most promising features of present-day aesthetics.

CHAPTER 2

Logical and Speculative
Analyses of the Nature of Art

Art and the Shaping of Human Experience

John Dewey

John Dewey (1859–1952) was an influential American philosopher and educator. He taught at the University of Chicago for some years, then spent the remainder of his academic career at Columbia University. A prolific author, his major works include Human Nature and Conduct *(1922),* Experience and Nature *(1925),* Art as Experience *(1934), and* Logic, The Theory of Inquiry *(1938).*

Experience, Nature and Art

Experience, with the Greeks, signified a store of practical wisdom, a fund of insights useful in conducting the affairs of life. Sensation and perception were its occasion and supplied it with pertinent materials, but did not of themselves constitute it. They generated experience when retention was added and when a common factor in the multitude of felt and perceived cases detached itself so as to become available in judgment and exertion. Thus understood, experience is exemplified in the discrimination and skill of the good carpenter, pilot, physician, captain-at-arms; experience is equivalent to art. Modern theory has quite prop-

From *Experience and Nature* (LaSalle, Ill.: The Open Court Publishing Co., 1925), pp. 287–304, 315–318. Reprinted by permission.

erly extended the application of the term to cover many things that the Greeks would hardly have called "experience," the bare having of aches and pains, or a play of colors before the eyes. But even those who hold this larger signification would admit, I suppose, that such "experiences" count only when they result in insight, or in an enjoyed perception, and that only thus do they define experience in its honorific sense.

Greek thinkers nevertheless disparaged experience in comparison with something called reason and science. The ground for depreciation was not that usually assigned in modern philosophy; it was not that experience is "subjective." On the contrary, experience was considered to be a genuine expression of cosmic forces, not an exclusive attribute or possession of animal or of human nature. It was taken to be a realization of inferior portions of nature, those infected with chance and change, the less *Being* part of the cosmos. Thus while experience meant art, art reflected the contingencies and partialities of nature, while science—theory—exhibited its necessities and universalities. Art was born of need, lack, deprivation, incompleteness, while science—theory—manifested fullness and totality of Being. Thus the depreciatory view of experience was identical with a conception that placed practical activity below theoretical activity, finding the former dependent, impelled from outside, marked by deficiency of real being, while the latter was independent and free because complete and self-sufficing; that is, perfect.

In contrast with this self-consistent position we find a curious mixture in modern thinking. The latter feels under no obligation to present a theory of natural existence that links art with nature; on the contrary, it usually holds that science or knowledge is the only *authentic* expression of nature, in which case art must be an arbitrary addition to nature. But modern thought also combines exaltation of science with eulogistic appreciation of art, especially of fine or creative art. At the same time it retains the substance of the classic disparagement of the practical in contrast with the theoretical, although formulating it in somewhat different language: to the effect that knowledge deals with objective reality as it is in itself, while in what is "practical," objective reality is altered and cognitively distorted by subjective factors of want, emotion and striving. And yet in its encomium of art, it fails to note the commonplace of Greek observation—that the fine arts as well as the industrial technologies are affairs of practice.

This confused plight is partly cause and partly effect of an almost universal confusion of the artistic and the esthetic. On one hand, there is action that deals with materials and energies outside the body, assembling, refining, combining, manipulating them until their new state yields a satisfaction not afforded by their crude condition—a formula that applies to fine and useful art alike. On the other hand, there is the delight that attends vision and hearing, an enhancement of the receptive appreciation and assimilation of objects irrespective of participation in the operations of production. Provided the difference of the two things is recognized, it is no matter whether the words "esthetic" and "artistic"

or other terms be used to designate the distinction, for the difference is not one of words but of objects. But in some form the difference must be acknowledged.

The community in which Greek art was produced was small; numerous and complicated intermediaries between production and consumption were lacking; producers had a virtually servile status. Because of the close connection between production and enjoyable fruition, the Greeks in their perceptive uses and enjoyments were never wholly unconscious of the artisan and his work, not even when they personally were exclusively concerned with delightful contemplation. But since the artist was an artisan (the term artist having none of the eulogistic connotations of present usage), and since the artisan occupied an inferior position, the enjoyment of works of any art did not stand upon the same level as enjoyment of those objects for the realization of which manual activity was not needed. Objects of rational thought, of contemplative insight, were the only things that met the specification of freedom from need, labor, and matter. They alone were self-sufficient, self-existent, and self-explanatory, and hence enjoyment of *them* was on a higher plane than enjoyment of works of art.

These conceptions were consistent with one another and with the conditions of social life at the time. Nowadays we have a messy conjunction of notions that are consistent neither with one another nor with the tenor of our actual life. Knowledge is still regarded by most thinkers as direct grasp of ultimate reality, although the practice of knowing has been assimilated to the procedure of the useful arts—involving, that is to say, doing that manipulates and arranges natural energies. Again while science is said to lay hold of reality, yet "art" instead of being assigned a lower rank is equally esteemed and honored. And when within art a distinction is drawn between production and appreciation, the chief honor usually goes to the former on the ground that it is "creative," while taste is relatively possessive and passive, dependent for its material upon the activities of the creative artist.

If Greek philosophy was correct in thinking of knowledge as contemplation rather than as a productive art, and if modern philosophy accepts this conclusion, then the only logical course is relative disparagement of all forms of production, since they are modes of practice which is by conception inferior to contemplation. The artistic is then secondary to the esthetic: "creation," to "taste," and the scientific *worker*—as we significantly say—is subordinate in rank and worth to the dilettante who enjoys the results of his labors. But if modern tendencies are justified in putting art and creation first, then the implications of this position should be avowed and carried through. It would then be seen that science is an art, that art is practice, and that the only distinction worth drawing is not between practice and theory, but between those modes of practice that are not intelligent, not inherently and immediately enjoyable, and those which are full of enjoyed meanings. When this perception dawns, it will be a commonplace that art—the mode of activity that is charged

with meanings capable of immediately enjoyed possession—is the complete culmination of nature, and that "science" is properly a handmaiden that conducts natural events to this happy issue. Thus would disappear the separations that trouble present thinking: division of everything into nature *and* experience, of experience into practice *and* theory, art *and* science, of art into useful *and* fine, menial *and* free.

Thus the issue involved in experience as art in its pregnant sense and in art as processes and materials of nature continued by direction into achieved and enjoyed meanings, sums up in itself all the issues which have been previously considered. Thought, intelligence, science is the intentional direction of natural events to meanings capable of immediate possession and enjoyment; this direction—which is operative art—is itself a natural event in which nature otherwise partial and incomplete comes fully to itself; so that objects of conscious experience when reflectively chosen, form the "end" of nature. The doings and sufferings that form experience are, in the degree in which experience is intelligent or charged with meanings, a union of the precarious, novel, irregular with the settled, assured and uniform—a union which also defines the artistic and the esthetic. For wherever there is art the contingent and ongoing no longer work at cross purposes with the formal and recurrent but commingle in harmony. And the distinguishing feature of conscious experience, of what for short is often called "consciousness," is that in it the instrumental and the final, meanings that are signs and clews and meanings that are immediately possessed, suffered and enjoyed, come together in one. And all of these things are preëminently true of art.

First, then, art is solvent union of the generic, recurrent, ordered, established phase of nature with its phase that is incomplete, going on, and hence still uncertain, contingent, novel, particular; or as certain systems of esthetic theory have truly declared, though without empirical basis and import in their words, a union of necessity and freedom, a harmony of the many and one, a reconciliation of sensuous and ideal. Of any artistic act and product it may be said both that it is inevitable in its rightness, that nothing in it can be altered without altering all, and that its occurrence is spontaneous, unexpected, fresh, unpredictable. The presence in art, whether as an act or a product, of proportion, economy, order, symmetry, composition, is such a commonplace that it does not need to be dwelt upon. But equally necessary is unexpected combination, and the consequent revelation of possibilities hitherto unrealized. "Repose in stimulation" characterizes art. Order and proportion when they are the whole story are soon exhausted; economy in itself is a tiresome and restrictive taskmaster. It is artistic when it releases.

The more extensive and repeated are the basic uniformities of nature that give form to art, the "greater" is the art, provided—and it is this proviso that distinguishes art—they are indistinguishably fused with the wonder of the new and the grace of the gratuitous. "Creation" may be asserted vaguely and mystically; but it denotes something genuine and indispensable in art. The merely finished is not fine but ended, done with,

and the merely "fresh" is that bumptious impertinence indicated by the slang use of the word. The "magic" of poetry—and pregnant experience has poetical quality—is precisely the revelation of meaning in the old effected by its presentation through the new. It radiates the light that never was on land and sea but that is henceforth an abiding illumination of objects. Music in its immediate occurrence is the most varied and etherial of the arts, but is in its conditions and structure the most mechanical. These things are commonplaces; but until they are commonly employed in their evidential significance for a theory of nature's nature, there is no cause to apologize for their citation.

The limiting terms that define art are routine at one extreme and capricious impulse at the other. It is hardly worth while to oppose science and art sharply to one another, when the deficiencies and troubles of life are so evidently due to separation between art and blind routine and blind impulse. Routine exemplifies the uniformities and recurrences of nature, caprice expresses its inchoate initiations and deviations. Each in isolation is unnatural as well as inartistic, for nature is an intersection of spontaneity and necessity, the regular and the novel, the finished and the beginning. It is right to object to much of current practice on the ground that it is routine, just as it is right to object to much of our current enjoyments on the ground that they are spasms of excited escape from the thraldom of enforced work. But to transform a just objection against the quality of much of our practical life into a description and definition of practice is on the same plane as to convert legitimate objection to trivial distraction, senseless amusement, and sensual absorption, into a Puritanical aversion to happiness. The idea that work, productive activity, signifies action carried on for merely extraneous ends, and the idea that happiness signifies surrender of mind to the thrills and excitations of the body are one and the same idea. The first notion marks the separation of activity from meaning, and the second marks the separation of receptivity from meaning. Both separations are inevitable as far as experience fails to be art: when the regular, repetitious, and the novel, contingent in nature fail to sustain and inform each other in a productive activity possessed of immanent and directly enjoyed meaning.

Thus the theme has insensibly passed over into that of the relation of means and consequence, process and product, the instrumental and consummatory. Any activity that is simultaneously both, rather than in alternation and displacement, is art. Disunion of production and consumption is a common enough occurrence. But emphasis upon this separation in order to exalt the consummatory does not define or interpret either art or experience. It obscures their meaning, resulting in a division of art into useful and fine, adjectives which, when they are prefixed to "art," corrupt and destroy its intrinsic significance. For arts that are merely useful are not arts but routines; and arts that are merely final are not arts but passive amusements and distractions, different from other indulgent dissipations only in dependence upon a certain acquired refinement or "cultivation."

craft

The existence of activities that have no immediate enjoyed intrinsic meaning is undeniable. They include much of our labors in home, factory, laboratory and study. By no stretch of language can they be termed either artistic or esthetic. Yet they exist, and are so coercive that they require some attentive recognition. So we optimistically call them "useful" and let it go at that, thinking that by calling them useful we have somehow justified and explained their occurrence. If we were to ask 'Useful for what?' we should be obliged to examine their actual consequences, and when we once honestly and fully faced these consequences we should probably find ground for calling such activities detrimental rather than useful.

We call them useful because we arbitrarily cut short our consideration of consequences. We bring into view simply their efficacy in bringing into existence certain commodities; we do not ask for their effect upon the quality of human life and experience. They are useful to make shoes, houses, motor cars, money, and other things which *may* then be put to use; here inquiry and imagination stop. What they also *make* by way of narrowed, embittered, and crippled life, of congested, hurried, confused and extravagant life, is left in oblivion. But to be useful is to fulfill need. The characteristic human need is for possession and appreciation of the meaning of things, and this need is ignored and unsatisfied in the traditional notion of the useful. We identify utility with the external relationship that some events and acts bear to other things that are their products, and thus leave out the only thing that is essential to the idea of utility, inherent place and bearing in experience. Our classificatory use of the conception of some arts as merely instrumental so as to dispose of a large part of human activity is no solving definition; it rather conveys an immense and urgent problem.

The same statement applies to the conception of merely fine or final arts and works of art. In point of fact, the things designated by the phrase fall under three captions. There are activities and receptivities to which the name of "self-expression" is often applied as a eulogistic qualification, in which one indulges himself by giving free outward exhibition to his own states without reference to the conditions upon which intelligible communication depends—an act also sometimes known as "expression of emotion," which is then set up for definition of all fine art. It is easy to dispose of this art by calling it a product of egotism due to balked activity in other occupations. But this treatment misses a more significant point. For all art is a process of making the world a different place in which to live, and involves a phase of protest and of compensatory response. Such art as there is in these manifestations lies in this factor. It is owing to frustration in communication of meanings that the protest becomes arbitrary and the compensatory response wilfully eccentric.

In addition to this type—and frequently mingled with it—there is experimentation in new modes or craftsmanship, cases where the seemingly bizarre and over-individualistic character of the products is due to discontent with existing techniques, and is associated with an attempt

to find new modes of language. It is aside from the point either to greet these manifestations as if they constituted art for the first time in human history, or to condemn them as not art because of their violent departures from received canons and methods. Some movement in this direction has always been a condition of growth of new forms, a condition of salvation from that mortal arrest and decay called academic art.

Then there is that which in quantity bulks most largely as fine art: the production of buildings in the name of the art of architecture; of pictures in the name of the art of painting; of novels, dramas, etc., in the name of literary art; a production which in reality is largely a form of commercialized industry in production of a class of commodities that find their sale among well-to-do persons desirous of maintaining a conventionally approved status. As the first two modes carry to disproportionate excess that factor of particularity, contingency and difference which is indispensable in all art, deliberately flaunting avoidance of the repetitions and order of nature; so this mode celebrates the regular and finished. It is reminiscent rather than commemorative of the meanings of experienced things. Its products remind their owner of things pleasant in memory though hard in direct-undergoing, and remind others that their owner has achieved an economic standard which makes possible cultivation and decoration of leisure.

Obviously no one of these classes of activity and product, or all of them put together, mark off anything that can be called distinctively fine art. They share their qualities and defects with many other acts and objects. But, fortunately, there may be mixed with any one of them, and, still more fortunately, there may occur without mixture, process and product that are characteristically excellent. This occurs when activity is productive of an object that affords continuously renewed delight. This condition requires that the object be, with its successive consequences, indefinitely instrumental to *new* satisfying events. For otherwise the object is quickly exhausted and satiety sets in. Anyone who reflects upon the commonplace that a measure of artistic products is their capacity to attract and retain observation with satisfaction under whatever conditions they are approached, while things of less quality soon lose capacity to hold attention becoming indifferent or repellent upon subsequent approach, has a sure demonstration that a genuinely esthetic object is not exclusively consummatory but is causally productive as well. A consummatory object that is not also instrumental turns in time to the dust and ashes of boredom. The "eternal" quality of great art is its renewed instrumentality for further consummatory experiences.

When this fact is noted, it is also seen that limitation of fineness of art to paintings, statues, poems, songs and symphonies is conventional, or even verbal. Any activity that is productive of objects whose perception is an immediate good and whose operation is a continual source of enjoyable perception of other events exhibits fineness of art. There are acts of all kinds that directly refresh and enlarge the spirit and that are instrumental to the production of new objects and dispositions which

are in turn productive of further refinements and replenishments. Frequently moralists make the acts *they* find excellent or virtuous wholly final, and treat art and affection as mere means. Estheticians reverse the performance, and see in good *acts* means to an ulterior external happiness, while esthetic appreciation is called a good in itself, or that strange thing, an end in itself. But on both sides it is true that in being preëminently fructifying the things designated means are immediate satisfactions. They are their own excuses for being just because they are charged with an office in quickening apprehension, enlarging the horizon of vision, refining discrimination, creating standards of appreciation which are confirmed and deepened by further experiences. It would almost seem when their non-instrumental character is insisted upon as if what was meant were an indefinitely expansive and radiating instrumental efficacy.

The source of the error lies in the habit of calling by the name of means things that are not means at all; things that are only external and accidental antecedents of the happening of something else. Similarly things are called ends that are not ends save accidentally, since they are not fulfillments, consummatory, of means, but merely last terms closing a process. Thus it is often said that a laborer's toil is the means of his livelihood, although except in the most tenuous and arbitrary way it bears no relationship to his real living. Even his wage is hardly an end or consequence of his labor. He might—and frequently does—equally well or ill—perform any one of a hundred other tasks as a condition of receiving payment. The prevailing conception of instrumentality is profoundly vitiated by the habit of applying it to cases like the above, where, instead of an operation of means, there is an enforced necessity of doing one thing as a coerced antecedent of the occurrence of another thing which is wanted.

Means are always at least causal conditions; but causal conditions are means only when they possess an added qualification; that, namely, of being freely used, because of perceived connection with chosen consequences. To entertain, choose and accomplish anything as an end or consequence is to be committed to a like love and care for whatever events and acts are its means. Similarly, consequences, ends, are at least effects; but effects are not ends unless thought has perceived and freely chosen the conditions and processes that are their conditions. The notion that means are menial, instrumentalities servile, is more than a degradation of means to the rank of coercive and external necessities. It renders all things upon which the name of end is bestowed accompaniments of privilege, while the name of utility becomes an apologetic justification for things that are not portions of a good and reasonable life. Livelihood is at present not so much the consequence of a wage-earner's labor as it is the effect of other causes forming the economic régime, labor being merely an accidental appendage of these other causes.

Paints and skill in manipulative arrangement are means of a picture as end, because the picture is *their* assemblage and organization. Tones

and susceptibility of the ear when properly interacting are the means of music, because they constitute, make, are, music. A disposition of virtue is a means to a certain quality of happiness because it is a constituent of that good, while such happiness is means in turn to virtue, as the sustaining of good in being. Flour, water, yeast are means of bread because they are ingredients of bread; while bread is a factor *in* life, not just *to* it. A good political constitution, honest police-system, and competent judiciary, are means of the prosperous life of the community because they are integrated portions of that life. Science is an instrumentality of and for art because it is the intelligent factor *in* art. The trite saying that a hand is not a hand except as an organ of the living body —except as a working coördinated part of a balanced system of activities —applies untritely to all things that are means. The connection of means-consequences is never one of bare succession in time, such that the element that is means is past and gone when the end is instituted. An active process is strung out temporarily, but there is a deposit at each stage and point entering cumulatively and constitutively into the outcome. A genuine instrumentality *for* is always an organ *of* an end. It confers continued efficacy upon the object in which it is embodied.

The traditional separation between some things as mere means and others as mere ends is a reflection of the insulated existence of working and leisure classes, of production that is not also consummatory, and consummation that is not productive. This division is not a *merely* social phenomenon. It embodies a perpetuation upon the human plane of a division between need and satisfaction belonging to brute life. And this separation expresses in turn the mechanically external relationship that exists in nature between situations of disturbed equilibrium, of stress, and strain, and achieved equilibrium. For in nature, outside of man, except when events eventuate in "development" or "evolution" (in which a cumulative carrying forward of consequences of past histories in new efficiencies occurs) antecedent events are external transitive conditions of the occurrence of an event having immediate and static qualities. To animals to whom acts have no meaning, the change in the environment required to satisfy needs has no significance on its own account; such change is a mere incident of egocentric satisfactions. This physically external relationship of antecedents and consequents is perpetuated; it continues to hold true of human industry wherever labor and its materials and products are externally enforced necessities for securing a living. Because Greek industry was so largely upon this plane of servile labor, all industrial activity was regarded by Greek thought as a *mere* means, an extraneous necessity. Hence satisfactions due to it were conceived to be the ends or goods of purely animal nature in isolation. With respect to a truly human and rational life, they were not ends or goods at all, but merely "means," that is to say, external conditions that were antecedently enforced requisites of the life conducted and enjoyed by free men, especially by those devoted to the acme of freedom, pure thinking. As Aristotle asserted, drawing a just conclusion from the assumed premises,

there are classes of men who are necessary materials of society but who are not integral parts of it. And he summed up the whole theory of the external and coerced relationship of means and ends when he said in this very connection that: "When there is one thing that is means and another thing that is end, there is *nothing common* between them, except in so far as the one, the means, produces, and the other, the end, receives the product."

It would thus seem almost self-evident that the distinction between the instrumental and the final adopted in philosophic tradition as a solving word presents in truth a problem, a problem so deep-seated and far-reaching that it may be said to be *the* problem of experience. For all the intelligent activities of men, no matter whether expressed in science, fine arts, or social relationships, have for their task the conversion of causal bonds, relations of succession, into a connection of means-consequence, into meanings. When the task is achieved the result is art: and in art everything is common between means and ends. Whenever so-called means remain external and servile, and so-called ends are enjoyed objects whose further causative status is unperceived, ignored or denied, the situation is proof positive of limitations of art. Such a situation consists of affairs in which the problem has *not* been solved; namely that of converting physical and brute relationships into connections of meanings characteristic of the possibilities of nature.

It goes without saying that man begins as a part of physical and animal nature. In as far as he reacts to physical things on a strictly physical level, he is pulled and pushed about, overwhelmed, broken to pieces, lifted on the crest of the wave of things, like anything else. His contacts, his sufferings and doings, are matters of direct interaction only. He is in a "state of nature." As an animal, even upon the brute level, he manages to subordinate some physical things to his needs, converting them into materials sustaining life and growth. But in so far things that serve as material of satisfaction and the acts that procure and utilize them are not objects, or things-with-meanings. That appetite as such is blind, is notorious; it may push us into a comfortable result instead of into disaster; but we are pushed just the same. When appetite is perceived in its meanings, in the consequences it induces, and these consequences are experimented with in reflective imagination, some being seen to be consistent with one another, and hence capable of co-existence and of serially ordered achievement, others being incompatible, forbidding conjunction at one time, and getting in one another's way serially —when this estate is attained, we live on the human plane, responding to things in their meanings. A relationship of cause-effect has been transformed into one of means-consequence. Then consequences belong *integrally* to the conditions which may produce them, and the latter possess character and distinction. The meaning of causal conditions is carried over also into the consequence, so that the latter is no longer a mere end, a last and closing term of arrest. It is marked out in perception, distinguished by the efficacy of the conditions which have entered into it. Its

value as fulfilling and consummatory is measurable by subsequent fulfillments and frustrations to which it is contributory in virtue of the causal means which compose it.

Thus to be conscious of meanings or to have an idea, marks a fruition, an enjoyed or suffered arrest of the flux of events. But there are all kinds of ways of perceiving meanings, all kinds of ideas. Meaning may be determined in terms of consequences hastily snatched at and torn loose from their connections; then is prevented the formation of wider and more enduring ideas. Or, we may be aware of meanings, may achieve ideas, that unite wide and enduring scope with richness of distinctions. The latter sort of consciousness is more than a passing and superficial consummation or end: it takes up into itself meanings covering stretches of existence wrought into consistency. It marks the conclusion of long continued endeavor; of patient and indefatigable search and test. The idea is, in short, art and a work of art. As a work of art, it directly liberates subsequent action and makes it more fruitful in a creation of more meanings and more perceptions.

It is the part of wisdom to recognize how sparse and insecure are such accomplishments in comparison with experience in which physical and animal nature largely have their way. Our liberal and rich ideas, our adequate appreciations, due to productive art are hemmed in by an unconquered domain in which we are everywhere exposed to the incidence of unknown forces and hurried fatally to unforeseen consequences. Here indeed we live servilely, menially, mechanically; and we so live as much when forces blindly lead to us ends that are liked as when we are caught in conditions and ends against which we blindly rebel. To call satisfactions which happen in this blind way "ends" in a eulogistic sense, as did classic thought, is to proclaim in effect our servile submission to accident. We may indeed enjoy the goods the gods of fortune send us, but we should recognize them for what they are, not asserting them to be good and righteous *altogether.* For, since they have not been achieved by any art involving deliberate selection and arrangement of forces, we do not know with what they are charged. It is an old true tale that the god of fortune is capricious, and delights to destroy his darlings after having made them drunk with prosperity. The goods of art are not the less good in their goodness than the gifts of nature; while in addition they are such as to bring with themselves open-eyed confidence. They are fruits of means consciously employed; fulfillments whose further consequences are secured by conscious control of the causal conditions which enter into them. Art is the sole alternative to luck; and divorce from each other of the meaning and value of instrumentalities and ends is the essence of luck. The esoteric character of culture and the supernatural quality of religion are both expressions of the divorce.

The modern mind has formally abjured belief in natural teleology because it found Greek and medieval teleology juvenile and superstitious. Yet facts have a way of compelling recognition of themselves. There is little scientific writing which does not introduce at some point

or other the idea of tendency. The idea of tendency unites in itself exclusion of prior design and inclusion of movement in a particular direction, a direction that may be either furthered or counteracted and frustrated, but which is intrinsic. Direction involves a limiting position, a point or goal of culminating stoppage, as well as an initial starting point. To assert a tendency and to be fore-conscious of a possible terminus of movement are two names of the same fact. Such a consciousness may be fatalistic; a sense of inevitable march toward impending doom. But it may also contain a perception of meanings such as flexibly directs a forward movement. The end is then an end-in-view and is in constant and cumulative reënactment at each stage of forward movement. It is no longer a terminal point, external to the conditions that have led up to it; it is the continually developing meaning of present tendencies—the very things which as directed we call "means." The process is art and its product, no matter at what stage it be taken, is a work of art.

To a person building a house, the end-in-view is not just a remote and final goal to be hit upon after a sufficiently great number of coerced motions have been duly performed. The end-in-view is a plan which is *contemporaneously* operative in selecting and arranging materials. The latter, brick, stone, wood and mortar, are means only as the end-in-view is actually incarnate in them, in forming them. Literally, they *are* the end in its present stage of realization. The end-in-view is present at each stage of the process; it is present as the *meaning* of the materials used and acts done; without its informing presence, the latter are in no sense "means"; they are merely extrinsic causal conditions. The statement is generic; it applies equally at every stage. The house itself, when building is complete, is "end" in no exclusive sense. It marks the conclusion of the organization of certain materials and events into effective means; but these materials and events still exist in causal interaction with other things. New consequences are foreseen; new purposes, ends-in-view, are entertained; they are embodied in the coördination of the thing built, now reduced to material, although significant material, along with other materials, and thus transmuted into means. The case is still clearer, when instead of considering a process subject to as many rigid external conditions as is the building of a house, we take for illustration a flexibly and freely moving process, such as painting a picture or thinking out a scientific process, when these operations are carried on artistically. Every process of free art proves that the difference between means and end is analytic, formal, not material and chronologic.

What has been said enables us to redefine the distinction drawn between the artistic, as objectively productive, and the esthetic. Both involve a perception of meanings in which the instrumental and the consummatory peculiarly intersect. In esthetic perceptions an object interpenetrated with meanings is given; it may be taken for granted; it invites and awaits the act of appropriative enjoyment. In the esthetic object tendencies are sensed as brought to fruition; in it is embodied a means-consequence relationship, as the past work of his hands was

surveyed by the Lord and pronounced good. This good differs from those gratifications to which the name sensual rather than sensuous is given, since the former are pleasing endings that occur in ways not informed with the meaning of materials and acts integrated into them. In appreciative possession, perception goes out to tendencies which *have* been brought to happy fruition in such a way as to release and arouse.

Artistic sense on the other hand grasps tendencies as possibilities; the invitation of these possibilities to perception is more urgent and compelling than that of the given already achieved. While the means-consequence relationship is directly sensed, felt, in both appreciation and artistic production, in the former the scale descends upon the side of the attained; in the latter there predominates the invitation of an existent consummation to bring into existence further perceptions. Art in being, the active productive process, may thus be defined as an esthetic perception together with an *operative* perception of the efficiencies of the esthetic object. . . .

There are substantially but two alternatives. Either art is a continuation, by means of intelligent selection and arrangement, of natural tendencies of natural events; or art is a peculiar addition to nature springing from something dwelling exclusively within the breast of man, whatever name be given the latter. In the former case, delightfully enhanced perception or esthetic appreciation is of the same nature as enjoyment of any object that is consummatory. It is the outcome of a skilled and intelligent art of dealing with natural things for the sake of intensifying, purifying, prolonging and deepening the satisfactions which they spontaneously afford. That, in this process, new meanings develop, and that these afford uniquely new traits and modes of enjoyment is but what happens everywhere in emergent growths.

But if fine art has nothing to do with other activities and products, then of course it has nothing inherently to do with the objects, physical and social, experienced in other situations. It has an occult source and an esoteric character. It makes little difference what the source and the character be called. By strict logic it makes literally no difference. For if the quality of the esthetic experience is by conception unique, then the words employed to describe it have no significance derived from or comparable to the qualities of other experiences; their signification is hidden and specialized to a degree. Consider some of the terms which are in more or less current use among the critics who carry the isolation of art and the esthetic to its limit. It is sometimes said that art is the expression of the emotions; with the implication that, because of this fact, subject-matter is of no significance except as material through which emotion is expressed. Hence art becomes unique. For in works of science, utility, and morals, the character of the objects forming this subject-matter is all-important. But by this definition, subject-matter is stripped of all its

own inherent characters in art in the degree in which it is genuine art; since a truly artistic work is manifest in the reduction of subject-matter to a mere medium of expression of emotion.

In such a statement emotion either has no significance at all, and it is mere accident that this particular combination of letters is employed; or else, if by emotion is meant the same sort of thing that is called emotion in daily life, the statement is demonstrably false. For emotion in its ordinary sense is something called out *by* objects, physical and personal; it is response *to* an objective situation. It is not something existing somewhere by itself which then employs material through which to express itself. Emotion is an indication of intimate participation in a more or less excited way in some scene of nature or life; it is, so to speak, an attitude or disposition which is a function of objective things. It is intelligible that art should select and assemble objective things in such ways as to evoke emotional response of a refined, sensitive and enduring kind; it is intelligible that the artist himself is one capable of sustaining these emotions, under whose temper and spirit he performs his compositions of objective materials. This procedure may indeed be carried to a point such that the use of objective materials is economized to the minimum, and the evocation of the emotional response carried to its relative maximum. But it still remains true that the origin of the art-process lay in emotional responses spontaneously called out by a situation occurring without any reference to art, and without "esthetic" quality save in the sense in which all immediate enjoyment and suffering is esthetic. Economy in use of objective subject-matter may with experienced and trained minds go so far that what is ordinarily called "representation" is much reduced. But what happens is a highly funded and generalized representation of the formal sources of ordinary emotional experience.

The same sort of remark is to be made concerning "significant form" as a definition of an esthetic object. Unless the meaning of the term is so isolated as to be wholly occult, it denotes a selection, for sake of emphasis, purity, subtlety, of those forms which give consummatory significance to every-day subject-matters of experience. "Forms" are not the peculiar property or creation of the esthetic and artistic; they are characters in virtue of which anything meets the requirements of an enjoyable perception. "Art" does not create the forms; it is their selection and organization in such ways as to enhance, prolong and purify the perceptual experience. It is not by accident that some objects and situations afford marked perceptual satisfactions; they do so because of their structural properties and relations. An artist may work with a minimum of analytic recognition of these structures or "forms"; he may select them chiefly by a kind of sympathetic vibration. But they may also be discriminatively ascertained; and an artist may utilize his deliberate awareness of them to create works of art that are more formal and abstract than those to which the public is accustomed. Tendency to composition in terms of the formal characters marks much contemporary art, in poetry, painting,

music, even sculpture and architecture. At their worst, these products are "scientific" rather than artistic; technical exercises, sterile and of a new kind of pedantry. At their best, they assist in ushering in new modes of art; and by education of the organs of perception in new modes of consummatory objects they enlarge and enrich the world of human vision.

Thus, by only a slight forcing of the argument, we reach a conclusion regarding the relations of instrumental and fine art which is precisely the opposite of that intended by seclusive estheticians; namely, that fine art *consciously* undertaken as such is peculiarly instrumental in quality. It is a device in experimentation carried on for the sake of education. It exists for the sake of a specialized use, use being a new training of modes of perception. The creators of such works of art are entitled, when successful, to the gratitude that we give to inventors of microscopes and microphones; in the end, they open new objects to be observed and enjoyed. This is a genuine service; but only an age of combined confusion and conceit will arrogate to works that perform this special utility the exclusive name of fine art.

Experience in the form of art, when reflected upon, we conclude by saying, solves more problems which have troubled philosophers and resolves more hard and fast dualisms than any other theme of thought. As the previous discussion has indicated, it demonstrates the intersection in nature of individual and generic; of chance and law, transforming one into opportunity and the other into liberation; of instrumental and final. More evidently still, it demonstrates the gratuitous falsity of notions that divide overt and executive activity from thought and feeling and thus separate mind and matter. In creative production, the external and physical world is more than a mere means or external condition of perceptions, ideas and emotions; it is subject-matter and sustainer of conscious activity; and thereby exhibits, so that he who runs may read, the fact that consciousness is not a separate realm of being, but is the manifest quality of existence when nature is most free and most active.

Justus Buchler

Formerly Johnsonian Professor of Philosophy at Columbia University, Justus Buchler is presently Distinguished Professor of Philosophy at the State University of New York, Stony Brook. He has written Nature and Judgment *(1955),* The Concept of Method *(1961), and* The Metaphysics of Natural Complexes *(1966).*

Exhibitive Judgment

The interplay of the human individual's activities and dimensions, their unitary direction, constitutes a process which I shall call *proception.* The term is designed to suggest a moving union of seeking and receiving, of forward propulsion and patient absorption. Proception is the composite, directed activity of the individual. Any instance of his functioning, any event in his history enters into the proceptive direction. Reciprocally, and perhaps more significantly, the way that an individual will act at any time, and the way in which his intellectual and moral character will be modified, depends on his proceptive direction. Proception is the process in which a man's whole self is summed up or represented. On this idea that the whole individual is the cumulative representative of the moving individual I should like to lay the major stress. To say that the human animal is a proceiving animal is to state the most general or pervasive attribute of his being, and at the same time the most distinctive attribute. The theory of the distinctive human activities, such as imagination and creation, should become more intelligible when these are seen as properties of the proceiver rather than as properties of the thinker or feeler. It could be said that these are functions of the man and not of the mind, if this impoverished form of expression could manage to convey the suggestion of directed, integral movement. It is the proceiver, then, not a physiological or intellectual capacity of the proceiver, that wonders, asserts, interrogates. These are proceptive functions. Traveling, hearing, and eating are certainly relevant to proception, but they are not generic in the sense that they can characterize the proceptive direction. So far as the nature of the individual influences the nature of the individual's world, it can be said that the hearing apparatus determines what is heard, but that the proceptive direction determines the quality of conscience and the image of gods, the demand for harmonious satisfaction and the tolerance of possibilities, the hunger of eros and of reason and of art.

From *Towards a General Theory of Human Judgment* (New York: Columbia University Press, 1951), pp. 4–7, 45–57. Reprinted by permission.

The content of the summed-up-self-in-process, the individual's world, is the proceptive domain. The proceptive domain of an individual is a part of the world and the whole of a self uniquely represented. By nature man proceives—he moves as an accumulating whole. What changes within a man, and varies from man to man, is the specific character of the proceptive domain. Within the process of proception the character of the proceptive domain may alter in kind and in degree, and in an indefinite number of ways. The proceptive domain defines the relative largeness and scope of the self. How much of heaven and earth is part of the individual determines how much he is part of them. The proceptive process is the ongoing representation of the human aspect of the human animal. Spinoza, and Aristotle before him, held that the divine in a man is a function of his rational largeness. Rationality in its most fundamental sense is a property of the proceptive process; a property predicable of the proceptive domain but not of every proceptive domain.

An object or situation falls within the proceptive domain if it is present to the individual in the sense of being available for his potentialities. I mean to use the phrase "present to" in a temporal as well as in a structural sense—though certainly not in the sense of being confined to the so-called immediate present—for it is his gross present possession and present direction that define or determine the individual. Of all the facts and situations that may be said to relate to an individual, some modify, some promote or reinforce, and some are irrelevant to his proceptive direction. An object or situation is present to an individual, is part of his proceptive domain—and when it is we shall call it a procept—if it actually either modifies or reinforces his proceptive direction. Some objects or facts, like the depth of a crater on the moon, may be irrelevant to the character of proception and hence fall outside the proceptive domain. To be a procept is not necessarily to be noticed, felt, or attended to in awareness. An occupational routine is as much a procept as a pain; past moral training as much as a momentary sense of obligation. But far-off diplomatic intrigue may for a given individual not be a procept. Ontologically, it stands in some relation to him, but it may not actually modify or reinforce his proceptive direction. . . .

The property of communication can distinguish proception from mere biological perseverance only in so far as something emanates from it. In the life of man all things are either subjects or products of communication. Nature is the domain of possible subjects. The domain of the actual subjects is the measure of man's impact on nature and of the degree to which he has assimilated nature. The products of communication constitute the realm of human creation, man's addition to nature; or, otherwise expressed, the transformation of natural properties and the actualization of natural potentialities.

Every living moment represents an implicit discovery. What is com-

monly singled out as the object or occasion of discovery is the novel, but it is plain that the novel is always embedded in a familiar framework, and that all things familiar are novel in some perspective. The novel is the development in the old of an unexpected significance, or the appearance in the old of a trait that cannot immediately be reconciled with its official essence. Discovery, then, is inevitable. Significant discovery requires utterance for its delivery. Utterance is no less primordial and no less inevitable, though in common usage it bears much less of a eulogistic flavor. It is a relation between proception and production: procepts, by one or another mode of combination, give rise to products. The leap by which natural complexes assume a role in the human direction or by which they are preempted and represented, and the leap by which utterance is born, are the most rudimentary steps in technology or the economy of manipulation. If utterance is the realization or fulfillment of discovery, articulation is the realization of utterance. On the usual view, what we articulate are words and what we do when we articulate is to clarify or illuminate verbal meanings. There is no reason why all signs whatever may not be articulated. But more fundamentally, there is no reason why all products whatever may not be said to be susceptible of articulation. Articulation is the manipulation (and the implied proceptive deliverance) of products as ends in themselves, that is, as subjects of communication for the sake only of further communication.

Traditionally a distinction is made between products, acts, and assertions. In Aristotle, this takes the form of the threefold distinction between productive, practical, and theoretical science. But regardless of the undoubted admissibility and utility of such a distinction, we can with superior generality regard whatever emanates from any proceptive domain as a product. Acts and assertions are products no less than sensuous configurations of material are. The same applies to the constituents of acts, such as movements and gestures, and to the constituents of assertions, such as words and other types of signs. The tendency to distinguish between actions and products stems from the natural and altogether defensible distinction between doing and making. But in terms of the category of proception specific instances of doing and making are seen to emerge from the same cumulative process. What is done and what is made are equally symptomatic of the world that is proceived.

Merely to discern the status as products of all of the ultimate human materials for communication, and to recognize products as proceptive transformations, is not yet sufficiently clarifying. The product, representing nature re-created by human nature, has a voice. Nature refashioned is nature interpreted. Every product is a judgment. A judgment is a pronouncement: every product is a commentary on the proceiver's world as well as a faint image of the proceptive direction. It is a version, a rendition of nature, born of manipulation. Human utterance cannot be understood solely in terms of assertion, for every concretization emanating from proception and communication is as much a procept-transformation as any other. Any product, moreover, can function to communicate.

We cannot arbitrarily or antecedently limit what may and what may not function as a sign. A medieval cathedral is not a malleable instrument of direct or intended communication, but it would be folly to deny that its historical burden carries meaning and that this meaning is continually operative. An exclamation may communicate more than a declaration, and a gesture may influence understanding more than a verbal explanation.

To speak of products and judgments, then, is one and the same thing; but the former terms suggests the source and the natural history of man's concretizations, while the latter suggests their ultimate function, status, and direction. In looking upon every product as judicative, it becomes necessary to explain the sense in which non-assertive products share the same basic properties as assertive. Human judgment appears to be of three kinds, which we may call assertive, active, and exhibitive. Assertive judgments include all products of which a certain type of question is ordinarily asked: Is it true or false? Exhibitive judgments include all products which result from the shaping or arranging of materials (and these materials include manipulatable signs). Active judgments comprise all instances of conduct to which the terms "act" or "action" are ordinarily applied. The difficulty of drawing sharp lines among these classes is obvious. The distinctions are not primarily structural but functional. Whether certain gestures are acts, or whether they are assertions in an unconventional medium, depends partly upon the context of utterance and partly upon emphasis and communicative intent. The extent to which a literary work is assertive and the extent to which it is exhibitive depends upon similar factors. A "proposition" is an assertion; but its proceptive location or its place in a larger propositional scheme may give it an active or an exhibitive role. A "propositional function" is potentially assertive, but primarily exhibitive of a propositional structure. An exclamation may be an exhibitive judgment to the extent that it crystallizes an emotion in verbal form; an active judgment to the extent that it is the behavioral response to a situation; and an assertive judgment to the extent that it describes a situation elliptically or covertly.

Some philosophers would doubtless want to distinguish emphatically between assertions and the other two types of products. They would want to regard only the former as judgments on the ground that these alone are instruments of communication, while the other products function as means of stimulation. In an assertion, presumably, there is a "content" transmitted, and a content delimits the sphere of interpretation; whereas in the case of the other products interpretation is not called for by the product as such but is only an accidental concomitant or behavioral response. But to accept this distinction is to be committed, in the first place, to a dubious notion of "content." Any product has content in so far as it *is* interpreted. The real difference is that from a linguistic assertion the content is traditionally something expected, and there is much greater unanimity on the correlation of a given content with the given linguistic utterance. That language as we ordinarily understand

the term has numerous special advantages for communication, such as susceptibility to abstraction and to easy manipulation in the economy of thought, no one would wish to deny. But assertion and linguistic assertion are hardly synonymous. Those who think of human judgment solely in assertive terms cannot appeal solely to the properties of language to warrant the restriction. For many types of behavior can be and are deliberately intended to function assertively.

Whoever thinks of communication as effected by assertion alone greatly oversimplifies the notion of assertion and communication alike. The individual who understands, whose proceptive domain is influenced by a human product, is not a target on whom a mark is made, nor a receptacle in which an object is deposited. What the traditional epistemology of consciousness and conscious contents obscures is the fact that symmetrical communication is a relation between proceivers. Assertive judgments are too often regarded as discrete vehicles of meaning, transmitted by one agent and accepted by another. It might appear that ordinary verbal exchange is largely of this character. But even an elementary mode of communication is made possible by the proceptive disposition of the assimilator. And where two highly articulate persons fail to achieve rapport, proceptive divergence is responsible. Communication can be limited or can be actually impossible even after endless dialectic, not because of the absence of any mysterious affinity that is the alleged *sine qua non,* but because certain conditions required by the situation remain unfulfilled. The simplest type of assertion presupposes the power of symbolic identification, however habitual this may be. Whether judgment be assertive or non-assertive, then, identification, grouping, and inference are elemental requisites of the recipient; and these are proceptive phenomena.

A judgment is a selection, discrimination, or combination of (natural) characters, rendered proceptively available. No product can be more of a selection and discrimination of characters than any other, and this is why no one type of judgment is more fundamental than any other. The trouble with older conceptions of "judgment" is that they incline to identify it as intellectual utterance—"utterance" and "intellectual utterance" are tacitly equated—or as an entity of a peculiarly "mental" status, as the product of that dimension of the individual in which utterance is supposed to be possible. But utterance in the human individual is proceptive, and hence multifarious; and utterance which is interindividual results not from a community of minds but from a community.

The most commonplace of active judgments, such as walking from one place to another, represents selection and discrimination by the walker, though not necessarily, of course, on the level of deliberate awareness or self-conscious representation. We have already had sufficient evidence that conscious awareness is not a basic category so far as the natural foundations of method are concerned. Neither active judgments nor the other modes of judgment derive their judicative character from the concomitant fact of awareness but rather from the fact that

they are periodical expressions of the ongoing interplay of assimilation and manipulation. What is fundamental is not that each product is reflexively represented (by the producer) but that each is representable or interpretable. The former circumstance is occasional, the latter essential to judgment. Every product is a judgment precisely because it offers itself, as product, for interpretation and appraisal. Thus a work of art, whether a mechanically produced chest of drawers or a poem, invites interpretation or assimilation by preempting sensory materials and through them contriving a determinate or unitary order. It is ordinarily exhibitive rather than assertive or active: that is, it does not call primarily or at all for interpretation in terms of truth or falsity, nor for interpretation in terms of expediency or rightness in the pattern of conduct. What it calls for minimally (certainly not exclusively) is approbation and assimilation in respect of the combination of characters as such. In so far as a work of art is interpretable in terms, say, of its moral implications, it is an active judgment; in so far as it is interpretable in terms of its influence on the type of cognitive enterprise known as factual inquiry, it is assertive. No product is intrinsically active, assertive, or exhibitive: its judicative function is determined by its proceptive or communicative context.

The judgments of man are not only commentaries on the world; they are the only devices by which process is arrested and appropriated. They are crystallized manipulations. But they function also to render nature assimilable. The world of judgments is not just nature pictured—the metaphysical difficulty inhering in such an account is notorious—but nature, as it were, in process of self-illumination. Judgment, however, is more than the vehicle by which life distinctively human is made possible. It is the means by which nature allows the individual to transcend himself. Through each product the individual is literally multiplied. In reflexive communication he multiplies the dimensions of his individuality, in social communication he makes possible new life and growth. But it is in the very occurrence of the product that self-transcendence is potential. True, the great majority of products originate and die inconsequentially in this or that proceptive domain. Yet each product, in so far as it is a judgment, is so to speak more than a mere product. The product is an event in time; the judgment is eternal in that the circumstances of its origin do not comprehend its entire being. There can be no assurance that any judgment is mortal or infertile. It always represents in its utterance more than it reflects in its occurrence. And yet the individual or the community is not just a natural seedbed for an instrument that becomes miraculously self-sufficient. It will become clear from our analysis of perspective that the judgment is not separable from any of an indefinite number of networks, so that its potential universality may be said to be one and the same with that which resides naturally within the individual.

Some procepts become subjects of reflexive communication, others do not. A burn unnoticed might fall in the latter class, the moon as an

object of study in the former. In other words, some procepts become represented as elements of sign-complexes, which may be called projects. All products are ultimately the outcome of the proceptive direction, but not all are necessarily the outcome of reflexive communication, that is, of projects. The latter products are products of *query:* they comprise the judgments of the arts and of the sciences, and in general all judgments that emanate from deliberative invention. A project, or distinguishable instance of query, already entails judgment; it is, in a sense, a product—one not yet universally available. Not every project actually culminates in a socially available product; and in fact it is doubtful that any product of query can be considered the outcome of a "single" project. And if this is so, the line between products of query and other products is not a sharp one, despite the usefulness of the distinction.

Signs are essential to communication, but it is a mistake to think that the materials of communication are exclusively signs, if by a "sign" we understand that which serves to represent or interpret a natural complex and which is itself interpretable. Only abstract thinking involves signs exclusively; communication, the guiding mechanism of proception, is a much more pervasive and fundamental process. Physical objects may be direct materials of communication, no less than they may be direct materials for perception or observation. When I contemplate a house under construction and reflect upon it, weighing its merits, comparing it with other houses, and bringing standards to bear upon it, the house is as much a part of the project in my query as the signs conjoined with it. This is precisely what is to be understood when we say that the house is a procept for me. Projects and other products are procept-transformations in the sense that they are alterations of my relation to the object. In any case, objects-in-relation-to-me are the materials of both reflexive and social communication, along with the instruments by which they are representable (the signs). Both the objects and the signs which represent them are procepts: both are natural complexes bearing upon the proceptive direction.

The house itself may have a representative function: it may function as a sign. But it may not. When I discuss the house-in-process with another spectator, it is as much a datum of communication as the other ingredients of the analysis. The supposition that only signs are involved in communication arises partly from the tendency to think of signs as portable vehicles, but more subtly, from the view that the subjects of communication are mutually transferred or literally shared (and in the case of reflexive communication, posited at will and dismissed at will from consideration). This supposition is rendered plausible by the correlative supposition that communication is between minds and that therefore it is not the house but only a sense-image, idea, or concept that can be "in the mind" at all. Thus there is apparent justification for the view that communication is "about" the house, that the house "itself" is not "communicated." But in the very same sense, neither are the symbols employed by the analysis "communicated" in the sense of being

actually given by one to another. The communicators *refer* to the symbols no less than to the house, and they *utilize* the house no less than the symbols. Thus the house is part of the project of reflexive communication in two proceivers and of the social communication in which they are engaged, and the judgments made about the house constitute the products of the communication.

Now it is the house witnessed, not the house financed or the house originally conceived that is here part of the project. Some philosophers cannot abide the view that it is the *house* we witness. They feel that it is only a sense-datum or essence or appearance or image that enters as the subject of communication or as the direct object of attention. When I recede from the house, the "house" grows smaller—but not the "real" house, only an image of the house; the smallness belongs to the sensum, the idea. This way of speaking is gratuitous, to say the least: we can certainly discard the assumption of a distinction between appearance and reality in favor of an assumption that the house really changes its properties in different perspectives. The house unquestionably grows smaller in the perspective of vision. That is to say, under the conditions of backward movement on my part, it occupies less and less of a place in the visual field. At the same time it remains the same size in the perspective of physical measurement with respect to mass or shape. Not only are both judgments consistent; the qualifications introduced actually make it possible to predict one from the knowledge of the other. The philosophers who find it necessary to distinguish between posited objects and perceptual appearances have been likely to find the object twice removed in their philosophic reckoning: as the idea is necessarily proxy for the thing, so the sign must necessarily designate the idea. Presumably we communicate about our own products directly and about the world only remotely. Not that anyone who suffers and aspires in this life can take such an implication and such a position seriously in his waking moments. A world which creates and destroys men, and amidst the indifferent circumstances of which communication is born and is permitted, can hardly be so distant as their epistemologies would believe.

Defining Art and the Work of Art

G. E. Moore

George Edward Moore (1873–1958) taught philosophy at Cambridge from 1911 to 1939. In addition to Principia Ethica *(1903), he published a number of highly influential papers, some of them collected in* Philosophical Studies *(1922).*

The major works of Ludwig Wittgenstein (1889–1951), the Philosophical Investigations *(1953) and the* Tractatus Logico-Philosophicus *(1961), have greatly influenced 20th century philosophic thought. Originally Viennese, Wittgenstein taught at Cambridge from 1930 to 1947.*

Wittgenstein's Lectures on Aesthetics: 1930–33

He introduced his whole discussion of Aesthetics by dealing with one problem about the meaning of words, with which he said he had not yet dealt. He illustrated this problem by the example of the word "game," with regard to which he said both (1) that, even if there is something

From "Wittgenstein's Lectures in 1930–3," *Mind*, New Series, Vol. 64 (1955), pp. 17–21. Reprinted by permission.

common to all games, it doesn't follow that this is what we mean by calling a particular game a "game," and (2) that the reason why we call so many different activities "games" need not be that there is anything common to them all, but only that there is "a gradual transition" from one use to another, although there may be nothing in common between the two ends of the series. And he seemed to hold definitely that there is nothing in common in our different uses of the word "beautiful," saying that we use it "in a hundred different games"—that, *e.g.,* the beauty of a face is something different from the beauty of a chair or a flower or the binding of a book. And of the word "good" he said similarly that each different way in which one person, A, can convince another, B, that so-and-so is "good" fixes the meaning in which "good" is used in that discussion—"fixes the grammar of that discussion"; but that there will be "gradual transitions," from one of these meanings to another, "which take the place of something in common." In the case of "beauty" he said that a difference of meaning is shown by the fact that "you can say more" in discussing whether the arrangement of flowers in a bed is "beautiful" than in discussing whether the smell of lilac is so.

He went on to say that specific colours in a certain spatial arrangement are not merely "symptoms" that what has them *also* possesses a quality which we call "being beautiful," as they would be, if we meant by "beautiful," *e.g.* "causing stomach-ache," in which case we could learn by experience whether such an arrangement did always cause stomach-ache or not. In order to discover how we use the word "beautiful" we need, he said, to consider (1) what an actual aesthetic controversy or enquiry is like, and (2) whether such enquiries are in fact psychological enquiries "though they look so very different." And on (1) he said that the actual word "beautiful" is hardly ever used in aesthetic controversies: that we are more apt to use "right," as, *e.g.,* in "That doesn't look quite right yet," or when we say of a proposed accompaniment to a song, "That won't do: it isn't right." And on (2) he said that if we say, *e.g.,* of a bass "It is too heavy; it moves too much," we are not saying "If it moved less, it would be more agreeable to me": that, on the contrary, that it should be quieter is an "end in itself," not a means to some other end; and that when we discuss whether a bass "will do," we are no more discussing a psychological question than we are discussing psychological questions in Physics; that what we are trying to do is to bring the bass "nearer to an ideal," though we haven't an ideal before us which we are trying to copy; that in order to show what we want, we might point to another tune, which we might say is "perfectly right." He said that in aesthetic investigations "the one thing we are not interested in is causal connexions, whereas this is the only thing we are interested in in Psychology." To ask "Why is this beautiful?" is not to ask for a causal explanation: that, *e.g.,* to give a causal explanation in answer to the question "Why is the smell of a rose pleasant?" would not remove our "aesthetic puzzlement."

Against the particular view that "beautiful" means "agreeable" he

111

pointed out that we may refuse to go to a performance of a particular work on such a ground as "I can't stand its greatness," in which case it is disagreeable rather than agreeable; that we may think that a piece of music which we in fact prefer is "just nothing" in comparison to another to which we prefer it; and that the fact that we go to see "King Lear" by no means proves that that experience is agreeable: he said that, even if it is agreeable, that fact "is about the least important thing you can say about it." He said that such a statement as "That bass moves too much" is not a statement about human beings at all, but is more like a piece of Mathematics; and that, if I say of a face which I draw "It smiles too much," this says that it could be brought closer to some "ideal," not that it is not yet agreeable enough, and that to bring it closer to the "ideal" in question would be more like "solving a mathematical problem." Similarly, he said, when a painter tries to improve his picture, he is not making a psychological experiment on himself, and that to say of a door "It is top-heavy" is to say what is wrong with it, *not* what impression it gives you. The question of Aesthetics, he said, was not "Do you like this?" but "*Why* do you like it?"

What Aesthetics tries to do, he said, is to give *reasons, e.g.,* for having this word rather than that in a particular place in a poem, or for having this musical phrase rather than that in a particular place in a piece of music. Brahms' *reason* for rejecting Joachim's suggestion that his Fourth Symphony should be opened by two chords was not that that wouldn't produce the feeling he wanted to produce, but something more like "That isn't what I meant." *Reasons,* he said, in Aesthetics, are "of the nature of further descriptions": *e.g.* you can make a person see what Brahms was driving at by showing him lots of different pieces by Brahms, or by comparing him with a contemporary author; and all that Aesthetics does is "to draw your attention to a thing," to "place things side by side." He said that if, by giving "reasons" of this sort, you make another person "see what you see" but it still "doesn't appeal to him," that is "an end" of the discussion; and that what he, Wittgenstein, had "at the back of his mind" was "the idea that aesthetic discussions were like discussions in a court of law," where you try to "clear up the circumstances" of the action which is being tried, hoping that in the end what you say will "appeal to the judge." And he said that the same sort of "reasons" were given, not only in Ethics, but also in Philosophy.

As regards Frazer's "Golden Bough," the chief points on which he seemed to wish to insist were, I think, the three following. (1) That it was a mistake to suppose that there was *only one* "reason," in the sense of "motive," which led people to perform a particular action—to suppose that there was "one motive, which was *the* motive." He gave as an instance of this sort of mistake Frazer's statement, in speaking of Magic, that when primitive people stab an effigy of a particular person, they believe that they have hurt the person in question. He said that primitive people do not *always* entertain this "false scientific belief," though in some cases they may: that they may have quite different reasons for

stabbing the effigy. But he said that the tendency to suppose that there is "one motive which is *the* motive" was "enormously strong," giving as an instance that there are theories of play each of which gives *only one* answer to the question "Why do children play?" (2) That it was a mistake to suppose that *the* motive is always "to get something useful." He gave as an instance of this mistake Frazer's supposition that "people at a certain stage thought it useful to kill a person, in order to get a good crop." (3) That it was a mistake to suppose that why, *e.g.,* the account of the Beltane Festival "impresses us so much" is because it has "developed from a festival in which a real man was burnt." He accused Frazer of thinking that this was the reason. He said that our puzzlement as to why it impresses us is not diminished by giving the *causes* from which the festival arose, but is diminished by finding other similar festivals: to find these may make it seem "natural," whereas to give the causes from which it arose cannot do this. In this respect he said that the question "Why does this impress us?" is like the aesthetic questions "Why is this beautiful?" or "Why will this bass not do?"

He said that Darwin, in his "expression of the Emotions," made a mistake similar to Frazer's, *e.g.,* in thinking that "because our ancestors, when angry, wanted to bite" is a sufficient explanation of why we show our teeth when angry. He said you might say that what is satisfactory in Darwin is not such "hypotheses," but his "putting the facts in a system"—helping us to make a "synopsis" of them.

As for Freud, he gave the greater part of two lectures to Freud's investigation of the nature of a "joke" (Witz), which he said was an "aesthetic investigation." He said that Freud's book on this subject was a very good book for looking for philosophical mistakes, and that the same was true of his writings in general, because there are so many cases in which one can ask how far what he says is a "hypothesis" and how far merely a good way of representing a fact—a question as to which he said Freud himself is constantly unclear. He said, for instance, that Freud encouraged a confusion between getting to know the *cause* of your laughter and getting to know the *reason* why you laugh, because what he says sounds as if it were science, when in fact it is only a "wonderful representation." This last point he also expressed by saying "It is all excellent similes, *e.g.* the comparison of a dream to a rebus." (He had said earlier that all Aesthetics is of the nature of "giving a good simile.") He said that this confusion between *cause* and *reason* had led to the disciples of Freud making "an abominable mess": that Freud did not in fact give any method of analysing dreams which was analogous to the rules which will tell you what are the causes of stomach-ache; that he had genius and therefore might sometimes by psycho-analysis find the *reason* of a certain dream, but that what is most striking about him is "the enormous field of psychical facts which he arranges."

As for what Freud says about jokes, he said first that Freud makes the two mistakes (1) of supposing that there is something common to all jokes, and (2) of supposing that this supposed common character is the

meaning of "joke." He said it is not true, as Freud supposed, that *all* jokes enable you to do covertly what it would not be seemly to do openly, but that "joke," like "proposition," "has a rainbow of meanings." But I think the point on which he was most anxious to insist was perhaps that psycho-analysis does not enable you to discover the *cause* but only the *reason* of, *e.g.,* laughter. In support of this statement he asserted that a psycho-analysis is successful only if the patient agrees to the explanation offered by the analyst. He said there is nothing analogous to this in Physics; and that what a patient agrees to can't be a *hypothesis* as to the *cause* of his laughter, but only that so-and-so was the *reason* why he laughed. He explained that the patient who agrees did not think of this reason at the moment when he laughed, and that to say that he thought of it "subconsciously" "tells you nothing as to what was happening at the moment when he laughed."

Frank Sibley

Although he has not published widely, Frank Sibley's articles have evoked considerable interest among contemporary aestheticians. He is currently Professor of Philosophy at Bowland College, University of Lancaster.

Is Art an Open Concept? An Unsettled Question

Aestheticians have often attempted to define art by specifying its necessary and sufficient properties. Recently, however, it has been claimed [1] that such definition is impossible; it has been argued that art is an "open" concept. I believe that, though this may be so, the considerations that may establish it have not been investigated in detail.

To say that art is an open concept is taken to mean that we "can list . . . some conditions under which (we) can apply correctly the concept of art but (we) cannot list all of them." This, it is urged, is because

From Proceedings of the IVth International Congress of Aesthetics, Athens, 1960. By special permission of the author.

"unforeseeable or novel conditions are always forthcoming or envisageable," because of the "expansive, adventurous character of art, its ever-present changes and novel creations," and because closing the list would foreclose "on the very conditions of creativity in the arts."

Now I want it to be clear that "art," as I am discussing it, is not a neutral term. If there is a sense of "art" which embraces both excellent and worthless works, I am not concerned with that here. It is the sense according to which only works with some artistic merit count as art that I am considering; for this is what traditional theorists sought to define, by specifying properties which artistic achievements possess but which failures lack. There may be certain conditions that an object must meet if it is to be *either* a fine work *or* an artistic failure; perhaps, say, it must be man-made. But that is not the present question. The question is whether, over and above any such necessary conditions, the *further* qualities which are sufficient to make the object a work of art, or constitute artistic merit, form an open list or not.

Three arguments have been thought, mistakenly, to prove that art is an open concept: (1) New works are always being produced; there is no closed set. We cannot provide a definition, since other examples of art are yet to come. But this argument in no way proves that new works will not be art in virtue of the same *general* properties as existing works. (2) It is argued that constant creativity in art gives rise to new art-forms, the mobile and the collage. But this consideration is at best inconclusive; traditional definitions did not merely attempt to list art-forms exhaustively. Traditionalists could admit new *forms,* and yet might insist that new objects, if they are art, and whether in new forms or not, are art in virtue of the same qualities—though perhaps achieved by different means—as existing works, say, "significant form" or "expressiveness." (3) It is argued that sub-concepts like the novel are open; for any definition we could set up might exclude such new productions as, e.g., *Finnegans Wake,* to which we should naturally want to extend the concept. It is then concluded that the general concept, art, must similarly be open. But this too does not follow. Indeed, such terms as "novel" and "painting" are artistically neutral; novels may be good or worthless. I do not think, then, that these arguments will serve.

It is not difficult to find qualities which constitute artistic merits: graceful, elegant, dynamic, unified, subtly balanced, powerfully constructed, full of vitality, vivid (of a description), etc. By contrast, some qualities carry no implication of merit: red, square, diagonal, trochaic. Others, again, constitute defects: tedious, pretentious, laboured, disorganized, stilted. It seems clear therefore that the list of artistic merits does have limits; we cannot include any terms at will. But is it open or not? Could we make an exhaustive list, or must we always allow for new additions? This question raises puzzling issues, including also the question what we are to count as "a quality" or "the same quality." It needs careful examination, though I can only touch upon some puzzles here.

1. Suppose one picked out from a dictionary or thesaurus all the

expressions that clearly imply artistic merit. There would still remain, it might be said, all the varied and complex remarks in the writings of critics; for language presents endless resources for phrase-making. But this does not necessarily entail any extension of the list of artistic qualities. What the critic says in his lengthier phrases need be no more than an elegant or striking paraphrase of what we could say, in more stilted or pedestrian ways, using our original list of expressions. So too for many uses of simile, metaphor and allusion in critical discourse.

2. Works of art are endlessly varied. This one evokes the excitement and fervour of revolutionary days, that one evokes an atmosphere of sultry langour, another the *ennui* of provincial life. But nothing follows from *this* sort of variety as to the list of merit terms being open. It is because each work *evokes* something that it succeeds.

What then would clearly constitute a new artistic merit, "a new property" added to the list of artistic qualities? One might imagine the list extended in two apparently different ways: (a) by admitting entirely new qualities hitherto unmet with or of which we are at present unaware; (b) by admitting familiar qualities not *now* regarded as artistic merits.

(a) The first supposition, that artists may create or we may become alive to completely new qualities, qualities which would nevertheless in any suitable object constitute artistic merits, sounds a radical one. It seems to suppose that we may come to develop at this late date an eye for qualities as different from dynamic or graceful, say, as these are from each other. If such a thing happened we could say, in the required sense, that art is an open concept. I believe such a thing does occasionally occur; but once again it is important to see that certain arguments from the "ever-present" creative character of art which might be thought to support this view do not in fact support it. For example, art is constantly "expansive" and "adventurous" in the sense that each artist or school of artists may produce new individual works each of which is moving or graceful in its own way; and there is no limit to the number and variety of these new and different graceful pieces. But though there is a place for saying that each has a *different* quality, there is a case also for saying that each has the *same* quality. Each, after all, is graceful. To deny this is to refuse to use these vital general terms like "graceful," or to pretend these words are equivocal, referring to a different quality on each occasion of use. The delicacy of Botticelli is not that of Watteau. But we can apply the word "delicate" to each, and it is the right word. If there is a relevant proof that artists create, or we come to see in art, quite new qualities, I think it must be shown in a different way: by appealing to the way in which we begin to apply to art works, as terms of praise, words we have not hitherto applied to art at all. With the introduction of certain sorts of painting it was natural to begin to use terms like "solidity," "weight," "atmospheric," and more recently perhaps, "freedom," "informality," "unpredictability" and "risk." The words are not always new; but these critical and metaphorical uses of them are. We become newly

aware of certain qualities which we recognize as merits, and we employ words for them with some change from their previous literal sense. We might recall that terms of artistic praise like "elegant" and "graceful" came to their now predominantly aesthetic use by similar extensions.

(b) The second supposition was that, faced with a new work, we might decide that a quite familiar quality, described by a word used in a familiar and literal way, should be added to the list of artistic merits, even though we had never thought so before. This is not simply a case of coming to see, as never before, that e.g. Donne is moving or subtle. It is the radical suggestion that certain qualities with which we are familiar are capable of becoming artistic merits, even though they are not so now. One wonders which qualities could come to be artistic merits in this way. Could being red, angular, or in trochaic measure ever be sufficient for artistic merit? I think this second suggestion is altogether unacceptable. Even in the most likely case where, say, a writer like Donne is condemned as harsh in one age and praised for his harshness in another, we find that in the one case harsh is amplified for example by crude, uncouth or clumsy, and in the other by rugged, honest, direct, powerful. It is tempting to say that the two sets of critics see a different quality even though they use the same word, rather than that one and the same quality was then a blemish but has now become a merit.

The list of aesthetic merit qualities may be an open one, and art may be an open concept. But it cannot be inferred, as has been thought, in any obvious way from the "expansive, adventurous" character of art. Difficult questions, especially about the notions of "a quality" and "seeing a quality" need investigation; and this might teach us more about the concept of art than merely to label it "open" or not.

Note

1. For instance by Morris Weitz, "The Role of Theory in Aesthetics," *Journal of Aesthetics and Art Criticism,* September 1956. All my quotations are from this article.

George Dickie

George Dickie, Professor of Philosophy at the University of Illinois at Chicago Circle, is the author of a number of significant articles, as well as of Aesthetics *(1971).*

Defining Art: II

The attempt to define "art" by specifying its necessary and sufficient conditions is a very old endeavor. The first definition—the imitation theory—despite what now seem like obvious difficulties, seems to have more or less satisfied everyone until some time in the nineteenth century. Since the expression theory of art broke the spell of the imitation theory, there has been a cascade of definitions which purport to reveal the necessary and sufficient conditions of art. About fifteen years ago several philosophers, inspired by Wittgenstein's talk about concepts, began arguing that there are no necessary and sufficient conditions for art. This argument had, until recently, persuaded so many philosophers that the flow of definitions had all but ceased. While I will ultimately try to show that "art" can be defined, the denial that it can be defined has had the very great value of forcing us to look deeper into the concept of *art.* The parade of dreary and superficial definitions which have been presented are, for a variety of reasons, eminently rejectable. The traditional attempts to define "art," from the imitation theory on, may be thought of as phase one and the contention that "art" cannot be defined as phase two. I want to supply phase three by defining "art" in such a way as to avoid the difficulties of the traditional definitions and to incorporate the insights of the later analysis.

The traditional attempts at definition have sometimes been victimized by prominent but accidental features of works of art, features which have characterized art at a particular stage in its historical development. For example, until quite recently, the things clearly recognizable as works of art were either obviously representational or assumed to be representational. Paintings and sculptures were obviously so, and it was widely assumed that music must in some sense also be representational. Literature was "representational" in the sense that it described familiar scenes of life. It was, then, easy enough to think that imitation must be

This article is a substantially revised version of an article entitled "Defining Art," which was published in the *American Philosophical Quarterly,* 1969, pp. 253–256. This revised version is to be a chapter in a projected book on the concepts of the aesthetic and art. It is published here by permission of the author.

the essence of art. The imitation theory focused on an obvious relational property of works of art, namely, art's relation to a subject matter. The development of nonobjective art showed that imitation is not even an always accompanying property of art, much less an essential property.

The theory of art as the expression of emotion focused on another relational property of works of art, namely, the works' relation to their creators. The expression theory in its various forms and in all subsequent definitions has proved inadequate, as recent philosophers have maintained. If, however, none of these definitions will do, we can take a clue from the imitation and expression theories. Both, as noted, singled out *relational* properties of art as essential. As it turns out, the two defining characteristics of art are relational properties and one of them turns out to be exceedingly complex.

I

The most well-known denial that "art" can be defined occurs in Morris Weitz's article "The Role of Theory in Aesthetics." [1] Weitz's conclusion depends on two arguments which may be called his "generalization argument" and his "classification argument." In stating "the generalization argument" Weitz distinguishes, quite correctly, between the generic conception of *art* and the various sub-concepts of art such as tragedy, the novel, painting, and the like. He then goes on to give an argument which purports to show that the sub-concept *novel* is open, i.e., that the members of the class of novels do not share any essential or defining characteristics. He then asserts without further argument that what is true of novels is true of all other sub-concepts of art. The generalization from one sub-concept to all sub-concepts may or may not be justified, but I am not questioning it here. I do, however, question Weitz's additional contention, also asserted without argument, that the generic conception of *art* is open. The best that can be said of his conclusion about the generic sense is that it is unsupported. It might very well be the case that all or some of the sub-concepts of art are open and the generic conception of art is closed. That is, it might be the case that all or some of the sub-concepts of art such as novel, tragedy, sculpture, painting, and the like lack necessary and sufficient conditions and that "work of art," which is the genus of all the sub-concepts, can still be defined in terms of necessary and sufficient conditions. There may not be any characteristics which all tragedies have in common which would distinguish them from, say, comedies *within the domain of art,* but it may be that there are common characteristics which works of art have which distinguish them from non-art. There is nothing to prevent a closed genus/open species relationship. Weitz himself has recently cited a similar (although reversed) example of genus-species relationship. He argues that *game* (the genus) is open but that *major league baseball* (a species) is closed.[2] His second argument, "the classification argument," purports to show

that not even the characteristic of artifactuality is a necessary feature of art. Weitz's conclusion here is something of a shocker because it has been widely assumed by philosophers and nonphilosophers alike that a work of art is necessarily an artifact. His argument is simply that we sometimes utter such statements as "This piece of driftwood is a lovely piece of sculpture," and as such utterances are perfectly intelligible, it follows that some non-artifacts such as certain pieces of driftwood are works of art (sculptures). In other words, something does not have to be an artifact in order to be correctly classified as a work of art. I will try to rebut this argument shortly.

Recently, Maurice Mandelbaum has raised a question about both Wittgenstein's famous contention that "game" cannot be defined and Weitz's thesis about *art*.³ His challenge to both is based on the charge that they have been concerned only with what Mandelbaum calls "exhibited" characteristics and that consequently each has failed to take account of the nonexhibited, relational aspects of games and art. By "exhibited" characteristics Mandelbaum means easily perceived properties such as that a ball is used in a certain kind of game, that a painting has a triangular composition, that an area in a painting is red, or that the plot of a tragedy contains a reversal of fortune. Mandelbaum concludes that when we consider the nonexhibited properties of games, we see that they have in common "the potentiality of . . . (an) . . . absorbing non-practical interest to either participants or spectators." ⁴ Although he does not attempt a definition of "art," Mandelbaum does suggest that feature(s) common to all works of art may perhaps be discovered which will be a basis for the definition of "art," if the nonexhibited features of art are attended to.

Having noted Mandelbaum's invaluable suggestion about definition, I now return to Weitz's argument concerning artifactuality. In an earlier attempt to show Weitz wrong about artifactuality and art, I thought it sufficient to point out that there are two senses of "work of art," namely an evaluative sense and a classificatory sense—senses which Weitz himself distinguishes in his article as the evaluative and the descriptive senses of art. My earlier argument was that if there is more than one sense of "work of art" then the fact that "This piece of driftwood is a lovely piece of sculpture" is intelligible does not prove what Weitz wants it to prove. Weitz would have to show that "sculpture" is being used in the sentence in question in the classificatory sense, and this he makes no attempt to do. My argument assumed that once the distinction was pointed out it is obvious that "sculpture" was here being used in the evaluative sense. Richard Sclafani has subsequently pointed out that my argument shows only that Weitz's argument is inconclusive and that Weitz might still be right, although his argument does not prove his conclusion. Sclafani, however, has constructed an argument against Weitz on this point and I here adopt his argument.⁵

Sclafani shows that there is a third sense of "work of art" and that "driftwood cases" (the non-artifact cases) fall under it. He begins by

comparing a paradigm work of art, Brancusi's *Bird in Space,* with a piece of driftwood which looks very much like it in certain respects. Sclafani says that it seems natural to say of the piece of driftwood that it is art and that we do so because it has so many properties in common with the Brancusi piece. He then asks us to reflect on our characterization of the driftwood and the *direction* it has taken. We say the driftwood is art because of its resemblance to some paradigm work of art or because the driftwood shares properties with several paradigm works of art. The paradigm work or works are of course always artifacts; the direction of our move is from paradigmatic (artifactual) works of art to nonartifactual "art." Sclafani quite correctly takes this to indicate that there is a primary, paradigmatic sense of "work of art" (my classificatory sense) and a derivative or secondary sense into which the "driftwood cases" fall. Weitz is right in a way in saying that the driftwood is art, but wrong in concluding that artifactuality is unnecessary for (the primary sense of) art.

There are then at least three distinct senses of "work of art"—the primary or classificatory sense, the secondary or derivative, and the evaluative. Perhaps in most uses of Weitz's driftwood sentence example, both the derivative and the evaluative senses would be at work: the derivative sense if the driftwood shared a number of properties with some paradigm work of art and the evaluative sense if the shared properties were found to be valuable by the speaker. Sclafani gives a case in which only the evaluative sense functions; the case in which someone says, "Sally's cake is a work of art." In most uses of such a sentence "work of art" would simply mean that its referent has valuable qualities. Admittedly, one can imagine contexts in which the derivative sense could apply to cakes. (Given the present situation in art today, it is not even difficult to imagine cakes to which the primary sense of art could be applied.) If someone were to say, "This Rembrandt is a work of art," both the classificatory and the evaluative senses would be functioning. The expression "This Rembrandt" would convey the information that its referent is a work of art in the classificatory sense and "is a work of art" could then only reasonably be understood in the evaluative sense. Finally, someone might say of a sea shell or some other natural object which resembles a man's face somewhat but which is otherwise uninteresting, "This shell (or other natural object) is a work of art." In this case, only the derivative sense would be being used.

We utter sentences in which the expression "work of art" has the evaluative sense with considerable frequency, applying it to both natural objects and artifacts. We speak of works of art in the derived sense with somewhat less frequency. The classificatory sense of "work of art," which indicates simply that a thing belongs to a certain category of artifacts, occurs, however, very infrequently in our discourse. We rarely utter sentences in which we use the classificatory sense because it is such a basic notion: we rarely find ourselves in situations in which it is necessary to raise the question of whether an object is a work of art in the

classificatory sense. We generally know immediately whether an object is a work of art, so that generally no one needs to say, by way of classification, "That is a work of art." Recent developments in art such as junk sculpture and found art, however, may occasionaly force such remarks. Even if, however, we do not often talk about art in this sense, the classificatory sense is a basic concept which structures and guides our thinking about our world and its contents.

II

It is now clear that artifactuality is a necessary condition (call it the genus) of the primary sense of art. This fact, however, does not seem very surprising and it would not even be very interesting except for the fact that Weitz and others have denied it. It is also clear that artifactuality alone is not the whole story and that another necessary condition (the *differentia*) has to be specified in order to have a satisfactory definition of "art." Like artifactuality, the second condition is a nonexhibited property, but it turns out to be as complicated as artifactuality is simple. The attempt to discover and specify the second condition of art will involve an examination of the intricate complexities of the *artworld.* W. E. Kennick contends that the kind of approach which will be employed here, following Mandelbaum's lead, is futile. He concludes that "The attempt to define Art in terms of what we do with certain objects is as doomed as any other."[6] He tries to support this conclusion by referring to such things as the fact that the ancient Egyptians sealed up paintings and sculptures in tombs. There are two difficulties with Kennick's argument. First, the fact that the Egyptians sealed up paintings and sculptures in tombs does not entail that they regarded them differently from the way in which we regard them. They might have put them there for the dead to appreciate, or simply because they belonged to the dead person, or for some other reason. The Egyptian practice does not prove a radical difference between their conception of art and ours such that a definition which subsumes both is impossible. Second, there is no need to assume that we and the ancient Egyptians share a common conception of art. It would be enough to be able to specify the necessary and sufficient conditions for the concept of art which we have (we present-day Americans, we present-day Westerners, we Westerners since the organization of the system of the arts in or about the eighteenth century—I am not sure of the exact limits of the "we"). Kennick notwithstanding, we are most likely to discover the *differentia* of art by considering "what we do with certain objects." Of course, there is no guarantee that any given thing we might do or an ancient Egyptian might have done with a work of art will throw light on the concept of art. Not every *doing* will reveal what is required.

Although he does not attempt to formulate a definition, Arthur Danto in his provocative article, "The Artworld," has suggested the direction

which must be taken by an attempt to define "art." [7] In reflecting on art and its history together with such present-day developments as Warhol's *Brillo Carton* and Rauschenberg's *Bed,* Danto writes, "To see something as art requires something the eye cannot descry—an atmosphere of artistic theory, a knowledge of history of art: an artworld." [8] Admittedly, this stimulating comment is in need of elucidation, but it is clear that in speaking of "something the eye cannot descry" Danto is agreeing with Mandelbaum that nonexhibited properties are of great importance in constituting something as art. In speaking of atmosphere and history, however, Danto's remark carries us a step further than Mandelbaum's analysis. Danto's remark points to the rich structure in which particular works of art are embedded: it indicates *the institutional nature of art.*

I shall use Danto's term, "the artworld," to refer to the broad social institution in which works of art have their place. But is there such an institution? George Bernard Shaw speaks somewhere of the apostolic line of succession which stretched from Aeschylus to himself. Shaw was no doubt speaking for effect and to draw attention to himself, as he often did, but there is an important truth implied by his remark. There is a long tradition or continuing institution of the theater which has its origins in ancient Greek religion and other Greek institutions. That tradition has run very thin at times and perhaps has ceased to exist all together during some periods, only to be reborn out of its memory and the need for art. The institutions which have been associated with the theater have varied from time to time: in the beginning it was Greek religion and the Greek state; in medieval times the theater was associated with the church; more recently the theater has been associated with private business and the state (national theater). What has remained constant with its own identity throughout its history is the theater itself as an established way of doing and behaving. This institutionalized behavior occurs on both sides of the "footlights": both the players and the audience are involved and go to make up the institution of the theater. The *roles* of the actors and the audience are defined by the traditions of the theater. What the author, management, and players present is art and it is art because it is presented within the theaterworld framework. Plays are written to have a place in the theater system and they exist as plays, that is, as art, within that system. Of course, I do not wish to deny that plays exist as literary works, that is, as art, within the literary system: the theater system and the literary system overlap.

Theater is only one of the systems within the artworld. Each of the systems of the artworld has had its own origins and historical development. We have some information about the later stages of these developments but we have to guess about the origins of the basic art systems. (I suppose that we have complete knowledge of certain recently developed subsystems or genres such as Dada and happening.) However, even if our knowledge is not as complete as we wish it were, we do have substantial knowledge about the systems of the artworld as they currently exist and as they have existed for some time. One central feature

which all of the systems of the artworld have in common is that each is a framework for the *presenting* of particular works of art. Given the great variety of the systems of the artworld it is not surprising that works of art have no exhibited properties in common. If, however, we step back and view the works in their institutional setting, we will be able to see the essential properties they share.

Theater is a rich and instructive illustration of the institutional nature of art. It is, however, a development within the domain of painting and sculpture—Dadaism—which most easily reveals the institutional essence of art. Duchamp and friends conferred the status of art on "ready-mades" (urinals, hatracks, snowshovels, and the like) and when we reflect on their deeds we can take note of a kind of human action which has until now gone unnoticed and unappreciated—the action of conferring the status of art. Painters and sculptors have, of course, been engaging all along in the action of conferring the status on the objects they create. As long, however, as the created objects were conventional, given the paradigms of the times, it was the objects themselves and their fascinating exhibited properties which were the focus of the attention of not only spectators and critics but of philosophers of art as well. When an artist of an earlier era painted a picture he did a number of things: depicted perhaps a human being, portrayed perhaps a certain man, fulfilled perhaps a commission, worked at his livelihood, and so on. In addition to these actions, he also acted as an agent of the artworld and conferred the status of art on his creation. Philosophers of art attended to only some of the properties the created object acquired from these various actions, to, say, the representational or expressive features of the objects. They entirely ignored the nonexhibited property of status. When, however, the objects are bizarre, as in the cases of the Dadaists, our attention is forced away from the objects' obvious properties to a consideration of the objects and their social context. As works of art, Duchamp's "ready-mades" may not be worth much, but as examples of art they are very valuable for art theory. It should be clear that I am not claiming that Duchamp and friends invented the conferring of the status of art, they simply used an existing institutional device and applied it in an unusual way. Duchamp did not invent the artworld, it was there all along.

The artworld consists of a bundle of systems: theater, painting, sculpture, literature, music, and so on; each of which furnishes an institutional background for the conferring of the status on objects within its domain. There is no limit to the number of systems which can be brought under the generic conception of art and each of the major systems contains further sub-systems. These features of the artworld provide the elasticity whereby creativity of even the most radical sort can be accommodated. It is possible, though unlikely, that a whole new system comparable to the theater could be added in one fell swoop. What is more likely is that a new sub-system will be added within a system. For example, junk sculpture added within sculpture, happenings added within theater, and so on. Such additions might in time develop into full-blown

systems. Thus, the radical creativity, adventuresomeness, and exuberance of art of which Weitz speaks is possible within the concept of art even though it is closed by the necessary and sufficient conditions of artifactuality and conferred status. Having now to some extent described the artworld, I am in a position to specify a definition of "work of art." The definition will be given in terms of artifactuality and the conferred status of art. In order, however, to avoid the appearance of circularity, the expression "status of art" will not appear in the definition. I think that a definition similar to the one that I am going to give but which contains "status of art" would not be viciously circular, but I will not discuss the issue at this point. Also, there are several things involved in the *status of art* which have to be unpacked and made clear and that may as well be reflected in the definition itself. Once the definition has been stated a great deal will remain to be said by way of clarification.

A work of art in the classificatory sense is 1) an artifact 2) upon which some person or persons acting on behalf of a certain social institution (the artworld) has conferred the status of candidate for appreciation.

The second condition of the definition makes use of four variously interconnected notions: 1) acting on behalf of an institution, 2) conferring of status, 3) being a candidate, and 4) appreciation. The first two of these are so closely related that they must be discussed together. I shall first describe paradigm cases of conferring status outside of the artworld and then show how or at least try to indicate how similar actions take place within the artworld. The most clear-cut examples of the conferring of status are certain actions of the state in which legal status is involved. A king's conferring of knighthood, a grand jury's indicting someone, the chairman of the election board certifying that someone is qualified to run for office, or a minister's pronouncing a couple man and wife are examples in which a person or persons acting on behalf of a social institution (the state) confer(s) *legal* status on persons. Congress or a legally constituted commission may confer the status of national park or monument on an area or thing. The examples given suggest that pomp and ceremony are required to establish legal status; but this is not so, although of course a legal system is presupposed. For example, in some jurisdictions common law marriage is possible—a legal status acquired without ceremony. The conferring of a Ph.D. degree on someone by a university, the election of someone as president of the Rotary, and the declaring of an object as a relic of the church are examples in which a person or persons confer(s) nonlegal status on persons or things. In such cases some social system or other must exist as the framework within which the conferring takes place, but as before ceremony is not required to establish status: for example, a person can acquire the status of wise man or village idiot within a community without ceremony.

It may be felt that the notion of conferring status within the artworld

is excessively vague. Certainly this notion is not as clear-cut as is the conferring of status within the legal system where procedures and lines of authority are explicitly defined and incorporated into law. The counterparts in the artworld to specified procedures and lines of authority are nowhere codified, and the artworld carries on its business at the level of customary practice. Still there *is* a practice and this defines a social institution. A social institution need not have a formally established constitution, officers, and bylaws in order to exist and have the capacity to confer status—some social institutions are formal and some are informal. The artworld could become formalized, and perhaps has to an extent in some political contexts, but most people who are interested in art would probably consider this a bad thing. Such formality would threaten the freshness and exuberance of art. The core personnel of the artworld is a loosely organized, but nevertheless related, set of persons which includes artists (understood to refer to painters, writers, composers, and the like), reporters for newspapers, critics for publications of all sorts, art historians, art theorists, philosophers of art, and others. These are the people who keep the machinery of the artworld working and thereby provide for its continuing existence. In addition, every person who sees himself as a member of the artworld is thereby a member.

Assuming that the existence of the artworld has been established or at least been made plausible, the problem is now to see how status is conferred by this institution. My thesis is that analogous to the way in which a person is certified as qualified for office, two persons acquire the status of common law marriage within a legal system, a person is elected president of the Rotary, or a person acquires that status of wise man within a community, an artifact can acquire the status of candidate for appreciation within the social system which may be called "the artworld." How can one tell when the status has been conferred? An artifact's appearance in an art museum as part of a show, a play's performance at a theater, and the like are sure signs that the status has been conferred. There is, of course, no guarantee that one can always know whether something is a candidate for appreciation, just as one cannot always tell whether a given person is a knight or is married. When an object's status depends on nonexhibited characteristics, a simple look at the object will not necessarily reveal that status. The nonexhibited relation *may* be symbolized by some badge, for example, by a wedding ring, in which case a simple look will reveal the status.

There is, however, the more important question of how the status of candidate for appreciation is conferred. The examples just mentioned— hanging in a museum and a performance in a theater—seem to suggest that a number of persons is required for the actual conferring of the status. In one sense a number of persons is required but in another sense only one person is required. A number of persons is required to make up the social institution of the artworld, but only one person is required to act on behalf of the artworld and to confer the status of candidate for appreciation. In fact, many works of art are seen only by one person—the persons who create them—but they are still art. The status in question

may be acquired by a single person's *treating an artifact as a candidate for appreciation.* Of course, nothing prevents a group of persons from conferring the status, but it is usually conferred by a single person, the artist who creates the artifact. It may be helpful to compare and contrast the notion of conferring the status of candidate for appreciation with a case in which something is simply presented for appreciation: hopefully this will throw light on the notion of status of candidate. Consider the case of a salesman of plumbing supplies who spreads his wares before us. There is an important difference between "placing before" and "conferring the status of candidate for appreciation" and this difference can be brought out by comparing the salesman's action with the superficially similar act of Duchamp in entering a urinal which he christened *Fountain* in that now famous art show. The difference is that Duchamp's action took place within the institutional setting of the artworld and the plumbing salesman's action took place outside of it. The salesman could do what Duchamp did, that is, convert a urinal into a work of art, but such a thing probably would not occur to him. Please remember that *Fountain*'s being a work of art does not mean that it is a good one, nor does this qualification insinuate that it is a bad one either. The antics of a particular present-day artist serve to reinforce the point of the Duchamp case and also to emphasize a significance of the practice of naming works of art. Walter de Maria has in the case of of one of his works even gone through the motions—no doubt as a burlesque—of using a procedure which is used by many legal and some nonlegal institutions— the procedure of licensing. His *High Energy Bar* (a stainless-steel bar) is accompanied by a certificate which bears the name of the work and states that the bar is a work of art only when the certificate is present. In addition to highlighting the status of art by "certifying" it on a document, this example serves to suggest a significance of the act of naming works of art. An object may acquire the status of art without ever being named but giving it a title makes clear to whomever is interested that an object is a work of art. Specific titles function in a variety of ways—as aids to understanding a work or as a convenient way of identifying a work, for example—but any title at all (even *Untitled*) is a badge of status.

The third notion involved in the second condition of the definition is candidacy: a member of the artworld confers the status of *candidate* for appreciation. The definition does not require that a work of art actually be appreciated, even by one person. The fact is that many, perhaps most, works of art go unappreciated. It is important not to build into the definition of the classificatory sense of "work of art" value properties such as actual appreciation: to do so would make it impossible to speak of unappreciated works of art. It might even make it awkward to speak of bad works of art. A theory of art must preserve certain central features of the way in which we talk about art, and we do find it necessary sometimes to speak of unappreciated art and of bad art. Also, not every aspect of a work is included in the candidacy for appreciation; for example, the color of the back of a painting is not ordinarily considered to be

something which someone might think it appropriate to appreciate. The problem of which aspects of a work of art are to be included within the candidacy for appreciation is a question which I have pursued elsewhere [9] in trying to give an analysis of the notion of aesthetic object. The definition of "work of art" should not, therefore, be understood as asserting that every aspect of a work is included within the candidacy for appreciation.

The fourth notion involved in the second condition of the definition is appreciation itself. Some may assume that the definition is referring to a special kind of *aesthetic* appreciation. I have argued elsewhere [10] that there is no reason to think that there is a special kind of aesthetic perception. Similarly, I do not think that there is any reason to think that there is a special kind of aesthetic appreciation. All that is meant by "appreciation" in the definition is something like "in experiencing the qualities of a thing one finds them worthy or valuable" and this meaning applies quite generally both inside and outside the domain of art.

Earlier I remarked that a definition of "art" which contained the expression "status of art" would not be viciously circular. The definition I did give does not contain the expression "status of art" but it does contain a reference to the *art*world. Consequently, some may have the uncomfortable feeling that my actual definition is viciously circular. Admittedly, there is a sense in which the definition is circular, but it is not viciously so. If I had said something like "A work of art is an artifact on which a status has been conferred by the artworld" and then said of the artworld only that it is the thing which confers the status of art, then the definition would be viciously circular because the circle would be so small and *uninformative.* I have, however, devoted a considerable amount of space to describing and analyzing the historical, organizational, and functional intricacies of the artworld, and if this account is accurate the reader has received a considerable amount of *information* about the artworld. The circle I have run is not small and it is not uninformative. If, in the end, the artworld cannot be described independently of art, that is, if the description contains references to art historians, art reporters, plays, theaters, and the like, then the definition strictly speaking is circular. It is not, however, viciously so because the whole account in which the definition is embedded contains a great deal of information about the artworld. One must not focus narrowly on the definition alone: for what it is important to see is that art is an institutional concept and this requires seeing the definition in the context of the whole account. I suspect that the "problem" of circularity will arise frequently (always?) when institutional concepts are dealt with.

III

The instances of Dadaist art and similar present-day developments which have served to bring the institutional nature of art to our attention

suggest several questions. First, if Duchamp can convert such artifacts as a urinal, a show shovel, and a hatrack into works of art, why cannot natural objects such as driftwood also become works of art in the classificatory sense? The answer is that perhaps they can become art if any one of a number of things is done to them. One way in which this might happen would be for someone to pick up a natural object, take it home, and hang it on the wall. Another way would be to pick up a natural object and enter it in an exhibition. It was assumed earlier, by the way, that the driftwood referred to by Weitz's sample sentence was a piece of driftwood in place on a beach and untouched by human hand, or at least "untouched" by any human intention, and that therefore it was art in the derivative sense. Natural objects which become works of art in the classificatory sense are artifactualized without the use of tools—artifactuality is conferred on the object rather than worked on it. This means that natural objects which become works of art acquire their artifactuality at the same time that the status of candidate for appreciation is conferred on them. But perhaps a similar thing ordinarily happens with paintings, poems, and the like; they come to exist as artifacts at the same time that they have the status of art conferred on them. Of course, being an artifact and being a candidate for appreciation are not the same thing—they are two properties which may be acquired at the same time. Many may find the notion of artifactuality being conferred rather than *worked* on an object too strange to swallow, and admittedly it is an unusual conception. It may be that a special account will have to be worked out for *exhibited* driftwood and similar cases.

Another question which arises with some frequency in connection with discussions of the concept of art and which seems especially relevant in the context of the institutional theory is "How are we to conceive of paintings done by individuals such as Betsy the chimpanzee from the Baltimore Zoo?" Calling Betsy's products paintings is not meant to prejudge that they are works of art, it is just that some word is needed to refer to them. The question of whether Betsy's paintings are art depends on what is done with them. For example, a year or two ago the Field Museum of Natural History in Chicago exhibited some chimpanzee and gorilla paintings. We must say that these paintings are not works of art. If, however, they had been exhibited a few miles away at the Chicago Art Institute they would have been works of art—the paintings would have been art if the director of the Art Institute had been willing to go out on a limb for his fellow primates. A great deal depends on the institutional setting: one institutional setting is congenial to conferring the status of art and the other is not. It must be noted that although paintings such as Betsy's would remain her paintings even if exhibited at an art museum, they would be the *art* of the person responsible for their being exhibited. Betsy would not (I assume) be able to conceive of herself in such a way as to be a member of the artworld and, hence, would not be able to confer the relevant status. Art is a concept which necessarily involves human intentionality. These last remarks are not intended to

denigrate the value (including beauty) of the paintings of chimpanzees shown at natural history museums or the creations of bower birds and the like, but as remarks about what falls under a particular concept.

Weitz charges that the defining of "art" or its sub-concepts forecloses on creativity. Some of the traditional definitions of "art" *may* have (and some of the traditional definitions of its sub-concepts probably did) foreclosed on creativity, but this danger is now a thing of the past. In the past it may very well have happened that, for example, a playwright conceived of and wished to write a play with tragic features that lacked a defining characteristic as specified by, say, Aristotle's definition of "tragedy." Faced with this dilemma the playwright might have been intimidated and put his project aside. However, with the present-day disregard for established genres and the clamor for novelty in art, this obstacle to creativity probably no longer exists. Today, if a new and unusual work is created and it is fairly similar to some members of an established type of art, it will usually be accommodated within that type, or if the new work is very unlike any existing works then a new sub-concept will probably be created. Artists today are not easily intimidated and they regard art genres as loose guidelines rather than as rigid specifications. Even if a philosopher's remarks could have an effect on what artists do today, the institutional conception of art would certainly not foreclose on creativity. The requirement of artifactuality cannot prevent creativity, since artifactuality is a necessary condition of creativity. There cannot be an instance of creativity without an artifact of some kind being produced. The second requirement involving the conferring of status could not inhibit creativity; in fact, it encourages it. Since it is possible under the definition that anything whatever may become art, the definition imposes no restraints on creativity.

The institutional theory of art may sound like saying, "a work of art is an object of which someone has said, 'I christen this object a work of art.' " And it is rather like that; although this does not mean that the conferring of the status of art is a simple matter. Just as the christening of a child has as its background the history and structure of the church, conferring the status of art has as its background the Byzantine complexity of the artworld. Some may find it strange that in the non-art cases discussed it appears that there are ways in which the conferring can go wrong, while there does not appear to be a way in which conferring the status of art can be invalid. For example, an indictment might be improperly drawn up and the person charged would not actually be indicted, but nothing parallel seems possible in the case of art. This fact just reflects the differences between the artworld and legal institutions: the legal system deals with matters of grave personal consequences and its procedures must reflect this; the artworld deals with important matters also but they are of a different sort entirely. The artworld does not require rigid procedures, it admits and even encourages frivolity and caprice without losing its serious purpose. It is perhaps worth noting that not all legal procedures are as rigid as court procedures and that mis-

takes made in conferring certain kinds of legal status are not fatal to that status. A minister may make mistakes in reading the marriage ceremony, but the couple that stands before him will still acquire the status of being married. If, however, it is not possible to make a mistake *in* conferring the status of art, it is possible to make a mistake *by* conferring it. In conferring the status of art on an object one assumes a certain kind of responsibility for the object in its new status—presenting a candidate for appreciation always faces the possibility that no one will appreciate it and that the person who did the conferring will thereby lose face. One can make a work of art out of a sow's ear, but that does not necessarily make it a silk purse.

Notes

1. *Journal of Aesthetics and Art Criticism,* 1956, pp. 27–35.
2. In a paper given in a symposium at Kansas State University in 1970.
3. "Family Resemblances and Generalizations Concerning the Arts," *American Philosophical Quarterly,* 1965, pp. 219–228. Reprinted in *Problems in Aesthetics,* Morris Weitz, ed., London, 1970, second edition, pp. 181–197.
4. Ibid., p. 185 in the Weitz anthology.
5. "Dickie on Defining Art," forthcoming in *The Journal of Aesthetics and Art Criticism.* See also his "Art and Artifactuality," *Southwestern Journal of Philosophy,* Fall, 1970.
6. "Does Traditional Aesthetics Rest on a Mistake?" *Mind,* 1958, p. 330.
7. *Journal of Philosophy,* 1964, pp. 571–84.
8. Ibid., 580.
9. "Art Narrowly and Broadly Speaking," *American Philosophical Quarterly,* 1968, pp. 71–77.
10. "The Myth of the Aesthetic Attitude," *American Philosophical Quarterly,* 1964, pp. 56–65.

The Ontological Status of the Work of Art

C. I. Lewis

An eminent American philosopher, C. I. Lewis (1883–1964) taught philosophy for many years at Harvard University. His most well known books are Mind and the World Order *(1929) and* An Analysis of Knowledge and Valuation *(1946).*

Aesthetic Objectivity as an Ontological Category

It is an obvious fact—and no criticism of anybody need be read into the observation of it—that the science of esthetics remains largely undeveloped. Subsidiary principles—"principles of composition" in one or another of the fine arts—are available in considerable number and fairly well attested. But these are about the only positive content of it which is presently assured. As has been observed, there is not even as yet any general agreement amongst estheticians as to the categories in terms of which such positive laws of the esthetic should be formulated. This indifferent success is doubtless attributable in part to the marked diversity which obtains amongst objects of esthetic interest, and to the fact that some classes of them at least are phenomena of extreme complexity.

From *An Analysis of Knowledge and Valuation* (LaSalle, Ill.: The Open Court Publishing Co., 1946), pp. 469–478. Reprinted by permission.

Consider, for example, what entity it is which is termed "Beethoven's Fifth Symphony." A musical composition is not a physical object: any particular rendition of it is a physical entity of its own complex sort; but between the rendition and the thing itself, there is an obvious difference. The rendition may not, and presumably will not, realize exactly the musical intention of the composer or the esthetic possibilities represented by the composition. And in the case of a sonnet or other product of the literary art, there is an even wider gap between the thing itself and the apprehension of it. Here we must ordinarily provide our own rendition; and in so doing we may not only miss a part of the intended meaning but inadvertantly introduce certain grace-notes and variations of our own. Also, that most complex of all esthetic things, the drama, is in some of these respects like music, and in others like poetry; but at least it is clear that a drama cannot be identified with any physical object.

On these points, a painting, a cathedral, or a piece of sculpture seems to differ from a musical composition or a literary product. A picture, edifice or statue may likewise fail to incorporate fully the intention of the creator. But at least esthetic objects of these classes are embodied once for all in physical individuals; and the distinction of any entity so incorporated from the physical embodiment of it seems uncalled for. On second thought, however, this difference can be viewed as one of degree rather than of kind. For example, when we stand before a masterpiece of painting or of sculpture, we may be reminded of something which is common to this physical object and various more or less adequate reproductions of it, some of which we may have observed before. Is it this canvas or this marble which is the object of esthetic contemplation, or is this only the 'original' and most adequate incorporation of it; the thing itself being an abstract entity here embodied or approximated to, in these fading pigments or this stone which already shows the marks of time? Even in the case of objects found in nature, the esthetic orientation may be directed upon an ideality not physically present: if the landscape should be intriguing, still the sketcher will at once begin moving this a little in his mind's eye and eliminating that; and in any case the eye of the beholder performs something of the same office. Do such considerations allow the simple identification of any kind of esthetic object with a physical thing; or must we rather say that even the artist's original is an instance and an "imitation" only of an entity which itself is abstract and ideal? And between those physical conditions which qualify presentation of it and those further and psychological conditions which likewise qualify its appearance to any subject, is there any fundamental difference of kind or only one of manner or degree; the true object being separated from our apprehension by a whole series of accidents of phenomenal appearance, some outward and physical, some inward and psychological?

It seems philistine to lay rude hands of logic on thoughts so edifying. However, there are at least three different kinds of things suggested here: first, the intention of the artist or the ideal which that intention projects;

second, the kind of abstract entity which may be instanced in two print-ings of a poem or two renditions of a piece of music; and third, the physical individual which incorporates this abstraction or approximates to this ideal, and serves on some occassion as the vehicle of its presenta-tion. Each of these requires at least passing attention because any one of them may be taken to represent the basic category of esthetics—*the* esthetic object.

First let us consider the ideality which is aimed at in any purpose of artistic creation, and which might be taken to be the object of our esthetic contemplation in any presentation. Confronting an art object of any kind, one may, and possibly should, seek to penetrate beyond the actual incorporation to the intent of its creator. This is especially impor-tant in the case of music and the drama, because a truer rendition may thus be brought about. And a similar attempt in the case of esthetic actualities of any kind may have its value for those who would learn, from the contemplation of past achievements, concerning the possibili-ties of future ones. Further, it is obvious—or should be—that if we were to discover the completely accurate and adequate laws of esthetics, these would project, as their exemplars, idealities rather than actualities, whether art-produced or natural.

However, neither of the two considerations mentioned reveals any compelling reason for conceiving of esthetic objects as transcendental entities. In other things than the fine arts, it is likewise true that we apprehend on occasion the intentions of another, which he does not fully achieve and may not even envisage adequately. And what it is that he thus fails to actualize, still has its own standing as the object of a purpose and perhaps as realizable though unrealized. Our 'interpretation' in such cases, is something rendered possible by an act of empathy and through the use of creative imagination. It is possible because such purposes are capable of being shared. To be sure, such attempts to penetrate beyond the actual thing to an intention behind it—in esthetics as in other mat-ters—lies always in some danger of ending in a romantic deception in-stead of genuine understanding. And in the case of objects in nature, the setting up of such intentions behind the presented object is sheer pa-thetic fallacy—either that or a mystic faith the validity of which should not be a question for the science of esthetics. The projected entity ideally realizing any specific attempt at esthetic envisagement or artistic crea-tion is indeed an intelligible kind of thing, subject to esthetic comprehen-sion and to esthetic critique. But there is no need to erect a metaphysical mystery upon the fact that human purposes are marked by a considera-ble degree of community, enabling us on occasion to pass beyond actuali-ties achieved to the esthetic purpose of them, and—in the case of music and the drama—to recreate from symbols the actualities which will ap-proximate to and convey such intentions. These facts provide no better ground for being transcendentalist about esthetic goals than there is, for example, about economic ones or those of engineering; nor any better reason to invent an empyrean habitat for the esthetically ideal than there is to believe in some New Atlantis as a metaphysical reality.

Nor does the fact that the exemplars of the laws of esthetics would be ideal entities rather than actualities, lend credibility to the transcendentalist point of view in esthetics, or distinguish that science from others. It is likewise true in physics, for example, that the understanding of its laws projects the conception of certain ideal exemplifications—the perfect vacuum, the frictionless surface, the perfectly elastic solid, the one-hundred percent efficient engine, and so on. Also, in any application of physics—which being practical will be directed to a purpose—those who are concerned with such creative endeavors must look to some projected ideality, though they must also have an eye to the limitations of materials and of human workmanship.

It is more important and more profitable to consider that kind of abstraction which may be literally actualized and exemplified by physical occasions—and not merely approximated to or "imitated" by physical things. First, because some esthetic objects definitely are thus abstract, and others may plausibly be so considered. A sonnet, for example, cannot be identified with any physical individual. Not only is it one and the same thing which we and our neighbor may read in different books, but what is essential to the thing presented is not physically there on the printed page, but only conveyed from one mind to another by a pattern of physical symbols. The relevant meanings are associated with this symbol-pattern by a complex and common and strongly enforced social habit. Even the rhythm and cadence of the language used, which lie within the esthetic phenomenon, are not presented to the eye but only associated with what is thus physically present. It is like the score of music rather than the rendition. Yet this poem is actual, as against those as yet undreamt of, solely by the fact that this language-pattern has its concrete and physically occurrent instances. Given the language-habit which makes it possible, these are the presentations of the esthetic object; and without them there would be no poem presented or presentable.

It requires also to be observed that this abstract entity which is the esthetic object itself in the case of literature, is not literally embodied in the physical thing which serves on any occasion as the medium of its presentation. Rather this abstraction, or its instance, is to be located in a context of the physical object—in this case, a mentally associated context. Yet this consideration would be poorly taken as evidence of any subjective character of the esthetic reality in question. What poem it is which is actual, is controlled and to be determined by the factually instanced pattern of language. To be sure, this fact that the esthetic actuality has to be recreated by the subject, in accordance with the conventions of language and other implicit rules of interpretation, leaves the literary object peculiarly liable to subjectivities of apprehension. We might even doubt the possibility of any completely common and perfectly objective interpretation of it. As someone has said, the aged man and the child by his side may both read the same responses from the prayer-book; but these words cannot have the same meaning for the two, because in the one case they are freighted with a lifetime of experience. That kind of consideration has its weight for any language-presented phenomenon;

and especially if it be an object of esthetic apprehension, because in that case the meanings conveyed will be predominantly expressive in significance.[1] But that fact does not condone any subjectivistic interpretation of the phenomenon itself. A poem is like a law (a legal enactment), which similarly depends upon community of language for its actuality, but is not thereby open to the wilful interpretation of the individual. What is here implied is, rather, that this actual poem, like any other artistic product, will be better grasped by some than by others; and that it may require experience and capacity in order to understand or judge it. But these conditions on the side of the subject are conditions of the *presentation to him,* not conditions of what is actually there for his apprehension. They are conditions of the esthetic experience but not of the esthetic object.

What needs to be observed here is that the esthetic actuality—the poem—is *physically presented,* when conveyed by the printed page or by a reader's voice, but that this esthetic entity is not, either spatially or in any other appropriate sense, to be located within the physical object or event which serves to present it. Some of the properties of the poem— the language pattern of it—genuinely characterize the print on the page or the temporal sequence of the sounds. In much larger part, however, the "poem itself," being constituted by the meanings thus physically symbolized, lies in the *context associated with* this physical entity which presents it. Second, it needs to be emphasized that what genuinely belongs to the character of the poem but is found in the context of what physically conveys it and not in that physical entity itself, is still not subjective but as fixed as law. And it is fixed in the same general way; that is, by understood conventions governing both the creation of it and its interpretation. Comprehension of it (or miscomprehension) has its conditions on the side of the subject; and the extent of these conditions is the greater according as less of the thing presented is literally disclosed by the physical properties of the physical object which serves to present it. But whatever the subject *must* bring to the presentation, in order correctly to understand the poem presented, belongs to the *poem.* Insofar as he fails to bring this associated context, or brings some other, the esthetic object presented fails to be apprehended in its actual esthetic character—is either misapprehended or not apprehended at all.

The poem is an abstraction which is actualized in the instances of its presentation, through the medium of some physical vehicle. It is an entity essentially repeatable in, or common to, different physical events or things which instance it. But it must be observed that this abstractness of it is *not* the kind by which universals like triangularity or honesty or incompatibility stand in contrast to anything which is sensuously qualitative and imaginal. It has the literal character of esthesis: we shall call it an esthetic essence.

It will be fairly obvious that, with respect to the points here in question, not all esthetic objects are like poems. The different classes of them form something like a series, in which products of the literary art repre-

sent one extreme. From these we pass on down through drama and music to the pictorial and plastic arts, and finally to esthetic objects found in nature. (Detailed examination of each of these classes would be essential for any full discussion, but must be omitted here.) But though this order suggests itself at once, the principle of ordering does not. A poem is an abstraction, actualized by physical occasions which instance it. But a sunset or a mountain is a physical individuality. And between the abstract and the concrete there can be no intervening stages.

The principle of order here will be found in the extent to which what is esthetically essential is simply the physical characters of the physical vehicle of presentation, and the extent to which this esthetic essence is to be located in an associated context of this physically present thing. In that respect, the objects of esthetic interest can and do differ in degree. Perhaps this can be crudely suggested by a diagram, in which the solid line bounds the esthetic essence and the broken line the physical vehicle:

Literary objects Pictures and sculpture Natural objects

Further, if we are prone to say that an esthetic object disclosed in nature is wholly concrete, then we must be reminded of two facts. First, there is no natural object which would inevitably solicit and reward esthetic contemplation if we merely open our outward senses to it. *Something* is essential which is not literally a physical property of it but associated with these: it is by that fact that genuinely esthetic values are to be distinguished from inherent values of a 'lower' order, like the gratefulness of water to the thristy man. (We do not say that 'lower' values are sheerly physical properties of what presents them, and independent of any context: we do say that esthetic values *additionally* depend on context.) Second, we must observe that in every physical object of esthetic interest there will be some characters which are irrelevant to the esthetic quality of it, and could be different without in any way affecting its esthetic quality or value. Thus even insofar as the esthetic essence should be contained within the physical object, it is still a literal abstraction from it, and theoretically could be identically presented by some other.

We can, therefore, say without exception that the entity contemplated in esthetic experience is *actualized* by presentation through the instrumentality of a physical object. But the direct object of contemplation is an esthetic essence; an abstraction which theoretically could be identically presented by another physical thing. This esthetic essence includes, in all cases, something not resident in the physical thing which

137

serves to present it but in some context to which it stands related, *in some manner which is not arbitrary or subjective.* And the extent to which such contexts of the physical thing which serves as vehicle of presentation are essential to the esthetic nature and value of what is presented or conveyed, is different for different types of esthetic objects.

When esthetic or any other kind of value is ascribed to anything, it is important to observe just what thing it is which in fact is the subject of the intended attribution. It may be an actual entity of the usual sort: a poem, a drama, a musical composition, a painting, a piece of statuary, a landscape. But also, as has been indicated, it may be the ideal and unactual object projected by a purpose. Or again, it may be a particular *rendition* of a piece of music or a drama. Or it may be the physical object which serves as vehicle of the esthetic presentation. Or it may be the esthetic experience itself to which the value is attributed. When we ask whether what is judged valuable is an abstract or a concrete entity, then the factualities of the intended predication must be observed. When we value a poem, we are not judging any concrete thing, because—typically at least—we are not even thinking of the printed page. If we judge music, then it will have to be decided just what the intention of the valuation is; whether it is directed upon what could be common to or approximated by many physical renditions, or upon the musical content of this particular occasion. Similarly—even if less obviously—when we judge a painting, it will have to become clear whether the intended object is this canvas and the physical pattern on it, or is instead what this canvas could have in common with some reproduction of it. In the case of the landscape or other object disclosed in nature, it may seem fantastic to suggest that what is valued is anything other than just this concrete physical thing. Yet there is that qualitative and abstract essence which is here incorporated, and is theoretically repeatable in some other physical object. Indeed there may be question, for any type of valuation, whether it is the concrete entity or the embodied qualitative abstraction which is the object—e.g., whether it is the apple we are enjoying, or the *flavor* of the apple, which it might share indistinguishably with another. Finally and most important: whatever the kind of thing it is which is presented, we must be careful to consider whether it is some objective entity to which the value is ascribed, or whether the subject of the attribution is the experience itself. Many highly regrettable errors have crept into esthetic theory through ascribing to objects the kind of value which could belong to experiences only. Lumping esthetic judgments all together, as if there were one type of object only, indicated in all of them, can only result in confusion.

That we may evaluate esthetically a concrete physical thing, in no wise contradicts the fact that there can be no physical object the esthetic evaluation of which is altogether independent of its relations to some context. The physical thing may be valued as the *instrument* of esthetic embodiment. *All* values in physically objective things are extrinsic only. The esthetic values attributable to concrete objects are a class of inherent

values. But to say that a value is inherent in an object, is not necessarily to locate this value in the physical properties of it. By our definition, a value is inherent if it is one which is realized in experience through the presentation of the object in question, and not through presentation of some other object. Thus a physical thing has esthetic value if it serves to present positive esthetic quality. But if it should be said that, on such conception, no *abstract* entity could have esthetic value; because an abstraction, being incapable of being presented, could not have any kind of inherent value; then it needs to be observed that this reasoning contains a false premise. The kind of abstractions which, like poems and musical compositions, have esthetic value, *can* be presented through the medium of physical things: they are sensuous or imaginal though repeatable in different exemplifications.

What can be said concerning all classes of objects of which esthetic value can be predicated, is that this value of them *depends upon* a complexus of properties constituting an esthetic essence, in some part literally embodied, or capable of being embodied, in some physical thing which is the instrument of presentation, and in some part belonging to a context of this object, which is associated with it in some manner which is not subjective merely. Whatever the nature of the entity which is direct object of the esthetic judgment, this esthetic essence by reason of which it has or lacks esthetic value, is an abstract entity. This kind of abstraction thus represents the basic category of esthetics.

These hastily summarized suggestions are plainly insufficient to the topic of them, and may be unclear. Still they will serve to indicate the general nature to be expected in any body of specific principles sufficient for the positive science of esthetics. As is indpendently suggested by such advances as have been made in the direction of this science, the key to the laws of it is probably to be found in what we have referred to as the complexus of properties constituting an esthetic essence; in the character of this as a phenomenal *Gestalt;* in relationships of constituent elements which make it some kind of configurational whole.

The overarching test by which such specific principles are themselves to be elicited, must be the test of a value disclosable as a relatively enduring enjoyment in contemplation. And where the more specific and empirical principles remain undetermined or doubtful, it is directly by that kind of test that correctness in esthetic valuation is principally to be assured.

Note

1. The line of division between *belles lettres* and literature of the more prosaic kind, probably is to be drawn with some reference to the predominance or the importance in it, of expressive meanings which convey something for the imagination rather than for the intellectual kind of understanding.

Richard Rudner

Educated at the University of Pennsylvania, Richard Rudner is Professor and Chairman of the Department of Philosophy at Washington University (St. Louis). He is Editor-in-Chief of Philosophy of Science *and author of* Philosophy of Social Science.

The Ontological Status of the Esthetic Object

In this discussion I shall be concerned with a certain puzzle which C. I. Lewis brings to light in *An Analysis of Knowledge and Valuation* regarding the ontological status of the esthetic object, and with the solution he proposes.

The "science of esthetics," Lewis feels, is quite undeveloped. And this he believes may be ascribed, in part at least, to the fact that a "marked diversity . . . obtains amongst objects of esthetic interest and to the fact that some classes of them [the objects] . . . are phenomena of extreme complexity" (p. 469).

To demonstrate this complexity, Lewis chooses as an example a musical composition.

> Consider what entity it is which is termed "Beethoven's Fifth Symphony." A musical composition is not a physical object: any particular rendition of it is a physical entity of its own complex sort; but between the rendition and the thing itself, there is an obvious difference. The rendition may not and presumably will not, realize exactly the musical intention of the composer or the esthetic possibilities represented by the composition (pp. 469–470).

It is important, if one is to understand Lewis, to be clear about what is being suggested here. Or, if this is not accomplishable, to be clear about some of the things which are not being suggested. First then, the esthetic object in music is no particular rendition of a score. It is not the actual physical sound waves which constitute any rendition; it is not the printed score from which the orchestra is playing; and, curiously enough, it is not what we might normally call the phenomenal content of the mind— that is to say, it is *never* any particular *heard* music. Moreover, the passage suggests that it may be one or the other of two things. It may be, we

From *Philosophy and Phenomenological Research,* Vol. 10, 1949–50, pp. 380–388. Reprinted by permission.

140

gather, either "the musical intention of the composer," or, it may be the full, presumably unrealizable, "esthetic possibilities of the composition." There is, I should say, although Lewis fails to point this out, an evident difference between the two last named; for there is a perfectly good sense in which we might say of a particular composer that his own musical intention does not coincide with the composition's esthetic possibilities.

But these are only initial considerations; when we come to products of literary art, we find "an even wider gap between the thing itself and the apprehension of it" (p. 470). Consider a poem for example. "Here," Lewis tells us, "we must ordinarily provide our own rendition; and in so doing we may not only miss a part of the intended meaning but inadvertently introduce certain grace-notes and variations of our own" (p. 470). As for the drama, this he feels is the most complex of all esthetic entities. In some of the above respects, he finds it like music, in others, like poetry. But this much he decides is clear: that "a drama cannot be identified with any physical object" (p. 470).

It will, perhaps, be best to give the remainder of Mr. Lewis's thoughts on the gap between physical work and actual esthetic object in his own words. He is here as succinct as an adequate paraphrase would be. He tells us, then, that

On these points, a painting, a cathedral, or a piece of sculpture seems to differ from a musical composition or a literary product. A picture, edifice or statue may likewise fail to incorporate fully the intention of the creator. But at least esthetic objects of these classes are embodied once for all in physical individuals; and the distinction of any entity so incorporated from the physical embodiment of it seems uncalled for. On second thought, however, this difference can be viewed as one of degree rather than of kind. For example, when we stand before a masterpiece of painting or of sculpture, we may be reminded of something which is common to this physical object and various more or less adequate reproductions of it, some of which we may have observed before. Is it this canvas or this marble which is the object of esthetic contemplation, or is this only the "original" and most adequate incorporation of it; the thing itself being an abstract entity here embodied or approximated to, in these fading pigments or this stone which already shows the marks of time? Even in the case of objects found in nature, the esthetic orientation may be directed upon an ideality not physically present: if the landscape should be intriguing, still the sketcher will at once begin moving this a little in his mind's eye and eliminating that; and in any case the eye of the beholder performs something of the same office. Do such considerations allow the simple identification of any kind of esthetic object with a physical thing; or must we rather say that even the artist's original is an instance and an "imitation" only of an entity which itself is abstract and ideal? And between those physical conditions which qualify presentation of it and those further and psychological conditions

which likewise qualify its appearance to any subject, is there any fundamental difference of kind or only one of manner or degree; the true object being separated from our apprehension by a whole series of accidents of phenomenal appearance, some outward and physical, some inward and psychological? (pp. 470–471).

From all of these considerations, Lewis finds that there emerge three possible candidates for the office of "the basic category of esthetics—*the esthetic object*" (p. 471). These are "first, the intention of the artist or the ideal which that intention projects" (p. 471). It should be pointed out that this is actually a double candidate—although Lewis nowhere explicitly recognizes that this is the case. The second candidate is "the kind of abstract entity which may be instanced in two printings of a poem or two renditions of a piece of music" (p. 471). Finally, the third is "the physical individual which incorporates this abstraction or approximates to this ideal, and serves on some occasions as the vehicle of its presentation" (p. 471).

Each of these prospects is now considered in turn. With respect to the intention of the artist (which Lewis seems to be taking as identical with the "ideal that intention projects"), two factors seem to favor its selection: a) it seems to be important in attempting to bring about "truer renditions" to look beyond the physical art work to what the artist intends; and, b) it is "obvious" that if we found the adequate and accurate "laws of esthetics" they would "project as their exemplars, idealities rather than actualities, whether art-produced or natural" (p. 471).

On the other hand, neither of these two factors gives us a "compelling" reason for taking esthetic objects to be transcendental entities—a position to which Lewis feels acceptance of this first candidate commits us and to which, at this particular point, he seems reluctant to be committed. To accept candidate 1, would, with respect to natural esthetic objects at least, make us guilty of the pathetic fallacy.

Also ruled out is the third candidate. The physical individual, in the light of what has already been said, cannot be the esthetic object. Also presumably ruled out, I might add, although Lewis seems to have forgotten this dark horse, is the phenomenal individual. In the case of music, for example, neither the physical sound waves nor the *phenomenally* heard music could be regarded as the esthetic object.

This leaves Lewis with the second candidate, i.e., the "abstract entity which may be instanced in two printings of a poem or two renditions of a piece of music."

The task which now confronts the expositor of Lewis in this connection, namely that of making clear what is meant by "abstract entity" here—or of telling what kind of a thing it is, is one which seems singularly difficult to accomplish. First of all, it is something which is "literally actualized and exemplified by physical occasions—and not merely approximated to or 'imitated' by physical things" (p. 472). This, Lewis

feels, is sufficient to differentiate it from the artist's intention or projected ideal which, one gathers, is never actualized but is only approximated or merely imitated by the creation. Similarly, it is also different from the physical art work—as has been already indicated above—but it does depend on the physical art work insofar as it cannot be presented as the esthetic object without the physical art work. Nevertheless, it is not "literally embodied in the physical thing which serves on any occasion as the medium of its presentation" (p. 473).

Where is it to be located? Well, "this abstraction, or its instance is to be located in a context of the physical object." In the case of a poem, its locus will be something he calls "a mentally associated context."

Let us, taking poetry as our example (as does Lewis), call this abstract esthetic object The Poem with a capital "T" and capital "P." The Poem then, is not located in the poem which presents it. However, The Poem does have properties in common with the poem—for example, its language pattern, or the temporal sequence of sounds. But, *The* Poem itself being "constituted by meanings . . . physically symbolized, lies in the *context associated with* this physical entity which presents it" (p. 474).

What now is an associated context? Lewis, I'm afraid, is not very kind to us on this point. All that he tells us is that a correct associated context is what an individual *must* bring to the presentation in order correctly to understand The Poem presented—and moreover, that which is so brought, belongs to The Poem—presumably this means, is a part of it.

Let me use his own words to sum up thus far:

> The poem is an abstraction which is actualized in the instances of its presentation, through the medium of some physical vehicle. It is an entity essentially repeatable in, or common to, different physical events or things which instance it. But it must be observed that this abstractness of it is *not* the kind by which universals like triangularity or honesty or imcompatibility stand in constrast to anything which is sensuously qualitative and imaginal. It has the literal character of esthesis: we shall call it an esthetic essence (pp. 474–5).

For Lewis, then, the esthetic object is not, to use his words in a wide sense, any particular rendition of an art work. It is rather an abstract entity. Particular renditions are concrete "instances" of the esthetic object but are not identical with it. It must be admitted that Lewis gives us very little specific information about what kind of a thing an abstract esthetic object could be, or about how it can be "embodied" in an "instance." How is it that we experience the abstract esthetic object when what seems present is merely a concrete instance? Lewis says we bring with us to the experience an "associated context." But this is scarcely illuminating. Finally, why should Lewis feel it incumbent to thus multiply the types of entities permissible in his esthetic ontology?

143

All of these things seem at the outset quite puzzling. We can, however, without too much difficulty gain some inkling of the kind of eventuality which motivates Lewis in the direction he takes. It is a fact that we do call two (frequently obviously different) renditions of *Beethoven's Fifth Symphony* by the same name. We feel that the art work, *Fifth Symphony,* which Beethoven created is one thing, one art work. We feel, also, that there is an overwhelming likelihood that no particular rendition of the symphony does more than approximate the "primal" symphony which was actually Beethoven's creation. One way of solving the difficulty thus presented, it would seem, would be to regard the "primal" symphony as an abstract entity of which particular renditions are instances.

Now, it seems clear, that any complete esthetic theory must account for this difficulty whether it be apparent or real. With respect to Lewis's account, I propose to show, negatively, that Lewis's solution has counter-intuitive consequences and is hence untenable as an analysis; and positively, I shall indicate a direction in which a solution might lie that may not have counter-intuitive consequences.

Lewis's analysis has as a consequence that the symphony which Beethoven composed was not something having the same "ontological status" with any heard symphony or with the physical score which Beethoven wrote out. Moreover, since Lewis is surely not proposing that anything which is imagined (in the sense of the content of someone's imaginings) is *thereby* abstract, on Lewis's view what Beethoven was imagining when he was writing the score (or preparing to write the score) was not insofar abstract and hence not the esthetic object either. But what activities *vis a vis* creation other than writing out the score, "imagining out" the music, or "working out" phrases on the piano, was Beethoven undertaking when he composed the *Fifth Symphony?* One does not see how the product of these actions as such need be an abstract entity; this is true as well of the imagining of music. Think of a tune. Let any simple melody run through the mind. This "tune" may be different from a heard tune just because it isn't *heard,* i.e., just because it isn't directly causally connected with an event consisting of the impingement of sound waves on the ear. But wherein are we justified in maintaining disparate status in level for the imagined tune and the heard tune? The fact that frequently the hearing of tunes is mistaken for the mere imagining of them, the fact that frequently the imagining of tunes is mistaken for the hearing of them, and the fact that we are sometimes at a loss to know whether we have just imagined or actually heard some familiar melody, seems to be decisive against any theory which holds that heard music is concrete but imagined music abstract. If Lewis's position commits him to hypostatizing as the esthetic object, an abstract entity which cannot be the product of the artist's activities, then a counter-intuitive consequence of the position is that Beethoven did not compose the *Fifth Symphony.* I am not, however, here attempting to

demonstrate that a creator's activities could not issue in an abstract entity. Rather, my point is that Lewis does not show us how they could so issue, an obvious desideratum for any such theory. More importantly, I shall show that the difficulties, i.e., the problematic locutions, which lead Lewis to posit an abstract entity, can be accounted for without taking such a step.

There is some evidence that Lewis is thinking of the relationship between the abstract art work and a particular rendition of it as being analogous to or identical with the type-token or symbol-token relationship which is frequently described in linguistic studies. In a given book, carbonic configurations similar to

<div align="center">man</div>

may make a number of appearances. Each occurrence, however, is not thought of as the occurrence of a different word, but rather as a different token or instance of *the* word or symbol "man." On different pages where a configuration similar to

<div align="center">man</div>

appears, we are said to have the same word, "man," but different tokens or instances of it. Lewis's thesis may be that this is also the case for the *Fifth Symphony* and particular renditions of it. But such a position would also have counter-intuitive consequences in esthetics. In linguistic studies the symbol is defined as the class of similar tokens.[1] But if the *Fifth Symphony* were defined as a class of similar renditions, we would again have as a counter-intuitive consequence a denial that Beethoven created the *Fifth Symphony.*

But the difficulty which seems to have set Lewis off does not in any event require the hypostatization of an abstract entity to take the place of the esthetic object. We do indeed say of two different musical renditions that they are both renditions of the *Fifth Symphony.* This, however, does not demonstrate that we have experienced two instances of the esthetic object—as is attested on a common sense level by the circumstance that we may react in an esthetically favorable way to the one and not the other. "Two renditions of the *Fifth Symphony*" can be interpreted as an ellipsis for "two musical renditions which are similar in a group of important respects." There is here no necessity for multiplying the types of ontological entity which shall be admitted to an Esthetic. Again, the sentence "Beethoven's *Fifth Symphony* is good but this is a bad rendition of it," could be taken as an ellipsis for "there is a musical rendition *called* Beethoven's *Fifth Symphony* which is pleasing esthetically but this musical rendition, while similar to it in important respects, is esthetically displeasing." [2] Here, too, there is no necessity for the manufacture of abstract entities. The problematic locutions are simply recognized as convenient shorthand.

In effect, what has been pointed out is that Lewis's question, "what is the esthetic object," is actually ambiguous; and that the source of his difficulties may lie in the confusion of at least two related but distinct problems. The question "what is the esthetic object" may, with some propriety, be taken as posing the problem: to what is our esthetic response directed; or it may be taken as posing the quite different problem: what, if anything, do names like *The Fifth Symphony* designate. That the problems are at least logically distinct can be seen in the possibility of attributing the names of art works to non-experienceable abstract or ideal entities, a procedure which would leave the first of the problems mentioned above yet unsolved and would indeed dictate for it a differing answer. That they are in fact distinct problems has been evidenced (if the above considerations are cogent) by the solution, to the difficulties Lewis presents, which has been proposed. What we have been maintaining is that in typical pronouncements of esthetics, such as "that was a poor rendition *of* Beethoven's *Fifth,*" the occurrence of the name of the art work is a syncategorematic one.[3] At the same time, we have maintained that there is an entity toward which we are esthetically responding. Lewis is forced to look for an "abstract entity with instances" because he assumes implicitly that what we have a given response to and that which the name of an art work designates, in typically esthetic locutions, must be the same thing. The way in which we use the names of art works confers a certain plausibility on the decision that their designata are abstract entities. But our ordinary experience of responses to concrete renditions renders the *same* answer to the other of the questions quite implausible. Other considerations aside, Lewis's difficulties, particularly the discomfort he manifests in the last pages of his treatment of esthetics, arise out of his attempts to make the one answer do for the two problems. Beyond this, our criticism has been that Lewis's solution to the question of the designata of names like *The Fifth Symphony* has only an apparent plausibility and should be rejected because it multiplies the types of ontological entity required beyond necessity.

Before continuing our discussion of Lewis's efforts in particular, it will be advisable to determine whether either one or both of the two problems we have delineated are uniquely esthetic problems; that is to say, whether there is a cogent sense in which the problem of the esthetic object may be interpreted as being of a different kind from the "problem of the object" in science and ordinary affairs. This latter problem presents a puzzle because of at least two unresolved difficulties which become apparent in Carnap's formulation in the *Logische Aufbau.* Suppose we want to clarify the meaning of an expression like "x is objectively red." The notion derived from Carnap is that being objectively red can be explained as some function of looking red, and we get in effect the analysis

x is objectively red if and only if x would look red to a normal individual under normal conditions.

Two, so far as I know, unresolved problems which this formulation presents are the problem of counterfactuals,[4] and the apparent involvement of vicious circularity indicated by the usages of "normal." [5]

Now, this is a problem in ordinary affairs—in science and practical activity—because in ordinary affairs our primary concern lies with the orientation of suitable responses toward the "objective" object. But in esthetics, on the contrary (this may be just what distinguishes esthetics from ordinary affairs) the pertinent responses are those toward particular phenomenal contents in a sense independent of "objectivity" or to the clues to "objectivity" which such contents might afford. The distinction I think is complex and subtle, but there is a distinction. Perhaps it can be better elucidated by an example. The question in esthetics that I pose when I ask what is it to which we esthetically respond in an experience of, e.g., *The Magic Mountain,* is different in kind from the scientific question, what is observed when we examine a certain area of the sky. One kind of answer which might satisfy the first of these questions but not the second would be: the phenomenal words. The difference may perhaps even more clearly be exhibited when we contrast the typically esthetic question, to what do we respond in an esthetic experience of *The Magic Mountain,* with the question, what, objectively, is *The Magic Mountain.* The phenomenal content to which I esthetically responded (and which might be, for example, causally related to the "objective" *Magic Mountain*) could not be the answer to the second of these questions. Moreover, the second of these questions would be a scientific rather than typically esthetic one.

The relevance of the foregoing to our consideration of Lewis is no doubt already obvious. The problem, what does an expression like *The Fifth Symphony* designate, which we took to be Lewis's primary concern, is not an esthetic problem, in the sense specified above, at all. Indeed, it is in all likelihood equivalent to the "scientific" problem, what is the objective *Fifth Symphony.*

For these reasons we have held that the occurrence of the names of art works in typically esthetic statements like "That was a poor rendition of *The Fifth Symphony*" is a non-designative one. It was this kind of locution in esthetics, it will be remembered, which led Lewis to hypostatize an abstract entity when he was confronted with the question of what we esthetically respond to. But no such entity is required when we realize that these locutions are a convenient shorthand of the type already described.

Nothing which has been said up to this point should, of course, be construed as questioning the propriety of referring to a particular rendition, i.e., some particular heard music, as Beethoven's *Fifth Symphony.* It is appropriate to call a rendition, Beethoven's *Fifth Symphony* rather than Beethoven's *Fourth Symphony* or *Sacre Du Printemps,* because the heard music is connected (at least causally) with a certain set of Beethoven's creative activities in a way in which it is not at all connected with another set or with Stravinsky.[6]

Notes

1. *Cf.,* H. Reichenbach, *Elements of Symbolic Logic,* pp. 4–5. I am not, of course, here subscribing to the view which is expounded by Reichenbach.
2. More rarely, perhaps, such a sentence is an ellipsis for "Beethoven's composition (a particular thing) is esthetically pleasing, but this rendition, which is similar to it in important respects, is esthetically displeasing."
3. *Cf.* Quine, "Designation and Existence," *Journal of Philosophy,* Vol. 36 (1939).
4. *Vide,* Nelson Goodman, "The Problem of Counterfactual Conditions," *The Journal of Philosophy,* Vol. 44, No. 5 (1957), pp. 113–128.
5. This formulation and its difficulties were brought to my attention by Morton G. White.
6. The brief mention of the "connection" which is relevant in this essay is not meant to suggest that the establishment of the precise nature of the connection would not be a task of some difficulty.

Jean-Paul Sartre

Jean-Paul Sartre is the leading French existentialist philosopher as well as a prominent playwright and critic. His works include Being and Nothingness *(1943),* The Psychology of Imagination *(1951), and* Literature and Existentialism *(1962).*

The Unreality of the Esthetic Object

It is not our intention to deal here with the problem of the work of art in its entirety. Closely related as this problem is to the question of the Imaginary, its treatment calls for a special work in itself. But it is time we drew some conclusions from the long investigations in which we used as an example a statue or the portrait of Charles VIII or a novel. The

following comments will be concerned essentially with the existential type of the work of art. And we can at once formulate the law that the work of art is an unreality.

This appeared to us clearly from the moment we took for our example, in an entirely different connection, the portrait of Charles VIII. We understood at the very outset that this Charles VIII was an object. But this, obviously, is not the same object as is the painting, the canvas, which are the real objects of the painting. As long as we observe the canvas and the frame for themselves the esthetic object "Charles VIII" will not appear. It is not that it is hidden by the picture, but because it cannot present itself to a realizing consciousness. It will appear at the moment when consciousness, undergoing a radical change in which the world is negated, will itself become imaginative. The situation here is like that of the cubes which can be seen at will to be five or six in number. It will not do to say that when they are seen as five it is because at that time the aspect of the drawing in which they are six is *concealed*. The intentional act that apprehends them as five is sufficient unto itself, it is complete and *exclusive* of the act which grasps them as six. And so it is with the apprehension of Charles VIII as an image which is depicted on the picture. This Charles VIII on the canvas is necessarily the correlative of the intentional act of an imaginative consciousness. And since this Charles VIII, who is an unreality so long he is grasped on the canvas, is precisely the object of our esthetic appreciations (it is he who "moves" us, who is "painted with intelligence, power, and grace," etc.), we are led to recognize that, in a picture, the esthetic object is something *unreal*. This is of great enough importance once we remind ourselves of the way in which we ordinarily confuse the real and the imaginary in a work of art. We often hear it said, in fact, that the artist first has an idea in the form of an image which he then *realizes* on canvas. This mistaken notion arises from the fact that the painter can, in fact, begin with a mental image which is, as such, incommunicable, and from the fact that at the end of his labors he presents the public with an object which anyone can observe. This leads us to believe that there occurred a transition from the imaginary to the real. But this is in no way true. That which is real, we must not fail to note, are the results of the brush strokes, the stickiness of the canvas, its grain, the polish spread over the colors. But all this does not constitute the object of esthetic appreciation. What is "beautiful" is something which cannot be experienced as a perception and which, by its very nature, is out of the world. We have just shown that it cannot be *brightened,* for instance, by projecting a light beam on the canvas: it is the canvas that is brightened and not the painting. The fact of the matter is that the painter did not *realize* his mental image at all: he has simply constructed a material analogue of such a kind that everyone can grasp the image provided he looks at the analogue. But the image thus provided with an external analogue remains an image. There is no realization of the imaginary, nor can we speak of its *objectification*. Each stroke of the brush was not made *for itself* nor even for the constructing of a coherent

149

real whole (in the sense in which it can be said that a certain lever in a machine was conceived in the interest of the whole and not for itself). It was given together with an unreal synthetic whole and the aim of the artist was to construct a whole of *real* colors which enable this unreal to manifest itself. The painting should then be conceived as a material thing *visited* from time to time (every time that the spectator assumes the imaginative attitude) by an unreal which is precisely the *painted object*. What deceives us here is the real and sensuous pleasure which certain real colors on the canvas give us. Some reds of Matisse, for instance, produce a sensuous enjoyment in those who see them. But we must understand that this sensuous enjoyment, if thought of in isolation—for instance, if aroused by a color in nature—has nothing of the esthetic. It is purely and simply a pleasure of sense. But when the red of the painting is grasped, it is grasped, in spite of everything, as a part of an unreal whole and it is in this whole that it is beautiful. For instance it is the red of a rug by a table. There is, in fact, no such thing as pure color. Even if the artist is concerned solely with the sensory relationships between forms and colors, he chooses for that very reason a rug in order to increase the sensory value of the red: tactile elements, for instance, must be intended through the red, it is a *fleecy* red, because the rug is of a fleecy material. Without this "fleeciness" of the color something would be lost. And surely the rug is painted there *for the red* it justifies and not the red for the rug. If Matisse chose a rug rather than a sheet of dry and glossy paper it is because of the voluptuous mixture of the color, the density and the tactile quality of the wool. Consequently the red can be truly enjoyed only in grasping it as the *red of the rug,* and therefore unreal. And he would have lost his strongest contrast with the green of the wall if the green were not rigid and cold, because it is the green of a wall tapestry. It is therefore in the unreal that the relationship of colors and forms takes on its real meaning. And even when drawn objects have their usual meaning reduced to a minimum, as in the painting of the cubists, the painting is at least not flat. The forms we see are certainly not the forms of a rug, a table, nor anything else we see in the world. They nevertheless do have a density, a material, a depth, they bear a relationship of perspective towards each other. They are *things.* And it is precisely in the measure in which they are things that they are unreal. Cubism has introduced the fashion of claiming that a painting should not *represent* or *imitate* reality but should constitute an object in itself. An an aesthetic doctrine such a program is perfectly defensible and we owe many masterpieces to it. But it needs to be understood. To maintain that the painting, although altogether devoid of meaning, nevertheless is a *real* object, would be a grave mistake. It is certainly not an object of nature. The real object no longer functions as an analogue of a bouquet of flowers or a glade. But when I "contemplate" it, I nevertheless am not in a realistic attitude. The painting is still an *analogue.* Only what manifests itself through it is an unreal collection of *new things,* of objects I have never seen or ever will see, but which are not less unreal

because of it, objects which do not exist *in the painting,* nor anywhere in the world, but which manifest themselves by means of the canvas, and which have gotten hold of it by some sort of possession. And it is the configuration of these unreal objects that I designate as *beautiful.* The esthetic enjoyment is real but it is not grasped for itself, as if produced by a real color: it is but a manner of apprehending the unreal object and, far from being directed on the real painting, it serves to consitute the imaginary object through the real canvas. This is the source of the celebrated disinterestedness of esthetic experience. This is why Kant was able to say that it does not matter whether the object of beauty, when experienced as beautiful, is or is not objectively real; why Schopenhauer was able to speak of a sort of suspension of the Will. This does not come from some mysterious way of apprehending the real, which we are able to use occasionally. What happens is that the esthetic object is constituted and apprehended by an imaginative consciousness which posits it as unreal.

What we have just shown regarding painting is readily applied to the art of fiction, poetry and drama, as well. It is self-evident that the novelist, the poet and the dramatist construct an unreal object by means of verbal analogues; it is also self-evident that the actor who plays Hamlet makes use of himself, of his whole body, as an analogue of the imaginary person. Even the famous dispute about the paradox of the comedian is enlightened by the view here presented. It is well known that certain amateurs proclaim that the actor *does not believe* in the character he portrays. Others, leaning on many witnesses, claim that the actor becomes identified in some way with the character he is enacting. To us these two views are not exclusive of each other; if by "belief" is meant actually real it is obvious that the actor does not actually consider himself to be Hamlet. But this does not mean that he does not "mobilize" all his powers to make Hamlet real. He uses all his feelings, all his strength, all his gestures as analogues of the feelings and conduct of Hamlet. But by this very fact he takes the reality away from them. He *lives completely in an unreal way.* And it matters little that he is *actually* weeping in enacting the role. These tears, whose origin we explained above (See Part III, Chapter II) he himself experiences—and so does the audience—as the tears of Hamlet, that is as the analogue of unreal tears. The transformation that occurs here is like that we discussed in the dream: the actor is completely caught up, inspired, by the unreal. It is not the character who becomes real in the actor, it is the actor who *becomes unreal* in his character.[1]

But are there not some arts whose objects seem to escape unreality by their very nature? A melody, for instance, refers to nothing but itself. Is a cathedral anything more than a mass of *real* stone which dominates the surrounding house tops? But let us look at this matter more closely. I listen to a symphony orchestra, for instance, playing the Beethoven Seventh Symphony. Let us disregard exceptional cases—which are besides on the margin of aesthetic contemplation—as when I go mainly "to

hear Toscanini" interpret Beethoven in his own way. As a general rule what draws me to the concert is the desire "to hear the Seventh Symphony." Of course I have some objection to hearing an amateur orchestra, and prefer this or that well-known musical organization. But this is due to my desire to hear the symphony "played perfectly," because the symphony will then be *perfectly itself.* The shortcomings of a poor orchestra which plays "too fast" or "too slow," "in the wrong tempo," etc., seem to me to rob, to "betray," the work it is playing. At most the orchestra effaces itself before the work it performs, and, provided I have reasons to trust the performers and their conductor, I am confronted by the symphony itself. This everyone will grant me. But now, what is the Seventh Symphony itself? Obviously it is a *thing,* that is something which is before me, which endures, which lasts. Naturally there is no need to show that that thing is a synthetic whole, which does not consist of tones but of a thematic configuration. But is that "thing" real or unreal? Let us first bear in mind that I am listening to the Seventh Symphony. For me that "Seventh Symphony" does not exist in time, I do not grasp it as a dated event, as an artistic manifestation which is unrolling itself in the Châtelet auditorium on the 17th of November, 1938. If I hear Furtwaengler tomorrow or eight days later conduct another orchestra performing the same symphony, I am in the presence of the same symphony once more. Only it is being played either better or worse. Let us now see *how* I hear the symphony: some persons shut their eyes. In this case they detach themselves from the *visual* and dated event of this particular interpretation: they give themselves up to the pure sounds. Others watch the orchestra or the back of the conductor. But they do not see what they are looking at. This is what Revault d'Allonnes calls reflection with auxiliary fascination. The auditorium, the conductor and even the orchestra have disappeared. I am therefore confronted by the Seventh Symphony, but on the express condition of understanding *nothing about it,* that I do not think of the event as an actuality and dated, and on condition that I listen to the succession of themes as an absolute succession and not as a real succession which is unfolding itself, for instance, on the occasion when Peter paid a visit to this or that friend. In the degree to which I hear the symphony it is *not here,* between these walls, at the tip of the violin bows. Nor is it "in the past" as if I thought: this is the work that matured in the mind of Beethoven on such a date. It is completely beyond the real. It has its own time, that is, it possesses an inner time, which runs from the first tone of the allegro to the last tone of the finale, but this time is not a succession of a preceding time which it continues and which happened "before" the beginning of the allegro; nor is it followed by a time which will come "after" the finale. The Seventh Symphony is in no way *in time.* It is therefore in no way real. It occurs *by itself,* but as absent, as being out of reach. I cannot act upon it, change a single note of it, or slow down its movement. But it depends on the real for its appearance: that the conductor does not faint away, that a fire in the hall does not put an end to the performance. From this we cannot conclude that

the Seventh Symphony has come to an end. No, we only think that the *performance* of the symphony has ceased. Does this not show clearly that the performance of the symphony is its *analogue?* It can manifest itself only through analogues which are dated and which unroll in our time. But to experience it on these analogues the imaginative reduction must be functioning, that is, the real sounds must be apprehended as analogues. It therefore occurs as a perpetual elsewhere, a perpetual absence. We must not picture it (as does Spandrell in *Point Counterpoint* by Huxley—as so many platonisms) as existing in another world, in an intelligible heaven. It is not only outside of time and space—as are essences, for instance—it is outside of the real, outside of existence. I do not hear it actually, I listen to it in the imaginary. Here we find the explanation for the considerable difficulty we always experience in passing from the world of the theatre or of music into that of our daily affairs. There is in fact no passing from one world into the other, but only a passing from the imaginative attitude to that of reality. Esthetic contemplation is an induced dream and the passing into the real is an actual waking up. We often speak of the "deception" experienced on returning to reality. But this does not explain that this discomfort also exists, for instance, after having witnessed a realistic and cruel play, in which case reality should be experienced as comforting. This discomfort is simply that of the dreamer on awakening; an entranced consciousness, engulfed in the imaginary, is suddenly freed by the sudden ending of the play, of the symphony, and comes suddenly in contact with existence. Nothing more is needed to arouse the nauseating disgust that characterizes the consciousness of reality.

From these few observations we can already conclude that the real is never beautiful. Beauty is a value applicable only to the imaginary and which means the negation of the world in its essential structure. This is why it is stupid to confuse the moral with the esthetic. The values of the Good presume being-in-the-world, they concern action in the real and are subject from the outset to the basic absurdity of existence. To say that we "assume" an esthetic attitude to life is to constantly confuse the real and the imaginary. It does happen, however, that we do assume the attitude of esthetic contemplation towards real events or objects. But in such cases every one of us can feel in himself a sort of recoil in relation to the object contemplated which slips into nothingness so that, from this moment on, it is no longer *perceived;* it functions as an *analogue* of itself, that is, that an unreal image of what it is appears to us through its actual presence. This image can be purely and simply the object "itself" neutralized, annihilated, as when I contemplate a beautiful woman or death at a bull fight; it can also be the imperfect and confused appearance of *what it could be* through what it is, as when the painter grasps the harmony of two colors as being greater, more vivid, *through* the real blots he finds on a wall. The object at once appears to be *in back of* itself, becomes *untouchable,* it is beyond our reach; and hence arises a sort of sad disinterest in it. It is in this sense that we may say that great beauty

in a woman kills the desire for her. In fact we cannot at the same time place ourselves on the plane of the esthetic when this unreal "herself" which we admire appears and on the realistic plane of physical possession. To desire her we must forget she is beautiful, because desire is a plunge into the heart of existence, into what is most contingent and most absurd. Esthetic contemplation of *real* objects is of the same structure as paramnesia, in which the real object functions as analogue of itself in the past. But in one of the cases there is a negating and in the other a placing a thing in the past. Paramnesia differs from the esthetic attitude as memory differs from imagination.

Note
1. It is in this sense that a beginner in the theatre can say that stage-fright served her to represent the timidity of Ophelia. If it did so, it is because she suddenly turned it into an unreality, that is, that she ceased to apprehend it for itself and that she grasped it as *analogue* for the timidity of Ophelia.

The Identity of the Work of Art

John Herman Randall, Jr.

*Emeritus Professor of Philosophy at Columbia University, where
he taught during his entire academic career, John Herman Randall, Jr.
is the author of many works in the history of philosophy, including*
The Making of the Modern Mind *(1926) and* The Career of
Philosophy *(1962–5).*

Identity as Functional Structure

We have been emphasizing the distinction between what is encountered and what can be formulated in discourse, between Substance and Structure, between operations and their ways, not to try to find out what Substance would be like if it had no discoverable and formulable Structure—if it were "pure matter"; or what operations would be like if they did nothing in particular, and were wholly indeterminate—if they were "pure activity"; or what powers would be like if they could do anything whatever—if they were "pure potentiality," "pure creativity," and could, like Santayana's restless matter, embody any essence whatever. Meta-

John Herman Randall: *Nature and Historical Experience: Essays in Naturalism
and the Theory of History.* New York: Columbia University Press, 1958. Pp. 157–
163.

physics is content to leave to God the creation of such a *materia prima*. He would have to create it, for even God could not discover it in this world. Human creators, theologians or evolutionists, trying to recreate the world as God and Evolution have created it, never stumble upon such a structureless matter, for they always know what is to come. They know that darkness was upon the face of the deep, for they know that God said, "Let there be light." What would darkness be like, were there no light to come? A far sounder theology tells us, In the beginning was the Word— Structure—for without Structure nothing could begin. Kantian creators, trying to reconstruct "experience" out of a "formless manifold" and a scheme of intelligibility, have likewise failed to discover a "pure matter"; for they know that their manifold "lends itself" to that scheme of intelligibility, and they know in detail the determinations to which it submits, the structure it can assume in actual "experience." What other knowledge of its structure could we ever hope to acquire? Pure matter, pure activity, pure immediacy, a manifold without any form or determinations whatsoever, are not only not discoverable; they could not possibly exist, they are quite literally "meaningless." For Structure is the basis of all meaning and signification. Without Structure nothing can either be or be conceived.

Yet there remains an inescapable difference between a symphony, and a score or phonograph record of the symphony. What they all possess in common is a single "structure," the structure of the symphony, expressed, we may say, in varying languages. What the score and the record both express is not coextensive: records being what they are, are not perfect, they leave out a lot. If we ask what they leave out, we are taken to the mechanisms of translation—to the grammar and the categories, we may put it, of the recorder, what it can reproduce, *its* structure. The score in turn leaves out everything that distinguishes the symphony as an activity, a process—the reading of the conductor, the playing of the orchestra, the particular way they "interpret" it, we say—that is, the distinctive structure involved in any particular rendition. And both score and record leave out the sound produced and heard, which takes us to the mechanisms of production and transmission, the physiological mechanisms of the auditors, etc—their ways of cooperating in the symphony heard, which includes them all. The sounds heard form a third language, expressing the same structure of the symphony expressed also in the score, and in the record, but with a further auditory structure of their own, a structure which likewise leaves out much, in most cases.

Whenever we ask, what is it that is not expressed in any of these languages, what is not revealed as structure, we are led back to the symphony itself, to the subject-matter, to the Situation, to Substance. But we do not emerge with "matter"—we emerge with additional structures. For we have in each case found further structures involved in the complex of processes that cooperate in the symphony. We have been led to analyse the complex of processes there discovered into the specific cooperating processes involved, each with its own complex structure or dis-

tinctive way of operating. We have found the writing of the symphony, the playing of the symphony, the recording of the symphony, the transmitting of the symphony, the reproducing of the symphony, the hearing of the symphony. And these are all involved in and related to each other in complex ways that can be explored.

Common to all these various expressions in differing languages—the symphony written, the symphony played, the symphony recorded, the symphony reproduced, the symphony heard—is something that has made it possible to say, it is the same symphony that is expressed in each language—something that makes it "that symphony" and not some other symphony. There is a distinctive structure, in terms of which that symphony is identified, no matter what the language in which it is expressed, without which it could neither be that symphony, nor be conceived as that symphony, nor expressed in any language as that symphony. This distinctive structure is "the structure of that symphony." And this structure, though expressed in various languages and embodied in various "materials"—in ink-marks on paper, in grooves in plastic, in the vibrations of air produced by various instruments, in audio-frequency modulations in an electric current, in a temporal sequence of complex auditory sensations—is not to be identified with the structure of any of those "matters." It is not the structure of the marks on paper, nor the structure of the grooves in plastic, nor the structure of sensations. It is rather the structure of "the symphony," to which all these expressions must conform, to which the material of the various mechanisms must conform, to which the operations of writing, playing, recording, transmitting, reproducing, hearing, etc., must all conform. It is the "Form," the λόγος or "formula," the "formal cause" of the symphony, in Aristotle's language. In Spinoza's, it is the "idea" of the symphony, conceived under various "attributes." It is what "makes" the symphony "*that* symphony," τὸ τί ἦν εἶναι of that symphony, its "intelligibility" or intelligible aspect. It is what we "grasp" intellectually, "recognize as," "understand by," "know as," "mean by," that symphony. It is an ultimate fact about the symphony. There can, I take it, be no question about this: it is non-controversial.

Yet this "structure of the symphony," though it is that by which we *identify* that symphony, is *not identical with* that symphony. It is not what we hear when we hear "that symphony." When we hear the symphony, we do not hear the structure, but music "conforming to" that structure. We do not play the structure, but the sounds our instruments can produce "in conformity with" that structure. We do not "make" the structure, but marks on paper, grooves in a record, "illustrating" or "embodying" that structure. The hearing, the playing, the making, all conform to that structure, but they themselves are not that structure. They are certainly not structure alone. They are activities, operations, behaviors, which "exhibit" a particular structure, "illustrate" a structure, are "instances" of a structure, "display," "possess," or "have" a structure, and are identified by their structure, but are not to be identified with their structure alone. They are not structure, but processes. Processes are ac-

tivities "conforming to" a structure, "understood" in terms of a structure, but not identical with that structure. They are experienced reflectively, or understood, in terms of their structure. But they are experienced in other ways: they are played and heard, as activities exhibiting structure. They are never experienced as activities without structure—though I an not too sure about some concertgoers.

The symphony is not identical with its structure, it is a process with that structure. And this leads to a further distinction, fundamental in all activity and process. We have found many symphonies; but they seem to fall into two classes. There is first the symphony played, and the symphony heard; and there is secondly the symphony written and recorded. Which is "the symphony"? the playing and the hearing, or the score and the record? What is "the symphony"? We are asking Aristotle's question: "What is a substance?" τì ἐστι οὐσία;

The answer is, clearly both classes are, but in different senses. The first two are activities and operations, the second two are something that is not activity and operation. The score and the record are δυνάμεις, "powers." Both are "the symphony," in an appropriate context. When we want to buy "the symphony" to study and enjoy, we want to buy a score, or a record, not an orchestra. But the score and the record are not the symphony merely because they are expressions of the same structure. When we play them, they *become* the symphony, and we understand them as what can be so played. We do not really understand them in other terms, as paper with marks, as plastic with grooves. They are that, to be sure: those things can be truly said of them, those are their properties, their own distinctive structures, quite apart from their cooperation in they can do, what their function is. Being the products of art and intelligence, that is what they were made for. They have, to be sure, many other powers: we can light the fire with the score, or throw the record at the cat. But those powers are not essential to what they are. And we can hardly be said to understand them if that is all we know what to do with them. We don't understand them adequately unless we know their use as mechanisms for producing the symphony. And "the symphony" is not really understood if we take it only as a score or a record, as a "power." It is fully understood only as an operation.

I have been using "the symphony" as an instance of an οὐσία, a substance, one that is indisputably encountered, something clearly found in our world, and indisputably "real." There is no question that we do find such symphonies; the existence of such substances is noncontroversial. We first found "the structure of the symphony," its "essence" or "idea," which identifies it as that symphony. This structure I shall call the "formal structure" of the symphony. If we ask, what makes *that* symphony *a* symphony, we should have to inquire further into that formal structure, into what it is to be a symphony rather than a concerto or a sonata; and the answer would be in terms of traits and characteristics of that formal structure. But when we went on to consider the symphony not merely as identified and expressed in terms of its formal structure, but

as a process—as music played and heard conforming to that structure, as cooperating processes exhibiting that structure—we were led to a further structure of a different type—a structure of powers and their operating, of the record and the score and the symphony played, of the symphony played and the symphony heard—a structure of means and ends. This second type of structure I shall call "functional structure," using the term "functional" to designate the relation between powers and their operations, the relation between means and ends.[1]

The "functional structure" of the symphony is the relation between the symphony as a process or operation and the means, mechanisms, or powers which cooperate to bring about the symphony as their eventuation. And this functional structure leads us to further structures of the various powers or means involved in the cooperating processes that *are* the symphony—of the score, the orchestra, the recorder, the reproducer, etc. Each of these mechanisms or powers has a "formal structure" of its own, and a "functional structure" of its distinctive way of operating. In other words, in the symphony, as in any complex process or substance, there are discoverable various structures of different types, variously related to each other.

Thus any analysis of process takes us to various structures of differing types. In the process of "house-building," for instance, we find first the formal structure of the house itself, the order and arrangement of its constituent parts or elements, its "constitution" or make-up. We find the functional structures of the materials or powers involved, what they can do in relation to other things, the ways in which they can cooperate and interact, their functional structure as means to the end of the completed house. We find that these means or materials also exhibit a formal structure of their own, in the constitutive sense, a particular way in which they are put together, as contrasted with the way in which they operate and behave. This may be called an "inherent" structure, in addition to their functional structure *as* means or materials *for* the house. Thirdly, we find a structure of the environment or field of house-building, a structure formulated in the laws of mechanics and gravitation, making possible the construction of the house. This structure of the environment is the functional structure of the way the environment cooperates with the materials employed to make the construction of the house possible. And we find a functional structure of the process of constructing itself, of the working with these powers of the materials and powers of the environment.

The major distinction I wish to press here is that between *formal structure* and *functional structure*, between "the way things are put together" and "the way they behave," between the constitutive structure *of* mechanisms and means, and the structure of the *functioning as* means and materials *for* a determinate process. The formal structure is an internal structure, their constitution or make-up; it is invariant through a range of different contexts. The functional structure is the structure of their way of cooperating in a specific context, their way of

159

interacting in a particular situation. The first structure is "inherent," self-contained, ἁπλῶδ, in isolation from that particular process. The second structure is "relative" to the process and its field, to that situation: it is a "function" of that context and its complex cooperation of powers.

Note

1. As to this terminology: I am rather arbitrarily selecting the adjective "functional" to designate the metaphysical distinction and relation between powers and their operations or functionings. "Function" and "operation" are one word in Greek: ἔργον. Aristotle's ἐνέργεια means literally "putting to work," for which the Latin equivalent is "operation." ἔργον means "function," ἐνέργεια means "functioning."

 I am using the adjective "teleological" to designate the metaphysical distinction and relation between means and ends, or τέλη. The relation between "functional" and "teleological" is the relation between the power-operation relation, and the means-ends relation. Obviously, the two relations and distinctions arise in two different contexts. But so far, it has not been necessary to emphasize the distinction between the two relations, and they are here used as equivalent.

Joseph Margolis

The Identity of a Work of Art

We speak ordinarily of a translation of a poem, but we are much exercised in explaining the sense in which the poem is the same poem in translation or in deciding that the would-be translation is a different poem—and if so, what its relation is to the other. Whether the problem of translation occurs in counterpart forms in the other arts is also not clear. What, for instance, is the relationship between the text of a play and the mounting of a play that employs that text, and what is the relationship between two interpretively different mountings that employ different versions or abridgements of a common text? Or are there even

further complications resulting for arts that are not merely literary, such as drama and opera, in using translations of an original text? Are there comparable problems in the so-called performing arts, even where the medium of the art does not serve the same discursive role as does language in literary art? How is a change of key in a performance related to the original score? What is the relation between two performances of a score, one in the original key or rhythm, the other altered? What is the relation between two performances of a score, one with the instruments originally indicated, the other with altered instruments? Are there important properties common to the translating of a poem and to the transcribed performance of a musical composition? What of the art of the dance, in which only incomplete scoring has been recently achieved? Are two performances by the same artist of a dance with a given title, ostensibly intended to be the same, really the same dance? What of performances by different dancers? What is the relation of a reproduction of a painting to the original?

There are, of course, too many questions here, and we know that they can be multiplied without end. The real question, obviously, is the identity of a work of art, the ways in which we individuate works of art. One can only suppose that, in seeking to answer this question, a responsible commentator has his mind on issues of the sort just raised. We ask of him not more than a series of clues or a number of model solutions. The rest is industry.

That we do not individuate works of art as we do physical objects is clear not only from the fact that we speak of the same work performed in substantially different ways but also from the fact that we allow seemingly incompatible accounts of a given work (the counterpart of the description of a physical object) to stand as confirmed.[1] A few typical remarks from a book review will suggest the familiarity of this practice:

> The central innovation in this stimulating study of Sophocles' tragedy is the suggestion that Oedipus is meant to represent Athens, not merely in a figurative sense as a text for a homily, but as a literal equation. . . . Too bare a summary cannot do justice to the cogency of Mr. Knox's proofs or to his valuable incidental insights. His interpretations must be welcomed with thanks, provided we do not (as he would doubtless insist we should not) exclude other modes of interpretation.[2]

The expression "other modes of interpretation" I take to indicate the reviewer's conviction that his study of the *Oedipus* cycle and of the critical literature surrounding it leads him to conclude that there are a number of plausible interpretations of the cycle, among which some, including now Knox's interpretation, are not reducible to, or subsumable under, other interpretations.

Granting such interpretations to be what we have in mind when we speak of aesthetic interest in a work of art, it is precisely our aesthetic

interest that threatens our effort to identify a work of art as a public object. If contrary descriptions of an ordinary natural object, an oak tree, for instance, were regarded as confirmed, we should then be obliged to insist that the descriptions were true of two different objects. Evidently, we do not speak of works of art in this way. The only shift possible appears to be to provide a model of confirmation other than that of simple truth and falsity.[3] Let us at least conclude that aesthetic design, although it makes a work of art distinctively what it is, cannot facilitate our speaking of a single work where we wish to, as we do among the questions initially posed. The argument drives us to suppose works of art to be different in certain fundamental respects from natural objects; and in the light of certain philosophical difficulties in aesthetic discourse, this is actually a welcome proposal.[4] Thus, we seem to have accommodated, in part, the circumstances in which, for example, we wish to speak of significantly different recordings of Bach's "Brandenburg Concerti." The fact that these different recordings will show variant aesthetic designs and even different combinations of instruments does not yet force us to deny that it is the "Concerti" that are interpreted in these recordings; so our discussion is all to the good. Common sense usuage in fact actually offers such comments as, "How differently Horowitz plays it from Rubinstein," and even, "You'll have to practice a lot if you want to play it as Horowitz does."

If we turn from that which makes a work of art what it distinctively is to that out of which it is somehow formed, there are some further puzzles to be considered. In principle, we can describe the properties of a physical system that serves as art medium, without admitting contrary accounts; but such a system is not yet a work of art. It almost seems as if the work of art must elude us. But we can actually advance to a first proposal about the identity of a work of art by combining what we already know about the design and what we have just observed about the medium. To denote a work of art must mean to denote a physical object or objects that can be construed as art medium, to which, that is, an aesthetic design can be defensibly imputed, however that may be done. Moving thus far only, we can say that if we impute alternative and even contrary designs to the medium, we are merely doubly confirming the presence of a work of art—we can point to the system that serves as common medium for all of these designs.[5]

This proposal is the most important advance. Everything else that one can say is intended to make adjustments and concessions, to solve problems of more detailed and particular importance.

The ambiguities that arise in speaking about works of art will include all the general ambiguities that arise concerning ordinary objects in nature or the use of terms in our language. We can afford to confine our attention therefore to the special difficulties that arise in speaking of works of art. I suggest this economy because C. L. Stevenson has, in a recent essay, usefully applied Peirce's distinction between tokens and types to ambiguities arising when we speak about a poem—though he

speaks in a way that is indifferent to its status as an object of aesthetic interest.[6] In this regard, he examines such remarks as "There are many poems that are about classical mythology," and "Each student was expected to write down the same poem that the teacher recited." [7] These surely raise legitimate issues, but we could easily substitute statements in which the same ambiguities would arise and all reference to art would disappear.[8] The questions Stevenson raises actually occur in subtler forms that he himself touches on in his discussion of translating a poem.[9] I should like to avail myself of Stevenson's version of the token-type ambiguity, because of its advantages, but with certain important reservations. Let us adopt the following phrasing, disregarding frankly the full context in which the statements occur:

> Now when we want to speak of [token poems] we obviously have a number of other terms available; we have such terms as "manuscript of a poem," "copy of a poem," "recitation of a poem," and so on. It may seem, then, that we should reserve the term "poem" itself for the corresponding type . . . it would . . . preserve a clear sense in which the copies, and so on, are *of* the poem. They are *of* it in the sense in which various individuals are *of* a certain kind, the relation being that of membership in a class.[10]

Peirce, it must be remembered, regarded tokens and types as signs: we shall want to remain neutral on the matter of the adequacy of a semiotic theory of art.[11]

In solving the question of translation, Stevenson interposes a third notion, "megatype":

> Two tokens will belong to the same megatype if and only if they have approximately the same meaning; so it is not necessary that the tokens belong to the same language or that they have that similarity in shape or sound that makes them belong to the same type. Thus any token of "table" and any token of "mensa," though not of the same type, will nevertheless be of the same megatype. The distinction need not be restricted to individual words, of course, but can be extended to larger linguistic units, including poems.[12]

Now, to remain neutral on the semiotic theory of art and to accommodate our own previous observations of the peculiarities of fine art as well as to anticipate further difficulties to some extent, we shall have to make the following adjustments: (*a*) read, with appropriate grammatical alteration, "impute a design to" for "have the meaning of";[13] and (*b*) take it that two tokens belong to the same megatype if and only if they share approximately some design from the range of alternative and even contrary designs that may be defensibly imputed to each; or if the designs of both, however different, can be defensibly imputed to the megatype

signified by an art notation. Furthermore, to paraphrase Peirce—misusing his terms as semiotically neutral terms—"in order that a type or megatype may be used, it has to be embodied in a token; such a token is an *instance* of the type or megatype."[14]

The apparatus in now very convenient. We normally wish to refer to a poem through the text of some critical manuscript; if we need to invent a term, we may call it not merely an instance of the poem but the prime instance. This way of referring to the poem surely corresponds to the practice of historical and critical studies in poetry. Other printings, including variant versions and translations, may then serve as additional instances of the megatype. We may even speak of good and bad translations in a non-evaluative sense, if we agree on the prime instance of a poem; this simply calls for specifying a procedure for applying (*b*). We may not agree on a prime instance, as in collecting variations of folk songs, but the application of (*b*) will allow us to decide to what extent two token songs are instances of the same megatype.

The notion of the prime instance is again of signal importance in the plastic arts, but in a novel way. Reproductions correspond either to copy tokens, as in plural sculpture castings or etchings from the same plate, or to translation tokens, as in reduced-scale color lithographs of great paintings.[15] In the case of sculpture casting, or etching, an adjustment may be made. We need not actually insist on a single prime instance; there is a causal factor that may be appealed to by which to designate a set of prime instances. We see here that an important difference develops, nevertheless. In the literary arts, the prime instance is used only as a device for controlling the enumeration of tokens for a given megatype. We are inclined to identify *the* poem with the megatype poem and *use* it in the form of an acceptable token. Even when we have before us the first quarto and first folio editions of Shakespeare's *King Lear*, we still speak in this way; that is, even when we have before us prime instances. Let me quote, to illustrate this way of speaking, from some expert remarks on the *Lear* manuscripts:

> There are two substantive editions [i.e., editions "which are not derived as to essential character from any other extant edition"] of *King Lear*—the first quarto edition, published in 1608, and the first folio edition, published in 1623. In Chapter II of the introduction to my edition of the play I have argued that we must accept the view that F *Lear* was printed from a copy of Q which had been brought by a scribe into general agreement with an authentic playhouse manuscript, doubtless a prompt-book. And in Chapter II, section (i), I have argued that we must accept the view that at some stage the Q text was memorially transmitted, i.e., that it is a reported text. In any given case, then, in which Q and F have different readings, we must assume that the F reading is genuine and the Q reading corrupt, *unless there is in that particular case, a definite reason for supposing that this is not so.*[16]

If we are considering a sculpture or a painting, we identify *the* work of art with the megatype sculpture or painting as it is actually embodied *in* the prime instance; and even when we speak of original copies of an etching, which returns us apparently to earlier usage, we mean to preserve the usage just specified. This contrast is interesting because it clearly indicates that we do not identify a work of art in precisely the same way in the different arts.

Nor is it sufficient to explain the difference in terms of such considerations as market value, since a first quarto *Lear* may prove a valuable piece of property as readily as an original painting. The clue to the difference seems to lie with the importance of the actual physical marks of any token for its megatype. The difference between a printed poem and a painting, in this regard, is quite important. It is possible to view the printed poem as a *notation* for *the* poem; it is not possible to view an original painting as such a notation. This is not to say that a physical medium is not required by a poem; surely, a poem depends on what we may call sound or voice just as a painting depends on pigments.[17]

Even Benedetto Croce, contrary to popular view, seems not to have intended to deny that the artist's imagination is a craft imagination, though he mistakenly thinks it differs from another's as a matter of degree.[18] It is, incidentally, ironic that Joyce Cary, who, as author of *The Horse's Mouth,* surely saw the distinction of the craft imagination of the artist—that is, the construing of things in terms of the materials of his craft: a scene as pigments arranged on a canvas or words spoken on an occasion—could not, as aesthetician, formulate his insight except as an enlargement of Croce's error.[19] Housman, he says, for example, "had to go and find words, images, rhyme, which embodied his feeling about the tree"—insisting thus on two distinct moments in artistic creation, joined by an unbridgeable gap.[20] Samuel Alexander's account is even more subtly misleading. Though he sees that "the external work [is] an organic part of the creative process," he concludes: "Except for the features which make the artist's act creative, there is no difference in kind between the discovery of the tree by perception and the discovery of the Slave in the block or of Hamlet in the English language. The artist's creativeness conceals from us his real passivity."[21]

But to return to our main theme, the pigments can be seen only as constitutive of the painting, whereas the written words of a page of poetry may be ambivalently taken to be constitutive of a poem, as in an actual token poem, or merely as a notation of what would be constitutive of any instance. The same difference is sustained through reproductions or translations in either art. In literary art, we *refer* to a prime instance in order to determine other instances of, say, a megatype poem; and any of these will then be on a par with the prime instance. But in painting and sculpture, we *mean* by a painting *only* the megatype painting as it is embodied in the prime instance; nothing else will do. I think our ordinary language bears this out. A student may be assigned the task of reading a poem, and he will do so by consulting at random any of a very

large number of alternative printings—sometimes, as in Shakespeare, even variant editions; it is not all appropriate to say he consults a likeness of the poem. But we have any number of locutions designed to caution against identifying a cheap reproduction of a painting with the painting itself—e.g., "Let me show you a slide of Van Gogh's Sunflowers; it's not quite like the original, there's too much lemon and not enough orange in the petals," or "You can get an idea of the painting from this postcard picture." The point is, and it is certainly an important point in the appreciation of art, that the skill we prize in the poet is his arrangement of words that will sustain interesting aesthetic designs, not some peculiarly accidental physical notation of the poem.[22] The skill of the painter or sculptor is precisely what would be, but no longer can be considered as, the counterpart of the poet's or editor's notation; it is his execution *in* pigment and stone that counts.

The distinction may be summarized in this way: we can use a poem by locating instances of the poem, but we can use a painting only by locating prime instances of the painting. I speak here of *identifying* a work of art, *locating* and *using instances* of a work of art, and *denoting* and *pointing to* the medium on which any instance depends. These are all, of course, distinctions in denotation.

Notes

1. See below, Ch. V.
2. Moses Hadas, Review of Bernard M. W. Knox, *Oedipus at Thebes* (New Haven, 1957), *New York Times Book Review,* June 16, 1957.
3. See below, Ch. VI.
4. Contrast the type of comments about works of art offered by Paul Ziff, "Art and the 'Object of Art,' " in William Elton (ed.), *Aesthetics and Language* (Oxford, 1954), pp. 182–86, with that offered by Margaret MacDonald, "Some Distinctive Features of Arguments Used in Criticism of the Arts," in Elton, *op. cit.,* pp. 125–28.
5. In effect, this is to support Paul Ziff's effort to lay to rest "that ghost of aesthetics, the mysterious aesthetic object"; cf. Ziff, *op. cit.,* p. 186. But his attack on Idealist aesthetics seems oversimplified; cf. below, Ch. V.
6. "On 'What is a Poem?' " *Philosophical Review,* LXVI (June 1957), 330–33. I find that Richard Rudner has made reference to Peirce's terminology in an interesting exploratory essay on C. I. Lewis' handling of related difficulties; cf. "The Ontological Status of the Esthetic Object," *Philosophy and Phenomenological Research,* X (March 1950), 380–88, especially 385. Cf. also, Stevenson, "Interpretation and Evaluation in Aesthetics," in Max Black (ed.), *Philosophical Analysis* (Ithaca, 1950), pp. 347, 353; and Rudner, *op. cit.,* p. 387. Cf also, Margaret MacDonald, *op. cit.,* p. 123; also MacDonald, "Art and Imagination," reprinted (in part) in Melvin Rader (ed.), *A Modern Book of Esthetics* (3rd ed.; New York, 1960), pp. 215–19.
7. Stevenson, *op. cit.,* pp. 331–32.
8. Stevenson implicitly acknowledges this; cf. *op cit.,* p. 330.

9. *Ibid.,* pp. 336–38.

10. *Ibid.,* p. 331.

11. Cf. *Collected Papers of Charles Sanders Peirce,* ed. Charles Hartshorne and Paul Weiss (Cambridge, 1933), IV, par. 537, cited by Stevenson. Stevenson's discussion of semiotic theory may be taken to be ambiguous—for example, his closing remarks; but cf. Stevenson, "Symbolism in the Nonrepresentative Arts," in Paul Henle (Ed.), *Language, Thought and Culture* (Ann Arbor, 1958). Cf. also, Ch. III.

12. Stevenson, *op. cit.,* p. 337.

13. Cf. above, Ch. III.

14. *Loc. cit.*

15. Cf. Jeanne Wacker, "Particular Works of Art," *Mind, LXIX* (April 1960), pp. 223–33.

16. George Duthie, *Elizabethan Shorthand and the First Quarto of 'King Lear'* (Oxford, 1949), p. I (my italics).

17. Cf. Margaret MacDonald, "Art and Imagination," *loc. cit.;* also, Bernard Bosanquet, *Three Lectures on Aesthetics* (London, 1915), Ch. II.

18. Cf. *Aesthetics* (2nd ed.; London, 1922), pp. 8–11.

19. This is in a sense the concern of the entire novel (New York, 1944); for example, the next to last paragraph of Ch. VII.

20. *Art and Reality* (New York, 1958); excerpted in Rader, *op cit.,* pp. 104–15, particularly pp. 104–5.

21. *Beauty and Other Forms of Value* (London, 1933); excerpted in Eliseo Vivas and Murray Krieger (eds.), *The Problems of Aesthetics* (New York, 1953), pp. 143, 153.

CHAPTER 3

Cognitive and Expressive
Aspects of a Work of Art

The Nature of Artistic Meaning

Arnold Isenberg

Arnold Isenberg, who died in 1964, was the author of a number of highly respected essays in aesthetics, and was co-editor of Aesthetic Theories *(1965). A collection of his previously unpublished writings is in preparation by the University of Chicago Press.*

The Esthetic Function of Language

The main problem of this paper can be stated as a paradox:

(1) If the "esthetic object" is purely sensuous, language can not be an esthetic object, because language is not purely sensuous.
(2) And the esthetic object *is* purely sensuous; for a non-sensuous object can not be directly perceived and enjoyed; and what is not directly perceived and enjoyed is not esthetic.
(3) But language is, or can be, an esthetic object.

Anyone who opens a textbook of esthetics must soon become aware that poetry and prose literature are somehow not taken in by the description given there of the esthetic state of mind. For esthetic experience is

From *The Journal of Philosophy,* Vol. XLVI, No. 1 (1949), pp. 5–20. Reprinted by permission.

characterized as "perception for its own sake" or as the "self-motivated and self-gratifying exercise of perception"; while language is, as Santayana says, a "symbol for intelligence rather than a stimulus to sense"; and as a symbol for intelligence language is an instrument for dealing with things other than the symbols themselves, with a world vastly transcending the scope of immediate attention. Yet poetry, drama, and fiction are fine arts, therefore esthetic objects, *par excellence.*

There are three ways of dealing with this predicament. You can deny my third proposition, that language is an esthetic object, saying, as D. W. Prall was in one vein inclined to say, that "the various arts differ very greatly as to the proportion of their value that is strictly esthetic, music being almost purely esthetic in essence, poetry very slightly so." Now nobody doubts that language has many extra-esthetic and anti-esthetic functions. But to limit the esthetic side of poetry to its phonetic surface, as Prall did, is to leave the great body of poetic values isolated, classified neither with theoretical and practical nor with esthetic values; it is to preclude the development of a unified theory of the fine arts. And, of course, it by no means spares us the necessity of giving some account of the class of values which have been thus set apart.

In the second place, you could deny my second proposition, that the esthetic object is purely sensuous, maintaining with Greene, Urban, Morris, and Langer that esthetic experience is a department of cognition and that the esthetic object is some sort of sign, containing a reference to something beyond itself. Now it seems as if we could show that this alternative is empirically false, false to the facts about the kind of attitude which is assumed by lovers of nature and devotees of the abstract arts, who certainly seem to be absorbed in what is given to their senses. But more significant is the fact that this approach invariably winds up by reinstating the original issue. If the esthetic object is a special kind of symbol or sign, what kind of symbol or sign is it? What is its referent and how shall we tell whether the reference to this referent is correct or incorrect? The answer, so far as we can understand it, always comes down to some such formula as that the esthetic object is the kind of sign which does not signify anything or the kind of symbol which symbolizes itself—a long way round to immediate experience. Notions like that of the "presentational symbol" and of the "form which asserts nothing yet conveys a truth" *look* like contradictions in terms and in my opinion *are* such. These devices bear witness to the simplicity and fruitfulness of the orthodox approach which assumes it to be the hallmark of the esthetic experience that sensory phenomena are therein divested of their sign functions.

As a third alternative you can show that language can be intelligible without indicating or referring to anything; and if you can show this, you can again deny that the esthetic object is purely or exclusively sensuous without denying that it is directly perceived and enjoyed. As rough names for the two processes that I wish to distinguish here, I will use the terms "meaning" and "reference." Our question, then, has to do with the existence and nature of non-referential meaning.

The existence of such a process is hardly open to doubt. To begin at the level of the natural sign, I would call your attention to Winslow Homer's painting, *The Gulf Stream,* in the Metropolitan Museum. (For the present purpose it will do as well as a good picture would.) In this picture we see a man lying in an open boat at sea, surrounded by sharks; while in the distance there is the shape of a waterspout which indicates an approaching hurricane. In another paper [1] I made the point that our use of the terms "man," "boat," "shark," and so on, to describe the forms in the picture, does not of itself show that we attach any meanings to these forms. But it is clear that the dramatic element in this picture, depending as it does on the quasi-anticipation of a "future" event, is not given to the sense of sight and can be apprehended only through some process of interpretation on the part of the observer. Yet the observer does not treat the forms in the picture as genuine signs; that is, he does not seriously believe in the reality of man, boat, sharks, water, or storm; does not *raise the question* of their reality; and does not respond emotionally as he would if he did. Hence these forms have a function which is somewhere between sensory stimulation on the one hand and reference or indication on the other; and our own state of mind is somewhere between pure esthesis and cognition. A person afflicted with a kind of sensory aphasia and a person deluded into belief would each miss the sense and the value of the picture.

At the more advanced level of language or symbolic function, the point is illustrated by the art of fiction, where sentences seem to withdraw their claims to truth. Suppose we read this sentence in a novel: "On the first of March, 1820, a man stood for three hours at the portal of the Cathedral of Notre Dame." This sentence is more than ink or wind. It conveys ideas. It introduces us to a "world" full of "people" and "events." Yet it does not inform us (or misinform us) about anything in the actual world outside of the novel. The same sentence could, however, be treated as an assertion and be tested for its historical accuracy. Hence the property, informativeness or non-informativeness, is not inherent in the sentence: it depends on the attitude of the reader. The ability of language to invest itself of its reference to reality without losing its intelligibility is thus a specialized function which can be assumed or discarded.

Now imagine that in place of this sentence we have a general observation on the part either of the author or one of his characters—for example, the first sentence of *Anna Karenina:* "Happy families are all alike; every unhappy family is unhappy in its own way." Needless to say, there are important differences between this statement and the particular statement quoted above. But there is no such difference as might lead us to say that though the first can be taken as fiction, without consideration of truth, the second never can or should be taken so. If any sentence can be comprehended without being credited or rejected, so can any other sentence down to the farthest theorem of physics or economics. There is a perfect continuity, from this standpoint, between the narrative and the speculative portions of a book like *War and Peace*—though the

chapters in which Tolstoy writes as a philosopher do naturally provoke the reader to an exercise of thought. Another step and we see that structures like *The Origin of Species, The Critique of Pure Reason, The Decline and Fall of the Roman Empire,* can be treated as figments of imagination, describing so many possible worlds, less pictorial than Lilliput or Erewhon but not less intelligible; though it is not to be expected that works which were not shaped primarily by artistic motives should prove to be very rewarding when taken purely as works of art. Bacon characterized the philosophies of his own time as "so many stage plays, representing worlds of their own creation after an unreal and scenic fashion." Our own point is somewhat different. *Any* philosophy, and any system of science, is a "stage play" in so far as we endeavor to understand it without caring to check up on it. The contemplative attitude embraces meanings which can be carried to any degree of depth whatsoever. The real world, displayed to us by science, figures as one spectacle among many. And when Thomas Hardy writes, "Art is concerned with seemings only," and holds it to be "the mission of art to record impressions, not convictions," we must understand that convictions *become* impressions when the sentences which record them are taken in a certain way.

So far I have been concerned only to establish the fact from which our paradox emerges: the fact that we are able to hold before our direct attention theories, systems, cities, worlds—structures so complexly elaborated in depth that sense-perception could not possibly comprehend them.

It is interesting to notice that this phenomenon could not have presented any problem for a psychology such as Hume's. A psychology of sensations interprets the phenomena of meaning in terms of the accrual of associated images to a sensory core. But that an image should become an object of direct contemplation is as easy to understand as that a sensory datum should be one: the esthetic attitude is, in fact, indifferent to the distinction between imagination and sensation. The free play of fancy in accordance with laws of association was the one thing Hume could regard as simply obvious. He was confronted with the inverse problem to our own: how to go forward to a description of cognitive processes rather than how to get back from cognition to pure ideation. What is the difference between *imagining* and *believing*, e.g., that I live in London? What is the difference between recollection and prediction? What is *added* to a notion when it becomes a reference? When does a word name an object and when does it merely remind us of one? These were the difficult questions for Hume as a psychologist; and it is the inability of his method to cope with these questions that has brought it into disrepute. It is generally believed today that there are reasons for which Hume's method in psychology must be rejected; that an introspective psychology can not give an adequate account of mental processes. It can not, for example, adequately analyze the features of generality and particularity, precision and vagueness, in meanings or in references. The differences in meaning among such terms as "a mile," "a mile and a

quarter," "a million miles," "a very great distance" can not be brought down to differences among mental images. On the other hand, it is considered that a dynamic psychology of cognition can attack such questions with greater success. But an apparent result of this shift in psychological approach is the following. The fact that a waterspout stands for a storm is to be understood in terms of expectancies, preparatory sets, the assumption in response to the waterspout of an attitude appropriate to a storm. The fact that the word "man" stands for men and the word "shark" for sharks is to be understood in terms of ostensive procedures or verificatory procedures. Every such index or criterion of meaning carries with it the idea of a discursus—a displacement of attention from the given object to an object not yet given. The analysis of meaning in the hands of philosophers, subordinating this topic as it does to the interests of theory of knowledge, reinforces this conception. To understand a sentence is to know on what conditions you would accept it as true; but to know this is to know where to go and what to look for—it is to rehearse a line of experimentation. The possibility of an eventual, conditional, and ulterior course of action becomes the criterion of intelligibility. At this point it becomes difficult to see how it should be possible merely to enjoy the content of an idea. If the understanding of language is nothing but the implicit commitment to a procedure of ostentation or of verification, then the values of language must lie in the results of that procedure. They would be such as clarity, precision, and truth (or their opposites); they could not be such as splendor, eloquence, poignancy, or wit. These values are inherent in the immediate grasp of meaning. They are subject to a critical check on a second or third reading; but they neither require nor depend on any process which goes beyond that.

Thus, while the statement, in general terms, of the fact that we can contemplate an object which is not presented but only symbolized, designated, thought of, is perhaps already paradoxical, it becomes flagrantly so on a behavioristic, or "operational," analysis of symbolization, language, or thought. For this reason I would like to make it clear, if I can, that the immanent or non-referential function of meaning in esthetic experience can be recognized and treated operationally. This will require several preliminary points.

(1) The word "contemplation" is imaginatively associated with sitting and with looking or listening; and it also seems to imply the existence of a contemplated object. An illiterate person, perceiving a man seated for several hours with a novel, could understand his preoccupation if he assumed either that there were interesting shapes inscribed on the pages or that there were shapes which evoked interesting mental images. But, with these two assumptions barred, what could he make of the information, "I am really absorbed in the life of a man named David Copperfield"? It would seem to him that there was nothing which *was* the "life of David Copperfield" to be absorbed *in.* Yet such a person would, after all, be equally mystified if he were told, "I am studying the life of Charles Dickens," or, "I am calculating the life-expectancy of the

present generation"; until perhaps it was pointed out to him that he was himself apparently engaged only in listening to spoken sounds yet was in some sense dealing with the question of other people's reading habits. The question "How can language be an esthetic object?" is partly rooted in a psychological confusion, in the fact that we take staring as a model for all contemplation and continue to feel that contemplation ought to be pictorial when we no longer suppose that to be the case with other kinds of thought. If there exists a genine difficulty in the fact that I can contemplate David Copperfield though there be no David Copperfield and no image or picture of him, the difficulty is not peculiar to the present topic. It holds equally for the question of false assertions, which refer to something though there is nothing to which they refer. And if one presumes to settle it by invoking ideal entities to serve as the designata of our thoughts, that will still not take us a single step towards distinguishing between contemplation and reference. That distinction is psychological; it marks a difference between two kinds of response to symbols.

(2) In the second place, we should take note of difficulties and limitations which mark the current behavioristic theories of interpretation. For one thing, it is difficult to identify the operational index to a given act of interpretation. When we say that a waterspout means "storm" to certain people, we judge this equally by people who are running away, people who are organizing rescue parties, people who are sending messages in the weather bureau, and by an indefinite variety of other actions. The psychologist's conception of this interpretative act is a construction from such facts as that you run away *if* you fear storms—with a good many other if's. The reference can not be identified with this act or with any finite set of such acts. A given reference is a characteristic component of a set of adjustive reactions. It is identified as a parallel change in direction of thousands of variously motivated and qualified types of response; and just what class of changes shall be regarded as a sufficient basis for imputing the reference is not an easy thing to formulate, even in the animal laboratory. This point has been emphasized by many writers.[2] Again, many references are put in evidence at most by implicit responses which would not serve us, in the present state of knowledge, to distinguish them from other references. Thus, you could not tell from the most refined description of the state of my muscles and glands as I approach the breakfast table whether I expect to have tea or coffee. Again, there is the point demonstrated by Tolman and other experimentalists: that the preparatory responses, for example, to a shock are not identical with those elicited by the shock itself. This exposes ambiguity in attempts to characterize sign-interpretation in terms of the display of responses "appropriate" to the signified objects. And such attempts meet a further and very formidable obstacle in the fact that we are capable of interpreting altogether unique and novel combinations of signs and of symbols, which refer to objects never encountered as direct stimuli in our past experience.

Now I believe that most of the objections you will have to the following account of non-referential meaning will be objections that apply to the operational approach to interpretation in general and not to the attempt to clarify operationally the peculiar function of meaning in esthetic experience.

Let us assume that the consummatory phases of behavior, in which terminal values are realized, can be accurately described; and that contemplative activity is a form of consummatory response. Let us assume, in other words, that we understand the nature of *sensuous* contemplation. The feeling-responses which are obtained when one adopts the contemplative attitude, though they may appear just alike to the naked eye, are highly variable. To put it crudely, there are subtle differences in heart-beat, respiration, circulation, etc., which correspond to the differences among the contemplated objects; and the subjective counterpart of this fact is the enormous wealth and range of esthetic feelings. Now if we suppose that the consummatory feeling-response is modified by associative connections established in the course of past experience and reactivated by the present stimulus, we can go on to say that the operational index of the fact that a certain shape in a painting by Winslow Homer has the meaning "storm" is the occurrence of a feeling-response appropriate to the contemplation of a storm. Potentially, there are millions of meanings attached to the surface of *The Gulf Stream.* The water can be resolved into oxygen and hydrogen; the boat can be burned; the man has perhaps a wife and children whom his death would afflict. In principle, any and all of these meanings can be taken into the experience without destroying its esthetic character; but whether a given meaning is artistically and critically *relevant* depends on the increment of positive value that it can contribute; and whether a given meaning is *in point of fact* active in somebody's experience is to be known by the particular feeling that he has and shows or expresses. Relevant feeling-response, plus the admittedly fragmentary and eccentric flow of imagery, is also what gives the rich life to the otherwise barren act of following a page of print.

As an essential precaution here, it should be added that there is no reason *a priori* why we should be able to say what the full meaning of a work of art is; for that would be either to describe the meaning it has for an observer, which presupposes an elaborate psychological theory that we do not possess, or to say something which has exactly the same meaning, that is, the same influence on feeling, as the work of art—and this, for various reasons, may well be impossible. One measure of mediocrity in Homer's *Gulf Stream* is the degree to which we can juggle its forms about on the canvas without destoying its value; and another measure is the fact that an expression like "a lonely Negro in an open boat at sea, in the path of a hurricane" conveys a feeling not *much* different from the feeling conveyed by the picture.

Esthetic feeling as an index of meaning is like any other index: it is nothing but a modification of behavior induced by previous learning.

The difference between what I have called meaning and what I have called reference corresponds to the difference between the *kinds* of behavior which are thus affected. The existence of a meaning attached to an esthetic object is to be recognized by a change in the quality of the *contemplative* feeling-response. The taste of an orange can bear out a prediction, or fail to bear it out; it can satisy an appetite or disappoint it. But to say that the taste of an orange can bear out a prediction, or fail to bear it out; it can satisfy an appetite or disappoint it. But to say that the taste of an orange can itself be borne out or satisfied is surely to make no sense whatever, even if the taste in question happens to be an acquired one. In quite a parallel sense: the shapes in *The Gulf Stream* are sufficient to suggest the idea of a rising storm; and once suggested, the idea is present as a possession to be enjoyed. To ask, then, whether the idea is correct, whether it is confirmed by the sequel or agrees with an archetype, is meaningless and irrelevant, because it ignores the nature of the act which we take as the index of the idea.

At the root of the whole difficulty is the persistence of the ancient dichotomy, contemplation *versus* action. Once convinced that learning is to be understood as the redirection of behavior, we naturally turn to theoretical and practical responses as models of learned behavior, simply because of the practical facility of discriminating responses when they are brought out into the open field; and mental processes seem to be clearly differentiated when we trace their implications for action and chart the courses or tendencies which they would follow if completely carried out. The esthetic attitude is by comparison apparently impassive, immobile, static—a sort of dark night for behaviorists where anything that happens looks like anything else. For this reason I have emphasized both the practical difficulty of discriminating "meanings." But some very eminent writers have taken a different tack. When their attention is called to the esthetic attitude, they observe its resemblance to a case of deferred response and accordingly interpret it, not as a full-fledged action of its own kind, but as an abortive action of some other kind. Thus, a picture like *The Gulf Stream* induces us by some of its features to assume that we are dealing with a dangerous situation; but the frame of the picture, the walls of the gallery, and other circumstances cut off this inference, leaving us like some of the stupider animals in the laboratory to display a reaction which is no longer appropriate. The esthetic emotion is a sort of abridged version of the alarm we should feel if we were present at the scene itself; and the significance of the picture lies, so to speak, in this false reference. It is impossible to mention all the valid objections to this type of theory as it applies itself to the arts: one is that we do not see how an emotion like alarm, merely by growing smaller, should become positive and pleasurable when it was negative and painful. But it is rather important to see the reason for the existence of such a theory. It is the assumption of the primacy of theory and practice based on the fact that esthetic contemplation, as traditionally conceived, provides no foothold for the study of meanings, which do nevertheless some-

times function in that experience. It is, if I may say so, not the *fault* of the esthetic attitude that it has its whole field before it and therefore can not and need not go outside. It is nature's fault, or perhaps even the fault of logic; for in the last analysis when we say that esthetic experience contains meanings but no references, we are saying something which is analytically true.[3]

Let us now consider a simple empirical statement. I choose Nietzsche's remark about the relatives of a suicide: "The relatives of a suicide take it in ill part that the deceased was not more considerate of their feelings and their reputations." Some of the normal reactions to a sentence like this would be the following: you can accept it; accept it "in part"; doubt it; reject it; or hold it before your mind as a hypothesis for further examination. In every case except perhaps the last it is clear that the *understanding* of the sentence must be distinct from the act in question, if only because it is also presupposed by the other acts: to accept, reject, or doubt a sentence you must first understand it. It is also clear that the act, for instance, of *accepting* the sentence expresses this fact about the person who performs it: that his response system is geared to one order of things or events in the environment rather than another; in other words, he has an expectation about the behavior of the relatives of suicides. He has also feelings which are conditional upon the expectation: one might feel despondent if one has to accept Nietzche's proposition and relieved if one is able to reject it.

The case in which we "entertain" the sentence as a mere "supposition" would seem to be different; and it is this frame of mind that we are apt to identify with the understanding of the sentence, as opposed to the various degrees and kinds of assertion. Yet it is in the nature of a supposition, after all, that it is something *to be* tested. It expresses a verificatory set, a group of implicit exploratory responses which look ahead to an eventual result—though a result which is not prejudged. One is, so to speak, prepared for this *or* that in the relatives of a suicide—the presence or the absence of a certain trait. And this attitude corresponds, on the psychological side, to a definition of the meaning of the sentence as the set of testable consequences that can be deduced from it. Considered as a supposition, Nietzsche's sentence would certainly be clearer if it were modified to indicate whether we are to look *only* for resentment in the relatives of a suicide or for a mixed attitude of resentment and grief; and, whether it means to say that they are resentful *if* they think of their own reputations or that they *do* think of their own reputations and *are* resentful; just as, considered as an assertion, it would have a better chance of proving true if it were modified by the word "frequently" or "sometimes." But any of these changes would spoil the quality of the sentence as a piece of writing. That quality is poignant, ironical, and shocking. It can be exhibited, though not duplicated, by a paraphase: "The dead man himself, among all those affected by his deed, was presumably the most unfortunate; we might suppose, then, that his family would be overwhelmed by pity and grief; but *on the contrary* they are resentful, for

they are thinking more of themselves than of him." Here the element of contrast, incongruity, which is without interest for the psychology of suicides or their relatives, is made plain. This element would be weakened and reduced by exactly those changes which would increase the theoretical value of Nietzsche's sentence. On the other hand, it would exist in that sentence if there were not a single case for which the sentence held good. It would exist in a note jotted down, perhaps, as the sketch for a play: "The relatives of a suicide *who* take it in ill part, etc." It would exist in an imaginary construction which ran counter to all the laws and facts of human psychology. There is, then, a quality of insight which is inseparable from the understanding of the sentence; which yet does not fluctuate with any shift in the weight of the evidence for its truth; and which is also distinguishable from the values characteristic of a good supposition. One is forced to assume that there must be a kind of understanding, not to be identified either with believing or with supposing, of which the criterion is the kind of feeling obtained in contemplation.

The example from Nietzsche was chosen precisely because it is *not* devoid of cognitive value; for, though probably false, it suggests that *some* relatives do *sometimes* act in the way it describes; and this is not only true but it might well be connected with some very important truths in psychology. One may therefore be tempted to conceive of its value for imagination as being that of a suggestive half truth. And so with many great passages from the world's literature of exposition and argument. You may admit that in many cases they are demonstrably false; you may admit that they frequently contradict one another; but when you are asked how in that case they can one and all be accepted as valuable, you will be tempted to reply that they are contributions—that they *contain* or *suggest* valuable truths—and to conceive their authors as collaborating on the single structure of knowledge and wisdom. This argument, I repeat, is plausible because its premise if fairly sound. These writers— Montaigne, Milton, Pascal, Swift, Goethe, Emerson, and so many others— *were* great thinkers, great moralists, contributors to science and philosophy. But as an objection to the point that there exists a distinct dimension of esthetic meaning and an imaginative insight which corresponds to it, the argument is exposed to a crushing retort. This is simply that the greatest contribution to knowledge is in principle supersedable, whereas these passages are not to be superseded: they have a final and permanent value.

The idea that poetry as poetry is neither true nor false goes back at least to Sir Philip Sidney and perhaps to St. Thomas; and it is rather widely insisted upon today. Quite obviously, it enables us to avoid certain difficulties which arise for some critics, for instance, from the fact that Shakespeare made equally magnificent capital out of the affirmation and the denial of immortality. But it seems to lead in its own turn to consequences embarrassing to criticism. Thus, if a poem is not to be judged through an evaluation of its content, what remains but the form? We are

led to the idea of an abstract poetic magic, a technical facility in the invention of rhythms or the management of vowels and consonants, which when superadded to an otherwise commonplace thought can render that thought poetical. And it is no wonder that such an interpretation of poetic value should seem to many people to be intolerably reductive. It is this dilemma which is posed for us by Professor Urban:

> Shelley, we are told, is not making a statement that must be accepted by the hearer as either true or false. The question of truth or falsity does not enter. Now . . . I may indeed "enjoy" these lines of Shelley merely for the music of his words, the beauty of his imagery. . . . If the hearer is enjoying the poet's utterances without any reference to their truth or falsity, he is not enjoying the poet's meaning but something else. If, on the other hand, he is really *understanding* the poet, that understanding does involve communication of meaning in which questions of truth and falsity are relevant.[4]

And it is this dilemma which is rejected by Mr. Cleanth Brooks when he says that the critic who refuses "to rank poems by their messages" is not thereby "compelled to rank them by their formal embellishments."[5]

Now I think we can see in what sense it is that a certain famous passage from *The Tempest* has the "same content" as the sentence, "Everything passes away," and in what sense it has a different content. If you will allow me to assume for the moment (what is certainly debatable) that both the passage—Prospero's speech—and its paraphase have an empirical character, I would say that they are equivalent in the sense that they express the same reference or, if you prefer to consider it from the evidential standpoint, that any observation which confirmed or weakened the one would confirm or weaken the other. It is on this understanding of the word "content" that Shakespeare's passage figures as a platitude with esthetic frills and the "cloud-capp'd towers, the gorgeous palaces, the solemn temples, the great globe itself" as so many ornamental flourishes; and it is for Mr. Urban to explain how two passages which have the same "content" should be so infinitely disparate in poetic value. In other words, it is just by ignoring the existence of a distinctively esthetic function of meaning, by assuming that the absence of a reference to reality would leave us with nothing but a sequence of meaningless sounds, that we are led inevitably to a formalistic interpretation of literary values. Before considering the alternative, we should disclaim any attempt to explain what we do not understand. Just as there is no theory of design from which we could deduce the fact that one bowl of flowers should be beautiful and another one worthless, so there is no theory of meaning which can explain why the exact combination of words in Prospero's speech should be uniquely valuable. But for our immediate purpose, which is the clarification of the word "content" as a critical concept, there is at least the point that the poem and its paraphrase are made up of entirely different words. The component mean-

ings are not the same. This means that the same body of meanings is *not* present to the mind in the two cases; and perhaps it is not more mysterious that two sentences which express the same proposition to be proved or disproved should have different effects upon feeling than that two such different sentences should manage to express the same proposition. In the modest paraphrase, "Even the solidest and apparently most enduring objects shall pass away," there already exist certain relationships among component meanings which are not to be found in the sentence, "All things shall pass away," from which it can be logically derived; and those relationships, which give to the one paraphrase some slight equivalence in point of emotionally appreciable content to Shakespeare's passage, constitute a difference between that passage and the other paraphrase. Thus the very features which are adventitious to the reference made by the passage are integral to its non-referential content.

Finally, I would like to suggest the bearing of my argument on another issue of some importance. To revert to our old example, let us suppose that in an upper corner of *The Gulf Stream* there was dimly sketched in a very small area a boat laden with women and children. It seems evident that our interest would focus mainly on the apathetic Negro in the foreground lying prone in the boat, rather than on them. It is his fate and not theirs which projects the romantic thrill, just as Achilles is more important to us than all his myrmidons and just as Macbeth, whether we are for him or against him, is more important to us than Lady Macduff and her children. In practical life it would be our business to correct the distorted evaluations which result from the nearness and prominence of certain objects; to give things the value and importance which they have in themselves; to be more concerned about the women and children than about the man in the boat; and not to bother about the conflicts in the soul of Macbeth when he is every day murdering innocent people. Plato's charge against the fine arts is that they impair the integrity of our intellects and wills, induce conflict and division in the human mind, by persuading us to judgments which are at variance with those of sober reason. Just as to cultivate the illusions of perspective without intellectual criticism is to remain rooted in the childish notion that a boat in the distance is smaller than one close at hand, so poetry and painting present the issues of life in a kind of moral perspective. Anyone not a fervent nationalist and imperialist who has felt himself deeply stirred by Heine's grenadier when he declares he will let his wife and child go begging for food while he follows the Emperor on his crazy and wicked adventures and has been troubled by the presence of an apparently treasonable element in his soul has implicitly registered Plato's whole problem. The critics of Plato from Aristotle down have been busy inventing queer kinds of truth to ascribe to the arts in order to defend them against Plato's charge. But Plato can not be refuted on his own ground. If factual or moral truth is the standard, some very great works will have to be condemned. At the very least we shall

be faced with the issue, explicitly underwritten by Plato's critics, whether to sacrifice the impartiality and catholicity of our taste or the integrity of our scientific and moral judgment. Yet Plato, when he assumes that the arts evoke responses *antagonistic* to those approved by reason, assumes that they evoke responses of essentially the *same kind,* leading ultimately toward practical decision; and it is at this point that his esthetic philosophy is vulnerable.

The reader of Heine's poem or of the passage in which Othello proclaims the "quality, pride, pomp, and circumstance of glorious war" has a limited number of choices. He can approve the sentiment, if he is enough of a militarist, and with it the poem. He can reject the sentiment and with it the poem. He can reject what he calls the "content" and acclaim the technical cunning which by manipulating sounds and metres knows how to make good poetry out of deplorable ideas. None of these choices fails to offend either against taste or against reason. Or he can ask himself, finally, what exactly he is committed to if he accepts the poetry, content and all. For what Heine, what Othello, is "saying" may bear a different construction from what a person "says" who expresses the evaluation—makes the claim—"War is glorious." That claim marks out a domain of morally relevant consequences: in other words, it is the whole phenomenon of war, with its glory, horror, advantage, and suffering weighed against one another, that we are presuming to judge. To base that judgment on a glimpse of one aspect is to be as irrational as Plato fears. But to *appreciate* that aspect is to be committed to no judgment whatever concerning the whole. In this mode of contemplative appreciation there is no ambivalence, no temptation, no rebellious impulse to be contended with. On the contrary, it is the doctrinaire moralist who, suppressing the honest deliverance of taste and feeling, leaves something out of his philosophy which is sooner or later to be reckoned with.

A thorough treatment of the esthetic function of language would have to concern itself with the didactic quality in literature where and when it appears, above all in those passages which take the explicit form of a moral judgment:

> It is better to be vile than vile esteemed
>
> Let not ambition mock their useful toil
>
> Neither a borrower nor a lender be

and so on. It would have to distinguish the non-referential meaning of such expressions from the moral reference or supposition or claim and this in turn from the acceptance or rejection of the claim.[6] If these distinctions are accurately drawn, it becomes possible to show how we may critically "accept" apparently conflicting creeds without subscribing to anything which we do not believe. Instead of endorsing either the moralistic judgment of poetry or the critical dogma which would banish didacticism from poetry as extraneous, it would develop a conception of literature as moral experience based on the apprehension of "moral

meaning." Thus the justification of a purely esthetic interpretation of the arts would be found in its ability to reconcile one with another all values which are recognized by intelligence, conscience, and taste.

Notes

1. "Perception, Meaning, and the Subject-matter of Art," *The Journal of Philosophy,* Vol. 41 (1944), pp. 561–575.
2. See C. L. Stevenson, *Ethics and Language,* p. 64.
3. Mr. Lucius Garvin, propounding the same question that I deal with in this paper ("The Paradox of Aesthetic Meaning," *Philosophy and Phenomenological Research,* Vol. 8, 1947, pp. 99–106), also offers what is apparently the same solution. "The solution proposed is as follows: What an art work means, aesthetically, is simply the feeling-response obtained from it in aesthetic contemplation." But this statement is, in my opinion, unsatisfactory.

 i. It implies that *every* art work has a meaning and thereby either denies the possibility of a response limited to sensuous quality and formal order or confers on that type of response the gratuitous designation of "meaning." Even if we adopted a sense of the word "meaning" so general as to make Garvin's statement acceptable, we should still be faced with the characteristic differences between decorative design and formal construction on the one hand and poetry and expressive prose on the other; and it is on the resemblance and difference between these kinds of esthetic object that the "paradox of esthetic meaning" rests.

 ii. It obliges us to say that a piece of music *signifies* the feeling which (as one would usually say) it produces. This is as if Pavlov had said that his unconditioned stimulus, e.g., food, signified salivation to the dog to whom it was given.

 iii. It would compel us to say that the meaning of the forms on the canvas of *The Gulf Stream* was "apprehension," "tension," "excitement," rather than "storm," "danger," "possible catastrophe"; or that Pavlov's conditioned stimulus (the bell) meant "salivation" rather than "food" to the dog.

 Feeling-response is not the meaning of a work of art. *Alteration* of feeling-response, in ways which remain to be specified by a theory of learning, is the tangible evidence (the only evidence, other than linguistic paraphrase, available to the student of esthetic experience) that a person is thinking of something more than what he perceives; or, in other words, that certain forms are endowed for him with certain meanings.
4. *Language and Reality,* p. 480.
5. *The Well Wrought Urn,* p. 180.
6. In this paper the term "non-referential," qualifying the term "meaning," is not identified with "emotive," "dynamic," or "expressive," and is not opposed to "factual," "indicative," "descriptive." We have seen how purely descriptive statements can be taken in such a way as to be appreciated for their meaning and make no reference to any state of affairs. On the other hand, moral propositions like those quoted above contain implicit references just in so far as the feelings which

they express are (genetically) conditioned by or (normatively) based on opinions with respect to fact. For esthetics the emphasis in *emotive meaning* must be on *meaning* rather than on *emotive,* because the emotion which is inherent in the *understanding* of a piece of didactic writing is different from the moral attitude which it expresses or produces. The second is a feeling about how people should behave; the first is a feeling taken in the contemplation of a *view* about how people should behave. I can have the first without the second.

Lewis White Beck

Burbank Professor of Intellectual and Moral Philosophy at the University of Rochester, Lewis White Beck's publications include Philosophic Inquiry *(1952) and* Studies in the Philosophy of Kant *(1965).*

Judgments of Meaning in Art

May works of art have a meaning as one of their esthetic properties? Answers to this question whether affirmative or negative have driven many critics and estheticians into untenable positions, yet it is a question which requires an answer doing justice to the esthetic experience and harmonious with an acceptable philosophy of art.

The following study of meaning as an esthetic property begins with two explicit assumptions. The first concerns the definition of an esthetic judgment and the second concerns the methodology of esthetics. First, it is obvious that many kinds of judgments and many different predicates can be employed in estimating those objects generally considered to make up the field of the fine arts. It is equally clear, however, that many of these judgments and their predicates are irrelevant to that by virtue of which certain artifacts do so constitute the field of the arts. Those which are irrelevant relate the work of art to non-artistic material, i.e., to material not esthetically refined and presented in the same integral

From the *Journal of Philosophy,* vol. XLI, No. 7, March 30 (1944), pp. 169–178. Reprinted by permission.

creation. A judgment that a picture costs a thousand dollars is such a judgment, which is about art but not an esthetic judgment. We may decide in general whether a particular judgment is genuinely esthetic by seeing if an affirmative answer can be given to the question, "Does tracing out the relation indicated by the judgment in question contribute to the direct and immediate sensory experience?" If it does not, if it dissipates the esthetic impact and corrodes its wholeness by diverting attention from the immediate givenness, it is not an esthetic judgment. This criterion is applicable within all esthetic theories which do not surrender the value of the esthetic experience to that of some other kind of experience, such as moral edification, for example.

Second, we have to presuppose the *prima facie* validity of judgments which claim to be esthetic and which meet the first requirement outlined above. In some fields of philosophy, and perhaps in all of them, it seems to me that the thinker should have a very high respect for relatively naïve judgments. I do not propose that we always admire complete naïveté or accept the doctrine of the incorrigibility of common sense. I merely mean that before theoretical construction begins, the "facts" on which it is to be based must be accepted as such, even if only tentatively. In the appreciation of art, basic judgments of preference have to be accepted as evident even though they are only provisory, since dialectical and phenomenological elaborations may sharpen some distinctions and obliterate others; but if the expectation that they will stand analysis is not at least held—for it is obvious it will not always be fulfilled—no theory of esthetics can get started and even less can it be tested, for these judgments, though occurring in a value context, have the office and authority of fact. To be sure, even in the construction of a scientific experience facts are to some extent variable, and consequently to look upon values as facts does not of itself guarantee their permanence. Yet certain empirical judgments will retain their credentials in science regardless of what interpretations are put on them and no matter if they are translated into a conceptual language different from that of the prescientific judgment. At least the same primacy must be conceded to the basic deliverances of the esthetic attitude.

These two presuppositions provide a starting point and give direction to the following discussion. The "basic fact" of the esthetic experience with which we here begin can be expressed in such a judgment as, "The hundredth symphony of Haydn is very beautiful, but it lacks the meaning (or meaning-fulness) that one of Beethoven's later quartets has." Both inexperienced listeners and connoisseurs can be heard making such judgments as this. It is conceivable that their approval of the latter is misstated in this terminology, but we should not decide dogmatically in advance that this is the case. If an esthetic theory can not find a place for the predicate "meaningful" in its categories, or can not find a more acceptable way of expressing this preference, it is simply inadequate to the fact which it should explain. The place of meaning need not be the same after an analysis has been carried out as before, nor does

it matter to our present purposes that artists and critics can not agree as to what has meaning and what lacks it. All that is asserted here is simply that some esthetic situations seem to demand the judgment that they have meaning, and this is a fact which should not be forgotten or simply explained away in the light of some *a priori* construction based on more convenient predicates.

The validity of the concept of meaning in art is more radically denied by those who follow the present enthusiastic developments in semantics. With a positivistic definition of meaning, it is quite obvious that most art can not have any meaning. In sharply distinguishing between the emotive and the symbolical use of language or any communicative medium, and in restricting art to the former, they make it a gesture which is a symptom of emotions in the creator and a stimulus to emotion in the observer. The statements art makes are to them merely "pseudo-statements," and the difference between a yawn and a concerto is not that one has "meaning" or "beauty" but that it has a structure which is supposed peculiarly to adapt it to stimulation of certain desirable emotional states. But the "Ohs!" and "Ahs!" to which they reduce the lyrical gesture can not compete with the simple yawn as a stimulus in arousing (and even sometimes in calming and satisfying). Though the theory is in part correct in pointing to the fact that most art does not leave our feelings "cold," this fact is hardly sufficient to support the entire edifice of a philosophy of art which attempts to deal justly with the manifold complexity of phenomena in esthetics. It will suffice to indicate only three disadvantages which are closely related to the present problem. (1) It does not explain why a certain pattern of lines or tones (though the case is easier with words) is adequate to represent and to cause feelings; empathy can accomplish much, but how "meaning" supervenes upon the physiological empathic reaction is not revealed. (2) It does not adequately explain why two gestures which we may consider equally expressive and exciting may have such obvious differences in their *prima facie* esthetic value. If it attempts to do so, it must be in terms of kinds or real objects of the aroused emotion, and art is surrendered to all kinds of extraneous standards. (3) It directs attention away from the esthetic immediacy since there is no requirement that our emotional excursion entered upon because of the esthetic stimulus should bring us back to our point of origin with a richer experience of it.

Nevertheless, the attempt to escape these difficulties by a completely objective reading of the immediate experience does not lead us much further towards an understanding of meaning in art. The Kantian esthetic is typical of this, and though it preserved art from all sorts of Philistinism and subjective sentimentalism, it did so only by denying that art was a communicative medium. Its autonomy was preserved, but its content was dissipated in order to preserve its universality.

A third theory remains, and that is one which holds art to be communicative because it consists of signs of particulars. To prove this constituted the program of impressionism, but the instability of the impres-

sionistic attitude can be discovered equally well by reviewing its actual history or by examining its presupposition. The latter was the assumption that the artist pictures things as he sees them, that he sees them as they are and not as they have come to appear as a result of habit and practical interest, and that he then immediately represents them. Immediate representation, however, is self-contradictory, since representation implies mediation by perspective, selection, and accent. The fact that the artist has an arbitrary choice in each, not dictated by the material, is the fatal element in the program, because he can not humanly choose all of the possibilities in each and therefore has to make use of non-imitative canons. That is, he has to import into imitation an element foreign to his object and thus forbidden by his own theory. (Positivism had to do the same, and if a comparison between positivism and impressionism is appropriate, then their respective issuance later in voluntarisms and expressionisms of various sorts is no less revealing of their instability.)

But it is nevertheless true that much art has its imitative components, selected and modified by artistic demands. To trace out these indications, however, is like discerning that of which art is a symptom, in that both require us to leave the field of the esthetically given without any assurance of being brought back to it. On the other hand, to remain within it to the exclusion of all else seems to be, from the example of Kant, to deny the validity of the concept of meaning. Meaning by its very structure seems to entail a reference from the given here-and-now to the not-given. If this is all there is to it, we must suppose that our first presupposition is inconsistent with our second when applied to judgments of meaning.

But can we find meaning within the medium, not in a bridge between it and something else? We can not save meaning with a theory that the esthetically formed content both means and is meant in the same esthetic experience. Various forms of this theory of inherent meaning have indeed been valuable as defenses of esthetic immediacy against the theories we have examined which hunt for a meaning outside. But this theory involves an equivocation which lies in allowing the word "meaning" to denote both the act of reference and that which is referred to, and while acknowledging that it denotes both, it allows them to coalesce in one object or one moving process. How absurd it is can best be seen by analogy: if one claimed that a word had meaning, but when asked what was its meaning replied that it meant itself, we would quite rightly conclude that it meant nothing.

This analogy is not merely destructive, however, for if we observe the ways a word seems to have meaning and yet turns out either not to have any or to have a different meaning from that which it seemed to have, I think we shall get some information which will help us to see how art can have a meaning without justifying the inadequate theories which we have already examined and rejected. The following account of the genesis of some communicative forms is not, of course, a genetic one; it

does not purport to be a history of language so much as a gross anatomy of one or two of its parts.

In an ideally simple case, we would have a sound or a mark universally agreed upon for every discriminable entity. Such a "perfect language" would be absolutely transparent in both the objective and the intersubjective dimension. It would, however, be so complex that it would be unusable; its structure would be as complicated as the world itself, and for practical purposes we might be able to find no structure in it at all. Actual language has little or nothing in common with this ideal schema by which the semanticists wish to make the "verbal maps" fit the "geography of objects." One of the greatest differences lies in the fact that our language consists largely of class names, not proper names; a distinctive feature of class names is that they themselves form classes, and the whole apparatus of the calculus of classes gives the schematism of connotational structures. These patterns and the structural relationships among the things outside the medium are probably never isomorphous, and this has led many philosophers from Heraclitus to Bergson to regard language as deceptive. Certainly language can deceive us, but the knowledge that it can do so is useful for keeping it from actually doing so, and the deceptions which we fall into are occasions for restructuring either the connotational or the denotational patterns. Of the two, the former is the easier to change.

The ease of restructuring the connotational pattern in comparison with the difficulty of changing the objects to which the former is supposed to correspond is the source of two divergent modes of symbolistic change. The first begins with what we call "correcting" ideas in the light of experience. In this change, however, it is observed that the most valuable relationship for practice between the connotational and the denotational structures is not that of 1:1 congruence, but that it is rather a direct relationship between only a few terms of the one and a few observations of the other, with the terms themselves being connected into complex systems of relations which need not be supposed to hold in exact congruence in nature. The only requirement we make of a connotational structure is that it keep its feet on the ground, so that whenever a term which has a denotation occurs in the connotational system, its factual counterpart can be found objectively in the denoted system under the conditions defined by the total connotational context. This status of meaning, which is the normal one in science, indicates that meaning can be preserved even when its elaboration goes on entirely within the symbolic medium and under the domination of its own logical, semantic, or mathematical laws. Its freedom from the vain ideal of perfect picturing of denotations can be called, for obvious reasons, "semantic dissociation," and its ultimate stage would be reached in a system of mathematics which would fit Mr. Russell's definition.

The other symbolistic change brought about by this greater plasticity of the connotational structure is what Friedrich Engels called "the innate casuistry of man, to change things by changing their names." This

change may be called "semantic arrest." Here the footing of the connotational structure may be lost by inadvertence or intention so that the referential contact with the object is broken off. This occurs because, if we are careless, words and other symbols come to be regarded primarily as things and not as the meanings of things,[1] and sometimes because it is useful to us to talk without saying anything, as in phatic communication and delusory propaganda. Many of our words, names of values which Nietzsche said are merely "banners marking the spot where men have experienced new blessednesses," gain intersubjective currency but lose meaning in the dimension of denotation because they are names of ill-defined objects of desire which lie in a region all too far from that of practical enjoyment, thus building up substitute satisfactions in pseudo-environments of words and rituals and illusions. These symbols are freed from the corrective intercourse with their objects, and they become super-charged with meanings derived from their manifold uses as ideals and substitutes—that is, they become "overdetermined," as the psychoanalyst says—because they serve too great a variety of the intentions to do full justice to any; thus they lose their denotations and become useless or even dangerous when denotation is needed. But the visible structure of meaning is preserved, since the incongruence between the two realms is not visible in the single experience when we are looking at only one; its strength lies in its feigning a meaning.

Semantic dissociation is more likely to occur when the elementary material which may have denotations is largely irrelevant to our emotional interests; semantic arrest occurs most readily when the material which may relate to an object or the object itself is strongly colored with emotions and interest. In the former case, the meaning may get through at selected points so long as a vocabulary of denotation is preserved; in the latter it may be peremptorily arrested because the denotations become completely indefinite, appearing only as incomplete acts of reference having direction (intention) but not specific termination. But in both, the appearance of meaning is preserved.

Now let us apply these distinctions to meaning as we find it claimed in some esthetic judgments. We have seen that though art may indicate an object and may let us discern the artist, this reference is not esthetic meaning. It has also been shown that we can not completely cut art off from all relationship to things outside it and still preserve the concept of meaning without equivocation. We have seen ways, however, in which the phenomenon of meaning can be preserved without there being any necessity other than a practical one (which is arbitrary for esthetics) for checking the precision of the reference, and the phenomenon is all that is needed in art. In a word, the question of the meaning of art is altogether different from (though perhaps basic to) that of its "truth."

It is my thesis that art has a meaning because its esthetically formed content is isomorphous with connotational structures which might be specified by contents which could have mediate meanings by virtue of the vocabulary-relations of the content to objects or non-esthetic ideas.

Art which has a meaning is a sensuous presentation of connotations without denotations. If I may paraphrase Kant, art is "meaning without the meant."

Semantic dissociation will account for the significance of formal structure; semantic arrest comes into play when the contents of art are not just sounds and colors having sensuous relationships to each other, but when they are chosen from things we know in non-esthetic experience with which we normally associate them when we do not take up the esthetically detached attitude.

Absolute music and abstract painting have a meaning-structure but lack a vocabulary and thus have meaning but no denotation; representative and narrative art has a connotational structure and, through its use of situations which are not restricted to the artistic medium, it often has an apparently specific and, in many cases, a real denotation. But due to the centrality of quality in the esthetic experience, or to our psychic distance in neglecting non-esthetic implications, the content is allowed to become relatively opaque in the denotative dimension. Thus it can be overdetermined for the spectator and can thereby gain in connotational richness (and intersubjective clarity) what it loses in having its denotation out of focus. I say it is "allowed" to become opaque, for it is obvious that it sometimes is prevented from this by our attempts to see through it to a denotation; my attitude to a novel, for example, can be that of a historian seeking information, and when it is I may both lose the esthetic immediacy and therewith any purely esthetic meaning it may have, and find that the non-esthetic or denotative meaning is in error and does not really lead me to things at all. But in the esthetic experience it has a meaning, and the fact that greater circumspection may show it to be denotatively delusory is irrelevant to the appreciation itself.

The meaning of a work of art, then, may lie in the contents which might in other circumstances be meaningful to us because of the denotations they have; but these salient meanings are arrested by the quality which will not let us go through it lightly. Ambiguity in it may be looked upon as a positive quality dependent upon overdetermination instead of being merely a name for lack of determinateness. Or meaning can lie in its form, which serves as a sensuous receptacle for many specific connotations but is not limited to one, being a sensuous schema or essence but not a discursive universal. The work of art can thus be the locus of the phenomenon of meaning without committing the artist to anything specific about the real world, moral or physical, subjective or objective; but the work of art is not isolationist for this reason, for it has the potentialities of an almost infinite number of references, no one of which it need specify because to specify means to deny other meanings. It is in this sense that even the non-verbal arts are more "philosophical" than history. This universality which transcends specificity of denotation also explains the paradox that we can both assert that a work of art has a meaning and yet deny in principle that we can enunicate its meaning. For any narration in a language makes specific denotative commitments

which the artist has transcended; if it does not do so it is clear that it will necessarily remain the unclear and confusing outpourings which are accepted as "art appreciation" and which have no more specific meaning and considerably less interest than the art itself. It is not the fault of the interpreter, however; it lies in the nature of the task he has rashly assumed. We can at most tell that a great work of art does *not* mean; to express its full meaning would be to recreate the work (and critics are not too competent here). To attempt to express a phrase of its meaning may be in part successful, for the form of the work will often fit many particulars; not one program but an indefinite number can be found for a piece of music if one sets about the task with imagination; but to hold that the form is preëminently congruent with one particular narrative pattern which is specified by having a denotative vocabulary is to miss the esthetic meaning which is potentially a great variety of specific meanings which never should be allowed to become actual by denying the equal appropriateness of the others. Thus Beethoven's third symphony can not be exclusively interpreted as an elegy to a great man without our losing some of the richness of meaning its phenomenon suggests as possible; but at the same time it is obvious that it does not mean, even in this tenuous way, the situation suggested by his "Fury over a Lost Penny." When a definite program is provided, or when the structure is organized in such a way as to make it conform obviously to one particular denoted circumstance, we get program music with a denotative meaning, the interpretation of which leads us away from the medium and thus reduces the pure esthesis.

Although we can not say what a work of art does mean, we can nevertheless point out some of the conditions in a work of art which seem to call for the particular response of a judgment of meaningfulness. Both the form and the content must be considered. First, the form must exhibit a pattern which a directly communicative system could have. Regardless of the differences in content, the analogy between music and mathematics has long been obvious; they both have an abstract semiotic structure. They are characterized by a variety which almost breaks through the limits of the allowable heterogeneity (of ideas or contents), but are saved from disintegration by subtle harmonies and a synoptic integrating unity in complexity; they are marked by a simultaneous progressive development of both the apparent variety and actual and (at least eventually) obvious wholeness; they are marked by assertion if not denotation;[2] their contents are unambiguous (fitting) in their own contexts no matter how far they are from uniqueness of denotation; and finally they go through various phases of development in which there is both a progressive and retrogressive effect upon the connotations of all other parts.

If we turn to the contents of those arts which seem to have a denotative meaning, it is even clearer how they can have a genuinely esthetic meaning. They have such a meaning to the extent that their vocabulary is overdetermined without semantic arrest causing the phenomenon of meaning to fade. Thus a photograph does not have the meaning that a

painting of the same person can have, because its vocabulary of indicators of something outside it is too transparent to hold attention to itself. Or when photography reaches the status of art, it no longer lets the attention go through it to the object so directly that it can not enrich itself with a variety of connotations (and thus ceases to be "photographic" in the ordinary pejorative sense of the word). Something between the extremes of complete objective opacity and transparency is required; *Finnegan's Wake* does not have as much meaning (at least to many people) as *Portrait of the Artist as a Young Man,* because in the former semantic arrest is so complete that the phenomenon of meaning is itself weakened and can be found, if at all, only in the form.

If we use "beauty" as the name of a specific esthetic category and not as a term of general esthetic approbation referring to perfection in all relevant values, it is clear that meaning can be a category of quality which may be distinguished, and though it is not independent of other esthetic qualities, it is nevertheless acceptable as a predicate in genuinely esthetic judgments. Not all esthetic objects have it; nor can it be said that the phenomenon of dissociated or arrested meaning is restricted to works of art. But works of art are preëminently receptive to it, for in creating the mood of immediate acceptance of the given and satisfaction with the phenomenon, we do not feel uneasy in view of the intrinsic ambiguity of the meanings adumbrated.

Notes

1. Though this account is not meant to be genetic, it is nevertheless well to point out that primitive language is at this stage and its development goes in the direction of a more stable denotative vocabulary and a connotational structure which is to a considerable degree semantically dissociated. This fact is relevant to the genesis of art if artistic communication depends upon the kind of arrest of the "normal" reference which is described here.

2. This distinction is made clear in Wheelwright's "Principle of Paradox: that two quasi-contradictory statements which lack full propositional assertibility may both be accepted as true, or both as false, within the same context."—Philip Wheelwright, "A Preface to Phenosemantics," *Philosophy and Phenomenological Research,* Vol. II (1942), pp. 511–519, especially page 517. This entire essay, explaining the modifications in ordinary semantic canons required by their application to "transformal" or "meta-logical" contexts (of which art is one) can not be too highly recommended.

The Nature of Artistic Expression

R. G. Collingwood

Robin G. Collingwood (1889–1943) was educated at Oxford, where he became Waynflete Professor in 1934. A distinguished historian as well as philosopher, he was the author of Speculum Mentis *(1924),* The Principles of Art *(1938),* The Idea of Nature *(1945) and* The Idea of History *(1946).*

Art as Expression and Imagination

Our first question is this. Since the artist proper has something to do with emotion, and what he does with it is not to arouse it, what is it that he does? It will be remembered that the kind of answer we expect to this question is an answer derived from what we all know and all habitually say; nothing original or recondite, but something entirely commonplace.

Nothing could be more entirely commonplace than to say he expresses them. The idea is familiar to every artist, and to every one else who has an acquaintance with the arts. To state it is not to state a philosophical theory or definition of art; it is to state a fact or supposed fact about which, when we have sufficiently identified it, we shall have later

From *Principles of Art* (London: Oxford University Press, 1938), pp. 109–115, 128–135, 139, 147–148. By permission of the Clarendon Press, Oxford.

to theorize philosophically. For the present it does not matter whether the fact that is alleged, when it is said that the artist expresses emotion, is really a fact or only supposed to be one. Whichever it is, we have to identify it, that is, to decide what it is that people are saying when they use the phrase. Later on, we shall have to see whether it will fit into a coherent theory.

They are referring to a situation, real or supposed, of a definite kind. When a man is said to express emotion, what is being said about him comes to this. At first, he is conscious of having an emotion, but not conscious of what this emotion is. All he is conscious of is a perturbation or excitement, which he feels going on within him, but of whose nature he is ignorant. While in this state, all he can say about his emotion is: 'I feel . . . I don't know what I feel.' From this helpless and oppressed condition he extricates himself by doing something which we call expressing himself. This is an activity which has something to do with the thing we call language: he expresses himself by speaking. It has also something to do with consciousness: the emotion expressed is an emotion of whose nature the person who feels it is no longer unconscious. It has also something to do with the way in which he feels the emotion. As unexpressed, he feels it in what we have called a helpless and oppressed way; as expressed, he feels it in a way from which this sense of oppression has vanished. His mind is somehow lightened and eased.

This lightening of emotions which is somehow connected with the expression of them has a certain resemblance to the 'catharsis' by which emotions are earthed through being discharged into a make-believe situation; but the two things are not the same. Suppose the emotion is one of anger. If it is effectively earthed, for example by fancying oneself kicking someone down stairs, it is thereafter no longer present in the mind as anger at all: we have worked it off and are rid of it. If it is expressed, for example, by putting it into hot and bitter words, it does not disappear from the mind; we remain angry; but instead of the sense of oppression which accompanies an emotion of anger not yet recognized as such, we have that sense of alleviation which comes when we are conscious of our own emotion as anger, instead of being conscious of it only as an unidentified perturbation. This is what we refer to when we say that it 'does us good' to express our emotions.

The expression of an emotion by speech may be addressed to some one; but if so it is not done with the intention of arousing a like emotion in him. If there is any effect which we wish to produce in the hearer, it is only the effect which we call making him understand how we feel. But, as we have already seen, this is just the effect which expressing our emotions has on ourselves. It makes us, as well as the people to whom we talk, understand how we feel. A person arousing emotion sets out to affect his audience in a way in which he himself is not necessarily affected. He and his audience stand in quite different relations to the act, very much as physician and patient stand in quite different relations towards a drug administered by the one and taken by the other. A person

expressing emotion, on the contrary, is treating himself and his audience in the same kind of way; he is making his emotions clear to his audience, and that is what he is doing to himself.

It follows from this that the expression of emotion, simply as expression, is not addressed to any particular audience. It is addressed primarily to the speaker himself, and secondarily to any one who can understand. Here again, the speaker's attitude towards his audience is quite unlike that of a person desiring to arouse in his audience a certain emotion. If that is what he wishes to do, he must know the audience he is addressing. He must know what type of stimulus will produce the desired kind of reaction in people of that particular sort; and he must adapt his language to his audience in the sense of making sure that it contains stimuli appropriate to their peculiarities. If what he wishes to do is to express his emotions intelligibly, he has to express them in such a way as to be intelligible to himself; his audience is then in the position of persons who overhear him doing this. Thus the stimulus-and-reaction terminology has no applicability to the situation.

The means-and-end, or technique, terminology too is inapplicable. Until a man has expressed his emotion, he does not yet know what emotion it is. The act of expressing it is therefore an exploration of his own emotions. He is trying to find out what these emotions are. There is certainly here a directed process: an effort, that is, directed upon a certain end; but the end is not something foreseen and preconceived, to which appropriate means can be thought out in the light of our knowledge of its special character. Expression is an activity of which there can be no technique. . . .

Expressing an emotion is not the same thing as describing it. To say 'I am angry' is to describe one's emotion, not to express it. The words in which it is expressed need not contain any reference to anger as such at all. Indeed, so far as they simply and solely express it, they cannot contain any such reference. The curse of Ernulphus, as invoked by Dr. Slop on the unknown person who tied certain knots, is a classical and supreme expression of anger; but it does not contain a single word descriptive of the emotion it expresses.

This is why, as literary critics well know, the use of epithets in poetry, or even in prose where expressiveness is aimed at, is a danger. If you want to express the terror which something causes, you must not give it an epithet like 'dreadful.' For that describes the emotion instead of expressing it, and your language becomes frigid, that is inexpressive, at once. A genuine poet, in his moments of genuine poetry, never mentions by name the emotions he is expressing.

Some people have thought that a poet who wishes to express a great variety of subtly differentiated emotions might be hampered by the lack of a vocabulary rich in words referring to the distinctions between them; and that psychology, by working out such a vocabulary, might render a

valuable service to poetry. This is the opposite of the truth. The poet needs no such words at all; the existence or nonexistence of a scientific terminology describing the emotions he wishes to express is to him a matter of perfect indifference. If such a terminology, where it exists, is allowed to affect his own use of language, it affects it for the worse.

The reason why description, so far from helping expression, actually damages it, is that description generalizes. To describe a thing is to call it a thing of such and such a kind: to bring it under a conception, to classify it. Expression, on the contrary, individualizes. The anger which I feel here and now, with a certain person, for a certain cause, is no doubt an instance of anger, and in describing it as anger one is telling truth about it; but it is much more than mere anger: it is a peculiar anger, not quite like any anger that I ever felt before, and probably not quite like any anger I shall ever feel again. To become fully conscious of it means becoming conscious of it not merely as an instance of anger, but as this quite peculiar anger. Expressing it, we saw, has something to do with becoming conscious of it; therefore, if being fully conscious of it means being conscious of all its peculiarities, fully expressing it means expressing all its peculiarities. The poet, therefore, in proportion as he understands his business, gets as far away as possible from merely labelling his emotions as instances of this or that general kind, and takes enormous pains to individualize them by expressing them in terms which reveal their difference from any other emotion of the same sort.

This is a point in which art proper, as the expression of emotion, differs sharply and obviously from any craft whose aim it is to arouse emotion. The end which a craft sets out to realize is always conceived in general terms, never individualized. However accurately defined it may be, it is always defined as the production of a thing having characteristics that could be shared by other things. A joiner, making a table out of these pieces of wood and no others, makes it to measurements and specifications which, even if actually shared by no other table, might in principle be shared by other tables. A physician treating a patient for a certain complaint is trying to produce in him a condition which might be, and probably has been, often produced in others, namely, the condition of recovering from that complaint. So an 'artist' setting out to produce a certain emotion in his audience is setting out to produce not an individual emotion, but an emotion of a certain kind. It follows that the means appropriate to its production will be not individual means but means of a certain kind: that is to say, means which are always in principle replaceable by other similar means. As every good craftsman insists, there is always a 'right way' of performing any operation. A 'way' of acting is a general pattern to which various individual actions may conform. In order that the 'work of art' should produce its intended psychological effect, therefore, whether this effect be magical or merely amusing, what is necessary is that it should satisfy certain conditions, possess certain characteristics: in other words be, not this work and no other, but a work of this kind and of no other.

This explains the meaning of the generalization which Aristotle and

others have ascribed to art. We have already seen that Aristotle's *Poetics* is concerned not with art proper but with representative art, and representative art of one definite kind. He is not analysing the religious drama of a hundred years before, he is analysing the amusement literature of the fourth century, and giving rules for its composition. The end being not individual but general (the production of an emotion of a certain kind) the means too are general (the portrayal, not of this individual act, but of an act of this sort; not, as he himself puts it, what Alcibiades did, but what anybody of a certain kind would do). Sir Joshua Reynolds's idea of generalization is in principle the same; he expounds it in connexion with what he calls 'the grand style,' which means a style intended to produce emotions of a certain type. He is quite right; if you want to produce a typical case of a certain emotion, the way to do it is to put before your audience a representation of the typical features belonging to the kind of thing that produces it: make your kings very royal, your soldiers very soldierly, your women very feminine, your cottages very cottagesque, your oak-trees very oakish, and so on.

Art proper, as expression of emotion, has nothing to do with all this. The artist proper is a person who grappling with the problem of expressing a certain emotion, says, "I want to get this clear." It is no use to him to get something else clear, however like it this other thing may be. Nothing will serve as a substitute. He does not want a thing of a certain kind, he wants a certain thing. This is why the kind of person who takes his literature as psychology, saying 'How admirably this writer depicts the feelings of women, or busdrivers, or homosexuals . . . ,' necessarily misunderstands every real work of art with which he comes into contact, and takes for good art, with infallible precision, what is not art at all. . . .

It has sometimes been asked whether emotions can be divided into those suitable for expression by artists and those unsuitable. If by art one means art proper, and identifies this with expression, the only possible answer is that there can be no such distinction. Whatever is expressible is expressible. There may be ulterior motives in special cases which make it desirable to express some emotions and not others; but only if by 'express' one means express publicly, that is, allow people to overhear one expressing oneself. This is because one cannot possibly decide that a certain emotion is one which for some reason it would be undesirable to express thus publicly, unless one first becomes conscious of it; and doing this, as we saw, is somehow bound up with expressing it. If art means the expression of emotion, the artist as such must be absolutely candid; his speech must be absolutely free. This is not a precept, it is a statement. It does not mean that the artist ought to be candid, it means that he is an artist only in so far as he is candid. Any kind of selection, any decision to express this emotion and not that, is inartistic not in the sense that it damages the perfect sincerity which distinguishes good art

from bad, but in the sense that it represents a further process of a non-artistic kind, carried out when the work of expression proper is already complete. For until that work is complete one does not know what emotions one feels; and is therefore not in a position to pick and choose, and give one of them preferential treatment.

Before we ask what in general are the occasions on which we use this word [creating], we must forestall a too probable objection to the word itself. Readers suffering from theophobia will certainly by now have taken offence. Knowing as they do that theologians use it for describing the relation of God to the world, victims of this disease smell incense whenever they hear it spoken, and think it a point of honour that it shall never sully their lips or ears. They will by now have on the tips of their tongues all the familiar protests against an aesthetic mysticism that raises the function of art to the level of something divine and identifies the artist with God. Perhaps some day, with an eye on the Athanasian Creed, they will pluck up courage to excommunicate an arithmetician who uses the word three. Meanwhile, readers willing to understand words instead of shying at them will recollect that the word 'create' is daily used in contexts that offer no valid ground for a fit of *odium theologicum.* If a witness in court says that a drunken man was creating a noise, or that a dance club has created a nuisance, if an historian says that somebody or other created the English navy or the Fascist state, if a publicist says that secret diplomacy creates international distrust, or the chairman of a company says that increased attention to advertisement will create an increased demand for its produce, no one expects a little man at the back of the room to jump up and threaten to leave unless the word is withdrawn. If he did, the stewards would throw him out for creating a disturbance.

To create something means to make it non-technically, but yet consciously and voluntarily. Originally, *creare* means to generate, or make offspring, for which we still use its compound 'procreate,' and the Spaniards have *criatura,* for a child. The act of procreation is a voluntary act, and those who do it are responsible for what they are doing; but it is not done by any specialized form of skill. It need not be done (as it may be in the case of a royal marriage) as a means to any preconceived end. It need not be done (as it was by Mr. Shandy senior) according to any preconceived plan. It cannot be done (whatever Aristotle may say) by imposing a new form on any preexisting matter. It is in this sense that we speak of creating a disturbance or a demand or a political system. The person who makes these things is acting voluntarily; he is acting responsibly; but he need not be following a preconceived plan; and he is certainly not transforming anything that can properly be called a raw material. It is in the same sense that Christians asserted, and neo-Platonists denied, that God created the world.

This being the established meaning of the word, it should be clear that when we speak of an artist as making a poem, or a play, or a painting, or a piece of music, the kind of making to which we refer is the kind we call creating. For, as we already know, these things, in so far as they are works of art proper, are not made as means to an end; they are not made according to any preconceived plan; and they are not made by imposing a new form upon a given matter. Yet they are made deliberately and responsibly, by people who know what they are doing, even though they do not know in advance what is going to come of it.

The creation which theologians ascribe to God is peculiar in one way and only one. The peculiarity of the act by which God is said to create the world is sometimes supposed to lie in this, that God is said to create the world 'out of nothing,' that is to say, without there being previously any matter upon which he imposes a new form. But that is a confusion of thought. In that sense, all creation is creation out of nothing. The peculiarity which is really ascribed to God is that in the case of his act there lacks not only a prerequisite in the shape of a matter to be transformed, but any prerequisite of any kind whatsoever. This would not apply to the creation of a child, or a nuisance, or a work of art. In order that a child should be created, there must be a whole world of organic and inorganic matter, not because the parents fabricate the child out of this matter, but because a child can come into existence, as indeed its parents can exist, only in such a world. In order that a nuisance should be created, there must be persons capable of being annoyed, and the person who creates the nuisance must already be acting in a manner which, if modified this way or that, would annoy them. In order that a work of art should be created, the prospective artist (as we saw in the preceding chapter) must have in him certain unexpressed emotions, and must also have the wherewithal to express them. In these cases, where creation is done by finite beings, it is obvious that these beings, because finite, must first be in circumstances that enable them to create. Because God is conceived as an infinite being, the creation ascribed to him is conceived as requiring no such conditions.

Hence, when I speak of the artist's relation to his works of art as that of a creator, I am not giving any excuse to unintelligent persons who think, whether in praise or dispraise of my notions, that I am raising the function of art to the level of something divine or making the artist into a kind of God.

We must proceed to a further distinction. All the things taken above as examples of things created are what we ordinarily call real things. A work of art need not be what we should call a real thing. It may be what we call an imaginary thing. A disturbance, or a nuisance, or a navy, or the like, is not created at all until it is created as a thing having its place in the real world. But a work of art may be completely created when it

has been created as a thing whose only place is in the artist's mind.

Here, I am afraid, it is the metaphysician who will take offence. He will remind me that the distinction between real things and things that exist only in our minds is one to which he and his fellows have given a great deal of attention. They have thought about it so long and so intently that it has lost all meaning. Some of them have decided that the things we call real are only in our minds; others that the things we describe as being in our minds are thereby implied to be just as real as anything else. These two sects, it appears, are engaged in a truceless war, and any one who butts in by using the words about which they are fighting will be set upon by both sides and torn to pieces.

I do not hope to placate these gentlemen. I can only cheer myself up by reflecting that even if I go on with what I was saying they cannot eat me. If an engineer has decided how to build a bridge, but has not made any drawings or specifications for it on paper, and has not discussed his plan with any one or taken any steps towards carrying it out, we are in the habit of saying that the bridge exists only in his mind, or (as we also say) in his head. When the bridge is built, we say that it exists not only in his head but in the real world. A bridge which 'exists only in the engineer's head' we also call an imaginary bridge; one which 'exists in the real world' we call a real bridge.

This may be a silly way of speaking; or it may be an unkind way of speaking, because of the agony it gives to metaphysicians; but it is a way in which ordinary people do speak, and ordinary people who speak in that way know quite well what kind of things they are referring to. The metaphysicians are right in thinking that difficult problems arise from talking in that way; and I shall spend the greater part of Book II in discussing these problems. Meanwhile, I shall go on 'speaking with the vulgar'; if metaphysicians do not like it they need not read it.

The same distinction applies to such things as music. If a man has made up a tune but has not written it down or sung it or played it or done anything which could make it public property, we say that the tune exists only in his mind, or only in his head, or is an imaginary tune. If he sings or plays it, thus making a series of audible noises, we call this series of noises a real tune as distinct from an imaginary one.

When we speak of making an artifact we mean making a real artifact. If an engineer said that he had made a bridge, and when questioned turned out to mean that he had only made it in his head, we should think him a liar or a fool. We should say that he had not made a bridge at all, but only a plan for one. If he said he had made a plan for a bridge and it turned out that he had put nothing on paper, we should not necessarily think he had deceived us. A plan is a kind of thing that can only exist in a person's mind. As a rule, an engineer making a plan in his mind is at the same time making notes and sketches on paper; but the plan does not consist of what we call the 'plans,' that is, the pieces of paper with these notes and sketches on them. Even if he has put complete specifications and working drawings on paper, the paper with these specifications

and drawings on it is not the plan; it only serves to tell people (including himself, for memory is fallible) what the plan is. If the specifications and drawings are published, for example in a treatise on civil engineering, any one who reads the treatise intelligently will get the plan of that bridge into his head. The plan is therefore public property, although by calling it public we mean only that it can get into the heads of many people; as many as read intelligently the book in which the specifications and drawings are published.

In the case of the bridge there is a further stage. The plan may be 'executed' or carried out; that is to say, the bridge may be built. When that is done, the plan is said to be 'embodied' in the built bridge. It has begun to exist in a new way, not merely in people's heads but in stone or concrete. From being a mere plan existing in people's heads, it has become the form imposed on certain matter. Looking back from that point of view, we can now say that the engineer's plan was the form of the bridge without its matter, or that when we describe him as having the plan in his mind we might equally have described him as having in mind the form of the finished bridge without its matter.

The making of the bridge is the imposing of this form on this matter. When we speak of the engineer as making the plan, we are using the word 'make' in its other sense, as equivalent to create. Making a plan for a bridge is not imposing a certain form on a certain matter; it is a making that is not a transforming, that is to say, it is a creation. It has the other characteristics, too, that distinguish creating from fabricating. It need not be done as means to an end, for a man can make plans (for example, to illustrate a text-book of engineering) with no intention of executing them. In such a case the making of the plan is not means to composing the text-book, it is part of composing the textbook. It is not means to anything. Again, a person making a plan need not be carrying out a plan to make that plan. He may be doing this; he may for instance have planned a text-book for which he needs an example of a reinforced concrete bridge with a single span of 150 feet, to carry a two-track railway with a roadway above it, and he may work out a plan for such a bridge in order that it may occupy that place in the book. But this is not a necessary condition of planning. People sometimes speak as if everybody had, or ought to have, a plan for his whole life, to which every other plan he makes is or ought to be subordinated; but no one can do that.

Making an artifact, or acting according to craft, thus consists of two stages. (1) Making the plan, which is creating. (2) Imposing that plan on certain matter, which is fabricating. Let us now consider a case of creating where what is created is not a work of art. A person creating a disturbance need not be, though of course he may be, acting on a plan. He need not be, though of course he may be, creating it as means to some ulterior end, such as causing a government to resign. He cannot be transforming a pre-existing material, for there is nothing out of which a disturbance can be made; though he is able to create it only because he already stands, as a finite being always does stand, in a determinate

situation; for example, at a political meeting. But what he creates cannot be something that exists only in his own mind. A disturbance is something in the minds of the people disturbed.

Next, let us take the case of a work of art. When a man makes up a tune, he may and very often does at the same time hum it or sing it or play it on an instrument. He may do none of these things, but write it on paper. Or he may both hum it or the like, and also write it on paper at the same time or afterwards. Also he may do these things in public, so that the tune at its very birth becomes public property, like the disturbance we have just considered. But all these are accessories of the real work, though some of them are very likely useful accessories. The actual making of the tune is something that goes on in his head, and nowhere else.

I have already said that a thing which 'exists in a person's head' and nowhere else is alternatively called an imaginary thing. The actual making of the tune is therefore alternatively called the making of an imaginary tune. This is a case of creation, just as much as the making of a plan or a disturbance, and for the same reasons, which it would be tedious to repeat. Hence the making of a tune is an instance of imaginative creation. The same applies to the making of a poem, or a picture, or any other work of art.

The engineer, as we saw, when he made his plan in his own head, may proceed to do something else which we call 'making his plans.' His 'plans,' here, are drawings and specifications on paper, and these are artifacts made to serve a certain purpose, namely to inform others or remind himself of the plan. The making of them is accordingly not imaginative creation; indeed, it is not creation at all. It is fabrication, and the ability to do it is a specialized form of skill, the craft of engineer's draughtsmanship.

The artist, when he has made his tune, may go on to do something else which at first sight seems to resemble this: he may do what is called publishing it. He may sing or play it aloud, or write it down, and thus make it possible for others to get into their heads the same thing which he has in his. But what is written or printed on music-paper is not the tune. It is only something which when studied intelligently will enable others (or himself, when he has forgotten it) to construct the tune for themselves in their own heads.

The relation between making the tune in his head and putting it down on paper is thus quite different from the relation, in the case of the engineer, between making a plan for a bridge and executing that plan. The engineer's plan is embodied in the bridge: it is essentially a form that can be imposed on certain matter, and when the bridge is built the form is there, in the bridge, as the way in which the matter composing it is arranged. But the musician's tune is not there on the paper at all. What is on the paper is not music, it is only musical notation. The relation of the tune to the notation is not like the relation of the plan to the bridge; it is like the relation of the plan to the specifications and drawings; for

these, too, do not embody the plan as the bridge embodies it, they are only a notation from which the abstract or as yet unembodied plan can be reconstructed in the mind of a person who studies them. . . .

If the making of a tune is an instance of imaginative creation, a tune is an imaginary thing. And the same applies to a poem or a painting or any other work of art. This seems paradoxical; we are apt to think that a tune is not an imaginary thing but a real thing, a real collection of noises; that a painting is a real piece of canvas covered with real colours; and so on. I hope to show, if the reader will have patience, that there is no paradox here; that both these propositions express what we do as a matter of fact say about works of art; and that they do not contradict one another, because they are concerned with different things.

When, speaking of a work of art (tune, picture, & c.), we mean by art a specific craft, intended as a stimulus for producing specific emotional effects in an audience, we certainly mean to designate by the term 'work of art' something that we should call real. The artist as magician or purveyor of amusement is necessarily a craftsman making real things, and making them out of some material according to some plan. His works are as real as the works of an engineer, and for the same reason.

But it does not at all follow that the same is true of an artist proper. His business is not to produce an emotional effect in an audience, but, for example, to make a tune. This tune is already complete and perfect when it exists merely as a tune in his head, that is, an imaginary tune. Next, he may arrange for the tune to be played before an audience. Now there comes into existence a real tune, a collection of noises. But which of these two things is the work of art? Which of them is the music? The answer is implied in what we have already said: the music, the work of art, is not the collection of noises, it is the tune in the composer's head. The noises made by the performers, and heard by the audience, are not the music at all; they are only means by which the audience, if they listen intelligently (not otherwise), can reconstruct for themselves the imaginary tune that existed in the composer's head. . . .

This suggests that what we get out of a work of art is always divisible into two parts. (1) There is a specialized sensuous experience, an experience of seeing or hearing as the case may be. (2) There is also a nonspecialized imaginative experience, involving not only elements homogeneous, after their imaginary fashion, with those which make up the specialized sensuous experience, but others heterogeneous with them. So remote is this imaginative experience from the specialism of its sensuous basis, that we may go so far as to call it an imaginative experience of total activity!

At this point the premature theorist lifts up his voice again. 'See,' he exclaims, 'how completely we have turned the tables on the old-fashioned theory that what we get out of art is nothing but the sensual pleas-

ure of sight or hearing! The enjoyment of art is no merely sensuous experience, it is an imaginative experience. A person who listens to music, instead of merely hearing it, is not only experiencing noises, pleasant though these may be. He is imaginatively experiencing all manner of visions and motions; the sea, the sky, the stars; the falling of the rain-drops, the rushing of the wind, the storm, the flow of the brook; [1] the dance, the embrace, and the battle. A person who looks at pictures, in-stead of merely seeing patterns of colour, is moving in imagination among buildings and landscapes and human forms. What follows? Plainly this: the value of any given work of art to a person properly qualified to appreciate its value is not the delightfulness of the sensuous elements in which as a work of art it actually consists, but the delightful-ness of the imaginative experience which those sensuous elements awake in him. Works of art are only means to an end; the end is this total imaginative experience which they enable us to enjoy.'

Note

1. The habit of calling aesthetic experience 'the pleasures of the imagi-nation' dates back, I think, to Addison; the philosophical theory of art as imagination, to his contemporary Vico.

John Dewey

Experience and Expression

It is this double change which converts an activity into an act of expression. Things in the environment that would otherwise be mere smooth channels or else blind obstructions become means, media. At the same time, things retained from past experience that would grow stale from routine or inert from lack of use, become coefficients in new adven-tures and put on a raiment of fresh meaning. Here are all the elements needed to define expression. The definition will gain force if the traits

mentioned are made explicit by contrast with alternative situations. Not all outgoing activity is of the nature of expression. At one extreme, there are storms of passion that break through barriers and that sweep away whatever intervenes between a person and something he would destroy. There is activity, but not, from the standpoint of the one acting, expression. An onlooker may say "What a magnificent expression of rage!" But the enraged being is only raging, quite a different matter from *expressing* rage. Or, again, some spectator may say "How that man is expressing his own dominant character in what he is doing or saying." But the last thing the man in question is thinking of is to express his character; he is only giving way to a fit of passion. Again the cry or smile of an infant may be expressive to mother or nurse and yet not be an act of expression of the baby. To the onlooker it is an expression because it tells something about the state of the child. But the child is only engaged in doing something directly, no more expressive from his standpoint than is breathing or sneezing—activities that are also expressive to the observer of the infant's condition.

Generalization of such instances will protect us from the error—which has unfortunately invaded esthetic theory—of supposing that the mere giving way to an impulsion, native or habitual, constitutes expression. Such an act is expressive not in itself but only in reflective interpretation on the part of some observer—as the nurse may interpret a sneeze as the sign of an impending cold. As far as the act itself is concerned, it is, if purely impulsive, just a boiling over. While there is no expression, unless there is urge from within outwards, the welling up must be clarified and ordered by taking into itself the values of prior experiences before it can be an act of expression. And these values are not called into play save through objects of the environment that offer resistance to the direct discharge of emotion and impulse. Emotional discharge is a necessary but not a sufficient condition of expression.

There is no expression without excitement, without turmoil. Yet an inner agitation that is discharged at once in a laugh or cry, passes away with its utterance. To discharge is to get rid of, to dismiss; to express is to stay by, to carry forward in development, to work out to completion. A gush of tears may bring relief, a spasm of destruction may give outlet to inward rage. But where there is no administration of objective conditions, no shaping of materials in the interest of embodying the excitement, there is no expression. What is sometimes called an act of self-expression might better be termed one of self-exposure; it discloses character—or lack of character—to others. In itself, it is only a spewing forth.

The transition from an act that is expressive from the standpoint of an outside observer to one intrinsically expressive is readily illustrated by a simple case. At first a baby weeps, just as it turns its head to follow light; there is an inner urge but nothing to express. As the infant matures, he learns that particular acts effect different consequences, that, for example, he gets attention if he cries, and that smiling induces another

definite response from those about him. He thus begins to be aware of the *meaning* of what he does. As he grasps the meaning of an act at first performed from sheer internal pressure, he becomes capable of acts of true expression. The transformation of sounds, babblings, lalling, and so forth, into language is a perfect illustration of the way in which acts of expression are brought into existence and also of the difference between them and mere acts of discharge.

There is suggested, if not exactly exemplified, in such cases the connection of expression with art. The child who has learned the effect his once spontaneous act has upon those around him performs "on purpose" an act that was blind. He begins to manage and order his activities in reference to their consequences. The consequences undergone because of doing are incorporated as the meaning of subsequent doings because the relation between doing and undergoing is perceived. The child may now cry for a purpose, because he wants attention or relief. He may begin to bestow his smiles as inducements or as favors. There is now art in incipiency. An activity that was "natural"—spontaneous and unintended —is transformed because it is undertaken as a means to a consciously entertained consequence. Such transformation marks every deed of art. The result of the transformation may be artful rather than esthetic. The fawning smile and conventional smirk of greeting are artifices. But the genuinely gracious act of welcome contains also a change of an attitude that was once a blind and "natural" manifestation of impulsion into an act of art, something performed in view of its place or relation in the processes of intimate human intercourse.

The difference between the artificial, the artful, and the artistic lies on the surface. In the former there is a split between what is overtly done and what is intended. The appearance is one of cordiality; the intent is that of gaining favor. Wherever this split between what is done and its purpose exists, there is insincerity, a trick, a simulation of an act that intrinsically has another effect. When the natural and the cultivated blend in one, acts of social intercourse are works of art. The animating impulsion of genial friendship and the deed performed completely coincide without intrusion of ulterior purpose. Awkwardness may prevent adequacy of expression. But the skillful counterfeit, however skilled, goes *through* the form of expression; it does not have the form of friendship and abide in it. The substance of friendship is untouched.

An act of discharge or mere exhibition lacks a medium. Instinctive crying and smiling no more require a medium than do sneezing and winking. They occur through some channel, but the means of outlet are not used as immanent means of an end. The act that *expresses* welcome uses the smile, the outreached hand, the lighting up of the face as media, not consciously but because they have become organic means of communicating delight upon meeting a valued friend. Acts that were primitively spontaneous are converted into means that make human intercourse more rich and gracious—just as a painter converts pigment into means of expressing an imaginative experience. Dance and sport are

activities in which acts once performed spontaneously in separation are assembled and converted from raw, crude material into works of expressive art. Only where material is employed as media is there expression and art. Savage taboos that look to the outsider like mere prohibitions and inhibitions externally imposed may be to those who experience them media of expressing social status, dignity, and honor. Everything depends upon the way in which material is used when it operates as medium.

The connection between a medium and the act of expression is intrinsic. An act of expression always employs natural material, though it may be natural in the sense of habitual as well as in that of primitive or native. It becomes a medium when it is employed in view of its place and role, in its relations, an inclusive situation—as tones become music when ordered in a melody. The same tones might be uttered in connection with an attitude of joy, surprise, or sadness, and be natural outlets of particular feelings. They are *expressive* of one of these emotions when other tones are the medium in which one of them occurs.

Etymologically, an act of expression is a squeezing out, a pressing forth. Juice is expressed when grapes are crushed in the wine press; to use a more prosaic comparison, lard and oil are rendered when certain fats are subjected to heat and pressure. Nothing is pressed forth except from original raw or natural material. But it is equally true that the mere issuing forth or discharge of raw material is not expression. Through interaction with something external to it, the wine press, or the treading foot of man, juice results. Skin and seeds are separated and retained; only when the apparatus is defective are they discharged. Even in the most mechanical modes of expression there is interaction and a consequent transformation of the primitive material which stands as raw material for a product of art, in relation to what is actually pressed out. It takes the wine press as well as grapes to ex-press juice, and it takes environing and resisting objects as well as internal emotion and impulsion to constitute an *expression* of emotion.

Speaking of the production of poetry, Samuel Alexander remarked that "the artist's work proceeds not from a finished imaginative experience to which the work of art corresponds, but from passionate excitement about the subject matter. . . . The poet's poem is wrung from him by the subject which excites him." The passage is a text upon which we may hang four comments. One of these comments may pass for the present as a reënforcement of a point made in previous chapters. The real work of art is the building up of an integral experience out of the interaction of organic and environmental conditions and energies. Nearer to our present theme is the second point: The thing expressed is wrung from the producer by the pressure exercised by objective things upon the natural impulses and tendencies—so far is expression from being the direct and immaculate issue of the latter. The third point follows. The act of expression that constitutes a work of art is a construction in time, not an instantaneous emission. And this statement signifies

a great deal more than that it takes time for the painter to transfer his imaginative conception to canvass and for the sculptor to complete his chipping of marble. It means that the expression of the self in and through a medium, constituting the work of art, is *itself* a prolonged interaction of something issuing from the self with objective conditions, a process in which both of them acquire a form and order they did not at first possess. Even the Almighty took seven days to create the heaven and the earth, and, if the record were complete, we should also learn that it was only at the end of that period that he was aware of just what He set out to do with the raw material of chaos that confronted Him. Only an emasculated subjective metaphysics has transformed the eloquent myth of Genesis into the conception of a Creator creating without any unformed matter to work upon.

The final comment is that when excitement about subject matter goes deep, it stirs up a store of attitudes and meanings derived from prior experience. As they are aroused into activity they become conscious thoughts and emotions, emotionalized images. To be set on fire by a thought or scene is to be inspired. . . .

That art is selective is a fact universally recognized. It is so because of the role of emotion in the act of expression. Any predominant mood automatically excludes all that is uncongenial with it. An emotion is more effective than any deliberate challenging sentinel could be. It reaches out tentacles for that which is cognate, for things which feed it and carry it to completion. Only when emotion dies or is broken to dispersed fragments, can material to which it is alien enter consciousness. The selective operation of materials so powerfully exercised by a developing emotion in a series of continued acts extracts matter from a multitude of objects, numerically and spatially separated, and condenses what is abstracted in an object that is an epitome of the values belonging to them all. This function creates the "universality" of a work of art.

CHAPTER 4

Presuppositions Concerning the Work of Art

The Presupposition of Artistic Unity

Meyer Schapiro

*Now University Professor at Columbia University, Meyer Schapiro
has also taught at Harvard and at the Warburg Institute
(London University). He is the author of a variety of articles
and books on medieval and modern art.*

Coherence and Other Aesthetic Criteria

I

My aim in this paper is to examine the ascription of certain qualities
to the work of art as a whole, the qualities of perfection, coherence, and
unity of form and content, which are regarded as conditions of beauty.
While rooted in an immediate intuition of the structure of the whole, the
judgments of these qualities often change with continuing experience
of the object. They are never fully confirmed, but are sometimes in-
validated by a single new observation. As criteria of value they are not
strict or indispensable; there are great works in which these qualities are

Reprinted by permission of New York University Press from "On Perfection, Co-
herence, and Unity of Form and Content" by Meyer Schapiro from ART AND
PHILOSOPHY edited by Sidney Hook, copyright © 1966 by New York University.

lacking. Coherence, for example, will be found in many works that fail to move us, and a supreme work may contain incoherences. Order in art is like logic in science, a built-in demand, but not enough to give a work the distinction of greatness. There are dull and interesting orders, plain and beautiful ones, orders full of surprises and subtle relations, and orders that are pedestrian and banal.

II

The word perfection is often a rhetorical term expressing the behold-er's feeling of rightness, his conviction that everything in the work is as it should be, that nothing can be changed without ruining the whole. Our perception of a work is not exhaustive, however. We see only some parts and aspects; a second look will disclose much that was not seen before. We must not confuse the whole in a large aspect, co-extensive with the boundaries of the work, with the whole as the totality of the work. Expert scrutiny will discern in the acknowledged masterpieces not only details that were defective when the artist produced them, but changes brought about by others who have repaired the work. Few old paintings are today in their original state. Even acute observers will often fail to notice these changes. A painting that has seemed complete and perfectly propor-tioned will, like Rembrandt's "Night Watch," turn out to have lost a considerable part. In Homer's *Iliad* numerous passages are later interpo-lations. Few visitors to the cathedral of Chartres can distinguish the original painted glass from the replacements made in the same windows in later and especially in modern times. The example of Chartres re-minds us, too, that for the judgment of artistic greatness it is not neces-sary that a work be consistent in style or complete. Many architects, sculptors, and painters collaborated on this marvel. The varying capaci-ties of these artists, their unlike styles, even their indifference to consist-ency with each other, have not kept generations of beholders from ador-ing this beautiful church as a supreme achievement. It is not a single work of art, but, like the Bible, a vast collection of works which we value as a single incomparable whole. If the Parthenon holds up artistically in its ruined state through the grandeur of its qualities in all that remains of the original, in Chartres we accept a whole in which very different conceptions of form have been juxtaposed. The two West towers, begun by two architects of the twelfth century, were completed at different times, one of them in the late Gothic period in a style that is opposed in principle to the rest of the façade. The great West portal, too, is not as it was originally designed; several sculptors of different temperament and capacity have worked together; and parts have been arbitrarily cut and displaced to adjust to a change in the construction.

Even where a single great artist has been responsible for a work one can detect inconsistencies brought about by a new conception introduced in the course of work. So in the Sistine ceiling, Michelangelo has changed

the scale of the figures in mid-passage. One can recall other great works of literature, painting, and architecture that are incomplete or inconsistent in some respects. And one might entertain the thought that in the greatest works of all such incompleteness and inconsistency are evidences of the living process of the most serious and daring art which is rarely realized fully according to a fixed plan, but undergoes the contingencies of a prolonged effort. Perfection, completeness, strict consistency are more likely in small works than in large. The greatest artists— Homer, Shakespeare, Michelangelo, Tolstoy—present us with works that are full of problematic features. Samuel Johnson, in considering Shakespeare, drew up a list of weaknesses which, taken alone, would justify dismissing as inferior any other writer in whose poems they occurred. The power of Shakespeare, recognized by Johnson, is manifest in the ability to hold us and satisfy us in spite of these imperfections. Arnold, reviewing Tolstoy's *Anna Karenina,* remarked that it was not a well-constructed story and was defective as a work of art. But then he added —as others have done since in speaking of Tolstoy—his novel is not art, but life itself.

It is clear from continued experience and close study of works that the judgment of perfection in art, as in nature, is a hypothesis, not a certitude established by an immediate intuition. It implies that a valued quality of the work of art, which has been experienced at one time, will be experienced as such in the future; and in so far as the judgment of perfection covers the character of the parts and their relation to the particular whole, it assumes that the quality found in parts already perceived and cited as examples of that perfection will be found in all other parts and aspects to be scrutinized in the future. There is, of course, the negative evidence from the absence of observable inconsistencies and weaknesses. But we have learned often enough how limited is our perception of such complex wholes as works of art. In a circle a very tiny break or dent will arouse our attention. But in an object as complex as a novel, a building, a picture, a sonata, our impression of the whole is a resultant or summation in which some elements can be changed with little apparent difference to our sense of the whole; perception of such complexities is rapid and tolerant, isolating certain features and passing freely over others, and admitting much vagueness for the sake of the larger effects. We cannot hold in view more than a few parts or aspects, and we are directed by a past experience, an expectation and a habit of seeing, which is highly selective even in close scrutiny of an object intended for the fullest, most attentive perception. The capacity of an expert to discern in a familiar work unnoticed details and relationships that point to its retouching by others is therefore so astonishing. Here the sensibility of the expert, trained and set for such investigation, is like the power of the microscope to disclose in a work features beyond ordinary sensitive vision.

But even the experts are often blind or mistaken. To see the work as it is, to know it in its fullness, is a goal of collective criticism extending

over generations. This task is sustained by new points of view that make possible the revelation of significant features overlooked by other observers. In all these successive judgments there is an appeal to the freshly seen structure and qualities of the work.

III

What I have said about the fallibility of judgments of coherence and completeness applies also to judgments of incoherence and incompleteness. These are often guided by norms of style which are presented as universal requirements of art and inhibit recognition of order in works that violate the canons of form in that style. The norms are constantly justified in practice by perceptions—supposedly simple unprejudiced apprehensions of a quality—which are in fact directed by these norms. This is familiar enough from the charge of formlessness brought against modern works and especially the Cubist paintings that were criticized later from another point of view as excessively concerned with form. It is clear that there are many kinds of order and our impression of order and orderliness is influenced by a model of the quality. For someone accustomed to classic design, symmetry and a legible balance are prerequisites of order. Distinctness of parts, clear grouping, definite axes are indispensable features of a well-ordered whole. This canon exludes the intricate, the unstable, the fused, the scattered, the broken, in composition; yet such qualities may belong to a whole in which we can discern regularities if we are disposed to them by another aesthetic. In the modern compositions with random elements and relations, as in the works of Mondrian and the early Kandinsky and more recent abstract painting, are many correspondences of form: the elements may all be rectilinear, of one color or restricted set of colors, and set on a pronounced common plane; however scattered they appear, these elements are a recognizable family of shapes with an obvious kinship; the density in neighboring fields is about the same or the differences are nicely balanced. In time one comes to distinguish among all the competing models of chaos those which have the firmness of finely coherent forms like the classic works of the past.

I may refer also to a striking medieval example of a long misjudged order, the Romanesque relief at Souillac, with the story of Theophilus, the Virgin, and the Devil. It had seemed to critical observers, sensitive to this style of art, an uncoherent work, in spite of its clarity as an image. Its defect was explained by its incompleteness, the result of a loss of parts when the large monumental relief was moved from its original place to the present position. Study of the jointing of the sculptured blocks of stone has shown that no part is missing; and a more attentive reading of the forms has disclosed a sustained relatedness in the forms, with many surprising accords of the supposedly disconnected and incomplete parts. It was the radical break with the expected traditional mode of

hierarchic composition in this strange and powerful work that made observers feel it to be chaotic and incomplete.

IV

I shall turn now to the unity of form and content, a more subtle and elusive concept. As a ground of value, it is sometimes understood as a pronounced correspondence of qualities of the forms to qualities and connotations of a represented theme—a stimulating kind of generalized onomatopoeia. So in a painting of violent action, many crossed, colliding, and broken forms, even among the stable accessories, and in a scene of rest, mainly horizontal shapes and considerable voids. It is the poetic ideal of a marriage of sound and sense.

This concept of unity must be distinguished from the theoretical idea that since all forms are expressive and the content of a work is the meaning of the forms both as representations and expressive structures, therefore content and form are one. In a representation every shape and color is a constituting element of the content and not just a reinforcement. A picture would be a different image of its object and have another meaning if the forms were changed in the slightest degree. So two portraits of the same person, done with different forms, are different in content, though identical in subject. It is the specific representation together with all the ideas and feelings properly evoked by it that makes the content. And where there is no representation, as in architecture and music and abstract painting, the qualities of the forms, their expressive nature, in the context of the work's function, are the content or meaning of the work.

Conceived in this second way, the unity of form and content holds for all works, good and bad, and is no criterion of value. It is a sort of definition of art as well as of content, though it applies also to spoken language in which the physiognomic characteristics of speech are included with the intended message as part of the content. Unity in this indivisible oneness of form and content has another sense, it seems, than in the concepts of unity of form and unity of content, where distinguishable parts are judged to harmonize or to fit each other. What is expressed in this oneness of form and content need not, however, be unified in the sense of an inner accord; it is compatible with inconsistencies in the meanings themselves. To judge that a work possesses oneness of form and content it is not even necessary to contemplate it; the oneness follows from the definition of content in the work of art. The sense of the conjunction in "form and content" is not clear then; we do not know what it is that has been united with form as a distinguishable entity or quality in the work. It is different from saying that the content is the sum of the meanings—meanings given in the subject, the forms, and the functions of the work, with many different levels of connotation—a content unbounded rather than definite, and open to successive discovery rather

than apprehended completely in a single moment of divination. The unity of form and content is then an accord of specifiable forms and meanings and may in certain works appear comprehensive enough to induce the conviction that everything in the work is stamped with this satisfying accord which is a ground of its beauty.

This judgment of an extensive unity is an interpretation, a hypothesis; there is no one preception or series of perceptions that make it complete and certain. Judgments of unity and perfection in art, as in nature, rest on a selecting vision, an unreflective and sometimes habitual choice of aspects, as in other engagements with complex fields. In attributing a unity of form and content to a work we are free to abstract the aspect of forms and meanings that might coincide. It is not *the* form and *the* content that appear to us as one, but an aspect or part of each that we bring together because of analogy or expressive correspondence. Content and form are plural concepts which comprise many regions and many orders within the same work. The vagueness of the form-and-content usage is due to the failure to specify in which region the connection or the unity lies. In any work form and meaning cover several layers and scales of structure, expression, and representation. Line, mass, space, color, dark-and-light constitute different orders in painting, as do words, actions, characters, and the large sequence of narrative in a play or story. Besides, within each of these aspects of the work are elements and characterics that belong to the style of the time, others that are personal, and still others that are unique solutions for the particular work. To disengage these in their contribution to the content, even to interpret their expression, is beyond the power of an immediate apprehension of the whole.

In an extensive cycle of paintings—let us take Giotto's Paduan frescoes as an example—each scene has a unique form that builds its distinct image; but all hold together through common forms and colors, though the subjects are different. It would be difficult to match this large order of the whole—given at once to the eye and confirmed by scrutiny of the recurrent elements and connections—with a summating expression and meaning found also in Giotto's conception of the story of Christ. But even if found, it would remain true that we can respond to one without grasping the other fully. If there is a common spiritual attitude in all these scenes, which we regard as a quality of the content, there is a particular form in each scene with features that are not distinctive for the governing spiritual attitude.

How far the unity of form and content is an ideal hypothesis, even a program, is clear from the fact that we often appreciate forms without attending seriously to their represented meanings; for certain works we could not begin to consider that unity with content since so little of the original meanings is available to us. There are few works of older art that are legible now as they were to their makers. Some of the greatest are still problematic in meaning and continue to engage the ingenuity of iconographers. To assume that the forms would necessarily acquire an-

other aspect if we knew what they represented or what their deeper content was originally is only a guess, although there are examples of works restructured after a new interpretation of their meaning. It is unlikely that Titian's "Sacred and Profane Love" would change in artistic character and value if one of the alternative interpretations of its uncertain subject were adopted as certain.

After long study the content of the Sistine ceiling is less evident to us than the structure of the forms; to speak of a unity of form and content there is to pretend to a grasp that is still denied us. The uncertainty is not inherent in the untranslatability of artistic content into words, but in the difficulty of knowing fully enough the broad organizing ideas through which we can perceive the meanings as a unity embracing the subjects, the spheres of connotation, and numerous connections between otherwise isolated elements of representation.

For the painter each figure had a specific sense as well as many connotations, and his conception of the whole as a composition and many details of form were shaped by the need to make that sense visible. To ignore it and yet to speak of the unity of form and content is to strip the content of an essential core of meanings, and the work itself of a great part of its purpose. There is also the pictorial meaning of each figure as a form with a definite place and artistic function in the appearance of the whole. This can be grasped without our knowing what the figure represents or symbolizes, what is its role in the story. The fact that we are still deeply moved by the undeciphered whole makes us wonder at a theory that regards the experience of forms as necessarily fused with that of content. Here the forms have become for us the main content of the work in a literal sense; they speak to us powerfully and we feel that we have perceived through them the force of the artist's creative powers, his imagination and conception of man, his style as a living person.

If, before Rembrandt's famous picture of "Man with a Knife," a beholder is unable to say whether it's a portrait of a butcher or an assassin or of Saint Bartholomew who was martyred by a knife, he can still enjoy the painting as a beautiful harmony of light and shadow, color and brushwork, and appreciate the artist's power of making the figure visible as a complex human presence steeped in feeling and revery; and all this without linking in a specific way the qualities of the painting to the attributes of an intended subject. In a portrait we need not know the identity of the person in order to admire the realization of individuality by painterly means. Yet for the artist that identity was essential. Certain expressive forms were conceived as uniquely adequate to a particular sitter with traits of character and a significance that we divine only incompletely from the portrait.

Seen as form, different works have a different explicitness of structure. In a novel we often hardly attend to the form; in architecture, in music, in certain kinds of painting and especially in short poems, the form is more evident and is an unmistakable physiognomy of the work. Who, after reading a novel by Tolstoy, can recall the form as distinctly

215

as he can retell the story or find summarizing words for the thought and feeling that pervade the action? Surely there is an order, a pattern of narration, peculiarities of syntax and phrasing, contrasts and repetitions of language, of character and of plot, that build the whole in its large and intimate meanings. But we do not fix upon these as we read; the style, the form of narration, seems a transparent medium through which we experience the action itself and the feelings of the characters. But this is true also of inferior writing for the reader who is completely bemused by a story. What is relevant for the problem of unity of form and content as a value is that we do not speak of Tolstoy's form—even when we recognize it—as we do of his content. One may find in the remarkable transparency of the medium in Tolstoy's writing the same purity and sincerity as in the substance of his narrative, a confirmation of the oneness of his art in at least certain aspects of form and content. Here again the unity would lie in a common quality rather than in an undecomposable resultant.

In practice form and content are separable for the artist who, in advance of the work, possesses a form in the habit of his style which is available to many contents, and a conception of a subject or theme rich in meaning and open to varied treatment. In the process of realization these separable components of his project are made to interact and in the finished work there arise unique qualities, both of form and meaning, as the offspring of this interaction, with many accords but also with qualities distinctive for each. The beautiful simple language of a writer in a complex story may be appreciated without being considered a property of the content.

The relation between forms and what they represent may be intimate or conventional, as in the beauty of a written or printed book as a work of calligraphic and typographic art. We admire the perfection of the script, the spacing of the page, the ornament, without ever referring to the meaning of the words. From the qualities of the page we cannot imagine the qualities of the text; and we know that this same artistic form can represent whatever text is committed to the calligrapher's art which is, in general, indifferent to the sense of the script. But if this is regarded as a low order of art because of the shallowness of its content, limited to the expressive import of the melody of script, we shall also find in the same books miniature paintings of greater complexity which we contemplate with delight while ignoring most of their meanings—they are inaccessible to any but scholars.

The concept of unity of form and content must contend with the fact that there are conventions of form which are independent of the subject and appear the same in a great variety of individual styles. In painting and sculpture, what is called the style of representation is a system of forms applied to varying themes. An example is the use of the black ground with red figures and the red ground with black figures in Greek vase painting, a highly characteristic and striking form. It would be hard to show that the choice of one or the other solution has much to do with

the content of the painting, however broadly we interpret the latter. Themes of myth and everyday reality, the tragic and festive, the athletic and erotic, are represented alike with this contrast of figure and ground. Accepting the convention, artists of different style endow the basic form with qualities that might be connected with distinct features of a personal style and perhaps even with their individual conceptions of certain themes. But at least some characteristics of the form are distinguishable from the specific content and even from the content considered as a domain of subjects with a typical set of meanings. Perhaps the convention contributes a quality of feeling, an archaic strength consonant with the robust objectivity of the representations. But even if I accepted this interpretation, I would not dare to say in advance that all the conventions and motifs in that art could be seen as fused with the meanings of an image in a consistent expression—even if I felt the painting to be perfect. On the other hand, to connect such a form as the black and red of figure and ground with a world view implicit also in the choice and conception of a whole class of Greek subjects is to construct a special layer of meaning to which no explicit reference is found in the work. The Greek artist is not illustrating or presenting his world view as he illustrates the mythical tales; but he is expressing it somewhat as the structure of a language, it is supposed, embodies in certain features attitudes prevalent in a culture and found also in some revealing utterances in a more explicit way. Yet it must be said that while the assumed connection between form and world view is alluring to the imagination and as a hypothesis has become embedded in our perception of Greek objects until it has acquired for us the simplicity and self-evidence of a directly grasped meaning, the world view is not a clear expressive feature of the work of art like the feeling of a painted smile or the contrast of black and red, but a complex and still uncertain interpretation.

Both concepts of unity—the perfect correspondence of separable forms and meanings and the concept of their indistinguishability—rest on an ideal of perception which may be compared with a mystic's experience of the oneness of the world or of God, a feeling of the pervasiveness of a single spiritual note or of an absolute consistency in diverse things. I do not believe that this attitude, with its sincere conviction of value, is favorable to the fullest experience of a work of art. It characterizes a moment or aspect, not the work as disclosed through attentive contemplation, which may also terminate in ecstasy. To see the work as it is, one must be able to shift one's attitude in passing from part to part, from one aspect to to another, and to enrich the whole progressively in successive perceptions.

I have argued that we do not see all of a work when we see it as a whole. We strive to see it as completely as possible and in a unifying way, though seeing is selective and limited. Critical seeing, aware of the in-

completeness of perception, is explorative and dwells on details as well as on the large aspects that we call the whole. It takes into account others' seeing; it is a collective and cooperative seeing and welcomes comparison of different perceptions and judgments. It also knows moments of sudden revelation and intense experience of unity and completeness which are shared in others' scrutiny.

The Presupposition of Artistic Uniqueness

William E. Kennick

W. E. Kennick studied at Oberlin and Cornell. Presently Professor of Philosophy at Amherst College, he is author of Art and Philosophy *(1964).*

Does Traditional Aesthetics Rest Upon a Mistake?

It rests, I think, on at least two of them, and the purpose of this paper is to explore the claim that it does.

By 'traditional aesthetics' I mean that familiar philosophical discipline which concerns itself with trying to answer such questions as the following: What is Art? What is Beauty? What is the Aesthetic Experience? What is the Creative Act? What are the criteria of Aesthetic Judgment and Taste? What is the function of Criticism? To be sure, there are others, like: Are the aesthetic object and the work of art the same? Or, Does art have any cognitive content?—but these questions are commonly taken to be subordinate to those of the first group, which might be called the 'basic questions' of traditional aesthetics.

1. *The Basic Questions as Requests for Definitions.* If someone asks

From *Mind,* Vol. 67, New Series (1958), pp. 317–334, by permission of the editor and the author.

me 'What is helium?' I can reply: 'It's a gas' or 'It's a chemical element' or 'It's a gaseous element, inert and colourless, whose atomic number is 2 and whose atomic weight is 4·003.' A number of replies will do, depending upon whom I am talking to, the aim of his question, and so on. It is a pretty straightforward business; we get answers to such questions every day from dictionaries, encyclopedias, and technical manuals.

Now someone asks me 'What is Space?' or 'What is Man?' or 'What is Religion?' or 'What is Art?' His question is of the same form as the question 'What is helium?' but how vastly different! There is something very puzzling about these questions; they cannot be answered readily by appealing to dictionaries, encyclopedias, or technical manuals. They are philosophical questions, we say, giving our puzzlement a name, although we should not think of calling 'What is helium?' a philosophical question. Yet we expect something of the same sort of answer to both of them. There's the rub.

We say that questions like 'What is Space?' or 'What is Art?' are requests for information about the nature or essence of Space or of Art. We could say that 'What is helium?' is a request for information about the nature or essence of helium, but we rarely, if ever, do; although we do use questions like 'What is helium?' as analogues of questions like 'What is Space?' to show the sort of reply we are looking for. What we want, we say, is a definition of Space or of Art, for as Plato and Aristotle taught us long ago, "definition is the formula of the essence." So, just as the traditional metaphysicians have long sought for the nature or essence of Space and of Time, of Reality and of Change, the traditional aesthetician has sought for the essence of Art and of Beauty, of the Aesthetic Experience and the Creative Act. Most of the basic questions of traditional aesthetics are requests for definitions; hence the familiar formulae that constitute the results of traditional aesthetic inquiry: 'Art is Expression' (Croce), 'Art is Significant Form' (Clive Bell), 'Beauty is Pleasure Objectified' (Santayana), and so on. Given these definitions we are supposed to know what Art is or what Beauty is, just as we are supposed to know what helium is if someone tells us that it is a chemical element, gaseous, inert, and colourless, with an atomic number of 2 and an atomic weight of 4·003. F. J. E. Woodbridge once remarked that metaphysics searches for the nature of reality and finds it by definition. We might say that traditional aesthetics searches for the nature of Art or Beauty and finds it by definition.

But why should it be so difficult to discern the essence of Art or Beauty? Why should it take so much argument to establish or defend such formulae as 'Art is Expression'? And once we have arrived at such formulae or have been given them in answer to our question, why should they be so dissatisfying?

To come closer to an answer to these questions, we must look at what it is the aesthetician expects of a definition of Art or Beauty. De Witt Parker has stated with unusual clarity the "assumption" of the aesthetician in asking and answering such questions as 'What is Art?';

at the beginning of his essay on "The Nature of Art" (note the title) he says:

> The assumption underlying every philosophy of art is the exist-ence of some *common nature* present in all the arts, despite their differences in form and content; something the *same* in painting and sculpture; in poetry and drama; in music and architecture. Every single work of art, it is admitted, has a unique flavour, a *je ne sais quoi* which makes it incomparable with every other work; nevertheless, there is some mark or set of marks which, if it applies to any work of art, applies to *all* works of art, *and to nothing else*—a common denominator, so to say, which consti-tutes the definition of art, and serves to separate . . . the field of art from other fields of human culture.[1]

What we are after, it should be clear, is what the traditional logic texts call a 'definition *per genus et differentiam*' of Art and Beauty.

2. *The Assumption Questioned; the First Mistake.* The assumption that, despite their differences, all works of art must possess some com-mon nature, some distinctive set of characteristics which serves to sepa-rate Art from everything else, a set of necessary and sufficient conditions for their being works of art at all, is both natural and disquieting, and constitutes what I consider to be the first mistake on which traditional aesthetics rests. It is natural, because, after all, we do use the word 'art' to refer to a large number of very different things—pictures and poems and musical compositions and sculptures and vases and a host of other things; and yet the word is one word. Surely, we are inclined to say, there must be something common to them all or we should not call them all by the same name. *Unum nomen; unum nominatum.*

Yet the assumption is disquieting when we come to search for the common nature which we suppose all works of art to possess. It is so elusive. We ought to be able to read a poem by Donne or by Keats, a novel by George Eliot or Joseph Conrad, or a play by Sophocles or Shakespeare, to listen to Mozart and Stravinsky, and to look at the pictures of Giotto and Cezanne and the Chinese masters and *see* what Art is. But when we look we do not see what Art is. So we are inclined to suppose that its essence must be something hidden, something that only an aesthetician can see, like the sounds that only a dog can hear, or else, as Parker, for example, supposes, that it must be something very complex, involving many characteristics (*op.cit.* p. 93). This explains why an adequate defi-nition of Art is so hard to arrive at, why it is so much harder to answer questions like 'What is Art?' than it is to answer questions like 'What is helium?' Perhaps this also explains why there is a Philosophy of Art when there is no Philosophy of Helium?

But this explanation will not do. It will not do, that is, to suppose simply that the essence or nature of Art is elusive, very hard to detect, or very complex. It suggests that what we are faced with is a problem of scrutinizing, that what we have to do is to look long and hard at works

of art, examine them carefully and diligently and, *voila!* we shall *see*. But no amount of looking and scrutinizing gives us what we want. All we see is this poem and that play, this picture and that statue, or some feature of them that catches our attention; and if we find some resemblances between poems or plays or pictures, or even between poems *and* pictures, pictures *and* musical compositions, these resemblances quickly disappear when we turn to other poems and plays and pictures. That is why in aesthetics it is best not to look at too many works of art and why, incidentally, aesthetics is best taught without concrete examples; a few will do. We can readily believe that we have seen the essence of Art when we have selected our examples properly; but when we range farther afield we lose it.

Despite the temptation to think that if we look long enough and hard enough at works of art we shall find the common denominator in question, after all the fruitless scrutinizing that has already been done, it is still more tempting to think that we are looking for something that is not there, like looking for the equator or the line on the spectrum that separates orange from red. No wonder that in aesthetics we soon begin to feel the frustration of St. Augustine when he asked himself 'What is Time?': "If I am not asked, I know; if I am asked, I know not." Something must be wrong.

What is wrong, as I see it, has nothing to do with the nature or essence of Art at all; that is, there is neither anything mysterious nor anything complicated about works of art which makes the task of answering the question 'What is Art?' so difficult. Like St. Augustine with Time, we do know quite well what Art is; it is only when someone asks us that we do not know. The trouble lies not in the works of art themselves but in the concept of Art. The word 'art,' unlike the word 'helium,' has a complicated variety of uses, what is nowadays called a complex 'logic.' It is not a word coined in the laboratory or the studio to name something that has hitherto escaped our attention; nor is it a relatively simple term of common parlance like 'star' or 'tree' which names something with which we are all quite familiar. As Professor Kristeller has shown us,[2] it is a word with a long, involved, and interesting history; a complicated concept indeed, but not for the reasons which the aestheticians suppose. Any good dictionary will indicate some of its many meanings, some of the variety of uses which the word 'art' has; but no dictionary will give us the kind of formula which the aestheticians seek. That is why we suppose that the nature of Art is a philosophical problem and why there is a Philosophy of Art but no Philosophy of Helium. It is the complicated concepts like those of Space, Time, Reality, Change, Art, Knowledge, and so on that baffle us. Dictionaries and their definitions are of use in making short shrift of questions of the form 'What is X?' only in relatively simple and comparatively trivial cases; in the hard and more interesting cases they are frustrating and disappointing.

Doubtless there is an answer to this, and it might run somewhat as follows: "We know that the word 'Art' has a variety of uses in English.

222

Most commonly it is used to refer to pictures alone; when we visit an art museum or consult an art critic, we expect to see pictures or to hear pictures talked about. We say that painting, painting pictures, *not* painting houses or fences, is *an* art, that cooking and sewing and basket-weaving, bookbinding and selling are *arts*, but only some pictures do we call *works* of art, and rarely do we refer to dishes or garments or baskets as works of art, except honorifically. We speak of the liberal arts and the industrial arts and of the art of war. But all of this is beside the point. As aestheticians we are interested only in what are sometimes called the 'fine arts', or what Collingwood calls 'art proper'—works of art. Surely all of these have something in common, else how should we be able to separate those paintings and drawings and poems and plays, musical compositions and buildings which are works of art from those which are not?"

To answer the last question first and make a long story short: we are able to separate those objects which are works of art from those which are not, because we know English; that is, we know how correctly to use the word 'art' and to apply the phrase 'work of art.' To borrow a statement from Dr. Waismann and change it to meet my own needs, "If anyone is able to use the word 'art' or the phrase 'work of art' correctly, in all sorts of contexts and on the right sort of occasions, he knows 'what art is,' and no formula in the world can make him wiser." [3] "Art proper" is simply what is properly called 'art.' The 'correctly' and 'properly' here have nothing to do with any 'common nature' or 'common denominator' of all works of art; they have merely to do with the rules that govern the actual and commonly accepted usage of the word 'art.'

Imagine a very large warehouse filled with all sorts of things—pictures of every description, musical scores for symphonies and dances and hymns, machines, tools, boats, houses, churches and temples, statues, vases, books of poetry and of prose, furniture and clothing, newspapers, postage stamps, flowers, trees, stones, musical instruments. Now we instruct someone to enter the warehouse and bring out all of the works of art it contains. He will be able to do this with reasonable success, despite the fact that, as even the aestheticians must admit, he possesses no satisfactory definition of Art in terms of some common denominator because no such definition has yet been found. Now imagine the same person sent into the warehouse to bring out all objects with Significant Form, or all objects of Expression. He would rightly be baffled; he knows a work of art when he sees one, but he has little or no idea what to look for when he is told to bring an object that possesses Significant Form.

To be sure, there are many occasions on which we are not sure whether something is a work of art or not; that is, we are not sure whether to call a given drawing or musical composition a work of art or not. Are "Nearer My God to Thee" and the political cartoons of Mr. Low works of art? But this merely reflects the systematic vagueness of the concepts in question, or what Dr. Waismann on another occasion has called their 'open texture'; a vagueness, note, which the definitions of the aestheti-

cians do nothing at all to remove. On such occasions we can, of course, tighten the texture, remove some of the vagueness, by making a decision, drawing a line; and perhaps curators and purchasing committees of art museums are sometimes forced for obvious practical reasons to do this. But in doing so, they and we are not discovering anything about Art.

We do know what art is when no one asks us what it is; that is, we know quite well how to use the word 'art' and the phrase 'work of art' correctly. And when someone asks us what art is, we do *not* know; that is, we are at a loss to produce any simple formula, or any complex one, which will neatly exhibit the logic of this word and this phrase. It is the compulsion to reduce the complexity of aesthetic concepts to simplicity, neatness, and order that moves the aesthetician to make his first mistake, to ask 'What is Art?' and to expect to find an answer like the answer that can be given to 'What is helium?'

What I have said about Art in this section applies, *mutatis mutandis,* to Beauty, the Aesthetic Experience, the Creative Act, and all of the other entities with which traditional aesthetics concerns itself.

Where there is no mystery, there is no need for removing a mystery and certainly none for inventing one.

3. *Common Denominators and Similarities.* Is the search for common characteristics among works of art, then, a fool's errand? That depends upon what we expect to find. If we expect to find some common denominator in Parker's sense, we are bound to be disappointed. We shall get ourselves enmeshed in unnecessary difficulties, and the definitions which we hope will free us from the net will be specious at best. If we say 'Art is Significant Form' we may feel momentarily enlightened; but when we come to reflect upon what we mean by 'significant form' we shall find ourselves entangled again. For the notion of Significant Form is clearly more obscure than is that of Art or Beauty, as the example of the warehouse above amply illustrates; the same holds for Expression, Intuition, Representation, and the other favoured candidates of the aestheticians. Nor will it do to say, as Professor Munro does,[4] that "art is skill in providing stimuli to satisfactory aesthetic experience." This has merely a scientific *sound,* and this sound is about as close as the effort to make aesthetics scientific comes to science. The notion of aesthetic experience is fraught with the same difficulties as the notion of art. To put it dogmatically, there is no such thing as *the* Aesthetic Experience; different sorts of experiences are properly referred to as aesthetic. Do not say they must all be contemplative. Does that really help at all?

There is, however, a fruitful and enlightening search for similarities and resemblances in art which the search for the common denominator sometimes furthers, the search for what, to torture a phrase of Wittgenstein's, we can call 'family resemblances.' When we squint we can sometimes see features of an object which otherwise we should miss. So in aesthetics, when we narrow our view, when in the search for the common denominator we carefully select our examples and restrict our sight, we may not see what we are looking for, but we may see something of

more interest and importance. The simplifying formulae of the aestheticians are not to be scrapped merely because they fail to do what they are designed to do. What fails to do one thing may do another. The mistake of the aestheticians can be turned to advantage. The suspicion that aesthetics is not nonsense is often justified. For the idea that there is a unity among the arts, properly employed, can lead to the uncovering of similarities which, when noticed, enrich our commerce with art. Croce's supposed discovery that Art is Expression calls our attention to, among other things, an interesting feature of some, if not all, works of art, namely, their indifference to the distinction between the real and the unreal.

Or, to take examples from critics, when F. R. Leavis says of Crabbe, "His art is that of the short-story writer," [5] and when Professor Stechow compares the fourth movement of Schumann's "Rhenish" Symphony with certain features of the Cologne Cathedral,[6] we have something of interest and importance. Our attention is refocused on certain works, and we see them in a new light. One of the offices of creative criticism, as of creative aesthetics, is the finding and pointing out of precisely such similarities.

4. *Aesthetic Theories Reconsidered.* Philosophical mistakes are rarely downright howlers; they have a point. What I have said is, I think, correct, but it neglects an important facet of the quest for essences, a by-product of that search, so to speak, which we should not ignore. An aesthetic theory, by which I mean a systematic answer to such questions as 'What is Art?', 'What is Beauty?' and the like, frequently does something quite other than what is sets out to do. The assumption underlying traditional aesthetics, as Parker states it in the passage quoted above, is wrong, and I hope I have shown why it is wrong. It does not follow from this, however, that aesthetic theories are wholly without point, that they are merely mistaken, that formulae like 'Art is Significant Form' are worthless, useless, or meaningless. They do serve a purpose, but their purpose is not that which Parker assigns them. Considered in context, in the historical or personal context, for example, they are frequently seen to have a point which has nothing to do with the philosophical excuses that are made for them.

Take Bell's famous dictum that 'Art is Significant Form.' It does not help us to understand what art is at all, and to that extent it is a failure; its shortcomings in this direction have been exposed on numerous occasions. It is easy to beat Bell down; he is so vulnerable. But when we stop to consider that he was an Englishman and when he wrote his book on art (1913) and what the taste of the English was like then and of his association with Roger Fry, the statement that 'Art is Significant Form' loses some of its mystifying sound. It has a *point.* Not the point that Bell thinks it has, for Bell was also looking for the common denominator; another point. We might put it this way. The taste of Edwardian Englishmen in art was restricted to what we pejoratively call the 'academic'. Subject-matter was of prime importance to them—portraits of eminent

persons, landscapes with or without cows, genre scenes, pictures of fox hunts, and the rest. Bell had seen the paintings of Cezanne, Matisse, and Picasso, and he was quick to see that subject-matter was not of prime importance in them, that the value of the paintings did not rest on realism or sentimental associations. It rested on what? Well, 'significant form'; lines and colours and patterns and harmonies that stir apart from associations evoked by subject-matter. He found also that he could look at other paintings, older paintings, paintings by the Venetian and Dutch masters, for example, and at vases and carpets and sculptures in the same way he looked at Cezanne. He found such looking rewarding, exciting. But when he turned to the pictures of the academicians, the thrill disappeared; they could not be looked at profitably in this way. What was more natural, then, than that he should announce his discovery by saying 'Art *is* Significant Form'? He *had* discovered something for himself. Not the essence of Art, as the philosophers would have it, although he thought that this is what he found, but *a new way of looking at pictures*. He wanted to share his discovery with others and to reform English taste. *Here* is the point of his dictum; 'Art is Significant Form' is a slogan, the epitome of a platform of aesthetic reform. It has work to do. Not the work which the philosophers assign it, but a work of teaching people a new way of looking at pictures.

When we blow the dust of philosophic cant away from aesthetic theories and look at them in this way, they take on an importance which otherwise they seem to lack. Read Aristotle's *Poetics,* not as a philosophical exercise in definition, but as instruction in one way to read tragic poetry, and it takes on a new life. Many of the other dicta of the aestheticians can also be examined in this light. We know that as definitions they will not do; but as instruments of instruction or reform they will do. Perhaps that is why they have had more real weight with practising critics than they have had with philosophers. The critics have caught the point, where the philosophers, misguided from the start by a foolish preoccupation with definition, have missed it.

5. *Aesthetics and Criticism; the Second Mistake.* One of the prime reasons for the aesthetician's search for definitions of Art, Beauty, and the rest, is his supposition that unless we know what Art or Beauty is, we cannot say what good art or beautiful art is. Put it in the form of an assumption: Criticism presupposes Aesthetic Theory. This assumption contains the second mistake on which traditional aesthetics rests, namely, the view that responsible criticism is impossible without standards or criteria universally applicable to all works of art. The second mistake is in this way closely related to the first.

To see more clearly how this assumption operates, we can turn to a recent book by Mr. Harold Osborne,' *Aesthetics and Criticism.* Osborne believes that "a theory of the nature of artistic excellence is implicit in every critical assertion which is other than autobiographical record," and he thinks that "until the theory has been made explicit the criticism is without meaning" (p. 3). By a 'theory of the nature of artistic excellence' Osborne means a theory of the nature of Beauty (p. 3).

Osborne examines several theories of the nature of Beauty and finds them all wanting. His moves against them are instructive. Take, for example, his move against a version of the Realistic Theory in Chapter V, that theory holding that artistic excellence consists in 'truth to life'—or so Osborne states it. He correctly notes that practising critics have rarely insisted that verisimilitude is a necessary condition of artistic excellence, and we should all agree that it is not. "But," says Osborne, "if correspondence with real or possible actuality is not a necessary condition of artistic excellence, then most certainly it is not and cannot be of itself an *artistic* virtue, or an aesthetic merit, in those works of literature where it happens to occur" (p. 93). This is a curious argument. It seems to contain a glaring non sequitur. But what leads Osborne from his protasis to his conclusion is the assumption that the only acceptable reason offerable for a critical judgment of a work of art is one framed in terms of a characteristic which all works of art, *qua* works of art, must possess. Since we admit that not all works of art must possess truth to life or verisimilitude, we cannot use their adventitious possession of this property as a reason for praising, judging, or commending them as works of art.

Now surely this is mistaken. We can agree that correspondence with real or possible actuality, whatever that may mean, is not a *necessary* condition of artistic excellence; that is, it is *not* necessary that it appear among the reasons offerable for the judgment that a given work of art is good or beautiful. But it does not follow that therefore it does not and cannot appear as *a* reason for such a judgment. We can and do praise works of art, *as* works of art, whatever the force of that is, for a variety of reasons, and not always the same variety. Osborne's reply here is that in doing so we are being 'illogical and inconsistent.' Attacking the users of the Hedonistic Criterion, he says, "In so far as he [the critic] also uses other criteria [than the hedonistic one] for grading and assessing works of art, he is being illogical and inconsistent with himself whenever he does introduce the hedonistic—or emotional—assumption" (p. 139). But why? There is nothing whatever illogical or inconsistent about praising, grading, or judging a work of art for more than one reason, unless we assume with Osborne that one and only one reason is offerable on pain of inconsistency, which is clearly not the case in art or anywhere else.

Osborne, true to the assumptions of traditional aesthetics, is looking for that condition which is both necessary and sufficient for artistic excellence or merit. His own candidate for that condition is what he calls "configurational coherence." But if anything pointed were needed to convince us of the emptiness of the search, it is the unintelligibility of Osborne's account of "beauty as configuration." If what I have said above about the concepts of Art and Beauty is true, we should not be surprised by this. For 'art' and 'beauty' do not name one and only one substance and attribute respectively; no wonder we cannot find the one thing they name or render intelligible the felt discovery that they do name one thing. We can *make* each of them name one thing if we wish. But why should we bother? We get along very well with them as they are.

6. *Ethics and Criticism; the Second Mistake Again.* 'But surely,' someone will say, 'this cannot be the whole story. We can and do say that this work of art, this picture, for example, is better than that, or that this is a good one and that one is not. Do we not presuppose certain standards or criteria when we make such judgments? And isn't this really all that Osborne and other aestheticians have in mind when they insist that criticism presupposes aesthetic theory? They are looking for the standards of critical judgment and taste in the nature of art, just as many moralists have looked for the standards of right conduct in the nature of man. They may be looking in the wrong place, but clearly they are right in assuming that there must be something to find.'

My reply is this: they are not looking in the wrong place so much as they are looking for the wrong thing. The bases of responsible criticism are indeed to be found *in* the work of art and nowhere else, but this in no way implies that critical judgments presuppose any canons, rules, standards, or criteria applicable to all works of art.

When we say that a certain knife is a good knife, we have in mind certain features of the knife, or of knives in general, which we believe will substantiate or support this claim: the sharpness of the blade, the sturdiness of the handle, the durability of the metal, the way it fits the hand, and so on. There are a number of such considerations, all of which refer to characteristics of the knife and not to our feelings about or attitudes towards it, which may be said to constitute the criteria of a good knife. Special criteria may be adduced for fishing knives as opposed to butcher knives, and so on, but this does not affect the issue in question. Note first that there is no definite or exhaustively specifiable list of criteria in common and universal employment; it does not make sense to ask how many there are or whether we have considered them all. But there are generally accepted criteria with which we are all familiar which we use to support our judgments, though in cases of special instruments or implements, like ophthalmoscopes, only specialists are acquainted with the criteria. Secondly, note how the criteria are related to the purposes or functions of knives, to the uses to which we put them, the demands we make upon them. 'Knife,' we might say, is a function-word, a word that names something which is usually defined by its function or functions. The criteria, we can say loosely, are derivable from the definition. This second consideration has led some aestheticians to look for the standards of taste and criticism in the function of art.

Now take apples. They have, of course, no function. We use them, we do things with them—eat them, use them for decoration, feed them to pigs, press cider from them, and so on—but none of these things can be said to constitute the function of an apple. Depending, however, on how we use them or what we use them for, we can frame lists of criteria similar to the lists for knives. The best apples for decoration are not always the best for eating, nor are the best for making pies always the best for making cider. Now take mathematicians. A mathematician, unless he is assigned a particular work to do, again has no function. There

are certain things a mathematician does, however, and in terms of these we can again frame criteria for judging, praising, grading, and commending mathematicians. Finally, take men in general. We often praise a man, *as* a man, as opposed to as a plumber or a mathematician, and we call this sort of praise moral praise. Here again, we have criteria for assessing the moral worth of men, although, theological considerations aside, we do not frame them in terms of man's function, purpose, or task, even if some moralists, like Aristotle, have tried to frame them in terms of man's end. But we make demands on men, moral demands on all men, and our criteria reflect these demands.

Let us turn now to art. The question we have to raise is this: Are critical judgments of pictures and poems logically symmetrical to the sorts of judgments we have been considering? I think they are not, or not entirely. Not because they are somehow more subjective or unreliable than other value judgments (this issue is as false as an issue can be!), but because the pattern of justification and support which is appropriate to them is of a different sort. Any critical judgment, to be justified, must be supported by reasons; this goes without saying, for this is what 'justification' means. But must the reasons offerable and acceptable in cases of critical appraisal be of the same order or type as those offerable and acceptable in cases of instruments, implements, useful objects, professional services, jobs, offices, or moral conduct? In particular, must there be any general rules, standards, criteria, canons, or laws applicable to all works of art by which alone such critical appraisals can be supported? I think not.

In the first place, we should note that only a man corrupted by aesthetics would think of judging a work of art *as* a work of art in general, as opposed to as this poem, that picture, or this symphony. There is some truth in the contention that the notions of Art and Work of Art are special aestheticians' concepts. This follows quite naturally from the absence of any distinguishing feature or features common to all works of art as such, and from the absence of any single demand or set of demands which we make on all works of art as such. Despite the occasional claim that it has, Art has no function or purpose, in the sense in which knives and ophthalmoscopes have functions, and this is an insight to be gained from the 'art for art's sake' position. This does not mean that we cannot use individual works of art for special purposes; we can and do. We can use novels and poems and symphonies to put us to sleep or wake us up; we can use pictures to cover spots on the wall, vases to hold flowers, and sculptures for paper weights or door stops. This is what lends point to the distinction between judging something *as* a work of art and judging it *as* a sedative, stimulant, or paper weight; but we cannot conclude from this that Art has some special function or purpose in addition to the purposes to which it can be put.

Similarly there is no one thing which we *do* with all works of art: some we hang, some we play, some we perform, some we read; some we look at, some we listen to, some we analyse, some we contemplate, and

so on. There is no special aesthetic use of works of art, even though it may make sense, and even be true, to say that a person who uses a statue as a door stop is not using it as a work of art; he is not doing one of the things we normally do with works of art; he is not treating it properly, we might say. But the proper treatment of works of art varies from time to time and from place to place. It was quite proper for a cave man to hurl his spear at the drawing of a bison, just as it was quite proper for the Egyptians to seal up paintings and sculptures in a tomb. Such treatment does not render the object thus treated not a work of art. The attempt to define Art in terms of what we do with certain objects is as doomed as any other. From this and the first consideration it follows that there is no way by which we can derive the criteria of taste and criticism from the function of art or from its use.

The remaining parallel is with moral appraisal, and this is the most interesting of them all. It has been, and perhaps still is, a common view among philosophers that Beauty and Goodness are two species of the same genus, namely, Value, and that therefore there are at least two classes of value judgments, namely, moral judgments and aesthetic judgments. For this reason there is a tendency further to suppose that there is a logical symmetry between the two. But the supposition of symmetry is a mistake, and I am led to suspect that it does little but harm to suppose that Beauty and Goodness are two species of the same genus at all. There are clearly certain similarities between the two, that is, between the logic of statements of the form 'This is good' and the logic of statements of the form 'This is beautiful'—they are used in many of the same ways—but this must not blind us to the differences. Criticism suffers from a very natural comparison with ethics.

Moral appraisal is like the other forms of appraisal, in this respect; it expresses a desire for uniformity. It is when we are interested in uniformity of size, milk producing capacity, conduct, and so on, that standards or criteria become so important. We maintain standards in products and in workmanship; we enforce them, hold ourselves up to them, teach them to our children, insist on them, and so on, all for the sake of a certain uniformity. In morals we *are* interested in uniformity, at least in what we expect men not to do; that is one reason why rules and laws are necessary and why they play such an important role in moral appraisal. But in art, unless, like Plato, we wish to be legislators and to require something of art, demand that it perform a specified educational and social service, we are not as a rule interested in uniformity. Some critics and aestheticians are, of course, interested in uniformity—uniformity in the works of art themselves or uniformity in our approach to them. For them it is quite natural to demand criteria. For them it is also quite natural to formulate theories of Art and Beauty. Remember what we said about aesthetic theories above: the definitions in which they issue are often slogans of reform. As such they are also often devices for the encouragement of uniformity. But this merely betrays the persuasive character of many aesthetic theories, and the peculiar legislative posture

of some critics and aestheticians is no warrant for the assumption that the criteria in question are necessary for responsible criticism. Nor should it blind us to the fact that we do quite well without them. Criticism has in no way been hampered by the absence of generally applicable canons and norms, and where such norms have been proposed they have either, like the notorious Unities in the case of tragedy, been shown to be absurd, or else, like the requirements of balance, harmony, and unity in variety, they have been so general, equivocal, and empty as to be useless in critical practice. Ordinarily we feel no constraint in praising one novel for its verisimilitude, another for its humour, and still another for its plot or characterization. We remark on the richness of Van Gogh's impasto, but we do not find it a fault in a Chinese scroll painting that it is flat and smooth. Botticelli's lyric grace is his glory, but Giotto and Chardin are not to be condemned because their poetry is of another order. The merits of Keats and Shelley are not those of Donne and Herbert. And why should Shakespeare and Aeschylus be measured by the same rod? Different works of art are, or may be, praiseworthy or blameworthy for different reasons, and not always the same reasons. A quality that is praiseworthy in one painting may be blameworthy in another; realism is not always a virtue, but this does not mean that it is not sometimes a virtue.[8]

Mr. Hampshire has put the reason why the criteria sought by the aestheticians are so 'elusive' and why the parallel with ethics is a mistake in this way: "A work of art," he says, "is gratuitous. It is not *essentially* the answer to a question or the solution of a presented problem" (*op. cit.* p. 162). There is no one problem being solved or question answered by all poems, all pictures, all symphonies, let alone all works of art. If we set a number of people to doing the same thing, we can rate them on how well they do it. We have, or can frame, a criterion. But not all artists are doing the same thing—solving the same problem, answering the same question, playing the same game, running the same race. Some of them may be, we do group artists together by 'schools,' and in other ways, to indicate precisely this kind of similarity; but only in so far as they are does it make sense to compare and appraise them on the same points. It is no criticism of Dickens that he did not write like Henry James. Writing a novel or a lyric poem may, in some interesting respects, be like playing a game or solving a problem, we in fact speak of artists as solving problems. But it is also different; so that if we wish to retain the analogy we must call attention to the differences by saying that not all poets or novelists are playing the *same* game, solving the *same* problems. There is indeed a certain gratuitousness in art which destroys the parallelism or symmetry between moral and aesthetic appraisal.

But there is also a gratuitousness in aesthetic criticism. Moral appraisal, like legal judgment, is a practical necessity; aesthetic appraisal is not. That is why the claim that in art it is all a matter of taste is tolerable, even if it is false, when this sounds so shocking in morals. We can live side by side in peace and amity with those whose tastes differ

quite radically from our own; similar differences in moral standards are more serious. And yet, of course, aesthetic criticism is not merely a matter of taste, if by taste we mean unreasoned preferences. Taste does play an important part in the differences among critical appraisals, but we are clearly not satisfied when, in answer to our question 'Why is it good?' or 'What's good about it?,' we are told 'It's good because I like it.' Mrs. Knight correctly notes that "my *liking* a picture is never a criterion of its goodness" (*op. cit.* p. 154). That is, my liking a picture is no reason for its *being* good, though it may be a reason for my *saying* that it is good.

But if it is not all a matter of liking and disliking, why is it that a certain feature is a virtue in a given work of art? If someone tells me that a certain work of art is good for such and such reasons, how can I tell whether the reasons he offers are good reasons or not, or even if they are relevant? These questions are not easily answered, for in practice we adduce many considerations for saying that a work of art is good or that a certain feature of it is a virtue. I will make no attempt to canvass these considerations but will close with some observations on a logical feature of the problem.

We are confronted, I think, with a problem that is really two problems: there is the problem of saying why a given work of art is good or bad, and there is the problem of saying why our reasons are good or bad, or even relevant. We may praise a picture, say, for its subtle balance, colour contrast, and draughtsmanship; this is saying why the picture is good. We may now go on to raise the more 'philosophical' question of what makes balance, or this sort of colour contrast, or this kind of draughtsmanship an artistic virtue. The first sort of question, the question of why the work of art is good or bad, is decided by appeal to the 'good-making characteristics' or 'criterion-characters' of the work of art in question, that is, by an appeal to certain objectively discriminable characteristics of the work under discussion. These characteristics are many and various; there is a large variety of reasons offerable for a work of art's being a good or bad work of art. The second sort of question, the question of the worth or relevance of the reasons offered in answer to the first question, is settled by appeal either to custom or to decision. In this respect aesthetic criticism is very like moral appraisal. We either simply praise what is customarily praised and condemn what is customarily condemned or we *decide* what the criteria shall be. This does not mean that the criteria, that is, the reasons offerable for a work of art's being good or bad, are arbitrary. There may be plenty of reasons why one feature is a 'criterion-character' and another is not. Part of the reason may be psychological, part sociological, part metaphysical, or even religious and ethical. Only an aesthete ignores, or tries to ignore, the many relations of a poem or picture to life and concentrates on what are called the purely 'formal' values of the work at hand; but in doing so he *determines* what he will accept as a reason for a work of art's being good or bad. That a work of art assists the cause of the proletariat in the class

struggle *is* a reason for its being a good work of art to a convinced Marxist, but it is not a reason, let alone a good reason, to the bourgeois aesthete. That a picture contains nude figures is a reason, to the puritan and the prude, for condemning it, though no enlightened man can be brought to accept it. Thus morals and politics and religion do enter into our critical judgments, even when we claim that they should not.

I noted above that there is no one use which we make of all works of art, nor is there any one demand or set of demands which we make on them. This is, I think, important, and serves to explain, at least in part, the actual relativity of aesthetic criteria. What one age looks for in painting or in literature, another age may neglect. What one group demands, another forbids. We are not always consistent in even our own demands on art, and I can see no reason why we should be. We can be interested in works of art for many reasons, and some of these reasons may be more decisive at one time or in one set of circumstances than they are at another time or in another set of circumstances. This affects the very logic of critical appraisal by determining the relevance and merit of the reasons we offer for our judgments. We are well aware of the fact that the estimate of a given poet or painter changes from period to period. El Greco's or Shakespeare's reputation has not always been what it is, and no one should be surprised if it should change in the future. But if we examine the reasons that have been offered for the different estimates, we find that they too are different. Different reasons are persuasive at different times and in different contexts. The same explanation is operative: the needs and interests that art gratifies are different from time to time and, to a lesser extent perhaps, from person to person. But as the needs and interests vary, so also will the criteria and the weight we place on them. This is a vicious relativism only to those who are morally disposed to insist on the uniformity of taste.

Summary: I have tried to show (1) that the search for essences in aesthetics is a mistake, arising from the failure to appreciate the complex but not mysterious logic of such words and phrases as 'art,' 'beauty,' 'the aesthetic experience,' and so on. But (2) although the characteristics common to all works of art are the object of a fool's errand, the search for similarities in sometimes very different works of art can be profitably pursued, and this search is occasionally stimulated by the formulae of the aestheticians. (3) Although the definitions of the aestheticians are useless for the role usually assigned to them, we must not ignore the live purpose they frequently serve as slogans in the effort to change taste and as instruments for opening up new avenues of appreciation. (4) If the search for the common denominator of all works of art is abandoned, abandoned with it must be the attempt to derive the criteria of critical appreciation and appraisal from the nature of art. (5) Traditional aesthetics mistakenly supposes that responsible criticism is impossible without a set of rules, canons, or standards applicable to all works of art. This supposition arises from an uncritical assimilation of the pattern of critical appraisal to that of appraisal in other areas, particularly morals,

233

and from a failure to appreciate the gratuitousness of art and the manner in which reasons are operative in the justification of critical judgments.

Notes
1. De Witt H. Parker, "The Nature of Art," *Revue Internationale de Philosophie,* July 1939, p. 684; reprinted in E. Vivas and M. Krieger, eds., *The Problems of Aesthetics* (New York, 1953), p. 90. Italics mine.
2. P. O. Kristeller, "The Modern System of the Arts: A Study in the History of Aesthetics," *Journal of the History of Ideas,* xii (1951), 496–527; xiii (1952), 17–46.
3. See F. Waismann, "Analytic-Synthetic II," *Analysis,* 11 (1950), p. 27.
4. Thomas Munro, *The Arts and Their Interrelations* (New York, 1949), p. 108.
5. F. R. Leavis, *Revaluation: Tradition and Development in English Poetry* (London, 1936), p. 125.
6. Wolfgang Stechow, "Problems of Structure in Some Relations Between the Visual Arts and Music," *The Journal of Aesthetics and Art Criticism,* 11 (1953), 325.
7. Routledge and Kegan Paul Ltd., London, 1955.
8. I owe much in this section to Helen Knight's "The Use of 'Good' in Aesthetic Judgments," *Aesthetics and Language,* William Elton ed. (Oxford, 1954), pp. 147 ff., and to Stuart Hampshire's "Logic and Appreciation," ibid., pp. 161 ff.

Stuart Hampshire

Presently Warden of Wadham College, Oxford, Stuart Hampshire has long been associated with the analytical movement. He has been Grote Professor of Mind and Logic at University College, London, and Professor of Philosophy at Princeton University. His works include Spinoza *(1951),* Thought and Action *(1959) and* Freedom of the Individual *(1965).*

Logic and Appreciation

It seems that there *ought* to be a subject called 'Aesthetics.' There is an alexandrianism which assumes that there are so many classified

From *World Review,* 1952. Reprinted by permission of the author.

subjects waiting to be discussed and that each one ought to have its place in the library and in the syllabus. There is moral philosophy—the study of the nature of the problems of conduct—in every library and in every syllabus; there ought surely to be a philosophical study of the problems of Art and Beauty—if there are such problems; and this is the question which comes first. That there are problems of conduct cannot be doubted; people sometimes wonder what they ought to do and they find reasons for solving a moral problem to their own satisfaction; one can discuss the nature of these problems, and the form of the arguments used in the solution of them; and this is moral philosophy. But what is the subject-matter of aesthetics? Whose problems and whose methods of solution? Perhaps there is no subject-matter; this would fully explain the poverty and weakness of the books. Many respectable books can be, and have been, written on subjects which have no subject matter; they may be written for the sake of system and completeness, to round off a philosophy, or simply because it is felt that there ought to be such a subject.

There is a simple and familiar way of finding the subject matter of aesthetics, by begging the question. One may invent a kind of judgment called a value judgment, and let it be either a judgment about conduct or a judgment about Art and Beauty: a single genus with two species. From this beginning, one may go on to distinguish value judgments from other kinds of judgment. But the existence of the genus has been assumed, the assimilation of moral to aesthetic judgment taken for granted. One has certainly not isolated the subject matter of aesthetics by this method; the original material has simply been dropped from view. What questions under what conditions are actually answered by aesthetic judgments? This must be the starting point. I shall argue that aesthetic judgments are not comparable in purpose with moral judgments, and that there are no problems of aesthetics comparable with the problems of ethics.

There are artists who create and invent, and there are critics and a wider audience who appraise and enjoy their work. An artist has the technical problems of the medium in which he works; he may discuss these technical problems with other artists working in the same medium and with those who intimately understand the difficulties of his material. As an artist, he has his own conception of what his own work is to be; clearly or confusedly, he has set his own end before himself; even if his work must satisfy some external demand, he has his own peculiar conception of it, if he is to be regarded as more than a craftsman in some applied art. He has therefore created his own technical problems; they have not been presented to him; they arise out of his own conception of what he is to do. He did not set himself to create Beauty, but some particular thing. The canons of success and failure, of perfection and imperfection, are in this sense internal to the work itself, if it is regarded as an original work of art. In so far as the perfection of the work is assessed by some external criterion, it is not being assessed as a work of art, but rather as a technical achievement in the solution of some presented problem. A work of art is gratuitous. It is not *essentially* the answer to

a question or the solution of a presented problem. Anyone may dance for any reason and to achieve any variety of purposes; but a spectator may attend to the movements of the dance for the sake of their own intrinsic qualities, and disregard the purposes which lie outside; and, so regarded, the dance becomes gratuitous; it ceases to be an action, and becomes a set of movements; the subject of the spectator's attention has changed.

Compare the subject matter and situation of moral judgment. Throughout any day of one's life, and from the moment of waking, one is confronted with situations which demand action. Even to omit to do anything positive, and to remain passive, is to adopt a policy; Oblomov had his own solution to the practical problems confronting him; his was one possible solution among others. One can suspend judgment on theoretical questions and refuse either to affirm or to deny any particular solution; but no one can refuse to take one path or another in any situation which confronts him; there must always be an answer to the question 'What did you do in that situation?' even if the answer is: 'I ignored it and did nothing; I went to bed and to sleep.' If that is the answer, that was the solution adopted. One can always describe, first, the situation and the possibilities open, and, secondly, the solution of the problem which the agent adopted. Action in response to any moral problem is not gratuitous; it is imposed; that there should be some response is absolutely necessary. One cannot pass by a situation; one must pass *through* it in one way or another.

When there are unavoidable problems, a rational man looks for some general method of solving them; a rational man may be defined as a man who adheres to general methods, allotting to each type of problem its own method of solution. Unless general methods of solution are recognized, there can be no grounds for distinguishing a valid from an invalid step in any argument in support of any solution. To be irrational is either to have no reasons at all for preferring one solution to another, or to give utterly different reasons in different cases of the same type; to refuse any general method of solving problems of a particular type is to accept either caprice or inconsistency in that domain. 'Must there be some general method of solving problems of conduct?' Or 'Must to act rightly be to act rationally and consistently?'—these have always been the principal questions in moral philosophy. Aristotle, the most accurate of moral philosophers, gave a carefully ambiguous answer, Kant an unambiguous 'Yes,' Hume a qualified 'No'; for Hume held that morality was ultimately a matter of the heart and not of the head, of sympathy and not of consistency. But none of these philosophers denied that it always makes sense to ask for the reasons behind any practical decision; for constant ends may be served by a variety of different means. Actions (unlike works of art) do not bear their justification on the face of them; one must first inquire into reasons and purposes. Even if it is not necessary, at least it is always possible, to adopt some general ends of action, or (it is ultimately the same) to acknowledge some universal principles. Since any action susceptible of moral judgment can be viewed as the solution of

a problem presented, one can always criticize and compare different methods of solution. Consistent policies are needed in order to meet common human predicaments; men may discuss the reasons which have inclined them to solve the same problem in different ways. Their arguments (since arguments must be consistent) will lead them to general principles; anyone, therefore, who moralizes necessarily generalizes; he 'draws a moral'; in giving his grounds of choice, he subsumes particular cases under a general rule. Only an aesthete in action would comfortably refuse to give any grounds of decision; he might refer the questioner to the particular qualities of the particular performance; precisely this refusal to generalize would be the mark of his aestheticism. Virtue and good conduct are essentially repeatable and imitable, in a sense in which a work of art is not. To copy a right action is to act rightly; but a copy of a work of art is not necessarily or generally a work of art.

In a moralizing climate there will always be a demand, based on analogy, for principles of criticism, parallel with principles of conduct. But this analogy must be false. Where it makes sense to speak of a problem, it makes sense to speak of a solution of it; and where solutions are offered, it makes sense to ask for reasons for preferring one solution to another; it is possible to demand consistency of choice and general principles of preference. But if something is made or done gratuitously, and not in response to a problem posed, there can be no question of preferring one solution to another; judgment of the work done does not involve a choice, and there is no need to find grounds of preference. One may, as a spectator, prefer one work to another, but there is no *necessity* to decide between them; if the works themselves are regarded as free creations, to be enjoyed or neglected for what they are, then any grading is inessential to the judgment of them; if they are not answers to a common problem, they do not compete and neither need be rejected, except on its own merits. A critical judgment is in this sense non-committal and makes no recommendation; the critic may reject the work done without being required to show what the artist ought to have done in place of the work rejected. But the moralist who condemns an action must indicate what ought to have been done in its place; for something had to be done, some choice between relative evils made. All practical decision is choice between relative evils or relative goods; if what was done was wrong, the agent must have failed to do what he ought to have done. Any moral comment has therefore some force of recommendation and is itself a practical judgment. A moral censor must put himself in the place of the agent and imaginatively confront the situation which the agent confronted; the censor and the agent censored have so far the same problem. But a critic is not another artist, as the moral censor is another agent; he is a mere spectator and he has the spectator's total irresponsibility; it is only required that he should see the object exactly as it is. Nothing which he says in judgment and description necessarily carries any exclusions with it, or necessarily reflects upon the merit of other work; the possible varieties of beautiful and excellent things are inexhaustible. He

may therefore discuss any work on its merits alone, in the most strict sense of this phrase; he need not look elsewhere and to possible alternatives in making his judgment. On the contrary, his purpose is to lead people *not* to look elsewhere, but to look here, at precisely this unique object; not to see the object as one of a kind, but to see it as individual and unrepeatable.

One engages in moral argument in order to arrive at a conclusion—what is to be done or ought to have been done; one had the practical problem to begin with, and the conclusion ('this is better than that') is always more important than the route by which one arrives at it; for one *must* decide one way or the other. But a picture or poem is not created as a challenge or puzzle, requiring the spectator to decide for or against. One engages in aesthetic discussion for the sake of what one might see on the way, and not for the sake of arriving at a conclusion, a final verdict for or against; if one has been brought to see what there is to be seen in the object, the purpose of discussion is achieved. Where the logicians' framework of problem and conclusion does not apply, the notion of 'reason' loses some of its meaning also; it is unnatural to ask '*why* is that picture or sonata good?' in parallel with 'why was that the right thing to do?' There are no reasons why some object is ugly in the sense that there are reasons why some action is wrong. Perhaps it may be said that there are particular features of the particular object which *make* it ugly or beautiful, and these can be pointed out, isolated, and placed in a frame of attention; and it is the greatest service of the critic to direct attention in this analytical way. But when attention is directed to the particular features of the particular object, the point is to bring people to see these features, and not simply to lead them to say: 'That's good.' There is no point in arguing that the object is good *because* it possesses these qualities, if this involves the generalization that all objects similar in this respect are good; for if one generalizes in this manner, one looks away from the particular qualities of the particular thing, and is left with some general formula or recipe, useless alike to artist and spectator. One does not need a formula or recipe unless one needs repetitions; and one needs repetitions and rules in conduct, but not in art; the artist does not need a formula of reproduction and the spectator does not need a formula of evaluation.

The spectator-critic in any of the arts needs gifts precisely the opposite of the moralist's; he needs to suspend his natural sense of purpose and significance. To hold attention still upon any particular thing is unnatural; normally, we take objects—whether perceived by sight, touch, hearing, or by any combination of the senses—as signs of possible actions and as instances of some usable kind; we look through them to their possible uses, and classify them by their uses rather than by sensuous similarities. The common vocabulary, being created for practical purposes, obstructs any disinterested perception of things; things are (in a sense) recognized before they are really seen or heard. There is no practical reason why attention should be arrested upon a single object, framed

and set apart; attention might always be practical attention, and therefore always passing from one thing to the next; in the sense in which thunder 'means' rain, almost everything means something else; 'what does it mean?' is the primitive reaction which prevents perception. One may always look through a picture as if it were a map, and look through a landscape towards a destination; for everything presented through the senses arouses expectations and is taken as a signal of some likely reaction. Nothing but holding an object still in attention, by itself and for its own sake, would count as having an aesthetic interest in it. A great part of a critic's work, in any of the arts, is to place a frame upon the object and upon its parts and features, and to do this by an unnatural use of words in description. Perception, of any kind and on any level, has degrees; some perceive more than others, and it is difficult to see and hear all that there is to see and hear. There is a metaphysical prejudice that the world consists of so many definite objects possessing so many definite qualities, and that, if we perceive and attend to the objects, we necessarily notice their qualities; as if the things and their qualities were somehow already isolated and labelled for us, ready for the camera-brain to record. So it seems that in principle a vast inventory might be made of all the things in the world with their qualities, passively received and recorded; when one had gone through the inventory of literal description, any further statements about the furniture of the world would be subjective impression and metaphor. There is the prejudice that things really do have colours and shapes, but that there do not exist, literally and objectively, concordances of colours and perceived rhythms and balances of shapes; these are supposed to be added by the mind. It seems that the more recondite qualities of form, expression, style, atmosphere, cannot properly be entered in the inventory of the world, alongside the weights and measures of things; the relations of stress and balance between masses in sculpture or building cannot *really* be seen in any literal sense; the expression of a voice is not as much a perceptible reality as its loudness. The qualities which are of no direct practical interest are normally described metaphorically, by some transference of terms from the common vocabulary; and the common vocabulary is a vocabulary of action, classifying by use and function. The assumption is that only these literal descriptions are descriptions of realities; so descriptions of aesthetic qualities become subjective impressions. But a colony of aesthetes, disengaged from practical needs and manipulations, would single out different units of attention (things), and they would see different resemblances and make different comparisons (qualities). Descriptions of aesthetic qualities, which for us are metaphorical, might seem to them to have an altogether literal and familiar sense. They might find complete agreement among themselves in the use of a more directly descriptive vocabulary, singling out different units of attention. A critic in any one of the arts is under the necessity of building such a vocabulary in opposition to the main tendency of his language; he needs somehow to convince himself that certain isolated objects of his attention really do have the

extraordinary qualities which they seem to have; to this end he will need to discuss his perceptions with others, and to try to bring others to notice these qualities. He may have seen (in the wider sense of 'see') more than there is to be seen; and the only test of whether the qualities are really there must be some agreement among careful and disinterested observers. This is the point at which an aesthetic judgment is made—what are the relationships of elements here? What pattern or arrangement of elements is there to be seen, when one attends to the thing carefully and disinterestedly? Anything may be seen or heard or read in many different ways, and as an arrangement of any number of elements of different kinds. The picking out of the elements and of their pattern, in defiance of habit and practical interest, is a work of practice and skill; and the use of words in description is an aid to this perception. Anything whatever may be picked out as an object of aesthetic interest—anything which, when attended to carefully and apart altogether from its uses, provides, by the arrangement of its elements and their suggestion to the imagination, some peculiar satisfaction of its own. An aesthetic judgment has to point to the arrangement of elements, and to show what constitutes the originality of the arrangement in this particular case; what one calls originality in one case may bear little analogy to originality found elsewhere; for there was no common problem to be solved and the achievements were essentially different.

But a moralist in criticism (and there exist such critics) will always be making unnecessary choices and laying down principles of exclusion, as a moralist must. He will make 'value judgments,' and a value judgment is essentially a grading of one thing as better than another. If the judgment is an assessment of the particular excellences of works which are very similar, it may be enlightening and useful; but there can be larger comparisons of scale and greatness between things which are in themselves very different. Judgments of this second kind may be taken as practical advice that certain things ought to be read, seen, and heard, and the advice must involve some reference to the whole economy of human needs and purposes; but at this point the critic has actually become a moralist, and the arguments supporting his recommendations are the subject-matter of ethics. 'Is this thing more worth attention than other objects of its kind?' is one question, and 'What is the peculiar arrangement of elements here and what are the effects of this arrangement?' is another. Most aesthetic theories have involved a confusion of answers to these two very different questions; no positive answer to the second by itself entails any answer to the first. One would need to add some further premises about changing human needs and interests; and there is no reason to assume that all works of art satisfy the same needs and interests at all times and for all people. The objects themselves, and the artists who made them, make no unavoidable claim on the spectator's interest, and anyone may neglect the work done when it is of no interest to him. But the peculiar features of particular objects, with their own originality of arrangement, remain constant and unaffected by the spec-

tator's choices and priorities; and there can be no place for exclusive theories and general principles in identifying their originality; they must be seen as they are, individually, and not judged as contestants in a single race called Art or The Novel or Painting.

I conclude that everyone needs a morality to make exclusions in conduct; but neither an artist nor a critical spectator unavoidably needs an aesthetic; and when in Aesthetics one moves from the particular to the general, one is travelling in the wrong direction.

Maurice Mandelbaum

Andrew W. Mellon Professor of Philosophy at Johns Hopkins University, Maurice Mandelbaum has written numerous books and articles in philosophy, including The Problem of Historical Knowledge *(1938),* The Phenomenology of Moral Experience *(1955), and* Philosophy, Science and Sense Perception *(1964).*

Family Resemblances and Generalization Concerning the Arts

In 1954 William Elton collected and published a group of essays under the title *Aesthetics and Language.* As his introduction made clear, a common feature of these essays was the application to aesthetic problems of some of the doctrines characteristic of recent British linguistic philosophy.[1] While this mode of philosophizing has not had as pervasive an influence on aesthetics as it has had on most other branches of philosophy,[2] there have been a number of important articles which, in addition to those contained in the Elton volume, suggest the direction in which this influence runs. Among these articles one might mention "The Task of Defining a Work of Art" by Paul Ziff,[3] "The Role of Theory in Aesthetics" by Morris Weitz,[4] Charles L. Stevenson's "On 'What is a Poem'"[5] and W. E. Kennick's "Does Traditional Aesthetics Rest on a Mistake?"[6] In each of them one finds a conviction which was also present

From the *American Philosophical Quarterly,* Vol. 2, No. 3 (1965), pp. 219–223, 228. Reprinted by permission.

in most of the essays in the Elton volume: that it is a mistake to offer generalizations concerning the arts, or, to put the matter in a more provocative manner, that it is a mistake to attempt to discuss what art, or beauty, or the aesthetic, or a poem, *essentially* is. In partial support of this contention, some writers have made explicit use of Wittgenstein's doctrine of *family resemblances;* Morris Weitz, for example, has placed it in the forefront of his discussion. However, in that influential and frequently anthologized article, Professor Weitz made no attempt to analyze, clarify, or defend the doctrine itself. Since its use with respect to aesthetics has provided the means by which others have sought to escape the need of generalizing concerning the arts, I shall begin my discussion with a consideration of it.

I

The *locus classicus* for Wittgenstein's doctrine of family resemblances is in Part I of *Philosophical Investigations,* sections 65–77.[7] In discussing what he refers to as language-games, Wittgenstein says:

> Instead of producing something common to all that we call language, I am saying that these phenomena have no one thing in common which makes us use the same word for all—but they are *related* to one another in many different ways. And it is because of this relationship, or these relationships, that we call them all "language." (§65)

He then illustrates his contention by citing a variety of *games,* such as board games, card games, ball games, etc., and concludes:

> We see a complicated network of similarities overlapping and criss-crossing: sometimes overall similarities of detail. (§66)
> I can think of no better expression to characterize these similarities than "family resemblances"; for the various resemblances between members of a family: build, features, colour of eyes, gait, temperament, etc., etc. overlap and criss-cross in the same way.—And I shall say: "games" form a family. (§67)

In short, what Wittgenstein aims to establish is that one need not suppose that all instances of those entities to which we apply a common name do in fact possess any one feature in common. Instead, the use of a common name is grounded in the criss-crossing and overlapping of resembling features among otherwise heterogeneous objects and activities.

Wittgenstein's concrete illustrations of the diversity among various types of games may at first make his doctrine of family resemblances extremely plausible. For example, we do not hesitate to characterize tennis, chess, bridge, and solitaire as games, even though a comparison

242

of them fails to reveal any specific feature which is the same in each of them. Nonetheless, I do not believe that his doctrine of family resemblances, as it stands, provides an adequate analysis of why a common name, such as "a game," is in all cases applied or withheld.

Consider first the following case. Let us assume that you know how to play that form of solitaire called "Canfield"; suppose also that you are acquainted with a number of other varieties of solitaire (Wittgenstein uses "patience," i.e., "solitaire," as one instance of a form of game). Were you to see me shuffling a pack of cards, arranging the cards in piles, some face up and some face down, turning cards over one-by-one, sometimes placing them in one pile, then another, shifting piles, etc., you might say: "I see you are playing cards. What game are you playing?" However, to this I might answer: "I am not playing a game; I am telling (or reading) fortunes." Will the resemblances between what you have seen me doing and the characteristics of card games with which you are familiar permit you to contradict me and say that I am indeed playing some sort of game? Ordinary usage would not, I believe, sanction our describing fortune-telling as an example of playing a game, no matter how striking may be the resemblances between the ways in which cards are handled in playing solitaire and in telling fortunes. Or, to choose another example, we may say that while certain forms of wrestling contests are sometimes characterized as games (Wittgenstein mentions *"Kampfspiele"*)[8] an angry struggle between two boys, each trying to make the other give in, is not to be characterized as a game. Yet one can find a great many resembling features between such a struggle and a wrestling match in a gymnasium. What would seem to be crucial in our designation of an activity as a game is, therefore, not merely a matter of noting a number of specific resemblances between it and other activities which we denote as games, but involves something further.

To suggest what sort of characteristic this "something further" might possibly be, it will be helpful to pay closer attention to the notion of what constitutes a family resemblance. Suppose that you are shown ten or a dozen photographs and you are then asked to decide which among them exhibit strong resemblances.[9] You might have no difficulty in selecting, say, three of the photographs in which the subjects were markedly round-headed, had a strongly prognathous profile, rather deep-set eyes, and dark curly hair.[10] In some extended, metaphorical sense you might say that the similarities in their features constituted a family resemblance among them. The sense, however, would be metaphorical, since in the absence of a biological kinship of a certain degree of proximity we would be inclined to speak only of resemblances, and not of a *family* resemblance. What marks the difference between a literal and a metaphorical sense of the notion of "family resemblances" is, therefore, the existence of a genetic connection in the former case and not in the latter. Wittgenstein, however, failed to make explicit the fact that the literal, root notion of a family resemblance includes this genetic connection no less than it includes the existence of noticeable physiognomic

resemblances.[11] Had the existence of such a *twofold* criterion been made explicit by him, he would have noted that there is in fact an attribute common to all who bear a family resemblance to each other: they are related through a common ancestry. Such a relationship is not, of course, one among the specific features of those who share a family resemblance; it nonetheless differentiates them from those who are not to be regarded as members of a single family.[12] If, then, it is possible that the analogy of family resemblances could tell us something about how games may be related to one another, one should explore the possibility that, in spite of their great dissimilarities, games may possess a common attribute which, like biological connection, is not itself one among their directly exhibited characteristics. Unfortunately, such a possibility was not explored by Wittgenstein.

To be sure, Wittgenstein does not explicitly state that the resemblances which are correlated with our use of common names must be of a sort that are directly exhibited. Nonetheless, all of his illustrations in the relevant passages involve aspects of games which would be included in a description of how a particular game is to be played; that is, when he commands us to "look and see" whether there is anything common to all games,[13] the "anything" is taken to represent precisely the sort of manifest feature that is described in rule-books, such as Hoyle. However, as we have seen in the case of family resemblances, what constitutes a *family* is not defined in terms of the manifest features of a random group of people; we must first characterize the *family* relationship in terms of genetic ties, and then observe to what extent those who are connected in this way *resemble* one another.[14] In the case of games, the analogue to genetic ties might be the purpose for the sake of which various games were formulated by those who invented or modified them, e.g., the potentiality of a game to be of absorbing non-practical interest to either participants or spectators. If there were any such common feature one would not expect it to be defined in a rule book, such as Hoyle, since rule books only attempt to tell us how to play a particular game: our interest in playing a game, and our understanding of what constitutes a game, is already presupposed by the authors of such books.

It is not my present concern to characterize any feature common to most or all of those activities which we call games, nor would I wish to argue on the analogy of family resemblances that there *must be* any such feature. If the question is to be decided, it must be decided by an attempt to "look and see." However, it is important that we look in the right place and in the right ways if we are looking for a common feature; we should not assume that any feature common to all games must be some manifest characteristic, such as whether they are to be played with a ball or with cards, or how many players there must be in order for the game to be played. If we were to rely exclusively on such features we should, as I have suggested, be apt to link solitaire with fortune-telling, and wrestling matches with fights, rather than (say) linking solitaire with cribbage and wrestling matches with weight-lifting. It is, then, my contention that

Wittgenstein's emphasis on directly exhibited resemblances, and his failure to consider other possible similarities, led to a failure on his part to provide an adequate clue as to what—in some cases at least—governs our use of common names.[15]

If the foregoing remarks are correct, we are now in a position to see that the radical denigration of generalization concerning the arts, which has come to be almost a hallmark of the writings of those most influenced by recent British philosophy, may involve serious errors, and may not constitute a notable advance.

II

In turning from Wittgenstein's statements concerning family resemblances to the use to which his doctrine has been put by writers on aesthetics, we must first note what these writers are *not* attempting to do. In the first place, they are not seeking to clarify the relationships which exist among the many different senses in which the word "art" is used. Any dictionary offers a variety of such senses (e.g., the art of navigation, art as guile, art as the craft of the artist, etc.), and it is not difficult to find a pattern of family resemblances existing among many of them. However, an analysis of such resemblances, and of their differences, has not, as a matter of fact, been of interest to the writers of the articles with which we are here concerned. In the second place, these writers have not been primarily interested in analyzing how words such as "work of art" or "artist" or "art" are ordinarily used by those who are neither aestheticians nor art critics; their concern has been with the writings which make up the tradition of "aesthetic theory." In the third place, we must note that the concern of these writers has not been to show that family resemblances do in fact exist among the various arts, or among various works of art; on the contrary, they have used the doctrine of family resemblances in a *negative* fashion. In this, they have of course followed Wittgenstein's own example. The position which they have sought to establish is that traditional aesthetic theory has been mistaken in assuming that there is any essential property or defining characteristic of works of art (or any set of such properties or characteristics); as a consequence, they have contended that most of the questions which have been asked by those engaged in writing on aesthetics are mistaken sorts of questions.

However, as the preceding discussion of Wittgenstein should have served to make clear, one cannot assume that if there is any one characteristic common to all works of art it must consist in some specific, directly exhibited feature. Like the biological connections among those who are connected by family resemblances, or like the intentions on the basis of which we distinguish between fortune-telling and card games, such a characteristic might be a relational attribute, rather than some characteristic at which one could directly point and say: "It is this par-

ticular feature of the object which leads me to designate it as a work of art." A relational attribute of the required sort might, for example, only be apprehended if one were to consider specific art objects as having been created by someone for some actual or possible audience.

The suggestion that the essential nature of art is to be found in such a relational attribute is surely not implausible when one recalls some of the many traditional theories of art. For example, art has sometimes been characterized as being one special form of communication or of expression, or as being a special form of wish-fulfillment, or as being a presentation of truth in sensuous form. Such theories do not assume that in each poem, painting, play, and sonata there is a specific ingredient which identifies it as a work of art; rather, that which is held to be common to these otherwise diverse objects is a relationship which is assumed to have existed, or is known to have existed, between certain of their characteristics and the activities and the intentions of those who made them.[16]

While we may acknowledge that it is difficult to find any set of attributes—whether relational or not—which can serve to characterize the nature of a work of art (and which will not be as vulnerable to criticism as many other such characterizations have been),[17] it is important to note that the difficulties inherent in this task are not really avoided by those who appeal to the notion of family resemblances. As soon as one attempts to elucidate how the term "art" is in fact used in the context of art criticism, most of the same problems which have arisen in the history of aesthetic theory will again make their appearance. In other words, linguistic analysis does not provide a means of escape from the issues which have been of major concern in traditional aesthetics.

The work of any critic presupposes at least an implicit aesthetic theory, which—as critic—it is not his aim to establish or, in general, to defend. This fact can only be overlooked by those who confine themselves to a narrow range of criticism: for example, to the criticism appearing in our own time in those journals which are read by those with whom we have intellectual, political, and social affinities. When we do not so confine ourselves, we rapidly discover that there is, and has been, an enormous variety in criticism, and that this variety represents (in part at least) the effect of differing aesthetic preconceptions. To evaluate criticism itself we must, then, sometimes undertake to evaluate these preconceptions. In short, we must do aesthetics ourselves.

However, for many of the critics of traditional aesthetics this is an option which does not appeal. If I am not mistaken, it is not difficult to see why this should have come to be so. In the first place, it has come to be one of the marks of contemporary analytic philosophy to hold that philosophic problems are problems which cannot be solved by appeals to matters of fact. Thus, to choose but a single instance, questions of the relations between aesthetic perception and other instances of per-

ceiving—for example, questions concerning psychical distance, or empathic perception, or the role of form in aesthetic perception—are not considered to be questions with which a philosopher ought to try to deal. In the second place, the task of the philosopher has come to be seen as consisting largely of the unsnarling of tangles into which others have gotten themselves. As a consequence, the attempt to find a synoptic interpretation of some broad range of facts—an attempt which has in the past been regarded as one of the major tasks of a philosopher—has either been denigrated or totally overlooked.[18] Therefore, problems such as the claims of the arts to render a true account of human character and destiny, or questions concerning the relations between aesthetic goodness and standards of greatness in art, or an estimate of the significance of variability in aesthetic judgments, are not presently fashionable. And it must be admitted that if philosophers wish not to have to face either factual problems or synoptic tasks, these are indeed questions which are more comfortably avoided than pursued.

Notes

1. See William Elton (ed.), *Aesthetics and Language* (Oxford, Basil Blackwell, 1954), p. 1, n. 1 and 2.
2. A discussion of this fact is to be found in Jerome Stolnitz, "Notes on Analytic Philosophy and Aesthetics," *British Journal of Aesthetics,* vol. 3 (1961), pp. 210–222.
3. *Philosophical Review,* vol. 62 (1953), pp. 58–78.
4. *Journal of Aesthetics and Art Criticism,* vol. 15 (1956), pp. 27–35.
5. *Philosophical Review,* vol. 66 (1957), pp. 329–362.
6. *Mind,* vol. 67 (1958), pp. 317–334. In addition to the articles already referred to, I might mention "The Uses of Works of Art" by Teddy Brumius in *Journal of Aesthetics and Art Criticism,* vol. 22 (1963), pp. 123–133, which refers to both Weitz and Kennick, but raises other question with which I am not here concerned.
7. Ludwig Wittgenstein, *Philosophical Investigations,* translated by G. E. M. Anscombe (New York, Macmillan, 1953), pp. 31–36. A parallel passage is to be found in "The Blue Book": see *Preliminary Studies for the "Philosophical Investigations," Generally Known as The Blue and Brown Books* (Oxford, Basil Blackwell, 1958), pp. 17–18.
8. Ludwig Wittgenstein, *Philosophical Investigations,* §66, p. 31. For reasons which are obscure, Miss Anscombe translates *"Kampfspiele"* as "Olympic games."
9. In an article which is closely related to my discussion, but which uses different arguments to support a similar point, Haig Khatchadourian has shown that Wittgenstein is less explicit than he should have been with respect to the levels of determinateness at which these resemblances are significant for our use of common names. See "Common Names and 'Family Resemblances'," *Philosophy and Phenomenological Research,* vol. 18 (1957–58), pp. 341–358. (For a related, but less closely relevant article by Professor Khatchadourian see "Art-Names and Aesthetic Judgments," *Philosophy,* vol. 36 [1961], pp. 30–48.)

10. It is to be noted that this constitutes a closer resemblance than that involved in what Wittgenstein calls "family resemblances," since in my illustration the specific similarities all pertain to a single set of features, with respect to each one of which all three of the subjects directly resemble one another. In Wittgenstein's use of the notion of family resemblances there is, however, no one set of resembling features common to each member of the "family"; there is merely a criss-crossing and overlapping among the elements which constitute the resemblances among the various persons. Thus, in order to conform to his usage, my illustration would have to be made more complicated, and the degree of resemblance would become more attenuated. For example, we would have to introduce the photographs of other subjects in which, for example, recessive chins would supplant prognathous profiles among those who shared the other characteristics; some would have blond instead of dark hair, and protruberant instead of deep-set eyes, but would in each case resemble the others in other respects, etc. However, if what I say concerning family resemblances holds of the stronger similarities present in my illustration, it should hold *a fortiori* of the weaker form of family resemblances to which Wittgenstein draws our attention.

11. Although Wittgenstein failed to make explicit the fact that a genetic connection was involved in his notion of "family resemblances," I think that he did in fact presuppose such a connection. If I am not mistaken, the original German makes this clearer than does the Anscombe translation. The German text reads:

> Ich kann diese Ähnlichkeiten nicht besser charakterisieren, als durch das Wort "Familienähnlichkeiten"; denn so übergreifen und kreuzen sich die verschiedenen Ähnlichkeiten, die zwischen den Gliedern einer Familie bestehen: Wuchs, Gesichtszüge, Augenfarbe, Gang, Temperament, etc., etc. (§67).

Modifying Miss Anscombe's translation in as few respects as possible, I suggest that a translation of this passage might read:

> I can think of no better expression to characterize these similarities than "family resemblances," since various similarities which obtain among the members of a family—their build, features, color of eyes, gait, temperament, etc., etc.—overlap and criss-cross in the same way.

This translation differs from Miss Anscombe's (which has been quoted above) in that it makes more explicit the fact that the similarities are similarities among the members of a single family, and are not themselves definitive of what constitutes a *family* resemblance.

12. Were this aspect of the twofold criterion to be abandoned, and were our use of common names to be solely determined by the existence of overlapping and criss-crossing relations, it is difficult to see how a halt would ever be called to the spread of such names. Robert J. Richman has called attention to the same problem in " 'Something Common'," *Journal of Philosophy,* vol. 59 (1962), pp. 821–830. He speaks of what he calls "the Problem of Wide-Open Texture," and says: "the notion of family resemblances may account for our extending the application of a given general term, but it does not seem to place any limit on this process" (p. 829).

In an article entitled "The Problem of the Model-Language Game in Wittgenstein's Later Philosophy," *Philosophy,* vol. 36 (1961), pp. 333–351, Helen Hervey also calls attention to the fact that "a family is so-called by virtue of its common ancestry" (p. 334). She also mentions (p. 335) what Richman referred to as the problem of "the wide-open texture."

13. Ludwig Wittgenstein, *Philosophical Investigations,* §66, p. 31.

14. Although I have only mentioned the existence of genetic connections among members of a family, I should of course not wish to exclude the effects of habitual association in giving rise to some of the resemblances which Wittgenstein mentions. I have stressed genetic connection only because it is the simplest and most obvious illustration of the point I have wished to make.

15. I do not deny that directly exhibited resemblances often play a part in our use of common names: this is a fact explicitly noted at least as long ago as by Locke. However, similarities in origin, similarities in use, and similarities in intention may also play significant roles. It is such factors that Wittgenstein overlooks in his specific discussions of family resemblances and of games.

16. I know of no passage in which Wittgenstein takes such a possibility into account. In fact, if the passage from "The Blue Book" to which I have already alluded may be regarded as representative, we may say that Wittgenstein's view of traditional aesthetic theories was quite without foundation. In that passage he said:

> The idea of a general concept being a common property of its particular instances connects up with other primitive, too simple, ideas of the structure of language. It is comparable to the idea that *properties* are *ingredients* of the things which have the properties; e.g., that beauty is an ingredient of all beautiful things as alcohol is of beer and wine, and that we therefore could have pure beauty, unadulterated by anything that is beautiful (p. 17).

I fail to be able to identify any aesthetic theory of which such a statement would be true. It would not, for example, be true of Clive Bell's doctrine of "significant form," nor would it presumably be true of G. E. Moore's view of beauty, since both Bell and Moore hold that beauty depends upon the specific nature of the other qualities which characterize that which is beautiful.

However, it may be objected that when I suggest that what is common to works of art involves reference to "intentions," I overlook "the intentional fallacy" (see W. K. Wimsatt, Jr., and Monroe C. Beardsley, "The Intentional Fallacy," *Sewanee Review,* vol. 54 [1946], pp. 468–488). This is not the case. The phrase "the intentional fallacy" originally referred to a particular method of criticism, that is, to a method of interpreting and evaluating given works of art; it was not the aim of Wimsatt and Beardsley to distinguish between art and non-art. These two problems are, I believe, fundamentally different in character. However, I do not feel sure that Professor Beardsley has noted this fact, for in a recent article in which he set out to criticize those who have been influenced by the doctrine of family resemblances he apparently felt himself obliged to define art *solely* in terms of some characteristic in the object itself (see "The Definition of the Arts," *Journal of Aesthetics and Art Criticism,* vol. 20 [1961],

pp. 175–187). Had he been willing to relate this characteristic to the activity and intention of those who make objects having such a characteristic, his discussion would not, I believe, have been susceptible to many of the criticisms leveled against it by Professor Douglas Morgan and Mary Mothersill (*ibid.,* pp. 187–198).

17. I do not say *"all"* such definitions, for I think that one can find a number of convergent definitions of art, each of which has considerable merit, though each may differ slightly from the others in its emphasis.

18. For example, W. B. Gallie's "The Function of Philosophical Aesthetics," in the Elton volume, argues for "a journeyman's aesthetics," which will take up individual problems, one by one, these problems being of the sort which arise when a critic or poet gets into a muddle about terms such as "abstraction" or "imagination." For this purpose the tools of the philosopher are taken to be the tools of logical analysis (*op. cit.,* p. 35); a concern with the history of the arts, with psychology, or a direct and wide-ranging experience of the arts seems not to be presupposed.

A second example of the limitations imposed upon aesthetics by contemporary linguistic analysis is to be found in Professor Weitz's article. He states that "the root problem of philosophy itself is to explain the relation between the employment of certain kinds of concepts and the conditions under which they can be correctly applied" (*op. cit.,* p. 30).

The Presuppositions of
Artistic Authenticity and Originality

Nelson Goodman

A noted philosopher of science and language who has taught at various American universities and is presently at Harvard, Nelson Goodman has written The Structure of Appearance *(1951),* Fact, Fiction and Forecast *(1954), and* Languages of Art *(1968).*

Art and Authenticity

1. THE PERFECT FAKE

Forgeries of works of art present a nasty practical problem to the collector, the curator, and the art historian, who must often expend taxing amounts of time and energy in determining whether or not particular objects are genuine. But the theoretical problem raised is even more acute. The hardheaded question why there is any aesthetic difference between a deceptive forgery and an original work challenges a basic premise on which the very functions of collector, museum, and art his-

torian depend. A philosopher of art caught without an answer to this question is at least as badly off as a curator of paintings caught taking a *Van Meegeren* for a Vermeer.

The question is most strikingly illustrated by the case of a given work and a forgery or copy or reproduction of it. Suppose we have before us, on the left, Rembrandt's original painting *Lucretia* and, on the right, a superlative imitation of it. We know from a fully documented history that the painting on the left is the original; and we know from X-ray photographs and microscopic examination and chemical analysis that the painting on the right is a recent fake. Although there are many differences between the two—e.g., in authorship, age, physical and chemical characteristics, and market value—we cannot see any difference between them; and if they are moved while we sleep, we cannot then tell which is which by merely looking at them. Now we are pressed with the question whether there can be any aesthetic difference between the two pictures; and the questioner's tone often intimates that the answer is plainly *no,* that the only differences here are aesthetically irrelevant.

We must begin by inquiring whether the distinction between what can and what cannot be seen in the pictures by 'merely looking at them' is entirely clear. We are looking at the pictures, but presumably not 'merely looking' at them, when we examine them under a microscope or fluoroscope. Does merely looking, then, mean looking without the use of any instrument? This seems a little unfair to the man who needs glasses to tell a painting from a hippopotamus. But if glasses are permitted at all, how strong may they be, and can we consistently exclude the magnifying glass and the microscope? Again, if incandescent light is permitted, can violet-ray light be ruled out? And even with incandescent light, must it be of medium intensity and from a normal angle, or is a strong raking light permitted? All these cases might be covered by saying that 'merely looking' is looking at the pictures without any use of instruments other than those customarily used in looking at things in general. This will cause trouble when we turn, say, to certain miniature illuminations or Assyrian cylinder seals that we can hardly distinguish from the crudest copies without using a strong glass. Furthermore, even in our case of the two pictures, subtle differences of drawing or painting discoverable only with a magnifying glass may still, quite obviously, be aesthetic differences between the pictures. If a powerful microscope is used instead, this is no longer the case; but just how much magnification is permitted? To specify what is meant by merely looking at the pictures is thus far from easy; but for the sake of argument,[1] let us suppose that all these difficulties have been resolved and the notion of 'merely looking' made clear enough.

Then we must ask who is assumed to be doing the looking. Our questioner does not, I take it, mean to suggest that there is no aesthetic difference between two pictures if at least one person, say a cross-eyed wrestler, can see no difference. The more pertinent question is whether

there can be any aesthetic difference if nobody, not even the most skilled expert, can ever tell the pictures apart by merely looking at them. *But notice now that no one can ever ascertain by merely looking at the pictures that no one ever has been or will be able to tell them apart by merely looking at them.* In other words, the question in its present form concedes that no one can ascertain by merely looking at the pictures that there is no aesthetic difference between them. This seems repugnant to our questioner's whole motivation. For if merely looking can never establish that two pictures are aesthetically the same, something that is beyond the reach of any given looking is admitted as constituting an aesthetic difference. And in that case, the reason for not admitting documents and the results of scientific tests becomes very obscure.

The real issue may be more accurately formulated as the question whether there is any aesthetic difference between the two pictures *for me* (or for *x*) if I (or *x*) cannot tell them apart by merely looking at them. But this is not quite right either. For I can never ascertain merely by looking at the pictures that even I shall never be able to see any difference between them. And to concede that something beyond any given looking at the pictures by me may constitute an aesthetic difference between them *for me* is, again, quite at odds with the tacit conviction or suspicion that activates the questioner.

Thus the critical question amounts finally to this: is there any aesthetic difference between the two pictures for *x* at *t*, where *t* is a suitable period of time, if *x* cannot tell them apart by merely looking at them at *t*? Or in other words, can anything that *x* does not discern by merely looking at the pictures at *t* constitute an aesthetic difference between them for *x* at *t*?

2. THE ANSWER

In setting out to answer this question, we must bear clearly in mind that what one can distinguish at any given moment by merely looking depends not only upon native visual acuity but upon practice and training.[2] Americans look pretty much alike to a Chinese who has never looked at many of them. Twins may be indistinguishable to all but their closest relatives and acquaintances. Moreover, only through looking at them when someone has named them for us can we learn to tell Joe from Jim upon merely looking at them. Looking at people or things attentively, with the knowledge of certain presently invisible respects in which they differ, increases our ability to discriminate between them—and between other things or other people—upon merely looking at them. Thus pictures that look just alike to the newsboy come to look quite unlike to him by the time he has become a museum director.

Although I see no difference now between the two pictures in question, I may learn to see a difference between them. I cannot determine now by merely looking at them, or in any other way, that I *shall* be able

to learn. But the information that they are very different, that the one is the original and the other the forgery, argues against any inference to the conclusion that I *shall not* be able to learn. And the fact that I may later be able to make a perceptual distinction between the pictures that I cannot make now constitutes an aesthetic difference between them that is important to me now.

Furthermore, to look at the pictures now with the knowledge that the left one is the original and the other the forgery may help develop the ability to tell which is which later by merely looking at them. Thus, with information not derived from the present or any past looking at the pictures, the present looking may have a quite different bearing upon future lookings from what it would otherwise have. The way the pictures in fact differ constitutes an aesthetic difference between them for me now because my knowledge of the way they differ bears upon the role of the present looking in training my perceptions to discriminate between these pictures, and between others.

But that is not all. My knowledge of the difference between the two pictures, just because it affects the relationship of the present to future lookings, informs the very character of my present looking. This knowledge instructs me to look at the two pictures differently now, even if what I see is the same. Beyond testifying that I may learn to see a difference, it also indicates to some extent the kind of scrutiny to be applied now, the comparisons and contrasts to be made in imagination, and the relevant associations to be brought to bear. It thereby guides the selection, from my past experience, of items and aspects for use in my present looking. Thus not only later but right now, the unperceived difference between the two pictures is a consideration pertinent to my visual experience with them.

In short, although I cannot tell the pictures apart merely by looking at them now, the fact that the left-hand one is the original and the right-hand one a forgery constitutes an aesthetic difference between them for me now because knowledge of this fact (1) stands as evidence that there may be a difference between them that I can learn to perceive, (2) assigns the present looking a role as training toward such a perceptual discrimination, and (3) makes consequent demands that modify and differentiate my present experience in looking at the two pictures.[3]

Nothing depends here upon my ever actually perceiving or being able to perceive a difference between the two pictures. What informs the nature and use of my present visual experience is not the fact or the assurance that such a perceptual discrimination is within my reach, but evidence that it may be; and such evidence is provided by the known factual differences between the pictures. Thus the pictures differ aesthetically for me now even if no one will ever be able to tell them apart merely by looking at them.

But suppose it could be proved that no one ever will be able to see any difference? This is about as reasonable as asking whether, if it can be proved that the market value and yield of a given U.S. bond and one

of a certain nearly bankrupt company will always be the same, there is any financial difference between the two bonds. For what sort of proof could be given? One might suppose that if nobody—not even the most skilled expert—has ever been able to see any difference between the pictures, then the conclusion that I shall never be able to is quite safe; but, as in the case of the Van Meegeren forgeries[4] (of which, more later), distinctions not visible to the expert up to a given time may later become manifest even to the observant layman. Or one might think of some delicate scanning device that compares the color of two pictures at every point and registers the slightest discrepancy. What, though, is meant here by "at every point"? At no mathematical point, of course, is there any color at all; and even some physical particles are too small to have color. The scanning device must thus cover at each instant a region big enough to have color but at least as small as any perceptible region. Just how to manage this is puzzling since "perceptible" in the present context means "discernible by merely looking," and thus the line between perceptible and nonperceptible regions seems to depend on the arbitrary line between a magnifying glass and a microscope. If some such line is drawn, we can never be sure that the delicacy of our instruments is superior to the maximal attainable acuity of unaided perception. Indeed, some experimental psychologists are inclined to conclude that every measurable difference in light can sometimes be detected by the naked eye.[5] And there is a further difficulty. Our scanning device will examine color—that is, reflected light. Since reflected light depends partly upon incident light, illumination of every quality, of every intensity, and from every direction must be tried. And for each case, especially since the paintings do not have a plane surface, a complete scanning must be made from every angle. But of course we cannot cover every variation, or even determine a single absolute correspondence, in even one respect. Thus the search for a proof that I shall never be able to see any difference between the two pictures is futile for more than technological reasons.

Yet suppose we are nevertheless pressed with the question whether, if proof were given, there would then be any aesthetic difference for me between the pictures. And suppose we answer this farfetched question in the negative. This will still give our questioner no comfort. For the net result would be that if no difference between the pictures can in fact be perceived, then the existence of an aesthetic difference between them will rest entirely upon what is or is not proved by means other than merely looking at them. This hardly supports the contention that there can be no aesthetic difference without a perceptual difference.

Returning from the realm of the ultra-hypothetical, we may be faced with the protest that the vast aesthetic difference thought to obtain between the Rembrandt and the forgery cannot be accounted for in terms of the search for, or even the discovery of, perceptual differences so slight that they can be made out, if at all, only after much experience and long practice. This objection can be dismissed at once; for minute perceptual differences can bear enormous weight. The clues that tell me whether

I have caught the eye of someone across the room are almost indiscernible. The actual differences in sound that distinguish a fine from a mediocre performance can be picked out only by the well-trained ear. Extremely subtle changes can alter the whole design, feeling, or expression of a painting. Indeed, the slightest perceptual differences sometimes matter the most aesthetically; gross physical damage to a fresco may be less consequential than slight but smug retouching.

All I have attempted to show, of course, is that the two pictures can differ aesthetically, not that the original is better than the forgery. In our example, the original probably is much the better picture, since Rembrandt paintings are in general much better than copies by unknown painters. But a copy of a Lastman by Rembrandt may well be better than the original. We are not called upon here to make such particular comparative judgments or to formulate canons of aesthetic evaluation. We have fully met the demands of our problem by showing that the fact that we cannot tell our two pictures apart merely by looking at them does not imply that they are aesthetically the same—and thus does not force us to conclude that the forgery is as good as the original.

The example we have been using throughout illustrates a special case of a more general question concerning the aesthetic significance of authenticity. Quite aside from the occurrence of forged duplication, does it matter whether an original work is the product of one or another artist or school or period? Suppose that I can easily tell two pictures apart but cannot tell who painted either except by using some device like X-ray photography. Does the fact that the picture is or is not by Rembrandt make any aesthetic difference? What is involved here is the discrimination not of one picture from another but of the class of Rembrandt paintings from the class of other paintings. My chance of learning to make this discrimination correctly—of discovering projectible characteristics that differentiate Rembrandts in general from non-Rembrandts—depends heavily upon the set of examples available as a basis. Thus the fact that the given picture belongs to the one class or the other is important for me to know in learning how to tell Rembrandt paintings from others. In other words, my present (or future) inability to determine the authorship of the given picture without use of scientific apparatus does not imply that the authorship makes no aesthetic difference to me; for knowledge of the authorship, no matter how obtained, can contribute materially toward developing my ability to determine without such apparatus whether or not any picture, including this one on another occasion, is by Rembrandt.

Incidentally, one rather striking puzzle is readily solved in these terms. When Van Meegeren sold his pictures as Vermeers, he deceived most of the best-qualified experts; and only by his confession was the fraud revealed.[6] Nowadays even the fairly knowing layman is astonished that any competent judge could have taken a Van Meegeren for a Vermeer, so obvious are the differences. What has happened? The general level of aesthetic sensibility has hardly risen so fast that the layman of

today sees more acutely than the expert of twenty years ago. Rather, the better information now at hand makes the discrimination easier. Presented with a single unfamiliar picture at a time, the expert had to decide whether it was enough like known Vermeers to be by the same artist. And every time a Van Meegeren was added to the corpus of pictures accepted as Vermeers, the criteria for acceptance were modified thereby; and the mistaking of further Van Meegerens for Vermeers became inevitable. Now, however, not only have the Van Meegerens been subtracted from the precedent-class for Vermeer, but also a precedent-class for Van Meegeren has been established. With these two precedent-classes before us, the characteristic differences become so conspicuous that telling other Van Meegerens from Vermeers offers little difficulty. Yesterday's expert might well have avoided his errors if he had had a few known Van Meegerens handy for comparison. And today's layman who so cleverly spots a Van Meegeren may well be caught taking some quite inferior school-piece for a Vermeer.

Notes

1. And only for the sake of argument—only in order not to obscure the central issue. All talk of mere looking in what follows is to be understood as occurring within the scope of this temporary concession, not as indicating any acceptance of the notion on my part.

2. Germans learning English often cannot, without repeated effort and concentrated attention, hear any difference at all between the vowel sounds in "cup" and "cop." Like effort may sometimes be needed by the native speaker of a language to discern differences in color, etc., that are not marked by his elementary vocabulary. Whether language affects actual sensory discrimination has long been debated among psychologists, anthropologists, and linguists; see the survey of experimentation and controversy in Segall, Campbell, and Herskovits, *The Influence of Culture on Visual Perception* (Indianapolis and New York, The Bobbs-Merrill Co., Inc., 1966), pp. 34–48. The issue is unlikely to be resolved without greater clarity in the use of "sensory," "perceptual," and "cognitive," and more care in distinguishing between what a person can do at a given time and what he can learn to do.

3. In saying that a difference between the pictures that is thus relevant to my present experience in looking at them constitutes an aesthetic difference between them, I am of course not saying that everything (e.g., drunkenness, snow blindness, twilight) that may cause my experiences of them to differ constitutes such an aesthetic difference. Not every difference in or arising from how the pictures happen to be looked at counts; only differences in or arising from how they are to be looked at.

4. For a detailed and fully illustrated account, see P. B. Coremans, *Van Meegeren's Faked Vermeers and De Hooghs,* trans. A. Hardy and C. Hutt (Amsterdam, J. M. Meulenhoff, 1949). The story is outlined in Sepp Schüller, *Forgers, Dealers, Experts,* trans. J. Cleugh (New York, G. P. Putnam's Sons, 1960), pp. 95–105.

5. Not surprisingly, since a single quantum of light may excite a retinal receptor. See M. H. Pirenne and F. H. C. Marriott, "The Quantum Theory of Light and the Psycho-Physiology of Vision," in *Psychology,* ed. S. Koch (New York and London, McGraw-Hill Co., Inc., 1959), vol. I, p. 290; also Theodore C. Ruch, "Vision," in *Medical Psychology and Biophysics* (Philadelphia, W. B. Saunders Co., 1960), p. 426.

6. That the forgeries purported to have been painted during a period from which no Vermeers were known made detection more difficult but does not essentially alter the case. Some art historians, on the defensive for their profession, claim that the most perceptive critics suspected the forgeries very early; but actually some of the foremost recognized authorities were completely taken in and for some time even refused to believe Van Meegeren's confession. The reader has a more recent example now before him in the revelation that the famous bronze horse, long exhibited in the Metropolitan Museum and proclaimed as a masterpiece of classical Greek sculpture, is a modern forgery. An official of the museum noticed a seam that apparently neither he nor anyone else had ever seen before, and scientific testing followed. No expert has come forward to claim earlier doubts on aesthetic grounds.

Alfred Lessing

Born in the Netherlands, Alfred Lessing came to the United States in 1958. He obtained his doctorate at Yale University, and is presently Associate Professor of Philosophy at Oakland University in Michigan.

What is Wrong With a Forgery?

This paper attempts to answer the simple question: What is wrong with a forgery? It assumes, then, that something *is* wrong with a forgery. This is seen to be a reasonable assumption when one considers that the term *forgery* can be defined only in reference to a contrasting phenome-

From *Journal of Aesthetics and Art Criticism,* Vol. 23 (1965), pp. 461, 464–471. Reprinted by permission.

non which must somehow *include* the notion of genuineness or authenticity. When thus defined there can be little doubt that the concept of forgery is a normative one. It is clear, moreover, that it is a negative concept implying the absence or negation of value. But a problem arises when we ask what kind of value we are speaking of. It appears to be generally assumed that in the case of artistic forgeries we are dealing with the absence or negation of *aesthetic* value. If this were so, a forgery would be an aesthetically inferior work of art. But this, as I will try to show, is not the case. Pure aesthetics cannot explain forgery. Considering a work of art aesthetically superior because it is genuine, or inferior because it is forged, has little or nothing to do with aesthetic judgment or criticism. It is rather a piece of snobbery.[1]

It is difficult to make this position convincing to a person who is convinced that forgery *is* a matter of aesthetics. If a person insists that for him the aesthetic value (i.e., the beauty) of a work of art is affected by the knowledge that it is or is not genuine, there is little one can say to make that fact unreal for him. At most one can try to show that in the area of aesthetics and criticism we are easily confused and that his view, if carried through, leads to absurd or improbable conclusions. It is important that we do this because it is impossible to understand what is wrong with a forgery unless it be first made quite clear that the answer will not be in terms of its aesthetic worth. . . .

The matter of genuineness versus forgery is but another non-aesthetic standard of judgment. The fact that a work of art is a forgery is an item of information about it on a level with such information as the age of the artist when he created it, the political situation in the time and place of its creation, the price it originally fetched, the kind of materials used in it, the stylistic influences discernible in it, the psychological state of the artist, his purpose in painting it, and so on. All such information belongs to areas of interest peripheral at best to the work of art as aesthetic object, areas such as biography, history of art, sociology, and psychology. I do not deny that such areas of interest may be important and that their study may even help us to become better art appreciators. But I do deny that the information which they provide is of the essence of the work of art or of the aesthetic experience which it engenders. . . . We still need to answer our question: What is wrong with a forgery?

The most obvious answer to this question, after the aesthetic one, is that forgery is a moral or legal normative concept, and that thus it refers to an object which, if not necessarily aesthetically inferior, is always morally offensive. Specifically, the reason forgery is a moral offense, according to this view, is of course that it involves *deception*. Reasonable as this view seems at first, it does not, as I will try to show, answer our question adequately.

Now it cannot be denied, I think, that we do in fact often intend little

more than this moral connotation when we speak of forgery. Just because forgery is a normative concept we implicitly condemn any instance of it because we generally assume that it involves the breaking of a legal or moral code. But this assumption is only sometimes correct. It is important to note this because historically by far the majority of artistic fakes or forgeries have not been legal forgeries. Most often they have been the result of simple mistakes, misunderstandings, and lack of information about given works of art. We can, as a point of terminology, exclude all such instances from the category of forgery and restrict the term to those cases involving deliberate deception. There is, after all, a whole class of forgeries, including simple copies, misattributions, composites, and works "in the manner of" some reputable artist, which represent deliberate frauds. In these cases of forgery, which are undoubtedly the most notorious and disconcerting, someone, e.g., artist or art dealer, has passed off a work of art as being something which it is not. The motive for doing so is almost always economic, but occasionally, as with Van Meegeren, there is involved also a psychological motive of personal prestige or revenge. In any case, it seems clear that—if we leave out of consideration the factor of financial loss, which can of course be considerable, as again the Van Meegeren case proved—such deliberate forgeries are condemned by us on moral grounds, that is, because they involve conscious deception.

Yet, as a final answer to our question as to what is wrong with a forgery, this definition fails. The reason is the following: Although to some extent it is true that passing *anything* off as *anything* that it is not constitutes deception and is thus an undesirable or morally repugnant act, the case of deception we have in mind when we define forgery in terms of it is that of passing off the inferior as the superior. Although, strictly speaking, passing off a genuine De Hoogh as a Vermeer is also an immoral act of deception, it is hard to think of it as a forgery at all, let alone a forgery in the same sense as passing off a Van Meegeren as a Vermeer is. The reason is obviously that in the case of the De Hoogh a superior work is being passed off as a superior work (by another artist), while in the Van Meegeren case a presumably inferior work is passed off as a superior work.

What is needed, then, to make our moral definition of forgery more accurate is the specification "passing off the inferior as the superior." But it is just at this point that this common-sense definition of artistic forgery in moral terms breaks down. For we are now faced with the question of what is meant by superior and inferior in art. The moral definition of forgery says in effect that a forgery is an inferior work passed off as a superior one. But what is meant here by inferior? We have already seen that the forgery is not necessarily *aesthetically* inferior. What, then, does it mean? Once again, what is wrong with a forgery?

The attempt to define forgery in moral terms fails because it inevitably already assumes that there exists a difference between genuine works of art and forgeries which makes passing off the latter as the

former an offense against a moral or legal law. For only if such a differ-
ence does in fact exist can there be any rationale for the law. It is of
course precisely this assumed real difference which we are tying to dis-
cover in this paper.

It seems to me that the offense felt to be involved in forgery is not
so much against the spirit of beauty (aesthetics) or the spirit of the law
(morality) as against the spirit of art. Somehow, a work such as *The
Disciples* lacks artistic integrity. Even if it is beautiful and even if Van
Meegeren had not forged Vermeer's signature, there would still be some-
thing wrong with *The Disciples. What?* is still our question.

We may approach this problem by considering the following inter-
esting point. The concept of forgery seems to be peculiarly inapplicable
to the performing arts. It would be quite nonsensical to say, for example,
that the man who played the Bach suites for unaccompanied cello and
whom at the time we took to be Pablo Casals was in fact a forger. Simi-
larly, we should want to argue that the term *forgery* was misused if we
should read in the newspaper that Margot Fonteyn's performance in
Swan Lake last night was a forgery because as a matter of fact it was not
Margot Fonteyn who danced last night but rather some unknown person
whom everyone mistook for Margot Fonteyn. Again, it is difficult to see
in what sense a performance of, say, *Oedipus Rex* or *Hamlet* could be
termed a forgery.

Here, however, we must immediately clarify our point, for it is easily
misunderstood. There is, of course, a sense in which a performance of
Hamlet or *Swan Lake* or the Bach suites could be called a forgery. If, for
example, someone gave a performance of *Hamlet* in which every ges-
ture, every movement, every vocal interpretation had been copied or
imitated from the performance of *Hamlet* by Laurence Olivier, we could,
I suppose, call the former a forgery of the latter. But notice that in that
case we are interpreting the art of acting not as a performing art but as
a creative art. For what is meant is that Olivier's interpretation and
performance of *Hamlet* is itself an original and creative work of art
which can be forged. Similar comments would apply to Margot Fonteyn's
Swan Lake and Casal's Bach suites and, in fact, to every performance.

My point is then that the concept of forgery applies only to the crea-
tive and not to the performing arts. It can be denied of course that there
is any such ultimate distinction between creative and performing arts.
But we shall still have to admit, I think, that the duality on which it is
based—the duality of creativity or originality, on the one hand, and re-
production or technique, on the other—is real. We shall have to admit
that originality and technique are two elements of all art; for it can be
argued not only that a performance requires more than technique,
namely originality, but also that the creation of a work of art requires
more than originality, namely technique.

The truth of the matter is probably that both performances and
works of art vary greatly and significantly in the degree to which they
possess these elements. In fact, their relative presence in works of art and

performances makes an interesting way of categorizing the latter. But it would be wrong to assert that these two elements are inseparable. I can assure the reader that a portrait painted by me would be technically almost totally incompetent, and yet even I would not deny that it might be original. On the other hand, a really skillful copy of, for example, a Rembrandt drawing may be technically perfect and yet lacks all originality. These two examples establish the two extreme cases of a kind of continuum. The copy of Rembrandt is of course the forgery *par excellence*. My incompetent portrait is as far removed from being a forgery as any work can be. Somewhere in between lies the whole body of legitimate performances and works of art.

The implications of this long and devious argument are as follows. Forgery is a concept that can be made meaningful only by reference to the concept of originality, and hence only to art viewed as a *creative,* not as a reproductive or technical activity. The element of performance or technique in art cannot be an object for forgery because technique is not the kind of thing that can be forged. Technique is, as it were, public. One does or does not possess it or one acquires it or learns it. One may even pretend to have it. But one cannot forge it because in order to forge it one must already possess it, in which case there is no need to forge it. It is not Vermeer's technique in painting light which Van Meegeren forged. That technique is public and may be had by anyone who is able and willing to learn it. It is rather Vermeer's discovery of this technique and his use of it, that is, Vermeer's originality, which is forged. The light, as well as the composition, the color, and many other features, of course, were original with Vermeer. They are not original with Van Meegeren. they are forged.

At this point our argument could conclude were it not for the fact that the case which we have used throughout as our chief example, *Christ and the Disciples at Emmaus,* is not in fact a skillful copy of a Vermeer but a novel painting in the style of Vermeer. This threatens our definition of forgery since this particular forgery (always assuming it *is* a forgery) obviously possesses originality in some sense of the word.

The problem of forgery, in other words, is a good deal more complex than might at first be supposed, and before we can rest content with our definition of forgery as the lack of originality in works of art, we must show that the concept of originality can indeed account for the meaning of forgery as an untrue or objectionable thing in all instances, including even such a bizarre case as Van Meegeren's *Disciples at Emmaus.* It thus becomes important to examine the various possible meanings that the term *originality* may have in the context of art in order to determine in what sense *The Disciples* does and does not possess it, and hence in what sense it can meaningfully and justifiably be termed a forgery.

1) A work of art may be said to be original in the sense of being a particular object not identical with any other object. But this originality is trivial since it is a quality possessed by all things. *Particularity* or *self-identity* would be better names for it.

2) By originality in a work of art we may mean that it possesses a

certain superficial individuality which serves to distinguish it from other works of art. Thus, for example, a certain subject matter in a particular arrangement painted in certain colors may serve to identify a painting and mark it as an original work of art in the sense that its subject matter is unique. Probably the term *individuality* specifies this quality more adequately than *originality*.

It seems safe to assert that this quality of individuality is a necessary condition for any work of art to be called original in any significant sense. It is, however, not a necessary condition for a work to be called beautiful or to be the object of an aesthetic experience. A good reproduction or copy of a painting may be the object of aesthetic contemplation and yet it lacks all originality in the sense which we are here considering. Historically many forgeries are of this kind, i.e., more or less skillful copies of existing works of art. They may be described as being forgeries just because they lack this kind of originality and hence any other kind of originality as well. Notice that the quality which makes such a copy a forgery, i.e., its lack of individuality, is not a quality which exists in the work of art as such. It is a fact about the work of art which can be known only by placing the latter in the context of the history of art and observing whether any identical work predates it.

As we said above, it is not this kind of originality which is lacking in *The Disciples*.[2]

3) By originality in art we may mean the kind of imaginative novelty or spontaneity which is a mark of every good work of art. It is the kind of originality which attaches to individual works of art and which can be specified in formal or technical terms such as composition, balance, color intensity, perspective, harmony, rhythm, tempo, texture, rhyme, alliteration, suspense, character, plot, structure, choice of subject matter, and so on. Here again, however, in order for this quality to be meaningfully called originality, a reference must be made to a historical context in terms of which we are considering the particular work of art in question, e.g., this work of art is original because the artist has done something with the subject and its treatment which has never been done before, or this work is not original because many others just like it predate it.

In any case, *The Disciples* does, by common consent, possess this kind of originality and is therefore in this sense at least not a forgery.

4) The term *originality* is sometimes used to refer to the great artistic achievement of a specific work of art. Thus we might say that whereas nearly all of Milton's works are good and original in the sense of (3) above, *Paradise Lost* has a particularly profound originality possessed only by really superlative works of art. It is hard to state precisely what is meant by this use of the term *originality*. In justifying it we should probably point to the scope, profundity, daring, and novelty of the conception of the work of art in question as well as to the excellence of its execution. No doubt this kind of originality differs from that discussed under (3) above only in degree.

It is to be noted that it cannot be the lack of this kind of originality

which defines a forgery since, almost by definition, it is a quality lacking in many—maybe the majority of—legitimate works of art. Moreover, judging from the critical commentary with which *The Disciples* was received at the time of its discovery—commentary unbiased by the knowledge that it was a forgery—it seems reasonable to infer that the kind of originality meant here is in fact one which *The Disciples* very likely possesses.

5) Finally, it would seem that by originality in art we can and often do mean the artistic novelty and achievement not of one particular work of art but of the totality of artistic productions of one man or even one school. Thus we may speak of the originality of Vermeer or El Greco or Mozart or Dante or Impressionism or the Metaphysical Poets or even the Greeks or the Renaissance, always referring, I presume, to the artistic accomplishments achieved and embodied in the works of art belonging to the particular man, movement, or period. In the case of Vermeer we may speak of the originality of the artist's sense of design in the genre picture, the originality of his use of bright and pure colors, and of the originality of his treatment and execution of light.

We must note first of all that this meaning of originality, too, depends entirely on a historical context in which we are placing and considering the accomplishment of one man or one period. It would be meaningless to call Impressionism original, in the sense here considered, except in reference to the history of art which preceded it. Again, it is just because Vermeer's sense of pictorial design, his use of bright colors, and his mastery of the technique of painting light are not found in the history of art before him that we call these things original in Vermeer's work. Originality, even in this more profound sense, or rather especially in this more profound sense, is a quality definable only in terms of the history of art.

A second point of importance is that while originality as here considered is a quality which attaches to a whole corpus or style of works of art, it can be considered to exist in one particular work of art in the sense that that work of art is a typical example of the style or movement to which it belongs and therefore embodies the originality of that style or movement. Thus we may say that Vermeer's *A Painter in His Studio* is original because in this painting (as well as in several others, of course) we recognize those characteristics mentioned earlier (light, design, color, etc.) which are so typical of Vermeer's work as a whole and which, when we consider the whole of Vermeer's work in the context of the history of art, allow us to ascribe originality to it.

Turning our attention once more to *The Disciples,* we are at last in a position to provide an adequate answer to our question as to the meaning of the term forgery when applied to a work of art such as *The Disciples.* We shall find, I think, that the fraudulent character of this painting is adequately defined by stating that it lacks originality in the fifth and final sense which we have here considered. Whatever kinds of originality it can claim—and we have seen that it possesses all the kinds previously

discussed—it is *not* original in the sense of being the product of a style, period, or technique which, when considered in its appropriate historical context, can be said to represent a significant achievement. It is just this fact which differentiates this painting from a genuine Vermeer! The latter, when considered in its historical context, i.e., the seventeenth century, possesses the qualities of artistic or creative novelty which justify us in calling it original. *The Disciples,* on the other hand, in *its* historical context, i.e., the twentieth century, is not original, since it presents nothing new or creative to the history of art even though, as we have emphasized earlier, it may well be as beautiful as the genuine Vermeer pictures.

It is to be noted that in this definition of forgery the phrase "appropriate historical context" refers to the date of production of the particular work of art in question, not the date which in the history of art is appropriate to its style or subject matter.[3] In other words, what makes *The Disciples* a forgery is precisely the disparity or gap between its stylistically appropriate and its actual date of production. It is simply this disparity which we have in mind when we say that forgeries such as *The Disciples* lack integrity.

It is interesting at this point to recall Van Meegeren's reasoning in perpetrating the Vermeer forgeries. "Either," he reasoned, "the critics must admit their fallibility or else acknowledge that I am as great an artist as Vermeer." We can see now that this reasoning is not sound. For the notion of greatness involved in it depends on the same concept of historical originality which we have been considering. The only difference is that we are now thinking of it as an attribute of the artist rather than of the works of art. Van Meegeren's mistake was in thinking that Vermeer's reputation as a great artist depended on his ability to paint beautiful pictures. If this were so, the dilemma which Van Meegeren posed to the critics would have been a real one, for his picture is undeniably beautiful. But, in fact, Vermeer is *not* a great artist only because he could paint beautiful pictures. He is great for that reason plus something else. And that something else is precisely the fact of his originality, i.e., the fact that he painted certain pictures in a certain manner *at a certain time in the history and development of art*. Vermeer's art represents a genuine creative achievement in the history of art. It is the work not merely of a master craftsman or technician, but of a creative genius as well. And it is for the latter rather than for the former reason that we call Vermeer great.

Van Meegeren, on the other hand, possessed only craftsmanship or technique. His works lack the historical originality of Vermeer's and it is for this reason that we should not want to call him great as we call Vermeer great.[4] At the same time it must be recalled that Van Meegeren's forgeries are not forgeries *par excellence. The Disciples* though not original in the most important sense, possesses, as we have seen, degrees of originality generally lacking in forgeries.

In this connection it is interesting to speculate on the relations be-

tween originality and technique in the creative continuum which we came upon earlier. A totally original work is one which lacks all technique. A forgery *par excellence* represents the perfection of technique with the absence of all originality. True works of art are somewhere in between. Perhaps the really great works of art, such as Vermeer's, are those which embody a maximum of both originality and technique: Van Meegeren's forgeries can never be in this last category, for, as we have seen, they lack the most important kind of originality.

Finally, the only question that remains is why originality is such a signficant aspect of art. Now we need to note, of course, that the concern with originality is not a universal characteristic of art or artists. Yet, the fact that the search for originality is perhaps typical only of modern Western art tends only to strengthen the presumption of its fundamental relation to the concept of forgery. For it is also just in the modern Western tradition that the problem of forgery has taken on the kind of economic and aesthetic significance which warrants our concern with it here. But why, even in modern Western art, should the importance of originality be such that the concepts of greatness and forgery in art are ultimately definable only by reference to it? The answer is, I believe, not hard to find. It rests on the fact that art has and must have a history. If it did not, if artists were concerned only with making beautiful pictures, poems, symphonies, etc., the possibilities for the creation of aesthetically pleasing works of art would soon be exhausted. We would (perhaps) have a number of lovely paintings, but we should soon grow tired of them for they would all be more or less alike. But artists do not seek merely to produce works of beauty. They seek to produce *original* works of beauty. And when they succeed in achieving this originality we call their works great not only because they are beautiful but also because they have also unlocked, both to artists and to appreciators, unknown and unexplored realms of beauty. Men like Leonardo, Rembrandt, Haydn, Goethe, and Vermeer are great not merely because of the excellence of their works but also because of their creative originality which goes on to inspire other artists and leads through them to new and aesthetically valuable developments in the history of art. It is, in fact, this search for creative originality which insures the continuation and significance of such a history in the first place.

It is for this reason that the concept of originality has become inseparable from that of art. It is for this reason too that aesthetics has traditionally concerned itself with topics such as the inspiration of the artist, the mystery of the creative act, the intense and impassioned search of the artist, the artist as the prophet of his times, the artistic struggle after expression, art as the chronicle of the emotional life of a period in history, art as a product of its time, and so on. All such topics are relevant not to art as the production of works of beauty, but to art as the production of *original* works of beauty, or, more accurately, works of original beauty. As such they are perfectly legitimate topics of discussion. But we must not forget that the search for originality is, or ought to be, but the means

to an end. That end is, presumably, the production of aesthetically valuable or beautiful works of art; that is, works which are to become the object of an aesthetic experience. That experience is a wholly autonomous one. It does not and cannot take account of any entity or fact which is not aesthetically perceivable in the work of art itself. The historical context in which that work of art stands is just such a fact. It is wholly irrelevant to the pure aesthetic appreciation and judgment of the work of art. And because the fact of forgery—together with originality and greatness— can be ultimately defined only in terms of this historical context, it too is irrelevant to the aesthetic appreciation and judgment of *The Disciples at Emmaus* or any other work of art. The fact of forgery is important historically, biographically, perhaps legally, or, as the Van Meegeren case proved, financially; but not, strictly speaking, aesthetically.

In conclusion, let us consider the following paradoxical result. We have seen in what sense Vermeer is considered to be a great artist. We have also seen that despite the fact that *The Disciples* is indistinguishable from a genuine Vermeer, Van Meegeren cannot be thus called great. And yet we would suppose that Vermeer's greatness is somehow embodied in his work, that his paintings are proof of and monuments to his artistic genius. What are we to say, then, of this Van Meegeren forgery which hung in a museum for seven years as an embodiment and proof of Vermeer's genius? Are we to say that it now no longer embodies anything at all except Van Meegeren's skillful forging technique. Or are we to grant after all that this painting proves Van Meegeren's greatness as Vermeer's paintings do his? The answer is, I think, surprising but wholly appropriate: paradoxically, *The Disciples at Emmaus* is as much a monument to the artistic genius of Vermeer as are Vermeer's own paintings. Even though it was painted by Van Meegeren in the twentieth century, it embodies and bears witness to the greatness of the seventeenth-century art of Vermeer.

Notes

1. Cf. Arthur Koestler, "The Anatomy of Snobbery," *The Anchor Review,* No. 1 (Garden City: Doubleday Anchor Books, 1955), pp. 1–25.
2. A slightly more complex case is offered by forgeries (including probably some of Van Meegeren's less carefully executed Vermeer forgeries) which are not simple copies of other paintings but which are composites of other paintings. While such forgeries clearly have a measure of individuality totally lacking in the simple copy, I should want to maintain that it is only superficially that they lack the kind of originality here discussed.
3. To avoid all ambiguity in my definition of forgery, I need to specify whether "actual date of production" refers to the completion of the finished, concrete work of art or only of the productive means of such works. This question bears on the legitimacy of certain works in art forms where the means of production and the finished product are separable. Such works include lithographs, etchings, woodcuts, cast sculptures, etc. What, for example, are we to say of a modern bronze

cast made from a mold taken directly from an ancient bronze cast or a modern print made from an eighteenth-century block? Are such art objects forgeries? The answer, it seems to me, is largely a matter of convenience and terminology. Assuming that there is no moral fraud, i.e., deception, involved, whether or not to call such cases instances of forgery becomes an academic question. It depends entirely on what we take to be "the work of art." In the case of lithography or etching there may be some ambiguity about this. I myself would define "the work of art" as the finished concrete product and hence I would indeed call modern prints from old litho stones forgeries, though, assuming no deception is involved, forgeries of a perculiar amoral, non-offensive sort. In other arts, such as music, there is little or no ambiguity on this point. Clearly, no one would want to label the first performance of a newly discovered Beethoven symphony a forgery. In still other, e.g., the literary, arts, due to the absolute inseparability of the concrete work of art and the means of its production, this problem cannot arise at all.

4. Unless it be argued that Van Meegeren derives *his* greatness from the originality of his works when considered in the context not of the history of art but of the history of forgery.

PART THREE

When Is Experience Aesthetic?

Introduction

Aesthetic experience—like erotic and religious experience—has never lacked would-be analysts. But more often than not, those who come to analyze stay on only to celebrate. It is seldom that we find a thorough examination of major aspects of aesthetic experience. The works of such writers as Hepburn, Sibley and Ingarden are exceptional in this regard, for they represent serious efforts to come to grips with the structure of appreciation, the qualities that comprise it, and the logical status of those qualities.

Whether or not the term "quality" is an appropriate way to characterize the infinitely varied facets of experience is certainly open to question. It may very well turn out eventually that we will want to dispense with the term altogether, and substitute another which, though less succinct, might be more analyzable—say, "configuration of experience." Until such time, however, we probably must content ourselves with discussing qualities—both part-qualities and whole-qualities.

Part-qualities (specific musical notes, or patches of color on a canvas) are limited to specific portions of a work of art. Whole-qualities are pervasive and diffuse; they permeate the work in its entirety. But the distinction is rather a relative one, since that which is a part in respect to a larger whole is itself a whole in respect to its own constituents. Moreover, the isolation of a specific part of a work violates its identity by artificially ripping it out of context. It might therefore be better to say that whole-qualities are unfocused tertiary qualities, while part-qualities are focused tertiary qualities.

Tertiary qualities are analyzable, yet irreducible. A melody is not

reducible to the individual musical notes of which it is composed, nor are those notes reducible to the musical instruments which produce them—any more than the instruments are reducible to the musicians who play them. The quality of

> Bare, ruin'd choirs, where late the sweet birds sang

is utterly irreducible and unique, but the words of which it is composed are common enough. Yet the quality of Shakespeare's line is markedly different from Arnold's

> Vast edges drear and naked shingles of the world.

The quality of "drear and naked" may invite comparison with that of "bare" and "ruin'd," but for the rest, the difference is between the poignant and the grim.

Undoubtedly, each word (even, in a sense, each letter) has its own special quality. Take the word "calm," in the first line of Arnold's poem cited above:

> The sea is calm tonight.

The quality of the word is not the quality of the four individual letters that comprise the word. But what is this talk of a word possessing a quality? Isn't the word "calm" simply a *feeling-word*—that is, a word descriptive of human feelings, and of human feelings alone? And isn't it therefore inappropriate, strictly speaking, to call the sea "calm," since the sea is not a feeling? According to this way of looking at the matter, the sea reminds me of how I feel when I feel calm, so I borrow the term "calm" from the domain of feeling-words, where it can be said to belong, and use it to describe a physical thing, thereby deliberately committing a category-mistake.

An alternative and possibly preferable approach is to avoid committing ourselves to the notion that quality terms denote only feelings or emotions, and are therefore "subjective." Terms like "calm" and "joyous," "sad" and "disagreeable," would then be understood to denote certain configurations of experience, whether these be the structure of feelings or of thoughts or of things or of what not. In this sense, it is just as correct (and not at all a category-mistake) to describe the sea as calm as to describe one's feelings as calm. Undoubtedly there are times when things are more accurately and truthfully described in language normally reserved for feelings than in language normally reserved for things. Conversely, terms usually employed to describe things may be more appropriate for certain feelings than anything in the conventional range of feeling-terms.

The attention given here to the role of qualities in appreciation is not intended to minimize the importance to be attached to the discrimina-

tion of the structure (or structures) of aesthetic experience. But since the process of appreciation seems to be composed of strand upon strand of awareness, entwined together and threaded through with a central awareness, it does seem important to try to establish the logical status of the quality whose discovery each such awareness represents. Once this is accomplished, we can consider the possibilities of the aesthetic appreciation of nature.

While it is ordinarily assumed that appreciative experiences have little structure within themselves and little structure in common, Ingarden seeks to show that, despite the considerable differences that exist among the varieties of aesthetic experience, the phases of appreciation fall into a single, analyzable pattern. His essay represents an ambitious attempt to uncover and display the concatenated movements of thought and feeling that represent the inner orchestration of the aesthetic response.

The relevance of the analysis of tertiary qualities to the understanding of aesthetic experience is becoming increasingly apparent. Hepburn argues in favor of the notion that tertiary or "emotional qualities" are actually *in* works of art, rather than gratuitously attributed to them, although he concedes the legitimacy of alternative interpretations. Likewise, Sibley contends that much of the descriptive language employed by critics uses quality terms in their primary sense rather than derivatively or metaphorically, and he concludes that the qualities being described must be accounted objective.

Thanks to Hepburn, some reconsideration is now being given to the claim that appreciation of nature falls properly within the domain of aesthetics. More traditional writers never conceded that aesthetic analysis need restrict itself to the artifactual, as evidenced in the essays by Simmel and Valéry included here. The Valéry selection in particular displays a remarkable combination of skillful, graceful reasoning, together with a lucid, unfeigned wonder at the working procedures of nature. In showing us how something which is not art is made, Valéry hints, by contrast, at what is required for the making of art.

CHAPTER 2

The Structure of Appreciation

Roman Ingarden

Roman Ingarden (1893–1970) was educated at Lwow, Göttingen and Freiburg, and taught philosophy at Lwow and Cracow. Long associated with the phenomenological movement, his best-known work is Das Literarische Kunstwerk, *but he was also the author of numerous other books and articles.*

Aesthetic Experience and Aesthetic Object[1]

I. THE DIFFERENCE BETWEEN THE COGNITIVE PERCEPTION OF A REAL OBJECT AND THE AESTHETIC EXPERIENCE OF AN AESTHETIC OBJECT. The essential mistake of the views about an aesthetic experience consists in the opinion that the object of such an experience is *identical* with an element

From *Philosophy and Phenomenological Research,* Vol. 21, No. 3 (March, 1961), pp. 289–313. Reprinted by permission. Translated by Janina Makotz Krakow, with the co-operation of Professor Shia Moser, University of Buffalo.

of the real world and the object of our activities or cognition. There are, indeed, some circumstances which seem to justify this opinion. May it not happen that we lift the window-blinds in our room some day in spring and catch the sight of the garden where the trees have opened into flower during the night? We are suddenly dazzled and fascinated by the sight of apple trees abloom against the background of a fair sky. Are we not pleased with some real objects, which we find in the surrounding world, the same objects which we had seen before having experienced the feeling of ecstasy, and which we continue to see in spite of the fact that the wave of feeling and enchantment has passed away? And is it otherwise—we may be asked by someone—when we enter, for example, the rooms of the Louvre and see at once the perspective of several rooms at the end of which there appears against a dark background the snow-white Venus of Milo in all her wonderful slenderness and charm? Is it not just a piece of stone of a particular shape that we are pleased with and that our enthusiasm is directed to? The fact that this piece of stone is the work of an artist does not seem to alter, by any means, its reality [and to exclude the object we are pleased with from being studied by someone assuming a purely investigating attitude, e.g., when measuring the particular dimensions of the statue, testing the condition of the marble surface, etc.].

The facts mentioned do occur, indeed; nevertheless the theory suggested on their basis seems to be faulty. It is, namely, true that in cases similar to those described we *begin* with the perception of a real object. But the question is, first, whether, when starting from a real object, we remain within its limits while an aesthetic perception is taking place in ourselves, and, secondly, whether the starting from a real object is indispensable in every case of aesthetic perception.

The possibility of purely fictitious objects, which are devised by ourselves and by no means perceived, to be the objects of aesthetic perception, indicates that the second question should be answered in the negative. We may, e.g., imagine a very tragic situation to obtain for people, although we know by anticipation that it has never existed, and also that we have never perceived it in our intercourse with real persons. In spite of that we may assume toward this situation a positive or a negative aesthetic attitude. Another example may be furnished by every literary work of art. For it is neither among physical, psychical, nor psychophysical objects, that we find literary works. Among physical objects there are only the so-called books, i.e., in their present form some sheets of paper bound together and covered with various drawings. However, a book is not yet a literary work, but only a means to "fix" the work, or rather to render it accessible to the reader. Among the experiences, on the other hand, there occur only the acts of "reading," which do not constitute a literary work either. Nevertheless, the particular literary works may be the objects against the background of which aesthetic objects come to be constituted. Some doubts may be raised by the fact that when reading a literary work or listening to its being read aloud, as a

matter of fact, we have first to do with a real object or with a real process (letters on the paper, real material of sounds). As we have already stated elsewhere, we do not remain within the limits of those objects when becoming acquainted with a work of art. But it isn't even necessary that we begin the reading with the perception of a real object, because the possibility is not excluded that we only imagine the "letters" or the corresponding sounds, e.g., when we are repeating a poem from memory. It should therefore be stated that it is not in every case of aesthetic perception that one must start from the perception of a real object.

A conjecture presents itself, that also in those cases, where we have before us a real object at the *beginning* of an aesthetic perception-process—e.g., in sense perception—the *reality* of the object in question is not indispensable for the accomplishment of this perception or for the given aesthetic object to be there. Then we are perceiving a piece of marble which we call the "Venus of Milo" and are fascinated with the peculiar charm of its shape. It may happen that our perception is an illusion, that in reality there is in the room of the Louvre no piece of marble or that it is quite different from what has appeared to our perception. All this would not in the least alter either our being enchanted or what has been *given* to us as the object of this experience. The reality of an object isn't thus necessary for the accomplishment of an aesthetic experience. And it is also not the reality in question that brings about our being or not being pleased with something, in an aesthetic experience, because the occurrence of reality as a particular moment of the object perceived does not influence our *aesthetic* delight or aversion in any way. If this were not the case, *all* the objects which we perceive as real should be "beautiful," "fascinating," "pretty," or "ugly," which is not true.

However, this fact isn't sufficient in order to state that in every case in which we perceive an aesthetic object, grasping its beauty or its ugliness, *we do not remain* within the limits of the real object, with the perception of which our aesthetic experience has begun. For it may be that the reality of the object perceived is, indeed, in itself neither necessary nor such that it would entail the aesthetic values of the object of aesthetic experience, but instead of this some other qualities of the real object in question are both the source and the object of aesthetic experience. Those who think the objects of aesthetic experience to be simply some objects of particular qualities from among the real objects of sense perception usually argue just this way.

In order to decide this question let us consider, on the one hand, what we do when, in an investigating attitude, we aim at the obtaining of *knowledge* of a *real* object with the aid of sense perception, and, on the other hand, what we do when we experience a process which leads us finally to an object which presents itself in a direct experience, as having an aesthetic value. But we fail to explain the above question if we persist in the prejudice, often entertained, that the two opposed activities are some *momentary* experiences differing only by the feeling of "like" or "dislike" joining the momentary sense perception in the second case. For

the cognition of a real object by sense perception (or with the aid of it) as well as the so-called aesthetic experience are processes extended in time, having their various *phases,* often composed of many acts of consciousness differing from one another.

We can *cognize,* in an investigating attitude, the piece of marble, which is called today the "Venus of Milo," only in the way that we accomplish the whole *series* of visual, tactile, or other perceptions which do not necessarily follow one another continuously. In each of these perceptions, we have not only to become clearly conscious of *what* is given to us (what kind of object, of what kind of properties), but also to realize if what is given to us is given in *such a way and in such circumstances* that we are right in acknowledging it to appertain to an object as its property, immanent in it. Thus, besides the perception itself, there comes here into account some *judgments* expressing its results, then the comparison of the results of particular perceptions, binding them with one another and a steady taking into consideration of the objective and subjective conditions in which the perception has been accomplished (e.g., the lighting of the interior, the neighborhood of other objects in the field of perception, and even the presence of such objects which, though not entering themselves the field of perception, cause a transitory change of the object in question, or at least the occurrence, in perception, of some of its apparent properties; our psychic condition during the perception —e.g., some emotional disturbances, the condition of our sense organs, etc.). These conditions are taken into account with the aim of considering their influence on the data of our perceptions. But the leitmotiv of these considerations—which are, indeed, constantly carried out by naturalists in their scientific observations and experiments—is, on the one hand, to *deny* to the object which is being cognized all the properties which, though given in some circumstances in perception as the properties of the object in question, do not pertain to it, their appearance among the data of perception being caused by some foreign factors and not by the nature of the object investigated. On the other hand, the aim of these considerations is to *ascribe* some properties to the object which we cognize on the basis of perception. Two cases may occur here: either some qualities are *given* in perception as the properties of an object and these qualities should be ascribed to the object, but only if they appear in the whole cognitive process as *independent* of irrelevant circumstances, i.e., circumstances of perception or cognition lying *beyond* the object perceived; or these qualities are not at all given in any of the perceptions of the object which is being cognized. On the basis of a number of checked perceptions we may, however, *infer* that these qualities, which are independent of any foreign circumstances of perception, are an *indispensable condition* supplementing the *appearance,* among the data of perception, of a particular quality as an (apparent) property of the cognized object. In this case also they should be ascribed to the object as its own properties. Thus, the whole process of cognition, composed of many different cognitive acts, is directed—if it proceeds regularly—by

the idea of an exact *adjustment* of the cognitive results to the object to be cognized and of an exclusion of all those elements, which admit the slightest suspicion of having issued from factors *foreign* to the cognized object.

The matter—as it will be seen—presents itself quite differently in the pretty complicated process, which here will be called an "aesthetic experience." Those of us who have been in Paris and have looked at the piece of marble called the "Venus of Milo" know this piece to have various properties which, far from coming into account in an aesthetic experience, obviously hinder its accomplishment, in consequence of which we are inclined to *overlook* them, e.g., a dark stain on the nose of Venus, which impedes an aesthetic perception of its shape, or various rough spots, cavities, and holes in the breast, corroded probably by water, etc. In an aesthetic experience, we overlook these particular qualities of the stone and behave as if we didn't see them; on the contrary, we behave as if we saw the shape of the nose uniformly colored, as if the surface of the breast were smooth, with the cavities *filled up*, with a regularly formed nipple (without the damage actually to be found in the stone), etc. We *supplement* "in thought," or even in a peculiar perceptive representation, such details of the object as play a positive role in the attainment of the *optimum* of aesthetic "impression" possible in the given case; more exactly—details that give such a shape of the object of our aesthetic experience as distinguishes itself most fully by aesthetic values, which may appear, in the given conditions, *in concreto*. This kind of procedure would be most improper in the cognition, in an investigating attitude, of the properties of a real stone. Here, in an aesthetic perception, it "fits well." And this is by no means due to the persuasion, that all the details we "overlook" are only some "posterior damages" not to be taken into account, because they did not occur at the beginning when the statue issued from under the chisel of the artist. Such a way of posing the question would be proper only if we assumed the investigating attitude of art historians and if we wanted to learn, on the basis of the present condition of the stone-statue, what kind of statue it really *had been* as made by its creator. In this case we should also have to "supplement" the arms which are today broken off, etc. The reason for overlooking some details in an aesthetic perception is a different one: the details to be overlooked "shock" us; if they were perceived, they would introduce a *disharmonious* factor into the field of what is in perception *given* to us, they would bring *discordance* into the totality of an aesthetic object. Moreover, this object is, indeed, by no means identical with the given piece of marble. More exactly: it is *given* to us not as a piece of marble, but as the "Venus," i.e., as a woman or a goddess. Therefore we are right to speak of a head, of a breast, etc. We *see*—have *given*—a woman "body." And not only the mere body; in an aesthetic perception, we see the *Venus,* i.e., a woman or goddess in a situation and in a psychic condition, which expresses itself in her countenance, her movement, etc. At the same time, however, it is for us no *real* woman body and no *real* woman. If we met

a living woman with such arms knocked off (suppose already "healed") we should, surely, experience a strong aversion, reacting, maybe, at the same time with pity, compassion, etc. But in an aesthetic perception of the "Venus of Milo" there is no trace of such experiences. We cannot say here that either the "stumps" are not seen at all, or that they are seen distinctly, our attention being specially paid to them during the perceptive process and their existence as if stressed. Neither can it be said that the missing arms are supplemented "in thought" or in imagination (though this is possible). These missing arms are, in this case, no hindrance for us. Many a time—as it is known—it has been called into question whether it would be "better" if those arms had not been knocked off—"better," of course, not for the piece of marble, nor for a living woman, but for the totality of an object aesthetically valuable, which *comes into existence* while an aesthetic experience is being accomplished; more exactly: "better" for the aesthetic *value* of the object which is being constituted only when an aesthetic experience is going on and which is given to us when constituted. In an aesthetic attitude, we somehow entirely forget the lack of arms and the missing arms. Things have taken such a happy turn that the whole object "seen" in this way does not lose anything, but, perhaps, rather profits by the fact that the arms do not appear in the field of vision. Thanks to this circumstance there appear some aesthetic values (e.g., a greater slenderness of the figure, the uniformity of the silhouette of the chest, etc.) which would not reveal themselves in this form if the arms had been actually preserved.

At any rate, this whole question proves that, in this case, there takes place no simple sense perception of a real stone or of a real woman, but that the sense perception is here solely a *basis* for the further peculiar psychic acts, built over it, which lead us to the "Venus of Milo" as an object of aesthetic experience. And correlatively: the object of aesthetic experience is *not identical with any real object,* and only some real objects, formed in a peculiar way, serve as a *starting point* and as a basis for some aesthetic objects to be built, a proper attitude of the perceiving subject being assumed. Besides, the so-called "aesthetic experience" is no *single* composite experience but a certain number of experiences connected with one another. In order to see the "Venus of Milo" in an aesthetic experience it is insufficient to "look" at her for a moment from a single point of view. One has to "perceive" her from different sides, in various perspective abridgments, from a nearer or a further distance; to be able, in every phase of aesthetic experience, on the basis of sense perception (*nota bene* a modified one) to look for those *visible properties* of the Venus of Milo, which reveal her aesthetic values accessible in the given aspect; then one has to grasp the qualities aesthetically valuable and to bind them synthetically with one another in order to succeed, in this way, in grasping the *whole* of the harmony of those qualities, and, at that time only—in a peculiar emotional contemplation—to *give oneself up to the charm* of the beauty of the constituted "aesthetic object."

This whole complicated process, which lasts for a longer or a shorter

time, may proceed in particular cases in different manners. It is impossible to go into detail here. At present, the only thing certain is that this process cannot be identified with the process of sense perception which is accomplished in an investigating attitude. Its *beginning* alone may be a pure sense perception of a real object as found, but soon we pass from it to something else, which in the *course* of an aesthetic experience only is being *constituted* and to which we react emotionally, in some way or other, only when its constitution has been completed.

After this preparation let us now try to grasp briefly the main features of an aesthetic experience.

II. PHASES AND ELEMENTS OF AN AESTHETIC EXPERIENCE. As I have already stated, an aesthetic experience is not—contrary to what is often heard—a *momentary* experience, a momentary feeling of pleasure or displeasure, arising as a response to some data of sense perception, but a *composite process having various phases and a characteristic development* which contains many heterogeneous elements. That the opposed theory seems plausible is due to the fact that, many a time—in consequence of some irrelevant factors—the process does not attain its full development: it is either interrupted before the aesthetic object has been constituted and before the experience of it has culminated, or, in consequence of an artificial preparation, or of some professional habits, it does not commence from the beginning, but from the moment in which an aesthetic object is already constituted (e.g., when we look at a painting which we have already seen many times and which we have learned to see in the way it had been once constituted to us as an aesthetic object of peculiar properties). The duration and the complexity of this process depend, of course, on whether we have before us in a given case, a complicated or a simple aesthetic object. Sometimes it is simply a quality of color or a sound of voice which alone become such objects: then the process of aesthetic experience is correspondingly a more "fleeting" one, but even then it is not a momentary "feeling of pleasure" or "displeasure."

III. THE PRELIMINARY EMOTION OF THE AESTHETIC EXPERIENCE. If an aesthetic process starts from a pure sense perception (which is not always the case), the most interesting part of the process and, at the same time, a very difficult one to grasp is the *transition* from the sense perception of a real object to the phases of the aesthetic experience. This is *change of attitude* from a practical one, assumed in everyday life, or from an investigating one, to an aesthetic attitude. What *causes this change of attitude* to occur? What happens when—instead of continuing to be employed with our everyday, practical or theoretical affairs—we *interrupt* (how often in a sudden and unexpected way) the "normal" course of our life and begin to occupy ourselves with something which, while not appertaining, seemingly, to our life, enriches it, at the same time, and confers upon it a new sense?

This transition may proceed in different ways with different people according to various circumstances. However, I do not think I am far

from the truth in indicating the following essential moments: namely, while perceiving a real object we are *struck* with a peculiar quality or with a multiplicity of qualities or, at last, with a gestalt quality (e.g., a color or a harmony of colors, the quality of a melody, a rhythm, a shape, etc.) which not only focuses our attention on itself, but, in addition, is not indifferent to us. This initial quality evokes in us a special emotion which I shall call a *preliminary* emotion, because it is only this emotion which opens the proper process of aesthetic experience. As I have said, this quality "strikes" us, it imposes itself on us. Here I want to point out that the perception of this quality is *passive* and, in this phase of experience, a *fleeting* one, and, moreover, of such a kind that, if the whole process were in this phase suddenly interrupted, we ourselves probably would not know to answer the question what kind of quality it had been: we receive the impression of it, we experience it rather than perceive it.

The preliminary emotion, generated on this basis, is not that of "being pleased with" which is spoken of in various aesthetic treatises. In its very beginning it is a state of an excitement with the quality which has imposed itself on us in the object perceived. While not realizing, in the first moment, distinctly what kind of quality it is, we feel only that it has allured us to itself, impelled us to give attention to it, to possess it in a direct, intuitive contact. In this excitement there is also included a moment of a usually pleasant astonishment on account of the appearance of the preliminary exciting quality, or rather of astonishment that it is "such a one," though we have not yet even had time to attain a distinct, intended and conscious grasp of this quality. At first—to express ourselves metaphorically—it merely "touches" us, excites us, and stirs us up in a peculiar way. This excitement transforms itself into a form of falling in love (of "eros") with the quality, which imposes itself on us. In the further phase of preliminary emotion it changes into a composite emotional experience in which there may be distinguished the following moments: a) an emotional, and as yet still in germ, direct intercourse with the quality experienced; b) a sort of desire to possess this quality and to augment the delight promised by an intuitive possession of it; c) a tendency to satiate oneself with the quality in question, to consolidate the possession of it.

Hence, though the preliminary emotion undoubtedly includes an emotional element, there also distinctly occur in it some moments whose nature is rather that of desire, namely, of a desire directed to the *quality,* which is given to us at first against the *background* of an object perceived with our senses: to speak of "pleasure" in this phase is to trivialize the problem. Moreover, this deviates from the truth because even in the preliminary emotion where there is a moment of pleasure, it is neither characteristic of it, nor does it exhaust the experience. On the contrary, there may appear in it also a peculiar "displeasure" (if we are by no means to dispense with the use of such vague expressions). This is so because the preliminary aesthetic emotion is full of *dynamism—eagerness for satiation,* which occurs where and only where we have already been stirred up, excited with a quality, but not yet succeeded in the

attainment of such a direct, intuitive intercourse with it, that we could be "ravished" by it. This want of satiation ("desire") may be considered by some a moment of "disagreeableness." But from the moments of desire, included in a preliminary emotion, there develop both the continuation of the process of aesthetic experience and the formation of its intentional correlative: of an aesthetic object. This is why the emotion in question is a preliminary one.

IV. CONSEQUENCES OF THE PRELIMINARY EMOTION. But, let us consider first the *direct* consequences of the occurrence of a preliminary emotion. They go in various directions.

The occurrence of a preliminary aesthetic emotion (in one's stream of experiences) entails usually, first of all, a *check* of the previous "normal" course of experiences and activities concerning the objects of the surrounding real world. What we were occupied with a moment before, though maybe very important to us awhile ago, suddenly lost its significance, turned uninteresting, indifferent. Therefore we do not continue —even if it be only "for a moment"—our business in the course of which the quality (usually one related to an object) evoking the preliminary emotion has imposed itself on us. To take an example: how often when walking a mountain path—occupied with paying attention to the details of the way which is not always safe—we are involuntarily "struck" with the so-called beauty of the landscape. Then we stop automatically. The details of the bends of the path we had climbed up to the summit have turned uninteresting; we have no time for them, something else is "attracting" us now. Similarly, we interrupt suddenly, many times, a talk on some important practical or theoretical affairs, because we have been accidentally dazzled with a casual quality evoking a preliminary emotion, e.g., with the beauty and a peculiar expression of the person who has just passed the street.

Along with this "check" there goes a partial *extinguishing* or even the complete *removing* of actual experiences concerning the things and affairs of the surrounding real world. There occurs a distinct *narrowing* of the field of consciousness with reference to this world, and though we do not lose an unconscious sensation of its presence and existence, though we continue feeling in the world, the conviction of the existence of the real world, which constantly colors all our actuality, withdraws somehow into shade, loses its importance and strength. In the later phases of an intensive aesthetic experience there may occur a peculiar —and how well-known to us—phenomenon of a quasi-oblivion of the real world. This fact is directly connected with the change of attitude which is accomplished in us due to a preliminary aesthetic emotion. I shall soon come back to this question again.

The "check" of which we speak here may be stronger and may last for a longer time, or it may be weaker and fleeting, depending on the strength of the preliminary emotion and its relation to our previous concerns. If this strength is not great and if, at the same time, the affairs of

daily life are important enough, there is no continuation of an aesthetic experience. After a fleeting check of the course of daily life we come back to it and a disorientation occurring at this moment, on this occasion, proves best that a check has occurred. Again, if the process of aesthetic experience develops further, the check is permanent and it is necessary either that the whole aesthetic process take place or that a new, stronger stimulus of "daily life" intervene for us to come back to the course of affairs interrupted by the preliminary emotion. The *phenomenon of return* itself is very characteristic. It requires not only a repeated reference to the course of the interrupted activites and affairs, a fresh orientation in the past situation, and a search for its "continuation," but—what is more important—it involves a repeated *change of attitude* to the very same we had assumed *before* the commencement of the aesthetic process. This proves, *inter alia,* that in the moment in which we are excited with a quality not indifferent to us and experience the preliminary emotion, there is being accomplished in us—due to precisely this emotion—a change of psychic attitude. The "check" is only an external expression of this change.

Under the influence of a preliminary aesthetic emotion, however, there is accomplished in us not only the mere check of the further course of current activities of our daily life. As I have already remarked, the phase of our actual "present" is normally "rimmed" with a reminiscence of bygone experiences of not long ago and somehow connected, more or less loosely, with our "present" as well as with a perspective of our "nearest" future, which however, we usually do not clearly realize. Now, the preliminary emotion causes a considerable *damping* of the reminiscence of the experiences enacted directly before it and, at the same time, removes or damps this perspective of the future, which had appeared to us before the emotion in question. In consequence of this, our new "present," filled up with the preliminary emotion and with the continuance of the aesthetic experience, loses all distinct connection with our direct past and future within the course of our "daily life." It forms a *secluded whole,* which we include into the course of our life only *ex post,* when the aesthetic process is over. In this separation of an aesthetic experience from the course of affairs of daily life and in this immersion in an actual aesthetic experience is what is called by Stanislaw Ossowski—if I understand him well—the "living with a moment" and what is considered by him the principal moment characteristic of an aesthetic experience. As we see, this moment is derivative, descended from the preliminary emotion and closely connected with its consequences which will be spoken of soon. However, the moment mentioned is not characteristic of an aesthetic experience, because such an insulation, such a seclusion in an actual experiencing, may be evoked also by some other strong experiences, which carry us out beyond the range of our daily affairs, e.g., in a very concentrated purely theoretical research, when we are absorbed in a vexatious problem, a similar insulation of the present occurs. This appears distinctly especially where the investigations are concerned

with very abstract problems, of no relation to the surrounding phenomenal real world, e.g., in some mathematical or philosophical researches.

A preliminary emotion—and this is its most important function—causes a *change of our attitude:* a transition from a natural attitude of practical life into a specifically aesthetic one. The emotion (evoked by a quality or a so-called "gestalt" which excites us, containing, at the same time, a moment of desire, a longing for satiation with an intuitively given quality) brings the change about from a natural attitude directed to some existing *facts,* or to those to come in the range of the real world, to an attitude directed to *an intuitive intercourse with qualitative essences.* Both in sense, or inward, perception which is involved in our practical behavior (settling of daily life affairs, realizing the new state of things) and in the perception which we carry out for purely investigative purposes, we look for what *is.* In both cases *real* objects and facts are the matter of our perception. Of course, it is certainly not indifferent *what* the character of what we perceive is like—and our considerable efforts go in this direction—but, what is ultimately important to us is the fact that something *is* as it is. Therefore our cognitive activities (purely investigative ones or those undertaken for practical purposes) culminate in a *conviction of the existence* of a fact or of an object in the real or in the ideal world. Normally all those cognitive and practical activities are accomplished against the background of a general *conviction of the existence* of the real world in which we too exist, a conviction which is steadily entertained in our natural attitude. Now, the moment a preliminary aesthetic emotion has appeared in us, the conviction mentioned is not, indeed, either called in question or excluded from the range of our practical convictions, but it is—as I have already remarked—removed, as if to the periphery of consciousness, and damped. This goes along with the fact that, at the same time, due to the preliminary emotion, we begin to be orientated not to the *fact* of the real existence of qualities of some kind or other, but to the qualities *themselves* (if it may be said so—to the "contents" of these qualities). Their actual appearance in some real object, as its properties, becomes for us altogether indifferent. Thus, it does not matter in particular to us whether the given thing *is really* as we initially (before the preliminary emotion) perceive it, or only "appears" to be. For it might only "have appeared" so, and such appearing is fully sufficient for "seeing," for an intuitive grasp of the qualities themselves. Therefore, under the influence of the preliminary emotion, the sense perception, among the data of which there had primarily occurred the quality evoking the emotion in question, is essentially modified: a. the conviction of the existence of the thing perceived, which conviction is normally included in an act of sense perception, is deprived of its binding power, is—to use an expression of Husserl—"neutralized"; b. the quality, which had primarily occurred as a property of a real thing given in this perception, becomes, as it were, freed from this formal structure; it remains for a moment a pure quality, usually to become in the further phases of the process of the aesthetic experience *a center of crystalliza-*

tion for a new object: an aesthetic object. This is, perhaps, the most radical change of attitude that may be accomplished in our psychic life. Thus, it is no wonder that an aesthetic experience separates so much from the course of our daily lives and causes such a "check" of our daily activities that there occurs the phenomenon of "forgetting the world," and that either an exhaustion of the aesthetic experience itself or a stronger stimulus "from without"—i.e., from the real world—is necessary for the "return" we spoke of above to be accomplished.

However, it should not be supposed, on this basis, that an aesthetic experience is a purely passive, and noncreative "contemplating" of a quality (speaking more coarsely, a gaping at the quality), as opposed to an "active" practical life. On the contrary, it is a phase of a very *active,* intensive, and creative life of an individual, that these activities do not evoke any changes in the surrounding real world, nor are they "calculated" to do so. It is, moreover, true—as it will yet be proved—that the whole process of aesthetic experience includes, on the one hand, *active phases,* on the other hand, again, the fleeting phases of a passive experiencing, the moments of turning motionless and contemplative.

V. RETURNING TO THE INITIAL QUALITY AND THE BUILD-UP OF THE AESTHETIC OBJECT. The preliminary emotion includes, as I have already noted, a tendency toward a satiation with the exciting quality and toward a consolidation of the possession of it in an intuitive intercourse. Accordingly, the preliminary emotion—while not becoming extinct itself, but as if forming a basis for further phases of aesthetic experience—changes into such a stage of this experience in which an *intuitive grasp* (perception) of the same quality, which has evoked the emotion, prevails. After the phase of emotion, which absorbs us for a while, there follows a return to this quality. Though the grasp of it is accomplished against the *background* (on the basis) of the continuance of the previous sense perception, the modification of this perception, described above, brings it about that the given quality advances to the front and is now grasped much more distinctly and fully than at the time it only "imposed" itself on us. Secondly, it becomes now *itself* (and not the thing, against the background of which it occurs) an *object* of perception, and, at last, it begins to *separate from its primary surroundings.* As we perceive it, having previously experienced the preliminary emotion and being still moved by it, the quality perceived now assumes some secondary moments: it fulfills our desire to "see" it, satisfies our longing (at least to some degree), and in connection with this—to speak popularly—it becomes "more beautiful." It assumes a brightness, a grace, and a charm which it did not possess before. We satiate ourselves with this charm, and the quality which sates us in this way becomes for us a *value* of a peculiar kind—a value which is not estimated in an unimpassioned act of judgment, but is directly felt. This evokes in us a *new wave of emotion* which is, this time, really a form of *being pleased with,* or rejoicing and caressing ourselves by the "view," by the *presence* of the given quality, a moment

of "intoxication"—almost similar to getting intoxicated with the smell of flowers.

But becoming satiated with something almost always includes a germ of new longings and desires. Therefore, this second phase of emotion, arising in an intuitive intercourse with the quality perceived, is, likewise usually, no termination of the whole aesthetic process (though this is also possible). For two reasons, in particular, a feeling of a want of satiation may arise. Either the quality perceived aesthetically is such that it calls for a completion, or there appear, during the perception of it, some new details of the object against the background of which it has occurred, namely, details of such a kind that they harmonize with the quality given at first, enriching the primary essence. Then a further development of aesthetic experience begins, which is pretty complicated and diversified. Moreover, it may progress in two different situations, namely: either the preliminary emotion and the primary quality perceived aesthetically excite us to *freely* form an aesthetic object *without any further contact* with the object found in the surrounding world, or the quality in question appears against the background of the so-called work of art, i.e., usually a real object (sculpture, picture, edifice, etc.) shaped by the artist in such a way that, if perceived in an aesthetic attitude, it provides a psychic subject with stimuli to form a corresponding aesthetic object. I shall not analyze here the first case, because what matters in it is rather the creative process of the artist. We have to occupy ourselves with the second case.

Now, having returned to the quality which has evoked the preliminary emotion, we find anew, in this case, the object (the work of art), against the background of which this quality has primarily appeared and where it continues to appear. However, in a more different way, as in the meantime the corresponding perception has been modified. Oriented exclusively now to the qualities, eager to be satiated with the "view" of them (with their evident presence), we either notice a *deficiency* in the quality itself—this may be a quality of a developing melody the continuation of which "invites" to be finished, or a peculiar facial expression, e.g., in a sculpture, which has not itself been noticed in details, or a vague silhouette of the façade of a gothic cathedral which "calls" to be filled up with further details, and the like—or *new details* of the given work of art impose themselves on us. In the first case, we search ourselves for those qualities which "suggest themselves" for the completion of the whole. It may happen, however, that the object found (a work of art) does *not* supply us with a quality, the lack of which admits of being felt, and which, if found, would give a new harmony of qualities, as yet only anticipated. Then a separate painful effort is needed in order to *find* this complementary quality or an ensemble of qualities, with the aid of a corresponding *representation.* Suppose, we have succeeded in this. Then two different cases may yet occur:

1. The representation of the complementary quality found is so vivid that this quality (without our explicit knowledge of this fact) is *imposed*

upon the work of art perceived, though the work itself does not authorize us to do so. We see it, then, under the aspect of the harmony of qualities which is formed by us (from among these only the single quality, the "initial" one, is imposed on us as the work of art), and as if overlooking its deficiencies, we *improve it*. For an aesthetic object has been formed whose qualitative content is richer than that suggested by the work itself. At the same time, just by this imposing of a certain harmony of qualities, e.g., upon a piece of marble, it seems that it is this piece which functions as a basis of these qualities. We forget the difference between the aesthetic object formed and a real object, the more so as, at the same time, there has occurred a modification of the perception of this real object in its role of a basis. The work of art and the aesthetic object seem to be identical; the conviction arises that it is the work itself which possesses the aesthetic values contained in a harmony of qualities, that it is the work *itself* that we perceive, e.g., in the "beauty." From there the erroneous theories originate of which we spoke at the beginning, and it is only in a scientific analysis that the things prove different.

2. The representation of the complementary quality may, however, not be vivid and concrete enough to lead to the said "imposition" of this quality upon a work of art. It is true that this new quality (or, in the prolonged process, the whole ensemble of qualities) enters into harmony with the initial quality and forms with it a "well closed" qualitative whole. The details of the work of art that we perceive simultaneously not only do not contain the quality in question, but, moreover, do not agree with it. Thus it is for two reasons that there does not occur an imposition of the quality upon a seen work of art, and this work's being different from the harmony of qualities represented becomes in our eyes its *deficiency* or *defect*. In connection with this there occurs in us a response to the work of art perceived (in an already modified sense), a *negative emotional reaction:* we are not "pleased" with the work of art, it "shocks" us, it "falls short" of expectations. It may be said that, in this case, there are constituted, properly speaking, *two* aesthetic objects: the one, *imagined* vividly, with a full (finished) harmony of qualities, the other perceived against the background of perceptive data, "deficient," "ugly." We live, then, in a curiously composite, as if two-faced, aesthetic experience which includes the twofold *emotional responses* to the contrasting aesthetic objects formed. Our experience may end in this dissonance, or it may result in a rejecting of the "ugly" work of art and an exclusive immersion in the contemplation of the aesthetic object formed in representation, or, at last, the perception of the "deficient," ugly work of art may prevail, and then the whole experience will terminate in a final constitution of a negatively valuable aesthetic object with an emotional response proper to it.

The consideration of the last case has brought us nearer to the situation in which—after our return to an emotional perception of the initial quality—the work itself suggests its further details to us, and, in particular, the further qualities evoking in us a new wave of aesthetic excite-

ment (which we have described previously as the preliminary emotion). Suppose also—this case being of peculiar interest to us with regard to later considerations—that having once experienced a preliminary emotion, and returning to an intuitive grasp of the initial quality we do this in such an attitude of mind that the aesthetic object, which we hope to arrive at in the further aesthetic process, *will be shaped, if possible, in such a way that it will be near to the work of art* which has supplied us with the preliminary quality. Then we do not—so to speak—wait passively for the work of art itself to impose on us new qualities aesthetically exciting, but we do avail ourselves of the possibilities offered by the work of art and search *in it* for such sides and details as would enable us to grasp new qualities entering into harmony with the initial quality.

This requires that the work of art be perceived attentively, from all points of view, always in acts of perception modified by the preliminary emotion, i.e., in an *attitude oriented toward qualities,* and therefore disregarding—so to speak—their function of qualifying a real object, with a view to finding in it such qualities as would give with the initial quality a *harmony of qualities.* This usually cannot be done "at one stroke," nor in such a way that it would be possible to see beforehand at which harmony of qualities we finally arrive. Not "at one stroke," because such works of art as a sculpture, an architectural work, or a painting, must be beheld from different sides and different points of view and the qualities supplied us in each phase ought to be harmonized both within the particular phase and—if we are permitted to speak so—between the phases. This holds even with regard to paintings. Even if we grasp in the first moment (from a certain point of view) the *whole* of a picture, we pay attention, later on, to its various details and parts from various points of view, supplementing the "first impression" of the whole with the qualities of details and with their relations. It is not otherwise with the works of art which—as a literary or a musical work—cannot be comprised in concretization within a single moment of time.

In this whole perceptive process there is accomplished two kinds of *formation* of the qualities grasped: a. into *categorial structures,* b. into *qualitative harmony structures.*

If, e.g., the quality, which has evoked in us a preliminary emotion, is the slenderness of shape proper to a human body, having perceived this shape, we grasp it just as the shape of a *human* body, though confining the matter to pure vision, we are confronted with a piece of stone. We pose a corresponding *subject of properties,* which would underlie the quality of the given shape: *a human body,* and *not this* subject of properties which belongs *in reality* to the said shape (i.e., a piece of stone or that of a canvas covered with pigments). Similarly, in other cases of the so-called "representational art": upon the qualities given we are, as it were, imposing the categorial structure of such an object represented as may appear in the *given* qualities. Thereby we *leave the realm of the real* objects perceived (of a given work of art—stone, building, canvas), substituting an entirely different subject of properties for the removed sub-

ject of properties. The new subject should be chosen in such a way that it could be a substratum just of the qualities given; or, in other words: *this substratum is determined in its qualitative equipment by the choice of the qualities grasped as well as by the relations between them.* As this new subject of properties—having been posed by us—begins, in turn, to appear itself in concrete qualities given in an evident way, it assumes the *character of a separate entity, which becomes present to us.* After the phase of the categorial *forming* of the object (represented) there follows correlatively the phase of *perception* (as if of reception) of this object by the subject which has aesthetic experiences, as well as the phase of a manifold *emotional* reaction to the quasi-existing object posed.

Here, in this process of constructing a new subject of properties to supply a substratum to the qualities given, there is accomplished what is probably, *inter alia,* meant by Th. Lipps when he speaks of "empathy" (Einfühlung) and of "aesthetic reality" as an analogue of "empathy." This is especially the case when we add to the qualities given a *psychic* or a *psycho-physical* subject of properties. Then we "project" into the object of contemplation not only the said subject, but also its particular psychic states, those namely whose "outward expression" (e.g., the line of lips relaxed in smile) appears among the qualities given. The quality of this "expression" imposes itself on us; and if perceived in an emotional sympathy it leads to the *"projecting,"* e.g., of joy or of a joyous enthusiasm into the person posed by us. Again, when the "projection" has been accomplished, a peculiar *intercourse* with the person posed and with his psychic state takes place. There arise in us feelings *similar* to those we would entertain if we, "in fact," conversed in real life with such a person in such a psychic state, e.g., acts of joy or enthusiasm participating in another person's feelings. In other words, there arises a peculiar *community of experience* with the person posed by us and yet as if already possessing his own reality and his own life. These acts of emotional community of experience are the *first* form of emotional *response* of the experiencing subject to the aesthetic object formed. There exists also the *second* form of this response, but it is connected with the formation of the qualitative harmony structure, which will be discussed now.

The moment there is given to us, in an aesthetic process not a single simple quality but a multiplicity of qualities, these qualities do not usually appear loosely—so to speak—one alongside of another, but become harmonized into a single whole. "To become harmonized" means, *inter alia:*

Each one of the affects, in greater or less degree and in various ways, the remaining ones. This affecting manifests itself in a qualitative change, in a deviation of the given quality in this or that direction. Moreover, this reaction is usually reciprocal. The quality appearing in an "ensemble" with other qualities of a particuilar kind is not exactly the same as it would be, if it appeared quite separately (if this were possible) or if it appeared in another ensemble with different qualities.

Formally this manifests itself in a peculiar structure of "appertaining" of the given quality to a whole, in the loss of its absolute peculiarity and independence.

A reciprocal modification of the coexisting qualities may lead to the appearance of an entirely new quality, constituted "upon" those modified qualities. It cannot be identified either with any of these "underlying" qualities, or with the relations between them, or with the fact of coexistence of many different qualities. It is, as I have said, a *new quality* (with regard to its underlying qualities), the appearance of which depends on the coexistence of a number of various qualities reciprocally modified. If two tones, c and e, sound together, there appears, besides the *full* qualities of these tones reciprocally modified, a specific *quality of the chord* (so distinctly *different,* e.g., in the cases of the so-called minor or major third, as opposed to the fourth or the fifth), which is here—as it is known—independent of the absolute pitch of the tones, depending only on their relative pitch. This new quality is, as it were, a cramp joining its underlying modified qualities into a *whole* and conferring on this whole a peculiar *qualitative* stigma. I shall call it a "harmony quality." As it bestows a uniform character, a gestalt, upon the ensemble of qualities, it is also sometimes called, ever since the time of Ehrenfels and then by the so-called Gestaltpsychologie, a "gestalt quality" (Gestaltqualität), or "gestalt," "structure," "wholeness" (Ganzheit), and the like. This quality is characterized, *inter alia,* by the fact that it does not veil by its very presence its underlying qualities. Therefore, wherever it appears, we have before us not only this quality, something absolutely simple and uniform, but always a *qualitative ensemble,* at times very rich, displaying a harmonized variety of qualities *in spite* of the uniformity of the harmony quality. Moreover, though the harmony quality be *the same,* the ensemble of qualities may yet be diverse, because as it is proved by experience there may occur, *within certain limits,* various deviations and changes among the qualities underlying the harmony ("gestalt") quality which integrates them. On the contrary, it should be noticed that it is *by no means every* ensemble of qualities that could entail a harmony and a harmony quality. The laws determining the circumstances in which this is the case and those in which it is not have been, as yet, investigated little.

Among the qualities underlying the harmony quality there may occur *separate* groupings into some kind of *parts* of the whole, the relation between the qualities within the limits of each part being closer that that between the qualities belonging to different parts. In connection with this, there are produced the gestalt qualities of higher and lower degrees which in their turn harmonize with one another, etc. The whole, losing nothing of its uniformity due to the highest quality pervading the *whole* of the ensemble, is then characterized by a peculiar *arrangement of parts* which may be diverse, though the final harmony quality be the same. It is this "arrangement of parts" of a harmony of qualities which is what should be called, in the strict sense of the word, its "structure"

and what should be distinguished from the harmony quality (gestalt).

The formation in direct perception of such a harmony of qualities, having some structure or other, depends to a considerable degree on the mode of behavior of the person having aesthetic experiences. In particular, the division of the whole—while the choice of the qualities remains *the same*—is often effected in different ways, depending on the course of the aesthetic process. The accomplishment of this division is the second process of the *forming* of a harmony of qualities which I have mentioned above. It is only when this division has been accomplished that the whole of an aesthetic object assumes a transparent, organic design, that it possesses a finished aesthetic structure.

The obtaining of an arranged harmony of qualities with a final harmony quality is, so to speak, the final *aim* of the whole aesthetic process, and, at least, of its creating phase. To the attainment of this aim there is *subordinated, inter alia,* the categorial forming of an aesthetic object (cf. sub a). This means that the categorial forming of an aesthetic object is carried out in such a way that a possibly rich and valuable harmony of qualities is obtained. The harmony of qualities and, in particular, its quality, is—if one is permitted to say so—the final *principle of the creation and of the existence* of an aesthetic object. The work of art leads, if not to a single precisely determined harmony of qualities, at least to a number of admissible qualitative harmonies which are suggested to the percipient. Whether and just which of these harmonies will be constituted in an aesthetic experience depends, *inter alia,* on the course of the aesthetic process.

The formation of a harmony of qualities is many times a difficult and painful proceeding, especially if the work of art perceived, on account of its properties, refuses the amount of help that would suffice. It happens, therefore, that we are forced to compose the supplementary moments or parts of an ensemble, and feeling the lack of them as well as anticipating the final harmony quality we are, nevertheless, as yet unable to explicitly "see" the missing qualitative complement and, in consequence of this, to "see" the final harmony gestalt. When we, at last, succeed in doing this, the constitution of the aesthetic object is finished. Then the last phase of aesthetic experience begins, which is in a sense its culmination.

VI. THE FINAL PHASE OF AN AESTHETIC EXPERIENCE. The previous phases of the aesthetic experience are characterized by the fact that in a composite structure of this experience there may be distinguished the three kinds of elements: a. emotional (aesthetic excitement), b. creative (active)—constitution of an aesthetic object, c. passive—perception of the qualities already revealed and harmonized. The particular phases of the aesthetic experience are in various ways dominated by the particular elements, one time some of the elements prevailing, another time the others. This whole process is characterized by a peculiar *searching disquietude,* a changeability full of dynamism. In contrast with this, in the

final phase of an aesthetic experience there ensues an *appeasement* in the sense that, on the one hand, there is a rather quiet *gazing upon* (contemplating) the qualitative harmony of the aesthetic object already constituted and a "taking in" of these qualities. On the other hand, along with this, there proceeds what I have named the second form of emotional response to a harmony of qualities. And namely, there arise some feelings in which an *acknowledgement of the value* of the constituted aesthetic object is taking place. Such experiences as being pleased with, admiration, rapture, are various *intentional feelings*—M. Scheler spoke of an "intentionales Fühlen" as opposed to a "Gefühl"—in which, while directly confronting an aesthetic object perceived, we pay, so to speak, "homage" to it, we acknowledge its value in the very feeling. It is this acknowledgement, in a feeling, of the value of an aesthetic object which is our "worthy," proper response to the value (D. Hildebrand speaks of a "Wertantwort"), which is given to us in the contemplation of a constituted aesthetic object. This acknowledgement is, at the same time, so coalesced with a simultaneous "gazing" upon the qualities of the object that it forms with it a single whole.

It is only in such direct intercourse with an aesthetic object that a primary and vivid emotional response is possible. "To evaluate" without being moved, i.e., to form a *judgment* of the aesthetic value of something, is possible, when using proper technical criteria, even without the accomplishment of an aesthetic process, and thus also without waiting for a harmony of qualities to be constituted in an evident way. People who have much to do with works of art and who have accustomed themselves to those works so much that they are "spoiled" to a certain degree, and are not easily enraptured by anything, develop a peculiar routine to take notice of various derivative details of the works of art on the basis of which details they *infer* (dispensing with constituting or directly perceiving a harmony of qualities) whether a given work of art may or may not lead to a valuable aesthetic object. They evaluate a *work of art* considering the *possibilities* which are contained in it, and attribute a value to it if they expect it may lead to a valuable aesthetic object. To give, in these circumstances and in this sense, a judgment of the value of a work of art is a purely *intellectual* experience, and, at any rate, an experience as intellectual as e.g., stating that a certain tree is an oak, the only difference being that it is *something else* which is said of an object in the latter case as opposed to the former one. Such an inferred judgment concerning value may even be pertinent, nevertheless, the *experience* which alone, and in an essential way, makes this judgment *valid* (one may also say— which justifies it) lies in the final phase of the aesthetic process, and, in particular, in the acknowledgement of an aesthetic object, an acknowledgement which has a character of feeling and is grounded in the "seeing" of a harmony of qualities. Therefore, strictly speaking, it is only those judgments concerning value which are given *on the basis* of an aesthetic process, and when such a process has been accomplished, that are *justified*. Again, the judgments concerning value which are obtained

by professional critics, many times with great routine, are rather a merely *indirect* estimation not of the *value* of an *aesthetic* object itself, but only of a *work of art* as a means which may lead to a positively valuable aesthetic object if an aesthetic experience is accomplished. Therefore, even if they are not mistaken in their evaluation of the *works of art,* the professional critics know, and may say many times very little about the real contents of the corresponding *aesthetic objects.* They betray themselves the moment they begin to describe as seeming aesthetic objects what they have relevantly evaluated as works of art. The value of an aesthetic object is not the value of a means leading to an end. It is not something which may be ascribed to the object with regard to some objects or states of things existing *outside* it, but it is something *contained in the object itself* and based on the qualities and the harmony of qualities of the aesthetic object itself. Therefore, while acknowledging it and rendering justice to it in acts of emotional response, we remain in the nearest contact with the aesthetic object and confine ourselves to it. *Later on,* having experienced the whole aesthetic process and having detached ourselves from the aesthetic object which is present to us in an evident way, we may pronounce judgments on value, comparative evaluations, etc. All this is *no* longer accomplished in an aesthetic attitude but in an investigating-*cognitive* attitude to which we return each time we wish to realize, without being affected, what has been given to us in the aesthetic experience, and, so to speak, to determine notionally the *facit* of this experience.

No doubt, the *estimation* of the value of an aesthetic object is not to be disregarded, because it is a part of an *intellectual expression and grasp* of what has appeared in an aesthetic experience under the form of a harmony of qualities, directly seen and, at the same time, felt. To have aesthetic experiences, and, in particular, to contemplate a harmony of qualities in an intuitive grasp does not yet mean to *know* (in a narrow sense of this word) what the given aesthetic object is like, which are the qualities occurring in it, and what is its immanent value. In order to obtain this knowledge it is necessary to *return* to an investigating attitude, or, rather, speaking more exactly: it is necessary to *constitute* "upon" an already accomplished aesthetic experience, a new experience concerning the constituted aesthetic object, to analyze and to rationalize, to a certain degree, what has been given in direct intercourse with the object, an intercourse full of emotions, as well as to formulate all this in conscious notions or judgments. Again, this knowledge cannot be obtained without an *aesthetic experience,* and especially without its last phase. Hence, one who begins with a purely investigating cognition of a work of art as a real object, instead of constituting this object in an aesthetic experience and experiencing its peculiar visage, will never succeed in obtaining for himself a knowledge of *aesthetic* values. On the other hand, however, an aesthetic experience itself is unable to supply us this knowledge; it is an experience which is—as is every experience —only "half" of a cognition.

Of course, not every aesthetic experience ends with the delineated culmination of a *positive* emotional response to the value of an aesthetic object, revealing itself in it. A *negative* emotional response under the form of aversion, abomination, indignation, boredom, etc., may be another final tone of an aesthetic experience. This is the case, *inter alia,* when an aesthetic object is not a *uniform harmony of qualities* "joined" to one another by the final harmony quality, i.e., when it is a "conglomeration" of the qualities not harmonized, rather than a coherent whole, its qualities neither "suggesting" nor postulating one another at all, on the contrary, postulating rather that they *do not coexist* within a *single* object. In such a case, the experience does not result in this "gazing" upon the harmony, nor in the satiation with the qualities, nor, at last, in this *intimacy and immediacy of a relation* with an aesthetic object, which are characteristic of the positive culmination of an aesthetic experience. It may rather be said that there is an apparent *distance* in relation to the object, and a feeling of condemnation (as an opposite to "acknowledgement") increases the said distance and compels us to reject the given aesthetic object altogether, to desist from looking at it—unless some reasons, e.g., theoretical ones, incline us to occupy ourselves with it. On the basis of such a negative emotional response there may also be accomplished an intellectual estimation of the value of the given aesthetic object.

In *both* the cases considered—and this is to be stressed—there is a constitution of an aesthetic object. But an aesthetic experience may not attain this culmination, it may not begin at all; correlatively: no aesthetic object will be constituted. A certain real object, intended by its creator as a work of art, may be to us *completely indifferent* aesthetically. We may pass it by unaffected, not being excited to a preliminary emotion. And, but for outside information that the object in question is a work of art, it wouldn't even occur to our minds that an aesthetic attitude toward it is possible. In such cases we often evaluate a "work of art" *in a negative way,* criticizing it severely but, strictly speaking, we are not right in doing so. There is no real aesthetic evaluation in such a case and the "work of art" should simply be disregarded.

In conclusion of the present considerations I should like to return for a moment to a question on which I have already touched. An aesthetic experience, in all its course and, in particular, in its *positive* culmination, includes undoubtedly some pleasant elements, and also evokes in us some further pleasant or unpleasant states of mind. It is a great delight to hold intercourse with an aesthetic object of high value, in direct contemplation and enthusiasm. But whoever considers this delight to be an essential and main moment of an aesthetic experience is precisely omitting this experience, occupying himself with its *derivative* phenomenon, *nota bene* with a phenomenon which may *not only* be evoked by an aesthetic experience. Passing by this experience he does not any more understand its *essential function,* which is to constitute aesthetic objects and to experience harmonies of qualities as well as their values in an

emotional-contemplative way. Similarly, whoever, wishing to have aesthetic experiences, is searching only for delight attainable in such experiences, does not, strictly speaking, know *aesthetic* values. Nor does he usually obtain the final constitution of a harmony of qualities, but is delighted only with *his own experiences,* especially with the emotions which are, at best, the feelings of *sympathy* with the objects *represented* (he is, e.g., impressed with the fate of literary heroes, indulges himself in erotic excitement, grows inflamed with certain ideals—social ones, etc.), and not with an aesthetic emotion in the strict sense of the word.

If the emotional response is positive, the final constitution of an aesthetic object leads to one more peculiar moment in the culminating phase of the aesthetic experience. When discussing the modification in an aesthetic experience under the influence of a preliminary emotion the perception of the object against the background of which the initial quality has appeared is subjected I mentioned that I disagreed with the opinion that an aesthetic experience should be—to use an expression of Husserl—*neutralized.* It is only now that I can justify my view.

In an aesthetic experience there appear various moments of the nature of a conviction. Some of them, *akin* to those which occur in cognitive experiences (and particularly in perceptive ones) and are related to real objects, concern the objects represented. These convictions occur only in *some* aesthetic experiences, in an aesthetic intercourse with the works of sculpture, painting, literature. Thus they are not indispensable for an aesthetic experience, though they may enrich this experience and influence its course every time they appear, as is the case with an aesthetic object composed of many strata, the stratum of the represented objects included, which we consider to be richer. They are a peculiar *variety* of the conviction of the reality of the cognized object. It is true, we do not seriously believe the objects represented in a work do exist in reality, but we behave as if we *feigned* such a conviction. This is quite a peculiar variation of the conviction of reality, which is very difficult to describe, but which we know very well from direct experience. The occurrence of this *variety* of conviction is another consequence of the preliminary emotion, not yet considered, and its appearance in an aesthetic experience is directly related to the categorial forming of the contents of an aesthetic object: to the supplementing of the qualities given with corresponding subjects of properties, determined by the qualities themselves. This variety of conviction is thus directly connected with an aesthetic "empathy." The character of quasi-reality of the objects represented in an aesthetic object is an intentional analogue of these conviction-moments.

Though this variety of conviction may occur in a natural way in an aesthetic experience, it is not, as I have already mentioned, characteristic of this experience, it is not specifically "aesthetic." It does not occur in aesthetic experiences concerning the so-called abstract art, e.g., in those concerning music, architecture, abstract painting, and the like. Again, in *every* aesthetic experience in which there has occurred at all

the constitution of an aesthetic object, there is a conviction-moment concerning the *whole* aesthetic object as a *harmony of qualities.* This is also a moment of conviction of *existence* or nonexistence, but this existence cannot be identified with the *real* existence in the world. Though an aesthetic experience is *creative* in the sense that in its earlier phases it constitutes an aesthetic object, under the influence of certain real objects (works of art), it is, at the same time, an experience of a nature of discovery, as it detects peculiar harmonies of *qualities,* in particular the gestalt qualities pervading the whole of the ensemble. Now, the moment a harmony has been constituted and detected (similarly also *in the course* of experiencing particular qualities while detecting them) there arises in us a conviction of the existence or if one prefers—of the possibility of such a harmony of qualities, the existence of which we perhaps neither expected nor even anticipated. Many times when we are placed "in front" of such a harmony we are seized with a kind of astonishment: namely, we are surprised to see that "something of the kind" (such a harmony, such a contrast, such a rhythm, such a melodic line) is possible. This possibility is as if experimentally shown "ad oculos," "realized," in a creative-detective aesthetic experience. We see: *there is* something of this kind; and in the fact of stating and directly experiencing this existence there is contained this moment of conviction which I have just mentioned. This *detection* of a possible harmony of qualities "realized" in the concrete is where an essential kinship between an aesthetic and a cognitive experience lies. And, similarly as in the last case, there occurs here too a moment of conviction of the existence, in the world of pure qualities, of ideal qualitative harmonies, of particular qualities of some kind or other, of the qualitative harmony structures, etc.

It is impossible here to consider more thoroughly the sense in which we speak here of "existence," because some complicated existential-ontological considerations would be needed for which there is no place. For the time being, what matters is only to call attention to the fact that this kind of conviction-moment indeed occurs within an aesthetic experience, in its *positive* culmination; this moment is absolutely *independent* of the conviction of the reality of the surrounding real world, and even of the conviction concerning the quasi-existence of the objects represented in some aesthetic objects. This moment goes along with, or is transformed into, a *confirmation* of the existence, e.g., of a harmony, a confirmation which may also be described as *postulating* a prolonged existence of the harmony and its *being perpetuated.* The moment in question is closely related to an emotional acknowledgement of the value of the given harmony. Unlike this is what may be found in an aesthetic experience with a *negative* emotional response. The conviction-moment is here *negative*—in the sense of our being convinced of the nonexistence (impossibility) of a certain harmony of qualities which has failed to be constituted in the *given* aesthetic object (of a harmony searched for, anticipated, but—at least in the given case, with the aid of the qualities at disposal at the given moment—unattainable and therefore "unreal-

ized" in the concrete of the given aesthetic object). This negative conviction is at the same time connected with, or transformed into, a "denial" (refusal) of a continued existence to the qualitative essence occurring in the given aesthetic object. Not only do we not postulate or demand a "perpetuation" of something like the qualitative essence of the given aesthetic object, which has not been made uniform, but, moreover, we demand, as it were, its *annihilation*. This last suggestion, in turn, goes closely along with an emotional "rejection," with a "condemnation" of the nonuniform harmony of qualities the constitution of which has occurred in this case.

These are, in a most general outline, the main statements concerning an aesthetic experience. The present description contains some conscious simplifications, some idealizations, in order to grasp at once the whole of the general skeleton of an aesthetic experience. In practice there exist many varieties and many particular phases of the course of this experience, depending both on the type of the work of art from which the aesthetic experience is starting, and on the psychic type of person who has the aesthetic experiences, e.g., on his aesthetic susceptibility, his emotional and intellectual type, his aesthetic as well as general culture, etc. The elaboration of these varieties is a problem to be considered in detailed investigations which are impossible to carry out here. It is also beyond doubt that the above considerations require various supplements, even within the general scheme given here, as well as a critical discussion of various difficulties which arise in connection with the statements expressed. But all these questions are posterior ones and they require special studies and considerations.*

Note

1. This paper is a little part of my book in Polish about the cognition of a literary work (Lwów, 1937). It is a complementary study to the book "Das literarische Kunstwerk" (Halle, 1931).

 A literary work, and especially a literary work of art, can be read in many different ways: with a pure cognitive attitude as when we read, for example, a scientific work to obtain knowledge, and likewise with an aesthetic attitude, when we read it as literary consumers. It was therefore necessary to study the aesthetic experience (in German: "Erlebnis") in general to make clear what occurs in us during an aesthetic perception of a literary work of art.

Tertiary Qualities and Their Identification

R. W. Hepburn

Professor of Philosophy at the University of Edinburgh, Ronald W. Hepburn is co-author of Metaphysical Beliefs *(1957), and author of* Christianity and Paradox *(1958) as well as a number of philosophical articles.*

Emotions and Emotional Qualities

Works of art have, no doubt, something to do with emotion, but it is notoriously hard to determine what, precisely, this something is. Do works of art 'express' emotion, or 'evoke' it, 'represent' it, 'master' it, 'organize' it or 'purge' it? Or can they do several of these things—or all of them?

From *British Journal of Aesthetics,* Vol. 1, 1961. Reprinted by permission of the author and the British Society of Aesthetics.

From the constellation of problems here, problems on the border between aesthetics and the philosophy of mind, let us break off some manageable fragments for discussion. The fragments, I think, are important ones: but be it said at the start that many of the topics I shall *not* single out for treatment are quite as important in aesthetics as those I do. There is no attempt in this article to produce a general or comprehensive theory of 'art and emotion.' That would need a book.

Certain writers make a sharp distinction between the way in which ideas, concepts, meanings, can be *in* works of art, and the emotions, feelings, which a work is said to *evoke,* to *cause* in the reader or spectator. According to this view, if we often transfer emotion-epithets to works of art, and call them 'jolly,' 'joyous,' or 'frenzied,' we are well aware that we *are* transferring them, that in the last resort it is we who are made jolly or frenzied; and that our epithets are in fact characterizing the poem or piece of music in terms of its effects on us, not in terms of its own qualities. We are entitled to claim that meanings and ideas are 'objectively' in the works concerned: they can, for instance, be adequately and most often unambiguously specified. But since there can be no equally sensitive control of emotional response, we are here in the realm of the subjective.[1]

There are, however, a number of analyses which claim that emotions and feelings can be *in* works of art just as certainly as meanings and ideas can be in them. On this view, if I say 'The music is joyful,' I may not be speaking of my own feelings but of what I hear as a 'phenomenally objective quality of the music' itself. It is not the case, for instance, that listeners tend to report wildly divergent emotional qualities when attending to the same pieces of music: some experimental work has shown that if subjects are asked carefully to concentrate on the music (and not on their own feelings and fantasies), their reports on the music's emotional qualities are convergent. If, however, they are allowed to report on their own emotional states, their reports diverge noticeably. As O. K. Bouwsma put it: 'joy and sweetness, and sadness [can be] in the very words you hear.' 'The mood of a landscape,' wrote Otto Baensch, 'appears to us to be objectively given with it as one of its attributes belonging to it just like any other attribute we perceive it to have. . . . The landscape does not express the mood, but *has* it. . . .'[2]

Although neither of these two accounts of emotion and art-objects is free of difficulty, I think the stronger *prima facie* case can be made out for the second, the account which claims that emotional qualities can be described, with perfect propriety, as *in* works of art. We speak of a musical note as being 'high' or 'low'—the highness or lowness being heard as phenomenally in the note. From this there is a gentle transition to speaking of a phrase as 'incomplete,' 'questioning,' or 'nimble,' again reporting the heard quality of the sound, and on to emotional qualities in the strictest sense like 'melancholy,' 'tender,' 'plaintive.' Similarly in visual art, there is a gentle transition from speaking of a shape as having a 'three-dimensional look,' to having an 'awkward, unstable look' to hav-

ing a 'comic' or a 'melancholy' or 'angry' look. Without any sense of incongruity, we can bring together in one description of a shape words from different parts of this scale; for example, the shape is 'comic *and* awkward,' 'comically awkward.' At no point is there a shift from talk about the figure to talk about the spectator's response.

Note that the class of 'emotions proper' is not at all sharp-boundaried. In one direction, we gradually approach it from expressions (like 'awkward,' 'graceful,' 'elegant') that primarily describe manner-of-acting or -appearing. These tend to carry loose implications about what is *non*-behavioural. If, for instance, we say 'John rose to his feet awkwardly,' we are normally taken to imply that he lacked inner composure as well as outward grace. But the implication is certainly a loose one. A Bishop might mount the pulpit with great dignity (manner of acting); but the implication that he then experienced an inner sense of reverence and solemnity would be false, if such moments had long ago lost their power to move him. Yet the outward dignity might remain.

There are, however, some emotion-words, well within the territory of emotions proper, that make essential-reference to the non-behavioural. Sadness, nostalgia, depression, ecstasy—one may experience any of these and manage to inhibit most or all of their behavioural concomitants. The spectrum-scale from manner of acting to emotions with essentially 'inner' aspects is important to our present study; since works of art can display not only the former as emotional qualities but also the latter, which is the more remarkable feat.

Again—to resume the main argument—there are occasions when I may wish to say the following: 'The drawing (or the rondo) was joyful, but *I* was not joyful.' If I say 'This curve is graceful, and that jagged line intersecting it is tense and menacing,' I do not mean that *I* feel graceful on looking at the curve and then tense and menaced on looking at the jagged line. Instead, I may feel vaguely excited, delighted, or be entirely unmoved.

To claim that the emotional quality can be in the work of art is not of course to say that the word 'in' is used in precisely the same sense as when an emotion is said to be 'in' you or 'in' me. People experience emotions: works of art do not. (Cf. Bouwsma, op. cit., p. 78.) But nothing substantial would be gained by restricting the multi-purpose preposition 'in' to the case of emotions being 'in' persons. Had this been a *genetic* study, a study of the mechanisms by which aesthetic effects are produced, then we should have had to work out some theory of emotional 'projection,' and explore the analogies, hints and clues that we go on, when attributing emotional qualities to such inanimate things as carvings, lines, shapes and configurations of sounds. But our inquiry is phenomenological; we are asking what our experience is like, not how it is stage-managed.

Some elementary examples from music may help to clarify our claims so far. Within the classical idiom we feel that in most contexts a dominant seventh, or, say, a thirteenth, 'wants' to move to the tonic chord. The music wants, strives, to reach its resolution: the wanting is

not mine, as I listen to the chord, but the music's. This is one of *its* vicissitudes. If the music modulates into a 'bright' key, the brightness is not my brightness but again the music's. The music has its own phenomenal career. Suppose my radio is switched off while a seventh or leading-note of an ascending scale is being played, in a work of the classical period. It can readily be shown that I do not take this chord or note as a mere stimulus of unrest in me—an unrest that would be relieved by any tonic-chord stimulus in the same key, played fortuitously, say, by a boy in the street with a mouth-organ. What needs its resolution is that particular chord on the radio, not the disquiet aroused in me. But what of the gentleman who, hearing from his bed someone playing a seventh on the piano and carelessly leaving it unresolved, left his bed and resolved it himself? This is not really a counter-example to our theory. For, first, it was upon the same instrument that the seventh had to be resolved—not simply by humming or whistling the tonic chord in the warmth of bed. Second: we laugh at the story precisely because we normally objectify the uneasiness and disquiet as being in the music itself, one of its vicissitudes, and do not think of it as being transferred to the hearer so as to become *his* vicissitude instead.

Furthermore, one tends to be relatively detached from emotions in music. A piece of music may have the emotional quality of despair or grief, but I who listen enjoyably need by no means be in despair. I can relish and savour the anguish of the music: compound its despair with my delight. The emotion I feel, if any, is often a radically transformed version of the emotional quality of the music itself and not identical with it. Awareness of this transforming process helps to distance the music and the emotional qualities in it from me and my (hearer's) emotions. I have also an emotional *inertia:* even when the emotion I feel is roughly identifiable with the emotional quality of the music, the music's emotion may be intense, but mine sluggish. It may be uninterruptedly gay or wild, while my emotional response may be intermittent and fluctuating. In my ordinary perception of the external world I posit various abiding material objects, my house, my telephone, my watch, although my actual perception of these is intermittent and subject to the variations of perspective and lighting. Not very differently, I posit a continuing emotional progress in the music, despite the fact that I do not experience, do not 'have,' each successive emotion while the piece plays.

It might be tempting to argue that even if 'This tune is vivacious' does not mean 'This tune makes me feel vivacious now,' still it must mean 'This tune *tends* to make me, or most careful listeners, feel vivacious.' But I doubt whether this is so. As a psychological generalization it may be true that quite often vivacious tunes make us feel vivacious; but I may properly judge a tune to be vivacious by simply recognizing in it the presence of vivacity as a characteristic, without myself—or anyone else—even feeling vivacious on its account.

Try another sort of analysis. 'This musical phrase has emotion E' means 'The hearer of the phrase would experience emotion E (would come to have emotion E), *if*. . . .' *Prima facie,* one feels that this condi-

tional sentence must be completable. But what exactly would complete it? '. . . if the phrase were repeated several times, repeated until emotion is experienced.' That would not do; repetitions might cause the phrase to go dead on the hearer, to pall or exasperate or seem banal. '. . . if the phrase were played in isolation, under non-distracting conditions.' Again, no; since out of its musical context it might well take on a quite different emotional tone. These failures do not prove such a conditional-sentence analysis to be impossible, but it is hard to think up any other continuations after the 'if' that are not vulnerable to just as sharp objections.

One might try to make a last-ditch defence of the stimulus-response model of emotion in works of art by saying this: 'If works of art do not evoke full-blooded emotions, they at least arouse *images* of emotions.' 'Image of an emotion' is not an expression for which we often have a use—perhaps because having an emotion is not an affair of any single special sense, as seeing and hearing are. But it can easily be given a use. With emotions such as fear, exhilaration, despondency, the emotion-image would be a combination of kinaesthetic, visceral, visual or verbal images. And, just as, for example, visual images by themselves are most often schematic—a vague shape standing in for the appearance of a house—so with emotion-images: the kinaesthetic image of clenching fists may stand in for a constellation of occurrences and tendencies that make up 'being angry.' Suppose, then, that this is what we understand by an emotion-image. It needs no fresh argument to show that we often see or recognize what emotion is in a work of art without necessarily imaging any emotions at all. We can recognize anger without incipient clenching of fists; tranquillity without imaged relaxing of muscles.

Lastly, we can recall Coleridge's plain words in the *Dejection Ode:* 'I see, not feel, how beautiful they are.' We might substitute for 'beautiful' a more specific human-emotion word like 'fearsome,' 'serene'; and the sentences need not be uttered in Coleridge's mood of dejection.

We have been working so far with an unexamined and far too crude conception of emotion itself. Unless this crudeness is removed, our whole project of critically discriminating between rival accounts of emotion and art-works may well be jeopardized. It is not just that we may have to go a certain way with physicists and behaviourists and admit that emotions have much to do with overt, public behaviour. This does have to be admitted. But some recent philosophical analyses of emotion-concepts [3] have been shown that when, for instance, we say 'A feels remorse,' 'B is indignant,' 'C feels bitter,' we do something far more complex than claim A and B behave in certain identifiable ways and experience types of inner turmoil. Where is the extra complexity? Roughly speaking, it lies in the way concepts like 'remorse,' 'indignation' give interpretations of a situation, interpretations that go beyond the recording of acts and feel-

ings occurring at any particular moment. 'C feels bitter about the way he was treated' carries as part of its meaning 'C believes he *ought not* to have been so treated,' 'C believes he was treated *badly.*' That is, being bitter involves making certain evaluations, not simply having feelings or acting in particular ways. It is logically impossible to *hope* for something one does not favourably evaluate; or to *feel contrition,* unless one acknowledges oneself to have done something wrong. Traditional accounts of emotion tended to give central place to determinate, recognizable *feelings*—inner and private. Emotion-words were the labels of these feelings. The current opinion refuses to give pride of place to such feelings, and (in the case of some writers) denies even the *existence* of feelings specific to particular emotions. Instead, their analyses are given in terms of situation-appraisals plus an undifferentiated general excitation.

In the rest of this article I want to draw on these recent analyses of emotion, to the extent that they seem sound and helpful. In other respects, however, we should regard them as being as much *sub judice* as our two accounts of how emotions are communicated.

First of all, they can be invoked to support and reinforce the view that emotional qualities can be in works of art. Suppose I read a poem or attend a drama. I say 'This is jolly,' or 'this is pitiable'; and my judgment is possible only if I have made a conspectus, an overall survey of the situation presented, and deemed it appropriate to jollity or pity. Clearly, my judgment is an acknowledgment of qualities in the work itself. With a particular play, I may say 'No, not pitiable really'; and justify my remark by making value-judgments about the characters and situation concerned. 'He is not to be pitied: he is too much morally at fault.' The finale of an opera may ring false, because it simply has set aside all the pain and conflict that happened on the way to it. These, we judge, need to be reckoned with in the finale—as necessarily modifying, qualifying, its brash or headlong gaiety.

With emotional qualities like 'pitiable' or 'jolly' we are thinking of the presentation in a work of art of imagined human predicaments. These comprise the 'situations to be interpreted.' But a word of art *as a whole* may express a distinctive emotional quality, which is not simply that of the human predicaments it presents. Indeed, it may present none: or those it does present may be determined in their precise quality by stylistic factors and the individual handling of the medium. For instance, the emotional quality possessed by a human figure in an El Greco painting is determined both by the dramatic situation depicted and by the colouring, design and texture of the painting throughout.

We are, I think, exploring here one of the chief sources aesthetic value—both within art and in aesthetic experience of natural objects and events. First, within art: the complexity of the gestalts, the situation-conspectuses, the fusions of medium and human situations, all contribute to an unusually fine discrimination of emotional quality; and the savouring of this can be counted as one of the basic aesthetic worthwhileness.

On aesthetic experience outside art, two remarks may be offered. We could construct a scale on the following lines. At the one end are occasions when my emotions are based on awareness of only a minute part of my environment, and that sluggishly: or based on a sterotyped, generalized and meagre impression of it. I am sunk in apathy and passivity. I make no complex gestalt of my situation in its particularity. For example, I am aware only of the monotonous drumming of train-wheels, as I sit in my compartment. My emotion is a dull, undifferentiated depression. At the other end of the scale, my emotions are functions of an alert, active grasping of numerous features of my situation, held together as a single gestalt. In my compartment I make into one unity-of-feeling the train-wheels drumming, the lugubrious view from the window (steam and industrial fog), and the thought of meeting so-and-so, whom I dislike, at the end of my journey. My depression is highly particularized. Or again, if one is in love, an encounter with the loved one may acquire a specific, unrepeatable emotional quality—meeting so-and-so, on that particular day, in that particular park, with that wind and those exhilarating cumulus clouds overhead. Our scale, again, is a scale of increased emotional discrimination.

But as Kant reminds us, the world is not a given totality: my synopses can be complex but never complete. And it is one of the many distinctive things about works of art that our synopses of them can be complete: they are limited wholes, and in a great many cases wholes constructed so as to facilitate their being grasped synoptically. Disconsolate in the knowledge that synopses of nature are forever partial and ragged, we may turn to art in relief.

Especially important here are the contrasts between apathetic and alert perception, between a sluggish, passive and steroty ped impression and the active enterprise of organizing and unifying a situation. This makes it obvious that however we finally decide to describe the spectators' emotions in aesthetic experience, it will not be simply in terms of emotion-transfusions. For that is a language of passivity—the spectator as suffering manipulation, as having an emotion conjured up in him.

Further: if we locate one source of aesthetic value in fineness of emotional discrimination, we have a second source in the sense of alert conspectus-grasping itself, in the exhilarating activity of unifying far larger and more variegated 'manifolds' than we are accustomed or able to do in ordinary experience.[4]

Some pages ago I invoked Coleridge to testify that one can 'see, not feel how beautiful' things are, and suggested a reasonable extension to seeing, not feeling emotional qualities of specific kinds. But this use of Coleridge comes dangerously close to being *mis*use. Coleridge *was* dejected: and surely with some reason. Yet why should he have been, if aesthetic appreciation on its emotional side is simply the recognition of emotional qualities as in objects? Coleridge compels us to make some qualification to our account so far. One is not always content to say 'This music has the emotional quality of exuberance, but I am not in any way

stirred up by it.' This could very well be a discontented report; and the discontent can be of more than one kind. In some cases I may feel like a forlorn child looking through a window upon a party to which he has not been invited. Tiredness, anxiety, or some other psychological factors impair my responsiveness. Again, I might say 'I see what it is expressing, but it is too insipid to make a real impact on me.' I cannot feel that music as violent, fearsome or exuberant any more. Perhaps the musical idiom has gone jaded on me, or is over-familiar: or it now sounds anaemic because of more powerful effects obtained by more recent musical developments.

It might be asked of this last case, Why not retain the language of recognizing emotional qualities here? If a work is insipid, that could count as a quality of it as it is perceived by us to-day. But this would not really meet the case. It is a loss of *impact* that we are lamenting: the work fails to rouse us—and this is undeniably causal language, unlike the language we have so far examined. So it looks as if the model with which we have been working will not meet all aesthetic requirements.

Confirming this suspicion is the existence of a small class of emotions about which we seem able to speak *only* in the language of stimulus-response, cause-effect. For instance, in talking of that famous surrealist fur-lined cup, we do not say 'This painting is sick, nauseated,' but rather 'It makes me feel sick; it is nauseat*ing.*' We speak similarly about giddiness: not 'This is a dizzy picture,' but 'It makes one feel dizzy'—it is a dizzy-making picture.

The vocabulary of emotion-arousal may play a subordinate part in our talk of art-appreciation, but we seem unable to do without it. The two vocabularies (emotion-arousal and recognition of emotional quality) have interestingly different 'logics.' A conductor may say, while rehearsing an orchestra, 'Now, we'll take the vivacious passage once again—two bars after "M." Or, 'Clarinets, you made that lugubrious phrase sound almost skittish.' These and like remarks can be quite intelligible in their context, as they contain a reasonably clear descriptive content. But suppose the conductor says 'Now, back to the thrilling section again,' or 'You messed up the exciting (or overwhelming) passage,' members of the orchestra may well disagree over which bars are meant. That is to say, these emotion-words contain far less descriptive content, are in fact not emotional-quality words but response-to-stimulus words. We sense an oddness when someone says in a casual, unmoved voice (but without intending sarcasm), 'Yes, that was a sublime movement, wasn't it?" And we could add to the list of such words, 'awesome,' 'frightening,' 'dreadful,' 'harrowing,' 'touching,' 'exhilarating,' 'hilarious,' in most senses: all of which report on the successful arousal of emotion, not merely on the detection of an emotional quality. It is more logically odd to say 'That was exciting, overwhelming, music, but it didn't in the least excite me or make me feel overwhelmed' than to say 'That was tender, or sad, music, but I did not myself feel tender or sad.' With ingenuity, no doubt, contexts could sometimes be found that would mitigate the oddness. It is over-

simple to speak of two quite distinct vocabularies, for there are shadings, gradations, from one to the other.

And there are still other sorts of complexity. For instance, I may *recognize* in a painting the emotional quality of pathos, yet for some reason—perhaps because the painting too directly or crudely seeks to move me, because it rants or is sentimental—I feel not pathos nor any analogous emotion, but resentment instead. This would be not just another example of failing to be moved, but of being moved in a direction opposed to the emotional quality of the work, of emotionally resisting it. Alternatively and more happily, I may *submit* to a work of art, acquiesce, be in sympathy with its expression or portrayal of an emotion, whether or not I have the emotion aroused in me subsequently.

'Seeing, not feeling' can be sometimes an aesthetic impoverishment, somtimes normality. It is furthermore quite clear from reports upon aesthetic experience that individuals differ greatly in what proportions of 'recognition' and 'arousal' they judge to be acceptable to themselves in their traffic with works of art; how far lack of excitation is taken as a deficiency, a ground of 'dejection,' or how far it is welcomed as facilitating a calm awareness of the work of art, enjoyed but at the same time 'distanced.' To do more than note this, however, would involve leaving a philosophical, conceptual study for an empirical, psychological one.

It should be emphasized that to admit the role of emotion-arousal is not to contradict the earlier claim that emotional experience in art is an *active* affair, and not a matter of passively receiving emotion transfusions. There is certainly a passive element in emotion-arousal. Crudely, one wants to say it is what the music, poem, painting does to you, rather that what qualities you discern in it. But only very crudely and misleadingly: for inattentiveness, failure to grasp (actively) the full range of qualities offered to perception in the work, ensures that the emotions actually generated will be only loosely related to the particular work. If it is the work that is to command and control them, the work must be fully present to my consciousness.

To people who wish to deny the occurrence of a host of qualitatively specific inner feelings evoked in a spectator there must be a great attractiveness in an analysis worked out in terms of emotional qualities alone. For that model suggests that the host of nameless spectator-feelings can be replaced by an indefinitely large range of phenomenally different 'looks,' patterns of words, shapes or sounds, I want now to argue, however, that we cannot deny the occurence of highly particularized (and aesthetically relevant) feelings: that to have such feelings is not the same thing as to apprehend looks, aspects and situations, nor is it that plus an undifferentiated excitement.

First, let us deal with the complaint that the hosts of nameless feelings are postulated purely *ad hoc* by theorists attempting to patch up bad theories that seem to require them. Perhaps some of the theories are bad: but to make this complaint is not to demonstrate that no such specific feelings exist. Emotions, agitations, feelings of various kinds get them-

selves named, only when there is some utilitarian point in their having names—particularly if they tend to recur frequently in ordinary human experience. But, as we earlier reminded ourselves, art deals very little in the repetitive and stereotyped. Its slant on the world is often in striking contrast to that of workaday utility. The probability, then, is that its emotions should show the same contrast: their namelessness is no argument for their non-existence.

Are there such qualitatively distinctive, highly particularized feelings? Some people's aesthetic experience, including mine, prompts the answer, yes. It is difficult to say much more than that. Only introspection can confirm or rebut such a claim. Argument cannot. But if someone hesitates to admit such qualitatively distinctive feelings in art, it may be worth directing his attention for a moment to dream-experience. For the same distinctiveness can also sometimes be found there. If we agreed about dreams, we might in the end carry the insight back into art. With the forms in a dream there may go a feeling peculiar to that dream, one that is quite definitely aroused, not merely recognized as an emotional quality. On waking, I may recall the forms, the dream-events, savouring their character and 'look,' and yet lose memory of the precise feeling they evoked; and I may *know* that I have lost it. On other occasions I may be haunted by the feeling, the unnameable particular foreboding or exaltation or whatever it was, and lose altogether the 'look' of the dream-shapes that originally touched it off. *Mutatis mutandis,* the same can be true of the look and the feeling aroused by a peculiarly haunting melody, poem or painting. I recall the notes and the character of a musical phrase, but know very well that it no longer evokes the same poignant and not elsewhere obtainable emotional response that it once did evoke. I can individuate my emotion to the extent of saying 'I once had it: it is now lost: I am trying to recapture it.' I can attain *half*-descriptions of it—'strange, remote, nostalgic,' but I utter the words aware of their inadequacy, and using them only as hook and bait for the return of the unique experience itself. 'Looks' can be imaged, a painting recalled in memory, a tune 'heard in the mind's ear'; general and familiar human emotions can be imaged; but the only way in which these highly specific feelings can be recalled is by actual *revival,* by re-experiencing the feelings themselves, with more or less intensity. These differences should prevent their being assimilated either to the recognition of looks and sound-patterns or to the arousal of emotions that can be analyzed in terms of general excitation plus situation-appraisal. This, of course, leaves on our agenda the vexing question, how exactly to analyse the relation between the 'looks' and the 'feelings,' a question which the look-recognition theory must judge confused, but which I see no way of eliminating.

To summarize:

(i) Of the two ways of speaking—the evocation of emotion and the recognition of emotional qualities—the latter is truer to our actual experience in probably a majority of aesthetic contexts.

(ii) Yet a significant place needs to be left in aesthetic theory also for the *arousal* of emotion.

(iii) This leads us to ask 'What is it for an emotion to be aroused in one?' Sometimes this may mean that one interprets a situation in a particular way and experiences a general excitement. But this analysis fits not every case. Although excitement may often be undifferentiated, it sometimes is most highly particularized, and this differentiation is taken very often to be one source of aesthetic value.

Notes

1. See, for example, H. Khatchadourian, "Works of Art and Physical Reality," in *Ratio,* ii, pp. 148 ff.

2. See Bouwsma, "The Expression Theory of Art," in *Aesthetics and Language,* ed. Elton, pp. 73 ff.; M. C. Beardsley, *Aesthetics: Problems in the Philosophy of Criticism,* pp. 328f.; O. Baensch, "Kunst und Gefühl," quoted by S. Langer, *Feeling and Form,* p. 19.

3. See, particularly, E. Bedford, "Emotions," *Proc. Arist. Soc.,* 1956–57; J. R. Jones, "The Two Contexts of Mental Concepts," *Proc. Arist. Soc.,* 1958–59.

4. On these themes see, particularly, H. Osborne, *Theory of Beauty.* Also relevant is my article "Aesthetic Appreciation of Nature," *British Journal of Aesthetics,* 1963 (Vol. iii, No. 3).

I have indicated the bearing and relevance of these two observations to this study as a whole. It may be pointed out, however, that in the course of them I have referred both to the recognition of emotional qualities and to the "having" of emotions *tout court.* I have not, however, forgotten about the distinction between these: it is taken up again in what follows.

Frank Sibley

Objectivity and Aesthetics

I

In this paper I am concerned with aesthetic descriptions. I have in mind assertions and disagreements about whether, for instance, an art work (or, where appropriate, a person or thing) is graceful or dainty, moving or plaintive, balanced or lacking in unity. I deliberately ignore, by a partly artificial distinction, questions about evaluation, though many assertions of the sorts I discuss are relevant to whether a work has merits or defects.

Since aesthetic descriptions are of many types, the very general suggestions I make, even if on the right track, will, inevitably, fit some less well than others. But I shall not worry if details in what follows fail to fit this term or that, since I discuss no term in detail. That would require long and piecemeal investigations. But I hope elements of my account fit all of them to some extent. A bold sketch of a large terrain may best reveal the general lie of the land. Indeed, my remarks are intended to apply widely outside aesthetics, to many phenomena sometimes labelled tertiary or *Gestalt* properties, and much else.

Even within aesthetics the area is larger than my examples suggest. It embraces not only statements employing single terms like "graceful" or "moving," but also those lengthier remarks of critics which provide more complex and specific descriptions of the same general sort. I include, moreover, those remarks, metaphorical in character, which we might describe as *apt* rather than *true,* for these often say, only more strikingly, what could be said in less colourful language.[1] The transition from true to apt description is a gradual one. (These many sorts of remarks can be illustrated from many contexts besides art criticism, *e.g.* from writers on wines.)

The objectivity under consideration is that of these many sorts of remarks. Is it *true,* a *fact,* that some works *are* graceful, others moving or balanced; that someone denying it could be mistaken, blind to their character; that one man's assertion might contradict another's? Are there correct and incorrect aesthetic descriptions? Or, where a description is metaphorical and aptness rather than truth is in question, might the work be such that a remark *really* is apt or fitting?

From *The Aristotelian Society,* Supplementary Volume 42, 1968, pp. 31–54. © 1968 The Aristotelian Society. Reprinted by courtesy of the Editor of The Aristotelian Society.

I prefer these ways of putting the question of objectivity to certain others. Sometimes, for instance, it is asked whether the terms used connote "properties" or "objective characteristics" that are "in," "inherent in," or "intrinsic to" the object; sometimes it is said that we *mean* to attribute an objective characteristic and it is asked whether there *could be* such characteristics. One reason often given for answering these questions negatively and denying that there are aesthetic properties (in addition to genuine, *i.e.,* physical, properties) is that they would saddle us with intuitionism and a special quasi-sense as an "extra source of knowledge." [2] But it is less because of these disputes for and against intuitionism (surely by now has-beens) than for other reasons that I initially avoid stating the objectivity issue in these *property* and *inherence* locutions. First (a minor point), while we might replace the question "Is she graceful?" by talk of properties, we might feel less happy, with metaphorical remarks, saying that a work has the *property* of jemlike fire or marmoreal hardness (though we might say it has properties that make these descriptions apt). Secondly, the philosophical uses of "property," "inherence," *etc.* are varied and often obscure. Sometimes, for instance, colours and tastes are held not to be "properties in" objects as sizes or shapes are. Doubtless there are interesting differences to support this use of terminology—say, that colours and tastes are organism-related in ways that *bona fide* properties are not. But I ignore this since, if such differences are admitted, they are not germane to the typical disputes in aesthetics. Often the boundaries are drawn elsewhere, presumably because of *other* alleged differences. Many philosophers, when discussing aesthetics (or ethics), speak of colours as properties, while denying that there are aesthetic properties with anything like the same status; their opponents would be content to establish that aesthetic "properties" approached whatever degree of objectivity colours have.

The dispute therefore resolves itself into the questions I have mentioned, whether things can *be*, say, graceful, given that things *can* be, say, red. For if so, people making aesthetic remarks can be right or mistaken, and the remarks themselves, like remarks about colour, true or false. It is objectivity in this respect that the sceptic in aesthetics often denies (though he may think he is denying an aesthetic *sense*, or *intuition*, and that this is something additional). What is required first, therefore, as I see it, is an understanding of what is involved in a thing *being*, for instance, red,[3] since it is apparently being claimed that, with aesthetic terms, matters are in some vital respect *not like that*. We need to examine, in a general way, the characteristic features of aesthetic terms, comparing them constantly with colour words to bring out similarities and differences. This is what, very sketchily, I attempt. For if people deny an objectivity, a possibility of truth and error, to aesthetic descriptions which they allow to colour judgments, it is worth trying to see whether the differences warrant drawing such a sharp and crucial line. (If more is meant, by allowing that colours are properties while denying that there are aesthetic properties, than that colour judgments, but not aes-

thetic descriptions, are capable of truth and error, *etc.,* we might legitimately request more information about the use being made of "property," and wonder about its relevance to the traditional "objectivity" dispute I have indicated. Meanwhile, with this said, I shall hereafter, for brevity, allow myself a (perhaps) loose use of the term "property" to indicate those aspects of objectivity that interest me.)

II

I said that one reason for denying objectivity to aesthetic descriptive remarks has been the supposed need of a special quasi-sense or intuition to explain how we come by the knowledge they express. I prefer to put the matter another way, one which has frequently been implied or stated: that, with objective matters, there must be proofs, decision procedures, ways of establishing truth and falsity. Where proof is impossible, there is no objectivity. And since proof is a way of settling who is right and who wrong, there is the related supposition that, where unresolved disputes are endemic and widespread (as they are said to be in the aesthetic realm), matters are not objective. It is further said that, not only does extensive unresolved dispute indicate that decision procedures (and therefore objectivity) are lacking, but the very possibility of objectivity *requires* (what it is said we lack) a kind of widespread agreement.[4]

No doubt some test or decision procedure is requisite for objectivity. But, first, need it be possible *in fact,* frequently and on a large scale, to employ the tests fully and successfully? Need they be tests that would settle, even in principle, *all* individual cases beyond doubt, or even a *high* rather than *some* proportion of cases? The existence of a procedure might suffice for objectivity even though (*a*) it was complex and hard to apply, (*b*) it was seldom pursued and applied, and (*c*) it would settle only *some* proportion of cases conclusively. Then disagreements might conceivably abound, some genuinely irresolvable, many others *in fact* often unresolved; but a realm of objectivity might be made possible by some *limited* (not widespread) actual agreement including some settled and virtually indisputable cases, together with a perhaps elaborate and hard to describe procedure that offers the possibility, by envisageable ways, of attaining wider agreement. Secondly, are we sure that sceptics do not vastly exaggerate the amount of unresolved disagreement about aesthetic descriptions that exists, perhaps by looking too narrowly or being blind to the obvious? (I shall not argue this matter of fact here.)

We need also be sure that those who say there are no proofs, procedures or tests have not been looking for the wrong kind, appropriate, say, to concepts of other sorts which aesthetic concepts *could* not closely resemble. Indeed, the sceptic whose first move, when there are disputes, is to demand proofs in aesthetics, is likely to accept other matters as objective enough without making any such demand there. Nor is it *prima facie* obvious in detail what a conclusive proof, even in some of

these other areas, would come to: what would be involved in a *proof* that something is red, say, or that two brothers have a facial resemblance, or that a face is smiling? Still less have sceptics formulated what proofs in aesthetics would have to be like, before hastening to deny their possibility.

III

Suppose we assume, for trial purposes, that aesthetic terms do connote properties; it is obvious at once that these will differ markedly in kind from colours. They will be dependent or emergent in a way colours are not. That is, whereas there is nothing about the way a thing looks that makes it look blue, there are all sorts of visible features that make a thing look, or are responsible for its looking graceful (though their presence does not *entail* what they are responsible for); and any change in them may result in its being no longer graceful. So with the features that make a poem moving or a tune plaintive; and in non-aesthetic matters there is the same sort of situation, for instance, with the features that make a remark funny, are responsible for a facial resemblance or expression, and so on. The inevitable consequence is that unless one is in some degree aware of these features, one will not perceive the resultant quality. Hence, often, the need of perusal, or prolonged attention, of *trying,* if one is to see aesthetic qualities (and resemblances, jokes, and so on). Hence also the kind of talking, pointing and otherwise directing attention that may help someone to see them. There is no (or very little) counterpart to this with colours; when we look, we "just see them," or not.

But though this immense dissimilarity separates most aesthetic qualities from colours, there is also a notable similarity. With colours, the ultimate kind of proof or decision procedure, the only kind there *could* be ultimately, consists in a certain kind of appeal to agreement in reaction or discrimination. The ultimate proof that something *is* of a given colour is tied to an overlap of agreement in sorting, distinguishing and much else which links people present and past; and where different sets of people agree amongst themselves thus (*e.g.* groups of similarly colour-blind people), it is reference to the set with the most detailed discrimination that we treat as conclusive.

When I say the only ultimate test or proof, I mean that, since colours are simple properties in the sense that no other visible feature makes something the colour it is, one cannot appeal to other features of an object in virtue of possessing which, by some rule of meaning, it can be said to be red or blue, as one can with such properties as triangular, *etc.* With colours there is no such intermediate appeal; only directly an appeal to agreement. But *if* there are aesthetic properties—the supposition under investigation—they will, despite dissimilarities, be like colours in this respect. For though, unlike colours, they will be dependent on other

properties of things, they cannot, since they are not entailed by the properties responsible for them, be ascribed by virtue of the presence of other properties and some rule of meaning. Hence a proof will again make no intermediate appeal to other properties of the thing, but directly to agreement. (This does not deny what I said above, that one may have to attend carefully to the properties responsible for the aesthetic property; but *when* one has, "either one just sees or one doesn't"—one reason doubtless why aesthetic and other emergent properties have often been likened to "simple" perceptual properties.) Thus, if the sceptic demands a proof that something is graceful, requiring us to cite truths about its properties from which this follows, we must concede that proofs are impossible; *but so they are with colours,* and many other *prima facie* objective matters which he does not challenge. What then do I mean by ultimate proof? People often say that the only ultimate way to find out the colour of something is to look and see, perhaps adding, for caution, that the light must be good and the viewer not colour-blind. But this ignores what lies behind the interdependent notions of colour-blindness, good light, and of *being* a certain colour. All these notions depend, as I have said, upon there being agreement in discrimination of a certain sort. But this agreement is not easy to describe. Not *any* agreement will do; the fact that some of us, here and now, make identical discriminations need not settle the colours of things. We could all be temporarily colour-blind. By ultimate proof I refer to that complex set of conditions which specify those agreements in discrimination which ramify beyond the present moment and which settle that a thing is really red, or blue, *and* that people are not colour-blind. These are not conditions we are ready to state explicitly, or which we deliberately attempt to check on exhaustively to decide what colour a thing is; they are implied in our practice.

With aesthetic terms, *if* they connote properties, there should presumably be, for reasons given, similar possibilities of ultimate proof making reference to agreement. Again, one might say, the only way to find out whether something is graceful (or moving, or funny) is to look and see in suitable conditions. Only this time there is not just the matter of good eyesight and lighting; there is the noticing and attending to the features responsible for aesthetic qualities, already mentioned, and much else (see below). Because of the many things that may be done to focus our attention or left undone, we may sometimes give up without agreement reached. But again, as with colours, even if after doing various appropriate things, we *do* here and now agree, we could conceivably still be mistaken. It would not be just *any* agreement that would settle cases beyond possibility of doubt and so, as the sceptic demands, *guarantee* a judgment correct. We should expect the conditions that specify *which* agreements in discrimination are significant to comprise a more complex set than those for colours. Without such conditions there would be no ultimate proofs, and, what is the same, no such thing as *being* graceful; for they are conditions a thing must satisfy to *be* graceful (or whatever), conditions that give sense to this language of attribution. But

313

if we cannot readily state the conditions implied in our practice even for the objective attribution of colours, our inability to state explicity the (no doubt more fluid and complex) conditions for a conclusive proof, when challenged in aesthetics, need not, any more than the fact that disagreements are more common, oblige us, of itself and without more cogent arguments, to abandon the supposition that aesthetic descriptions are objective matters.

IV

I want now to look further at the possible sources of disagreement over aesthetic descriptions. The sceptic who emphasizes that disputes in aesthetics are rife and that widespread agreement is necessary for objectivity doubtless starts from an ideal where there is maximum actual agreement, as with colours. But, if there *were* aesthetic properties, they would *not* be like colours. We should, of necessity, have to expect additional sources of agreement. We could not expect anything like the ideal of maximum agreement, but rather perhaps the minimum consistent with their being properties. And how little is *too* little the sceptic does not specify.

One built-in source of disagreement has been mentioned already: aesthetic properties being emergent, the features responsible for them must be noticed in interrelation. If people are unwilling or unable to attend appropriately, disagreement will result, even though, with attention and help, agreement would often occur. These failures may be of many familiar sorts, akin to missing the face in a puzzle picture, missing colour harmonies because focusing on linear composition, seeing a cornice instead of a staircase, *etc.*

But there are other sources of disagreement. Even with colours, where little or nothing corresponds to responsible details that have to be noticed, agreement comes about only if the viewer is in such and such a condition (not suffering from jaundice, not recently dazzled, *etc.*). With colour vision, however, we are, as a contingent fact, reasonably fortunate. We need do little to put ourselves in condition to distinguish colours, beyond such things as avoiding being dazzled. (We are unfortunate, too, in that colour-blindness is incurable.) Consequently, differences in discrimination and resulting disagreements are few. But one can imagine things contingently more bothersome. We might have been fluctuatingly and variously colour-blind, with only part-time full colour vision, say, after meals, or until middle age (rather as ability to hear high frequencies deteriorates with age). No doubt these imagined differences would be attributed to the viewer's *physical* condition, though without our necessarily knowing their physiological causes. But my point is that the *sheer amount* of disagreement in discrimination, unsettleable in the sense that one could not get people to see differently, might be much enlarged without threatening the objectivity of colours. The difference

with aesthetic properties would be that a *similar* enlarged possibility of disagreement in discrimination would have a largely different *source,* in mental and experiential, rather than physical, variations in the condition of observers. What these differences in experience and knowledge are we cannot always precisely say (any more than we need know what physiological differences result in colour-blindness), except that many "emergent properties" clearly depend for their recognition on obviously related knowledge and experience, emotional, linguistic, *etc.* As jokes and humour depend on all sorts of knowledge of human nature and customs, so does the realization that passages in *Lear* or *Othello* are particularly moving. One *could* not expect this recognition from a child or a person lacking certain broadly specifiable experience and development. It is odd therefore that this relevance of one's mental condition should often be cited as a main reason why they cannot be objective matters.

Some people, I am saying, when they develop certain everyday capacities and acquire a diversity of not uncommon experience and knowledge, exhibit a tendency to make similar discriminations. Others with apparently similar knowledge and experience—as well as those lacking it—simply do not. The persisting tendency to agreement (though it may be approximate, more like a concentrated scatter than convergence on a point) is analogous to that which allows us to form the concept of *colours* as properties, and may similarly make it possible to speak of things *being* graceful, moving, etc. If there *were* properties discriminable only by people in certain mental conditions, and if there were variations in mental endowment, knowledge and experience, it would be unreasonable *not* to expect a good deal of disagreement in discriminations.

Numerous other factors, only some of which I can mention, help explain and mitigate the alleged seriousness of widespread disagreements. So far I have talked as if throughout the *whole* community a measure of honest and independently attained agreement in discrimination emerges, modified certainly by much actual failure to agree, though not more than might be expected for explicable reasons—lack of interest, cursory or ill-directed attention, inadequate experience or knowledge of the language, *etc.* I also indicated ways by which disagreements are often removed, by awakening interest, redirecting attention, allowing time and opportunity to acquire knowledge and experience of diverse kinds. As a matter of common experience all these things happen; a critic's remarks may enable us suddenly to see, people gradually come to agree there is more in something than they *could* have seen as children or adolescents. It is not myth or invention that agreement often comes about in these ways. And when our best efforts fail there is no certainty that the next critic's remark or the next year's experience will not bring about the change; so at no point can we say that *everything* has been done. But it would be unduly optimistic to suppose that, because other moves can always be tried, we may not have to rule some people out as apparently incurably insensitive, just as we pronounce some colour-blind. We may

know why some of them, insensitive or inexperienced in other matters, do not see what we see. What we do not know is whether, by continuing efforts, we might elicit a large measure of agreement in the *majority* of people, or whether many simply lack the latent capacities. Educators in art appreciation assume the former; history may suggest the latter. Though we need not quickly be pushed by apparent inability to discriminate to this last resort of alleging blind spots, we nevertheless sometimes seem justified in doing so (when, for instance, the aesthetic quality is logically connected with some sense or sensitiveness in other matters which independently we know the person to lack).

Here another imaginary colour-vision example becomes relevant. As things are, the fully colour-sighted are a vast majority. But the facts could be different; they might be a small minority, the rest shading off in various degrees and sorts of colour-blindness towards totally achromatic vision. There would then be patchy areas of agreement, separate groups and sub-groups, but one small nucleus regularly, at their best, making more detailed agreed discriminations than any other. The partly colour-blind majority might even find a more extensive agreement among themselves, though a less finely discriminated one; but none of this need cast doubts on the objectivity of colours. This pattern, with a minority "élite," ill-defined at the edges but fairly constant over generations and marked out by their *performance*, is more like the situation in aesthetic matters. (In some ways the situation is more hopeful than it would be with colours. There, the variations would be physical, and largely beyond our control; here we cannot be sure that further efforts, knowledge and experience will not bring more people into closer convergence on finer discriminations.) We may therefore regard much existing difference in discrimination as irrelevant. It is not the majority being colour-sighted that permits a property language for colours, but the existence of a nucleus (large *or* small) making regular, detailed and closely identical distinctions. And as the "opinions" of the colour-blind can be ignored, so, in aesthetics, we can concentrate on the perceptive "élite" group, even if it is a minority; for if we are dealing with properties, we shall be no more interested in the "opinions" and "disagreements" of people who cannot or can only fitfully recognize them than in those of people who evince no interest at all in aesthetic matters. What concerns us is the state of affairs, including occasional disagreements, *within* the nucleus who largely agree. For it is here—roughly speaking, amongst professional and lay critics through the ages (by virtue of whose broad agreement we classify them as critics)—that genuine disagreements without significant parallel in the realm of colours may occur (though, of course, no *sharp* line divides the nucleus from the rest; the fully colour-sighted, too, shade into the mildly colour-defective).

I have indicated briefly some of the sources of aesthetic disagreement. With colours there are not these sources, or the consequent disagreements; but in aesthetics, it would be odd *not* to expect extensive disagreements ranging round a nucleus of approximate consensus. And

if this consensus were somewhat limited, spotty and fragmentary, not virtually unanimous as with colours, the question remains *how much* one need demand before being able to speak of properties. I suggested, moreover, but did not argue, that the history of criticism exhibits in fact, over a long period, a very notable and stable consensus. Given the opportunities for disagreement, one could even imagine there being much less. It is thus far from clear that the existence of unresolved disagreement, often regarded as a conclusive argument against objectivism, is conclusive at all.

V

I mentioned earlier the view that we might think aesthetic terms "connoted properties," yet be totally mistaken. I now raise what seems to me a related but preferable question—about how we operate, or attempt to operate, with aesthetic terms.

The occurrence of even considerable disagreement need not show that we are employing words, for instance, as mere personal reaction terms, any more than unanimous application of a word to the same objects need show that we are employing it as a property term. If to say that something was "nice" were simply to indicate that one liked it, everyone could still like—find "nice"—the very same things. For us to be using a word as a property term, it is required that, to be using it correctly, people *must* (not merely *may*) in certain circumstances apply it to more or less the same cases. Where a person does not apply it as others do, there must be some range of explanations available (the light was poor, he was inattentive, untrained—or, ultimately, lacks even the latent ability). A personal response concept, as I have pretended "nice" might be, makes no such logical demand. Everyone might, or might not, like strawberries.

Thus two questions are separable: (1) whether we attempt to use a concept as a property concept, making, as part of its logic, these demands for agreement in application and for explanations where agreement is lacking; (2) whether, when we do, we find enough in the nature of things that fits with and permits this attempted use. But this needs a further qualification. If we invented property concepts *ad libitum* and tried to use them, in one sense the facts could not prevent us since we could, when no significant agreement occurred, allege explanations of the usual types, poor conditions, blind spots, total insensitivity in others, *etc.* But in another sense these concepts do not fit the facts and will not work; not only are the agreements so few, but the explanations are empty. We cannot begin to say how altering conditions or training oneself might help, and nothing we do is seen to get us anywhere. A property concept must be one we can work with if it is to gain and retain currency; and this means some agreement and some non-empty explanations. The questions therefore are (1), whether we use or attempt to use aesthetic

concepts with elements of an objective logic, requiring some agreement and explanations of disagreement and (2), whether we have reasonable success in using them thus, actually finding some agreement and some workable explanations of disagreement.

It seems to me that the answer to both questions, however qualified, is affirmative. We do demand a measure of agreement on cases before we allow that someone can use these terms, and we do demand explanations of disagreements. Moreover, we find what we demand: a measure of agreement sufficient for us to continue to use the terms thus, and a range of explanations—I have mentioned only some—that in many cases (we would not expect *all*) are *seen* to work. We often know on evidence we cannot ignore what we and our friends are insensitive to, where we make finer discriminations than they, that we discern things now that we could not see when we were younger; we allow we may be wrong, we try again, and we seek help, often successfully, from critics and friends.

I said we manage with reasonable success to treat aesthetic concepts as objective. But two objections will be made. First, some people, perhaps a majority, do *not* manage to any extent. This I have already admitted. They do not, even with effort, notice similarities and differences they find others agreeing on. They may then abandon further interest; or perhaps attempt to simulate discrimination. They may deny that others do independently find themselves agreeing, and reject the whole thing as snobbish perpetuation of the bogus by means of dishonesty. Those, by contrast, who find themselves agreeing certainly have not attempted any such fake. What impresses *them,* at least in their developing years is that, having themselves noticed the grace of X, or found Y moving, they often find others noticing precisely the same things; they then learn that a string of critics through the ages have done so too. But whereas the colour-blind, even if a majority, could hardly challenge the colour-sighted, here, because of the complexities and disagreements already discussed and a lack of practical urgency,[5] there is elbow room for the sceptical to ignore the significant agreements often lasting over centuries and across cultures, and to cite the disagreements amongst critics (without asking how or why *critics* were chosen)—disagreements which, I have argued, we could hardly expect to be without. This leads to the second objection—about disagreements *within* the nucleus of generally agreeing critics. My argument has been partly hypothetical. I asked what situation we should expect if there were aesthetic properties. The answer, I have suggested, is "Much like the situation we now have with existing aesthetic concepts." Some people, even if a minority, *do* manage to use aesthetic terms as objective, and with at least as much success as we might expect. If this is *admitted,* these concepts must be reasonably enough accommodated to the way things are, and it is not obvious why we should be dislodged from thinking if we wish—as in our non-theoretical moments we largely do—that we are dealing with objective characteristics. To admit that we use concepts as if objective with reasonable success, and yet suggest that it is *only* a matter of as-if and that there

are really no such properties is, I think, to invite a request for illumination of the intended contrast and of its relevance to traditional debates. By contast, to deny that, at least for some people, the attempt to use aesthetic concepts as if objective works with reasonable success is to disagree about the *facts*—a dispute to be cured only by surveying a wide enough scene in an unblinkered and undoctrinaire-sceptical way. The objection that might be made to this argument is that there *are* enough disagreements, even among the alleged elite, that *cannot* be explained merely by inattention, inexperience, *etc.,* and where adjudication of right and wrong is wholly impossible; and that this suffices to scotch any claim to objectivity. I postpone considering this till Section VIII.

VI

Different objections to the notion of aesthetic properties spring from the view that, since the alleged recognition of them is relative to our physical and mental condition (they are recognized only by beings of a certain sort in certain states), they cannot really be *properties in* objects. There are perhaps three distinguishable arguments here. (1) We cannot speak of properties when awareness of the alleged properties is relative to some type of organism. This seems irrelevant; colours are in the same position. (2) We cannot speak of properties when awareness of the alleged properties is relative not just to a certain physical condition, but to a certain mental condition, the result of experience, *etc.* But I see little reason why this, either, should exclude objectivity; it certainly applies to much outside the aesthetic that we regard as objective, recognition of faces as smiling, that sentences have meaning, and so on. Indeed, it would be absurd to require, for a thing to be *really* ϕ, that ϕ must be discernible by beings lacking the obviously relevant knowledge and experience. (3) Perhaps the real objection is that, since people differ and change, the choice of *which* group of people is held to discern the properties of things must be arbitrary. Now the principle we adopt with other matters, *e.g.* colours, is not arbitrary. The "is" of attribution is tied, for obvious reasons, to the group (not necessarily a majority) able to agree regularly on the maximum of discriminations. And though the boundaries are not clear-cut, we do this with aesthetic terms too. Some people—I called them the "nucleus" or "elite"—tend, at least when they take time and trouble and have age and experience, to agree on many more detailed discriminations, similarities and differences than others ever do. Just as we do not select the colour-sighted by physiological examination, so we do not select critics by "ideal spectator" critieria; we select both by performance.

This leads me, however, to further characteristics of aesthetic concepts. Since discrimination often depends on experience, knowledge and practised attention, the group to which the "is" of attribution is linked is inevitably not homogeneous. There will be a nucleus, and a large and

319

variable penumbra consisting of groups exhibiting partial and merging areas of agreement corresponding to what we ordinarily call areas of limited sensibility and levels of sophistication. These, of types too numerous to more than mention here, will account for the occurrence of various kinds of lesser disagreements. There is the sophistication that consists in making finer distinctions and employing a more precise vocabulary. Where the many lump certain things together under a common and generic term ("lovely" or "pretty"), the few may agree in differentiating them more specifically as, say, beautiful, dainty, elegant, graceful or charming (*cf.* the division of red into vermilion, crimson, carmine). Then there are hierarchies deriving from wider experience. What one at first thinks the epitome of some quality may be relegated to inferior status as one meets other examples (as if one first met with no bright hues, but only faded colours). Sometimes one *could* not recognize the finer cases until one can discern the more obvious, broader-brush examples. Then disagreements may show as differences less about degree than about related kinds: what we first think moving or tragic we later think merely sentimental or pathetic. Sometimes, with growing awareness of subtleties and nuances of style and language, reversals occur; what originally seemed monotonous (say, Bach) becomes subtly varied, moving and exciting, while what was powerfully moving (say, Bruckner or Tchaikovsky) becomes naïve or blatant.

Given experience of our own development, we might (if it did not sound condescending) liken these differences between penumbra and nucleus to those between children and adults. Children may laugh heartily at, or be moved strongly by, things we regard as only mildly amusing or moving. But we welcome their reactions; they are on the track that may lead to fuller discrimination, and at least have "agreed" with us in distinguishing the (for us only mildly) funny or moving from things they and we agree are neither. Indeed, this might be all in the circumstances we could (even logically) expect. So with the arts: within the penumbra, people of variously developed sensitivity tend to converge on a broad target of agreement, without making the more detailed or sophisticated distinctions that tend to mark out a central nucleus.

To which group then is the "is" of attribution linked? With colours it is the group agreeing on most distinctions. Roughly the same might be said here. This does not mean that we cannot say *e.g.* "funny for children," "exciting for schoolgirls" *etc.*, much as we speak of problems difficult for four-year-olds. Nor that we could not understand the use of "is" by people who still find moving what we have come to divide into the deeply moving and the merely touching. If everyone was red-green colour-blind till twenty, we might teach "red" to cover our red *and* green; and *we* could recognize that in a community that died before twenty there would be sound justification for their property use of "is." But, when pressed, we would say that some things they call red (deeply moving) are *really* green (merely touching). The "is" of attribution is thus linked to nucleus and penumbra alike, but in particular to the nucleus. Aesthetic concepts, if property-concepts, might be called minimally nu-

cleate in character since the nucleus is small relative to the penumbra, and cannot be sharply divided from it. The notion is not difficult; most concepts share this structure, but less markedly. Even in vision and hearing some people have greater visual or auditory acuity and can distinguish minute differences of colour or pitch; we could, if strict, say the colours and notes they distinguish are different, though for some purposes we follow the ordinary man in saying they are the same. It is an illusion to suppose there is always a crisp "Yes" or "No" to questions of colour, or to the question which is the reference group for the "is" of colour attribution. A judgment broadly agreed within the penumbra may sometimes be more secure than the more specific judgment of the nucleus or elite, as a judgment that something is red may be more secure than that it is crimson or vermilion. Where there are frequent shifts and divisions of *specific* opinion about a work by critics, but within a widely held but more generic opinion, we may hesitate, or prefer the less discriminating group as the secure reference-group. Whether we accept the detailed agreements of a small nucleus or the broader ones of the penumbra in particular cases (or refuse to prefer either) depends how the minority claim is upheld by related considerations, and sometimes there is not enough to decide. Where we cannot exactly pinpoint a reference-group we correspondingly cannot sharply adjudicate the judgments of nucleus or penumbra as right or wrong, though we can still reject outsiders' judgments (as we can clearly say a face is not scowling, while disputing whether it is smiling, smirking or leering).

VII

I return now to what earlier I called "ultimate proofs." If aesthetic concepts are as I have pictured them, a proof that X is ϕ will consist in a convergence of judgments in this direction. But this may require time—to study the object, to acquire varied knowledge and experience, *etc.*; time also over generations, so that detailed agreement emerges from the temporary variations we call fashions, fads, *etc.*

If, with aesthetic concepts, the situation is thus, there are inevitable consequences. In order (not to *be* ϕ, nor even to be *thought* rightly and with good reason to be ϕ, but) to be known beyond all doubt to be ϕ, a thing would need to exist unchanged over a long period and be regularly scrutinized with care by many people. Thus a work produced last week *could* not yet have met the decision procedure conditions, nor, if two or three generations are required for fashions and counter-fashions to neutralize each other, could works produced in, say, the last thirty years. We might insist that a new work is ϕ, and be right; but we could not, if challenged, give a conclusive proof. With a work thirty years old we could do only somewhat better, though—as critics often say—it might well look to be emerging as a prime example of ϕ. If any cases are utterly beyond question (if there are any "paradigms," in one use of that term), they will be, in art, predominantly the older works, whether masterpieces (passages

in *Oedipus* or *Lear* that have consistently been found moving, *etc.*), or minor pieces that have emerged as "paradigms" of lesser qualities (Herrick or the *Georgics*). Outside art, the "paradigms" will be natural kinds consistently celebrated for various properties (say, gazelles, deer, horses for grace), for we know they have not changed physically and we have recorded judgments over very long periods. By contrast, since many things we judge aesthetically are quite ephemeral, many disputes inevitably go unsettled; even where there may be widespread agreement (as over a dancer's performance on a particular evening), the judges (who may be right) are without a logically powerful riposte if a sceptic demands proof. (So, too, in a much modified way, I might be quite sure [and right] in saying a coloured flash is green; but I *could* be wrong, a possibility that diminishes as more people saw it, and one that has long since evaporated with, say, emeralds.)

Are any aesthetic judgments about natural kinds and older art-works *logically* beyond question as is, say, the colour of emeralds (*if* it is)? This *presupposes* an affirmative answer to the question whether anything could really *be* φ, *i.e.* whether there is an intelligible, if non-explicit, set of conditions that give sense to the "is" of attribution and that, if met, would settle certain cases. It is to ask instead whether anything is in fact known conclusively to have met these conditions; nor need there be a sharp line between having met and not having met them. As agreement on a given case, amongst those who make the widest range of detailed agreeing discriminations, collects over a longer period, it approaches more closely to absurdity to question the case. Enough is enough, though no *sharp* line divides what is questionable from what is not. Put otherwise, possibility of error with a case that has elicited long-lasting convergence decreases as possible *explanations* of error become more obviously absurd; *e.g.* we could not sensibly reject a centuries-spanning consensus about *Oedipus* as being the result of personal bias, enthusiasm for a novel style, or passing fashions or fads. I do not mean that, in *other* cases, there is always some reason for doubt; only that the long-attested cases may virtually exclude the *theoretical sceptics's* doubt as absurd. Many other points might be added. For example, there are certain asymmetries: it is harder to justify denying widely acknowledged qualities than to be right in claiming to discover qualities everyone has so far missed. Again, assurance might be strengthened by taking groups rather than single works as paradigms: it may be absurd to deny that the *group* A, B, C and D contains paradigms of grace, even though considerations might just conceivably be brought to make us question one of them.

VIII

The foregoing remarks about proof, if correct, indicate that some aesthetic judgments may be characterized as right, wrong, true, false, undeniable, or by similar strong vocabulary. But my remarks about nu-

cleate concepts indicate that this realm may not be rigidly objective; with some judgments (perhaps a sizeable number), we cannot demand or justify a clear "Yes," "No," "True" or "False." This is because, even as time goes by, the judgments of the nucleus, who agree largely in some detail on other cases, may be split on certain cases, some agreeing amongst themselves, others agreeing with the less specific or sophisticated judgments of the penumbra. But the fact that there is insufficient reason to endorse one judgment as right against the other (since *ex hypothesi* no recourse to anything else could show this) by no means plunges us into subjectivity. The judgment that the poem is cold does not become a permissible candidate because there is dispute whether it is really moving or only mildly touching. If the proportion of cases in which there is no sharp right and wrong about such judgments as these is large in relation to cases which, whether in fact settled or not, might have a clear answer, this is only an enlargement of a kind of in-principle-undecidable area which already characterizes other objective concepts. It does not and could not erase all right-wrong distinctions in the area since these indeterminable cases exist only in relation to the others; only, that is, because the principles that *do* settle cases are not in fact met by *these,* or are half met and half not. Indeed, I can now mention some more extreme situations; when the penumbra agree in saying something *general,* like "pretty," the nucleus of people whose specific judgments agree elsewhere may here form two nuclei, dividing equally over whether, say, "elegant" or "dainty" is the right *specific* word. Even more extremely, a few cases may occur where those who usually constitute nucleus and penumbra *together* split 50–50, falling into two camps, even over a very long period. These are the notorious cases (perhaps Liszt or Wagner) where no consensus settles down either way. Here we may offer explanations (*e.g.* by appeal to types of people, the cool and the emotional, the moral liberal and the moral puritan), understand the difference and see both sides, or we may find the explanations running dry. In either case we may just leave the differences standing; either judgment is acceptable. Indeed, for some ranges of judgments we prefer terms like "reasonable," "admissible," "understandable" or "eccentric" to "right" and "wrong." Here the rigid objectivist, fearful of giving too much away, might insist that one party *must* be mistaken; but, equally, we might allow that not all disputes are settleable as between certain alternatives. Whether or not we should insist that they are might be a matter for *decision,* though it might be an empty one ("*Something* must be preventing the other group from seeing its *true* character"). I suggest it would be a mistake to think that, in order to preserve objectivity *in general* in aesthetics, we need take the heroic line. Other objective matters exhibit undecidable areas; this may differ from those only in degree. In any case, at first-order level so to speak, it will still be the *critic's* duty firmly to give his own honest and careful opinion, for only thus can a genuine consensus emerge or fail to.

There is much in this ocean I have not touched: all the surface disa-

greements resulting from temporary fashions, the short-lived culture of the eye which makes wide lapels or long skirts look right one month and wrong the next, enthusiasms or satiations with new or old styles, *etc.* These are phenomena wherein no claims to objectivity might stand, as the sceptic who exploits them well knows. But there seem to me to be ground swells and prevailing currents as well as surface disturbances, and it is to those I have tried to attend.

I am far from thinking I have made a case for aesthetic properties, even in the weak sense that some aesthetic characterizations are true or false, apt or inappropriate, *etc.* I have simply suggested considerations that need exploring or disposing of before that case, which would refute some forms of scepticism, is abandoned. In giving aesthetic "properties" a trial run, I have examined no aesthetic terms themselves. I tried a more schematic approach. Starting from certain paradigms of properties (if that is what colours are) and retaining certain similarities, I added differences of kind and degree which would result in concepts less rigid than colours (surely, even among properties, very rigid indeed) and closely akin to existing aesthetic concepts. I then asked why concepts like these should *not* be said to concern objective matters. As I warned at the start, I imagine that the abstract account given will not fit all aesthetic terms equally well. Probably a much weaker case must be made for some (like "moving" or "nostalgic") than for others (like "graceful" or "balanced"); but all may have some of these features. Nor do I attach importance to using the philosopher's term "property," which (like "in" and "not in") suggests a sharp distinction, a picture of things with properties stuck on them or not. If we can sketch a continuum of cases, with "properties" merging into "non-properties," it will matter little whether the jargon of "properties" is enlarged to include aesthetic properties too, in order to indicate important similarities, or whether the line is drawn to include, say, at most, colours. If I am right that in actual practice we do manage to give aesthetic terms a partial but not unsuccessful run as property terms, we will not need to abandon all claims to objectivity. If, on the other hand, a fuller development of the arguments I have offered for assimilating aesthetic terms to property words can be shown to fail, that too would be something. Moreover, the inquiry could have wider implications since, in ethics as well as aesthetics, some illumination about the notions, *descriptive* and *property,* which so many things are said *not* to be, would be welcome.

Notes

1. For a fuller range of examples, see "Aesthetic Concepts," *Philosophical Review,* 1959, pp. 421 ff.

2. See, e.g., Margolis, *Journal of Aesthetics and Art Criticism,* Winter 1966, pp. 155 ff., and, for a similar view in ethics, Harrison, *Aristotelian Society, Supp. Vol.* XLI, pp. 201–9.

3. See "Colours," *Proc. Arist. Soc.,* 1967–8, sections I, II and IV.

4. "General agreement is not a test of truth; but is a necessary condition of the use of objective language. . . . We could not treat roundness as an objective property, we could not talk about things *being* round or say that statements about roundness were objectively true or false unless two conditions were fulfilled (*a*) we must agree about the tests. . . . (*b*) the tests used must be such as to give a *high degree of agreement* in their application *over a wide field*" (Nowell-Smith, *Ethics,* p. 55, my italics).

5. See "Colours," loc. cit., section IV.

CHAPTER 4

The Aesthetic Experience
of Nature

Paul Valéry

Paul Valéry (1871–1941) was an outstanding French poet, critic and essayist. He became professor of poetry at the Collège de France in 1937. Among his best known prose works are the Introduction to the Method of Leonardo da Vinci *(1895, trans. 1929) and* An Evening with Monsieur Teste *(1896, trans. 1936).*

Man and the Sea Shell

PREFACE

Since the strangely delicate drawings, woven rather than traced by the fine and sensitive point of Henri Mondor's pencil, have provided an

From THE COLLECTED WORKS OF PAUL VALÉRY, ed. by Jackson Matthews, Bollingen Series XLV, Volume 13, *Aesthetics,* translated by Ralph Manheim (copy-

occasion to reprint this little work, I should like to say a few words more on the subject, as though, having taken leave of a friend, I should go back to add a detail or two to our conversation.

It was chance that made me write about sea shells, very much as though bidding me, by the seashore, to take notice of one of these delightful objects. In taking this marvel as my theme, I did the same as a passer-by who has just picked up a small, curiously formed, calcareous shell in the sand; who examines it and handles it, admiring its mineral convolutions and the arrangement of spots, streaks, spines suggesting the past movement in which they were engendered. I meditated my unexpected theme and raised it closer to the eyes of my mind; I turned it over and over in my thoughts. . . . I knew next to nothing about mollusks, and I took pleasure in illumining, one by one, the facets of my ignorance.

Ignorance is a treasure of infinite price that most men squander, when they should cherish its least fragments; some ruin it by educating themselves, others, unable so much as to conceive of making use of it, let it waste away. Quite on the contrary, we should search for it assiduously in what we think we know best. Leaf through a dictionary or try to make one, and you will find that every word covers and masks a well so bottomless that the questions you toss into it arouse no more than an echo.

In the matter of shells, then, I did my best to define my ignorance, to organize it, and above all to preserve it.

Among the many objects that confront man's mind with questions, some more legitimate than others, he is particularly fascinated by those which, by their form or properties, lead him to reflect on his own powers or tendencies. He is amazed to find objects which, though it is inconceivable to him that they should have been made, *he can compare to those he is able to make. In such objects he seems to recognize his own familiar modes of thought, his own types of conscious action: his incorrigible "causality" and "finality"; his geometry; his ingenuity; his need for order and his bursts of inventiveness. As soon as he glimpses an adaptation, a regular functioning, definable forms, an order, in a product of "nature," he cannot help trying to "understand"; that is, the object becomes a* problem *for him and he begins to consider it as the effect or result of some sort of* making, *which remains to be defined.*

Complete human action, with its own possibility *and* necessity, *its means, its material, its aim, is the inevitable and unique type on which every "explanation" is modeled. What we know of ourselves, our acts, our impulses, of what satisfies our instincts and fits in with our struc-*

ture, in other words the "forces," the "time," the "space" that suit us, these are the instruments by which we reduce all things to our measure. When we are perplexed, that is, when we have carried our familiar questionnaire too far, an appropriately vague language comes to our aid, masks our helplessness, and enables us (what an admirable thing) to go on arguing indefinitely.

We talk about creation, evolution, chance, *and we endow these terms with precisely everything required in the way of power, disorder, time, and large numbers, to stimulate our minds and, by an odd contradiction, to satisfy them. It is a great mystery to me how opinions on subjects of this kind can differ as much as we know they do.*

But I see that I am gradually slipping from one problem to another, from the formation of shells to the formation of hypotheses, which is perhaps less disheartening to meditate upon. Our intellect is not so rich as it supposes in tenable hypotheses. A man is always at a loss when experience shows him that one phenomenon must be connected with another which seemed unrelated to it. He must own that the connection would never have occurred to him.

Yet mysterious as the genesis of shells may be to the metaphysical eye, an artist, at all events, can examine them as long as he pleases without wasting his time.

Run off by the billions, each different from the rest (though the difference is sometimes imperceptible), they offer an infinite number of solutions to the most delicate problems of art, and of absolutely perfect answers to the questions they suggest to us.

I have indicated in the text of my essay that it was child's play for what we call "living nature" to obtain the relation between form and matter that we take so much pains to attempt or to make some show of achieving. Our hands busy themselves in various acts, all distinct and determinate; with our eyes and our intention we order and supervise this superficial maneuver; but our activity is composite and must always be so; and thus we can never, in our object, arrive at the happy union of substance and shape that is achieved by the inarticulate creature which makes nothing, *but whose work, little by little, is differentiated from its flesh, progressively moving away from the living state as though passing from one state of balance to another.*

In this invincible and one might say flawless progression of form, which involves and develops its whole setting according to the continuous fatality of its convolutions and seems to create its own time, we admire the combination of rhythm, *marked by the regular spots or spines, and of* indivisible movement. *It is like seeing music. The correspondence of ornaments on successive spirals suggests a counterpoint, while the continuity sustains the main theme of the rotation of the surface.*

But suddenly an end must come. This strange torsion must cease,

the nacre on the inside and the coarser covering must join, and the distinction between the two substances of the shell must vanish or explain itself, while at the same time its form must be completed by some decision that remains to be arrived at.

The problem is very general in kind. Living nature must solve it in all the types it displays, all of which involve extremities to be modeled and cavities or tubes that must be made to reach the outside world. The mind staggers at the mere thought of analyzing the innumerable solutions it has found. We yearn for a profound geometry, a very exact knowledge of what is revealed by dissection and microscopic examination, and an exquisite artistic feeling which, taken together, might enable us to isolate some simple basic principle of natural morphology.

This is a mystery that has always teased my mind, for I can find nothing in the arts that captivates me more than forms or phases of transition, the refinements of modulation. For me, perfect modulation is the crown of art. But in our time little importance is attached to this ideal of mine. The architect knows only his rule and square. The musician does pretty much as he pleases. The poet proceeds by leaps and bounds. But nature has preserved her cautious methods, the inflection in which she envelops her changes of pace, direction, or physiological function. She knows how to finish a plant, how to open nostrils, a mouth, a vulva, how to create a setting for an eyeball; she thinks suddenly of the sea shell when she has to unfold the pavilion of an ear, which she seems to fashion the more intricately as the species is more alert.

If there were a poetry of the marvels and emotions of the intellect (something I have dreamed of all my life), it could find no subject more delightful and stimulating than the portrayal of a mind responding to the appeal of one of those remarkable natural formations which we observe (or rather which make us observe them) here and there, among the innumerable things of indifferent and accidental form that surround us.

Like a pure sound or a melodic system of pure sounds in the midst of noises, so a *crystal,* a *flower,* a *sea shell* stand out from the common disorder of perceptible things. For us they are privileged objects, more intelligible to the view, although more mysterious upon reflection, than all those which we see indiscriminately. They present us with a strange union of ideas: order and fantasy, invention and necessity, law and exception. In their appearance we find a kind of *intention* and *action* that seem to have fashioned them rather as man might have done, but at the same time we find evidence of methods forbidden and inaccessible to us. We can imitate these singular forms; our hands can cut a prism, fashion an imitation flower, turn or model a shell; we are even able to express their characteristics of symmetry in a formula, or represent them quite

329

accurately in a geometric construction. Up to this point we can share with "nature": we can endow her with designs, a sort of mathematics, a certain taste and imagination that are not infinitely different from ours; but then, after we have endowed her with all the human qualities she needs to make herself understood by human beings, she displays all the inhuman qualities needed to disconcert us. . . . We can conceive of the *structure* of these objects, and this is what interests us and holds our attention; but we do not understand their gradual *formation,* and that is what intrigues us. Although we ourselves were formed by imperceptible growth, we do not know how to create anything in that way.

The shell which I hold and turn between my fingers, and which offers me a combined development of the simple themes of the helix and the spiral, involves me in a degree of astonishment and concentration that leads where it may: to superficial remarks and observations, naïve questions, "poetic" comparisons, beginnings of reckless "theories." . . . And my mind vaguely anticipates the entire innate treasure of responses that rise within me in the presence of a thing that arrests and questions me. . . .

First I try to describe this thing to my own satisfaction. It suggests to me the movement we make when we roll a sheet of paper into a cone. One edge of the paper forms an inclined plane that rises toward the tip and ends after a few turns. The mineral cone, however, is formed by a tube and not by a flat sheet. With a tube closed at one end and assumed to be flexible, I not only can reproduce quite well the essential form of a shell, but can also fashion a number of others, some of which, like this one I am examining, might be inscribed in a cone; while the others, obtained by reducing the *pitch* of the conic helix, will end by coiling like the spring of a watch.

Thus the idea of a *tube* and the concept of *torsion* suffice for a first approximation of the form under consideration.

But this simplicity applies only in principle. If I examine a whole collection of shells, I find a marvelous variety. The cone lengthens or flattens, narrows or broadens; the spirals become more pronounced or merge with one another; the surface is incrusted with knobs or spines, sometimes strikingly long, radiating from a center; or it may swell, puffing out into bulbs separated by strangulations or concave gorges where the curved lines meet. Engraved in hard matter, furrows, wrinkles, or ribs follow and accentuate one another, while, aligned on the generatrix, the protuberances, the spines, the little bumps rise in tiers, corresponding from row to row and breaking up the regular intervals of the planes. The alternation of these "ornaments" illustrates, more than it interrupts, the continuity of the general *convolution* of the form. It enriches but does not modify the basic motif of the helical spiral.

Without modifying it, without ceasing to follow and confirm its own unique law, this *idea* of periodic progression exploits all the abstract fecundity of the helix and develops its full capacity for sensuous charm. It beguiles the eye, drawing it into a kind of controlled vertigo. A math-

ematician, no doubt, would easily read this system of "skew" lines and surfaces and would sum it up in a few signs, a numerical relation, for it is in the nature of the intelligence to do away with the infinite and to abolish repetition. But common language is ill suited to describing forms, and I despair of expressing their whirling grace. Actually, even the mathematician is baffled when in the end the tube suddenly broadens, breaks, curls back, and overflows into uneven lips, often bordered, waved, or fluted, which part as though made of flesh, disclosing in a fold of the softest mother-of-pearl the smoothly inclined starting point of an internal whorl that recedes into darkness.

Helices, spirals, spatial developments of angular relations—the observer who considers them and endeavors to translate them into his own modes of expression and understanding, cannot fail to perceive one essential characteristic of forms of this type. Like a hand, like an ear, one shell cannot be mistaken for another that is its symmetrical counterpart. If we draw two spirals, one the mirror image of the other, no manner of moving these twin curves will enable us to superimpose one on the other. It is the same with two stairways, similar but turning in opposite directions. All shells whose form derives from the rolling of a tube necessarily manifest this *dissymmetry,* to which Pasteur attached so profound an importance, and from which he derived the main idea for the investigations that led him from the study of certain crystals to that of ferments and their living agents.

But despite the dissymmetry of all shells we might, among a thousand specimens, expect the number of those whose spirals turn "clockwise" to be approximately equal to those turning in the opposite direction. This is not the case. Just as there are few left-handed men, there are few shells which viewed from the tip disclose a spiral receding from right to left. Here we have another, quite remarkable sort of statistical dissymmetry. To say that this difference in bias is *accidental* is only to say that it exists. . . . Thus the mathematician I mentioned a moment ago has been able to make three simple observations in his study of shells.

He first noted that he could describe their general form with the help of very simple notions drawn from his arsenal of definitions and operations. Next, he saw that quite sudden—one might say unforeseen—changes occurred in the forms he was contemplating: the curves and surfaces that made it possible to represent their construction suddenly broke off or degenerated: whereas the cone, the helix, the spiral can well go on "indefinitely," the shell suddenly wearies of following them. *But why not one turn more?*

Lastly, he finds that the statistics of right-handed and left-handed shells marks a strong preference for the former.

We have given a superficial and very general description of a shell chosen at random; and now, if we have time and the inclination to follow the development of our immediate impressions, we might ask ourselves a very naïve question, one of those questions that arise in us before we

remember that we are not newborn, but already know something. First of all, we must allow for this; and remember that our knowledge consists largely in "thinking that we know" and in thinking that others know.

We are always refusing to listen to the simple soul within us. We ignore the inner child who always wants to see things for the first time. If he questions, we discourage his curiosity, calling it childish because it is boundless, on the pretext that we have been to school and learned that there is a science of all things, which we might consult if we wished, and that it would be a waste of time to think in our own way and no other about an object that suddenly arrests us and calls for an answer. Perhaps we are too well aware that an enormous stock of facts and theories has been amassed, and that in thumbing through the encyclopedias we may find hundreds of names and words that represent this potential wealth; and we are too sure that we can always find someone somewhere who, if only to impress us, will be glad to enlighten us on any subject whatsoever. And we promptly withdraw our attention from most of the things that begin to arouse it, thinking of the learned men who must have explored or disposed of the event that has just stirred our intelligence. But such caution is sometimes laziness; and moreover, there is no proof that everything has really been examined, and in all its aspects.

So I shall ask my very naïve question. I can easily imagine that I know nothing about shells except what I see on picking this one up; and that I know nothing about this shell's origin, its function, its relations with what I am not considering at this particular moment. I am following the example of the man who one day made *tabula rasa.*

I look *for the first time* at this thing I have found. I note what I have said about its form, and I am perplexed. Then I ask myself the question: *Who made this?*

Who made this? asks the naïve moment.

My first stir of thought has been to think of *making.*

The idea of *making* is the first and most human of ideas. "To explain" is never anything more than to describe a way of *making:* it is merely to remake in thought. The *why* and the *how,* which are only ways of expressing the implications of this idea, inject themselves into every statement, demanding satisfaction at all costs. Metaphysics and science are merely an *unlimited* development of this demand. They may even lead us to pretend not to know what we know, when what we know refuses to be reduced to a clear knowledge of how to make something. . . . This is what we mean by going back to the beginnings of knowledge.

Here then I will introduce the artifice of a doubt: considering this shell, in whose shape I think I can discern a certain "construction" and as it were the work of some hand not acting "at random," I ask myself: *Who made it?*

But soon my question undergoes a transformation. It takes a short step forward along the path of my naïveté, and I begin to inquire by what sign we recognize that a given object is or is not *made by a man?*

It may seem somewhat absurd to pretend not to know that a wheel,

a vase, a piece of cloth, or a table has been produced by someone's industry, since we know perfectly well that it has. But what I say is that we do not know this *just by examining these things*. If no one had ever told us, then by what marks, by what signs should we know? What is it that indicates the presence or absence of a human operation? When an anthropologist finds a piece of flint, does he not often hesitate as to whether man or chance fashioned it?

The problem after all is not more futile nor any more naïve than speculation about *who made* a certain fine work in music or poetry; whether it was born of the Muse, or sent by Fortune, or whether it was the fruit of long labor. To say that someone composed it, that his name was Mozart or Virgil, is not to say much; a statement of this sort is lifeless, for the creative spirit in us bears no name; such a remark merely eliminates from our concern all men *but one,* within whose inner mystery the enigma lies hidden, intact. . . .

On the contrary I look at the object and nothing else: nothing could be more deliberately planned, or speak more harmoniously to our feeling for plastic shapes, to the instinct that makes us model with our fingers something we should delight to touch, than this calcareous jewel I am caressing, whose origin and purpose I wish for a time to disregard.

As we say a "sonnet," an "ode," a "sonata," or a "fugue," to designate well-defined forms, so we say a "conch," a "helmet," a "cameo," a "haliotis," a "porcelain"—all of them names of shells; and each one of these words suggests an action that aims to make something beautiful and succeeds.

What can prevent me from concluding that *someone* has made this curiously conceived, curiously turned and ornamented shell that troubles my imagination—and made it perhaps *for someone?*

I found this one in the sand. It attracted me because it was not a formless thing but one whose parts and aspects manifested an interrelation, a sequence and harmony as it were, that enabled me, after a single look, to conceive and foresee the aspects I had not yet examined. Its parts are joined by something more than the cohesion and solidity of matter. If I compare this thing to a stone, I find that the shell has an identity which the stone lacks. If I break them both, the fragments of the shell are not shells; but the fragments of the stone remain stones, just as the stone itself was once no doubt part of a still larger one. Yet even now certain fragments of the shell suggest the fragments that were joined to them; in a measure they engage my imagination and incite me to think further; they call for a *whole.* . . .

My observations thus far concur to make me think it would be *possible* to construct a shell; and that the process would be quite the same as that of making any of the objects I can produce with my hands by choosing some appropriate material, forming the design in my mind, and proceeding, part by part, to carry it out. The unity, the wholeness of the shell's form, force me to conclude that a directing idea presides over the execution; a pre-existing idea, quite separate from the work itself, an

idea that maintains itself, supervises and governs, while on the other hand and in *another area* it is put into execution by means of my energies successively applied. I divide myself in order to create.

Then someone made this object. But *of what?* And *why?*

However, if I now attempt to model or chisel out a similar object, I am first of all compelled to seek a suitable way of molding or cutting it; and it turns out that there are only too many possibilities. I am in a quandary. I can think of bronze, clay, stone: in respect to form, the final result of my operation will be independent of the material chosen. Of this material I demand only "sufficient," not strictly "necessary," conditions. According to the material employed, my acts will vary, no doubt; but different as they, and it, may be, I obtain in the end the same desired figure: I have several ways of passing from my idea to its effigy by way of the material.

In any case I am unable to imagine or define a *material* with such precision that the consideration of form will wholly determine my choice.

Moreover, just as I may hesitate in regard to the material, I may hesitate about the dimensions I shall give to my work. I see no necessary dependence between form and size; I can conceive of no form that might not be larger or smaller—it is *as though the idea of a certain figure called forth in my mind an endless number of similar figures.*

Thus I have been able to separate form from matter and both of these from size; and merely by thinking in some detail of my projected action, I have been able to see how it breaks down into stages. The least reflection, the slightest meditation on *how I should go about fashioning a shell,* tells me at once that I should have to act in several different ways, in several different capacities as it were, for I am not able to carry on all at once the numerous operations required to form the desired object. I shall have to connect them as though intervening from outside; and indeed, it is by a judgment independent of my action that I shall recognize that my work is "finished," that the object is "made," since the object in itself is only one possible stage, among others, in a series of transformations that might continue beyond their goal—*indefinitely.*

In reality I do not *make* this object; I only substitute certain attributes for certain others, and a certain relation that interests me for a certain diversity of forces and properties that I can only consider and utilize one by one.

I feel, finally, that if I have undertaken to produce one particular form, it is because I could have chosen to create entirely different ones. This is an absolute condition: if one can only make a single thing and in a single way, it means that the thing almost makes itself; therefore, such an action is not truly human (since thought is not necessary to it), and *we do not understand it.* What we make in this way really makes *us* more than we make it. What are we, if not a momentary balance between a multitude of hidden actions that are not specifically human? Our life is a tissue of such local acts in which choice plays no part, and

which in some incomprehensible way perform themselves. Man walks, breathes, remembers—but in all this he is in no way different from animals. He knows neither how he moves, nor how he remembers; and he has no need to know in order to move or remember, nor does he need to know *before* doing so. But if he builds a house or a ship, if he forges a tool or a weapon, a design must first act upon him and make him into a specialized instrument; an *idea* must co-ordinate what he desires, what he can do, what he knows, what he sees, what he touches and manipulates, and must organize all this expressly toward a particular and exclusive action, starting from a state in which he was entirely open and free from all intention. Once he is called upon to act, his freedom diminishes, relinquishes its rights, and for a time he accepts a constraint that is the price he must pay if he wishes to impress upon a certain "reality" the configured desire that he carries in his mind.

To sum up: all specifically human production is effected in successive, distinct, limited, enumerable acts. But up to this point certain animals, the builders of hives or nests, are quite like us. Man's specific work becomes unique when the separate, independent acts involved require his deliberate thinking presence to provoke them and adjust their diversity to an aim. Man consciously sustains his mental image and his will. We know only too well how precarious and costly this "presence of mind" is; how quickly the effort wanes, how our attention disintegrates, and that what arouses, assembles, corrects, and revives the efforts of our separate function is of a nature quite different from them; and this is why our *considered* projects, our *intentional* constructions or fabrications *seem very alien to our underlying organic activity.* . . .

I shall throw away this thing that I have found as one throws away a cigarette stub. This sea shell has *served* me, suggesting by turns what I am, what I know, and what I do not know. . . . Just as Hamlet, picking up a skull in the rich earth and bringing it close to his living face, finds a gruesome image of himself, and enters upon a meditation without issue, bounded on all sides by a circle of consternation, so beneath the human eye, this little, hollow, spiral-shaped calcareous body summons up a number of thoughts, all inconclusive. . . .

Georg Simmel

The Aesthetic Significance of the Face

The human face is of unique importance in the fine arts. This importance, however, is described only in very general and approximate terms when it is said that in the features of the face the soul finds its clearest expression. What is it about the face that makes this possible; and, apart from this question, does the face have certain intrinsic aesthetic qualities that account for its significance as a subject in art?

The essential accomplishment of the mind may be said to be its transformation of the multiplicity of the elements of the world into a series of unities. In the mind, things separated in space and time converge in the unity of a picture, a concept, a sentence. The closer the interrelation of the parts of a complex, and the livelier their interaction (which transforms their separateness into mutual dependence), the more the whole appears to be pervaded by mind. For this reason, the organism, with the intimate relation of its parts and the involvement of the parts in the unity of the life process, is only once removed from mind itself.

Of all the parts of the human body, the face has the highest degree of this kind of inner unity. The primary evidence of this fact is that a change which is limited, actually or apparently, to one element of the face—a curl of the lips, an upturning of the nose, a way of looking, a frown—immediately modifies its entire character and expression. Aesthetically, there is no other part of the body whose wholeness can as easily be destroyed by the disfigurement of only one of its elements. For this is what unity out of and above diversity means: that fate cannot strike any one part without striking every other part at the same time—as if through the root that binds the whole together. Of the rest of the body,

the hand, although closest to the face in organic character, still cannot compare with it. The marvelous interrelation and working together of the fingers give one the impression that each is, in reality, mutually independent. When, in fact, one hand always refers to the other; only the two together realize the idea, as it were, of "hand." The unity of the face is accentuated by the head's resting on the neck, which gives the head a sort of peninsular position vis-à-vis the body and makes it seem to depend on itself alone—an effect intensified by the fact that the body is clothed up to the neck.

Unity has meaning and significance only to the degree to which it contrasts with the multiplicity of whose synthesis it consists. Within the perceptible world, there is no other structure like the human face which merges such a great variety of shapes and surfaces into an absolute unity of meaning. The ideal of human co-operation is that completely individualized elements grow into the closest unity which, though composed of these elements, transcends each of them and comes into being exclusively through their co-operation. Among all perceptible things, this fundamental formula of life comes closest to being realized in the human face. By the spirit of a society we mean the content of those interactions which go beyond the individual—although not the individuals—which is more than their sum, yet still their product. In the same manner, the soul, lying behind the features of the face and yet visible in them, is the interaction, the reference of one to the other, of these separate features. From a purely formal viewpoint, the face, with its variety and diversity of parts, forms, and colors, would really be something quite abstruse and aesthetically unbearable—if, that is, the complexity were not at the same time a complete unity.

In other to make this unity aesthetically effective, it is essential that the spatial relation among the facial elements be allowed to shift only within very narrow limits. For aesthetic effect, a form must embrace its parts and hold them together. Any stretching and spreading of extremities is ugly because it interrupts and weakens their connection with the center of the phenomenon; that is, it weakens the perceivable domination of the mind over the circumference of our being. The large gestures of baroque figures, whose limbs appear to be in danger of breaking off, are repugnant because they disavow what is properly human—the absolute encompassment of each detail by the power of the central ego.

The structure of the face makes such centrifugal movement—that is, despiritualization—almost impossible from the outset. And when it does to some degree take place, as in gaping and staring, it is not only particularly unaesthetic, but, in addition, it is precisely these two expressions which indicate, as we now understand, the "loss of senses," spiritual paralysis, the momentary absence of spiritual control.

The impression of spirituality is also strengthened by the fact that the face shows the influence of gravity less than the other parts of the body. The human figure is the scene in which psychophysiological impulses struggle with physical gravity. The manner of fighting and resolv-

ing this battle repeatedly in each succeeding moment determines the style in which individuals and types present themselves to us. The fact that in the face mere bodily weight need not be overcome to any noticeable degree strengthens the impression of its spirituality. Here, too, suggestions of the opposite—closed eyes, head dropping to the chest, slack lips, lax musculature merely obeying gravity—are at the same time evidences of reduced spiritual life.

Man, however, is not simply the bearer of mind. He is not like a book in which spiritual contents are found, but which, as the mere locus of the contents, is indifferent to their intrinsic nature. His spirituality has the form of individuality. The face strikes us as the symbol, not only of the spirit, but also of an unmistakable personality. This feeling has been extraordinarily furthered in the period since the beginning of Christianity by the covering of the body. The face was the heir of the body; for in the degree to which nakedness was the custom, the body presumably had its share in the expression of individuality. The body's capacity in this respect, however, probably differs from that of the face in several ways.

To begin with, bodies differ to the trained eye just as faces do; but unlike faces, bodies do not at the same time *interpret* these differences. A definite spiritual personality is indeed connected with a definite, unmistakable body, and can at any time be identified in it. Under no circumstances, however, can the body, in contrast to the face, signify the *kind* of personality.

Further, the body by its movements—perhaps equally as well as the face—can certainly express psychological processes. However, only in the face do these movements become visible in features which reveal the soul clearly and ultimately. The flowing beauty we call gracefulness must re-create itself with every movement of the hand, bend of the torso, ease of step: it leaves no lasting form in which the individual movement is crystallized. In the face, on the contrary, the emotions typical of the individual—hate or timorousness, a gentle smile or a restless espying of advantage, and innumerable others—leave lasting traces. In the face alone, emotion first expressed in movement is deposited as the expression of permanent character. By virtue of this singular malleability, only the face becomes the geometric locus, as it were, of the inner personality, to the degree that it is perceptible. In this respect, Christianity, whose tendency to cover the body and permit man's appearance to be represented solely by his face, has been the schoolmaster for those who would seek consciousness of individuality.

Besides these formal means of aesthetic representation of individuality, the face has others which serve it in behalf of the opposite principle. The fact that the face consists of two halves which are similar to one another gives it an inner calm and balance which attenuate the excitement and intensity of the purely individual elements. For the very reason that the two halves usually do not present themselves *exactly* alike (owing to differences in profiling and lighting), each is a preparation for, or

a fading-away of, the other. The separateness of the individual features is complemented and balanced by the essential comparability of the two halves.

Like all symmetrical forms, that of the face is in itself anti-individualistic. In the symmetrical structure, either of the two parts can be inferred from the other and each points toward a higher principle which governs them both. In all situations, rationalism strives for symmetry, whereas individuality always involves something irrational, something which eludes every predetermining principle. Sculpture, therefore, which presents the halves of the face symmetrically, is confined to a more general or typical style that lacks ultimate individual differentiation; painting, on the other hand, by virtue of the difference in the immediate appearance of the halves of the face resulting from various positions of the profile and proportions of light and shadow, reveals from the beginning a more individualistic nature. The face is the most remarkable aesthetic synthesis of the formal principles of symmetry and of individuality. As a whole, it realizes individualization; but it does so in the form of symmetry, which controls the relations among the parts.

Finally, there is another formal relationship, already mentioned, which gives the face its aesthetic significance and uniqueness. Much of the aesthetic character of objects which are changeable or which exist in many similar forms is determined by the extent to which a modification of the parts must occur in order to result in a change in the over-all impression. Here, too, the ideal of conservation of energy is exemplified: in principle, an object is aesthetically more impressive or useful, the more sensitively it responds as a whole to the alteration of its smallest element. For this shows the sensitivity and strength of the interrelation of its parts, its inner logic, as it were, which requires that every change in a premise inevitably be followed by a change in the conclusion. Aesthetic contemplation and organization abolish the indifference of elements, a characteristic which belongs only to their theoretical images. Those objects, therefore, in which the mutual indifference of elements is suspended and the fate of each determines that of all others are the most receptive to aesthetic treatment.

The face, in fact, accomplishes more completely than anything else the task of creating a maximum change of total expression by a minimum change of detail. The universal problem of art is to elucidate the formal elements of things by relating them to one another—to interpret the perceptible through its connection with the perceptible. Nothing seems more suited to this than the face in which the character of each feature is integrated with the character of every other—that is, of the whole. The cause and effect of this circumstance is the immense mobility of the face. In an absolute sense, it commands only very slight changes of position; yet because of the influence of each change on its total character, the impression of intensified modifications, so to speak, results. It is as if a maximum of movements were invested even in its state of rest, or as if this state of rest were the non-extended moment toward which

innumerable movements have tended, from which innumerable moments will come.

The height of this extraordinarily dynamic effect is achieved with a minimal movement by the eye. In painting, in particular, the eye derives its effect not only from its relation to the totality of the features—a relation it mediates by its potential mobility—but also from the importance of the gaze of the persons portrayed in interpreting and structuring the space in the picture itself. There is no other thing which, staying so absolutely in place, seems to reach beyond it to such an extent; the eye penetrates, it withdraws, it circles a room, it wanders, it reaches as though behind the wanted object and pulls it toward itself. The artist's use of the direction, intensity, and whole formal character of the gaze for purposes of dividing and elucidating pictorial space needs a special study.

The eye epitomizes the achievement of the face in mirroring the soul. At the same time, it accomplishes its finest, purely formal end as the interpreter of mere appearance, which knows no going back to any pure intellectuality *behind* the appearance. It is precisely this achievement with which the eye, like the face generally, gives us the intimation, indeed the guarantee, that the artistic problems of pure perception and of the pure, sensory image of things—if perfectly solved—would lead to the solution of those other problems which involve soul and appearance. Appearance would then become the veiling and unveiling of the soul.

R. W. Hepburn

Aesthetic Appreciation of Nature

I

CONTEMPORARY WRITINGS on aesthetics attend almost exclusively to the arts and very rarely to natural beauty.[1] Aesthetics is even defined by some mid-century writers as 'the philosophy of art,' 'the philosophy of criti-

From *British Journal of Aesthetics,* Vol. 3 (1963), pp. 195–209. Reprinted by permission.

cism.' Two much-quoted anthologies of aesthetics (Elton's in this country, Vivas and Krieger's in America) contain no study of natural beauty.[2] Why is this so?

For part of the answer we have to look not to philosophers' theories but to some general shifts in aesthetic taste itself. Despite appearances to the contary (the cult of the open air, caravans, camps, excursions in the family car) serious aesthetic concern with nature is today rather an unusual phenomenon. If we regard the Wordsworthian vision as the great peak in the recent history of the subject, then we have to say that the ground declined very sharply indeed from that extraordinary summit, and that today we survey it from far below. The Wordsworthian nature was man's aesthetic and moral educator: whereas the characteristic image of twentieth-century man, as we all know, is that of a 'stranger' encompassed by a nature which is indifferent, unmeaning and 'absurd.'

The work of the sciences too has tended to produce some bewilderment and loss of nerve over the aesthetic interpretation of nature. Microscope and telescope have added vastly to our perceptual data; the forms of the ordinary landscape, ordinarily interpreted, are shown up as only a selection from countless different scales. 'What is nature?' The question can no longer be answered in terms of macroscopic, readily-discriminable, 'labelled' objects.

On the theoretical level there are other and distinctive reasons for the neglect of natural beauty in aesthetics itself, especially in an aesthetics that seeks to make itself increasingly rigorous. Certain important features of aesthetic experience are quite unobtainable in nature—a landscape does not minutely control the spectator's response to it as does a successful work of art: it is an unframed ordinary object, in contrast to the framed, 'esoteric,' 'illusory' or 'virtual' character of the art-object. And so the artefact tends to be taken as the aesthetic object *par excellence,* and the proper focus of study.

Linguistic or conceptual analysts have been understandably tempted to apply their techniques first and foremost to the arguments and manifestoes lying to hand in the writings of art critics. In the case of natural beauty, however, such a critical literature scarcely exists. The philosopher must first work out his own systematic account of the aesthetic enjoyment of nature. And this he has so far been slow—or reluctant—to do.

Having drawn attention to a neglected topic, I now want to argue that the neglect is a very bad thing: bad because aesthetics is thereby steered off from examining an important and richly complex set of relevant data; and bad because when a set of experiences is ignored in a theory relevant to them, they tend to be made less readily available as experiences. If we cannot find sensible-sounding language in which to describe them, the experiences are felt, in an embarrassed way, as off-the-map—and since off the map, seldom visited. This is specially unfortunate if for other reasons the experiences are already hard to achieve.

What, then, can contemporary aesthetics do about the topic of natural beauty?

II

If I am right that systematic description is one main lack here, I ought to supply some account of the varieties of aesthetic experience of nature. But their variety is immense, and mere cataloguing would be tedious. I shall select a few samples both interesting in themselves and useful for subsequent arguments.

We have already remarked that art-objects have a number of general characteristics not shared by objects in nature. It would be useful if we could show (and I think we can) that the absence of certain of these features is not merely privative in its effect, but can contribute valuably to the aesthetic experience of nature.

A good specimen is the degree to which the spectator can be involved in the natural aesthetic situation itself. *On occasion* he may confront natural objects as a static, disengaged observer; but far more typically the objects envelop him on all sides. In a forest, trees surround him; he is ringed by hills, or he stands in the midst of a plain. If there is movement in the scene, the spectator may himself be in motion and his motion may be an important element in his aesthetic experience. Think, for instance, of a glider-pilot, delighting in a sense of buoyancy, in the balancing of the air-currents that hold him aloft. This sort of involvement is well expressed by Barbara Hepworth: 'What a different shape and "being" one becomes lying on the sand with the sea almost above from when standing against the wind on a sheer high cliff with seabirds circling patterns below one.' [3] We have here not only a mutual involvement of spectator and object, but also a reflexive effect by which the spectator experiences *himself* in an unusual and vivid way: and this difference is not merely noted but dwelt upon aesthetically.

If this study were on a larger scale, we should have to analyse in detail the various senses of 'aesthetic detachment' and 'involvement' that are relevant here. This could prove a more slippery investigation than in the case of art-appreciation; but a rewarding one. The spectator is, of course, aesthetically detached in the sense that he is not *using* nature, manipulating it or calculating how to manipulate it. He is both actor and spectator, ingredient in the landscape and lingering upon the sensations of being thus ingredient, playing actively with nature and letting nature as it were play with him and his awareness of himself.

Secondly: though by no means all art-objects have frames or pedestals, a great many of them share a common character in being set apart from their environment in a distinctive way. We might use the word 'frame' in an extended sense to cover not only the physical boundaries of pictures but all the various devices employed in different arts to prevent the art-object being mistaken for a natural object or for an artefact

without aesthetic interest. Such devices are best thought of as aids to the recognition of the formal completeness of the art-objects themselves, their ability to sustain aesthetic interest.

In contrast natural objects are 'frameless.' This is in some ways a disadvantage aesthetically: but there are some compensations. Whatever lies beyond the frame of an art-object cannot normally become part of the aesthetic experience relevant to it. A chance train-whistle cannot be integrated into the music of a string quartet; it merely interferes with its appreciation. But where there is no frame, and where nature is our aesthetic object, a sound or a visible intrusion from beyond the original boundaries of our attention can challenge us to integrate it in our overall experience, to modify that experience so as to make room for it. This, of course, *need* not occur: we may shut it out by effort of will if it seems quite unassimilable. At any rate our creativity is set a task: and when things go well with us we experience a sudden expansion of imagination that can be memorable in its own right.

> And, when there came a pause
> Of silence such as baffled his best skill:
> Then sometimes, in that silence, while he hung
> Listening, a gentle shock of mild surprise
> Has carried far into his heart the voice
> Of mountain-torrents . . .

If the absence of 'frame' precludes full determinateness and stability in the natural aesthetic object, it at least offers in return such unpredictable perceptual surprises; and their mere possibility imparts to the contemplation of nature a sense of adventurous openness. In a painting the frame ensures that each element of the work is determined in its perceived qualities (including emotional qualities) by a limited context. Obviously this is one kind of determinateness that cannot be achieved with natural objects. The aesthetic impact made upon us by, say, a tree is part-determined by the context we include in our view of it. A tree growing on a steep hill-slope, bent far over by the winds, may strike us as tenacious, grim, strained. But from a greater distance, when the view includes numerous similar trees on the hillside, the striking thing may be a delightful stippled patterned slope, with quite different emotional quality—quixotic or cheery. Any aesthetic quality in nature is always provisional, correctible by reference to a different, perhaps wider context or to a narrower one realized in greater detail. In positive terms this provisional character of aesthetic qualities in nature creates a restlessness, an alertness, a search for ever new standpoints and more comprehensive unities.

Lastly: we can distinguish between the particular aesthetic impact of an object, whether natural or artefact, and certain general 'background' experiences common to a great many aesthetic situations and of aesthetic value in themselves. With an art-object there is the exhilarating activity of coming to grasp its intelligibility as a perceptual

343

whole. We find built-in guides to interpretation and contextual controls
for our response. We are aware of these features as having been expressly
put there by its creator. Now I think that we can locate a nearly parallel
but interestingly different background experience when our object is not
an artefact but a natural one. Again it is a kind of exhilaration, a delight
in the fact that the forms of the natural world *offer scope* for the exercise
of imagination, that leaf pattern chimes with vein pattern, cloud form
with mountain form and mountain form with human form. Indeed,
when nature is pronounced to be 'beautiful'—not in the narrower sense
of that word, which contrasts 'beautiful' with 'picturesque' or 'comic,' but
in the wide sense equivalent to 'aesthetically interesting' and 'aestheti-
cally excellent'—an important part of our meaning is just this, that na-
ture's forms do provide this scope for imaginative play. For that is surely
not analytically true: it might have been otherwise.

I have been arguing that certain important differences between
natural objects and art-objects furnish grounds for distinctive and valua-
ble types of aesthetic experience of nature. These are types of experience
that art cannot provide to the same extent as nature, or cannot provide
at all. Supposing that a person's aesthetic education fails to reckon with
these differences, supposing it instils in him the attitudes, the tactics of
approach, the expectations proper to the appreciation of art-works only,
such a person will either pay very little aesthetic heed to natural objects
or else will heed them in the wrong way. He will look—and of course look
in vain—for what can be found and enjoyed only in art. Furthermore, one
cannot be at all certain that he will seriously ask himself whether there
might be other tactics more proper and more fruitful for the aesthetic
appreciation of nature.

III

Accounts of the aesthetic appreciation of nature have sometimes
focused upon the contemplating of single natural objects in their in-
dividuality and uniqueness. They have centered upon the formal organi-
zation of such objects or their colours and textures. Other writers, with
greater metaphysical daring, or rashness, have spoken of the aesthetic
enjoyment of nature as leading to the disclosure of 'unity' in nature, or
as tending towards an ideal of 'oneness with nature.' The formulations
vary greatly and substantially among themselves: but the vocabulary of
unity, oneness as the key aesthetic principle, is the recurrent theme.[4]

There are strong influences in contemporary British philosophy that
prompt one to have the fullest sympathy with a particularist approach
to natural beauty—as the contemplating of individual objects with their
aesthetically interesting perceptual qualities; and to have very little sym-
pathy for the more grandiose language of 'oneness with' or 'in' nature.
None the less, it seems to me that we do not have here one good and one
bad aesthetic approach, the first sane and the second absurd. Rather we

have two well-separated landmarks between which lies a range of aesthetic possibilities: and in the mapping of this range those landmarks will play a valuable role.

We must begin by frankly denying the universal aesthetic need for unity, unity of form, quality, structure, or of anything else. We can take pleasure in sheer plurality, in the stars of the night sky, in a birdsong without beginning, middle or end. And yet to make 'unity' in some sense one's key concept need not be simply wrong-headed or obscurantist. I want to argue that there are certain incompletenesses in the experience of the isolated particular that produce a *nisus* towards the other pole, the pole of unity. But there is not a single type of unification or union: *several* notions are to be distinguished within the ideal.

We have already noted the nisus towards more and more comprehensive or adequate survey of the context that determines the perceived qualities of a natural object or scene. Our motives are, in part, the desire for a certain integrity or 'truth' in our aesthetic experience of nature: and of this more shortly. We know also that in all aesthetic experience it is contextual complexity that, more than any other single factor, makes possible the minute discrimination of emotional qualities; and such discrimination is accorded high aesthetic value. It is largely the pursuit of such value that moves us to accept what I called 'the challenge to integrate'—to take notice of and to accept as aesthetically relevant some shape or sound that initially lies outside the limit of our attention.

The expansion of context does not have to be a spatial expansion. What else can it be? Supposing I am walking over a wide expanse of sand and mud. The quality of the scene is perhaps that of wild, glad emptiness. But suppose that I bring to bear upon the scene my knowledge that this is a tidal basin, the tide being out. I see myself now as virtually walking on what is for half the day sea-bed. The wild glad emptiness may be tempered by a disturbing weirdness. Thus, in addition to spatial extension (or sometimes instead of it), we may aim at enriching the interpretative element of our experience, taking this not as theoretical 'knowledge-about' the object or scene, but as helping to determine the aesthetic impact it makes upon us. 'Unity' here plays a purely 'regulative' role. Nature is not a 'given whole,' nor indeed is knowledge about it. And in any case there are psychological limits to the expansion process; a degree of complexity is reached beyond which there will be no increase in discrimination of perceptual or emotional qualities.

A second movement away from contemplation of uninterpreted particulars is sometimes known as the 'humanizing' or the 'spiritualizing' of nature. I shall merely note its existence and relevance here, for there have been a good many accounts of it in the history of aesthetics. Coleridge said that: 'Art is . . . the power of humanizing nature, of infusing the thoughts and passions of man into every thing which is the object of his contemplation.' [5] And Hegel, that the aim of art is 'to strip the outer world of its stubborn foreignness.' [6] What is here said about art is no less true of aesthetic experience of nature itself. Imaginative activity is work-

345

ing for a *rapprochement* between the spectator and his aesthetic object: unity is again a regulative notion, a symbol of the unattainable complete transmutation of brute external nature into a mirror of the mind.

By developing and qualifying the 'humanization' ideal we can come to see yet a third aspect of the nisus towards unity. A person who contemplates natural objects aesthetically may sometimes find their emotional quality is describable in the vocabulary of ordinary human moods and feeling—melancholy, exuberance, placidity. But not always. A particular emotional quality can be roughly *analogous* to a nameable human emotion—let us say, desolation: but the precise quality of desolation revealed in some waste or desert in nature may be quite distinctive in timbre and intensity. Aesthetic experience of nature may be experience of a range of emotion that the human scene by itself, untutored and unsupplemented, could not evoke. In Barbara Hepworth's remark, once more, to be one with nature in her sense was to realize vividly one's place in the landscape, as a form among its forms. And this is not to have nature's 'foreignness' or otherness overcome, but rather to allow that otherness free play in modifying one's everyday sense of one's own being. In this domain, again, we need not confine ourselves to the contemplating of uninterpreted particulars. In a leaf-pattern I may 'see' also blood-vessel patterns, or the patterns of branching, forked lightning: or all of these. In a spiral nebula pattern I may see the pattern of swirling waters or whirling dust. I may be aware of a network of affinities, analogous forms, spanning the inorganic or the organic world or both. My experience has a quality of *multum in parvo*. If, with Mr. Eliot, one sees 'The dance along the artery/The circulation of the lymph' as 'figured in the drift of stars,' something of the aesthetic qualities of the latter (as we perceive them) may come to be transferred to the former. This is not necessarily a humanizing of nature; it may be more like a 'naturizing' of the human observer.

A fourth class of approaches to ideals of 'unity' is concerned with what we have called the 'background' quality of emotions and attitudes, common to a great many individual experiences. Here the background is a sense of reconciliation, suspension of conflict, and of being in that sense at one with the aesthetic object. This particular sort of 'at-one-ness' could hardly be present in art-experience, since it requires that the aesthetic object should be at the same time some part of the natural environment. This is the same environment from which we wrest our food, from which we have to protect ourselves in order to live, and which refuses to sustain our individual lives beyond a limited term. To attain, and sustain, the relevant detachment from such an environment in order to savour it aesthetically is in itself a fair achievement, an achievement which suffuses the aesthetic experiences themselves with that sense of reconciliation. The objects of nature may look to us as if their *raison d'être* were precisely that we should celebrate their beauty. As Rilke put it: 'Everything beckons to us to perceive it.' [7] Or the dominant stance may be that of benediction: the Ancient Mariner 'blesses' the watersnakes at his moment of reconciliation.

This fourth type of unity-ideal could arise in the contemplation of what is itself quite *un*-unified in the other senses, the night sky again, or a mass of hills with no detectable pattern to unite them. It is more strictly a concomitant, or a by-product, of an aesthetic experience that we are already enjoying, an experience in which there may have been no synoptic grasping of patterns, relating of forms or any other sort of unifying.

I suspect that someone who tried to construct a comprehensive aesthetic theory with 'unity' as its sole key concept would obtain his comprehensiveness only by equivocating or punning over the meaning of the key expression, only by sliding and slithering from one of its many senses to another. When one sense is not applicable, another may well be. The fourth sense in particular can be relevant to vivid aesthetic experience of any natural objects whatever.

So much the worse, we may conclude, for such a theory *qua* monolithic. But to say that is not to imply that our study has yielded only negative results. This is one of several areas in aesthetics where we have to resist the temptation to work with a single supreme concept and must replace it by a *cluster* of related key concepts. In searching out the relevant key concepts, the displaced pseudo-concept may yet be a useful guide—as it is in the present case. It is not, however, adequate for all explanatory purposes.

We began our study by referring to the contemplation of uninterpreted individual natural objects in their particularity. This was not a mere starting-point to be left behind in our pursuit of the 'unities.' On the contrary, aesthetic experience remains tethered to that concern with the particular even if on a long rope. The rope is there, although the development and vitality of that experience demand that it be stretched to the full. The pull of the rope is felt when the expanding and complicating of our synopses reaches the point beyond which we shall have not more but less fine discrimination of perceptual quality. It is felt again when we risk the blurring and negating of natural forms as we really perceive them in an anxious attempt to limit our experience of nature to the savouring of stereotyped and well-domesticated emotional qualities. It is even relevant to our fourth type of unity-ideal: for the sense of reconciliation is not an independent and autonomous aesthetic experience, but hangs entirely upon the occurrence of particular experiences of particular aesthetically interesting natural objects.

IV

Although recent aesthetics has been little concerned with natural beauty as such, yet at crucial points in its analyses of *art*-experience it has frequently made comparisons between our aesthetic approach to art-objects and to objects in nature. In the light of our reflections so far we may wish to ask at this point whether the comparing has been fairly done. We have room to examine one example only.

An important part of current controversy is the assessment of the Expression Theory. The Expression Theory saw the artefact as the middle link in a communication from artist to spectator. Its critics see the artefact first and foremost as an object with certain properties, properties which are, or should be, aesthetically interesting and which in their totality control the spectator's response. This is an aesthetic approach that reduces the gulf between art-object and natural object. Both are to be approached primarily as individual, self-contained entities, exciting to contemplate by virtue of their perceived qualities. But how far can we accept this comparison? Critics of the critics have pointed out some deficiencies. They have insisted upon the irreducible relevance of linguistic and cultural context to the interpretation of a poem. Identical words might constitute *two* poems, not one, if we read them in two different historical contexts.[8]

We could extend this criticism as follows. Suppose we have two perceptually identical objects, one an artefact and the other natural. They might be a 'carved stone' of Arp and a naturally smoothed stone; a carving in wood and a piece of fallen timber. Or they might be identical in pattern, though not in material; for example, a rock face with a particular texture and marking and an abstract expressionist painting with the same texture and the same markings. If we made the most of the *rapprochement,* we should have to say that we had in each of these cases essentially *one* aesthetic object. Yet this would be a misleading conclusion. If we knew them for what they are—as artefact or natural object—we should certainly attend and respond differently to them. As we look at the rock face we may realize imaginatively the geological turmoils that produced its pattern. The realizing of these need not be a piece of extra-aesthetic reflection; it may determine for us how we see and respond to the object itself. If we interpreted and responded to the abstract painting in the same way, our interpretation would this time be merely whimsical. If we arbitrarily restricted aesthetic experience of both nature and art to the contemplating of uninterpreted shapes and patterns, we could, of course, have the *rapprochement.* But we have seen good reason for refusing so to restrict it in the case of nature-experience, whatever be the case with art.

Take another instance. Through the eyepiece of a telescope I see the spiral nebula in Andromeda. I look next at an abstract painting in a circular frame that contains the identical visual pattern. My responses are not alike, even if each is indisputably aesthetic. My awareness that the first shapes are of enormous and remote masses of matter in motion imparts to my response a strangeness and solemnity that are not generated by the pattern alone. The abstract pattern may indeed impress by reminding me of various wheeling and swirling patterns in nature. But there is a difference between taking the pattern as that sort of reminder and on the other hand brooding on this impressive instantiation of it in the nebula.

A more lighthearted but helpful way of bringing out these points is

to suppose ourselves confronted by a small object which, for all we know, may be natural or may be an artefact. We are set the task of regarding it aesthetically. I suppose that we might cast upon it an uneasy and embarrassed eye. How shall we approach it? Shall we, for instance, see it its smoothness the slow mindless grinding of centuries of tides, or the swifter and mindful operations of the sculptor's tools? Certainly, we can enjoy something of its purely formal qualities on either reckoning; but even the savouring of these is affected by non-formal factors that diverge according to the judgment we make about its origin. To sum up: the swing, in some recent aesthetics, from 'intention' to 'object' has been healthful on the whole, delivering aesthetics and criticism from a great deal of misdirected labour. But it has countered the paradoxes of expressionism with paradoxes of its own. Differences between object and object need to be reaffirmed: indiscernibly different poems or carvings become discernibly different when we reckon with their aesthetically different cultural contexts; and the contextual controls that determine how we contemplate an object in nature are different from those that shape our experience of art. In other words, we have here a central current issue in aesthetics that cannot be properly tackled without a full-scale discussion of natural beauty.

V

That, however, is not the only current issue about which the same can be said. It can be said also (and this introduces our final topic) about the analysis of such expressions as 'true,' 'false,' 'profound,' 'shallow,' 'superficial,' as terms of aesthetic appraisal. These have been studied in their application to art-objects but scarcely at all in connection with nature. It might indeed be contested whether they have *any* meaningful use in the latter connection.

I think it can be shown that they have. We can best approach the topic by way of some analysis of an expression which we have used already but not explained. It is a sense of the word 'realize.' Here are some examples of the use. 'I had long known that the earth was not flat, but I never before *realized* its curvature till I watched that ship disappear on the horizon.' Here 'realize' involves making, or becoming, vivid to perception or to the imagination. Auxiliary imagings may attend my realizing of the earth's curvature, the image of my arms stretched out, fingers reaching round the sphere; and the realization of loneliness may involve imagining myself shouting but being unheard, needing help but getting none.

In some cases to realize something is simply to know or understand, where 'know' and 'understand' are analysable in dispositional terms. But our present sense of 'realize' has an essential episodic component: it is a coming-to-be-aware. In the aesthetic setting it is an experience accompanying and arising out of perceptions—perceptions upon which we

dwell and linger. I am gazing, say, at a cumulus cloud when I realize its height. I do not discard, or pass beyond, the experience, as if I were judging the height of the cloud in flight-navigation (or the loneliness of the moor in planning a murder). This sort of realizing is obviously one of our chief activities in the aesthetic experiencing of nature. It has been central in earlier illustrations, the contemplation of the rock face, the spiral nebula, the ocean-smoothed stone.

But my suggestion that realizing is 'episodic,' occurrent, may properly be challenged. Suppose that I am busy realizing the utter loneliness of the moor, when suddenly I discover that behind sundry bits of cover are a great many soldiers taking part in a field-exercise. Could I, without illogic, maintain that I had been realizing what is not in fact the case? Hardly. 'Realize' contains a built-in reference to truth. It has episodic components, but it cannot be exhaustively analysed in that way. I cannot be said to have realized the strength and hardness of a tall tree-trunk if, when I then approach it, it crumbles rotten at a touch. But surely I was doing *something:* My experience did occur; and nothing that subsequently occurs can alter it.

Now this experience was, of course, the aesthetic contemplation of apparent properties. That they turn out not to be also real properties may disturb the spectator, or it may not. For some people aesthetic experience is interested not at all in reality—only in looks, seemings: indifference to truth may be part of their definition of the aesthetic. If the soldiers appear or the tree crumbles, the aesthetic value of the prior experience is (to those people) not in the least affected. Others take a different view. One could agree that a large range of aesthetic experience is not concerned about truth but yet attach a peculiar importance to the range that is. I am not sure that the gulf between this and the contrasted view is wholly bridgeable by argument: but some reflections can be offered along the following lines.

If we want our aesthetic experiences to be repeatable and to have stability, we shall try to ensure that new information or subsequent experimentation will not reveal the 'seemings' as illusions. If I know that the tree is rotten, I shall not be able again to savour its seeming-strength. I could, no doubt, savour its 'deceptively strong appearance;' but that would be a quite different experience from the first.

Suppose the outline of our cumulus cloud resembles that of a basket of washing, and we amuse ourselves in dwelling upon this resemblance. Suppose that on another occasion we do not dwell on such freakish aspects, but try instead to realize the inner turbulence of the cloud, the winds sweeping up within and around it, determining its structure and visible form. Should we not be ready to say that this latter experience was less superficial than the other, that it was truer to nature, and for that reason more worth having? If there can be a passage, in art, from easy beauty to difficult and more serious beauty, there can also be such passages in aesthetic contemplation of nature.

Were there not a strong nisus in that direction, how could we account for the sense of bewilderment people express over how to bring their aesthetic view of nature into accord with the discoveries of recent science? Because of these discoveries (as Sir Kenneth Clark puts it): 'the snug, sensible nature which we can see with our own eyes has ceased to satisfy our imaginations.' [9] If the aesthetic enjoyment of nature were no more than the contemplation of particular shapes and colours and movements, these discoveries could not possibly disturb it. But they do: they set the imagination a task in 'realizing.'

An objector may still insist that reference to truth is aesthetically irrelevant. To him the only relevant factors are the savouring of perceptual qualities and formal organization. But a formalist might at least be reminded that a major element in his own enjoyment is the synoptic grasping of complexities. A particular colour-patch may be seen as part of an object, as modifying the colour of adjacent patches, and as contributing to the total perceived pattern—all simultaneously. One could argue that the striving to 'realize' should be taken as adding to our powers of synopsis and for the *exclusion* of it no good reason could be given.

But a more searching anxiety might be expressed. Sometimes indeed such realizings may enhance an aesthetic experience, but may they not sometimes destroy it? When I see the full moon rising behind the silhouetted branches of winter trees I may judge that the scene is more beautiful if I think of the moon simply as a silvery flat disc at no great distance from the trees on the skyline. Ought I to be realizing the moon's actual shape, size and distance? Why spoil my enjoyment? There may be cases when I have to choose between an aesthetic experience available only if I inhibit my realizing and on the other hand a different aesthetic experience available if I do some realizing. In our example, the first experience is of beauty (in the narrow sense); and we could not count on the alternative experience being also one of beauty, in the same sense. It might, of course, be still aesthetically exciting: that is, of beauty in the widest sense. But, the objector might press, even that cannot be guaranteed in all cases. And this is exactly the difficulty we feel about the bearing of present-day science on our vision of the natural world. Sometimes our attempts at realizing are aesthetically bleak and unrewarding; or they may fail altogether, as perhaps with some cosmologies and cosmogonies. Compromises, the balancing of one aesthetic requirement against another, may well be inevitable. One may say in a particular case: 'this is the nearest I can come to making imaginatively vivid what I know about that object. My realizing is still not quite adequate to my knowledge; but if I were to go any further in that direction, I should lose touch altogether with the sights, sounds and movements of the visible world seen from the human point of view. And that would impoverish, not enrich, my total aesthetic experience.' What we should be feeling again is the tug of the rope that tethers aesthetic experience to the perception of the particular object and its perceived individuality.

To be able to say anything more confident about this problem one would need to hold a metaphysical and religious view of nature and science which denied that the imaginative assimilating of scientific knowledge could ultimately lead to aesthetic impoverishment. That possibility we can only take note of in this essay without being able to explore it.

We recall at the same time, and in conclusion, that some important accounts of natural beauty have, historically, been closely allied with various sorts of nature-mysticism. I have argued that there are in fact not one but several unity-ideals; that it is most unlikely that any single aesthetic experience can fully and simultaneously realize them all; and I believe that with certain of them the notion of full attainment makes dubious sense. Yet the idea of their ever more intense and comprehensive attainment is not without value, and the link with nature-mystical experiences need not be severed.[10]

Very tentatively, I suspect that no more materials are required than those with which we are already furnished in order to render available certain limited varieties of mystical experience, and logically to map them. Those materials provide us, not with affirmations about a transcendent being or realm, but with a *focus imaginarius* that can play a regulative and practical role in the aesthetic contemplation of nature. It sees that contemplation as grounded, first and last, in particular perceptions, but as reaching out so as to relate the forms of the objects perceived to the pervasive and basic forms of nature; relating it also to the observer's own stance and setting, as himself one item in nature—a nature with whose forces he feels in harmony through the very success of this contemplative activity itself.

But even if something of the intensity and momentousness of mystical experience can be reached along such lines, this would be a mysticism without the God of theism. And surely the absence of belief in transcendence would make this quite different from a mysticism that centres upon it. Different, indeed, in the quality of available experience and in expectations aroused both for the here-and-now and the hereafter: but not so radically different as to make 'mysticism' a misnomer. Belief in a transcendent being means that, for the believer, the 'focus' is not imaginary but actual—in God; and it is doubtless psychologically easier to work towards a goal one believes to be fully realizable than towards a focus one suspects to be imaginary. Rather similarly, in ethics a student may experience a check to his practical moral confidence when he discovers that 'oughts' cannot be grounded in 'is's.' Yet it is seldom that he indulges for this reason in a permanent moral sulk. Perhaps, if I am right, it is no more reasonable to indulge in a nature-mystical sulk. But I begin to moralize: a sign that this paper has come to its proper end.

Notes

1. By 'nature' I shall simply mean all objects that are not human artefacts. I am ignoring the many possible disputes over natural objects

that have received a marked, though limited, transformation at man's hands.

2. W. Elton (ed.), *Aesthetics and Language* (1954): Vivas and Krieger (eds.), *The Problems of Aesthetics* (1953). Compare also H. Osborne's *Theory of Beauty* (1952), which likewise confines its investigation to art-experience. M. C. Beardsley's *Aesthetics* (1958) is subtitled *Problems in the Philosophy of Criticism.*

Mr. Osborne defines beauty as the 'characteristic and peculiar excellence of works of art.' Professor Beardsley's opening sentence reads: 'There would be no problems of aesthetics, in the sense in which I propose to mark out this field of study, if no one ever talked about works of art.'

3. *Barbara Hepworth: Carvings and Drawings* (1952) chap. 4.

4. (*a*) Graham Hough's *Image and Experience* (1960) contains some suggestive reflections stemming from his discussion of Ruskin and Roger Fry. 'By intense contemplation of . . . experiences of form and space we become conscious of the unity between ourselves and the natural world' (p. 175). 'It is Ruskin's special distinction to show . . . how the experience of the senses can lead directly to that unified apprehension of nature, and of ourselves as a part of nature, which can fairly constantly be recognized, under various mythological disguises, not only as that which gives value to aesthetic experience, but also as one of the major consolations of philosophy' (p. 176).

(*b*) The nature-mystical interpretation of unity-with-nature is briefly stated by Evelyn Underhill in her *Mysticism.* In moments of intense love for the natural world 'hints of a marvellous truth, a unity whose note is ineffable peace, shine in created things' (4th ed., 1912, p. 87).

W. T. Stace, listing the common characteristics of 'extrovertive mysticism' (to which nature-mysticism belongs), includes the following: 'The One is . . . perceived through the physical senses, in or through the multiplicity of objects.' 'The One [is apprehended more concretely] as being an inner subjectivity in all things, described variously as life, or consciousness, or a living Presence.' He adds: 'There are underground connections between the mystical and the aesthetic . . . which are at present obscure and unexplained.' (*Mysticism and Philosophy,* 1960, pp. 79, 81.)

(*c*) Coleridge wrote: 'The groundwork . . . of all true philosophy is the full apprehension of the difference between the contemplation of reason, namely that intuition of things which arises when we possess ourselves as one with the whole . . . and that which presents itself when . . . we think of ourselves as separated beings, and place nature in antithesis to the mind, as object to subject, thing to thought, death to life.' (*The Friend,* Bohn Ed., p. 366.)

These brief quotations, culled in near-random fashion from very diverse historical contexts, may suffice to show at least the existence of some of the tendencies with which we shall be concerned.

5. *Biographia Literaria,* vol. II, 'On Poesy or Art.'

6. *Introduction to Hegel's Philosophy of Fine Art* (trans. Bosanquet, 1886), p. 59.

7. *Later Poems* (ed. Leishman), p. 128.

8. See H. S. Eveling, 'Composition and Criticism,' *Proc. Arist. Soc.,* 1958–9.

9. *Landscape into Art* (1949), Pelican Books, 1956, p. 150. Sir Kenneth Clark is writing of art and artists, but his points are no less relevant to a contemplation of nature that never passes into the constructing of art objects.

10. Compare, once again, Graham Hough, *Image and Experience* (1960), pp. 174 f.

PART FOUR

How Is Art Made?

CHAPTER 1

Introduction

In speaking of the process by which art comes to be, one has to choose one's words with care. Terms such as "making," "producing," and "constructing" are not unsuitable, but a faint air of deceit permeates the connotation of "fabricating" and "contriving," while there are those to whom "creating" is embarrassingly eulogistic. Gods may create worlds *ex nihilo,* but for men to turn out works of art in this fashion seems quite unthinkable. Moreover, the term "creation" is seldom applied to the work of craftsmen, thereby surreptitiously endorsing the distinction between arts that are looked down upon as merely useful and arts that are looked up to as fine. If that distinction is rejected, then the need for an honorific term such as "creation" is further diminished. Yet the term "creation" continues to be widely employed, either through the formidable force of habit, or because those who use it feel that, although it refers to no specific difference in kind, it does refer to a subtle but important difference of emphasis. Craftsmen construct, it is argued, performers perform, parents beget, but only artists create, and while it may be admitted that they do not create out of nothing, still there is no term quite like "creation" to identify just what it is that artists do.

The controversy over terms should alert us to broad underlying differences regarding philosophic methods and perspectives. There are those who maintain that accounts of the ways in which art comes to be are not strictly philosophical, but properly belong to such disciplines as psychology or sociology or biology. However, a discipline such as philosophical psychology seems in no way logically irrelevant to aesthetics,

and the same must be acknowledged for philosophical sociology. Also, while many theories concerning the unfolding of the artistic process have emanated from nonphilosophers, to infer from this that such theories lack philosophic significance would seem to be a genuine instance of the genetic fallacy.

Certainly the existential context of artistic production may be portrayed in many ways: in terms of man's animal ancestry and impulses, or in terms of his metaphysical relationship to nature, or in terms of the pressures of social and historical developments. The naturalistic account provided by Stravinsky depicts artistry simply as making or inventing, an arduous discovery of the work which precedes and provokes the artist's emotional response to his own activities. Heidegger, on the other hand, seems to suggest that art rips an opening in our conventional understanding of the world, and through that opening, the truth of things is borne in upon us. Yet Heidegger sees the kinship of art with the domain of faithful, serviceable utensils and, while he is careful not to reduce art to mere utility, he nevertheless intimates that the fidelity of the work of art is primarily to man and to nature at large rather than to its own specific subject matter.

The essay by Freud represents a bold unification of very diversified materials. On the one hand, he maintains that the form-content distinction in art is the counterpart of the artist's conscious artistry giving an acceptable format to repressed fantasies or dreamwork. On the other hand, Freud obliquely suggests that the structure of aesthetic appreciation is analogous to that of erotic gratification. But although Freud does not delineate a psychoanalytic theory of aesthetic perception, Ehrenzweig's essay may be considered a stride in that direction. Perhaps most noteworthy is Ehrenzweig's contention that aesthetic attention is not necessarily a matter of intense focusing, but may be quite diffuse, free-floating and detached. In contrast, Koffka conceives of the work of art as activating a pattern of perceptual needs and strictures, so that a definite sense of requiredness emerges which the work in question may or may not efficiently satisfy.

Ecker's account of the artistic process is Deweyan in inspiration, and conceives of the artist as thinking in terms of qualities rather than words, so that art is seen as an intelligent procedure for resolving problems which the artist proposes to himself. To Beardsley, Ecker's description is not aesthetically relevant, since it deals with the origin of the work of art rather than its present structure and function. We are not concerned, Beardsley argues, with preliminary sketches, drafts, tentative titles of works, and the like, since we are not interested in what the artist might have done, but only in what he did. Yet, as Wollheim presents the thought of Gombrich on this point, to understand a work is to understand the choices the artist made in constructing it, and a choice always involves

a rejection of certain alternatives as well as an acceptance of others. We therefore must grasp the entire repertoire of alternatives from among which the artist made his selection in order to understand just what that selective act involved.

It may be added that there is a certain warrant for saying, as Beardsley does, that the term "creativity" refers not so much to the process by which the work of art was produced as to the manner in which it liberates the creativity of the individual into whose experience it has entered. But this fact—that creativity is regenerative—does not seem to oblige us to conclude that the study of making can be of no assistance in the study of what is made.

CHAPTER 2

Construction and Existence

Martin Heidegger

Martin Heidegger has been a major figure in contemporary existentialism. His most substantial work is Being and Time *(1927). Among his other publications are* What is Metaphysics? *(1929) and* Holzwege *(1950).*

The Origin and Thingness of the Work of Art

Origin here means that from and by which something is what it is and as it is. What something is, as it is, we call its nature. The question concerning the origin of the work of art asks about the source of its nature. On the usual view, the work arises out of and by means of the

From Martin Heidegger, *The Origin of the Work of Art,* in POETRY, LANGUAGE, THOUGHT, translated by Albert Hofstadter, and published by Harper and Row Publishers, New York, 1971. Copyright © 1971 by Harper and Row, Publishers. Reprinted by permission.

activity of the artist. But by what and whence is the artist what he is? By the work; for to say that the work does credit to the master means that it is the work that first lets the artist emerge as a master of his art. The artist is the origin of the work. The work is the origin of the artist. Neither is without the other. Nevertheless, neither is the sole support of the other. In themselves and in their interrelations artist and work *are* each of them by virtue of a third thing which is prior to both, namely by virtue of that which gives artist and work of art their names—art. . . .

In order to discover the nature of the art that really prevails in the work, let us go to the actual work and ask the work what and how it is.

Works of art are familiar to everyone. Architectural and sculptural works can be seen installed in public places, in churches, and in dwelling houses. Art works of the most diverse periods and peoples are housed in collections and exhibitions. If we consider the works in their untouched actuality and do not deceive ourselves, the result is that the works are as naturally present as are things. The picture hangs on the wall like a rifle or a hat. A painting, e.g. the one by Van Gogh that represents a pair of peasant shoes, travels from one exhibition to another. Works of art are shipped like coal from the Ruhr and logs from the Black Forest. During the First World War, Hölderlin's hymns were packed in the soldier's knapsack together with cleaning gear. Beethoven's quartets lie in the storerooms of the publishing house like potatoes in a cellar.

All works have this thingly character. What would they be without it? But perhaps this rather crude and external view of the work is objectionable to us. Shippers or charwomen in museums may operate with such conceptions of the work of art. We, however, have to take works as they are encountered by those who experience and enjoy them. But even the much-vaunted aesthetic experience cannot get around the thingly aspect of the art work. There is something stony in a work of architecture, wooden in a carving, colored in a painting, spoken in a linguistic work, sonorous in a musical composition. The thingly element is so irremovably present in the art work that we are compelled rather to say conversely that the architectural work is in stone, the carving is in wood, the painting in color, the linguistic work in speech, the musical composition in sound. "Obviously," it will be replied. No doubt. But what is this obvious thingly element in the work of art?

Presumably it becomes superfluous and confusing to inquire into this feature, since the art work is something else over and above the thingly element. This something else in the work constitutes its artistic nature. The artwork is, to be sure, a thing that is made, but it says something other than the mere thing itself is, *allo agoreue* . The work makes public something other than itself; it manifests something other; it is an allegory. In the work of art something other is brought together with the thing that is made. To bring together is, in Greek, *sumbellein.* The work is a symbol.

Allegory and symbol provide the conceptual frame within whose channel of vision the art work has for a long time been characterized.

361

But this one element in a work that manifests an other, this one element that joins with an other, is the thingly feature in the art work. It seems almost as though the thingly element in the art work is like the substructure into and upon which the other, authentic element is built. And is it not this thingly feature in the work that the artist really makes by his handicraft?

Our aim is to arrive at the immediate and full reality of the work of art, for only in this way shall we discover real art also within it. Hence we must first bring to view the the thingly element of the work. To this end it is necessary that we should know with sufficient clarity what a thing is. Only then can we say whether the art work is a thing, but a thing to which something else adheres; only then can we decide whether the work is at bottom something else and not a thing at all.

THING AND WORK

What in truth is the thing, so far as it is a thing? When we inquire in this way, our aim is to come to know the thing-being (thingness) of the thing. The point is to discover the thingly character of the thing. To this end we have to be acquainted with the sphere to which all those beings belong which we have long called by the name of thing.

The stone in the road is a thing as is the clod in the field. A jug is a thing, as is the well beside the road. But what about the milk in the jug and the water in the well? These too are things if the cloud in the sky and the thistle in the field, the leaf in the autumn breeze and the hawk over the wood are rightly called by the name of thing. All these must indeed be called things, if the name "thing" is applied even to that which does not, like those just enumerated, show itself, i.e., that which does not appear. According to Kent, the whole of the world, for example, and even God himself, is a thing of this sort, a thing that does not itself appear, namely a "thing-in-itself." In the language of philosophy both things-in-themselves and things that appear, all beings that in any way are, are called things.

Airplanes and radio sets are nowadays among the things closest to us, but when we have ultimate things in mind we think of something altogether different. Death and judgment—these are ultimate things. On the whole the word "thing" here designates whatever is not simply nothing. In this sense the work of art is also a thing, so far as it is not simply nothing. Yet, this concept of the thing is of no use to us, at least immediately, in our attempt to delimit entities that have the mode of being of a thing, as against those having the mode of being of a work. And besides, we hesitate to call God a thing. In the say way we hesitate to consider the peasant in the field, the stoker at the boiler, the teacher in the school as a thing. A man is not a thing. It is true that we speak of a young girl who is faced with a task too difficult for her as being a young thing, still too young for it, but only because we feel that human being is in a certain

way missing here and think that instead we have to do here with the factor that constitutes the thingly character of things. We hesitate even to call the deer in the forest clearing, the beetle in the grass, the blade of grass a thing. We would sooner think of a hammer as a thing, or a shoe, or an ax, or a clock. But even these are not mere things. Only a stone, a clod of earth, a piece of wood are for us such mere things. Lifeless beings of nature and use objects. Natural things and utensils are the things that are commonly so called.

We thus see ourselves brought back from the widest domain, within which everything is a thing (thing= *res* = *ens* = a being, an entity) including even the highest and last things, to the narrow precinct of mere things. "Mere" here means, first, the pure thing, which is simply a thing and nothing more; but then, at the same time, "mere" means that which is only a thing, in an almost pejorative sense. It is mere things, excluding even use objects that count as things in the strict sense. What does the thingly character of these things, then, consist in? It is in reference to these things that the thingness of things must be determinable. This determination enables us to characterize that which is thingly as such. Thus prepared, we are able to characterize the almost palpable reality of works, in which something else inheres.

Now it passes for a known fact that as far back as antiquity, no sooner was the question raised what beings are in general, than things in their thingness thrust themselves into prominence again and again as the standard type of beings. Consequently we are bound to meet with the definition of the thingness of things already in the traditional interpretations of beings. We thus need only explicitly to ascertain this traditional knowledge of the thing, to be relieved of the tedious labor of making our own search for the thingly character of the thing. The answers to the question "What is the thing?" are so familiar that we no longer sense anything questionable behind them.

The interpretations of the thingness of the thing which, predominant in the course of Western thought, have long become self-evident and are now in everyday use, may be reduced to three.

This block of granite, for example, is a mere thing. It is hard, heavy, extended, bulky, shapeless, rough, colored, partly dull, partly shiny. We can take note of all these features in the stone. Thus we acknowledge its characteristics. But still, the traits signify something proper to the stone itself. They are its properties. The thing has them. The thing? What are we thinking of when we now have the thing in mind? Obviously a thing is not merely an aggregate of traits, nor an accumulation of properties by which that aggregate arises. A thing, as everyone thinks he knows, is that around which the properties have assembled. We speak in this connection of the core of things. The Greeks are supposed to have called it *to hypokeimenon.* For them, this core of the thing was something lying at the ground of the thing, something always already there. The characteristics, however, are called *ta sumbebekota,* that which has always turned up already along with the given core and occurs along with it.

363

These designations are no arbitrary names. Something that lies beyond the purview of this essay speaks in them, the basic Greek experience of the Being of beings in the sense of presence. It is by these determinations, however, that the interpretation of the thingness of the thing is established which henceforth becomes standard, and the Western interpretation of the Being of beings stabilized. . . .

The three modes of defining thingness which have been specified conceive of the thing as bearer of traits, as unity of a manifold of sensations, as formed matter. In the course of the history of truth about beings, the interpretations mentioned have also entered into combinations, a matter which we may now pass over. In such combination they have further strengthened their innate tendency to expand so as to apply in similar way to thing, to equipment, and to work. Thus they give rise to a mode of thought by which we think not only about thing, equipment, and work but about all beings in general. This long-familiar mode of thought preconceives all immediate experience of beings. The preconception shackles reflection on the being of any given entity. Thus it comes about that the prevailing thing-concepts obstruct the way toward the thingly character of the thing as well as toward the equipmental character of equipment and all the more toward the workly character of the work.

This fact is the reason why it is necessary to know about these thing-concepts, in order thereby to take heed of their derivation and their boundless presumption, but also of their semblance of self-evidence. This knowledge becomes all the more necessary when we risk the attempt to bring to view and express in words the thingly character of the thing, the equipmental character of equipment, and the workly character of the work. To this end, however, only one thing is needful: keeping at a distance all the preconceivings and assaultings of the above modes of thought, to leave the thing to rest in its own self, for instance, in its thing-being. What seems easier than to let a being be just the being that it is? Or does this turn out to be the most difficult of tasks, particularly if such an intention—to let a being be as it is—represents the opposite of the indifference that simple turns its back upon the being in favor of an unexamined concept of being? We ought to turn toward the being, think upon it itself in regard to its being, but by means of this thinking at the same time let it rest upon itself in its very own being.

This exertion of thought seems to meet with its greatest resistance in defining the thingness of the thing; for where else could the cause lie of the failure of the efforts mentioned? The unpretentious thing evades thought most stubbornly. Or can it be that this self-refusal of the mere thing, this self-contained independence, belongs precisely to the nature of the thing? Must not this strange and uncommunicative feature of the nature of the thing become intimately familiar to thought that tries to think the thing? If so, then we should not force our way to the thingly character of the thing.

That the thingness of the thing is particularly difficult to express and

only seldom expressible is infallibly documented by the history of its interpretation indicated above. This history coincides with the destiny in accordance with which Western thought has hitherto thought the Being of beings. However, not only do we establish this point now; at the same time we discover a clue in this history. Is it an accident that in the interpretation of the thing the view that takes matter and form as guide attains to special dominance? This definition of the thing derives from an interpretation of the equipmental being of equipment. And equipment, having come into being through human making, is particularly familiar to human thinking. At the same time, this familiar being has a peculiar intermediate position between thing and work. We shall follow this clue and search first for the equipmental character of equipment. Perhaps this will suggest something to us about the thingly character of the thing and the workly character of the work. We must only avoid making thing and work prematurely into sub-species of equipment. We are disregarding the possibility, however, that differences relating to the history of Being may yet also be present in the mode of being of equipment.

But what path leads to the equipmentality of equipment? How shall we discover what a piece of equipment in truth is? The procedure necessary at present must plainly avoid any attempts that again immediately entail the encroachments of the usual interpretations. We are most easily insured against this if we simply describe some equipment without any philosophical theory.

We choose as example a common sort of equipment—a pair of peasant shoes. We do not even need to exhibit actual pieces of this sort of useful article in order to describe them. Everyone is acquainted with them. But since it is a matter here of direct description, it may be well to facilitate the visual realization of them. For this purpose a pictorial representation suffices. We shall choose a well-known painting by Van Gogh, who painted such shoes several times. But what is there much to see here? Everyone knows what belongs to shoes. If they are not wooden or bast shoes, there will be leather soles and uppers, joined together by thread and nails. Such gear serves to clothe the feet. Depending on the use to which the shoes are to be put, whether for work in the field or for dancing, matter and form will differ.

Such statements, no doubt correct, only explicate what we already know. The equipmental being of equipment consists in its usefulness. But what about this usefulness itself? In conceiving it, do we already conceive along with it the equipmental character of equipment? In order to succeed in doing this, must we not resort to the useful equipment in its use? The peasant woman wears her shoes in the field. Only here are they what they are. They are such all the more genuinely the less the peasant woman thinks about the shoes while she is at work, or looks at them at all, or is even aware of them. She stands and walks in them. That is how shoes actually serve. It is in this process of the use of equipment that we must actually encounter the character of equipment.

In contrast, as long as we only imagine a pair of shoes in general, or simply look at the empty, unused shoes as they merely stand there in the picture, we shall never discover what the equipmental being of the equipment in truth is. From Van Gogh's painting we cannot even tell where these shoes stand. There is nothing surrounding this pair of peasant shoes in or to which they might belong, only an undefined space. There are not even clods from the soil of the field or the field-path sticking to them, which would at least hint at their employment. A pair of peasant shoes and nothing more. And yet . . .

From the dark opening of the worn insides of the shoes the toilsome tread of the worker stares forth. In the stiffly rugged heaviness of the shoes there is the accumulated tenacity of her slow trudge through the far-spreading and ever-uniform furrows of the field swept by a raw wind. On the leather there lies the dampness and richness of the soil. Under the soles there slides the loneliness of the field-path as evening falls. In the shoes there vibrates the silent call of the earth, its quiet gift of the ripening grain, and its unexplained self-refusal in the fallow desolation of the wintry field. This equipment is pervaded by plaintless anxiety about the certainty of bread, the wordless joy of having once more withstood want, the trembling before the impending childbed and shivering at the surrounding menace of death. This equipment belongs to the *earth,* and it is protected in the world of the peasant woman. From out of this protected belonging, the equipment itself rises to its resting-within-itself.

But perhaps it is only in the picture that we notice all this about the shoes. The peasant woman, on the other hand, simply wears her shoes. If only this simple wearing were so simple. When the peasant woman takes off her shoes late in the evening, in deep but healthy fatigue, and reaches out for them again in the still dim dawn, or passes them by on the day of rest, she knows all this without noticing or reflecting. The equipmental being of the equipment consists indeed in its usefulness. But this usefulness itself rests in the abundance of an essential being of the equipment. We call it reliability. By virtue of this reliability the peasant woman is made privy to the silent call of the earth; by virtue of the reliability of the equipment she is sure of her world. World and earth exist for her, and for those who are with her in her mode of being, only thus—in the equipment. We say "only" and therewith fall into error; for the reliability of the equipment first gives to the simple world its security and assures to the earth the freedom of its steady thrust.

The equipmental being of equipment, reliability, keeps gathered within itself all things according to their manner and extent. The usefulness of equipment is nevertheless only the essential consequence of reliability. The former vibrates in the latter and would be nothing without it. A single piece of equipment is worn out and used up; but at the same time the use itself also falls into disuse, wears away, and becomes usual. Thus equipmental being wastes away, sinks into mere stuff. Such wasting of equipmental being is the vanishing of reliability. This dwindling,

however, to which use-things owe their boringly obtrusive usualness, is only one more testimony to the original nature of equipmental being. The worn-out usualness of the equipment then obtrudes itself as the sole mode of being, apparently peculiar to it exclusively. Only blank usefulness now remains visible. It awakens the impression that the origin of equipment lies in a mere fabricating that impresses a form upon some matter. Nevertheless, in its genuine equipmental being, equipment stems from a more distant source. Matter and form and their distinction have a deeper origin.

The repose of equipment resting within itself consists in its reliability. Only in this reliability do we descry what equipment in truth is. But we still know nothing of what we first sought, the thing's thingly character. And we know nothing at all of what we really and solely seek: the workly character of the work in the sense of the work of art.

Or have we already learned something unwittingly, in passing so to speak, about the work-being of the work?

The equipmental being of equipment was discovered. But how? Not by a description and explanation of a pair of shoes actually present; not by a report about the process of making shoes; and also not by the observation of the actual use of shoes occuring here and there; but only by bringing ourselves before Van Gogh's painting. This painting spoke. In the vicinity of the work we were suddenly somewhere else than we usually tend to be.

The art work let us know what shoes are in truth. It would be the worst self-deception to think that our description, as a subjective action, had first depicted everything thus and then projected it into the painting. If anything is questionable here, it is rather that we experienced too little in the neighborhood of the work and that we expressed the experience too crudely and too literally. But above all, the work did not, as it might seem at first, serve merely for a better visualizing of what a piece of equipment is. Rather, the equipmental being of equipment first genuinely arrives at its appearance throught the work and only in the work.

What happens here? What is at work in the work? Van Gogh's painting is the disclosure of what the equipment, the pair of peasant shoes, *is* in truth. This being emerges into the unconcealedness of its being. The Greeks called the unconcealedness of beings *"alatheia."* We say "truth" and think little enough in using this word. If there occurs in the work a disclosure of a particular being, disclosing what and how it is, then there is here an occurring, a happening of truth at work.

In the work of art the truth, an entity, has set itself to work. "To set" means here: to bring to a stand. Some particular being, a pair of peasant shoes, comes in the work to stand in the light of its being. The being of the being comes into the steadiness of its "showing."

The nature of art would then be this: the truth of beings setting itself to work. But until now art presumably, has had to do with the beautiful and beauty, and not with truth. The arts that produce such works are called the beautiful or fine arts, in contrast with the applied or industrial

arts that manufacture equipment. In fine art the art itself is not beautiful, but is called so because it produces the beautiful. Truth, in contrast, belongs to logic. Beauty, however, is reserved for aesthetics.

But perhaps the proposition that art is truth's setting itself to work intends to revive the fortunately obsolete view that art is an imitation and depiction of reality? The reproduction of what exists requires, to be sure, agreement with the actual being, adaptation to it; the Middle Ages called it *adaequatio;* Aristotle already spoke of *homoiosiso*—agreement with what has long been taken to be the essence of truth. But, then, is it our opinion that this painting by Van Gogh depicts a pair of peasant shoes actually existing and is a work of art because it does so successfully? Is it our opinion that the painting draws a likeness from something actual and transposes it into a product of artistic . . . production? By no means.

The work, therefore, is not the reproduction of some particular being that happens to be present at any given time; it is, on the contrary, the reproduction of the thing's general essence. But then where and in what way is this general essence, so that art works may agree with it? With what nature of what things should a Greek temple agree? Who could maintain the impossible view that the Idea of Temple is represented in the building? And yet, truth is set to work in such a work, if it is a work. Or let us think of Hölderlin's hymn "The Rhine." What is pre-given to the poet, and how is it given, so that it can then be re-given in the poem? And if in the case of this hymn and similar poems the idea of a copy-relation between something already actual and the art-work clearly fails, the view that the work is a copy is confirmed in the best possible way by a work of the kind presented in C. F. Meyer's poem "Roman Fountain. . . . This is neither a poetic painting of a fountain actually present nor a reproduction of the general essence of a Roman fountain. Yet truth is set into the work. Which truth is happening in the work? Can truth happen at all and thus be historical? Yet truth, people say, is something timeless and supertemporal.

We seek the reality of the art work in order actually to find there the art prevailing within it. The thingly substructure is what proved to be the most immediate reality in the work. But to comprehend this thingly feature, the traditional thing-concepts are not adequate; for they themselves fail to grasp the nature of the thing. The currently predominant thing-concept, thing as formed matter, is not even derived from the nature of the thing but from the nature of equipment. It also turned out that equipmental being generally has long since occupied a peculiar pre-eminence in the interpretation of beings. This pre-eminence of equipmental being, which however did not actually come to mind, suggested that we pose the question of equipment anew, while avoiding the current interpretations.

We allowed a work to tell us what equipment is. By this means, almost clandestinely, it came to light what is at work in the work: the disclosure of the particular being, the happening of truth. If, however,

the reality of the work can be defined solely by means of what is at work in the work, then what about our intention to seek out the real art work in in its reality? As long as we supposed that the reality of the work lay primarily in its thingly substructure we were going astray. We are now confronted by a remarkable result of our consideration—if it still deserves to be called a result at all. Two points become clear:

First: the dominant thing-concepts are inadequate as a means of grasping the thingly aspect of the work.

Second: that which we tried to treat as the most immediate reality of the work, its thingly substructure, does not belong to the work in such a way at all.

As soon as we look for such a thingly substructure in the work, we have unwittingly taken the work as equipment, but the work is not a piece of equipment that is fitted out in addition with an aesthetic value that adheres to it. The work is no more anything of the kind than the mere thing is a piece of equipment that merely lacks the specific equipmental characteristics of usefulness and being-made.

Our formulation of the question of the work has been shaken because we asked not about the work, but half about a thing and half about equipment. Still, this formulation of the question was not first developed by us. It is the formulation native to aesthetics. The way in which aesthetics views the art work from the outset is dominated by the traditional interpretation of all being. But the shaking of this accustomed formulation is not the essential point. What matters is a first opening of our vision to the fact that what is workly in the work, equipmental in equipment, and thingly in the thing comes closer to us only when we think the Being of beings. To this end it is necessary beforehand that the barriers of our preconceptions fall away and that the current pseudo-concepts be set aside. That is why we had to take this detour. But it brings us directly to the road that may lead to a determination of the thingly feature in the work. The thingly feature in the work should not be denied; but this thingly feature, if it belongs admittedly to the work-being of the work, must be conceived by way of the work's workly nature. If this is so, then the road toward the determination of the thingly reality of the work leads not from thing to work but from work to thing.

The art work opens up in its own way the Being of beings. This opening up, i.e., this deconcealing, i.e., the truth of being, happens in the work. In the art work, the truth of that which is has set itself into work. Art is truth setting itself to work. What is truth itself that sometimes it comes to pass as art? What is this setting-itself-into-work?

THE WORK AND TRUTH

The origin of the art work is art. But what is art? Art is real in the art work. Hence we first seek the reality of the work. In what does it consist? Art works universally display a thingly character, albeit in a

wholly distinct way. The attempt to interpret this thing-character of the work with the aid of the usual thing-concepts failed—not only because these thing-concepts do not lay hold of the thingly feature, but because, in raising the question of its thingly substructure, we force the work into a preconceived framework by which we obstruct our own access to the work-being of the work. Nothing can be discovered about the thingly aspect of the work so long as the pure self-subsistence of the work has not distinctly displayed itself.

Yet is the work ever in itself accessible? To gain access to the work, it would be necessary to remove it from all relations to something other than itself, in order to let it stand on its own for itself alone. But the artist's most peculiar intention already aims in this direction. The work is to be released by him to its pure self-subsistence. It is precisely in great art—and only such art is under consideration here—that the artist remains inconsequential as compared with the work, almost like a passage-way that destroys itself in the creative process for the work to emerge. . . .

To be a work means to set up a world. But what is it to be a work. . . ?

World is not the mere collection of the countable or uncountable, familiar and unfamiliar things that are just there. But neither is world a merely imagined framework added by our representation to the sum of such given things. *World worlds* and is more fully in being than the tangible and perceptible realm in which we believe ourselves to be at home. World is never an object that stands before us and can be beheld. World is the ever non-objective to which we are subject as long as the paths of birth and death, blessing and curse, keep us transported into Being. Wherever those decisions of our history that relate to our very being are made, are taken up and abandoned by us, go unrecognized and are rediscovered by new inquiry, there the world worlds. A stone is world-less. Plant and animal likewise have no world; but they belong to the covert throng of a surrounding into which they are linked. The peasant woman on the other hand, has a world because she dwells in the overtness of beings; of the things that are. Her equipment, in its reliability, gives to this world a necessity and nearness of its own. By the opening up of a world all things receive their lingering and hastening, their farness and nearness, their scope and limits. In a world's worlding is gathered that spaciousness out of which the protective grace of the gods is granted or withheld. Even this doom of the gods remaining absent is a way in which world worlds. . . .

However zealously we inquire into the work's self-sufficiency, we shall still fail to find its actuality as long as we do not also agree to take the work as something worked, effected. To take it thus lies closest at hand, for in the word "work" we hear what is worked. The workly character of the work consists in its having been created by the artist. It may seem curious that this most obvious and all-clarifying definition of the work is mentioned only now.

The work's createdness, however, can obviously be grasped only in terms of the process of creation. Thus, constrained by the facts, we must

consent after all to go into the activity of the artist in order to arrive at the origin of the work of art. The attempt to define the work-being of the work purely in terms of the work itself proves to be unfeasible. . . .

What then, if not craft, is to guide our thinking about the nature of creation? What else than a view of that which is to be created, the work? Although the work becomes actually only as the creative act is performed, and thus depends for its actual reality upon this act, the nature of creation is determined by the nature of the work. Even though the work's createdness has a relation to creation, nevertheless both createdness and creation must be defined in terms of the work-being of the work. And now it can no longer seem stange that we first and at length dealt with the work alone, to bring its createdness into view only at the end. If createdness belongs to the work as essentially as the word "work" makes it sound, then we must try to understand even more essentially what so far could be defined as the work-being of the work. . . .

The production of equipment is finished when a material has been so formed as to be ready for use. For equipment to be ready means that it is dismissed beyond itself, to be used up in serviceability.

Not so when a work is created. This becomes clear in the light of the second characteristic, which may be introduced here.

The readiness of equipment and the createdness of the work agree in this that in each case something is produced.

But in contrast to all other modes of production, the work is distinguished by being created so that its createdness is part of the created work. But does not this hold true for everything brought forth, indeed for anything that has in any way come to be? Everything brought forth surely has this endowment of having been brought forth, if it has any endowment at all. Certainly. But in the work, createdness is expressly created into the created being, so that it stands out from it, from the being thus brought forth, in an expressly particular way. If this is how matters stand, then we must also be able to discover and experience the createdness explicit in the work.

The emergence of createdness from the work does not mean that the work is to give the impression of having been made by a great artist. The point is not that the created being be certified as the performance of a capable person, so that the producer is thereby brought to public notice. It is not the "N.N. fecit" that is to be made known. Rather, the simple "factum est" is to be held forth into the Open by the work: namely this, that unconcealedness of that which is has happened here and that, as this happening, it happens here for the first time; or, that such a work *is* at all rather than is not. The thrust that the work as this work is, and the uninterruptedness of this plain thrust, constitute the steadfastness of the work's self-subsistence. Precisely where the artist and the process and the circumstances of the genesis of the work remain unknown, this thrust, this *"that* it is" of createdness, emerges into view most purely from the work.

To be sure, "that" it is made is a property also of all equipment that is available and in use. But this "that" does not become prominent in the

equipment; it disappears in usefulness. The more handy a piece of equipment is, the more inconspicuous it remains—that, for example, such a hammer is—and the more exclusively does the equipment keep itself in its equipmentality. In general, of everything present to us, we can note that it *is;* but this also, if it is noted at all, is noted only soon to fall into oblivion, as is the wont of everything commonplace. And what is more commonplace than this, that a being is? In a work, by contrast, this fact, that it *is* a work, is just what is unusual. The event of its being created does not simply reverberate through the work; rather, the work is as this work, and it has constantly this fact about itself. The more essentially the work opens itself, the more luminous becomes the uniqueness of the fact that it is rather than is not. The more essentially this thrust comes into the Open; the stronger and more solitary the work becomes. In the bringing forth of the work there lies this offering of the "that it be. . . ."

Was it then superfluous, after all, to enter into the question of the thingly character of the thing? By no means. To be sure, the work's work-character cannot be defined in terms of its thingly character, but as against that the question about the thing's thingly character can be brought into the right course by way of a knowledge of the work's work-character. This is no small matter, if we recollect that those ancient, traditional modes of thought attack the thing's thingly character and make it subject to an interpretation of what is as a whole which remains unfit to apprehend the nature of equipment and of the work, and which makes us equally blind to the original nature of the truth.

To determine the thing's thingness neither consideration of the bearer of properties is adequate, nor that of the manifold of sense data in their unity, and least of all that of the matter-form structure regarded by itself, which is derived from equipment. Anticipating a meaningful and weighty interpretation of the thingly character of things, we must aim at the thing's belonging to the earth. The nature of the earth, in its free and unhurried bearing and self-closure, reveals itself, however, only in the earth's jutting into a world, in the opposition of the two. This conflict is fixed in place in the figure of the work and becomes manifest by it. What holds true of equipment—namely that we come to know the equipmental character of equipment specifically only through the work itself—also holds of the thingly character of the thing. The fact that we never know the thingness directly, and if we know it at all then only vaguely, and thus require the work—this fact proves indirectly that in the work's work-being the happening of truth, the opening up or disclosure of what is, is at work. . . .

The reality of the work has become not only clearer for us in light of its work-being, but also essentially richer. The preservers of a work belong to its createdness with an essentiality equal to that of the creators. But it is the work that makes the creators possible in their nature, and that by its own nature is in need of preservers. If art is the origin of the work, this means that art lets those who naturally belong together at work, the creator and the preserver, originate, each in his own nature.

Igor Stravinsky

Possibly the most renowned and influential composer of the 20th century, Igor Stravinsky was born in Leningrad (St. Petersburg) in 1882. Prior to his study of music under Rimsky-Korsakoff, he studied law at St. Petersburg University. In 1946 he became an American citizen and spent most of his remaining years, until his recent death, in the United States.

Artistic Invention

We are living at a time when the status of man is undergoing profound upheavals. Modern man is progressively losing his understanding of values and his sense of proportions. This failure to understand essential realities is extremely serious. It leads us infallibly to the violation of the fundamental laws of human equilibrium. In the domain of music, the consequences of this misunderstanding are these: on one hand there is a tendency to turn the mind away from what I shall call the higher mathematics of music—in order to degrade music to servile employment, and to vulgarize it by adapting it to the requirements of an elementary utilitarianism—as we shall soon see on examining Soviet music. On the other hand, since the mind itself is ailing, the music of our time, and particularly the music that calls itself and believes itself *pure,* carries within it the symptoms of a pathologic blemish and spreads the germs of a new original sin. The old original sin was chiefly a sin of knowledge; the new original sin, if I may speak in these terms, is first and foremost a sin of non-acknowledgement—a refusal to acknowledge the truth and the laws that proceed therefrom, laws that we have called fundamental. What then is this truth in the domain of music? And what are its repercussions on creative activity?

Let us not forget that it is written: "Spiritus ubi vult spirat" (St. John, 3:8). What we must retain in this proposition is above all the word WILL. The Spirit is thus endowed with the capacity of willing. The principle of speculative volition is a fact.

Now it is just this fact that is too often disputed. People question the direction that the wind of the Spirit is taking, not the rightness of the artisan's work. In so doing, whatever may be your feelings about ontology or whatever your own philosophy and beliefs may be, you must admit that you are making an attack on the very freedom of the spirit—whether

From *Poetics of Music in the Form of Six Lessons* (Cambridge, Mass.: Harvard University Press, 1946), pp. 50–59, 63–65. Reprinted by permission.

you begin this large word with a capital or not. If a believer in Christian philosophy, you would then also have to refuse to accept the idea of the Holy Spirit. If an agnostic or atheist, you would have to do nothing less than refuse to be a *free-thinker* . . .

It should be noted that there is never any dispute when the listener takes pleasure in the work he hears. The least informed of music-lovers readily clings to the periphery of a work; it pleases him for reasons that are most often entirely foreign to the essence of music. This pleasure is enough for him and calls for no justification. But if it happens that the music displeases him, our music-lover will ask you for an explanation of his discomfiture. He will demand that we explain something that is in its essence ineffable.

By its fruit we judge the tree. Judge the tree by its fruit then, and do not meddle with the roots. Function justifies an organ, no matter how strange the organ may appear in the eyes of those who are not accustomed to see it functioning. Snobbish circles are cluttered with persons who, like one of Montesquieu's characters, wonder how one can possibly be a Persian. They make me think unfailingly of the story of the peasant who, on seeing a dromedary in the zoo for the first time, examines it at length, shakes his head and, turning to leave, says, to the great delight of those present: "It isn't true."

It is through the unhampered play of its functions, then, that a work is revealed and justified. We are free to accept or reject this play, but no one has the right to question the fact of its existence. To judge, dispute, and criticize the principle of speculative volition which is at the origin of all creation is thus manifestly useless. In the pure state, music is free speculation. Artists of all epochs have unceasingly testified to this concept. For myself, I see no reason for not trying to do as they did. Since I myself was created, I cannot help having the desire to create. What sets this desire in motion, and what can I do to make it productive?

The study of the creative process is an extremely delicate one. In truth, it is impossible to observe the inner workings of this process from the outside. It is futile to try and follow its successive phases in someone else's work. It is likewise very difficult to observe one's self. Yet it is only by enlisting the aid of introspection that I may have any chance at all of guiding you in this essentially fluctuating matter.

Most music-lovers believe that what sets the composer's creative imagination in motion is a certain emotive disturbance generally designated by the name of *inspiration.*

I have no thought of denying to inspiration the outstanding role that has devolved upon it in the generative process we are studying; I simply maintain that inspiration is in no way a prescribed condition of the creative act, but rather a manifestation that is chronologically secondary.

Inspiration, art, artist—so many words, hazy at least, that keep us from seeing clearly in a field where everything is balance and calculation through which the breath of the speculative spirit blows. It is afterwards, and only afterwards, that the emotive disturbance which is at the

root of inspiration may arise—an emotive disturbance about which people talk so indelicately by conferring upon it a meaning that is shocking to us and that comprises the term itself. Is it not clear that this emotion is merely a reaction on the part of the creator grappling with that unknown entity which is still only the object of his creating and which is to become a work of art? Step by step, link by link, it will be granted him to discover the work. It is this chain of discoveries, as well as each individual discovery, that give rise to the emotion—an almost physiological reflex, like that of the appetite causing a flow of saliva—this emotion which invariably follows closely the phases of the creative process.

All creation presupposes at its origin a sort of appetite that is brought on by the foretaste of discovery. This foretaste of the creative act accompanies the intuitive grasp of an unknown entity already possessed but not yet intelligible, an entity that will not take definite shape except by the action of a constantly vigilant technique.

This appetite that is aroused in me at the mere thought of putting in order musical elements that have attracted my attention is not at all a fortuitous thing like inspiration, but as habitual and periodic, if not as constant, as a natural need.

This premonition of an obligation, this foretaste of a pleasure, this conditioned reflex, as a modern physiologist would say, shows clearly that it is the idea of discovery and hard work that attracts me.

The very act of putting my work on paper, of, as we say, kneading the dough, is for me inseparable from the pleasure of creation. So far as I am concerned, I cannot separate the spiritual effort from the psychological and physical effort; they confront me on the same level and do not present a hierarchy.

The word *artist* which, as it is most generally understood today, bestows on its bearer the highest intellectual prestige, the privilege of being accepted as a pure mind—this pretentious term is in my view entirely incompatible with the role of the *homo faber*.

At this point it should be remembered that, whatever field of endeavor has fallen to our lot, if it is true that we are *intellectuals,* we are called upon not to cogitate, but to perform.

The philosopher Jacques Maritain reminds us that in the mighty structure of medieval civilization, the artist held only the rank of an artisan. "And his individualism was forbidden any sort of anarchic development, because a natural social discipline imposed certain limitative conditions upon him from without." It was the Renaissance that invented the artist, distinguished him from the artisan and began to exalt the former at the expense of the latter.

At the outset the name artist was given only to the Masters of Arts: philosophers, alchemists, magicians; but painters, sculptors, musicians, and poets had the right to be qualified only as artisans.

> Pl ing divers implements,
> The subtile artizan implants
> Life in marble, copper, bronze,

says the poet Du Bellay. And Montaigne enumerates in his *Essays* the "painters, poets and other artizans." And even in the seventeenth century, La Fontaine hails a painter with the name of *artisan* and draws a sharp rebuke from an ill-tempered critic who might have been the ancestor of most of our present-day critics.

The idea of work to be done is for me so closely bound up with the idea of the arranging of material and of the pleasure that the actual doing of the work affords us that, should the impossible happen and my work suddenly be given to me in a perfectly completed form, I should be embarrassed and nonplussed by it, as by a hoax.

We have a duty towards music, namely, to invent it. I recall once during the war when I was crossing the French border a gendarme asked me what my profession was. I told him quite naturally that I was an inventor of music. The gendarme, then verifying my passport, asked me why I was listed as a composer. I told him that the expression "inventor of music" seemed to me to fit my profession more exactly than the term applied to me in the documents authorizing me to cross borders.

Invention presupposes imagination but should not be confused with it. For the act of invention implies the necessity of a lucky find and of achieving full realization of this find. What we imagine does not necessarily take on a concrete form and may remain in a state of virtuality, whereas invention is not conceivable apart from its actual being worked out.

Thus, what concerns us here is not imagination in itself, but rather creative imagination: the faculty that helps us to pass from the level of conception to the level of realization.

In the course of my labors I suddenly stumble upon something unexpected. This unexpected element strikes me. I make a note of it. At the proper time I put it to profitable use. This gift of chance must not be confused with that capriciousness of imagination that is commonly called fancy. Fancy implies a predetermined will to abandon one's self to caprice. The aforementioned assistance of the unexpected is something quite different. It is a collaboration which is immanently bound up with the inertia of the creative process and is heavy with possibilities which are unsolicited and come most appositely to temper the inevitable over-rigorousness of the naked will. And it is good that this is so.

"In everything that yields gracefully," G. K. Chesterton says somewhere, "there must be resistance. Bows are beautiful when they bend only because they seek to remain rigid. Rigidity that slightly yields, like Justice swayed by Pity, is all the beauty of earth. Everything seeks to grow straight, and happily, nothing succeeds in so growing. Try to grow straight and life will bend you."

The faculty of creating is never given to us all by itself. It always goes hand in hand with the gift of observation. And the true creator may be recognized by his ability always to find about him, in the commonest and humblest thing, items worthy of note. He does not have to concern himself with a beautiful landscape, he does not need to surround himself

with rare and precious objects. He does not have to put forth in search of discoveries: they are always within his reach. He will have only to cast a glance about him. Familiar things, things that are everywhere, attract his attention. The least accident holds his interest and guides his operations. If his finger slips, he will notice it; on occasion, he may draw profit from something unforeseen that a momentary lapse reveals to him.

One does not contrive an accident: one observes it to draw inspiration therefrom. An accident is perhaps the only thing that really inspires us. A composer improvises aimlessly the way an animal grubs about. Both of them go grubbing about because they yield to a compulsion to seek things out. What urge of the composer is satisfied by this investigation? The rules with which, like a penitent, he is burdened? No: he is in quest of his pleasure. He seeks a satisfaction that he fully knows he will not find without first striving for it. One cannot force one's self to love; but love presupposes understanding, and in order to understand, one must exert one's self.

It is the same problem that was posed in the Middle Ages by the theologians of pure love. To understand in order to love; to love in order to understand: we are here not going around in a vicious circle; we are rising spirally, providing we have made an initial effort, have even just gone through a routine exercise.

Pascal has specifically this in mind when he writes that custom "controls the automaton, which in its turn unthinkingly controls the mind. For there must be no mistake," continues Pascal, "we are automatons just as much as we are minds . . ."

So we grub about in expectation of our pleasure, guided by our scent, and suddenly we stumble against an unknown obstacle. It gives us a jolt, a shock, and this shock fecundates our creative power.

The faculty of observation and of making something out of what is observed belongs only to the person who at least possesses, in his particular field of endeavor, an acquired culture and an innate taste. A dealer, an art-lover who is the first to buy the canvases of an unknown painter who will be famous twenty-five years later under the name of Cézanne—doesn't such a person give us a clear example of this innate taste? What else guides him in his choice? A flair, an instinct from which this taste proceeds, a completely spontaneous faculty anterior to reflection.

As for culture, it is a sort of upbringing which, in the social sphere, confers polish upon education, sustains and rounds out academic instruction. This upbringing is just as important in the sphere of taste and is essential to the creator who must ceaselessly refine his taste or run the risk of losing his perspicacity. Our mind, as well as our body, requires continual exercise. It atrophies if we do not cultivate it.

It is culture that brings out the full value of taste and gives it a chance to prove its worth simply by its application. The artist imposes a culture upon himself and ends by imposing it upon others. That is how tradition becomes established.

Tradition is entirely different from habit, even from an excellent

habit, since habit is by definition an unconscious acquisition and tends to become mechanical, whereas tradition results from a conscious and deliberate acceptance. A real tradition is not the relic of a past that is irretrievably gone; it is a living force that animates and informs the present. In this sense the paradox which banteringly maintains that everything which is not tradition is plagiarism, is true . . .

Far from implying the repetition of what has been, tradition presupposes the reality of what endures. It appears as an heirloom, a heritage that one receives on condition of making it bear fruit before passing it on to one's descendants. . . .

Musical art is limited in its expression in a measure corresponding exactly to the limitations of the organ that perceives it. A mode of composition that does not assign itself limits becomes pure fantasy. The effects it produces may accidentally amuse but are not capable of being repeated. I cannot conceive of a fantasy that is repeated, for it can be repeated only to its detriment.

Let us understand each other in regard to this word fantasy. We are not using the word in the sense in which it is connected with a definite musical form, but in the acceptation which presupposes an abandonment of one's self to the caprices of imagination. And this presupposes that the composer's will is voluntarily paralyzed. For imagination is not only the mother of caprice but the servant and handmaiden of the creative will as well.

The creator's function is to sift the elements he receives from her, for human activity must impose limits upon itself. The more art is controlled, limited, worked over, the more it is free.

As for myself, I experience a sort of terror when, at the moment of setting to work and finding myself before the infinitude of possibilities that present themselves, I have the feeling that everything is permissible to me. If everything is permissible to me, the best and the worst; if nothing offers me any resistance, then any effort is inconceivable, and I cannot use anything as a basis, and consequently every undertaking becomes futile.

Will I then have to lose myself in this abyss of freedom? To what shall I cling in order to escape the dizziness that seizes me before the virtuality of this infinitude? However, I shall not succumb. I shall overcome my terror and shall be reassured by the thought that I have the seven notes of the scale and its chromatic intervals at my disposal, that strong and weak accents are within my reach, and that in all of these I possess solid and concrete elements which offer me a field of experience just as vast as the upsetting and dizzy infinitude that had just frightened me. It is into this field that I shall sink my roots, fully convinced that combinations which have at their disposal twelve sounds in each octave and all possible rhythmic varieties promise me riches that all the activity of human genius will never exhaust.

What delivers me from the anguish into which an unrestricted freedom plunges me is the fact that I am always able to turn immediately

to the concrete things that are here in question. I have no use for a theoretic freedom. Let me have something finite, definite—matter that can lend itself to my operation only insofar as it is commensurate with my possibilities. And such matter presents itself to me together with its limitations. I must in turn impose mine upon it. So here we are, whether we like it or not, in the realm of necessity. And yet which of us has ever heard talk of art as other than a realm of freedom? This sort of heresy is uniformly widespread because it is imagined that art is outside the bounds of ordinary activity. Well, in art as in everything else, one can build only upon a resisting foundation: whatever constantly gives way to pressure, constantly renders movement impossible.

My freedom thus consists in my moving about within the narrow frame that I have assigned myself for each one of my undertakings.

I shall go even further: my freedom will be so much the greater and more meaningful the more narrowly I limit my field of action and the more I surround myself with obstacles. Whatever diminishes constraint, diminishes strength. The more constraints one imposes, the more one frees one's self of the chains that shackle the spirit.

To the voice that commands me to create I first respond with fright; then I reassure myself by taking up as weapons those things participating in creation but as yet outside of it; and the arbitrariness of the constraint serves only to obtain precision of execution.

From all this we shall conclude the necessity of dogmatizing on pain of missing our goal. If these words annoy us and seem harsh, we can abstain from pronouncing them. For all that, they nonetheless contain the secret of salvation: "It is evident," writes Baudelaire, "that rhetorics and prosodies are not arbitrarily invented tyrannies, but a collection of rules demanded by the very organization of the spiritual being, and never have prosodies and rhetorics kept originality from fully manifesting itself. The contrary, that is to say, that they have aided the flowering of originality, would be infinitely more true."

CHAPTER THREE

Psychoanalytic and Gestalt Approaches to Art

Sigmund Freud

Sigmund Freud (1856-1939) founder of psychoanalysis, was also the author of numerous essays on mythology, wit, literature and art.

Poetry and Fantasy

We laymen have always wondered greatly—like the cardinal who put the question to Ariosto—how that strange being, the poet, comes by

From "The Relation of the Poet to Day-Dreaming," *Collected Papers*, Vol. 4, translated under the supervision of Joan Rivière (N.Y.: Basic Books, 1959), pp. 173–83. Published in England as "Creative Writers and Day-Dreaming" in Volume IX of the *Standard Edition of the Complete Psychological Works of Sigmund Freud,* revised and edited by James Strachey. Reprinted by permission of Basic Books; Sigmund Freud Copyrights Ltd., The Institute of Psycho-Analysis, and The Hogarth Press Ltd.

his material. What makes him able to carry us with him in such a way and to arouse emotions in us of which we thought ourselves perhaps not even capable? Our interest in the problem is only stimulated by the circumstance that if we ask poets themselves they give us no explanation of the matter, or at least no satisfactory explanation. The knowledge that not even the clearest insight into the factors conditioning the choice of imaginative material, or into the nature of the ability to fashion that material, will ever make writers of us does not in any way detract from our interest.

If we could only find some activity in ourselves, or in people like ourselves, which was in any way akin to the writing of imaginative works! If we could do so, then examination of it would give us a hope of obtaining some insight into the creative powers of imaginative writers. And indeed, there is some prospect of achieving this—writers themselves always try to lessen the distance between their kind and ordinary human beings; they so often assure us that every man is at heart a poet, and that the last poet will not die until the last human being does.

We ought surely to look in the child for the first traces of imaginative activity. The child's best loved and most absorbing occupation is play. Perhaps we may say that every child at play behaves like an imaginative writer, in that he creates a world of his own or, more truly, he rearranges the things of his world and orders it in a new way that pleases him better. It would be incorrect to think that he does not take this world seriously; on the contrary, he takes his play very seriously and expends a great deal of emotion on it. The opposite of play is not serious occupation but—reality. Notwithstanding the large affective cathexis of his play-world, the child distinguishes it perfectly from reality; only he likes to borrow the objects and circumstances that he imagines from the tangible and visible things of the real world. It is only this linking of it to reality that still distinguishes a child's 'play' from 'day-dreaming.'

Now the writer does the same as the child at play; he creates a world of phantasy which he takes very seriously; that is, he invests it with a great deal of affect, while separating it sharply from reality. Language has preserved this relationship between children's play and poetic creation. It designates certain kinds of imaginative creation, concerned with tangible objects and capable of representation, as 'plays'; the people who present them are called 'players.' The unreality of this poetical world of imagination, however, has very important consequences for literary technique; for many things which if they happened in real life could produce no pleasure can nevertheless give enjoyment in a play—many emotions which are essentially painful may become a source of enjoyment to the spectators and hearers of a poet's work.

There is another consideration relating to the contrast between reality and play on which we will dwell for a moment. Long after a child has grown up and stopped playing, after he has for decades attempted to grasp the realities of life with all seriousness, he may one day come to a state of mind in which the contrast between play and reality is again

381

abrogated. The adult can remember with what intense seriousness he carried on his childish play; then by comparing his would-be serious occupations with his childhood's play, he manages to throw off the heavy burden of life and obtain the great pleasure of humour.

As they grow up, people cease to play, and appear to give up the pleasure they derived from play. But anyone who knows anything of the mental life of human beings is aware that hardly anything is more difficult to them than to give up a pleasure they have once tasted. Really we never can relinquish anything; we only exchange one thing for something else. When we appear to give something up, all we really do is to adopt a substitute. So when the human being grows up and ceases to play he only gives up the connection with real objects; instead of playing he then begins to create phantasy. He builds castles in the air and creates what are called day-dreams. I believe that the greater number of human beings create phantasies at times as long as they live. This is a fact which has been overlooked for a long time, and its importance has therefore not been properly appreciated.

The phantasies of human beings are less easy to observe than the play of children. Children do, it is true, play alone, or form with other children a closed world in their minds for the purposes of play; but a child does not conceal his play from adults, even though his playing is quite unconcerned with them. The adult, on the other hand, is ashamed of his day-dreams and conceals them from other people; he cherishes them as his most intimate possessions and as a rule he would rather confess all his misdeeds than tell his day-dreams. For this reason he may believe that he is the only person who makes up such phantasies, without having any idea that everybody else tells themselves stories of the same kind. Day-dreaming is a continuation of play, nevertheless, and the motives which lie behind these two activities contain a very good reason for this different behaviour in the child at play and in the day-dreaming adult.

The play of children is determined by their wishes—really by the child's *one* wish, which is to be grown-up, the wish that helps to 'bring him up.' He always plays at being grown-up; in play he imitates what is known to him of the lives of adults. Now he has no reason to conceal this wish. With the adult it is otherwise; on the one hand, he knows that he is expected not to play any longer or to day-dream, but to be making his way in a real world. On the other hand, some of the wishes from which his phantasies spring are such as have to be entirely hidden; therefore he is ashamed of his phantasies as being childish and as something prohibited.

If they are concealed with so much secretiveness, you will ask, how do we know so much about the human propensity to create phantasies? Now there is a certain class of human beings upon whom not a god, indeed, but a stern goddess—Necessity—has laid the task of giving an account of what they suffer and what they enjoy. These people are the neurotics; among other things they have to confess their phantasies to

the physician to whom they go in the hope of recovering through mental treatment. This is our best source of knowledge, and we have later found good reason to suppose that our patients tell us about themselves nothing that we could not also hear from healthy people.

Let us try to learn some of the characteristics of day-dreaming. We can begin by saying that happy people never make phantasies, only unsatisfied ones. Unsatisfied wishes are the driving power behind phantasies; every separate phantasy contains the fulfilment of a wish, and improves on unsatisfactory reality. The impelling wishes vary according to the sex, character and circumstances of the creator; they may be easily divided, however, into two principal groups. Either they are ambitious wishes, serving to exalt the person creating them, or they are erotic. In young women erotic wishes dominate the phantasies almost exclusively, for their ambition is generally comprised in their erotic longings; in young men egoistic and ambitious wishes assert themselves plainly enough alongside their erotic desires. But we will not lay stress on the distinction between these two trends; we prefer to emphasize the fact that they are often united. In many altar-pieces the portrait of the donor is to be found in one corner of the picture; and in the greater number of ambitious day-dreams, too, we can discover a woman in some corner, for whom the dreamer performs all his heroic deeds and at whose feet all his triumphs are to be laid. Here you see we have strong enough motives for concealment; a well-brought-up woman is, indeed, credited with only a minimum of erotic desire, while a young man has to learn to suppress the overweening self-regard he acquires in the indulgent atmosphere surrounding his childhood, so that he may find his proper place in a society that is full of other persons making similar claims.

We must not imagine that the various products of this impulse towards phantasy, castles in the air or day-dreams, are stereotyped or unchangeable. On the contrary, they fit themselves into the changing impressions of life, alter with the vicissitudes of life; every deep new impression gives them what might be called a 'date-stamp.' The relation of phantasies to time is altogether of great importance. One may say that a phantasy at one and the same moment hovers between three periods of time—the three periods of our ideation. The activity of phantasy in the mind is linked up with some current impression, occasioned by some event in the present, which had the power to rouse an intense desire. From there it wanders back to the memory of an early experience, generally belonging to infancy, in which this wish was fulfilled. Then it creates for itself a situation which is to emerge in the future, representing the fulfilment of the wish—this is the day-dream or phantasy, which now carries in it traces both of the occasion which engendered it and of some past memory. So past, present and future are threaded, as it were, on the string of the wish that runs through them all.

A very ordinary example may serve to make my statement clearer. Take the case of a poor orphan lad, to whom you have given the address of some employer where he may perhaps get work. On the way there he

falls into a day-dream suitable to the situation from which it springs. The content of the phantasy will be somewhat as follows: He is taken on and pleases his new employer, makes himself indispensable in the business, is taken into the family of the employer, and marries the charming daughter of the house. Then he comes to conduct the business, first as a partner, and then as successor to his father-in-law. In this way the dreamer regains what he had in his happy childhood, the protecting house, his loving parents and the first objects of his affection. You will see from such an example how the wish employs some event in the present to plan a future on the pattern of the past.

Much more could be said about phantasies, but I will only allude as briefly as possible to certain points. If phantasies become over-luxuriant and over-powerful, the necessary conditions for an outbreak of neurosis or psychosis are constituted; phantasies are also the first preliminary stage in the mind of the symptoms of illness of which our patients complain. A broad bypath here branches off into pathology.

I cannot pass over the relation of phantasies to dreams. Our nocturnal dreams are nothing but such phantasies, as we can make clear by interpreting them.[1] Language, in its unrivalled wisdom, long ago decided the question of the essential nature of dreams by giving the name of 'day-dreams' to the airy creations of phantasy. If the meaning of our dreams usually remains obscure in spite of this clue, it is because of the circumstance that at night wishes of which we are ashamed also become active in us, wishes which we have to hide from ourselves, which were consequently repressed and pushed back into the unconscious. Such repressed wishes and their derivatives can therefore achieve expression only when almost completely disguised. When scientific work had succeeded in elucidating the distortion in dreams, it was no longer difficult to recognize that nocturnal dreams are fulfilments of desires in exactly the same way as day-dreams are—those phantasies with which we are all so familiar.

So much for day-dreaming; now for the poet! Shall we dare really to compare an imaginative writer with 'one who dreams in broad daylight', and his creations with day-dreams? Here, surely, a first distinction is forced upon us; we must distinguish between poets who, like the bygone creators of epics and tragedies, take over their material ready-made, and those who seem to create their material spontaneously. Let us keep to the latter, and let us also not choose for our comparison those writers who are most highly esteemed by critics. We will choose the less pretentious writers of romances, novels and stories, who are read all the same by the widest circles of men and women. There is one very marked characteristic in the productions of these writers which must strike us all: they all have a hero who is the center of interest, for whom the author tries to win our sympathy by every possible means, and whom he places under the protection of a special providence. If at the end of one chapter the hero is left unconscious and bleeding from severe wounds, I am sure to find him at the beginning of the next being carefully tended and on the way to recovery; if the first volume ends in the hero being shipwrecked

in a storm at sea, I am certain to hear at the beginning of the next of his hairbreadth escape—otherwise, indeed, the story could not continue. The feeling of security with which I follow the hero through his dangerous adventures is the same as that with which a real hero throws himself into the water to save a drowning man, or exposes himself to the fire of the enemy while storming a battery. It is this very feeling of being a hero which one of our best authors has well expressed in the famous phrase, *'Es kann dir nix g'schehen!'*[2] It seems to me, however, that this significant mark of invulnerability very clearly betrays—His Majesty the Ego, the hero of all day-dreams and all novels.

The same relationship is hinted at in yet other characteristics of these egocentric stories. When all the women in a novel invariably fall in love with the hero, this can hardly be looked upon as a description of reality, but it is easily understood as an essential constituent of a day-dream. The same thing holds good when the other people in the story are sharply divided into good and bad, with complete disregard of the manifold variety in the traits of real human beings; the 'good' ones are those who help the ego in its character of hero, while the 'bad' are his enemies and rivals.

We do not in any way fail to recognize that many imaginative productions have travelled far from the original naïve day-dream, but I cannot suppress the surmise that even the most extreme variations could be brought into relationship with this model by an uninterrupted series of transitions. It has struck me in many so-called psychological novels, too, that only one person—once again the hero—is described from within; the author dwells in his soul and looks upon the other people from outside. The psychological novel in general probably owes its peculiarities to the tendency of modern writers to split up their ego by self-observation into many component-egos, and in this way to personify the conflicting trends in their own mental life in many heroes. There are certain novels, which might be called 'excentric,' that seem to stand in marked contradiction to the typical day-dream; in these the person introduced as the hero plays the least active part of anyone, and seems instead to let the actions and sufferings of other people pass him by like a spectator. Many of the later novels of Zola belong to this class. But I must say that the psychological analysis of people who are not writers, and who deviate in many things from the so-called norm, has shown us analogous variations in their day-dreams in which the ego contents itself with the role of spectator.

If our comparison of the imaginative writer with the day-dreamer, and of poetic production with the day-dream, is to be of any value, it must show itself fruitful in some way or other. Let us try, for instance, to examine the works of writers in reference to the idea propounded above, the relation of the phantasy to the wish that runs through it and to the three periods of time; and with its help let us study the connection between the life of the writer and his productions. Hitherto it has not been known what preliminary ideas would constitute an approach to this problem; very often this relation has been regarded as much simpler

than it is; but the insight gained from phantasies leads us to expect the following state of things. Some actual experience which made a strong impression on the writer had stirred up a memory of an earlier experience, generally belonging to childhood, which then arouses a wish that finds a fulfilment in the work in question, and in which elements of the recent event and the old memory should be discernible.

Do not be alarmed at the complexity of this formula; I myself expect that in reality it will prove itself to be too schematic, but that possibly it may contain a first means of approach to the true state of affairs. From some attempts I have made I think that this way of approaching works of the imagination might not be unfruitful. You will not forget that the stress laid on the writer's memories of his childhood, which perhaps seems so strange, is ultimately derived from the hypothesis that imaginative creation, like day-dreaming, is a continuation of and substitute for the play of childhood.

We will not neglect to refer also to that class of imaginative work which must be recognized not as spontaneous production, but as a refashioning of ready-made material. Here, too, the writer retains a certain amount of independence, which can express itself in the choice of material and in changes in the material chosen, which are often considerable. As far as it goes, this material is derived from the racial treasure-house of myths, legends and fairy-tales. The study of these creations of racial psychology is in no way complete, but it seems extremely probable that myths, for example, are distorted vestiges of the wish-phantasies of whole nations—the age-long dreams of young humanity.

You will say that, although writers came first in the title of this paper, I have told you far less about them than about phantasy. I am aware of that, and will try to excuse myself by pointing to the present state of our knowledge. I could only throw out suggestions and bring up interesting points which arise from the study of phantasies, and which pass beyond them to the problem of the choice of literary material. We have not touched on the other problem at all, *i.e.* what are the means which writers use to achieve those emotional reactions in us that are roused by their productions. But I would at least point out to you the path which leads from our discussion of day-dreams to the problems of the effect produced on us by imaginative works.

You will remember that we said the day-dreamer hid his phantasies carefully from other people because he had reason to be ashamed of them. I may now add that even if he were to communicate them to us, he would give us no pleasure by his disclosures. When we hear such phantasies they repel us, or at least leave us cold. But when a man of literary talent presents his plays, or relates what we take to be his personal day-dreams, we experience great pleasure arising probably from many sources. How the writer accomplishes this is his innermost secret; the essential *ars poetica* lies in the technique by which our feeling of repulsion is overcome, and this has certainly to do with those barriers erected between every individual being and all others. We can guess at

two methods used in this technique. The writer softens the egotistical character of the day-dream by changes and disguises, and he bribes us by the offer of a purely formal, that is, aesthetic, pleasure in the presentation of his phantasies. The increment of pleasure which is offered us in order to release yet greater pleasure arising from deeper sources in the mind is called an 'incitement premium' or technically, 'fore-pleasure.' I am of opinion that all the aesthetic pleasure we gain from the works of imaginative writers is of the same type as this 'fore-pleasure,' and that the true enjoyment of literature proceeds from the release of tensions in our minds. Perhaps much that brings about this result consists in the writer's putting us into a position in which we can enjoy our own daydreams without reproach or shame. Here we reach a path leading into novel, interesting and complicated researches, but we also, at least for the present, arrive at the end of the present discussion.

Notes
1. Cf. Freud, *Die Traumdeutung (The Interpretation of Dreams)*.
2. Anzengruber. [The phrase means 'Nothing can happen to *me!*' —Trans.]

Kurt Koffka

Born in Berlin, Kurt Koffka (1886–1941) came to the United States in 1924, and became professor of psychology at Smith College. His major works include The Growth of the Mind *(1924) and* Principles of Gestalt Psychology *(1935).*

Art and Requiredness

A GENERAL CHARACTERISTIC OF WORKS OF ART

If our discussion of the relation between art-objects and emotions has led us anywhere near the truth, it has revealed something about the

From "Problems in the Psychology of Art," in *Art: A Bryn Mawr Symposium* (Bryn Mawr, Pa., Bryn Mawr College, 1940), pp. 230–250.

nature of the work of art itself. We said that a work of art tells us what to do. This statement attributes to the art-object a characteristic which may at first seem to be incompatible with any object. Objects, so we are inclined to think, are just objects, facts just indifferent facts. Surely our proposition about a work of art telling us what to do must not be taken seriously.

But if we failed to take our proposition seriously we should be bound to accept one (or several) of the different theories we rejected. Nor need we be afraid of attributing to (phenomenal) objects a quality by which they not only are what they are but issue demands, since in his recent book Professor Köhler has established and justified the difference between indifferent facts and facts with "requiredness." Everybody will admit that when he wants something, he experiences his self not as an "indifferent fact" but as a "fact with requiredness." But to many readers it may seem a far cry from this admitted case to our postulation of other objects endowed with requiredness besides the self. We found a similar reluctance when it came to the attribution of physiognomic characters to objects. There we showed it to be based on a prejudice. If now we remember that physiognomic characters are outstanding instances of qualities with requiredness, then, if we admitted the cogency of the previous argument, we shall also have to admit that if requiredness can be found in selves, there is no reason why it should not also be found in other objects; and since we constantly find it there, there is no need to mistrust our direct naive experience.

Even so, we do not know much about a work of art when we know that it issues certain demands which our Egos have to fulfill. For such demands may be carried by other objects as well; thus a glass of foaming beer is almost irresistible after a long walk on a hot summer day. To come closer to an insight into the characteristics of an art-object, we must analyze the concept of requiredness a little further. Requiredness, this is the result of Köhler's analysis, occurs always in a context, and inasmuch as the requiredness refers to the self, the self must be included in such a context. The glass of beer, as part of the context, gains its demand character by the fact, and by the fact alone, that it is an object eminently fitted to satisfy a need for a cool drink. No intrinsic quality of this phenomenal object makes it a carrier of a demand; it becomes so only by dint of its relation to a self and its pre-existing appetite. The requiredness that inheres in a work of art is of a very different kind. It tells us what to do, not because it happens to be able to satisfy one of our needs or desires, but because of certain qualities which it, and no other object in the world, possesses. We can indeed compare its demand with those of human faces which may reveal a beauty which demands worship, a pathos of suffering which asks for mercy, or a stupid brutality which makes us shrink and withdraw. If we tried to discover from which part of the face these demands issue, we should find that no sufficiently small part by itself is the seat of such requiredness. The structure of the face as a whole carries the qualities which I have tried to describe. And the same is, of course,

true of the appeal of a work of art: we are in contact with it by virtue of its structural qualities. Imagine a face that expresses extreme kindness and sympathy; you think, "what a beautiful soul," then discover an ever so slight contraction and drooping of the lips. At once you are startled: something is wrong. Either the kindness and sympathy are put on to deceive, or some bitter experience has left its indelible mark on this fine countenance. How do you know? Because certain parts of the structure did not "fit" into its total pattern. They did not fit; they were out of place; they should have been different. A strong structure like a face, then, is a seat of requiredness quite apart from the ego-context; and so is a work of art. It appeals as a structure; and that means that it is not an assemblage of parts, but a coherent whole in which each part demands the others. Thus a consideration of object-ego requiredness has led us to a requiredness *within* the art object itself. And inasmuch as the appeal of the work of art issues from its structure, it is this structure, and not the emotion which this structure arouses, that is of primary importance for our understanding of the psychology of art. And truly, we do experience again and again that we are in the presence of a work of art even when we cannot feel any emotion, be it that our own mood is totally different from that demanded by the work of art, or that our personality is so different from that of the artist that he cannot touch us. In order to discover more about this internal requiredness we turn now to the psychology of the artist.

THE AIM OF THE CREATIVE ARTIST

What is it that the artist wishes to create? In formulating this question we encounter again the concept of requiredness and see its connection with *motivation*. But this general term may lead us far away from our quest for the nature of art. For the artist may be impelled to do his work by circumstances that are in themselves quite alien to the realm of art: he may be commissioned to paint a portrait, compose a symphony, build a church; and so his motive may be financial gain, ambition, rivalry, or what not, factors that have nothing to do with art. Such motives may start the artist and keep him going, but they cannot *direct* him; if they do that, they are certain to mislead him. What is it, then, that guides his labour?

My answer to this question will be given after a short detour. I shall describe my own experience, not in creating a work of art, but in planning these lectures. When I was asked to deliver them, I accepted for certain reasons which I explained in the beginning of this essay. But these reasons did not produce the lectures. How, then, did I set about? I tried to evoke some picture of my task, of the problems involved in the general topic, and let myself be guided by the demands of these problems. I was given complete liberty by Dr. Bernheimer in issuing the invitation, but my freedom was severely restricted by my subject matter: something

389

was required of me, not by Dr. Bernheimer, but by the problem of the psychology of art. I was demanded to give an adequate and clear formulation of the psychology of art, or rather such a formulation was demanded. My Ego entered this situation only inasmuch as it was instrumental in producing such a formulation; apart from that it had to stay outside. This fact is of great importance for any theory of motivation; for it shows that motivated, purposive activity is not wholly ego-determined, that the requiredness in the context of such activity does not all issue from the self but that even in purposive activity the Ego may be subservient to something else; it is compelled to operate in such a way as to bring into existence something objective, as to fulfill objective requiredness.

We can now return to the artist; for our last proposition characterizes artistic creation: something objective demands to be created, and the artist has to submit to this demand. Thus his work is guided by the requiredness of his intended creation. The psychology of art will have to study the various kinds of requiredness contained in the various works of art. They will differ from artist to artist, from one field of art to another, aye from one individual work to the next. Thus a portrait may be the realization of character, of beauty, of gracefulness, or of dignity; it may emphasize the full tridimensional solidity of the human skull and its relation to the surrounding spaces or it may concentrate on some vital expression and leave tridimensional space more or less undetermined, producing primarily effects of design in one plane. In each case the object of his creations will issue different special demands on the artist.

It is one thing to be aware of such demands and another to be able to fulfill them. That his power of complying with the demands of the objects of his imagination distinguishes the artist from the rest of mankind is a truism. The artist learns his craft in order not to be hampered by the inadequacy of his technique. But technique is not yet art. Sometimes one hears a pianist on the vaudeville stage whose skill in controlling his finger movements equals that of the greatest interpretative artist, and who is, nevertheless, just an *artiste*. Technique is but one part of the executive side of the artist's work, and probably less important than the other: the strict compliance with the requiredness of the work of art.

Artistic creation may then be said to have two poles: the demand issued by the task which the artist sets himself, and his own capacity of complying with these demands. This bi-polarity contains the source of a great conflict; the higher the goal, the greater the demands and the more difficult their satisfaction. Therefore it is not surprising to find that most great artists were seldom, if ever, satisfied with their works; they knew that they were not able to achieve all that was required of them.

THE ARTIST'S EGO-WORLD RELATIONSHIP

Important as this insight is, it is not specific enough to distinguish art from other forms of creation. For in purely intellectual productivity a similar bi-polarity obtains, be it in the work of the mathematician, the

development of general theories, the planning of crucial experiments. In all such activities the scientist like the artist is guided by demands of objects. The rôle of the "object" is in all these fields of tremendous *psychological* significance not yet sufficiently recognized by psychologists.

There must, however, be something essential in art which has induced psychologists to treat it as a chapter of the psychology of affective behaviour in contradistinction to science. I shall now try, with hesitation and uncertainty, to do justice to those facts which are responsible for this treatment.

In order to do this I have to return to the distinction between subjective and objective as belonging or not belonging to the self. We can then say that the result of scientific enquiry, the thought object created by the thinker, is completely objective. The self, or Ego, has no place in the finally achieved pattern or structure of knowledge; in pure thinking, as I explained previously, the Ego plays no other part than that of giving the demands of the objective situation a chance. The self concentrates on the problem, it does not allow it to "slip"; but it stays outside the organization which the various parts of the problem will eventually achieve.

Such procedure is possible only where the organization of the total field has developed to the point of a sharp ego-environment separation. It is of immense value because there *are* demands in the universe that do not concern Egos. But there are also demands in the world that do concern our selves. We all know the thousand oughts we encounter in our daily lives, founded on practical utility, on conventions, customs and manners, and on deep moral convictions. But it is not these we are concerned with now; for whatever may be the nature of these various demands upon our Egos, they do not lead to the creation of persisting objects such as works of art. Art, which shares with them demands involving Egos, shares with science the permanence of its creations. But if we exclude moral and practical demands, what kind of ego-demands do we retain for art?

The world which we know of directly, functionally subjective though it be, contains phenomenologically objective constituents and a self. As a rule the objective constituents, the environment, do *not* exclude the Ego; on the contrary, all our lives gain significance through our respective ego-environment relationships. We have already seen that this relationship may have various degrees of intimacy, and that pure theoretical thinking can develop only when this intimacy has been reduced to a minimum, when Ego and environment have been separated as much as it is possible. Then, and then only, all demands experienced at the time may be environmental or objective. But even we Westerners do not habitually live in such a stern and almost alien world: normally we *belong* to our environment; and that means that we are connected with it by innumerable threads, some pulling us in certain directions, others barring us from certain modes of movement; in short the environment is shot through with demands that concern our Egos.

So the artist, when he strives to create a new piece of reality, will not

follow the scientist into his world, which often is entirely unknown to him; but will produce a world that includes in some way or other his own Ego. Indeed, the artist does not create only because he had a commission, but often primarily in order to define, to externalize, to eternalize, a section of his own world and his place within it.

This determination introduces us to another factor that accounts for the inexhaustible variety of art. The ego-world relationship is extremely variable; at the one end there is a world that contains also a self, at the other, a self that also is surrounded by a world. Individual artists, periods, schools, might be distinguished by the relative importance they attribute to the self and the world in their creations. The much discussed opposition between classicism and romanticism is partly based on this very difference.

If a work of art involves an ego-world relationship, then it must require for its completeness an Ego; and the greater the emphasis laid on the Ego in this relationship, the stronger will this requiredness be. To give examples: Wagner requires the Ego much more than Bach, lyric poetry requires it more than epic, van Gogh more than Manet. This ego-world relationship, characteristic of art, is far too complex to be described by the few words I can say about it. Take this apparent paradox: we may enjoy Bach or Mozart infinitely more than Wagner, i.e. in some sense our Egos will be more affected by art that has less strong ego-requirements. This paradox can be fully dissolved only when the study of art has analysed the different kinds of ego-world relationships contained in different works of art, a task that would transcend the limits of this paper but presents the psychologist and the aesthetician with problems of intense interest. We shall, however, try in the following section to indicate a possible explanation.

PURITY OF ART—THE GOOD GESTALT

We shall derive from this relationship a rule for the purity, or sincerity, of art. If, as we said, the artist wants to externalize a significant part of his own world with its particular ego-world relationship, then, if he is successful, the object which he creates will be such as to comply with the demanded relationship; and that means, looked at from the other side, that the way in which the Ego is drawn into the situation must be demanded by the art-object and not by any outside factors which, however they may be suggested by the art-object, are not part of it. And so we have arrived at what we call purity of art: demands on the Ego must not issue from sources that are extraneous to the art-object. This does not mean that art is to be lodged in an ivory tower, or imply a view that art should be enjoyed in a purely formal and abstract manner. On the contrary, there is no subject-matter, nothing that happens in human experience, that may not be a true part of a work of art. If we disregard purely decorative design, every work of art has a quality of transcendence; there

is more in a picture than is enclosed within its frame, there is more in a drama than happens on the stage. A picture of the Holy Mother with the Christ-child presupposes the Christian faith; the historical plays of Shakespeare presuppose the historical events they are dramatizing. But in pure art, what is presupposed is not extraneous to the art-object. This proposition, easy as it is to formulate, contains some of the fundamental problems of art and its psychology: when is this transcendence genuine and inherent in the art-object, when a mere extraneous factor? And how is genuine transcendence in art possible?

The solution of these problems will be found, I believe, in the analysis of requiredness. We saw that the artist works under the coercion of certain demands imposed on him by his subject. If we could more precisely define or describe these demands, our psychology of art would be a much more satisfactory field than it is. At present we can give no more than a few indications. We speak of the demands imposed on the artist by his subject; but not only have we failed to specify the demands, we have not even defined his subject! Let us take a subject in the ordinary sense of the word, a subject moreover that has been used by many artists in different fields. "The Death of a Hero" has been the theme of drama and epic and novel, of painting and of music; but it has also been the subject for historians, for political writers, for journalists and for propagandists. Let us briefly in our minds try to compare (say) Shakespeare's Coriolanus, the second movement of the Eroica, a learned historical disquisition on the assassination of Caesar, and the demagogical exploitation of the death of a leader who fell for his cause in the interest of well planned and organized propaganda. As soon as we try to do this, we become aware that the formulation under which I introduced this subject is essentially false: these different products of human activity do *not* have the same subject. Quite apart from the concrete details that distinguish the death of one hero from that of another, "The Death of a Hero" is something different in our two first examples from what it is in the third and again from what it is in the fourth. In each case the subject draws its own limits or boundary lines, and what may fall inside or outside these lines will differ in the different cases. Thus what is "extraneous" to a work of art, in the sense used in defining the purity of art, is determined by the subject and its self-limitation. We saw before that a work of art is a strongly coherent whole, a powerful *gestalt;* and such self-limitation is a definite *gestalt*-property. But this determination of the term extraneous is still too narrow: a demand issuing from a part of an art object is extraneous, and, therefore, an effect produced by it artistically impure, if it is not itself demanded by the total pattern of the work. For a *gestalt* not only makes its own boundaries, but also within its boundaries rules and determines its parts in a sort of hierarchy, giving this a central position, this the role of a mere decorative detail, that the function of contrast, and so forth. If then a part, by virtue of properties which belong to it quite independently of the role it plays in the whole, acquires a weight and thereby an effect that is greater than that accorded

to it by the law of the whole, then to this extent the demand lodged in this part is extraneous, the effect impure.

This suggestion ought to be followed up by the analysis of a great number of examples, because only such analysis can decide its value. But this I shall have to leave to the future; instead I shall return to the paradoxical situation mentioned above, *viz.* that a work of art with a greater ego-requiredness than another may nevertheless affect us less deeply. The preceding discussion has made it possible to hazard a guess as to a solution of this paradox. It is characteristic of a good *gestalt* not only that it produces a hierarchical unity of its parts, but also that this unity is of a particular kind. A good *gestalt* cannot be changed without changing its quality, and must deteriorate if the changes introduced are of a minor order. Which changes are of a major, which of a minor order, cannot be defined independently of the *gestalt;* we can only say that certain changes will "distort" the existing *gestalt,* others will transform it into a new *gestalt*—which may be superior or inferior to the old one. Changes of the first kind are minor, those of the second are major. The application of this to art is simpler than it seems, since as a rule we may confine ourselves to minor changes. Thus, a melody is perfect if the change of any one of its tones robs it of some of its beauty; in a masterpiece of painting no line, no form, no colour, can anywhere be changed without detracting from the quality of the picture. (It is hardly necessary to say that the effect of a change on the whole will depend on the place which the changed part holds in the total hierarchy.)

This definition of a good *gestalt* does not mean that it is devoid of stresses. If it were, it would not be a *gestalt:* no hierarchy of parts would be demanded, there could be no self-limitation of the whole, no requirements could issue from such a dead object. The implication of our definition is only that the forces within the *gestalt* are well balanced; that each part is where it is because of the demands of the whole and not owing to extraneous factors or constraints.

Think now of the artist's subject, the task that he sets himself or that imposes itself upon him, or of a finished work that fulfills the demands of this subject as much as possible. They also may be more or less perfect, in them also the stresses may be more or less well balanced. In short, quite apart from execution, the subjects themselves, in the sense defined above, the problems which the artists want to solve, the visions they want to embody, will be of different *value.*

I am fully aware that I have thus introduced another fundamental topic, the question of value, more controversial even than any of the others, without being able to follow it up. My excuse is again that I want to stake out a field of psychological theory and research in the domain of art, and that my psychological reflections forced me to draw this conclusion.

I must now resume the main argument. If the vision of the artist lacks perfection, then the stresses existing between the various parts of his total work will not be perfectly balanced. Since, as we saw, the work

of art does in some way require an Ego, this requirement itself may be the cause of the disharmony: in the original vision the Ego occupies too large a place, or a wrong place, so that the whole is "distorted." Such a view would indeed explain why the degrees of ego-requiredness need not at all parallel the degree of artistic satisfaction produced by a work of art. Perhaps we might even say that in cases like the one just discussed the purity of art is violated—in which case our previous definition of purity would have to be broadened.

Anton Ehrenzweig

Anton Ehrenzweig came to London in 1938 from Vienna, where he had taken a degree in law. He taught at the London Central School of Arts and Crafts, and was the author of The Psycho-Analysis of Artistic Vision and Hearing *(1953) and* The Hidden Order of Art.

The Hidden Order of Art

Psychoanalysis teaches that artistic creativeness is fed from very deep unconscious levels of the mind. The artist, more than other men, is able to give freer rein to his repressed drives and in doing so can discipline them by the magic of aesthetic order and harmony. Little is known, however, about the way in which the artist is helped by his unconscious in doing his work, in painting a picture or composing a piece of music. Yet the help of the unconscious is indispensable, owing to the limitations of consciousness.

Art structure is very complex; in a great work of art we continually discover new formal ideas which have escaped attention on previous occasions. Even the simplest work of art has this complexity, however bare its construction may appear on superficial scrutiny. This is the reason why it is impossible to control consciously the many form-processes of art. The focus of conscious attention is far too precise, too

From British Journal of Aesthetics, Vol. I, No. 3 (1961), pp. 121–133. Reprinted by permission.

narrow for that. We owe to Gestalt psychology a detailed study of the limitations of conscious focusing. In countless laboratory experiments the Gestalt psychologists established that our eye—or rather our brain— has an overwhelming need to select a precise, compact, simple pattern from any jumble of forms presented. This selectiveness, narrowness, precision of conscious focusing is not sufficiently elastic for controlling the complexity of art form. For instance in looking at a painterly picture by Monet, we can either focus on the large-scale composition—then the richness of the brushwork will recede into a fog of inarticulate grey tone-values—or else we can focus on the single strokes of the brushwork and forget the all-over structure. We can never do both at the same time. Yet this feat is precisely what is expected from a good artist who has to consider the inter-relations between all details of his work as well as their integration with the entire composition. We expect from a good conductor—though this seems an ideal which is never entirely realized— that he should shape every detail of a symphony not only in its immediate context but also as part of the entire symphonic structure. This all-over grasp can never be satisfactorily achieved by conscious form-analysis alone.

In order to achieve this all-over view we have to let go of the narrow focus of conscious attention and broaden it out into a seemingly empty daydream-like stare. Some examples of modern art disrupt narrow focusing from the outset. It was Sir Herbert Read who in his early book *Art and Industry* first drew attention to this strange feature of modern art. He called it the 'eye-wandering' effect of such modern painting. The lack of stable focusing points is noticeable already in French Impressionism and early Cubism. Picasso's cubistic portraits split up all coherent surfaces into a great number of superimposed, broken planes that our eye can arrange in many different ways. Since Sir Herbert wrote, American action painting, French tachism and much modern music have made the prevention of stable focusing almost a matter of principle. There is no coherent line and closely knit structure on which our eye or ear could rest and our attention is left to drift without direction. This, for many people is a most disagreeable and even anxiety-creating experience. Sir Herbert rightly commented that this eye- or ear-wandering effect contradicted the Gestalt theory which preached that the human mind, and the artist in particular, strove to form the simplest, stablest and most compact patterns possible. The only conclusion to be drawn is, not to criticize the artist for offending against basic psychological laws—as has sometimes been done—but to revise the laws of psychology so as to make them conform with the facts of art. My own conclusion which led me to investigate unconscious perception processes, was to assume that precise and stable focusing was found only in our conscious mind, but not in deeper usually unconscious levels where the narrow focus of consciousness broadens out into a wide all-comprehensive stare.

The artist has recourse to this diffuse, half unconscious stare quite naturally. It is not an unusual sight to see an artist step back from his

canvas and gaze at it with curiously empty, wide-open eyes. Nothing seems to happen in his mind; yet after a while some hidden small detail will obtrude itself on his attention. It had somehow upset the balance of his composition, but had escaped his conscious scrutiny. During his spell of absent-minded staring his unconscious attention scanned the complexities of his work and discovered the offending detail. Reassured the artist will return to his canvas and correct the detail which to the average spectator may well seem insignificant and petty. I will later discuss a similar diffuse type of hearing in music which allows the composer to control the hidden complexities of polyphonic writing.

The traditional artist uses his diffuse stare for scanning the complexities of the work of art and then returns to the normal state of consciousness and shapes his work to satisfy the conscious need for precision, coherence and 'good' Gestalt; the modern artist remains to a certain extent in the diffuse state of vision and his work therefore reflects very directly the incoherence, scatteredness of unconscious vision which is more akin to the diffuse vision of our dreams than to waking consciousness. Our dreams may seem very precise and well-defined while we are dreaming; and yet they may dissolve when we try to bring them in the sharp focus of our waking attention. They often seem to contain all and nothing; the well-circumscribed things of our waking life do not fit their wide fluid frame. In my view it is this diffuse gestalt-free technique of attention on a low level which enables the artist to comprehend the complexities of artistic creativeness. What seems chaos and disorder in a dream, becomes an instrument of utmost precision in the hands of the artist. The great psychoanalyst, the late Ernst Kris, once said that the artist can make his mind regress to primitive states and still keep control. This celebrated dictum makes good sense in my argument where I maintain that the diffuseness and vagueness and seeming emptiness of dream vision becomes in the artist's hands an exact instrument for controlling the complexity of art. This is in fact the main hypothesis of my investigation into creativeness and I cannot fully elaborate it here.

Only in the uncreative personality would the diffuse, unfocused imagery of the unconscious act disruptively. Abandonment of directed purposeful thought and conscious control then constitutes a real danger and would bring on severe anxieties. But in the creative mind the diffuse imagery of the unconscious and its dream-like diffuse stare is made to perform highly technical tasks that assist in building up the complex order of art. The artist has learned from hundredfold experience that he can afford to allow conscious control to lapse; then, as if from nowhere, sometimes by what seems a miraculous accident, new ideas will emerge and bring the longed for solution of a problem. I am not suggesting that the artist can leave the solution of all formal problems to an unconscious-automatic method of working. Rather is there constant interaction between different levels of mental functioning—focused or unfocused—which co-operate in their specific way in performing the common task of building up the work of art.

As long as this co-operation between conscious and unconscious is not achieved any untoward stimulation of unconscious dream-like vision at the expense of precise focusing may bring on considerable discomfort and anxiety. The American psychoanalyst, the late Elsa Frenkel-Brunswik, found that ambiguous pattern which prevented stable focusing was liable to cause discomfort to certain rigid people. Yet ambiguity of pattern and form relationship is characteristic of artistic structure, for instance in counterchange patterns which are frequently found in primitive ornamentation. You can see them either as black pattern on a white ground or with equal ease as white pattern on a black ground. It is quite impossible to comprehend both the black and the white pattern into a single focused glance; counterchange patterns compel diffuse staring. For this reason they can be both useful and dangerous in art teaching. If the student is unable to relinquish precise focusing, it is useless and even harmful to draw his attention to the many complexities of art form which he cannot control by conscious focusing alone. A counterchange pattern is only one instance of artistic complexity. It is better for the still rigid art student not to realize how every brush stroke affects a great number of parallel relationships, such as the flow of lines, the balance of colour, the graduation of tone values and other imponderables such as hidden counterchange patterns. Impressed by these immense responsibilities, the student's rigidity may well turn into complete paralysis. He might find himself in the predicament of the famous Centipede of the fable who was asked how he was able to control his hundred feet all moving at once. The poor animal reflected and was no longer able to move at all. The fable brings out well the incapacity of narrowly focused conscious attention to control the many simultaneous superimposed form processes of art.

It is no use to ask a rigid student to abandon his narrow focusing and let things happen in a diffuse almost passive state of attention in order to integrate his composition properly. He will not believe you. Such a rigid art student in his unconscious fear of letting go, might consider his main task to be the learning of precise draughtsmanship, an ability to set down on paper or canvas exactly what he sees in front of him or some other pre-determined shape. When he has acquired complete conscious control over his medium he will be able to draw neatly with machine-like precision; but he might discover that his work lacks vitality; he might now understand that only automatic, unconsciously controlled nervous draughtsmanship gives life to conscious precision. He may try to affect a nervous kind of handwriting by making his hand self-consciously wobble along each line he draws. This kind of skilful mannerism however will, of course, not do the trick.

There is no definite recipe for breaking the pernicious rule of narrowly focused preconceived design and for freeing the diffuse inarticulate vision of the unconscious. Michelangelo, a superb craftsman, sometimes started with a wholly traditional scheme, but under his hands the scheme bulged and swelled and assumed gigantic proportions. Adrian

Stokes in his book *Michelangelo, A Study in the Nature of Art* (1955) put forward a convincing explanation how, unconsciously to Michelangelo, the realistic forms of his male nudes bulged and distended as an unconscious symbol of their ambi-sexuality, where male and female characteristics become intermingled. He explains Michelangelo's 'terribilità' from this unconscious ambiguity which defeats rational comprehension and so evokes anxiety. Beethoven is often compared with Michelangelo; yet his method of composition was quite different. Like Michelangelo, he finally arrived at structures on a grand scale, but he did not as a rule start with traditional structures and allow them to burst at the seams. He often adopted something like a *tachist* method; he teased and worried little bits of inarticulate melody, insignificant in themselves, until they yielded, often over a struggle lasting years, extended phrases, whole movements and perhaps the all-over structure itself. In the third slow movement of the Hammerclavier Sonata, I am still startled by a sudden abrupt twist that breaks into the broad beautiful cantilene and produces a melodic as well as an harmonic rupture. The notebooks tell us that it was not the broad adagio theme, but this abrupt transition which Beethoven first noted down. How strange: a transition between melodies not yet existing! The melodies themselves unfolded only later from this rupture between them. Beethoven never revised the break while he kept on filing and refining the broad melodies. Here we have a good example of an inarticulate disruptive idea which guides and unfolds the large-scale structures. A fully articulate well-knit melody belongs altogether too much to consciousness. An incoherent fragment, a disruptive form element is better able to break the narrow focus and produce a fissure in the mind's smooth surface which leads down to the depth of the unconscious. Heinz Koppel, a painter friend of mine, once talked about the conflict between the painter's point of departure and the resisting medium. The recalcitrance of the medium may upset the artist's conscious intentions; yet in the end his initial idea will be better realized because of these constant disruptions and modifications that break the hold of preconceived design and cliché, unrelated to the rest of his personality.

Hence the enormous importance, in art teaching and artistic creativeness, of unpremeditated accident. It seems to come from outside and to have nothing to do with the artist's personality, yet it is precisely the break-down of conscious cliché and mannerism that realizes his true submerged personality. It is an old stand-by of the good art teacher to make the student change his medium as soon as he achieves a too conscious and sure control over it; or even to make the student use accident-inviting techniques, or to make him use both hands or only the left hand, or to draw with the eyes closed. His awkwardness, his failure to impose his conscious will on the medium, gives his unconscious personality its chance to come through the fissures created by accident and failure. The teacher's battle is won when the student overcomes his anxieties over the breakdowns of his conscious control and discerns underneath all his awkwardnesses and accidental performances, a common denominator

that was at first strange or even threatening to him, but which he gradually learns to accept as expression of his own personality.

Before this self-knowledge is gained, self-expression, or more ironically still, 'free' self-expression has no meaning. If persuaded to let go of conscious control, the student may slash at the canvas with an insensitive aggressiveness that is a measure of his anxiety; his insensitivity and overactivity prevent him from adopting that watching passive attitude towards the happenings on the canvas, accidental or non-accidental, that carry the message from his unknown self and would lead him to true self-expression. The exploration of the medium and the exploration of his own self then become one and the same process; the outside and the inside merge in unity. The artist himself does not know of this. His passionate interest in the outside world, in the functional properties of the material in which he works, makes him forget that he is also at grips with himself. I have called this, the artist's self-deception, the externality illusion of art which turns the artist's attention from his inner to the outer world. It is no contradiction if action painting appears to the painters and some critics mainly as an exploration of the medium, of its dripping, splashing, scratching properties, *i.e.* of objective facts in the outside world, while Sir Herbert Read called action painting an art of inner necessity, a direct projection of unconscious form processes; both descriptions are true, of course, and refer to different aspects of one and the same psychological process. While the artist struggles with his medium, unknown to himself he wrestles with his own unconscious.

The externality illusion which locates the process exclusively in the outside world of the medium can produce dangerous misunderstandings. The spate of bad action paintings may be caused by it. To use certain gimmicks for distributing paint in an interesting texture over the canvas is no more art than the old arty-crafty tricks such as pouring oil paints on water, combing them and taking monoprints from the resulting streaks of colour. The struggle, the inner conflict projected into the outside world, is missing.

This misunderstanding is due to the persistent tendency in the history of art to externalize or rationalize the manifestations of the unconscious. Only now do we recognize the continuity between action painting and early French Impressionism. Like the action painting of today, Impressionism arose from an irresistible desire to break up the narrow focus of surface vision, to disrupt continuity of line and surface in an apparent chaos of free brush work. The violent antagonism of the contemporary public is well explained by this violent attack on its conscious sensibilities. But as time went on the disruption of coherent pattern was rationalized into a scientific discovery of the effects of light and of a new dimension in pictorial space. Some of the Impressionists themselves succumbed to this secondary rationalization. But their leader Monet broke through this barrier again and in his late paintings, such as his famous lily ponds, produced paintings of unrealistic freedom of broken-up lines and surfaces that are rightly acclaimed as precursors of action painting.

We know, of course, less of the earlier phases of European realism. But we know that the early Renaissance painters did not experiment with perspective foreshortenings in order to represent space more realistically and precisely. I myself have little doubt that the unconscious psychological source was the same unconscious desire to break up conscious coherence and geometric regularity, such as the symmetry of the human body which required that both arms or legs should be of equal length. In the beginning the distortion of this symmetry must have been emotionally as disturbing as are the distortions of the human form by our modern art today. How little realistic space mattered in the beginning can be seen from the oppressive flatness that extreme perspective foreshortening produced in the early experiments as in Uccello's painting of the *Great Flood.*

It is only in really new art that we can fully appreciate the attack on conscious sensibilities and the anxiety which all artistic innovation entails. There the secondary rationalization process has not yet pulled together the disruptions. If we hold on to our ingrained cliché habits of seeing and listening formed in appreciating traditional art, we are bound to feel as if attacked and to experience the acute discomfort connected with unconscious anxiety. In fairness it must be conceded that only certain psychological types can easily relinquish the conscious need for stable focusing and rational coherence. Lowenfeld explained the difference between the so called haptic and visual types of artists by pointing to the discomfort that people of the visual type feel in looking out from a moving railway train. They have an overwhelming need to connect up the scraps of landscape carried past the window in chaotic sequence, while other passengers of the haptic type are content enough to watch empty-eyed the constant change of scenery. Haptic artists would work more from an unconscious discipline and care little for surface coherence, while visual and more rational types of artists need surface coherence and stable focusing.

Extreme examples of action painting such as the unending loops of Jackson Pollock cannot fail to cause discomfort in people of the more rational type. To avoid discomfort we have to give up our focusing tendency and our conscious need to integrate the colour patches into coherent patterns. Rather must we allow our eye to drift without sense of time or direction, living always in the present moment without trying to connect the colour patch just now in our field of vision with others we have already seen or are going to see. If we succeed in evoking in ourselves such a purposeless daydream-like state, not only will we lose our sense of unease but the picture may suddenly transform itself, it may lose its appearance of haphazard construction and incoherence. Each new encounter will now come as a logical development and after a while we shall feel that we have grasped some hidden all-over structure which is contained in each nucleus of colour, just as I assumed that for Beethoven's inner vision an incoherent scrap of melody could stand for the all-over structure of a whole symphony. Conscious surface coherence has

to be disrupted to bring unconscious form discipline into its own. As this unconscious form discipline cannot be analysed in rational terms, we are thrown back on our aesthetic sensibility alone in order to distinguish irresponsible arty-crafty gimmicks from truly creative art ruled by that inner necessity of which Sir Herbert Read has spoken.

You might concede that action painting has this disrupting effect on our conscious faculties and so stimulates low-level sensitivity, but you might maintain that this was only an isolated phenomenon in modern art, an excess rather than the rule. For instance, the second school of modern art, constructivist painters and sculptors, served our conscious need for precision and coherence well enough.

But constructivism and its manipulation of age-old geometric forms may need our faculties for diffusion even more urgently than action painting. In fact constructivist exercises are a good method for teaching the student to abandon all too conscious control. Alan Davie, in a basic design course at the Central School of Arts and Crafts, made his students manipulate ready-made material, such as the capital letters of the alphabet or a few geometric forms, triangle, circle and the like. The need to use ready-made forms militated against their compulsion to force their will on the medium. You will understand that breaking down such ready-made forms, to explore their innumerable permutations and distributions, again requires that diffuse empty stare, perhaps even more so than tachist exercises. To infuse life into the hard forms of constructivism we must break down in our vision their rigid frontiers so that they begin to interact, to deform each other in innumerable complex interrelations. Pasmore's constructions in wood and perspex are utterly simple distributions of oblong wooden slabs in front of and behind a glass plate. Yet Pasmore succeeded in breaking down their sharp delineation, they fuse with each other in countless combinations determined by accident of perspective and illumination. In short, though the constructivists may not themselves be able to break down physically the form elements, yet the response they evoke in the sensitive spectator will be to diffuse these hard, inhuman forms into fluid organic interaction.

Much of modern music can be defined as being both constructivist and tachist at the same time. Boulez began his exploration of sound by drawing up complex mathematical charts for constructing melodic, rhythmic and other sequences according to complex rules of permutation, expanding Schönberg's law of permutating the twelve tones of the chromatic scale to the permutation of any musical forms. By such constructivism he succeeded in disrupting any coherence of the surface form far more incisively than any tachist or action painter could do. Opponents of twelve-tone music in general and of Boulez's experiments in serialization in particular criticised them on the ground that the regularity of their constructions was not consciously apparent, without realizing that psychologically this was just the aim of this tachist constructivism. As in action painting, any attempt at consciously organizing such music is bound to end in acute discomfort. Any continuity of me-

lodic line or harmonic progression seems missing; the instrumental sounds tumble like the tinkles of an Aeolian harp responding to irregular gusts of the wind. But just as we allowed our eye to drift through an action painting without sense of time, so we must listen to this music without trying to connect the present sound with the past and future; again after a while the sounds will come with the feeling of inevitable necessity, obeying an unconscious submerged coherence of a different order that defies conscious analysis.

Music generally allows us to distinguish clearly between articulate surface coherence and a submerged more diffuse order and cohesion. The musically insensitive listener will expect of his music a single resonant and coherent melody set against a mushy background of full chords. This type of naive listening is called vertical because the polyphonic structure of music is not appreciated except as solid chord sound; as in musical notation the tones constituting a chord are written vertically on top of each other, this kind of solidified listening is called vertical. It cannot be denied, however, that vertical listening obeys the fundamental law of simplicity, precision, in short good Gestalt, ruling our conscious mind in hearing as well as in seeing; the listener naturally focuses on a coherent melodic line that is easily grasped and memorized. Such a listener will already feel discomfort in listening to symphonic music. There the thread of the dominant melody is taken up by various instruments in turn, but not always as a continuous coherent line. Interruption as well as overlapping occurs, which prevents stable focusing on a single continuous melody. The result of course is confusion and unease. Not so for the musician, who will not even be aware of overlapping and lack of continuity; he has already learned to diffuse his attention into a more horizontal type of listening, so called because chords are not heard merely as solid compact sound but as loose combination of several voices. As in musical notation these polyphonic voices are written out running horizontally along the five lines, hence we speak of 'horizontal' listening. The more our listening is diffuse and horizontal, the more the chords lose in solidity and dissolve into the intricate polyphonic web which is the really significant structure of European music. There are extreme examples requiring diffuse horizontal hearing, such as the structure of a fugue by Bach where attention can never fix itself on any melody for any length of time, but should remain diffused on the entire structure in that seemingly empty yet full stare the nature of which we now know well enough.

Modern music is usually criticized for its want of melodiousness, not only today but also in Mozart's and Beethoven's time. The Emperor Joseph II of Austria complained to Mozart that his music was overloaded with too many notes, his displeasure was probably caused by the confusion of more polyphonic writing that may have obscured the main melody. Mozart, in his later works, purposely strengthened the middle voices in the hope that their intricacy would escape the average listener and please the connoisseur. The Emperor's criticism shows that he failed in his hope of deceiving the naive vertical listener. Today most people will

hear Mozart and Haydn, particularly Haydn, merely as pleasant coherent melody lightly underscored by a few, now hackneyed chords; we cannot realize how the Emperor could feel such featherlight, lucid music to be overloaded and confusing.

Sir Thomas Beecham had a certain mannerism in conducting Mozart's late works which partly counteracts this verticalization of polyphonic complexity; he gave more weight to the middle voices and so tried to make it more difficult to concentrate exclusively on the dominant melody. But even so, the average listener will probably refuse to let go his iron grip on a single melody.

This verticalization of polyphonic sound is a psychological reaction which I have first demonstrated to you in the realization of French Impressionism. The scattered brush strokes of Impressionism were reinterpreted as realistic interpretation of light, which made it possible for the public to see in them the old familiar solid objects which the Impressionists had been at such pains to disrupt. The gradual shift from horizontal to vertical hearing represents the same solidification of an original diffuse experience so that our conscious attention can again comfortably focus on well-defined simple forms, here the single melody. I can still clearly remember the time in my youth when I got to love the music of Brahms. He then still went as a modernist in conservative Viennese circles; his music sounded sharp and brittle, lacking in smooth finish, and his intricate polyphonic writing grated against, and disrupted, the smooth flow of melody. But I loved this austere music for its harshness and masculinity that seemed to agree well with Brahms's forbidding personality. Yet as time went by, the sound of his music became transformed into its opposite: today there is a luscious velvetiness, an almost erotic warmth about Brahms that makes him almost too rich and sweet a fare. His once hesitant melody has duly thickened into broad solid song. We cannot reverse this transformation by any trick; as little as Sir Thomas Beecham could restore to Mozart that greater complexity which presumably existed in his own time. Though I myself can clearly remember my experience of the ice-cold harsh quality of sound when I first came to hear Brahms, I can no longer associate this memory with the lushness and richness of sound which now meets me when I listen to the same music in the concert-hall today.

Today's generation may go through similar experiences with the music of Bartok and Stravinsky. Where is the harsh uncompromising sound of Stravinsky's *Rite of Spring* that once stabbed our sensitivities in the raw? We cannot welcome this transmutation as increase in understanding due to greater familiarity, but must deplore it as permanent loss in the profundity of our experience which can never be wholly retrieved from the past.

The re-creation of old music in the spirit of modern art may come more dramatically, with a sense of shock and suddenly disrupt comfortable habits of listening. Once the young British composer Alexander Goehr played a most unsettling joke on me which, however, was very

instructive. Goehr claimed that he could demonstrate to me that Boulez, in spite of his deliberate destruction of traditional forms, really worked within an established French tradition. He played first the full recording of Boulez's *Le Marteau sans Maître*. This naturally conditioned my attention to the diffuse disconnected type of listening that this music requires. Afterwards without much warning he continued with Debussy's *La Mer*. I did not recognize this well-worn piece of Impressionistic writing! Normally Debussy's tone-poem produces realistic associations, like the roar of the waves and of the wind. Now I heard for the first time a constant variation and mixtures of tone-colour so subtle and fleeting that they forced me to live eternally in the present as Boulez's music had done. Obviously the realistic associations with nature's noises tend to coarsen our sensibility and we fail to accord to Debussy the place on the side of the greatest that is due to him. The experiment came as a shock because I was not prepared for this twist of my sensibilities. I felt driven to compulsive laughter. Such laughter may occur when we are suddenly forced to acknowledge a hidden identity between very distant objects, such as animal form transformed into a human face and the like, here the hidden affinity between a worn piece of musical Impressionism and a modern exponent of twelve-tone music. I said that Debussy's disconnected tone-colour mixtures and contrasts had been dulled and coarsened by too realistic interpretations. We might remember that exaggerated realistic reinterpretation did the same disservice to Claude Monet's Impressionistic painting of the same period. In either case the sharpened modern sensibility for disconnected textures in tone and colour may help us to regain some of the original tensions. So the action painters rediscovered Monet. So also Boulez allows us not only to reassess Debussy's true achievement, but explains the immense antagonism which his disruption of traditional harmonic cliché must have first aroused at a time when he still went for a modernist and his loose tone-colour sequences were not safely tied together into crudely naturalistic sound.

I do not maintain, for a moment, that sensitivity for modern art allows us to restore the original impression of an historic work of art; far from it. In my view, the secondary rationalization process, once imposed on art, is irreversible and the original experience is lost for ever. Monet and Debussy *were*, after all, realistic Impressionists, only not quite as much as later rationalization and verticalization has made them appear to us. Monet *did* paint lily ponds though he was obviously not very interested in producing easily focused coherent forms. By imposing the disruption of modern action painting on the late Monet or of Boulez's music on Debussy, we simply blow the entire hardened surface of rational realism to bits and expose the raw diffuse matrix below, and reinterpret it at the same time according to our own contemporary form feeling. This is of course quite arbitrary, but not more so than the shallow rationalizations of previous generations. It is the glory of great art that it can tolerate this arbitrary manipulation of its conscious surface, because its real

substance belongs to deeper untouched levels. We do not really mind that we cannot reconstruct the conscious intentions of the stone-age cave painters or of the old Mexicans, because we feel instinctively the relative unimportance of the artist's conscious message. It is perhaps due to the fact that our own modern art is often content to work from low irrational levels of the mind alone, that our civilization has become so receptive to the art of other civilizations, prehistoric, historic, primitive and exotic. What alone seems to matter to us is the complex diffuse substructure of all art which had its source in the unconscious and to which our own unconscious still reacts readily, preparing the way for ever new reinterpretation. The immortality of great art seems bound up with the inevitable loss of its original surface meaning and its rebirth in the spirit of every new age.

The Problem of Creativity

David W. Ecker

*David W. Ecker, who formerly taught at Ohio State University, is
presently Professor of Art Education, School of Education, New York
University. He has co-authored* Readings in Art Education *(1966),
and has published a number of articles dealing with aesthetics.*

The Artistic Process as Qualitative Problem-Solving

The general impression one gets from a survey of writings of artists
and non-artists alike is that the closer the writer has stood to the work
of the studio, the more the techniques and means of production are ap-
preciated. Conversely, it seems that the farther he moves back to view
the role of art in education, society, or civilization, the more the writer
becomes concerned with the ends of art, its ultimate value to mankind.[1]

From *Journal of Aesthetics and Art Criticism,* Vol. 21 (1963), pp. 283–284, 285–290.
Reprinted by permission.

My interest in artists' discourse is methodological. By this I mean to indicate that my problem is one of formulating warranted generalizations about the controlled process of artistic production. These perspectives may be usefully merged. A close examination of the shop talk and the work of the studio will provide certain data about the process of constructing an art object. These generalizations will be expanded to a level of abstraction inclusive of the immediacies of any given artistic production. I will call the latter qualitative problem solving. It is my contention that careful study of what painters *do* when ordering their artistic means and ends, as well as to what they *say* they are doing, will provide the bases for significantly improving our generalizations about the plastic arts and our conceptions about education in the arts. If it *is* possible to describe the artistic process as a series of problems and their controlled resolution, the ensuing generalizations may be of no small consequence to the teaching of art. Thus, my interest in and criteria for the evaluating of the verbal and qualitative materials of the artist will be methodological: my interest will be in artistic means and ends and my criteria that which will evaluate discourse in terms of its ability to explain and describe deliberately conducted procedures involved in artistic production. . . .

I

[The] painter, Yasuo Kuniyoshi, states:

> There are numerous problems that beset the artist in his work. Consciously or unconsciously each artist tries to solve them. Lately I have come to the stage where I actually take a problem and try to solve it. For instance I was interested in painting a dark object within the dark. In order to carry this out successfully it may take me several years. Once accomplished to my satisfaction, however, it becomes an integral part of me, enabling me to go on to another problem.[2]

This last statement about going on to another problem suggests the notion of a development—or learning sequence—whereby the artist increases his control, over a period of time, by solving problems which are qualitatively related to one another in technique, style, or theme. It also suggests a conception of art history as a series of problems and solutions; those solutions which provoke the most artists in succeeding generations to work at related problems are named "masterpieces." Successive problems with perspective, modelling, proportions, color, composition, expression, and so on, are literally a part of art history. . . .

If this conception of the art process as a problem-solution-problem continuum is warranted by the qualitative evidence of art history, much of the shop talk between artists is verbal evidence. For shop talk is largely

a by-product of their mutual problems of painting or sculpting. The words incorporated into this shop talk have common sense meanings, or, rather, sense common to fellow artists. That is, the words refer to the shared qualities of their work. Consider the empirical character of the following examples of shop talk: "If you use a cool green here you can get this plane to recede." "My painting is beginning to get a cubist quality." "This jagged shape contrasts sharply with those open volumes." The things dealt with by such language are what I choose to call the means and ends of artistic production, the *qualities* artists manipulate, orchestrate, modify, and create in solving their problems. Even the limited sample of artists' statements reviewed thus far suggests the broad features of the artistic thinking that is involved in the production of plastic art.

Given this initial data it seems plausible to suggest that: (1) Artists at their work think in terms of relations of qualities, *think with qualities;* their thought, in a word, is qualitative. (2) This thought is exercised on behalf of the construction of further qualities—the qualitative problem. (3) Qualitative problems are not so much "in the mind" as they are "mindings." Artistic problem solving takes place in the artist's medium—line, plane, color, texture, form are the qualities distinctive to or possible for such materials as stone, wood, paint, or fabric. (4) Qualitative problems are not "inner conflicts" or "states of confusion" but awareness of elements or prospects within a range of qualities with regard to some intended order, end-in-view, or pervasive quality. Thus qualitative problems, like theoretical problems, are publicly available to student and instructor alike for shared criticism and work. (5) The means for the resolution of a qualitative problem are component qualities. Words as qualities may, of course, enter into the art, say, of collage, or the poster. (6) While language may be of help in the definition of the qualitative problem, that is, in its location or delimitation, the ability to describe verbally a qualitative problem is not a necessary condition for having one. (A painting may be labelled after its completion.) (7) Critical judgment is not necessarily antecedent, nor totally subsequent, to a creative act, but often occurs during the act. Judgment, or judging, is choosing among alternative actions and qualities, choosing among alternative qualitative means-ends and methods. Cubism as a style has acted to determine what elements, planes, structures may be organized. As such the style regulates or controls the production of a given canvas. Because of this control one would identify the canvas as cubistic. The painter may, at any time, choose to destroy his canvas, that is, embrace *another* control. Or he may indicate verbally his satisfaction with its development or otherwise *affirm* his control. (8) None of the laws of formal logic as such seems to be directly applicable to the qualitative thought of the artist. While logic can order the theoretical symbols used in scientific inquiry and control statements and assertions, whether about art objects or other subject matters, it is not applicable to the qualitative ordering that yields a piece of sculpture. (9) One may locate within the history of

art the history of art criticism; the historical series of qualitative solutions to artists' problems sets the qualitative standards for evaluation of art.

II

John Dewey is one of the few modern philosophers who have offered us some methodological analyses of controlled production both in the arts as well as in scientific inquiry. These analyses are exceedingly pertinent to the theme of this paper. Dewey held that all thinking depends upon the awareness of qualities. He claimed it is the unique quality that pervades a situation that acts as a control over all means to ends-in-view ordering. But in his most systematic effort to explain thought processes Dewey is essentially occupied with the nature of the "pattern of inquiry," or *scientific* problem solving. Dewey's analysis of the steps of inquiry are well known: "(i) a felt difficulty; (ii) its location and definition; (iii) suggestion of possible solution; (iv) development by reasoning of the bearings of the suggestion; (v) further observation and experimentation leading to its acceptance or rejection; that is, the conclusion of belief or disbelief." [3] As to his conception of artistic thinking he leaves only a series of rather unsystematic, albeit seminal, ideas which suggests the possibility of extending the conception of "problem" to include both scientific and artistic aspects of human intelligence. For example one reads:

> The artist has his problems and thinks as he works. But his thought is more immediately embodied in the object. Because of the comparative remoteness of his end, the scientific worker operates with symbols, words and mathematical signs. The artist does his thinking in the very qualitative media he works in, and the terms lie so close to the object that he is producing that they merge directly into it.[4]

Dewey finds many similarities between art and science and he often identifies the two. He insists that

> . . . science is an art, that art is practice, and that the only distinction worth drawing is not between practice and theory, but between those modes of practice that are not intelligent, not inherently and immediately enjoyable, and those which are full of enjoyed meanings. . . .[5]

According to Dewey the method of inquiry is the method of art: "Scientific method or the art of constructing true perceptions is ascertained in the course of experience to occupy a privileged position in undertaking other arts. . . ." [6] Furthermore, he claims that artists and scientists have much in common:

There is . . . a tendency among lay critics to confine experimentation to scientists in the laboratory. Yet one of the essential traits of the artist is that he is born an experimenter. Without this trait he becomes a poor or a good academician. The artist is compelled to be an experimenter because he has to express an intensely individualized experience through means and materials that belong to the common and public world. This problem cannot be solved once for all. It is met in every new work undertaken. Otherwise an artist repeats himself and becomes esthetically dead. Only because the artist operates experimentally does he open new fields of experience and disclose new aspects and qualities in familiar scenes and objects.[7]

Having stated the basic similarities between artistic and scientific activities, Dewey does not ignore their differences, although perhaps he fails to draw the line to the degree of sharpness his critics might desire. Between the two,

. . . the only significant distinction concerns the kind of material to which emotionalized imagination adheres. Those who are called artists have for their subject-matter the qualities of things of direct experience; "intellectual" inquirers deal with these qualities at one remove, through the medium of symbols that stand for qualities but are not significant in their immediate presence.[8]

Inasmuch as the theme of intelligence as the one valid instrument to control and enrich human experience is central to all Dewey's writings, it is quite understandable that we find him insisting throughout these passages on the indispensable part thought plays in the production of art. He insists that "the odd notion that an artist does not think and a scientific inquirer does nothing else is the result of converting a difference of tempo and emphasis into a difference in kind:"[9] Or again, when he writes, "any idea that ignores the necessary role of intelligence in production of works of art is based upon identification of thinking with use of one special kind of material, verbal signs and words."[10] Citations such as these could be continued, but nowhere does one find a systematic analysis of the method of "artistic" thinking.

III

Two students of Dewey's thought, N. L. Champlin and F. T. Villemain, of Wayne and Toledo Universities respectively, have exploited these suggestions by extending methodological analysis to include the controls in "qualitative thought" and the formal character of qualitative ordering. Following Peirce and Dewey, they define intelligence as a human process or activity rather than as some kind of entity within hu-

mans. But intelligence is not limited to arranging theoretical symbols—
that with which scientists think primarily.

The artist, too, exhibits deliberate control over his materials: he ar-
ranges qualitative *means* such as lines, colors, planes, and textures, to
achieve his qualitative *end,* which we might name "cubist," "impres-
sionist," or "expressionist." In his selecting, rejecting, and relating of
qualitative means, he is guided by a quality which is common to his
previous work or to a particular style, such as Cubism. Thus, a certain
kind of general or "pervasive" quality acts as his *method.* Just as the laws
of logic are the controls by which theoretical symbols are arranged in
scientific inquiry, so these pervasive qualities act as *controls*—directive
criteria—by which component qualities are arranged in the artistic proc-
ess. The artist utilizes qualitative method to arrange the qualitative
means toward qualitative ends. Art, therefore, is an affair of intelli-
gence—it is intelligence in qualitative ordering.

The arts can now be seen as *specialized* products of qualitative intel-
ligence. Dewey's idea that the pervasive quality of experience is the
"regulative principle of all thinking," and that this quality provides the
necessary conditions for scientific knowing as well as qualitative opera-
tions, form the basis for Villemain's and Champlin's theory of education.
The traditional distinction between scientific and artistic activities—that
science has to do with "reason," and "intelligence," while art traffics with
"feelings" and "emotions"—is rejected as inherently un-testable. (The
latter terms do not have publicly shareable referents.) In its place, their
theory establishes qualitative (aesthetic) and theoretical (scientific) in-
telligence as operating in *all* areas of human experience.[11]

IV

With the broad features of the artistic process staked out and with
a conception of art as qualitative means-ends relating as our theoretical
base, we may now undertake to generalize the statements of artists into
a statement of qualitative problem solving in methodological terms. It
may be noted that, historically, much attention has been given to the
description of the parts of word or number ordering. For example, there
are the labels *verb, noun, adjective; hypothesis, assertion, deduction;
division, multiplication, addition; assumption, verification, proof.*
Many writers have wanted to use these or similar terms to describe
artistic ordering. And although it is true that much talk about the arts
incorporates the terminology of theoretical ordering—such terms as "ar-
tistic truth," "visual statement," "aesthetic validity," "perceptual knowl-
edge" are terms which come to mind—this is no doubt due to the vague
morphological resemblance noted between artistic and scientific proce-
dures. The reflections of artists and scientists alike point up striking
similarities in all original thinking. But the use of these quasi-scientific
terms to refer to qualities of art is, I think, grossly misleading.

The initial stages of art may appear to be random, uncontrolled behavior; but the appearance of an object is not a stage of artistic problem solving any more than the indeterminate situation was, strictly, a stage of inquiry for Dewey. A problem has to be taken in thought as either (1) *an object* such as a painting, costume, or table setting, or (2) *a situation* in which the relations of component elements seem present not in virtue of an ordering. In painting, for instance, if the work is to proceed, choices must be made; the alternatives are many and varied before the initial brush stroke (and the artist often may be in a hurry to make even "aimless" marks on the paper or canvas to gain a basis for future choice). But after these first elements—whether a bit of color, a line of a poem, or a bar of music—the alternatives diminish in number. . . .

Artistic thinking, then, occurs when present and possible qualities are taken as means, or ways of proceeding, toward a qualitative end-in-view, a total quality. The pervasive quality directs artistic behavior from stage to stage until a coherent whole is realized. This purposive activity may be conducted entirely in qualities—component, pervasive, and total. However, there *may* be ordering of theoretical symbols which may not be found as elements of the art work itself, but which are, nevertheless, helpful and in some cases demanded for the solution of a qualitative problem. It may be necessary, for example, for a painter to test a certain new formula for a particular gesso ground so as to achieve a highly *mat* finish when colors are applied over the canvas.

Qualitative problem solving is, as Dewey insisted of scientific inquiry, not a neat progression of steps but a single, continuous means-ends progression, sometimes hesitating, halting, groping; it may be rethought, move forward again, start over, in short, it is *experimental* behavior. And all that one can attempt is a logical analysis of distinguishable phases of the artistic process, as Dewey did in his description of scientific processes of thought. Rules, or recipes, as such, for producing good art (or science, for that matter) have never been established, and are perhaps anathema to the genuinely creative art of each age.

To reinterpret Dewey's definition of "inquiry": The artistic process is qualitative problem solving; it is the controlled procedure of instituting qualitative relationships as means to the achievement of a qualitative end or total. Not all of the following steps or stages are to be taken as necessarily proceeding in the order of presentation; but they are herein held to correspond with what Dewey has called "the stages of a complete act of reflective thinking":

1. *A presented relationship.* The initial and perhaps rambling phase is the instituting, taking, selecting, the discrimination of component or total qualitative relationships—the confrontation of that quality or those qualities which achieve candidacy for alteration, reconstruction, or change. These qualities (including those sometimes designated by the term "materials") vary, of course, from medium to medium, from substantive context to substantive context, and are components to be developed.

2. *Substantive mediation.* There follows, sometimes quickly or sometimes over a prolonged period, the instituting of new qualitative relationships. In some instances these relationships become, however hazily, candidates for means, whose status as means is dependent upon having an end-in-view. The choice for *these* relationships rather than some other possible relationships conditions succeeding choices among qualities. A future choice, however, may involve the "destruction" of a previous choice in the sense that another quality appears to compete with the initiating quality.

3. *Determination of pervasive control.* The controlling pervasive quality may emerge more clearly *as a pervasive*—as a control—at any time of the process' development; it results from the qualitative components being introduced, manipulated, and related to *other* components and the qualities emerging from *these* respective relations. "Components" of a unique end-in-view gain identity as such by virtue of the envisioned total quality now emerging. The *pervasive* quality may, however, be that of some "traditional" or already available art form or style. Nevertheless the total sought may maintain its uniqueness as a total quality. (The achieved total may appear as unique in the sense of being a distinctive forming according to a pervasive quality already available historically, *e.g.,* impressionism, and thereby contribute to that pervasive control, or it may be unique as a total which itself becomes a pervasive or control quality for future orderings, *i.e.,* the appearance of a new style.)

4. *Qualitative prescription.* Given a pervasive quality, whether arriving early or late in the art production, future mediations follow according to patterns of qualitative relatedness. The artist "infers" quality from quality in the sense that future "qualitative steps" are anticipated or intended by virtue of presently instituted qualities.

5. *Experimental exploration.* With each brush stroke, push of the thumb, touch of the key, tap of the mallet, gouge of the burin, voice inflection, gesture, a "testing" operation is being performed. Such testing takes place as component qualities (now here or yesterday there) are thought in relation to total and/or pervasive quality also empirically there.

6. *Conclusion: the total quality.* The work is judged complete—the total achieved—the pervasive has adequately been the control. It is a tentative affair because future evaluations may yield a conclusion for future modifications. (Indeed, some artists have maintained that they have never really "finished" a canvas.)

In this attempt to establish methodological generalizations about artistic processes, I have argued for a discrimination between two kinds of problem solving—the scientific and the qualitative, each with its distinctive controls. These distinctions together with the analysis of qualitative procedures extend Dewey's conception of method and flow from the general theory of intelligence being explored by Villemain and Champlin.

To summarize the methodological conception of the artistic process

advanced here, it may be said that qualitative problem solving is a mediation in which qualitative relations as means are ordered to desired qualitative ends. Thus to choose qualitative ends is to achieve an artistic problem. Whenever qualitative problems are sought, pointed out to others, or solved, therein do we have artistic endeavor—art and art education.

Notes

1. This generalization is not entirely true, however, since from the nineteenth century on artists in their writings reveal an increasing concern with the ends served by art, often expressing quite diverse opinions. *See Artists on Art From the XIV to the XX Century,* ed. Robert Goldwater and Marco Treves (New York, 1947), and *The Creative Process,* ed. Brewster Ghiselin (New York, 1955).
2. *Ibid.,* p. 62.
3. *How We Think* (Boston, New York, Chicago, 1910), p. 72.
4. *Art As Experience* (New York, 1934), p. 16.
5. *Experience and Nature* (Chicago, London, 1926), p. 358.
6. *Ibid.,* p. 379.
7. *Art As Experience,* p. 144.
8. *Ibid.,* p. 73.
9. *Ibid.,* p. 15.
10. *Ibid.,* p. 46.
11. This section is, of course, a highly schematic presentation of some features of their theory. For a more comprehensive view, see F. T. Villemain, "The Qualitative Character of Intelligence," and N. L. Champlin, "Controls in Qualitative Thought," both unpubl. diss. (Columbia, 1952). Also see their article, "Frontiers for an Experimentalist Philosophy of Education," *The Antioch Review, XIX* (1959), 345–359. Of further interest is "John Dewey Centennial: A Special Section," co-ed. Villemain and Champlin, *Saturday Review,* November 21, 1959, pp. 16–26.

Monroe C. Beardsley

On the Creation of Art

Many students of art have assumed, or expected to find, that there is such a thing as *the* process of art creation—that is, a pattern universally or characteristically discoverable whenever substantial works of art are produced. They would allow, of course, for many differences between one creative process and another, depending on the artist's habits and temperament, the medium in which he moves, and the demands of the particular work in progress. But they argue that beneath these differences there is what we might call the *normal creative pattern,* and that to understand this pattern would contribute much to our understanding of the finished product.

Nor is it unreasonable to suppose that there is such a creative pattern to be isolated and described. First, it might be said, the common character of works of art in all media—whatever it is that enables us to class them together—presents a prima-facie case for a creative pattern. For things that are alike may well have been produced in a similar way. Second, there is the analogy with aesthetic experience. For if there is a pattern of appreciation common to the arts, then why should there not be a pattern of creation, which would, in a sense, be its inverse? Third, there is the analogy with other kinds of creative activity. Dewey's classic description of the process of inquiry, or problem-solving, remains the standard one, though it has been refined and extended since its first appearance in *How We Think.* Practical and scientific problems differ considerably among themselves, just as works of art do, and if there is a common pattern of thought provoked by the former, there may be a common pattern of activity required for the latter.

It is true that the thory of a common character of the arts and the theory of a special aesthetic experience have been questioned in recent years.[1] I appreciate the force of the objections, which I won't go into here, but, like many others, I am not ready to abandon either of the theories. In any case, of course, the three arguments I have mentioned above are not conclusive; they are but suggestive analogies. If there is a common creative pattern, then it can be discovered only by direct study of creative processes. . . .

It is no doubt high time to face up to the question . . . what difference does it make to our relationship with the arts that we understand the creative process in one way or another? And here my answer is brief and

From *Journal of Aesthetics and Art Criticism,* 23 (1965), pp. 291–292, 301–303. Reprinted by permission.

unequivocal. It makes no difference at all. I think it is interesting in itself to know, if we can, how the artist's mind works, but I do not see that this has any bearing upon the value of what he produces. For that value is independent of the manner of production, even of whether the work was produced by an animal or by a computer or by a volcano or by a falling slop-bucket.[2]

This statement would be vigorously repudiated by some who have studied the creative process: they claim that their studies throw light on the "meaning" and "beauty" of poems, to use the words of Donald Stauffer, writing on "Genesis, or the Poet as Maker." If we knew, says Stauffer, the genesis of a poem by Housman, it would "enable us to interpret this particular work with more precision." But his method puts the enterprise in none too favorable a light, it seems to me. Digging through the early stages of the composition of Marianne Moore's poem, "The Four Songs," he finds a typescript in which the poem is entitled "Poet to Lover (Admitting Limitations)." Moreover, he turns up other titles that the poet considered and rejected: "Poet to Plain-Reader," "Poet to Ordinary Man," and, oddly, "Asphodel." (This poem has as many titles as the White Knight's song "A-sitting on a Gate.") All these titles, says Mr. Stauffer, "should prove of value in interpreting the complete poem," [4] and he proceeds to put them to use. But think of the implications. The poet discards the titles, and the genetic interpreter plucks them out of the wastebasket and uses them as though they had not been discarded. This is a pretty high-handed way to treat Marianne Moore. The logic of the situation is clear. Either the title of a poem makes a difference to the way it is read, or it does not. If not, then knowing the discarded titles has no effect on our interpretation. If so, then each title makes a slightly different poem, and Mr. Stauffer is simply refusing to read the poem that Miss Moore wanted us to read. Granted that her choice does not have to be final; some of the titles she threw away could conceivably be better than the one she kept. (After all, remember the time she was commissioned to suggest names for a brand-new car that the Ford Motor Company was planning to bring out. She came up with some lovely ones, but in the end they called it the Edsel.) But if you do not accept her title, then at least do not pretend that you are interpreting her final poem.

The informed observer will, of course, detect in these genetic maneuvers a particularly persuasive form of that vulgar error which William Wimsatt, Jr. and I stigmatized some years ago as the Intentional Fallacy. I do not know whether it is in good taste for me to rake over these old coals, but whenever a fallacy gets to be so old-fashioned and so familiar as this one, it is always heartening to find new instances of it, so that you know you are not beating a dead horse—even if he is not exactly the picture of health. What we attacked under a single name (intentionalism) were in fact two closely related forms of unsound argument: that which attributes a certain meaning to a work on the ground that the artist intended the work to have that meaning, and that which appraises the work at a certain value on the ground that it does or does not fulfill

the artist's intention. If we took to interpreting poems in terms of what they were like before they were finished, we would be turning the whole creative process upside down, by refusing to consider the final product on its own terms. Let this method become popular, and you can expect poets, painters, and musicians to keep their wastebaskets emptied, by burning their early sketches just as soon as possible.

Is this our final conclusion, then—that questions about creativity are irrelevant to questions about actual works of art? Somehow it does not seem enough. From the beginning of thought about art, though in many different forms, the creativity of art has been noted and pondered. Associationists, intuitionists, romantics, and idealists have offered explanations. In the making of such works, something very special seems to be happening; something fresh is added to the world; something like a miracle occurs. All this is true. There is such a thing as creativity in art, and it is a very important thing. What I want to say is that the true locus of creativity is not the genetic process prior to the work but the work itself as it lives in the experience of the beholder. Let me explain—all too briefly and puzzlingly, no doubt—what I mean.

To begin with, what is a melody? It is, as we all know, a gestalt, something distinct from the notes that make it up, yet dependent upon them for its existence. And it has its own quality, which cannot be a quality of any particular note or little set of notes. Recall that melody from Beethoven's E flat Quartet—grave, serene, soaring, affirmative, yet in a way resigned. Now when we hear a melody, however simple, we hear two levels of things at once: the individual notes and the regionally qualified melody that emerges from them. We hear the melody being born out of the elements that sustain it; or we hear the elements, the tones and intervals, coming together in an order that calls into existence an entity distinct from them, and superior to them. In the experience of a melody, creation occurs before our very ears. And the more intense the created qualities, the more complex the sets of cooperating elements, the tighter their mutual relations, the more fully we can participate in that basic aesthetic experience.

I need not argue in detail that the same holds for works of fine art. The essential feature of such a work—I am tempted to say, but recognizing that I am likely to sound dogmatic—the essential feature is not merely that certain visual elements (lines, shapes, colors) are assembled together, but that as we concentrate on their natures and relations, we become aware, suddenly or gradually, of what they add up to as a whole. For what they add up to is not an addition at all, but the projection of a new pattern, a new quality of grace or power.

When we consider a poem in this perspective, we see again that the important creativity is in the operation of the work itself. The sound-qualities, such as meter and rhyme-patterns, are one sort of emergent; more importantly, the interactions and interinanimations of words, in figurative or unusual language, create hitherto unmeant meanings; and more importantly, the objects and events of the poem mysteriously are made to accumulate symbolic reverberations, by which they seem to

have a significance far beyond themselves. And this takes place in the act of reading; the excitement of seeing it happen is precisely the peculiar excitement of reading poetry.

The British literary critic, L. C. Knights, has made some comments that seem to me very similar to what I want to say, in a special issue of *The Times Literary Supplement,* on "The Critical Moment." [5] His example is from Wordsworth's famous sonnet,

> Dull would he be of soul, who could pass by
> A sight so touching in its majesty.

That is a strange combination of ideas—"touching" and "majesty." Knights says this:

> The peculiar pleasure of that last line—though the pleasure is independent of conscious recognition of the source—comes from the movement of mind by which we bring together in one apprehension 'touching' and 'majesty': feelings and attitudes springing from our experience of what is young and vulnerable, that we should like to protect, fuse with our sense of things towards which we feel awe, in respect of which it is we who are young, inexperienced or powerless.

The "movement of mind" of which he speaks, in bringing these two opposed feelings into a fusion, through the words of the poem, is an act of creation, for out of that fusion comes a new, complex, vital feeling that has elements of both and yet is reducible to neither. So, says Knights, the creative use of words "energizes" the mind—"new powers of vision and apprehension come into being."

It may seem that this way of looking at artistic creativity demeans the artist by making not him, but the work itself, the creative thing. But I do not think so. I do not forget that man is the maker—of nearly all the great works we have, or are likely to have. But the finest qualities of a work of art cannot be imposed on it directly and by fiat; the artist can, after all, only manipulate the elements of the medium so that *they* will make the quality emerge. He can only create a solemn melody by finding a sequence of notes that will have that quality. The powers he works with are, in the end, not his own but those of nature. And the miracle he makes is a miracle that celebrates the creative potentialities inherent in nature itself. But when in this way the artist makes plain to us over and over the marvellous richness of nature's potentialities, he also presents us with a model of man's hope for control over nature, and over himself. Artistic creation is nothing more than the production of a self-creative object. It is in our intelligent use of what we are given to work with, both in the laws of the universe and in the psychological propensities of man, that we show our mastery, and our worthiness to inhabit the earth. In this broad sense, we are all elected, or perhaps condemned, to be artists. And what keeps us going in the roughest times is the reminder that not all the forms and qualities and meanings that are to emerge in the fullness of time have already appeared under the sun—that we do not know

the limits of what the universe can provide or of what can be accomplished with its materials.

Notes
1. The former by Paul Ziff and Morris Weitz, whose views I have discussed in "Art and the Definitions of the Arts," *JAAC, XX* (1961), 175–87; the latter by George Dickie, in "Is Psychology Relevant to Aesthetics?" *Philosophical Review,* LXXI (1962), 285–302, and more fully in "The Phantom Aesthetic Experience," forthcoming.
2. For a decisive argument along this line, see John Hospers, "The Concept of Artistic Expression," *Proceedings of the Aristotelian Society,* LV, (1955) 313–344.
3. In *Poets at Work,* p. 43
4. *Ibid.,* p. 63.
5. July 26, 1963, p. 569.

Richard Wollheim

*Since, 1963, Richard Wollheim has been Grote Professor of
Philosophy of Mind and Logic in the University of London. He is the
author of* Socialism and Culture *(1961),* On Drawing An Object
(1965), and Art and Its Objects *(1968).*

*Ernst Gombrich, Vienna-born art historian, has been Professor of
History of the Classical Tradition at the University of London since
1959. Among his books are* Art and Illusion *(1960),* Norm and Form
(1966) and In Search of Cultural History *(1969).*

The Artist's Repertoire

I am now ready to turn to expressive properties. In sections 15–19 I argued that there is no absurdity in attributing expressiveness as such

to physical objects. The question I want to consider here is whether we can attribute specific expressive properties to physical objects solely on the basis of what is given. Of recent years a powerful and subtle argument has been brought forward to show that we cannot. This argument I shall call the Gombrich argument: though the actual argumentation I shall produce will be a reconstructed, and here and there a simplified, version of what is to be found in *Art and Illusion* and in the collection of essays entitled *Meditations on a Hobby-Horse*.

The starting point of this argument is an attack on an alternative account of expression in terms of "natural resonance." According to this account, certain elements, which can occur outside as well as inside art e.g. colours, notes, have an intrinsic link with inner states, which they are thereby able both to express and to invoke: it is through the incorporation of these elements that works of art gain or have assigned to them this or that emotive significance. Such an account, Gombrich argues, is vulnerable because it overlooks the fact, to which a lot of art testifies, that one and the same element or complex of elements can have a quite different significance in different contexts. "What strikes us as a dissonance in Haydn," Gombrich writes "might pass unnoticed in a post-Wagnerian context and even the *fortissimo* of a string quartet may have fewer decibels than the *pianissimo* of a large symphony orchestra." Again, Gombrich cites Mondrian's *Broadway Boogie-Woogie* which, he says, in the context of Mondrian's art is certainly expressive of "gay abandon": but would have quite a different emotional impact on us if we learned that it was by a painter with a propensity to involuted or animated forms e.g. Severini.

What these examples show, Gombrich argues, is that a particular element has a significance for us only if it is regarded as a selection out of a specifiable set of alternatives. Blue as such has no significance: blue-rather-than black has: and so has blue-rather-than-red, though a different one. In the light of this, the notion of "context" can be made more specific. In order for us to see a work as expressive, we must know the set of alternatives within which the artist is working, or what we might call his "repertoire": for it is only by knowing from what point in the repertoire the work emerges that we can ascribe to it a particular significance. It is this fact that is totally ignored in the theory of natural resonance.

The scope of this argument might be misconstrued. For it might be taken simply as an observation about how a spectator can acquire a certain skill i.e. that of expressively understanding a painting; so that if he doesn't acquire this skill, the artist goes misunderstood. But this is to take too narrow a view of Gombrich's thesis: for what in effect he is doing is to lay down the conditions for expression itself. An artist expresses himself if, and only if, his placing one element rather than another on the canvas is a selection out of a set of alternatives: and this is possible only if he has a repertoire within which he operates. Knowledge of the repertoire is a presupposition of the spectator's capacity to understand what the artist is expressing: but the existence of the repertoire

is a presupposition of the artist's capacity to express himself at all.

We may now ask: Granted that the spectator cannot understand the expressive significance of a work of art until he has knowledge of the artist's repertoire, why is it that, as soon as he does have knowledge of the artist's repertoire, he is able to come to an expressive understanding? To go back to the simplest example: If we need further knowledge before we can understand a particular placing of blue on the canvas, e.g. knowledge that it is a case of blue-rather-than-black, alternatively of blue-rather-than-red? And the answer is that, though it is a matter of decision or convention what is the specific range of elements that the artist appropriates as his repertoire and out of which on any given occasion he makes his selection, underlying this there is a basis in nature to the communication of emotion. For the elements that the artist appropriates are a subset of an ordered series of elements, such that to one end of the series we can assign one expressive value and to the other a contrary or "opposite" value: and the crucial point is that both the ordering relation that determines the series e.g. "darker than" in the case of colours, "higher than" in the case of musical notes (to give naïve examples), and the correlation of the two ends of the series with specific inner states, are natural rather than conventional matters. It is because a move towards one end of the series rather than the other is, or is likely to be, unambiguous that, once we know what alternatives were open to the artist, we can immediately understand the significance of his choice between them.

There is the question, which belongs presumably to psychology or so-called experimental aesthetics, whether in point of fact it is correct to regard the elements that comprise the constituents of art as falling into ordered series in respect of their expressive value. The question, however, which belongs to the philosophy of art is why someone with a theory of expression should have a special interest in maintaining that this is so.

If it is correct, as I have argued in section 18, that our disposition to consider inanimate objects as expressive has its roots in certain natural tendencies, i.e. that of producing objects to alleviate, and that of finding objects to match, our inner states, it is nevertheless evident that by the time we come to our attitude towards the objects of art, we have moved far beyond the level of mere spontaneity. To put it at its lowest: what is in origin natural is now reinforced by convention. Evidence for this exists in the fact that if someone is versed or experienced in art, no upper limit can be set to his capacity to understand expressively fresh works of art, even if both the works themselves and what they express fall outside his experience. For what we might have expected is that his capacity to understand works of art would stop short at those correlations of objects and inner states with which he has a direct acquaintance. In point of fact the situation that obtains is close to that in language where,

as it has been put (Chomsky), it is a central fact, to which any satisfactory linguistic theory must be adequate, that "a mature speaker can produce a new sentence of his language on the appropriate occasion, and other speakers can understand it immediately, though it is equally new to them." The implication would seem to be that there is, at least, a semantic aspect or component to the expressive function of art.

Nevertheless, there seems to be a difference. For even if a "mature spectator of art" is in principle capable of an expressive understanding of any new work of art, just as the mature speaker can understand any new sentence in his language, still the understanding in the two cases would differ. For we see or experience the emotion in the work of art, we do not "read it off." In other words, if we press the parallel of expressive with semantic properties, we shall find ourselves thinking that art stands to what it expresses rather in the way that a black-and-white diagram with the names of the colour written in stands to a coloured picture: whereas the relation is more like that of a coloured reproduction to a coloured picture.

A technical way of making this point is to say that the symbols of art are always (to use a phrase that originates with Peirce) "iconic."

That works of art have this kind of translucence is a plausible tenet, and it should be apparent how a belief in a natural expressive ordering of the constituents of art would go some way to preserving it. It would not, that is, preserve it in the strong sense, i.e. that from a simple observation of the work of art we could invariably know what it expressed: but it would preserve it in a weak sense, i.e. that once we knew what the work of art expressed, we could see that it did so. Since Gombrich has already maintained that some collateral information is essential for expressive understanding, he obviously does not require works of art to be iconic in the strong sense. Moreover, there is a general argument against maintaining that they are: namely, that the element of inventiveness that we believe to be intrinsic to art would be in jeopardy. A work of art would threaten to be little more than an assemblage or compilation of preexistent items.

Let us now return to the Gombrich argument itself. The argument is obviously very powerful; nevertheless, there are certain significant difficulties to it, which largely concern the idea of the repertoire and how the repertoire is determined for any given artist.

As a starting point it might be suggested that we should identify the repertoire with the range of the artist's actual works. But this is unacceptable: because, except in one limiting case, it gives us the wrong answer, and, even when it gives us the right answer, it does so for the wrong reason.

The limiting case is where the artist in the course of his work expresses the full range of inner states conceivable for him: where, to put

it another way, there is nothing that he could have expressed that he didn't. In all other cases there will be parts of the repertoire that were not employed, i.e. the parts that he would have employed if he had expressed those states which he didn't, and the question then arises how we are to reconstruct these parts. And the answer must ultimately come to this: that we ask ourselves how the artist would have expressed those states which he never expressed. In other words, we credit him with certain hypothetical works. But on the Gombrich argument this becomes impossible. For it is obvious that, before we can even set about doing this, we must first know what states the artist did express, i.e. in his actual works; but this, Gombrich argues, we cannot do until we know the repertoire as a whole. So we can never start.

To put the matter another way: Confronted with the *oeuvre* of a given artist, how are we to decide, on the Gombrich argument, whether this is the work of an artist who within a narrow repertoire expressed a wide range of inner states, or of one who within a much broader repertoire expressed a narrow range of states? Internal evidence is indifferent as to the two hypotheses: and it is unclear what external evidence the argument allows us to invoke.

I have said that, even in the limiting case where the identification of repertoire with the range of actual works gives us the right answer, it does so for the wrong reason. What I had in mind is this: that it isn't the fact that such and such a range of works is everything that the artist in fact produced that makes this range his repertoire. For otherwise the identification of repertoire with actual range would be correct in all cases. It is rather that the range as we have it coincides with everything he could have produced. But how (and here the question comes up again) do we establish what he could, and what he could not, have produced?

One suggestion is that we should, at this stage, go back to the artist's situation. In other words, we do wrong to try to determine the repertoire by reference to how the spectator would determine it. For what the spectator does is at best to reconstruct what the artist has initially done.

But do we have greater success in arriving at the repertoire by considering it from the artist's point of view? There is once again a limiting case. And this is where the artist *explicitly* sets up a range of alternatives within which he works: or where the constraints of nature or society prescribe precisely what he may do. Such cases will be very rare. Otherwise, we simply have the artist at work. And if it is now asserted that we can observe the artist implicitly choosing between alternatives, the question arises, How can we distinguish between the trivial case, where the artist does one thing, e.g. A, and not another, e.g. B (where this just follows from A and B being distinct), and the case that is of interest to us, where the artist does A in preference to B? One suggestion might be that we are entitled to say the latter where it is clear that, if the artist had done B, it would have expressed something different for him. But on the Gombrich argument this is something we can say only after we

have determined the repertoire: hence we cannot use it in order to determine the repertoire.

The preceding objection may seem very abstract: which indeed it is. But this only a reflection of the extremely abstract character of the argument itself, from which indeed it gains a great deal of its plausibility. For what it leaves out of account, or introduces only in an unrecognizable form, is the phenomenon of style and the corresponding problem of style formation.

For the notion of style cannot be unreservedly equated with that of the repertoire. For what we think of as a style has a kind of inner coherence that a mere repertoire lacks. This is well brought out in a supposition that, as we have seen, Gombrich asks us to consider in the course of expounding his argument. Let us suppose, he writes, that Mondrian's *Broadway Boogie-Woggie* had been painted by Severini. . . . But if this appeal is not to be taken in such a way that the names "Mondrian" and "Severini" function as mere dummies or variables, it is hard to know how to interpret it. For the only way in which the hypothetical situation would be conceivable, would be if we imagined that for a phase Severini adopted the style of Mondrian as a *pasticheur.* Now such an eventuality would occasion an increase in the range of Severini's repertoire but without any corresponding increase in the range of his style. The same phenomenon occurs less schematically in the case of an artist in whose work we notice a sharp break of style (e.g. Guercino). These cases show us that what we should really be interested in is style, not repertoire.

There are two further differences between a style and a repertoire, both of which are relevant to the issue of expressive understanding. The first is that a style may have been formed in order to express a limited range of emotions, and in such cases it is virtually impossible for us to imagine the expression of a state which falls outside this range being accomplished within the style. The supposition of an optimistic painting by Watteau, or a monumental sculpture by Luca della Robbia, or a tortured or tempestuous group by Clodion, all verge upon absurdity. Secondly—and this is a closely connected point—a style may have such an intimate connection or correspondence with the states that are typically expressed within it, that we do not have to go outside the work itself and examine related cases in order to gauge its expressive significance. A style could be self-explanatory.

Wölfflin, in the introduction to the *Principles of Art History,* sets out to characterize what he calls "the double root of style." What in point of fact he does is to separate out two levels on which style can occur: perhaps even two senses of the word "style." On the one hand, there are the many particular styles, the styles of individuals or nations, which vary according to temperament or character and are primarily expressive. On

the other hand, there is style in some more general sense, in which a style approximates to a language. In the first sense, Terborch and Bernini (the examples are Wölfflin's) have their own very differing styles, being very different kinds of artist; in the second sense, they share a style. Each style in the first sense corresponds to, or reflects, a preselection of what is to be expressed or communicated. By contrast a style in the second sense is a medium within which "everything can be said." (We may for our purpose disregard Wölfflin's insistence that a style in this latter sense, of which for him the supreme, perhaps the sole, instances are the linear and the painterly, exhibits a distinctive "mode of vision" or incorporates specific "categories of beholding": phrases which the *Principles* does little to illuminate.) Now, the point I have been making about the Gombrich argument might be put by saying that it recognizes style only in the second of Wölfflin's senses, in which it is something akin to language. Where Gombrich, of course, differs from Wölfflin is in the variety of such styles that he thinks to exist: there being for him roughly as many styles in this sense as there are for Wölfflin styles in his first sense.

Another way of making the same point would be to say that for Gombrich a style is roughly equivalent to a method of projection in cartography. We can make a map of any region of the world according to any projection: although some methods of projection may be more suitable for one region than another. The difference simply is that the region, alternatively the map, will look quite different, depending on which projection is actually employed.

PART FIVE

Is There a Logic
of Aesthetic Analysis?

CHAPTER 1

Introduction

Before we ask how works of art are to be evaluated, it is perhaps well to raise the question of whether or not they need to be or should be evaluated. In other words, of what value is evaluation? We seem poised on the threshhold of an infinite regress, and it is not surprising that sceptics, relativists, positivists and others have joined forces to cast doubt upon both the possibility of and the necessity for the evaluation of works of art. One possible rejoinder, however, has been that suggested by Nelson Goodman: that our assessment of aesthetic merit is itself a means to an end. According to Goodman, we do not seek to improve our perception of works of art because they have been classified as "good," but rather, we classify them as "good" so that we may better perceive them. There is nothing final about aesthetic evaluation; it is simply an instrument for the heightening of aesthetic experience.

In certain respects, an eagerness to portray the population of works of art as made up of "good works of art versus bad works of art" is rather akin to the infantile moralism that reduces the human population to a contrast between "good guys" and "bad guys." One who deplores the note of moralism will therefore be likely to suggest that we employ instead such terms as "better" versus "worse," or "stronger" versus "weaker," and no doubt such a substitution has much to commend it.

But still there will be those who seek some sort of touchstone by means of which they can distinguish the "better" from the "worse." Some years ago, for example, Monroe Beardsley threw out the suggestion that

perhaps "good" art is art that has lived up to the critic's reasonable expectations, while "bad" art has fallen short of such expectations. (Since Beardsley has so often stressed the irrelevancy of intentions, he might have been expected to be somewhat wary when it came to a question of expectations.) Now the very notion of "critic" implies a person who is prepared to offer reasons for his standards and for his expectations. It is doubtful that we would call a person a "critic" who refused to supply us with such reasons. Unfortunately, the premises which one critic uses as his reasons, and from which he deduces his standards, are seldom those used by another critic. One critic will offer plausible enough reasons to justify his high expectations, and another will offer plausible enough reasons to justify his low expectations. The critic with high expectations will then judge much art to be "bad," while the critic with low expectations will judge much art to be "good." The Beardsley formula seems to leave us in the dark, unless the expectations referred to are not the expectations that we bring to the work (which are often shallow and uncreative), but expectations aroused in us by the work itself. After all, we have no right to judge a work according to the vagaries of our anticipations of it. We should not demand that a work conform to our expectations; we should demand that our expectations conform to the possibilities projected by the work itself, and inherent in it.

In the above-mentioned remark by Goodman that the finding of merit in works of art should be seen as a means to enhancing the perception of art, there is implicit the notion that such perception is a terminal or consummatory value, and indeed many aestheticians have argued that aesthetic experience is "intrinsically" rather than "instrumentally" valuable. But this contention has been rejected by Dewey and, more succinctly, by Beardsley, who maintains that the value of aesthetic experiences is itself instrumental in character, for there are no intrinsic values whatsoever. But Beardsley does not indicate whether he believes that the three major criteria (unity, intensity and complexity) which he proposes to apply to works of art should be applied also to aesthetic experience; and, indeed, in view of the strictures placed elsewhere in this volume, by Schapiro on unity and by Ehrenzweig on intensity of perception, one can see the limitations of such criteria.

Sibley, as usual, presents a scrupulous and meticulous analysis, in this instance of the relationship between judgments of non-aesthetic qualities and judgments of aesthetic qualities. But Sibley is hesitant concerning the possibility of arriving at the sort of generalizations in aesthetics which might serve as a foundation for reliable aesthetic verdicts or evaluations.

It is frequently assumed that evaluations must be in the form of merely comparative gradings among works of art, or the comparison of such works with independent and external standards. These assump-

tions are questioned by Yoos, who suggests that it is possible to isolate the "primary aspect" of each particular work of art and to use that as the standard against which the contributions of the secondary aspects of the work are to be measured. Yoos believes he has thus side-stepped the troublesome temptation to take into account the artist's apparent intention in the process of aesthetic appraisal.

The methodology of aesthetic judgment is given careful considera-tion by C. I. Lewis. Holding that an appreciative experience is a prizing rather than an appraising, he notes that such prizings may be considered as part of the evidence upon which an appraisal of the object's value may ultimately be made. The consequent evaluation, he contends, is objective and cognitive, and the value thus discriminated is a potentiality resident in the object and not gratuitously attributed to it.

Hofstadter, however, argues that normative judgments in art cannot be formulated without specifying the reference public to whom the work of art is presented for appreciation. Acknowledging the difficulties of postulating an ideal public, Hofstadter nevertheless asserts that, with each aesthetic judgment, we make a claim to membership in such a public.

In a closely reasoned analysis, Redpath raises the question of whether a value judgment can be logically inferred from the reasons offered in support of it. Redpath argues that, if it be granted that proba-bility is a logical relation, then the relationship between reasons and evaluation is indeed a logical one. He concedes, however, that the rela-tionship does not appear to be of a type in which the evaluation could be *necessarily* deduced from the reasons.

It can hardly be said that the writers considered in this section give a heartily affirmative response to the question of whether there is a logic of aesthetic analysis. Yet it must be acknowledged that they have begun a careful delineation of those aspects of aesthetic appraisal which prom-ise to be susceptible to logical investigation, while candidly noting other aspects which must be considered unpromising for the foreseeable fu-ture. At the present state of aesthetics, such demarcations represent a useful and welcome advance.

CHAPTER 2

Critical Judgment of Aesthetic Values

Frank Sibley

Aesthetic and Non-Aesthetic[1]

Many judgments about the shape, color, sound, wording, subject matter, or composition of things, including works of art, are such that it would be ludicrous to suggest that aesthetic sensitivity, perceptiveness, or taste had been exhibited in making them. Similarly, it would be ridiculous to suggest that aesthetic sensitivity was required to *see* or *notice* or otherwise *perceive* that something is, say, large, circular, green, slow, or monosyllabic. Accordingly, I speak of nonaesthetic judgments, qualities, descriptions, and concepts. By contrast, there are other judgments the making of which could clearly be said to exhibit an exercise of aesthetic sensitivity or perceptiveness. Similarly, it would be natural

From *Philosophical Review,* Vol. 74 (1965), pp. 135–59. Reprinted by permission.

to say that aesthetic sensitivity was required to see, notice, or otherwise perceive, for instance, that something is graceful, dainty, or garish, or that a work of art is balanced, moving, or powerful. Accordingly, I speak of aesthetic judgments, qualities, descriptions, and concepts.[2]

I make this broad distinction by means of *examples* of judgments, qualities, and expressions. There is, it seems to me, no need to defend the distinction. Once examples have been given to illustrate it, I believe almost anyone could continue to place further examples—barring of course the expected debatable, ambiguous, or borderline cases—in one category or the other. To deny such a distinction is to be precluded from discussing most questions of aesthetics at all, just as one could hardly begin ethics without the prior recognition that some judgments and notions do, while others do not, concern morality. One must be able to recognize examples of one's subject matter. Those who in their theoretical moments deny any such distinction usually show in their practice that they can make it quite adequately.

Some aesthetic judgments employ a characteristically aesthetic term ("graceful," "balanced," "gaudy") while others do not ("it's not pale enough," "there are too many characters"); I am concerned with both sorts. About a third and much-discussed class of judgments, however, I have nothing to say in this paper. These are the purely evaluative judgments: whether things are aesthically good or bad, excellent or mediocre, superior to others or inferior, and so on. Such judgments I shall call *verdicts*. Nor shall I raise any other questions about evaluation: about how verdicts are made or supported, or whether the judgments I am dealing with carry evaluative implications.

These judgments that I mean to discuss are the most common and perhaps the most important of aesthetic judgments. Making, supporting, and explaining them occupies much of the critic's time. We make them constantly, moreover, in realms where verdicts of good and bad, better and worse are rarely made at all—about scenery and sunsets, animals, faces, and people. Since aesthetics is largely occupied about the nature of aesthetic judgments, these (constituting as they do a central part of aesthetic discourse), together with the ways they may be supported, deserve examination. Yet it has more often been verdicts and their justification that have attracted attention, these other judgments being treated only in passing. Consequently, the many questions about them that do not parallel questions about verdicts have seldom been adequately raised. We need therefore to investigate how we make such judgments and how we justify and explain them; we need also to examine further the aesthetic qualities and concepts I began by illustrating. To do this, various relationships must be disentangled; for although it is obvious that there are close connections between the aesthetic and nonaesthetic properties of things, and relationships between some aesthetic and nonaesthetic judgments, these connections and relationships have even so not received due attention.

I. AESTHETIC PERCEPTION

In order to avoid various confusions I shall at once separate questions about relationships between aesthetic and nonaesthetic properties, concepts, and judgments from questions about aesthetic perception and judgment itself.

It is of importance to note first that, broadly speaking, aesthetics deals with a kind of perception. People have to *see* the grace or unity of a work, *hear* the plaintiveness or frenzy in the music, *notice* the gaudiness of a color scheme, *feel* the power of a novel, its mood, or its uncertainty of tone. They may be struck by these qualities at once, or they may come to perceive them only after repeated viewings, hearings, or readings, and with the help of critics. But unless they do perceive them for themselves, aesthetic enjoyment, appreciation, and judgment are beyond them. Merely to learn from others, on good authority, that the music is serene, the play moving, or the picture unbalanced is of little aesthetic value; the crucial thing is to see, hear, or feel. To suppose indeed that one can make aesthetic judgments without aesthetic perception, say, by following rules of some kind, is to misunderstand aesthetic judgment.

This therefore is how I shall use "aesthetic judgment" throughout. Where there is no question of aesthetic perception, I shall use some other expression like "attribution of aesthetic quality" or "aesthetic statement." Thus, rather as a color-blind man may infer that something is green without seeing that it is, and rather as a man, without seeing a joke himself, may say that something is funny because others laugh, so someone may attribute balance or gaudiness to a painting, or say that it is too pale, without himself having judged it so.

II. SOME RELATIONSHIPS OF DEPENDENCE

I turn now to statements of the relationships between aesthetic and nonaesthetic properties. These are of several sorts. The first two that follow are purely general, that is, they state relationships between *types* of qualities; I do no more than mention them. Thereafter I discuss statements of those relationships that interest me more particularly, namely, those holding between *specific* qualities. In (iii) and (iv) below I consider two sorts of relationships which may hold between specific qualities in *individual instances.* Later (Secs. VII and VII) I shall consider various sorts of *general* relationships which hold between specific qualities.

(i) Aesthetic qualities are dependent upon nonaesthetic ones for their existence. They could no more occur in isolation than there could be facial resemblances without features, or grins without faces; the converse is not true.

(ii) The nonaesthetic qualities of a thing determine its aesthetic

qualities. Any aesthetic character a thing has depends upon the character of the nonaesthetic qualities it has or appears to have, and changes in its aesthetic character result from changes in its nonaesthetic qualities. Aesthetic qualities are "emergent." Like (i) above, which it entails, (ii) concerns the nature of aesthetic properties in general.

(iii) In addition to being able to state the general truth that aesthetic qualities depend on and result from nonaesthetic characteristics, we can state particular truths about individual objects—for example, that these particular nonaesthetic qualities of this object (described as fully as one wishes) give it *some* aesthetic property rather than none, and that what they give it is, say, *grace* or *balance.* There are, however, two different relationships here that must be distinguished.

First, the particular aesthetic character of something may be said to result from the *totality* of its relevant nonaesthetic characteristics. It is always conceivable that, by some relatively small change in line or color in a picture, a note in music, or a word in a poem, the aesthetic character may be lost or quite transformed (though possible also that by some considerable changes it may not be significantly altered). A somewhat different totality might result in an aesthetic difference. Features one would hardly think of singling out as notably contributing to its aesthetic character—say, background colors, hardly noticed brush strokes, and so on—nevertheless do contribute because, being as they are, they at least allow it to have the character it has, a character it conceivably might not have if they were altered. One might say that it is here, that line there, and so on indefinitely—that it is graceful or moving or unbalanced. (Doubtless this possibility is one thing that leads people to speak of the uniqueness of works of art.) This third relationship might therefore appropriately be called the relation of *total specific dependence.*

(iv) The other relationship, the fourth, remains to be considered. A critic frequently tries, as one of his central occupations, to say why a picture is unbalanced, or what gives a complex work its grace, unity, or serenity. In doing so, he is not setting out to assert the merely general truth that its nonaesthetic features make it so; but neither is he ordinarily trying to state the kind of relationship just mentioned, that it is *all* these lines together with *all* those colors (describing the totality of features of the work as fully as he can) that make it so. He is usually interested in much more pointed explanations: he tries to select certain peculiarly important or salient features or details. He may mention a concentration of blues and greys as responsible for the unity of tone, certain wavy lines as giving a restless quality, a change in key as giving a somber or indecisive character; more broadly, he may point out that the aesthetic character results from organization rather than from coloring, from changes of tempo rather than harmonic devices. In short, what the critic is doing is selecting from a work those features which are *notably or especially* responsible for its character. For often in a work there are some features that strike us as making the most outstanding contribution, usually those in which a small alteration would work a

remarkable aesthetic change. This fourth relationship might therefore be called that of *notable specific dependence;* statements of such relationships bulk large in criticism.

Often, then, one can say without any conflict both that *all* the features of a thing are jointly responsible for its aesthetic character and that *one particular* feature is responsible. Usually in criticism it is remarks of the latter kind that interest us; even so, it must not be thought that remarks of the other kind are always trivial or pointless. When we have singled out certain features in a work that strike us as notably responsible, it may sometimes still be worthwhile for someone else to point out in turn that these particularly noticeable features achieve their effect only because other elements in the complex, elements that do not force themselves on our attention, are exactly as they are. Such comments may be especially worth making at times, since some works, unlike others, are so constructed that the slightest change, even in seemingly unimportant details, would altogether destroy their effect. A critic's comment that in this work is it is everything together, ordered just as it is, that is responsible for its character may bring home to us that here is a work of that sort. Everything that could possibly be relevant seems on examination so exactly calculated that it plays a vital part in the work.

I have entitled this section "Relationships of Dependence" to stress that aesthetic qualities, which, as I said above, are broadly speaking perceptual, are emergent or dependent. So too are many other qualities, Gestalt, physiognomic, and other. They thus contrast sharply with those perceptual qualities like red and green which do not depend for their character upon other perceptual qualities of things.

III. TWO CRITICAL ACTIVITIES

(i) The relationships that I have just described hold between qualities independently of a person's realizing in particular cases that they do. Whether or not one sees that a picture lacks balance, and lacks it notably because of the placing of a certain figure, in no way bears on the fact that the placing of the figure *is* what unbalances the picture. In describing the third and fourth relationships, however, we could not avoid mention of one of the central activities of critics: *explanation.* This consists largely in showing how aesthetic effects are achieved in a work by isolating and pointing out what is (notably, mainly, in part) responsible. Even when we have remarked the grace, unity, or ungainliness of something, we may yet be unable to say why it has these qualities. But a good critic should be able to point out what makes it so. Such explanations satisfy an interest and curiosity we often have about the aesthetic qualities of things (especially when the artist has achieved new effects or achieved something in an unusual way). But they may do more than this. When we see in detail how and why the work has its character, we may find our initial judgment strengthened and trust it more confidently.

Moreover, as we come to realize how boldly or subtly, with what skill, economy, and exactness, the effect is achieved, how each detail is judged to a nicety and all work together with a fine precision, our appreciation is deepened and enriched and becomes more intelligent in being articulate.

Explanations of this sort frequently consist, as I said in discussing relationships (iii) and (iv), in mention of *nonaesthetic* features of things (colors, lines, composition). Frequently also, of course, they consist in reference to responsible *aesthetic* qualities ("The firmness and grace of line give the word both stability and elegance"). But in either case we have been led back from the discussion of independent relationships to activities involving aesthetic sensitivity and judgment. For it requires such sensitivity, both in the critic who gives and in those who follow his explanations, to see that these shapes and colors unbalance the picture, or that exactly this word order makes the poem moving, no less than to see initially that the works have these aesthetic qualities. So too, although aesthetic sensitivity is not involved in seeing that a figure is on the far left of a picture, it *is* involved in seeing that it is *too* far left for the composition to balance, or that it is *so* far to the left as to dissipate dramatic intensity. Explaining why a work has an aesthetic character, even where the reasons involve mentioning only nonaesthetic features, requires aesthetic discrimination.

(ii) The second activity I have in mind is less limited and more important than that of providing explanations for the aesthetic qualities one has already seen; it consists instead in helping people to see and judge for themselves that things have those qualities. Since, as I emphasized at the start, aesthetic perception is what is really vital, a major occupation of critics is the task of bringing people to see things for what, aesthetically, they are, as well as why they are. (This does not exclude other activities like *re*interpretation, bringing people to see new and different features.) Contemporary philosophers have rightly emphasized this activity. The critic is successful if his audience began by not seeing, and ends by seeing for itself, the aesthetic character of the object. Sometimes when a critic helps us to see aesthetic qualities, we have missed them by simply overlooking some important and responsible nonaesthetic features, or by not seeing these in relation, in a certain light, or in the light of the title; one cannot expect to see a dancer's grace without in some degree noticing the features that make her graceful. But sometimes, although these *were* seen, the resultant aesthetic quality was still missed. Somewhat analogously one might, even after scrutiny, miss an aspect of a puzzle picture, see a face and not notice its tired look, or see two faces and be unable to see their resemblance.

How a critic manages by what he says and does to bring people to see aesthetic qualities they have missed has frequently puzzled writers. But there is no real reason for mystification. One might puzzle equally over how *on my own* I come to perceive, after ten minutes in front of a picture or several replayings of a sonata, what I had not previously per-

ceived. What mainly is required is a detailed description of the sorts of things critics in fact do and say, for this is what succeeds if anything does. Prominent, of course, among these things is drawing attention to the features that are notably responsible for the effect the critic wants his audience to see ("Notice how the language used here echoes the previous stanza and sets a unity of tone"). But this is far from being the only thing that may bring success; the critic may make similes and comparisons, describe the work in appropriate metaphors, gesticulate aptly, and so on. Almost anything he may do, verbal or nonverbal, can on occasion prove successful. To go on to ask how these methods can possibly succeed is to begin to ask how people can ever be brought to see aesthetic (and Gestalt and other similar) properties at all. That they can is neither more nor less puzzling than that human beings can, by various means, be brought to do other things, such as distinguishing shades of color, seeing facial resemblances of jokes, and so on. We do these things; and what critics say and do are the sorts of things that help us to do the one under discussion.[3]

A second question about this activity is whether it is a way of *supporting* or *justifying* aesthetic judgments. Some aestheticians have held that this—showing the work, getting people to see—is the only way of supporting an aesthetic judgment, even perhaps the only point of critical activity. This is to overlook a great deal; but I see no reason why it should not be called *a* way of supporting or justifying, even of proving, an aesthetic judgment. If I say the apples are sour and someone doubts my claim, I may ask him to taste them. With more complex or subtle things I may have to help him in appropriate ways. If I say that a figure can be seen as either a staircase or a cornice, that a cloud looks like a giraffe, that two people look somewhat alike, or that the brandy is soft and velvety, and he questions what I say, it may not be enough merely to invite him to look or taste. I may need to draw attention to this and that, suggest he look at the figure thus or taste the brandy in a certain way. So too it may not do simply to play the music again or set the picture in a good light; I may give instructions, tell him to stand further off, to concentrate on certain features, to try to take in the whole at once; I may compare it with other works, describe it in metaphors, and so on indefinitely. If he then finds himself agreeing with me, I have vindicated my claim in the best possible way, by getting him to see for himself. There is no reason not to say, if one wishes, that I have supported, justified, or even proved my original judgment. One might refer to this activity therefore as *perceptual proof.* (There is no excuse for confusing this with the activity of explanation already discussed. Both may proceed, it is true, by drawing attention to features responsible for aesthetic effects. But they have different aims; and much that may be said and done—by simile, repetition, comparison, gestures, almost any means—to open someone's eyes to the aesthetic qualities of an object could not count as explaining why it has those qualities.)

Nevertheless, if we do choose to call this *support* of an aesthetic judgment, we must be clear what kind it is and what kind it is not. The

critic cannot be said to have *reasoned* in support of it. Where someone tries to bring another to agree with him by reasoning, or by offering rational support for a judgment, he offers statements which, if true, render it certain, likely, or reasonable to suppose, that this judgment was correct. The person to whom the reasons are offered may, after reviewing them, conclude or infer or decide that the judgment is indeed correct or justified. He has been offered reasons for *thinking* something, and so may end accepting the judgment originally offered. But it was neither the aim nor the outcome of the critic's activity I described to provide reasons from which his audience might reasonably conclude that his judgment was true. He might have achieved that even in the absence of the work by telling, say, how many reliable and distinguished critics had independently made the same judgment. His aim was to bring his audience to agree with him because they perceived for themselves what he perceived; and this is what, if successful, he achieved. But an activity the successful outcome of which is seeing or hearing cannot, I think, be called *reasoning*. I may have reasons for thinking something is graceful, but not reasons for seeing it is. Yet aesthetic perception, I have said, is essential to aesthetic judgment; one could not therefore be brought to make an aesthetic judgment simply as the outcome of considering reasons, however good. It is a confusion of disparate activities to suppose that in this sense one could have a "rational justification" for making an aesthetic judgment. Thus the aesthetic judgments I am concerned with can neither *have* nor *lack* a rational basis in this sense, namely, that they can either be or fail to be the outcome of good or bad reasoning. Perception is "supported" in the manner described or not at all.

IV. REASONS

Even if "perceptual proof" is not a matter of giving reasons, and even if the notion of an aesthetic judgment being the outcome solely of considering reasons in an impossible hybrid, the question must nevertheless be raised whether the aesthetic judgments I am discussing may be justified or supported by reasons in some other way. Many writers insist that some sort of rational support must be possible. "If criticism is a respectable enterprise at all," says one recent writer, and "if it is correct to say that the critic gives reasons for his judgments, then it must be possible for us to see the reasons *as* reasons. . . . An adequate account of criticism should provide a way of seeing that the remarks offered in support can count as support." [4]

Consider the following question. Suppose someone makes the aesthetic judgment that something is graceful. Regardless of whether he attempts to get *me* to see that it is, even indeed if I never see the object, is it possible for him, by presenting reasons, to support the *truth* of his claim and so, in this sense, to provide reasonable support for his judgment?

Now obviously, to meet as broad a request as this, he might offer all

kinds of supporting reasons—for example, "It's likely my judgment is right because I'm usually reliable on such things," "Many notable critics have also independently thought so," and so on. The question I intend to raise, however, is much narrower: whether any statements about the *nonaesthetic* qualities of a thing, judgments requiring no aesthetic sensitivity, could be made such that, even if one has not seen the work and a fortiori has not appreciated its qualities, one would have to admit that, if these statements are true, the work must be or probably is as the critic claims it to be. Could any statements about a thing's nonaesthetic properties alone serve as reasons for agreeing or concluding that it has a certain aesthetic property? If so, one would not, of course, have been brought by such arguments to *see* the grace of the work; nor therefore, as a result of them, would one have made an aesthetic *judgment* about it. It would simply be that, with justification, one could attribute to it certain aesthetic properties. It might be suggested that such a justification or support, even if possible, would be practically pointless and aesthetically worthless. For reasons it would take time to develop I do not altogether believe this. But in any case, the investigation into whether it is possible is a legitimate inquiry for aesthetics.

This inquiry will occupy the last sections of this paper (Sec. VII ff.). But I will postpone it a little longer. For after all, even if such a kind of support for aesthetic judgments were possible, it would still not account for the widespread inclination to say that the critic should have reasons for his judgments. Those who insist on this certainly mean that, in some sense, a critic will have made a responsible and trustworthy judgment only if there were reasons for making that judgment rather than some other, that he should have made it *because* he had those reasons, and that he should be able to cite those reasons. This therefore concerns reasons upon which, in some sense, a critic's judgment is based. But the supposed activity outlined in the previous paragraph would be quite different: it would be at best the auxiliary activity of providing reasonable *opinions* and of perhaps confirming by argument the judgments that the critic, confronting the work, had already independently made. How or in what sense then can a judgment be based on reasons given that, in one sense already explained (p. 144), judgments *cannot* be the outcome of reasons? Perhaps it is a matter of distinguishing two ways of using "reason."

V.

In discussing the four relationships earlier, we saw that there must be some (ultimately nonaesthetic) features responsible for any aesthetic quality. Another way of putting this is that there always is, and must be, some *reason* why a thing has that quality. We also saw that critics largely occupy themselves in discovering the reasons why a work is, say, graceful or unbalanced; that someone who has seen that it is graceful must in some degree have noticed these responsible features; and that a good

critic should be able to point out these reasons. But these are reasons why the *work* is graceful, and to be distinguished from reasons—good or bad, a critic's or anyone else's—for concluding or inferring that the work is graceful.

If a work is graceful there will be reasons why it is, and this will be so whether anyone ever know, or thinks, or has any reasons for thinking it so or not. The reason one unnoticed pebble on a beach does not fit snugly against another may be that one is flat and the other slightly convex. The statement of such a reason is a statement why things are as they are. A person might notice that something is graceful, or that two pebbles do not fit closely, without yet knowing or being able to specify exactly the reason why. As "reason" is used here, a man may judge something to be graceful and not be able to give the reason, though he may have tried hard to find it. But "reason" is also used to mean, roughly, a true statement or a fact such that, on the basis of knowing *it,* it would be reasonable, right, or plausible to infer, suppose, or judge that something is so.

I have already argued that it is absurd to ask that an aesthetic *judgment* (involving, as it does, perception) be based upon reasons in this latter way. The sense in which a responsible critical judgment should be based on reasons and in which a critic should be able to give reasons for this judgment depends on the other use of the word. To have reasons for his judgment he must have attended carefully enough, while seeing, hearing, or reading the work, to have noticed in some measure the features of the work that make it moving or unbalanced or ungraceful, and his judgment must have resulted from that. Moreover, he should be able to cite these features and, if challenged ("Why don't you think this line is graceful?"), reply with some mention of actual detail ("Well, it breaks and wobbles just in the middle"). In general, then, my suggestion is that two things are often confused: people insist that aesthetic judgments should be based on, in the sense of rationally derived or derivable from, supporting reasons; but all they can sensibly insist is that the critic, having realized why the thing is or is not graceful, should be able to say so.

The distinction is one that ought not to cause confusion. Consider some other cases. "The reason the pack of cards is incomplete is that the ace of clubs is missing." "The reason he is sulking is that you refused his request." "The reason he looks so funny is that he screws up his eyes in an odd way." "The reason it sounds so solemn is that there are several long vowels in the line." Each gives a reason why something is so. In each case someone might notice or know that this something is so first—that the pack is incomplete, that he is sulking, that his face looks funny—without yet knowing the reason or being able to say why. On the other hand one might notice or know the other fact first and independently—that the ace of clubs is missing, that you refused his request. Then, on the basis of *these* facts or reasons, one might infer that the pack is incomplete, that he is probably sulking, and so on. One would suppose it dif-

ficult to confuse these two activities; yet I believe they are sometimes confused, perhaps because quite often the very same words (for example "because the ace is missing") may express either the reason why things are as they are, or an adequate or conclusive reason for thinking or concluding that they are. Thus if the reason the pack is incomplete is that is contains only three aces, it is also true that if one knew it contained only three aces one would have a conclusive reason for asserting that it was incomplete. Similarly, if the reason he is sulking is that you refused his request, it may also be true that if I know you refused his request I may have a good, though this time not conclusive, reason for thinking he is sulking.

But although one and the same clause may sometimes express either the reason why something is so or a good reason for believing it is, this is not always the case. The reason the music is sad at a certain point may truly be that just there it slows and drops into a minor key. The reason a man's face looks funny may be that he screws up his eyes in an odd way. But knowledge that a piece of music slows and drops into a minor key at a certain point or that a man screws up his eyes in an odd way would be very poor reasons for believing or inferring that the music must be, or even probably is, sad, or that the face looks funny. The music might instead be solemn or peaceful, sentimental, or even characterless; the face might look pained or angry or demonic. It is, then, a quite unwarranted assumption that, if a critic has notice or discovered the reasons why something has a certain aesthetic quality and in *that* sense can cite reasons which support his judgment, he thereby has reasons the citing of which provide rational support for his judgment or show it to be reasonable. A may in fact *be* the reason why something is B, and yet the knowledge that that thing has A may provide *no* reason or justification for supposing that it has B.

If this is so, the supposition that, because critics do indeed give reasons for their judgments, it must be possible for them to give "good, or cogent, reasons" needs further examination.[5] Monroe Beardsley, for instance, holds, as against the "critical skeptic," that the critic "armed with reasons" is a "reasoner" and he attempts "to make sense of what the critic does when he gives reasons, and back him up with a philosophical account of how those reasons really work." Beardsley, however, like most writers, is concerned here especially with the support of verdicts or "appraisals," a realm where the issues may not be the same and what he says may be correct. Since my present focus of attention is different, I do not here discuss his views. What is of interest is his account of what it is for a critic to give reasons for a judgment, since he says nothing about restricting this to reasons for verdicts. A reason, he says, is a proposition which cites some property of the work; and "if one proposition is a reason for another, in the sense of actually supporting it, then there must be a logical connection of some sort between them. And, being a logical connection, it must relate general concepts in an abstract way." Moreover, he adds, "*generality* . . . appears to be essential to reasons in the logical

sense" and "some form of generality is essential to reason-giving." He therefore attacks those critical skeptics who "hold that we can still talk of giving reasons in particular cases . . . without committing ourselves to any general principles at all." Here then is a view about what giving reasons for aesthetic judgments consists in, and it can be asked whether it is applicable to the judgments I am discussing.

I have argued above that a critic may, in giving reasons for one of these judgments, offer considerations which do not allow generalization and do not support the judgment by permitting inference to its truth. I believe therefore that, in so far as critics give reasons for these judgments (and not merely auxiliary support for their truth) by citing nonaesthetic features, they are not giving reasons in Beardsley's sense of propositions having "a logical connection" with the judgment they support, nor are they relating "general concepts in an abstract way." Consequently, when critics give such reasons, they are exemplifying an activity wherein we *can* in certain respects "still talk of giving reasons in particular cases . . . without committing ourselves to any general principles." There is a familiar and important form of reason-giving, at least for the aesthetic judgments under discussion, which does not consist in citing properties of the work in propositions which *logically* support—that is, make certain or likely—the truth of the critic's judgment. We must not therefore be misled by the fact that we frequently use the same words to ask for the reason on which someone's *inference* is based and for the reason *why something* has a certain quality. The question "Why do you think these stones won't fit together?" may in both cases take the answer "I think they won't because one is slightly convex." But this may be asking and answering the question "Why do you *infer* that they won't?" or the question "What's *your* explanation of why they don't?" It is ordinarily in this latter sense that we ask the critic why he thinks something is graceful, and the reason he gives, even when he is correct, need not be deductively or inductively capable of justifying the claim that such is the case. In this latter sense, it is a mistake to say that the critic's claim ought to be rationally supported by his reasons, although this again is not to deny that some of a critic's reasons might be irrelevant, inappropriate, or absurd.

VI.

I have now differentiated the following often confused topics: (1) explanation of aesthetic effects, (2) support of a judgment by a "perceptual proof," (3) the impossibility of making aesthetic judgments by deriving them from reasons, (4) the sense in which a critic may and should be able to give reasons why the work has the aesthetic character he claims, (5) the question (raised and postponed in Sec. IV) whether, given statements solely about nonaesthetic properties, one could be justified in making or accepting attributions of aesthetic qualities. This question, to

which I turn now, commits us to an examination of certain other relationships.

The reasons for investigating this question are several. Aesthetic qualities are intimately connected with, and in various ways dependent on, nonaesthetic ones. It would seem therefore that statements truly attributing aesthetic qualities—and aesthetic judgments generally—are true because, and would not be true unless, certain statements attributing nonaesthetic qualities were true. If there are such relationships, does it follow that the truth of certain statements of the second sort supports, guarantees, makes likely, or excludes the truth of some aesthetic claims?

If this were so, although a critic would not ordinarily arrive at or support his aesthetic claims in this way, certain other things might be possible. Someone lacking aesthetic discrimination who could himself perceive the nonaesthetic qualities of an object might reason or conclude justifiably, and so find out or prove, that it was, say, graceful, citing possibly conclusive reasons for his opinion. Given the requisite information, he might even reach true and justified opinions about objects he had not seen. Someone who judged a statue graceful or a poem moving but felt unsure of his judgment might ascertain, independently of his own impression, or have additional reason for thinking, that they were so. There might thus sometimes be a way of verifying aesthetic judgments and an alternative way of correctly applying aesthetic terms. It is a matter of some importance to show whether or how far such things can be done. Certain answers to these questions would bear upon the truth of various traditional and contemporary theories; they should clarify some further relationships between the nonaesthetic and the aesthetic and so illuminate further the nature and logic of aesthetic terms and judgments.

VII. SOME FURTHER RELATIONSHIPS: CONCEPTUAL

That there are certain *general* relations or associations between various aesthetic and nonaesthetic features is fairly clear. Although attention has not usually been focused on the distinction between aesthetic and nonaesthetic, but rather on some broader one (basic properties and dependent, emergent, or Gestalt properties), the existence of relationships and the possibility of stating them generally has been widely assumed, especially by those who have attempted certain experimental researches.

In music and verse, quietness and slowness have some close connection with sadness and solemnity, and speed with gaiety and excitement; bright colors are somehow related to garishness and gaudiness, curving lines to gracefulness, and so on. I shall say that they are *typically* or *characteristically* associated. Similarly there are typical antitheses or oppositions: pale and gaudy, angular and graceful, fast-moving and solemn. Exactly what these general relationships are often remains

clouded; certainly a common assumption, sometimes explicit, is that they are empirical and contingent.[6] That there may be certain conceptual relationships has been less noticed; in aesthetics, as elsewhere, logical or conceptual associations have commonly been taken to be contingent. In this section I discuss some kinds of conceptual relationships.

(i) First, let me consider certain relationships which do not hold. Although a thing's aesthetic character is dependent on and results from its nonaesthetic features, in general there are no sets of nonaesthetic features that are logically sufficient for it to have a certain aesthetic quality. In saying this I mean to exclude several possibilities. There is no *one* set, no *group* of sets of logically sufficient conditions, no "defeasible" sets, and no wholly non-aesthetic descriptions which logically entail a certain aesthetic character or in virtue of which to deny such a character would be a linguistic error. Some qualities of a thing may be sufficient to make it graceful, but it will not be a case of *logical* sufficiency. No nonaesthetic conditions or descriptions logically require the application, though some may require the rejection, of an aesthetic term.[7]

Throughout the foregoing I have restricted myself entirely to the relation of nonaesthetic terms and judgments to aesthetic ones. It may be that some descriptions in aesthetic terms are logically sufficient for the application of another aesthetic term, but if there are such relationships I am not concerned with them.[8] Again, it is sometimes flatly said that the terms I call aesthetic are indefinable.[9] This is most probably false although, if I am correct, they cannot be defined in a certain way solely by *non-aesthetic* terms. But to make this point requires first admitting my initial distinction of two types, a distinction not explicitly made by many who allege the indefinability of these terms. Further, there are no doubt other concepts that lack sufficient or positive conditions (of some specified sort); hence I am not claiming that aesthetic concepts differ from all others in this respect. It should be noticed also that to discuss the relationships between my two sorts of concepts, the two sorts must be identified independently of such relationships. One could not distinguish aesthetic concepts from others by the fact that they lack a certain relationship to those others. I have taken the two types to be adequately indicated by my original examples and by what was said briefly about sensitivity or taste. I have not examined or analysed the distinction further, and since the arguments of this paper take it as given, they cannot be regarded as helping to explain the difference or to say what aesthetic sensitivity consists in.

Nevertheless, if it is, as I believe, an essential feature of aesthetic judgments in general (whether they contain aesthetic terms or not) that their truth is never logically assured by the truth of any number of nonaesthetic judgments, there are certain clear consequences. It will be impossible for a person to verify or infer, by appealing in the sense explained only to nonaesthetic properties, that a thing must of necessity have a certain aesthetic quality.

(ii) In making this negative claim I have not said that aesthetic

concepts are governed by no logical conditions at all. Indeed it is apparent on very little reflection that they are.[10] First, certain nonaesthetic qualities seem to be *logically necessary* for some aesthetic qualities. Consider *gaudy* and *garish.* It seems clear that with only pale pastels and no instances of bright (or apparently bright) colors in existence, there could be no examples of gaudy or garish coloring, and it would be dubious whether anyone could have learned, or whether there would be, any such concepts. Similarly, if there were only bright and intense colors, there could be none describable aesthetically as delicate. If all lines and movements were either straight or sharply angular, never being or giving the impression of being curving or flowing, there might be no use for the term "graceful." Were such relationships merely contingent, it would be conceivable that we might find occasional exceptions, a graceful straight line or some garish pastels.

Secondly, some nonaesthetic qualities might be appropriately spoken of as *logically presupposed* by certain aesthetic qualities. It seems impossible to say of a dot, a flash, or a uniformly colored surface either that it is or that it is not deeply moving, either that it has or that it lacks grace, unity, or balance. Roughly, only something with line, stance, or movement, or the appearance of such can be graceful or lack grace, and only something consisting of parts in relation can have or lack unity or balance.

Thirdly, however, there may be a characteristic association or relationship which, though still not merely contingent, is much less stringent than logical necessity or presupposition. Consider "sad" as applied to music. Characteristics that typically come to mind are slow tempo, quietness, low pitch, pauses, falling intervals, minor key, and so on. Gaiety and sprightliness connect similarly with speed, rapid sequences of short notes, and so on. Now although some of these connections—that between sadness and minor key, for instance—may not be either obviously conceptual or obviously contingent, others are fairly obviously conceptual. Yet they are no more logically necessary than they are logically sufficient: sometimes despite its fast tempo a piece of music has a sad quality, and sometimes despite a certain angularity in a dancer's movements she is nevertheless graceful. One can conceive of sad music which is not slow or soft, as one cannot conceive of a graceful line which is simply straight.

Among the features logically associated with any particular term in this looser way, some may be closer than others to being necessary without actually being so; one might find a continuum of cases. The same is true of the same terms used in nonaesthetic contexts: an inclination to move slowly and without bustle seems more essential to sadness in people than a down-turned mouth or drooping shoulders. While its presence is not vital in any one case, its absence may be quite exceptional, whereas a down-turned mouth is characteristic but less important. At the end of Section V, I said a critic's reasons might be inappropriate or absurd; the reason lies in the logical affinities and oppositions I have just discussed. To say a line is graceful because it is so straight or that a piece of music

is cheerful because it is so slow is to say something absurd or logically odd.

In Section VII (i) I denied that aesthetic concepts are governed by sufficient conditions; I have now sketched some ways in which they may be logically related to other concepts. Thus, if a thing has the aesthetic property A, it may be very likely to have, or may even necessarily have, certain nonaesthetic properties $N_1, N_2, N_3 \ldots$, the latter being properties with some conceptual relationship to A. But having the properties $N_1, N_2, N_3 \ldots$ is no guarantee of A; as far as logical connections go, all one can say is that it may well have A.

VIII. SOME FURTHER RELATIONSHIPS: CONTINGENT

I turn finally to general relationships of a contingent sort between the two sorts of qualities and the possibility, correspondingly, of making various sorts of empirical generalizations. It is important to see what plausible generalizations can and cannot be made for several reasons, not least so as to avoid confusing them with statements of the empirical and logical relationships already discussed in Sections II and VII.

To do this I consider briefly what Beardsley says in discussing empirical generalizations. He does not explicitly discuss the relationship between aesthetic and nonaesthetic qualities, for he makes no such distinction; instead he speaks of relationships between "regional qualities" (which are "emergent") and their "perceptual conditions." His discussion therefore has a wider range, since some nonaesthetic qualities, like squarish and grinning, are examples of regional qualities, as well as aesthetic qualities like graceful and gaudy. But this does not matter, because my aesthetic qualities are, roughly, a subclass of his regional qualities.

I shall take just one of Beardsley's many examples, the connection between slowness and sadness in music, as a typical illustration of his views. The kind of empirical generalization he offers is expressed in several ways: when things have certain qualities they will tend as a result to have another (dependent or emergent) quality; for example, "music having such and such features (slow tempo, and so on) . . . tends to be sad"; certain qualities "tend to make" music sad; these are "sad-making" qualities, and so on.[11]

Now various interpretations, resulting from the shiftiness of the verb "tend," might be put on these remarks. They might mean that slow music *will* be sad provided that other features present (say, a major key) do not bring an incompatible character that overwhelms the effect of the slow tempo. Slow tempo in itself *is* sad-making; the force of "tends" is simply that the effect of the tempo may be swamped out. This, as I read him, is Beardsley's meaning,[12] and presumably, since he mentions no other, the pattern he would adopt for other examples, like *bright* and *gaudy*. Now it is true that he disavows any truth claim for the particular gener-

alizations he uses as examples;[13] yet he does seem to suppose that many generalizations of this kind might be true and that his own probably are. But these and many similar generalizations seem in fact to be fairly obviously false: slow tempo is just as closely associated with *other* characters, like solemnity, majesty, pensiveness, and serenity, as with sadness. Even if one interprets these tendency statements in other ways that come to mind—for instance, that slow music is *usually* sad, or that it is *always somewhat* sad—they still seem false: much slow music is pensive, majestic, solemn, or serene, not sad, and there must have been thousands of slow compositions with no particular character at all.

There are many empirical generalizations one might make connecting aesthetic and nonaesthetic qualities. But many of those that seem true are not of Beardsley's type and are relatively weak—for example, that slow music is *sometimes* sad and, when it is, is often sad notably because of its tempo. Other statements, like "sad music is usually slow" may be true too. But others again, like "slow tempo tends to make music sad *rather than gay*" or "slow tempo is the sort of feature that *may* make music sad," seem to me not obviously empirical.

I do not mean to deny that with care we might produce much more powerful generalizations telling in detail that works with various features always or usually have a certain aesthetic quality. All I have argued is that some tempting generalizations that have been proposed are questionable. I suggest that in part they may be offered because various relationships are not clearly differentiated or investigated. It is seen that some intimate connection of a general sort holds between, say, slow tempo and sadness; slowness is, if one wishes, a "sad-making quality" (but only in the sense that it is the sort of quality that, unlike swiftness, *may* make something sad). The conceptual character of this relationship is overlooked, however, because specific claims that the slow tempo of this or that work is what in fact makes it sad are clearly contingent; and since these specific claims are often true, it is supposed that a fairly strong generalization can be made from them—namely, that slowness is a "sad-making quality" in the sense that slowness in music "tends to make it sad."

IX. "JUSTIFICATION"

Having examined some of the relationships, logical, quasi-logical, and contingent, between the aesthetic and nonaesthetic realms, I return to the question whether it could ever legitimately be argued, solely from statements about the nonaesthetic properties of things, that certain aesthetic judgments must be, or even probably are, true.

I have already suggested in general (Sec. VII) that no statements about nonaesthetic qualities could by themselves logically ensure the truth, though some may logically ensure the falsity, of an aesthetic judgment. In this respect aesthetic judgments are not capable of rational or

reasoned support. The question remaining is whether some nonaesthetic statements could by themselves provide, say, a reasonable measure of inductive support for the truth of an aesthetic judgment. Some writers seem to have held that in some such way aesthetic judgments might be adequately and rationally supported, indeed that criticism might in such a way be "set on a rational basis."

The procedure would presumably go thus. If someone wished to provide reasons supporting the truth of an aesthetic judgment, or reasons on the basis of which an aesthetic quality might be attributed to something, he would point out that the work has nonaesthetic properties of a kind which always or generally make a work sad or graceful or unified, and that therefore the claim that *this* work is so is a reasonable one. Now although the generalizations I examined in Section VIII seemed either false or too weak to function thus, with more careful research, it might be argued, we could perhaps provide reliable generalizations that would be at once strong and detailed enough. Given the complexity of most aesthetic objects and the fact that small differences are often of great significance, it seems most doubtful. But if we could, then it is at least conceivable that in the future people might with justified assurance attribute aesthetic properties solely by inference from nonaesthetic features. They might also employ such inferences to add confirmation to genuine and independently made aesthetic judgments, and in doing this their judgments might be said to have received a kind of rational support.

But this is of limited interest. In so far as people have sought, by empirical research, to provide rational justification *generally* for aesthetic judgments, claiming that without such justification criticism is unacceptable, the hope is forlorn. The program of a general "underpinning" is misconceived. For clearly, at least some of the aesthetic judgments from which the investigator began when he set out to establish his generalizations were necessarily without benefit of such justification, and yet had to be accepted as bona fide data. Without them, no investigation of "perceptual conditions" could have got under way. This kind of "justification" of aesthetic judgments by means of generalizations could not therefore be supplied for *all* such judgments.

X. FOOTNOTE

I stress again that I have dealt only with certain kinds of aesthetic judgments. In considering how they may be supported by reasons, I have also restricted myself to reasons which cite the nonaesthetic properties of things. It is often said that works of art are unique and that each must be judged by its own standards; also that aesthetic judgments cannot be made mechanically or by following rules. These sayings are not unconnected. Moreover, given the diversity of issues they hint at, they can hardly be rejected. I have not argued that aesthetic judgments (the kind I deal with) cannot be made mechanically, or by rules, or—as I take it

this may mean—without aesthetic perception. I have treated this as a tautology. But if what I have said about deductive and inductive support is correct, it is also the case for this class of judgments as a whole that their truth cannot be verified, confirmed, or supported "mechanically" or by appeal to rules. I do not think this should prove surprising; but I have tried to show some of what lies behind it.

Notes

1. I wish to acknowledge the support of an American Council of Learned Societies Fellowship during the writing of this paper, 1962–63.
2. I have illustrated this distinction more fully by examples in "Aesthetic Concepts," *Philosophical Review,* 68 (1959), 421–450.
3. For a fuller discussion, including a more detailed description of what things a critic usefully may do, see Sibley, op. cit., pp. 437–450. Cf. also John Holloway, "What Are the Distinctive Features of Arguments Used in Criticism of the Arts?," *Proceedings of the Aristotelian Society,* supp. vol. 23 (1949), 173–174; and Robert Hoffman, "Aesthetic Argument," *Philosophical Quarterly,* 11 (1961), 309–312.
4. H. R. G. Schwyzer, "Sibley's 'Aesthetic Concepts,' " *Philosophical Review,* 72 (1963), 74.
5. For this and following quotations, see Monroe C. Beardsley, "On the Generality of Critical Reasons," *Journal of Philosophy,* 69 (1962), 477–480.
6. See Monroe C. Beardsley, *Aesthetics* (New York, 1958), pp. 87, 331, and *passim.*
7. I discuss this more fully in "Aesthetic Concepts," pp. 423–437. Cf. a series of similar points made for other purposes by H. P. Grice, "Some Remarks about the Senses," in R. J. Butler, *Analytical Philosophy* (Oxford, 1962), pp. 142–143.
8. See "Aesthetic Concepts," n. 9, p. 436.
9. See Beardsley, op. cit., pp. 86, 192, 194; cf. also E. F. Caritt, *An Introduction to Aesthetics* (London, 1947), pp. 20–21.
10. In "Aesthetic Concepts" I had logical relationships in mind throughout in speaking both of "negative conditions" and of "characteristically associated features" (pp. 426–428).
11. Beardsley, op. cit., pp. 330–331. Cf. also pp. 194 and 198.
12. Beardsley, op. cit., p. 331.
13. Beardsley, op. cit., p. 195.

George E. Yoos

*George E. Yoos studied at the Universities of Missouri and
Chicago, and now teaches philosophy at St. Cloud College, in
Minnesota. He has published several articles on aesthetics in
professional journals.*

A Work of Art as a Standard of Itself

One application of the term *good* to a work of art follows from the
application of certain good-making criteria. Criticism using such cri-
teria is fundamentally comparative, since the criteria are thought of as
qualitative and admit a degree of conformity of an object to a standard.
What we have in this activity of criticism is ranking or grading according
to these good-making criteria. For example, Ben Jonson's *Volpone* might
be treated as a good example of didactic comedy. Or we might rank
Verdi's *Requiem* lower on a scale with other great requiems in that it is
overly operatic, not conforming to the restraint and solemnity demanded
by a true requiem. Such artistic evaluations, estimations, or judgments
have been criticized on the ground that there can be no justifiable, fixed,
or universal criteria to rank or grade art. Another ground for criticism
of such artistic evaluations is that artistic works are unique, particular,
or novel creations, and not essentially comparable.

One mistake in the discussion of such oppositions is not to recognize
that ranking art objects is a minor activity in criticism and that there
is a more fundamental type of artistic judgment required before such
comparative judgments are in order. It is the proposed theory of this
paper that art criticism and, consequently, sound artistic judgment take
place after the appreciation of a particular work of art. Criticism evalu-
ates the recall of the experience of appreciation. Such criticism relates
the experience of secondary and discrete values to a primary aspect.
Until the primary aspect sets a standard for us, we have no standard to
measure the degree to which the discrete values accrue to the work of
art. Finally, only when this kind of artistic judgment in terms of a pri-
mary aspect has taken place do we find that comparative judgments are
in order.

An adequate justification of such a type of judgment cannot be ade-
quately defended in a short paper. The task would require a complete
theory of art. It is hoped that the following outline of a theory of criticism
will be suggestive of what may be required for an adequate defense of

From *Journal of Aesthetics and Art Criticism,* Vol. 26 (Fall, 1967), pp. 81–89.
Reprinted by permission.

451

the contention that such a type of judgment is fundamental in criticism. It is also hoped that the outline will reshape our perspective of criticism in the arts in such a way that many of the current issues in aesthetics will be seen from a new vantage point.

One mistake, if this theory is correct, is to take as a paradigm case of artistic judgment that which takes place in the minds of judges at art contests or that which occurs in the discussion of art historians where, in either case, the requirement of the context or of the inquiry makes comparison the fundamental activity. The more profitable point of attack is to look at value judgment as it occurs in the individual critique of a work of art either by a teacher or a critic. Comparative judgments can be instruments, however, in such critique. For example, if two novels have the same plot or theme, it may be useful to the critique of one to note how the other develops its plot or theme better; but usually such judgments are mere addenda and of secondary interest to the fundamental critical activity. The primary thrust of criticism in such basic critique is in the elicitation of standards from the very object being judged or criticized. Such criticism does not impose a standard derived externally. Instead of judging the work of art according to criteria, principles, or standards that are given or accepted externally, the standards are recognized in and drawn from the very work of art itself.

Several questions arise concerning standards that are found internally in a work of art. The first is how a work of art that is unique and novel can provide a standard to judge itself if, as some say, a standard must be of a universal nature applicable to more than one work of art. But not all standards need be of such a universal character. In one sense an ideal of a particular set of events is such a standard. Such an ideal visualizes or conceives of a particular or unique set of circumstances which would be valuable to achieve on a particular occasion, with no thought of the same thing possibly ever happening again.

Another question is, since the intention of the artist affords a standard similar in many respects to that proposed, how does intentional criticism differ from the sort of criticism claimed here to be fundamental. An answer to the above question requires somewhat of a digression into the subject of artistic intentions.

But, first, in order to be clear about intentions in creating works of art, it is useful to make a preliminary distinction between fine art and craft. The clarification of intentions about fine art presupposes clarity about the difference between fine art and craft. Whether or not the differences between the two are essential is a puzzle that I propose to side-step. But I should like to point to one distinction that seems to have escaped the attention of most people dealing with this topic and which is fundamental to the analysis that follows.

A work of fine art, as distinguished from craft, is entitled to a proper name. This entitlement is something more than a grammatical rule or a rule of style. It is a demand made by the nature of our attitude towards and our attention to works of fine art. The function of titles is to give a

unique reference. They function to distinguish or to mark off as distinct a certain individual or particular that has distinction. We do give such distinction to some items of craft by giving them proper names. But we do so only in so far as we find good reasons for wanting to identify a given item or craft. When we flood the world with similar or replaceable objects of craft, the grounds for the demand for distinction disappears. But, on the other hand, increasing the number of works of fine art is no reason for altering the demand that they be entitled. Our attitude toward fine arts is conditioned by the nature of the object. It is a kind of object that has a value within itself, worthy of a distinction of a name. The title or name directs our attention to that object as something possessing features and values apart from other things.

The intention of an artist is to create a work of art. To create such an entity he must work with materials, medium, and a guiding ideal. Thus, there is a twofold intention. First, there is the intention of creating a work with its own individuality. If we use the distinction made between fine art and craft, the intention is to create a work that warrants a title to identify its particular or peculiar value. Second, there is the intention of the ideal guiding the activity of the artist. Intentional criticism sets up the second intention as a standard by which to measure the success of what is accomplished. Such a standard invites comparison with what has been attempted before in the history of art. In this sense the standard is comparative. But intentional criticism is not comparative if the intention is a novel one and affords no comparison to measure its success. In this last respect the intention as a particular ideal or standard is similar to the standard I propose as fundamental.

On the other hand, two points indicate that intentions of the artist are not comparable to the standard I am presenting. First, an artist may announce his intentions. In this case the standard is found outside rather than in the work of art itself, as I claim about the fundamental type of artistic judgment. Second, if intentions are not announced and are not directly apprehended in the work of art, then they are determined by hypothesis and, consequently, are a matter for inductive inference from data in the work of art. Intentions then become part of the artistic process, rather than a part of the product available to experience. Consequently, inferred intentions, as well as intentions announced by the artist, are external. They are not a standard found in or present in the work itself.

Talk about intentions, however, does have in one sense a very important function in criticism, very much in line with the claim being made about internal standards in this paper. Such talk should direct the attention of the beholder of the art object to aspects of features of the work of art and not to mental events occurring in the artist's mind. To the beholder what a given feature of the work of art has done is what the artist did. In speaking of, say, a painting it is easy to identify as equivalent in use the comment that the artist was unsuccessful and the comment that certain aspects of the painting failed to carry through. What the

artist was trying to do and what form and direction developed in the work of art are thought to be for all practical purposes of criticism identical. Those given to declarations about intentional fallacies seem, in part, merely to be objecting to a way of speaking that, if taken literally, might be in error. The use of expressions about intent are harmless in criticism if they have the same use as remarks about structure, form, or design doing something. But to speak of a structure, form, or design doing something is just as spooky or just as *literally* in error as to talk of intentions when actually referring to features in the work of art.

What is important in such judgments about works of art is the recognition as objective in the work of art of what I choose to call a *primary aspect*. The recognition in the work of art of a primary aspect acts as a standard in judging the work, its success or failure. The question whether or not the work in question has such a primary aspect, or whether what is recognized is *really* in fact secondary, is incidental to the act of judgment. What is crucial in such a judgment is that the recognition of a primary aspect is a necessary condition for the act of judgment of fulfillment or success.

I call it an *aspect,* for it is *the* perceived feature of a work of art which enables us to take up a point of view or a perspective of that work. I call it *primary* in that our recollection of the experience of the work begins, continues, and terminates in that perspective. What I am calling a primary aspect is *directly prehended* in the recall of the experience of the work. It is that aspect of the work which is essential to our identification of the work. If we apprehended it as changed, we would think of the work as altogether different, just as we might think of a person as entirely different if there would be a radical change in his personality. Consequently, when we think of possible alterations that could be made in a work of art, we think of them as limited by those features that if altered would give us a new work.

We make a judgment about a work of art after the fact of experience. It would be absurd to render a verdict on a work that you have not experienced. It would again be absurd to make a final judgment on a novel that you have half read. One must have a ground for judgment. Without an experience of the full work you can never rule out the possibility that something might alter for the good. Segments of great arts standing by themselves can be bad works of art. To cut down some paintings is to destroy their value. Of course there is no necessity in all this. It is even quite possible that fragments of works, such as the *Venus de Milo,* may be inprovements on the originals. A judgment of a work of art thus must start with the completed experience of recall. To judge the whole on the basis of a part is the fallacy of composition. The critic may refer back to the work to re-experience a certain feature to assist recall of the experience necessary for a considered judgment, or he may even re-experience the work to increase familiarity. But always the critic makes the judgment about the work after the fact of experience of the entire work. Therefore, if a work of art is being judged at any point in

the appreciation or in the act of creation, *in medias res,* we are not taking into consideration the totality of the work. We are making a judgment either in reference to a stage in the creation or in reference to what is developing in the experience of appreciation. From either point of view there can be no judgment of *the* work of art. Judgments of works of art differ from ethical judgments in at least one respect. Judgments of works of art can be made only after the deed. Ethical judgments can be made both before and after the deed.

In discussing the primary aspect we can abstract from it dominant features in order to discuss it. It is these features discussed in the abstract that give rise to our classifications of genre, style, and form. The primary aspect is that which gives unity to our prehension of the work of art. Those features of it that can be repeated and identified in different words of art can be designated and compared. In comparative criticism it is these abstracted features of the primary aspect that are compared. The abstracted features from one work are compared with those of another to see if the development or enhancement of those features is more successful in the one than in the other.

Given the thesis proposed, that the primary aspect ultimately sets the standard by which we judge a work of art, then comparative criticism would be justifiable on the assumption that two primary aspects are the same. But, this is not possible as I have defined a primary aspect. What gives identity to two different individuals cannot be identical. Comparative criticism must then be grounded on practical considerations. For all practical purposes dominant features of primary aspects are developed and enhanced in similar ways. Critics can, consequently, build up a common fund of knowledge about what kind of features are enhanced by various other features. What undermines these rules of experience is to mistake the abstracted features of a primary aspect for the primary aspect. We also misuse the rules of experience when we allow knowledge of traditional forms and genre to direct our prehension of the primary aspect of a work. We simply allow tradition to obscure our vision of the work.

It is always in terms of abstract characterizations of the primary aspect that we make estimations of the relative value of the work in terms of itself. In so far as these abstract features of the primary aspect are enhanced or developed, values accrue to the work. But, in so far as we formulate these abstracted features, they are standards only derivatively. Ultimately the standard is the primary aspect as directly prehended. There can be no complete formulation of such a standard. When we speak of the features of the primary aspect, we use abstract terms that refer to features productive of unity or organicity. We speak abstractly of plot, character, theme, pervasive quality, form, style, pattern, or structure. Where such features are dominant in a primary aspect comparative criticism is practically very much in order. Where there are many dominant features comparison breaks down altogether.

If we think of the plot of *Volpone,* for example, in its primary aspect

as not being dominantly didactic, we would have an altered standard by which to judge the play. If, for instance, we were to view the play as a boisterous comedy, we might be dissatisfied with the outcome of the last act, as not properly enhancing what we take to be the primary aspect of the play. To take another example, Swift's *Gulliver's Travels* has been criticized on the grounds that in the last sections the satire destroys the story. If we take as a dominant feature of the primary aspect the narrative of the work, it would seem that such criticism would be valid. On the other hand, if we feel the primary aspect to be characterized by a pervasive, vituperative misanthropy, then the last sections are seen as developments or enhancements of what is primary. Again, the considerations on whether *The Adventures of Huckleberry Finn* falls apart in the end rest upon the same distinctions. The important point in alternative interpretations is the consideration of the primary aspect. Disagreements, if based upon differences as to what is a primary aspect, are sometimes solved by directive criticism. Such criticism redirects attention. What was previously taken to be the primary aspect changes. The primary aspect ultimately turns on a perspective of a work in the recall of the experience of the work. What is necessary to alter such a perspective, and consequently the primary aspect, is a redirection of our attention in the recall of our experience of the work. A discussion of artistic intentions sometimes effects this redirection. Historical considerations also alter such a perspective. In the last analysis, however, intentions and historical considerations cannot be used to synthesize or formulate the primary aspect. Our prehension of the primary aspect follows after an experience of the work. Our experience is conditioned by the knowledge of intentions and the historical considerations.

Whether or not the primary aspect is or is not the primary aspect intended by the artist poses several knotty puzzles. It seems that what is *really* a primary aspect is a consequent of intent and to know what is primary ultimately depends upon intent, the knowledge of which is not available to the beholder. An indirect way of approaching these puzzles is to indicate that we do judge natural objects by the same formal standards that we use in judging works of art. This suggests either that we are mistaken in judging natural objects in the same manner that we judge works of art, i.e., utilizing a primary aspect as a standard, or that intent is superfluous in such judgments. To say that we are mistaken is apparently to deny the value of such appreciations of natural objects. But still it seems an assumption in discussing the primary aspect of a work of art that what it is doing is a consequent of intent.

Several considerations throw some light on the above difficulty. When we judge natural objects in the same manner that we do works of art, we are treating them as individual things or places. Scenery, for instance, is a spot with a location or place name. An object such as a mountain is identified by a proper name. Comparably, works of art are identified by titles. Thus, both natural objects and works of fine art are referred to by proper names. When we judge objects, places, and persons

with proper names, we are not fundamentally evaluating kinds of things. Our concern or interest is with the specific object referred to by the proper name. To evaluate or judge a work of art or a natural object referred to by a proper name is thus to evaluate that which is essential to the designation of that proper name. We are uniquely concerned with such objects as things in themselves. Since what is used in the identification of an object with a proper name is the primary aspect, this suggests that when we use a primary aspect to evaluate natural objects, we do so not relative to the intent of an artist, but relative to the primary aspect as fundamental to the identification of the object as a unique object.

To evaluate both natural objects and works of art as unique objects is to relate what is primary in their identification to the values inherently related to what is primary. But in the case of the work of art we are puzzled by the connection between what we take to be primary and the intention of the artist. What needs to be clear here is the fundamental artistic purpose. To call a work of art a work of art is to assume the existence of the intent to create a unique object referred to by proper name, but in no way does this artistic purpose necessarily determine that what is primary in the work of art be a fulfillment of a specific purpose or intent of the artist. With this purpose to create a unique object it is perfectly consistent that the primary structure could come into being without any specific intent. It could happen by accident in the creative activity, by the discovery of it in the form of the artistic materials, or even as a result of factors in the artist's personality over which he has no control. What is important ultimately with regard to a work of art is that it be created with the intent to create a unique entity.

A feature that can be conceived to be altered without changing the identity of the work will be called *secondary*. Secondary features are directly apprehended to enhance or develop what is primary. A view of art as an organic unity seems to deny the possibility of such an identification of a secondary feature, for in an organic view everything in a work of art is thought to be essential. The difficulty, however, in thinking of a work of art as an organic unity is that works of art are subject to a variety of interpretive performances, mutilations, editing, and poor conditions of apprehension, and still they preserve their identity and value. If this is true, it is reasonable to think that the identity of a work of art is comparable to the identity of any object or person. Not all features of objects are of primary importance in identification.

The next question is what possible standard can we have for judging any secondary feature enhancing or developing what is primary. One of the worst things that a critic can do for an artist, destroying his integrity as an artist, is to point out to him possibilities that would enhance or develop what is primary in the work of art. What impresses us about great artists is that we could never possibly conceive of ourselves doing what was done with the enhancement or development of what is primary. All of us can think of possible themes, plots, designs which are potential schemes for works of art. The greatness of art depends upon

the genius, the creativity of the artist, the power that he has in doing what we could not possibly do. The moment we recognize aspects or features that we could modify for the better in a work of art, the work of art is judged to be unsuccessful in that respect. This sort of criticism is a matter of degree. The more we can point to that which will enhance or develop what is primary, the more we are justified in saying that the work of art is unsuccessful. The more that we find qualities enhancing and developing what is primary beyond our expectation the higher our valuation. The qualities enhancing the primary aspect that we could not anticipate account for the fundamental character of suspense, surprise, novelty, and denouement that characterizes great art. It is not novelty that is of value here but novel enhancement. Novelty is merely a necessary condition of good art. but not a sufficient condition.

Any possible fulfillment of a primary aspect has no prior limits to its manner of fulfillment. We cannot make an a priori judgment that a given primary aspect is capable of a higher development than another, nor can we make the same judgment upon the basis of what has or has not been successfully done with a dominant feature of the primary aspect in the past. Most great art breaks with tradition in some respect. It violates what we are led to expect. Imaginativeness and creativeness in art are not simply the unexpected, but unexpected development or enhancement. We are able to measure imaginativeness and creativeness to the degree that the development or enhancement of the primary aspect transcends what we might have predicted or might have expected. Thus, the primary aspect sets up a pattern of what could be expected. Good or great art transcends that expectation. We are able to establish the degree of goodness or greatness of the work by the degree the work transcends expectation. Finally, imaginativeness and creativeness are in a large part the cause of the awe and respect that we have toward art and the artist. It is so, not because we compare the work with other great works, but because we compare the completed work with what we might have expected to develop from its primary aspect. The awe and respect develop as a result of our awareness of the limitations of our own powers. We feel powerless with respect to the accomplishment in the work of art.

Expectation as a standard is obviously relative to the beholder of the work of art. If he is unacquainted with the historical tradition of a given art form or if he is unfamiliar with the materials and medium of that art form, his standard of judgment on the basis of expectation would be quite different from that of the critic and historian of that art form. The beholder with deficient experience would tend to have a low level of expectations. Consequently, such a beholder might rate a work as superior that the competent critic would rate as inferior. On the other hand, the beholder deficient in experience might fail to apprehend the value of the enhancements or developments altogether. In this latter case he might rate as inferior a work that the competent critic would judge as superior.

Since our expectations are established by comparison with other

works, it is easy to confuse a judgment on the basis of expectation with a comparative judgment. For a comparative judgment to take place properly, not only do we have to ignore the dissimilar features of the primary aspects of the respective works, but also we must put aside historical considerations. Critics cannot ignore the dissimilar features of primary aspects without peril, nor can critics detach themselves from their historical position in their experiences of works of art. Consequently, expectation cannot be practically divorced from a full consideration of the primary aspect, nor can it be divorced from the history of any art form.

The question of imitation raises some difficult problems for artistic evaluation in terms of expectation. Imitation in art of artist by artist is a difficult thing to judge. Obviously historical considerations are necessary to confirm such imitations. If we do confirm that a work of art is in part imitative, we have shifted our level of expectations. Consequently, our judgment of the work alters. If, again, several artists develop independently similar patterns of enhancement of a common feature of a primary aspect, our estimate of their achievement is lowered. Our lower estimate of the work occurs because our estimate of how much the work transcends expectations has altered. When others appear equally capable of doing the same thing, our estimate of the difficulty is lowered. To think that monkeys could with the proper amount of time type out the manuscripts of Shakespeare is to lower our estimate of Shakespeare's art. Our high valuation of Shakespeare causes us to be shocked when we think that his monumental achievements can occur by chance. There is always, however, a factor of chance admissible in the creation of art works. The proper utilization of chance to develop the unexpected is part of an artist's technique. But in so far as chance is something that normally allows us to expect a given feature, we cannot estimate highly that feature in a work of art.

In the above discussion of criticism that uses the primary aspect as a standard, development and enhancement are directly apprehended values. Directive criticism assists us in the apprehension of such values. Thus, we have a different level of criticism presupposed by criticism using the primary aspect as a standard. Directive criticism has the function of pointing out enhancement or development. Without the recognition of such enhancement or development we have failed to measure adequately the degree of enhancement or development. Consequently, directive criticism is important for the full appreciation of a work of art. Without a full appreciation there can be no adequate judgment of the work of art in terms of the standard it sets for itself in the primary aspect.

The following principle is implicit in directive criticism. What is valuable is always ultimately a matter of direct appreciation. Such criticism that finds differences between values directly appreciated can either claim that what is not appreciated is not seen or not heard, or that what is appreciated is of private concern and has thus no basis for objectivity. Since criticism seeks agreement, what is of mere private concern can have by definition no public concern. If criticism credits a given

apprehended value with objectivity, it can only proceed by giving us directions for perception of the values in relationship to the work of art. If such directions fail, we are still where we started. We cannot decide ultimately whether the appreciation is private or whether the apprehended value has some basis for intersubjective agreement. Prolonged directions to the perceiving beholder which fail to elicit the proper apprehension, on the other hand, tend merely to confirm the private character of the appreciation of the critic.

But at the above discussed level of criticism no standards are involved in judgment. What aspects are considered as valuable cannot be evaluated in terms of one another. The valuations are not considered to grow out of the work; and, consequently, these discrete valuations give us no ground for judging the work as something possessing an identity or value of its own. It is only when these perceptions of value are related to the primary aspect of a work of art that we are able to attribute the value to the work of art itself. Thus, the discrete values are seen as enhancements of what constitutes the primary aspect. The discrete values cannot accrue to the work of art itself unless they grow out of or enhance the primary aspect. Otherwise the values only conflict with the primary aspect. This is one way of saying that a work of art has unity and coherence.

What seems to be true of the organic theory of art is that what is discretely valuable can enhance what is of primary importance in such a way that the importance of what is discrete is enhanced in turn. This reciprocity of enhancement of secondary to primary to secondary explains in turn the intensification of value in art objects. Criticism that starts with secondary aspects of painting has a tendency to be cumulative. But as in the hedonic calculus, where the interrelationships of pleasures interfere in a satisfactory summation, so in art criticism, a summation of discrete valuations cannot do justice to an evaluation of the whole. The reverse must be the case. One must relate the potential value of the whole to the actual intensification of its value by its parts. Works of art must be judged in terms of the open possibilities of their primary aspect. The open structure of its primary aspect sets the standard of fulfillment. But the standard of fulfillment is not one that can be predetermined. It merely presents itself as ripe with possibilities.

In comparative judgments of art the primary aspect as discussed in terms of its abstract features is open to classifications, comparisons, and consequently judgments of ranking or grading. But only in so far as the primary aspect has been used to judge a work of art as successful or unsuccessful can such comparative judgment be made with confidence; success or failure is determined in relationship to a primary aspect that is unique and that is a particular object for the beholder. Comparisons fail in that a primary aspect in many respects has no basis for comparison. Consequently we have explained in all this the adventitious and unreliable character or artistic judgments which establish criteria for ranking and grading.

To conclude, the theory expounded is that criticism of works of art involves two levels of criticism, directive and comparative, which are auxiliary to a level of criticism which judges a work in terms of a standard discovered within the work itself. The standard is found in the primary aspect of a work of art. The primary aspects sets a standard of what can fulfill or enhance it. Such a standard is a particular ideal objectively identified by the beholder. It is a presupposition of any judgment of what is ordinarily called a work of fine art that it is a unique entity designated by a proper name or title. Artistic purpose is fundamentally the creation of such an entitled entity. The primary aspect of a work of art is the necessary condition for a work of art to be such an entitled entity. Its function in a work is the fundamental concern of a value judgment about the work of art. The primary aspect becomes the standard by which to judge the degree of success or failure on the basis of its possibilities. The higher the degree to which discrete values found in a work of art fulfill or enhance what is primary beyond the anticipations of any beholder or critic the higher the judgment of value placed upon the work of art. Ultimately we come to appreciate the discrete values that enhance what is primary directly. It is the function of directive criticism to indicate discrete values, but only in so far as these perceptions of value are fulfillments or enhancements of the primary aspect of a work of art are we able to attribute these values as accruing to the work or art itself.

CHAPTER 3

The Justification of Critical Judgments

C. I. Lewis

Esthetic Judgment

1. We have, so far, been mainly occupied with what might be called the phenomenology of the esthetic; with the nature and conditions of the esthetic in experience. And little has been said, except incidentally, about esthetic *judgment.* Immediate prizings of the directly presented as such, are not judgments. If expression is given to them, then what is expressed is a value-quality of the experience as given, or of the merely phenomenal content of it. The direct finding of positive value-quality may be evidence of an objective value-property in the thing presented; as felt hardness in experience or seen redness may be evidence that the thing presented has the objective property of being hard or being red. And if we pass readily and thoughtlessly from apprehension of the phe-

From *An Analysis of Knowledge and Valuation* (LaSalle, Ill.: The Open Court Publishing Co., 1946), pp. 457–468. Reprinted by permission.

nomenal qualities of experience-content to a judgment of the objective properties of the thing, that is commonplace and understandable, in the case of value as in these others. It represents a habit of interpretation, due to and in large measure justified by the general character of pertinent experience in the past. But however unmarked and however well warranted this transition from the disclosure of intrinsic value in direct experience to attribution of esthetic or otherwise inherent value in the object, it is one which is validatable only as an inference. The value found in the experience is *evidence* of value in the object; it is even the best possible kind of evidence, since such value-findings represent the ruling confirmations of value in the thing (whereas for non-value properties like hardness, the apprehension of felt hardness upon contact would not constitute such a ruling confirmation). But the single value-finding in experience would never be *conclusive* evidence of objective value in the thing: in any instance, a value-judgment so based may be in error, and it is always subject to possible correction by later experience.

It is precisely at this point that value-theory can so easily go wrong by failing to distinguish between the intrinsic value which lies in the quality of experience itself and the property of inherent value in the object, which consists of a potentiality for such experience in the presence of it. A wrong decision here makes all the difference between the conception of value as subjective and merely relative to particular persons and occasions, and hence of value-predications as merely 'emotive,' non-cognitive and lacking any objective truth or falsity—between that, and the recognition that evaluations of things are objective and cognitive, and are not relative to particular persons or circumstances or occasions in any fashion which differentiates them from attributions of other properties to objects.

Any property of an object is something determinable through experience, and in that sense definable in terms of the experience which would sufficiently assure it. It could thus be said to be a potentiality in the object for leading to experiences of a specifiable kind under suitable conditions; and could even be said to be relative to experience if one should choose to use this phrase 'relative to' in that somewhat dubious fashion. But a property so specified is not relative to any *particular* experience, or to experience of any particular person, but is an independent character of the thing, inasmuch as any particular experience may fail to be indicative of the character of experience in general to which it is capable of conducing. Further, a property defined as a potentiality of experience is independent and objective in the sense that any potentiality of a thing depends on what it would, could, might, lead to, but not necessarily on what it does effect in actual fact. An actual trial of it may happen to be inconclusive or misleading as to the objective potentiality tested; and at best will be confirmation or disconfirmation only and not a final verification. Furthermore, what potentiality is resident in a thing, is independent of the question whether in point of fact it is tested at all.

Thus the conception of esthetic or inherent value as constituted by the quality of the particular experience in the presence of the object, represents such a value as relative to the individual subject. And failure to distinguish between the quality of the experience and the value-property attributable to the object, must inevitably lead to such subjectivism. But the conception of it as a potentiality for conducing to certain positive value-qualities in experience, represents esthetic or inherent value in an object as an independent property of it; one which, like other properties, is tested by experience, but is not relative to any particular experience or to the value-findings of the individual.

Nor is it any mark of the subjective in esthetic or otherwise inherent value that there are variable conditions on the side of the subject which affect the apprehension of such value. Remarking such conditions is important in the discussion of esthetics because they notably affect the practice of the arts and the necessary discipline of those who would enlarge their capacity for esthetic enjoyment or cultivate that discernment by which they may more surely and accurately judge, from a single inspection, the potentialities of an object for their own further value-findings in the presence of it, and those of other persons. That is, such subjective conditions are important for esthetic evaluation, not because they are conditions of the value in the presented *object,* but precisely because they are conditions of any reliable *test* of a value whose authenticity is still independent of any such single value-finding.

Those who emphasize such 'subjective conditions of esthetic value' as if they were peculiar to this particular property of things and to situations in which value is disclosed, would seem to forget that other properties also have their test-conditions in terms of the subject or observing organism. That we cannot reliably determine temperature with cold hands, or judge of shape without reference to our spatial orientation, or tell the weight of things by looking at them without lifting, is not a consideration affecting the independent reality of color or shape or weight in things, or the potentialities of the objects in question for experience in general. And one who should express the fact that we cannot observe colors with our eyes shut by saying that open eyes are an essential condition of those situations in which alone color occurs, would at least be using language in a strange fashion. One who makes the corresponding statement concerning esthetic value in objects, is likely to be similarly misleading. He stands, moreover, in some danger of the fallacy of subjective relativism, which says that beauty is in the eye of the beholder and that concerning tastes there is no disputing.

That value in objects is a potentiality of them for conducing to experience of positive value-quality, has no such relativistic implication: this property of the object remains just what it is regardless of the question whether the further conditions for such value-realization in experience—those on the side of the subject—are met in any particular case or not. It likewise avoids any suggestion that the arithmetic of counting noses has any relevance to an inherent value like the esthetic ones.[1] That

a sentimental picture like The Doctor is more widely appreciated than Still Life with Apples, has no bearing on their esthetic rank. And even if the inherent value of tea has no higher significance than that of democratic appreciation (which our Chinese friends will not admit), still there are such people as tea-tasters, whose discrimination affords a better test of the properties in question than others can make. In measure, the same social process which we rely upon to elicit the truths of natural science works also in the assessment of esthetic values: there are those who are especially to be relied upon for judgment, because they have a greater breadth of pertinent experience, and perhaps some higher degree of the requisite powers of discernment, as well as their special place in the continuity of a tradition which represents the social working of a human critical capacity. Their judgment may stand as against any number of contrary votes gathered indiscriminately, because it is something objective which is judged, and not something relative to the particular and perhaps undiscerning experience. If this social process is less essential and works less reliably with respect to the esthetic than in the natural sciences, and the connoisseurs are a less surely distinguished class, that fact too has its explanations: on the one side, the subjective conditions for apprehending the beautiful are somewhat more commonly satisfied than are those for the appreciation of truth in quantum mechanics; and on the other side, there are no crucial experiments in art. In art as in science, there are subjective conditions of the disclosure of the properties of things which are in question; and these conditions of discernment are satisfied in varying degree in different experiences and the experience of different people. But in art as in science, what these subjective conditions affect is the discovery and discrimination of the properties of things: they have no part in creating the objective character which is to be discerned and assessed. If it were not for this independent status of the esthetic qualities of things, training and cultivation of our capacity to discern them would be pointless, and mistakes in the determination of esthetic value would be impossible. And there can be no implication contrary to this objective character of esthetic value in objects, in the fact that this objective character consists in a potentiality for the disclosure of positive value in the presence of the object. As we have observed above, other properties than value are likewise interpretable as potentialities in the object for leading to experiences of a predictable kind; and for other properties also, there are subjective conditions of such experience which confirms the predication of them to the object.

The contrary conception that subjective conditions exercise some creativity in the case of values, commonly arises from one of two mistakes; either there is confusion as to what it is which is judged in a value-judgment, or this term 'value-judgment' (or some synonym) is applied where in fact there is nothing which is judged. If what is to be reported is the value-quality in a present experience, such as our confrontation with an art-object, then no judgment is called for. This value-quality resident in the phenomenal content of the experience itself, is

merely found. Applying the term 'judgment' to such a direct value-finding is simply a poor and misleading use of the word. This same experience may also have cognitive significance as a clue to or a confirmation of a judgment as to the potentialities of the object for *further* experience. But such predictive judgment based upon this experience must not be confused with the immediate value-finding within the experience itself: the potentiality judged is a property of the object, and the judgment of it is something calling for confirmation; but the value immediately disclosed belongs to the given experience itself, and the attribution of it neither calls for nor could have any confirmation.

There are, however, certain complicating considerations which require to be observed—even though they do not, in the end, imply any qualification of what is said above. First, there is a certain sense in which the value directly disclosed in given experience may still be said to be *assessed;* and second, there is a further sense in which the *esthetic* quality of an experience may be *judged*. Third, the object of esthetic judgment is oftentimes not a physical thing but something ingredient in it which is easily confused with a quality of experience, or with a mental entity. The first two of these considerations will be taken up in the order mentioned. The third of them is incidental to the larger and more important topic of the laws or specific principles of esthetics.

2. We frequently evaluate experiences as such; because having or not having experiences of a particular character is a matter over which we have partial control, and in which we have a ruling interest. One experience is better than another; characterized by a positive value-quality which is higher in degree; and we are concerned to make such comparisons of different experiences. Such comparative evaluation is clearly an assessment of a particular kind. Whether or not we call it a judgment, will be a matter of no great moment, provided we are clear as to its nature.

Let us first consider an analogue here, which is somewhat simpler. If we are presented with two apples at the same time, we may observe that one is redder than the other; or more accurately, what we may observe directly is that one is redder-*looking* than the other. We may make direct comparison of the phenomenal or presentational quality of apparent redness and assess the degree in which this characterizes one of these presentational items as compared with the other. Whether such assessment should be called a judgment, is doubtful: the comparison being direct, and the items compared being directly given, the decision, "This is more red-looking than that," is subject to no possible error, unless it be one having to do with linguistic expression and not with what is expressed. Perhaps we would best say that no judgment is involved but only recognition of a presentational fact.

The case might, however, be slightly different: the appearance of a presented apple might be compared with that of one seen yesterday. In such a case there definitely would be a judgment, though one of a peculiar sort, because one of the two presentational items to be compared is

not now given, and its present memorial surrogate may fail to coincide with the actual character of what it stands for, in the respect which is pertinent. If, then, I decide, "This apple looks redder than the one yesterday," I have made a judgment which is subject to possible error. But the element of judgment in this comparison concerns the *absent* member of the pair compared. The relation of the now-given item to this absent one calls for judgment, not on account of any possible dubiety about the red appearance presently given but only because it is related to something not now given. The redness of this present appearance is indubitable; but its *comparative* redness is something judged because related to something which can be determined only by a judgment.

Or the case may be of a third sort: one apple only may be now presented, and I may assess it as a very red-looking apple—implicitly by comparison with the whole class of apple-appearances in my past experience. This assessment of a *degree* of redness of the present appearance, is plainly a judgment, or involves a judgment. But again, it is, in an obvious sense, the class of other apple-presentations, mnemically presented, which is subject of the judgment, and the red character of the given presentation is not judged but is indubitable.

The assessment of a degree of value in a present experience, differs from assessment of the degree of redness in the presentation of an apple, in two respects. First, if we should say that the red-appearance of a presented apple is only *apparent* redness, then we must observe that the *value*-appearance in a present experience is not merely apparent value, but actual and intrinsic value; that kind of value in the light of which all other values are to be determined. And second, while two presentational items within a single given experience might be compared as to their immediate value, the value-quality of one experience cannot be directly compared with that of any other, since no other can be present. When we assess the value-quality of a present experience, we do so in the manner of the second or the third of the above cases. Thus in assigning a *degree* of value-quality to present experience, or to the phenomenal content of it, we make a judgment. Yet in the sense pointed out, it is not the present and indubitable value-quality which is judged, but rather the value-quality of other and absent experience with which, explicitly or implicitly, we compare it, which is the subject of the judgment.

This kind of consideration has its pertinence to assessments of esthetic value. Even in cases where what we wish to judge esthetically is not the directly given presentation but the objectively real thing presented, we may make this judgment of the object mainly or exclusively from the character of our experience in the presence of it. Thus our attribution of esthetic value to the object may be based on and reflect an assessment of comparative value as characterizing our direct experience. And these two somewhat different assessments—of value found in the experience and of value in the real object presented—may fail to be distinguished.

Thus the directly found value-quality disclosed in an experience

may, first, be confused with a comparative assessment of it; and second, this comparative assessment of a value in present experience may be further confused with the objective value-property of the presented object; with the result that the value-quality which is found in experience and not judged, comes to be identified with the objective value of the thing observed, which is a property which has to be judged—and may be erroneously judged—because it is not given but only evidenced in some measure by the quality of immediate experience. Perhaps this failure to make distinctions which are required, plays its part in the inappropriate extension of the word 'judgment' to direct apprehensions of esthetic quality, as well as in the fallacious supposition that the esthetic character of an object is somehow created by the nature of experience in the contemplation of it, or characterizes the subject-object confrontation only, and cannot be attributed to a presented thing in the same sense as color or shape or other properties.

But one thing at least should remain clear in this whole matter. Wherever there is a judgment of esthetic value in an object, based on the value-character of an immediate experience, or on an assessment of comparative value in the experience itself, it still remains true that the value disclosed in the experience need not be judged. The value directly found need not be assessed in order to be disclosed and enjoyed, nor compared with any other in order to have its own apprehended quality. It is this immediate value-quality which is the fixed and indubitable element in any comparative assessment of it: the dubitable element or elements, by reason of which evaluation of it may be a judgment, is not the value attributable to this experience which is given but the value attributable to that with which it may be compared.

3. Turning to the second point mentioned above: we may observe that even in the sense in which the value of the phenomenal as such, is one which is found and not judged, the *esthetic* quality of experience may still be a matter of judgment. If our account of the manner in which esthetic experience is marked off from experiences characterized by other intrinsic values should be correct, then there is no purely presentational quality which, for example, is sufficient to distinguish genuinely esthetic experience from the non-esthetic satisfaction of an appetite, or the child's satisfaction in some novel and intriguing noise, or the writer's satisfaction in seeing his name in print. Immediate enjoyments, though various in quality, are still too nearly of one kind to afford any sure indication of the purely esthetic. For that, we must have recourse to criteria which are indirect and reflect, for example, the fact that this kind of experience is one which can be well-maintained instead of exhausting itself soon and leading to dissatisfaction. We learn, in measure, to recognize immediately in experience the signals of such enduring character or the opposite, which admit or rule out an enjoyment from the category of the esthetic; but it is not the enjoyability itself—not the direct value of the given experience—which constitutes this criterion. The artist and the connoisseur doubtless acquire in high degree such

ability to determine from directly given clues whether the satisfaction in a painting or a piece of music is the kind that will endure or one which will soon fade; and their apprehension of the enduring ones doubtless is infused with a subtle and derivative immediate quality in their cultivated enjoyment itself. But—to use a comparison—if the tea-taster's experience has developed his capacity to forecast that the tea will soon lose its bouquet, and such tea does not taste quite right to him, still it is the predictable fact signalized and not this subtle immediate signal of it, which marks the tea as not good-quality tea. And if the esthetician's sixth sense of the enduring in art enables him to classify enjoyments as esthetic or non-esthetic by clues which are immediate and immediately affect his own enjoyments, still it remains true that it is not the immediate enjoyability but the signalized endurability of enjoyment which constitutes the sufficient criterion of genuine esthetic character in the experience. Such judgment is directly an assessment of esthetic quality in the *object;* and only indirectly of the genuine esthetic character of the *experience.*

In this sense, the distinctively esthetic character of experience is not simply disclosed but has to be judged. But the judgment in question is one of its classification as esthetic (which calls in some measure for a prediction), and is not the judgment of an immediate value as such. Thus even if, or insofar as, the esthetic quality of experience must be determined by judgment, it still remains true that the directly disclosed value in an experience, whether esthetic or not, calls for no judgment but is indubitable when found. And such values directly disclosable in experience are the final basis and the ultimate referents of all judgments of value.

4. It is no part of our task in this book to attempt any contribution to the science of esthetics. Our concern is with the analysis of esthetic judgments; with the question, "What does it mean to say that x has esthetic value?," and with further problems subsidiary to that. The positive science of esthetics concerns a different and a further question; namely, "By what specific criteria, or by reference to what laws, is the esthetic value of a particular thing to be gauged?"; or "What principles must govern the creative activity of the fine arts, in order that their esthetic purposes may be realized?" As a preliminary let us observe the difference of aim which must govern the attempt at analysis of esthetic judgment and the attempt to determine the specific principles of esthetics, as well as the relation between these two different objectives.

We may help ourselves out on this point by observing the analogous distinction in the case of two other sciences, logic and physics. With respect to the topic of validity in inference, there are similarly two different kinds of questions. First, "What does it mean to say that a piece of reasoning is valid: in what does this character of validity consist?" That question belongs to analysis; to the *theory* of logic. As we saw in Book I, we may return to it the answer; "An inference is logically valid if it can be certified by reference to intensional meanings alone." Second, there

is the question, "By what specific principles may particular inferences be adjudged valid; by what laws should our procedures of inference be governed in order to attain validity; by what specific criteria may validity be attested in case of doubt?" The answer to that question is to be given by a sufficient canon of inference; by a body of principles belonging to the positive science of logic. The connection between these two different questions lies in the fact that a correct answer to the first, the analytic question or question of theory, determines the underlying and general criterion by reference to which it can be determined whether a particular statement put forward as a rule of logic, is in fact a true law and affords a specific test of valid inference. Any mind which grasped this general nature of the logically valid, would thereby be in position to proceed to solution of the second problem of finding laws of the positive science of logic. However, something more than such grasp of the meaning of 'logically valid' would be required for this; namely, acquaintance with more specific meanings in terms of which such positive laws of logic could be formulated.[2]

So too in physics, we have first the general questions of theory, which concern the meanings of attributions of the various essential properties of physical entities: what it means to say that a thing is so long; that a physical particle has a certain position and a certain velocity; that two events are simultaneous; and so on. Such questions belong to physical theory, and are to be answered by analysis; by adequate and accurate explication of physical concepts.[3] It is, implicitly, on the basis of such theory that one can proceed to discovery of the laws of positive physical science (those which are not disguised definitions or merely logical consequences of them). But for this second question of the specific laws of physics, observation of physical phenomena is also requisite. And for the sake of comparison with esthetics we may also note in passing that these positive laws of physics exercise a normative function in engineering and other creative activities which operate with physical things.

However, a fundamental difference is to be observed between logic and physics with respect to the phenomena acquaintance with which is essential for the positive science. The phenomena of logic are themselves phenomena of meaning only, and of relations of meaning. And any meaning is expressible by some statement the truth of which is analytic and *a priori.* No recourse to empirical facts (unless facts of the use of symbols to *express* meanings) is required for the science of logic. Its investigations can be inductive only in the Aristotelian (or Socratic) sense of eliciting from instances something which, when elicited, can be attested 'by reason.' But assuming correct answers to the questions of physical theory, which call for an analytic answer, the second kind of question, of the positive laws of physics, can only be answered by inductive generalization in the usual sense. Logic is an *a priori* science, and by that fact continuous with logical theory; but physics is an empirical science; though determination of the overall criteria of the various physical properties is analytic and *a priori,* and could not be otherwise, however much it looks to something implicit in the unself-conscious practice

of physical science for those meanings which it is called upon to explicate.

In esthetics similarly, there is the first or theoretical question of the meaning of esthetic attributions. The answer to this is to be determined analytically and *a priori,* however essential it may be that, in arriving at it, we should look to and be governed by something which is already implicit in practice and in particular evaluations. But assuming a correct answer to this question of the nature of esthetic value—for example, the answer we have hazarded, that it consists in a quality which solicits contemplative regard and affords a relatively enduring enjoyment for such contemplation—there is the second kind of question also; *"But what particular character or characters of things makes them sources of enduring contemplative enjoyment?";* "By what marks, universally present in objects which offer such enjoyment and universally absent from those which do not, may we recognize the esthetically valuable in case of doubt?"; "To what specific principles shall we look for guidance in activities directed to creation of the esthetically valuable?" And that kind of question can be answered only through induction: it requires generalization from observed instances of the esthetically valuable. The answers to this kind of question belong to the positive science of esthetics.

Here, as in logic or in physics, the definitive explication of what is meant in attributing esthetic value operates as the basic criterion of those phenomena which are pertinent to determination of any specific law, and thus represents the basis from which, either explicitly or implicitly, investigations of the positive science must proceed. But esthetics, like physics, is an empirical science; and the positive laws of it require to be elicited by inductive generalization from particular instances of esthetic phenomena. Thus the nature of esthetic value is a question to be answered by analysis and *a priori,* and constitutes a topic for philosophic investigation. But the laws of the positive science of esthetics are a question which must be left to those who possess sufficiently wide acquaintance with esthetic phenomena and are sufficiently expert to be capable of arriving at trustworthy empirical generalizations in this field.[4]

There are, however, certain generalities in the field of the positive science of esthetics which it will be well for us to consider. Some of these have important bearing upon those epistemological problems with which we are primarily concerned; in particular, upon the distinction between the subjective conditions of esthetic *experience* and the objective conditions of esthetic value in things. For this reason it will not be out of place here to observe briefly, in conclusion, certain facts having this kind of pertinence, even though full discussion of them would lie outside our province.

Notes

1. Economic value is peculiar in this respect: being definable in terms of salability, it is thus relative. Certain other social values would also have a similar character.

2. As was observed in Book I, there is also a still further question in the case of logic: "What statements capable of attesting validity of inferences are of sufficiently frequent use to be regarded as principles of logic?"; and to this question, there is none but a conventional or pragmatic answer.

3. As examples of physical theory, in the sense of 'theory' here used, one may cite Bridgman, *The Logic of Modern Physics;* Lenzen, *Physical Theory;* and the early chapters of Eddington, *The Philosophy of Physical Science.*

4. It is of course true that particular esthetic judgments do not necessarily wait upon the development of the positive science, nor presume command of it. In any field, the development of positive science requires an antecedently determined body of particular truths. There were correct logical judgments before Aristotle, geometrical determinations before Euclid, and attested physical facts before Galileo or Newton. Had there not been, these positive sciences could never have arisen.

Albert Hofstadter

A graduate of Columbia, Albert Hofstadter taught at that school from 1950 to 1967. He is now Professor of Philosophy, Stevenson College, University of California at Santa Cruz, and author of Truth and Art *(1965) and* Agony and Epitaph *(1970).*

On the Grounds of Aesthetic Judgment

The particular question before us, as I see it, is not to say what we mean when in ordinary language we predicate some form of "good" of an esthetic object. It is rather to indicate a possible sense of "good" which can be accepted by artists, the public, historians, and estheticians as suited to the purpose of making esthetic judgments. It is a question, not of analysis of ordinary language but of proposal for critical language, not of description but of reconstruction of usage.

From *The Journal of Philosophy,* Vol. 54 (1957), pp. 679–88. Reprinted by permission of the author and the publisher.

1. SPECIFICATION OF THE PREDICATE IN ESTHETIC JUDGMENT. To speak of an object as esthetically good, better, best, is not yet to make a specific predication. What is good as design is not necessarily also good as representation; what is good as comic is not necessarily also good as tragic. The statement "*A* is esthetically good" asserts no more than that there exists some esthetic respect, not specified, in which *A* is good.[1] The esthetic goodness of an object depends on the particular respect we have in mind. Thus "good" should preferably be "good in such and such a respect" or "in regard to such and such a characteristic."

Of special interest among these respects are characteristics like beauty, sublimity, the comic, the tragic. Traditional esthetics concentrated on traits of this sort because it saw in them the forms of peculiarly esthetic value. There is insufficient space to discuss this point, but I shall assume that the normative problem hinges mainly upon such value traits and shall restrict my discussion to this type of characteristic. My remarks, therefore, will have to do with judgments like: "*A* is good in respect of its beauty of design," "*B* is good in respect of its ludicrousness of aspect." Even these should be thought of as further specified in the predicate, as: "good in respect of the beautiful proportions and rhythms of its longitudinal plan," "good in respect of the ludicrous deformation of nose and chin." Without such specification of the predicate our judgment loses specificity of content and definiteness of direction and tends to degenerate into a mere existential generalization.

2. SPECIFICATION OF THE REFERENCE PUBLIC IN ESTHETIC JUDGMENT. Predication of "good" also tends to lose meaningful direction when the public whose valuations are considered in judging the object is not specified. I do not see how we can hope to speak sensibly about the esthetic goodness of objects unless we think of them in the context of reception and valuation by persons, the so-called "context of consumption." Properties by virtue of which we value objects esthetically—e.g., beauty, grace, charm, the tragic, the comic, balance, proportion, expressive symbolism, verisimilitude, propriety—always require some reference to the apprehending and valuing person. To call something a joke, for instance, is to imply that it is an object apt to arouse a comic sentiment in the hearer; or to speak of a visual design as balanced is to refer to phenomena in the perceptual field of a viewer.

When judgment is based solely upon one's own appreciative experience, the public presupposed consists of a single individual, oneself. A public may, however, be a narrower or wider group ranging from the self to the whole of mankind: the company assembled in a living room, gallery, concert hall, or theatre, American middle-class children from 10 to 14 years of age, Canadian women's club members, old New Zealanders.

Two forms of universality, or interpersonal consensus, should be carefully distinguished:

(1) *Universality of appeal.* This is a possible property of an *esthetic object,* e.g., a sunrise, which might be appreciated or valued by

all members of a given public, eventually all human beings. This is a consensus in *valuation*.

(2) *Critical universality*. This is a desired property of a *judgment about an esthetic object*. It consists in the agreement of all qualified investigators regarding the truth or probability of the judgment. It is a consensus in *evaluation*.

It is not necessary for an esthetic object to have universality of appeal in order that a normative judgment about it should have critical universality. "This is a good story in regard to the valuations of children aged 10–14" may have critical universality even though the story may appeal only to 89% of children aged 10–14. The question whether there are esthetic objects, and if so which, of which we can truly say "*A* is good in such and such a respect in regard to valuations of the set of all human beings" is interesting, but only one of many esthetic questions.

Any public taken as the public referred to in a normative esthetic judgment I shall call the judgment's *reference public*. The reference public is the group whose appreciations or valuations are used as data on which to base the judgment. It is the group to which universality of appeal may or may not appertain. It is not the group of investigators whose consensus is necessary for critical universality.

Specification of the public means recognition of a fact admitted by all, namely, the variation of appreciative valuation among persons and classes of persons. It does not imply relativism in regard to normative judgment, unless we identify appreciation (i.e., valuation) with judgment (i.e., evaluation), or at least make appreciation an essential part of judgment. The requirement of critical universality for all qualified investigators holds of judgment regardless of the extent or nature of the public referred to in the judgment.

It should be noted that the public envisaged may be one which exists partly or wholly in the future, as is suggested in the judgment, "This is a good symphony, although the present age is not capable of appreciating it; it requires a mode of experience and comprehension which will be forthcoming only in another generation or two, when the musical ear has been further trained by it and other music like it."

3. THE COMMON ELEMENT IN THE MEANING OF "GOOD" IN ESTHETIC JUDGMENT. There are various theories of what is common to normative judgments *qua* normative, e.g., reference to a genuine ideal standard, intuitive insight into value, ceremonial function, emotive or attitudinal expression, the effort to persuade. It is not necessary to discuss such theories here so far as they attempt merely to describe ordinary, traditional, or current usage. Our aim is rational reconstruction, not description. While in some uses "good" may refer to a standard accepted by the user as authoritative, and in other uses it may be a ceremonial means, an expression of feeling or attitude, a means of exerting psychological pressure, or the verbal statement of an alleged intuition, it is desirable for esthetic and critical purposes to have its meaning cognitive and em-

pirically confirmable, no matter what further functions it may then assume. Evidence advanced for the ideal standard theory has been insufficient to satisfy qualified students of esthetics and criticism. Ceremonial, expressive, persuasive, and other non-cognitive theories have a certain validity as descriptive of some phases of actual usage, but do not satisfy the cognitive requirement. Intuitionalism does not satisfy the requirement of empirical confirmability.

What is common to all normative judgments of the sort entertained by us? On our view, it is a reference to the capacity of the object to function as focus of a particular valuation response or sentiment experienced by members of a reference public.

This may be illustrated by the case of ludicrous percepts. A face is a good comic object for a given reference public in the degree to which it is able to arouse comic sentiment in the members of that public. I cannot stop to try to describe this sentiment. It is a familiar, much discussed complex of perceptual, ideational, affective, and conative factors, often outwardly expressed in a smile or laughter. It carries pleasant affective tone and is therefore a valuation event, but it is not a mere isolated pleasure (if there are any such at all). It is a complex response focused upon an object in a situation. It is thus a specific response directed toward a specific object.

The point cannot be argued here, but I proceed on the hypothesis that there are specific sentiments of various sorts which are valuation responses to specifically different esthetic objects. Some of these were recognized by traditional esthetics under its categories of beauty, sublimity, grace, charm, the comic, the tragic, etc., but I believe that they are more numerous and that it would be important to study them in order to extend the terrain of normative judgment. On this hypothesis, esthetic response is not the mere having of a pleasure due to perception of an esthetic object. It is rather the formation of a definition sentiment response. (I assume, by definition, that a sentiment is a complex affective occurrence, including always some affective tone of pleasure or displeasure, involving always some pro or con attitude, or ambivalent combination of them, toward the object.)

The goodness of a ludicrous object, then, is conceived as the degree of its capacity to function as focus of the comic sentiment in the given reference public. Crudely speaking, the factors of this goodness are:

(1) *Extensity,* which measures goodness by the number of members of the reference public who are affectible by the object;
(2) *Quality,* which measures goodness by the satisfactoriness to the individuals of the sentiment arousable.

Goodness, conceived here as a capacity, is rather an instrumental or relational than an intrinsic or absolute value. The criterion is pragmatic and experimental. The object's goodness is measured by its capacity for effect or success in affording satisfying esthetic sentiment in a given reference public.

4. THE COGNITIVE GROUND OF JUDGMENTS OF ESTHETIC GOODNESS. On the above view, a judgment of goodness is interpretable more or less in the following fashion: "A is a good joke in regard to American middle-class children aged 10–14" means "A has the capacity to arouse comparatively satisfying comic sentiment in a comparatively large proportion of American middle-class children aged 10–14." This is a kind of "market research study" statement.

Such a judgment presupposes the existence of a capacity, i.e., it presupposes a lawful (or at least statistically significant) connection between certain characteristics of the object (the ones that make it ludicrous, e.g., exaggeration, duplicity of meaning, an unfortunate outcome, etc.) and certain psychological conditions in the persons (e.g., a playful mood, apperceptive background for perceiving exaggeration, etc.) on the one hand, and the onset of the comic sentiment on the other. Adopting the simplest form, it presupposes something like the following to be a law:

> For all objects O_x of type X and for all persons P_y of type Y, O_x has the capacity to arouse comic sentiment in P_y, and this capacity is a function of (1) certain specified characteristics of O_x (the ones that make it ludicrous) and (2) certain specified conditions in P_y (which enable him to respond with the comic sentiment).

I believe that connections of this sort—or, more probably, of a subtler and more complex kind—are real, and I proceed on that belief as an hypothesis. It is my conviction that one major goal of scientific esthetics is the discovery of such laws. To the extent to which we know them, we can predict what objects with what characteristics will arouse what esthetic sentiments in what publics with what extensity and quality. Knowledge of this kind would provide solid and dependable cognitive grounds for judgments of esthetic goodness as interpreted above.

5. THE PROBLEM OF RIGHTNESS IN APPRECIATION AND CONSTRUCTION. What has been said thus far must appear insufficient in many ways, but especially in three.

(1) It is crude, hypothetical, indefinite, and depends more on possibilities than actualities. I will not try to answer this charge, since it is for the most part true.

(2) It omits the heart of the matter in regard to appreciation. What we want is not relative goodness but something more absolute or categorical, something really normative. Granted we may achieve knowledge telling us that one kind of object is more sentiment-arousing than another in some reference public, or that an object is more sentiment-arousing in a first than in a second reference public, we want to know whether there are rational grounds for asserting that one object is simply better esthetically than another. We want to be able to say, with good reason, not merely that A is more comical than B in a given refer-

ence public, but that *A* is really more comical than *B* and that this superiority makes it really better esthetically than *B*. We want to be able to say to someone who prefers *B* to *A* that his taste is wrong, that he does not know how to appreciate *A* and *B* truly, properly, or rightly.

(3) In a similar way, the artist may dismiss goodness relative to a reference public as only a matter of market research study. What he wants to know is not how effective his work is in arousing particular sentiments or valuation responses in indiscriminate publics, or even in all of mankind, but how to construct a really good work, one which *ought to be* responded to with approval. He does not want to be told, "Develop the hero in this way rather than that, in order to arouse such and such a sentiment in such and such a public." He wants to be told, "Develop the hero in this way rather than that, in order to improve your story in such and such a way." One manner of development is righter than the other, or one is right and the other wrong, artistically.

These two latter charges raise a single fundamental question. Is it meaningfully possible to search for a judgment resting on rational grounds which would assert *without regard to any reference public whatever* that one object is more beautiful, more comic, more graceful, more tragic than another?

I believe that the answer is, No.

(1) Esthetic traits are such because, among other things, they are due to objects operating within experience, objects as phenomenal. Incongruity in a percept does not belong to the object independently of a subject whose apperceptive tendencies are needed to provide the implicit pattern of congruity and whose perception supplies the object that disagrees with this pattern; and congruity of visual elements in a pattern of esthetic fitness is simply not a property that a physicist could find in the object outside the perceptual response.

(2) These traits obtain their value content in and through the sentiments which focus upon the perceptual objects. No sentiment, no valuation. Valuation requires the adoption of a pro or con attitude (or a combination of them) toward an object, and such attitudes occur only in the form of a sentiment response to the object (in matters esthetic).

Hence, if we are to say that one object is more graceful, more comic, more beautiful than another in senses which connote value, we must refer to *some* public.

6. THE PROBLEM OF A STANDARD PUBLIC. The question therefore becomes: Is there a *privileged* public for normative esthetic judgment? Is there some reference public whose sentiment responses can be used to define genuinely good taste, as a standard of taste? Is it the public that consists in the common man, the secretary of the party, Congress, the artist's coterie, the man of pure reason? Or are there *rational* grounds for choosing a public as authoritative?

The question of a standard public is, in another form, the question of right or appropriate conditions in a given public qualifying its mem-

bers as privileged. Thus the question is: Are there rational grounds for viewing certain conditions or qualifications of persons as being right or appropriate in order that their valuations or sentiment responses should be supposed authoritative for evaluation of an esthetic object? Is there a criterion of genuinely good taste consisting in "appropriate conditions or circumstances of the appreciator"?

One would not want to include in a public that was to determine comic values the *agelast,* the person with no sense of humor. One would want him to have a wide, deep, strong, fine, light, and flexible capacity to feel, think, and perceive the aspects of objects that make them comic for various publics. One would want him to be able to feel what it is to laugh at objects exactly as people in various publics do, so that he would be acquainted in his own experience with the laughter of childhood and maturity, folly and wisdom, vulgarity and refinement, the primitive and the civilized, the West and the East. If such a person preferred one to another comic object, it would not be because he was limited in capacity or viewpoint but because, being able to experience all the kinds in all the ways, he would be able to compare. And what he chose as more comic would be likely to be more comic in an eminent sense just because of his qualifications.

Suppose there existed a number of such persons. Would their preferences agree? There seems to be no *a priori* reason to suppose that they would. To discover whether they would, we should have to know laws such as were mentioned earlier, or, better, know a theory which would enable us to derive the laws of esthetic experience of these ideal personages. But we have no such laws or theory at the present time and are hardly likely to obtain them in the foreseeable future of mankind.

If we are to have a standard public, then, must we follow a Kantian procedure and believe, without available evidence, in the real possibility of Ideal Persons of this sort among whom valuation consensus reigns? Shall we postulate an *Ideal Kingdom of Good Taste?* This would seem to be the only kind of privileged public that could ground normative judgments which are more than merely relative to an existent defective public. What the Ideal Public agreed on as most comic, most tragic, most beautiful, most sublime, we could take to be simply such. Its taste would be legislative for us, and our categorical judgments would be nothing but hypotheses concerning what the Ideal Public would say about the particular object under consideration.

The difficulty is that we do not know that such an Ideal Public is really possible and do not know what, even if it were possible, it would say. Thus our hypotheses about its pronouncements are at present unverifiable, even though in principle they might be verifiable in the distant future. For the present, therefore, we are reduced to seeking a more mundane substitute.

Shall it comprise real persons of the past, present, and future who, in our opinion, approach most closely to an Ideal Public? Shall it be, as

it were, an *Earthly City of Taste,* numbering among its citizens connois-
seurs, sensitive historians, talented critics, artists when not on their hob-
byhorses, producers, performers, and amateurs? This is a highly mixed
public, in which consensus is not always great. It is more serviceable,
perhaps, for rating objects of the past than the present, and that part of
it that has still to be born and grow is beyond our consultation. In saying
that a work will be rated by it as more beautiful or more comic than
another, we risk an hypothesis whose truth the future, as well as the past
and present, must determine. And even this public of the wisest and best
cannot be granted unquestioned authority. There are times when we
must risk defying it and reach out on our own responsibility toward a
public more ideal, not knowing but only trusting that something really
possible is there to support us.

This need to assume responsibility suggests a third alternative (from
among many more), and that is to take on by ourselves, in collaboration
with others also willing, the task of striving to reach the condition of a
member of an Ideal Public. It consists in learning to discern aspects of
objects that make them beautiful, sublime, comic, tragic for various
publics and in developing our affective-conative nature as far as possible
so that we may know what it is to feel the sentiments that naturally arise
in response to those objective aspects in different publics. Then, trusting
to our own sentiments or valuations as those of a privileged public, we
judge the value of an object by its capacity to arouse a pro-sentiment in
ourself. In this process we try to make our own nature a more refined and
more sensitive instrument capable of responding better to the esthetic
state of affairs than it would if less developed, and we judge the object
on the basis of our recording of its sentiment-arousing capacity. We have
not escaped all subjectivity, but we have made our subjectivity less blind
and less limited. In our judgment we make a claim to act as a member
of an Ideal Public. Our judgment must compete with the judgments of
others, and we will respect the judgments of those who also strive toward
this ideality, for they are honorable competitors and make the same
claim as ourself. In this market place the critical struggle is carried on.
There is no magic way of avoiding conflict. The only hope is for each to
do the best he can.

When we turn to the question of esthetic rightness in construction,
the story is not very different. If a constructional proposal says, "Draw
this line rather than that, because your drawing will thereby be better
in such and such a respect," we must ask, "In what respect is improve-
ment being considered?" I believe the answer is, "In respect of beauty,
or of comic effect, or of sublimity, etc." We cannot escape the context of
consumption by shifting our language to the context of production, for
production is always with reference to some trait to be realized in the
work by which an esthetic effect in a person or public is made possible.
The question then arises, "Is this trait—this particular source of beauty,
ludicrousness, sublimity, grace—to be preferred?" The answer cannot

avoid specifying some reference public; and if the reference public is to be privileged, the artist has the responsibility of deciding on its constitution.

7. SUMMARY. The upshot of our discussion is this. All normative judgment must include a reference to the respect in which the object is judged and to a public whose sentiment responses to the object are to be used as valuation data for evaluation of the object. The common element in predicating goodness is the capacity of the object to serve as focus for a satisfying esthetic sentiment in the reference public. To arrive at rational cognitive grounds for such predication it is necessary to know, or make use of an hypothesis about, the connections of objective and subjective conditions with the particular sentiment involved. To achieve normative judgment with some claim to authority (which will express genuinely good taste or create new good taste) one must specify a standard reference public. We might postulate an ideal public, and if we knew enough we could say whether there is such a public and what it would pronounce. In the absence of such knowledge, we might choose the wisest and best people of the past, present, and future, or some analogous though more restricted group. But their dictates do not come with a single voice, they cannot claim irresponsible sovereignty, and we must risk what the future will bring and, sometimes, risk flouting the whole of past, present, and future.

Thus in the end we cannot evade judging on our own responsibility, but we can reasonably be asked to try to develop our own taste so that, approaching an ideal condition, our judgment rests on valuations less defective than might otherwise be the case.

Note
1. Such a respect, as, e.g., subtlety of balance, intensity of dramatic development, grace of movement, charm of facial expression, sublimity of utterance, is sometimes spoken of as a ground or reason for a predication of goodness: "A is good because it is subtly balanced, develops with dramatic intensity, etc." A respect of this sort can serve as ground or reason because the statement "A is esthetically good" has existential generality, i.e., asserts in a unspecified way the existence of some such respect. Citing the respect validates the existential claim.

Theodore Redpath

Theodore Redpath is well-known in Great Britain for his literary scholarship. He is co-editor of William Shakespeare's Sonnets *(1964).*

The Relations Between Evaluations, Reasons and Descriptions in Aesthetics

Suppose someone were asked why he thought Jane Austen's *Emma* a good novel, and replied (whether justifiably or not is not in question) that it was a good novel for many reasons, and, in particular, because it showed a deep knowledge of human nature, and because its moral judgments were always well-grounded, and because it showed a subtle sense of the finer points of day-to-day living, and because the language was always alive and clear, and often striking, and the whole work was strewn with touches of shrewd humour. And, to prevent any misunderstanding, let us take all the reasons given for the overall value-judgment as themselves value-judgments. With regard to such a case an interesting question is whether the relations between the reasons and the overall value-judgment (meaning value-*proposition,* not the psychological act of judgment), are *logical.* A closely allied but different question, carefully to be distinguished from our first question, is whether the relation between the *consideration* that the novel had these various good qualities, and the overall evaluation that *mma* is a good novel, would be *merely causal.* Now the *consideration* referred to would often also be called a *'reason'* for the final judgment; and so our two questions could both be called questions as to the relations between reasons and aesthetic value-judgments (value-propositions or evaluations, as the case may be). These two questions, then, are the first questions I wish to consider in this lecture.

Let us look into the first question.

One way of cutting near to the root of the matter is perhaps to ask: Could there be a novel which showed a deep knowledge of human nature, gave well-grounded moral judgments, showed a subtle sense of the finer points of day-to-day living, and was written in language always alive and clear, and often striking, and was strewn with touches of shrewd humour, and yet was not a good novel?

From "Some Problems of Modern Aesthetics," in *British Philosophy in the Mid-Century,* edited by C. A. Mace (London: Geo. Allen and Unwin Ltd., 2nd ed., 1966), pp. 375–390. Reprinted by permission.

I am afraid we should have to admit that there *could* be such a novel. However much all the good qualities mentioned might be taken to weigh, there might still be some radical defect, say, for instance, a strong tendency to needless digression, or a hopeless weakness of plot construction, which even in a novel with all those good qualities, would nevertheless spell ruin to overall value.

Jane Austen's *Emma,* however, is itself deficient in neither of these two respects. It is admirably economical, and the plot, on a careful reading, gives almost as much cause for wonder as the insight into human nature. This suggests the possibility that if we went on long enough with our list of good qualities we might eventually bar out any chance of some sneaking defect putting paid to our overall value-judgment. *If* such a list were possible, moreover, it would seem as if the relation between the complete list and the overall value-judgment would quite certainly be a logical one: for any novel with the good qualities $q^1_g q^2_g q^3_g \ldots q^n_g$, would *necessarily* be a good novel.

Is it possible to compile such a list of good qualities? I myself cannot *see* that it would be impossible: but I am not proposing to attempt the feat of compiling one in this lecture. Indeed, though I cannot *see* that it would be impossible to compile such a list, I believe it might be difficult to do so. One reason for thinking this seems to me to be as follows: Suppose we compiled a list of good qualities which seemed satisfactory, and then some great moral or aesthetic teacher were to arise in course of time, and either suggest some important criterion of value, which seemed to outweigh in importance all that we had previously considered, or show that the criteria we had employed were, in any case, of small importance, then our list might no longer appear satisfactory to us. A Tolstoy, for instance, might persuade us that we had overvalued the qualities which had made us think the work of Shakespeare great: another St. Thomas Aquinas might see something which made all his writings seem useless, and, by telling us so, might bring us to believe that we ourselves had shallowly overrated them. The ways of evolution are so incalculable that we cannot rule out such possibilities. On the other hand, as far as our question goes, the existence or non-existence of some further awkward criterion, the consideration of which might upset the connexion between our list of good qualities and the overall value-judgment, would not affect the point that the relation between the reasons and whatever overall value-judgment were then valid, would still be logical. The 'reasons' would in that case militate against the new judgment, just as they had supported the old one.

But ignoring the difficulties of compiling such a list, and assuming for a moment that such a list is possible, let us consider its logical status. The complete list would be a statement of a *sufficient condition* of any novel's being good. On the other hand, it would not be a statement of any *necessary* condition of a novel's being good. A novel might not have any of the good qualities listed, and might still be a good novel. Moreover, the list would only be a statement of *a* sufficient condition of any novel's

being good, and so, as I have said, the relation between the proposition that any particular novel had all the qualities contained in this list, and the overall value-judgment that the novel was a good one, would be a *logical* relation.

Let us now assume, though, that it would not be possible to compile a list of good qualities such that any novel which possessed them all would *necessarily* be good. It might still be possible to compile a list of good qualities such that any novel which possessed them would *almost certainly* be good, or at least would *probably* be good. Unfortunately, the same difficulty arises here as with the other list already discussed, namely that it would always be *possible* that some criterion might come to light which would make it clear that a work with the good qualities listed would not even be probably good. Consider the case of Tolstoy and Shakespeare. Tolstoy promulgated criteria of value, such as contribution to the love of God or the love of one's fellow men,[1] according to which (among other more usual criteria [2]) the work of Shakespeare seemed to him inferior. Now Tolstoy was a very great man, and these criteria have a certain impressiveness. The reconsideration of Shakespeare's work in the light of them may even lessen its value in the eyes of some of us. On the other hand, there is little doubt that except with fanatics such reconsideration will not prevent people from thinking Shakespeare's words *good*. Even in Soviet Russia, where one could expect Tolstoy's anti-aristocratic strictures against Shakespeare, based on the second of the above criteria, to have had some powerful and lasting effect, the reputation of Shakespeare is as high as ever. This may indeed be partly due to critical opinion there not having agreed wholeheartedly with Tolstoy as to the tendencies of Shakespeare's work; but it is hard to believe that it is not also partly due to the value attached even in Russia to other literary criteria, though it may also be partly due to disagreement with judgments Tolstoy based on some of *those*. This sort of case suggests that it might be feasible to make a list of good qualities of a novel or other literary work, such that, although it would still be *possible* that the consideration of other criteria would reverse the judgment that the novel was good, such a *possibility* would itself be *highly improbable*. In the case of Shakespeare's work, for instance, we might say that though indeed at some future time some criteria of value might be applied which would reveal that Shakespeare's work was, after all, not good, yet it is very improbable that any such criteria will be applied. Moreover, if that were so, then the relation between the proposition that the literary work in question had the good qualities in the list, and the overall judgment that the novel was a good one, would still be one of probability. To me at least it would seem that such a list of good qualities could be compiled. It might, indeed, not be much longer in the case of a novel, for instance, than the list of good qualities mentioned in connection with *Emma* at the start of this lecture. Now, suppose we had such a list, would the relation between the proposition that a novel had all the qualities in the list, and the overall value-judgment (value-proposition) that the novel

was good, be a *logical* relation? The answer seems to me clearly to be that, if we call probability a logical relation, then the relation between those propositions is a logical relation. The answer, therefore, depends ultimately on whether probability is a logical relation. This is, as you know, a highly controversial issue, on which great brain-power has been exerted.[3] It would be presumptuous even to start to attack that difficult problem in this lecture. I shall only say that I personally feel attracted, as far as this case goes, by Keynes's view that probability *is* a logical relation. That being so, I feel inclined to the view that the relation between the proposition that a novel has all the qualities in the supposed list, and the overall value-judgment (value-proposition) that the novel is good, is a logical relation.

Let us now turn to the second question, namely, whether the relation between the *consideration* that a novel had all the good qualities in a list of either of the two main types considered, and the overall value-judgment (act of evaluation), would be a *logical* relation or a *merely causal* relation. The answer to this question seems to me to be that we should not be stretching usage at all to say that the relation would be at least partly a logical relation, and not merely causal relation. Let us look into the matter. Certainly, if a person A on some occasion considers the fact that a certain novel has the *bare* qualities[4] $q^1 q^2 q^3 \ldots q^n$, that consideration may or may not *cause* him to hold that the novel is a good one. If he himself *thinks* that $q^1 q^2 q^3 \ldots q^n$ *are* good qualities, i.e. are $q^1_g q^2_g q^3_g \ldots q^n_g$, the consideration that the novel has those qualities could hardly cause him to think that the novel is a bad one. On the other hand, if he himself *thinks* that $q^1 q^2 q^3 \ldots q^n$ are bad qualities, i.e. are $q^1_b q^2_b q^3_b \ldots q^n_b$, then the consideration that the novel has bad qualities might well *cause* him to hold that the novel is a bad one. It might be suggested, then, that whether a person will be caused to think the novel good or bad, will depend on whether the person concerned *thinks* the qualities are good or bad. Thus the consideration that the novel has the bare qualities $q^1 q^2 q^3 \ldots q^n$ will have a *mere causal relation* to a judgment that the novel is good, if by 'mere causal relation' we mean (and this seems the most important sense) a relation such that there would be no contradiction involved if the consideration that the novel had the qualities $q^1 q^2 q^3 \ldots q^n$ caused the judgment that the novel was a bad one. This argument, in my opinion, may be perfectly sound, but is quite irrelevant to our question. For the relation we are considering in our second question is *not* the relation between the consideration that a novel has the *bare* qualities $q^1 q^2 q^3 \ldots q^n$ and the overall judgment that the novel is good: but the relation between the consideration that the novel has the *good* qualities $q^1_g q^2_g q^3_g \ldots q^n_g$ and the overall judgment that the novel is good. Now a contradiction would certainly be involved if A should assert: 'the fact that the novel has the good qualities $q^1_g q^2_g q^3_g \ldots q^n_g$ makes it probable that it is a bad novel' or if he should assert: 'the fact that the novel has the good qualities $q^1_g q^2_g q^3_g \ldots q^n_g$ goes no way towards making it probable that it is a good novel' or if he should

assert: 'the fact that the novel has the good qualities $q^1_g\ q^2_g\ q^3_g \ldots q^n_g$ goes no way towards making it true that the novel is a good one.' And the type of case we are discussing is of this sort, and not one involving bare qualities. The supposed critic mentioned at the beginning of this lecture clearly considered that the qualities of *Emma* which he enumerated were *good* qualities, and if he had said that the fact that *Emma* had these qualities made it a bad novel; or (by themselves) made it probable that *Emma* was a bad novel; or went no way towards making it probable that it was a good novel: that would have involved a contradiction. The relation between the consideration that a novel has qualities deemed by the critic to be good, and his judgment that the novel is good, cannot therefore be a mere causal relation, in the sense indicated earlier in this paragraph.

I hope I have now shown that the relation between the consideration that a novel has certain good qualities and the subsequent value-judgment that the novel is good, is not a merely causal one.

Thus in the sort of case (the case about *Emma*) mentioned at the beginning of this lecture, the relation between the 'reasons' or 'reason' for the value-judgment that the novel is good, and the value-judgment itself, is at least partly logical, whether the 'reasons' be taken to be (a) the *facts* that *Emma* has this good quality, that good quality and the other good quality, in which case the relation is *wholly* logical, or the 'reason' be taken to be (b) the *consideration* by a critic that *Emma* has this good quality, that good quality and the other good quality, in which case the relation is *partly* logical.

Both our questions have been concerned, as you know, with good qualities attributed to a work, or at least with qualities clearly *taken* to be good by the critic concerned. It will readily have occurred to you that analogous questions could be raised with regard to *bare* qualities, that is, qualities considered without any value-charge which may be attached to them. These questions might be expressed (restricting them somewhat so as to make them more pointed) as follows: (I) Is the relation between the fact that a novel has a certain bare quality, and the value-proposition that the novel has at least one good quality, a logical relation? and (2) Is the relation between the *consideration* that a novel has a certain bare quality, and the *act of evaluation* that the novel has at least one good quality, a merely causal relation?

I wish to spend most of the remainder of my lecture discussing the first of these two questions, to follow this with a brief passage on the second question, and finally to say something about the relation between our two *sets* of questions.

Let us consider question (1), then, and for the sake of clarity let us at first focus attention on one of the bare qualities forming the descriptive (as opposed to evaluatory) element of one of the good qualities attributed to *Emma* by the supposed critic at the start of my lecture. We may ask the following question: Is the relation between the fact that a novel shows a deep knowledge of human nature, and the fact that it has

at least one good quality, a logical relation? The term 'deep knowledge,' in this question, is to be taken *purely descriptively* (at least with respect to a novel), abstracting completely the evaluative element or value-charge present in the phrase on so many occasions when it is used in criticism. It is to be taken, that is, as meaning, *roughly,* correct plumbing of human motive, accurate description of less obvious human reactions, correct prediction of basic human behaviour, a full and precise sense of human feeling. (I do not wish to insist on the detail of this particular analysis.) Now to this question taken in this sense I am inclined to think we ought to reply in the negative. As it happens, the best judges consider that a deep knowledge of human nature is a point in favour of a novel: but they might equally well have found deep knowledge of human nature, where shown in any novel, an *execrable* quality. Admittedly the best judges may often have *reasons* for the view they *do* hold on this point; and the relation between these *reasons* and their judgment that a deep knowledge of human nature *is* a good point in a novel, would be a logical relation, or at least not a merely causal one: but however long the chain of reasons might be, I for one find it hard to believe that there will not come a point at which a brute preference is reached. (Indeed I do not think that the chain of reasons likely to be adduced in the present case is a long one at all.) Now if in fact there always *does* come a point at which a brute preference is reached, then between the fact that the novel has a certain bare quality, and the fact that it has at least one good quality, there is at a certain point a logical gap, the only bridge over which is the brute preference itself. I said a moment ago that 'I for one find it hard to believe' that there will not come a point in the chain of reasons for the positive evaluation of a quality, at which a brute preference is reached. Now it might well appear that such a difficulty of belief is not definite enough evidence for strict philosophical thinking. It might be suggested that if it could be shown that there *must* come a point in the chain of reasons, at which a brute preference is reached, then that would be more satisfying. *Can* it be shown? It seems clear that it could only be shown by deduction from some proposition or propositions admitted to be true. Now a proposition which clearly presents itself as a candidate for the premise of such a deduction is the general proposition that no value-judgment follows logically from a purely descriptive proposition. Is this proposition true? That is a crucial point.

It might be said against the view that this proposition is true, that when we make aesthetic value-judgments we often give as reasons propositions which are purely descriptive. For instance, we often give as a reason for saying that a portrait is good, that it is 'like' the person of whom it purports to be a portrait. (For the purposes of our argument let us take the slippery word 'like' to mean in this context 'bearing a strong physical resemblance to.') With regard to this sort of case I want to raise the following problem, namely, whether *any* value-judgment really *follows* from the reason given; and, in particular, whether it *follows* that the portrait has at least one good point. In favour of the view that this *does* follow, it might be urged that a portrait *is* something which should

be like the person it purports to be a portrait of; that part at least of the meaning of the term 'portrait' is: 'picture that should be like the person whom it purports to represent.' If that is so, the argument would continue, then, to say that a certain portrait is like the person whom it purports to represent, is to say something from which it follows that the portrait has at least one good point, since to say that a certain portrait is like the person whom it purports to represent is to say that a certain picture which *should be like* the person it purports to represent, *is* like that person; and if it *is* what it should be, that is obviously a point in favour of it. Thus, it might be concluded, this one value-judgment, slight though it may be, *follows* from a purely descriptive statement. This argument seems to me formally sound; so that much if not everything seems to hinge on whether a portrait *is* something which *should be* like the person whose portrait it purports to be: or, to put the point in linguistic terminology (without suggesting any exact equivalence), much if not everything seems to hinge on whether part at least of the *meaning* of the term 'portrait' is: 'picture that should be like the person whom it purports to represent.'

This is rather a hard question. Suppose that up till now portraits had in fact been like the persons they purported to represent, but that a new technique of what its exponents called 'portrait-painting' were evolved, such that a 'portrait' of this new type was a representation of a person, but was not required to be like that person physically. (I can remember that when I was an undergraduate here there was a woman student at Newnham College who used to draw pictures of the 'souls' of her male acquaintances, to whom the pictures were quite clearly not required to bear any physical resemblance.) Should we call such a picture a 'portrait'? There would probably be some people who would say: 'That picture is not a "portrait"' or 'That picture does not deserve to be called a "portrait."' On the other hand, we could expect some others to rejoin: 'Why not? It is a "portrait" all right: you are just narrow-minded.'

What is the situation here? It seems to me to be as follows: The first party is regarding it as an essential criterion of a portrait that it *should be* like (i.e. that it *ought to be* like) the person of whom it purports to be a portrait: or (in linguistic terms) the first party would hold that the term 'portrait' cannot be correctly used to refer to a picture unless that picture ought to be like the person of whom it purports to be a portrait. The second party, on the other hand, does not regard it as an essential criterion of a portrait that it ought to be like the person of whom it purports to be a portrait: or (in linguistic terms) the second party would hold that the term 'portrait' *can* be correctly used to refer to a picture even if it is not true that that picture ought to be like the person of whom it purports to be a portrait. The second party *might* perhaps add that it would be quite enough for the picture to be required to be in some way a representation of that person (e.g. a highly distorted projection, or one of the Newnham student's 'soul'-pictures) without it needing to be required to resemble that person physically.

The situation we have been considering has actually arisen in con-

nection with some ultra-modern pictures which certain people would call 'portraits,' while other people would deny them that title, even though some of the latter class of people might admire them as works of art, all the same.

Now which of our two parties would be right? This again is a hard question. It might seem that we could answer it, if at all, by reference to the correct idea of a portrait: or (in linguistic terms) by reference to the meaning of the word 'portrait' as it is correctly used in the English language. Now what is the correct idea of a portrait: or (in linguistic terms) what is the meaning of the word 'portrait' as it is correctly used in the English language? The true answer seems to me to be that we do not know exactly. We do know a fair amount about these matters: for instance, we know that a portrait is a picture and not a sort of cricket-bat, and (in linguistic terms) we know that it *is* part of the meaning of the term 'portrait' (in at least one of its most important uses) that it is a picture. On the other hand, there are points on which we are in the dark, and one such point is as to whether to be a portrait at all a picture must be *required to be like* (*not* must *be like,* of course) the person of whom it is a picture: and we are in the dark as to whether (in linguistic terms) it is at least part of the meaning of the word 'portrait' as correctly used in the English language, that it is a picture which ought to be like the person whose portrait it purports to be. We are in the dark on these points, I suggest: but that is not, I believe, because there is some true answer; but because our ideas and correct usage are on these points *indetermi-nate.* If this is so, then, of our two parties, the first was wrong in holding that it is definitely an essential criterion of a portrait that it ought to be like the person whose portrait it purports to be: while the second was wrong in holding that the term 'portrait' can correctly (i.e. according to established usage) be used to refer to a picture even if it is not true that that picture ought to be like the person of whom it purports to be a portrait. Whether it will *become* correct usage is a question. The issue is being fought out: and while it is being fought out, we can only say that it is *better* to extend the use of the term to cover such cases, or that it is *better not* to extend the use of the term to cover such cases, not that it is *correct* to do so, or *correct* not to do so. It might be *better,* for instance, in view of the practical effects, e.g. the encouragement or discouragement of a looser or freer style of painting. A new style 'portrait' by any other name might still be as good a work of art: but if it was not called a 'portrait' there might not be as many commissions for its painter. Another way in which it might be better to extend or not to extend the use of the term 'portrait' to cover the new cases, would be that it would emphasize the likenesses or differences between these new portraits and the 'respectable' old ones. If it were more important to emphasize the likenesses, that would be a point in favour of extending the use. If, on the other hand, it were more important to emphasize the differences, that would be a point in favour of *not* extending the use.

If I am right in my analysis of this matter so far, it is uncertain

whether it should be part of the meaning of the term 'portrait' that it ought to be like the person whose portrait it purports to be. That issue is not yet fought out. Now, if that is so, it is also uncertain whether to say that a certain portrait is like the person whom it purports to represent is to say something from which it *follows* that the portrait has at least one good point. It might be instructive here to compare this case of the portrait with the case of sugar. It is certainly part of the meaning of the term 'sugar' that it *ought to be* sweet. There the doubtful matter is not whether it is part of the meaning of the term 'sugar' that it *ought to be* sweet, but whether it is part of the meaning of the term 'sugar' that it *is* sweet.[5] (That is quite a different point, however, and we need not go into it.) We should certainly not call anything 'sugar' if it ought not to be sweet. That is a point in our language that has been decided: whereas in the case of the portrait, whether we should call a picture a 'portrait' if that picture has no need to be like the person it purports to represent, has *not* been decided. But there is a further, and I think, deeper point. When it is decided, if ever it is decided, *either* that the term 'portrait' *cannot* be correctly used to refer to a picture unless that picture ought to be like the person it purports to represent, *or* that the term *can* be correctly used to refer to a picture even if it is not true that that picture ought to be like the person whom it purports to represent, then the meaning of the term 'portrait' in the English language will be different from what it is now, and, putting the point in nonlinguistic terms, the concept of a portrait will be different from what it is now. For now the usage of the term 'portrait' is vague, and the concept of a portrait is radically indeterminate: whereas then the usage of the term 'portrait,' and the concept of a portrait, will be in this respect fixed and definite. From this it follows that nothing decided by that change would provide an answer to the questions we have asked: for the questions we have asked concern the situation as it is now. And in the situation as it is now, there are two views on this point as to the meaning of the term 'portrait,' and those two views correspond to the tendencies in people to emphasize the likeness or the difference between the old 'respectable' portraits and the new type of pictures. These new pictures, of course, are just as like or unlike the old ones as they are, and nothing we can say about them can make them more or less like the old ones than they in fact are. *In this respect* (and I should wish these words to bear considerable emphasis) it is a matter of indifference whether we *call* the new type of picture a 'portrait' or not. But it is not at all a matter of indifference with respect to the answer to our original question, namely, whether it *follows* from the fact that a portrait is like the person whom it purports to represent, that the portrait has at least one good point. For, as we saw, the answer to that question hinged on whether or not a portrait *is* a picture which ought to be like the person whose portrait it purports to be, or, to put the point in linguistic terminology, whether part, at least, of the *meaning* of the term 'portrait' is: 'picture that should be like the person whom it purports to represent.' The original question was about *portraits,* that is, about those

things referred to by the term 'portrait' as it is at present used in English: and, as I have said, in my view it is quite uncertain whether only a picture that *ought to be like* the person whom it purports to represent can be a portrait. And that being so, it seems to me quite uncertain whether it *follows* from the fact that a portrait is like the person whom it purports to represent, that the portrait has at least one good point. It seems to me, therefore, quite uncertain whether any value-judgment *follows* from the supposedly purely descriptive proposition that the portrait is like the person whom it purports to represent.

But supose it had turned out in this case that portraits *are* in fact pictures that *ought to be like* the persons whom they purport to represent, or, in linguistic terms, that part at least of the meaning of the term 'portrait' is: 'picture that ought to be like the person whom it purports to represent,' then would it really *be* a purely descriptive proposition (i.e. a proposition making no value assertion), that a certain portrait was like the person it purported to represent? Let us consider the sentence:

'The portrait P is like A whom it purports to represent.'

Now *ex hypothesi* part of the meaning of this sentence is:

The picture P which ought to be like A *is* like A.

And this is a value proposition. Thus what may have seemed to be a purely descriptive proposition would, if the very condition required for the argument had been fulfilled (i.e. if part of the meaning of the term 'portrait' had been 'picture that ought to be like the person it purports to represent'), have in fact been merely a value proposition in disguise.

The case of the portrait, then, fails on two grounds to provide an instance where a value proposition follows from a purely descriptive proposition.

Yet this seemed a plausible case in favour of the view that value propositions sometimes follow from purely descriptive propositions. Can some more plausible cases be suggested, and, if so, will they turn out on analysis not really to be instances of value-judgments *following* from *purely descriptive* propositions? Finally, if we are unable to find any cases which stand up to analysis, and feel therefore led, as we might be, to maintain that perhaps no value-judgment ever follows from a purely descriptive proposition, we shall then naturally be called upon, I think, to try to describe as precisely as possible the relationship between value-judgments and the apparently purely descriptive propositions which are often quite rightly given as reasons for them.

One thing that is certain is that if we are eventually led to the conclusion that no value-judgment ever follows from a purely descriptive proposition, then we shall have to admit that the relation between the *consideration* that a work of art has a certain bare quality, and the judgment that the work has at least one good quality, may well be merely causal.

I shall end by trying very briefly to fulfil my promise to say something about the connexion between the two sets of questions which have formed the subject of this lecture. The situation seems to me to be this: When we make aesthetic value-judgments, we sometimes support them by other value-judgments. In that case, it seems to me, the relation between the supporting value-judgments and the main value-judgment is, where the support is valid, a logical relation, sometimes one of probability, sometimes perhaps one of necessity. Moreover, the relation between the consideration that the work has the qualities which we attribute to it in the supporting value-judgments, and our overall evaluation, is more than merely causal, in that it would involve us in contradiction to assert that positive value elements failed to contribute to overall value.

On the other hand, sometimes we give in support of our aesthetic value-judgments what may seem to be purely descriptive propositions. The existence of such cases might suggest that value-judgments sometimes *follow* from purely descriptive propositions. In one plausible case, however, which I investigated in some detail, it did not appear that we could definitely say that *any* value-judgment *followed* from the supposedly purely descriptive proposition, if it was indeed a purely descriptive proposition. On the other hand, examination of the case showed that if we could have said that the value-judgment *followed* from the proposition in question, then that proposition would not have been a purely descriptive proposition, but a value-judgment in disguise.

Once we are within the magic circle of value-judgments, then, logical relations seem to hold between some value-judgments and other value-judgments which seem to support them: but the questions remain as to whether we can be compelled to enter that magic circle of value-judgments by the logical force of purely descriptive propositions sometimes offered as reasons for value-judgments, and, if not, what the precise relation is between these purely descriptive propositions and both the overall value-judgments they are used to support, and the lesser value-judgments which these logically include. And corresponding questions concern the relations between 'considerations' and 'evaluations.' Anything like an adequate attempt to answer these questions, however, would require at least another lecture: and I shall therefore now leave them with you in the hope that what I have said here may have both sharpened the questions and at least cleared the ground for satisfactory answers.

Notes

1. See Tolstoy, "What is Art?" (*Works,* tr. Maude, Oxford, 1929, Vol. 18, pp. 241–2).
2. E.g. Sincerity, naturalness of situation, appropriateness of speech to character, sense of proportion. See Tolstoy's essay, "Shakespeare and the Drama" (*Works,* tr. Maude, Oxford, 1929, Vol. 21, especially pp. 363–64).
3. For exposition of the view that probability is a logical relation see

J. M. Keynes, *A Treatise on Probability,* Macmillan, 1921; H. Jeffreys, *Theory of Probability,* Oxford, 1939; C. D. Broad in *Mind,* 1918, 1920, and in *Proceedings of the Aristotelian Society,* Vol. 28 (1927–28). For opposing views see R. von Mises, *Probability, Statistics and Truth,* London, 1939; K. R. Popper, *Logik der Forschung,* Vienna, 1935; Hans Reichenbach, *Logical Foundations of Probability,* Berkeley, 1949; R. A. Fisher, *Statistical Methods for Research Workers,* Edinburgh, 1923.

4. By "bare qualities" I mean qualities considered without any value-charge which may be attached to them, e.g. *complexity,* which may or may not be valued by some critic or some culture.

5. It is interesting to find that in the American dictionary of Funk and Wagnall the primary sense of "sweet" is given as "Agreeable to the sense of taste; having a flavor like that of sugar . . ."

PART SIX

Can Art Itself Be Symbolized?

CHAPTER 1

Introduction

Nowadays, when it is fashionable to distinguish sharply between the aesthetic and the non-aesthetic, we may also pause to consider whether the non-artistic and the artistic are separated by a gulf, or are connected by a viable buffer zone. It is the contention of the article which follows that the "pre-artistic" is such a transitional zone, that the actions comprising it are *structurings* as contrasted with strictly artistic *constructions,* and that such structurings form a rudimentary vocabulary to be later utilized in more mature phases of artistic development.

But the style of this article, alternately mythologizing and de-mythologizing, masking and unmasking, expressing figuratively what is implied literally and implying figuratively what is expressed literally, suggests that new pathways have constantly to be explored if we are to answer such questions as "How is art possible?," "What are the conditions of art?," and "Can art itself be symbolized?"

CHAPTER 2

The Arts of Prometheus

Matthew Lipman

Matthew Lipman teaches philosophy at Montclair State College and City College of New York and is Research Associate at Columbia University. He is the author of What Happens in Art *and* Discovering Philosophy.

The Arts of Prometheus

1. Despite Nietzsche's heroic effort to make two archetypal life styles, the Apollonian and the Dionysian, serve as paradigms of what were for him the two basic types of art, the fact remains that the Greeks simply had no deity who symbolized art *per se.* Terpsichore, Thalia, Calliope and the other Muses seem to us today charming nymphs—nice girls, but we wonder if they could ever have been revered as deities. The Muses were presumably expected to inspire artistic behavior, but they could hardly have effectively represented it.

 The absence of such a deity among a people as concerned with art as the Greeks seem to have been is striking. Was it due to a failure on

their part to create a suitable legend, or was it due to a failure to enshrine and transmit through tradition the legend once created? The latter interpretation plausibly implies censorship and repression, those lifelong companions of art. But repression for what purpose? Could it have been that the Greeks, with their longing for a serenity and repose so alien to their turbulent lives, were actually so terrified of their own creativity that they associated its origins with crime? One thinks of the fate of Prometheus, whose gift to mankind of the fire he had stolen from the gods was in germ the gift of technology and science. It requires no great stretch of imagination to suppose that the fire also symbolized artistic creativity, and that the Greeks, overwhelmed by what they had dared to suggest, sought to neutralize Prometheus by means of an eternal punishment, thereby implicitly heading off any future aspirant to the role of artistic deity. We may readily suppose that the creators of the Prometheus legend doomed him to his endless torment on the rock in order to show—this is their "tragic insight"—that thus it is to be with all who would bring independence and enlightenment to mankind. But a more circuitous explanation might portray their action as stemming from their own guilt at having created so magnificent a symbol of the free spirit—a guilt subsequently dramatized by the punitive and repressive figure of Zeus, who seems to possess all the frailties of humans, yet never manages to be a *Mensch.*

However it may have been, we should not be content to assume that the interpretations of the Prometheus legend to be found in Hesiod and Aeschylus are authoritative or exhaustive. There is always a cultural underground of speculation, a subversive current of social thought brimming with heterodox interpretation and commentary. It may be merely the petty gossip of archivists, or it may reflect some tenaciously held but unofficial folklore of illiterate and only crudely articulate masses. But if tinkering with mythology seldom achieves prominence, neither does it ever wholly cease. It continues even among philosophers who realize that it never occurred to the Greeks to invent a special deity for art because it never occurred to them to make art an isolated category of human life.

2. It was the lame artisan-God Hephaestus, god of skills and crafts, who, under orders from Zeus, forged the chains which were to hold Prometheus to the rock. If Hephaestus seemed to find the work more than ordinarily enjoyable, it must be recalled that it had been his fire which Prometheus had stolen, to give to mankind. Hephaestus agreed fully with Zeus that the punishment of Prometheus should be made to fit the crime. But he nevertheless was unhappy that his wife, Aphrodite, should have appeared, an expression of horror on her face, just as he was forging the final link. He completed the chaining quickly and with a vengeance, to the very same rock as was at another time to be assigned to Sisyphus.

It has been said that Prometheus did not remain chained to the rock because Zeus eventually had come to feel that the punishment was no longer suitable or effective. Actually, there is more than a suspicion that Zeus had been having trouble with an interminable succession of vultures, virtually all of whom bitched continually about the dreariness of the work and the monotony of the fare. One of them, even more disreputably feathered than his predecessors, had had the temerity to assert that he felt he was being punished no less than Prometheus, although he had actually been guilty of no crime whatsoever, and had Zeus not dismissed him, he might very well have raised the question of *habeas corpus.*

Besides, it was suspected that some of the vultures had begun to fraternize with Prometheus during their non-lunch hours.

In any case there seems little doubt that, after having partaken of Prometheus, they had become increasingly independent, and increasingly difficult to manage. One account goes so far as to suggest that Zeus, in desperation, finally conceived the expedient of transforming the despised Sisyphus into a vulture, and putting him to the task. To Sisyphus, the work was no improvement over what he had been doing, and he particularly detested his new shape. But Zeus could hardly have forgiven him for the fact that, though required to perform the most inane of chores, Sisyphus had seen fit to look upon his punishment in an oddly favorable light, with the consequence that he eventually got to be publicized for the dubious achievement of making the meaningless seem meaningful. It turned out that, as a vulture, Sisyphus was considerably lazier than any of the others had been, and for this small favor Prometheus was immensely grateful.

If I have been especially concerned with Prometheus, it is because I suspect him of being—for the underground of all ages—the god of art. I say "underground," because divine power and human creativity seem to have been quite incompatible in the established or official legendary tradition. But that is another story. We can always return to Prometheus; for the present, let us consider how art is possible.

3. To ask "How is art possible?" is to ask "From what sort of conditions would art emerge more or less as a matter of course?" Let no one at this point so misunderstand me as to commit the "genetic fallacy" fallacy. For however severable an art *product* may be from the process which engendered it, art itself cannot be thoroughly studied apart from its history.

Now a tempting answer to the foregoing question about the conditions of art would be that such conditions are intrinsically non-aesthetic, art being the result of their combination. Normally, such an answer would be quite acceptable, as when we say that aesthetic experience, though not itself physical, is the product of physical conditions. But if we were to assume that art involves a process of refinement (a question-

able assumption, indeed), then another approach is necessary. For there is no such thing as "raw" or "unrefined" experience with which the art process could begin. The question might well be raised whether there ever was. It would seem then that the emergence of aesthetic sensibility did not follow upon the emergence of the human in nature, but, at the very least, coincided with it. For had it followed, one might be led to infer that the early phases of man were non-aesthetic and literal, whereas the more plausible interpretation would seem to be that the literal temper is of relatively recent origin, and represents a fairly sophisticated development.

On the other hand, to say that art showed up at about the same time man did would be to presume too much. It might be considerably better to maintain that the earlier phases of human history were not wholly non-aesthetic, but were of a texture that always contained an aesthetic component interspersed within the magical, religious, mythic and other aspects of primitive awareness. Much of human experience is still of this texture, and it might be simplest just to label it "pre-artistic." Art itself could very well have emerged at just the point at which the emerging literal awareness, though not yet dominant, was beginning to establish an equilibrium of sorts with the non-literal forms of sensibility.

In remarking that there is no such thing as raw or unrefined experience, I meant to deny categorically that there is ever any experience so inchoate as to be considered wholly structureless. For whatever is, in nature, is complex, and whatever is complex is structured.

Among the pre-artistic conditions from which art emerges are those characterized by *structuring* (as distinct from artistic *constructing*.) Structuring is not so much a category of art as of action. It is one type of action—whether methodological or not—and involves the arranging of feelings, media and other materials which may subsequently be utilized in artistic construction. Thus one prepares to construct a still life by arranging some fruit or vegetables. Or one prepares oneself for a distant future as an artist by learning to crosshatch, or to play a little Czerny exercise, or to engage in any of the other technical performances that figure among the rudimentary conditions of artistic construction.

Structuring differs from other varieties of action in that its test is solely the test of form. Thus the student in the gymnastics class and the student in a ballet class may each begin the hour with rather similar preparations. But each movement of the dancer is engaged in for the sake of its method and form, while for the practising gymnast what is of primary importance is the act itself, not the way it is done. Once he achieves a double somersault, his aim is not so much to perfect it, as to achieve a triple somersault. Or we have one golfer practicing his swing in order to develop greater driving power, while another practices purely to perfect the movement itself. The latter performance is a structuring act. I would guess that even the savage who made the first crude stone ax before long came to appreciate the heft and swing of it as he whirled it in a lovely arc that ended by crushing the skull of some poor beast.

What is being emphasized here then is that structuring is to art as signaling is to language. For just as language and the symbols it consists of cannot be reduced to mere signals, so structuring acts form the basic material of art, although art is not reducible to such acts. Structuring acts make up, as it were, the *alphabet* and to some extent even the *vocabulary* of art. Artistic behavior itself makes use of or draws upon (without being limited to) that alphabet and that vocabulary. Art is not just an aggregate of words; a painting is not just an aggregate of brushstrokes. To assume they could be would be to neglect the indispensable role of artistic composition. This is why it must be insisted that structuring is primarily a pre-artistic rather than an artistic function and that *insights* and *ideas* must be thought of as among the foremost of such structurings, even though they are not deliberately contrived.

Indeed, if we interest ourselves in historical questions, if we wonder why it is that such-and-such an art style seems at a certain point to be exhausted, pushed to its limits, we would do well to examine the *pre-artistic* conditions of the time. It would often be found, I suspect, that significant changes in the technical conditions, in the structurings of the period, had been taking place, and had just about doomed any continuation of artistic construction in that particular style. For a style is dependent upon a particular vocabulary, and when the vocabulary is no longer viable, the style is drained of energy and quickly becomes exhausted. We can always learn a dead language, but we cannot use it to communicate effectively about the world of today. Similarly we can learn the Renaissance or Baroque artistic vocabularies, but they will not enable us to deal effectively with our 20th century experience. I certainly do not mean that new styles emerge only when previous styles have become exhausted; I am merely suggesting that the devising of new artistic vocabularies may hasten the exhaustion of the older styles.

4. Let us return to Prometheus.

It has become clear to Zeus that the punishment is a failure. It has brought neither remorse nor expiation. Consequently, Prometheus is to be sent into exile, which in his case means that he is to be sent beyond the furthest bounds of the universe, into the great void.

As a parting gesture, Zeus picks up the rock to which Prometheus had been chained, and flings it at him. Prometheus is struck in the head—not squarely, but hard enough to cause amnesia. It is a bewildered Titan who is then hustled to his dreadful banishment.

Like any Titan, Prometheus had feared nothing. Now, nothing envelops him, and he is terrified. After all, he had loved the light and warmth of the sun, and the solid ground beneath his feet. The dark utter emptiness of his exile, its terrible coldness, with nothing to touch or hold to, reduces him to wretchedness.

He has neither memory nor environment. He can think, but he can

remember nothing to think of. He can perceive, but there is nothing around him that is perceivable. To keep warm, he must keep moving about. His cries and howls are lost in the night. He dreams constantly of fire: a gigantic fire, in a titanic fennel stalk.

He is primarily concerned with his perceptions of himself. The temptation is strong to regress into narcissism, to treasure each of his acts solely because it is his. Prometheus somehow manages to decline this gambit, and proceeds to consider each of his acts from the point of view of its configuration, as well as the structuring method which that configuration requires and presupposes. He still howls, but less monotonously. He still leaps about, but more variedly, more experimentally. He learns to delight both in graceful actions and in those that are abrupt, that shock and jar and surprise him. He learns that even the slack and the insipid can be valid aesthetic qualities in hospitable contexts. He has discovered that the pattern of his own actions can be detached from those actions. He has discovered the isolability of relationships, and that discovery leads him beyond the merely schematic or fragmentary performances, out to where he begins to feel the pull of constructive adventure.

It has been a long way from his early, inartistic behavior—stamping about and slapping his hands to keep warm, howling into the void, groaning—to his earliest structurings—the swaying, the chanting, the first organized gestures. It will be an equally long way from these rudimentary structurings to mature artistic behavior. In time, Prometheus will be able to look back and to recognize that these structurings were neither play nor work, neither erotic nor communicative. They were too elementary to fit any of these more sophisticated categories. They were foundational, existential. In a sense, he owes them his life.

His wound heals, his memory returns. Now, each act takes on far greater significance, as his relevant past can be brought to bear upon the present. Every structuring acquires a richer ambience of meanings, unexpected conjunctions appear, and for every new illumination there are untold new mysteries.

Prometheus remembers nature, and longs to return. His longing gnaws at him like a vulture.

5. There are three basic types of structuring acts: (a) those, already discussed, which function pre-artistically as well-formed fragments that might eventually compose an artist's vocabulary; (b) those which take place during the aesthetic experience itself, and which magnetize the myriad filings of our funded experience into diffuse patterns rich with sympathetic meanings; and finally, (c) those in which the trivial events of subsequent everyday experience are enmeshed in networks of relevent connections and interstices. This is the *contextualization* by means of which routine episodes are invested with a significance far beyond the ordinary, for the episode summons up in us a wealth, not simply of

associations, but of modes of structuring those associations, so that each context becomes a world whose center is the prosaic incident itself, like a stone in a jewelled setting.

The relationship between (b) and (c) is that, in aesthetic experience, the object of art works in us to reorganize, if only momentarily, the vast, far-flung economy of our individual being, whereas in contextualization, a prosaic perception touches off the actualization of a variety of possible contexts, drawn from our past experience, in which the present perception can be ensconced. In other words, in the one case, what is brilliantly perceived meaningfully illuminates our world; in the other, it is our sparkling world which meaningfully illuminates what is perceived.

I should not like to be misinterpreted as saying that the work of art, in the moment of aesthetic experience, somehow "opens the floodgates of our memories." Doubtless this may in fact at times occur, but when it does, it is not aesthetically relevent. Indeed, what we do discover, in retrospect, is the *dissociation* of the aesthetic moment from any particular memories we may have had. For memory, after all, is only one aspect of our funded past experience, and it is precisely this cumulative experience which, in all its depth and massiveness, is aroused by the poetic or tonal or visual image, which is brought to bear upon the living instant, and which, in a flash, is structured. The aesthetic object itself can be incredibly simple: a few metal reeds that wave gently and casually about, or a canvas in which there is only a turquoise shading imperceptibly and exquisitely into aquamarine, or a few moments of seemingly random sound. But because it affects and rearranges our funded experience totally, lighting up even its darkest corners, the aesthetic experience takes on cosmic overtones, for it is pregnant with diffuse meanings, yet no particular meaning appears assignable. Thus the aesthetic perception takes as its context not some specific set of relevant connections, but the great mass of one's funded experience, that great mass which we lug about or inhabit the way we lug about or inhabit our bodies, so that one's funded experience becomes, as it were, to use Valéry's phrase, "the body of the spirit." The aesthetic perception, by structuring this fund into a contextual manifold rich in diverse implications, may be considered another type of structuring act, but one that is post-artistic rather than pre-artistic.

The contextualization of routine episodes or fragments of experience represents yet another type of structuring act through which the circle is completed and we are brought back to everyday experience. The mundane incident which now occurs becomes the center of an experiential configuration or an array of such configurations, many of which have been made available by previous aesthetic experiences. It is a commonplace that the biblical scholar hears the everyday world through the cadences of Old Testament poetry, and understands the world in the perspectives provided by Old Testament insights. But as a widely cultivated man he may respond in many perspectives: he sees the whale not only in terms of the Jonah legend, but also in the perspective of the

history of oil, in the perspective of Melville, and in many others as well. Thus the vast domain of art affords us countless instances of possible ways of structuring our experience so as to make it aesthetic, and of contextualizing the routine incidents of everyday life so as to make them meaningful. That we should have such an array to choose from is one of the basic conditions of human freedom.

6. It was wholly coincidental that the friends of Prometheus should have arranged his escape when they did, for hardly an instant before the exile returned, Zeus had issued a general amnesty. Thus when Prometheus suddenly appeared out of nowhere, Zeus was quite startled that the Titan should be so prompt. But other Olympians greeted Prometheus with open arms, especially Aphrodite, who was overheard saying she had always thought him quite a swinger.

With Parnassus the center of his operations, Prometheus promptly set to work. From the moment of his return, he had been overwhelmed by his fresh perceptions of the world and the things of which it consists. It was as if he were newborn and had never perceived before.

No longer was he concerned simply to express himself, as he had been during his exile. Now he wanted to express individual things—in fact, to express the whole world, to enable it to articulate itself through the countless art forms with which he had begun to experiment. It was at about this time that Prometheus noted in his *Journal:*

> "We do not teach a child to speak in order that we may better express ourselves. We do so in order to enable him to express himself, for otherwise he would be mute. Likewise, we do not paint an orchard or a forest primarily in order to project our own character, but rather we do so in order to help them bring theirs more fully to expression. Nature everywhere sends up inarticulate objects, dunes and stars and grass and all sorts of things which are unable to express or to realize themselves fully. They turn to us and address us imploringly in the hope that we will deliver them. A flower or a shrub needs to be expressed as much as it needs sunlight or water. Thus each of us has towards nature an absolutely binding aesthetic responsibility, and each of us is responsible for everything and to everything."

Yet, increasingly, Prometheus became conscious, not simply of things, but of the relationships that obtained among them, and of the rapports between them and himself as well. Somewhere he had once heard the phrase "only connect." Now he knew what it meant. So to those relationships he now addressed himself. Seeking to bring them to expression, he became aware that only as he did so could these mute connections also realize and enunciate themselves. They counted on him to help release them from their captivity, as he had been released from his. I

cannot resist citing another passage from his *Journal,* since it bears so tellingly upon his concern with this very point:

> "When one unpacks a trunk, one takes out things—clothes, souvenirs and the like. But when one unpacks a work of art, one discovers relationships. And these relationships have relationships in turn with one another, on and on in a dizzying, untraceable progression. Just the other day, I came across these two lines at the beginning of a poem by Auden:
>
>> Lay your sleeping head, my love
>> Human on my faithless arm . . .*
>
> What stood out most pronouncedly for me at first was the word "faithless," It tied all the other words together, like a net knotted just at that point. Substitute another word for it, say, "faithful," and the entire couplet becomes mawkish. It then occurred to me that there was a crucial relationship between the two words, "sleeping" and "human," at or near the beginnings of their respective lines. Why did their connection seem so strong and positive? Sleeping, after all, is not a characteristic peculiar to human beings: it's a common biological phenomenon. But then I remembered that passage in Marcel in which he speaks of the uncanny way in which the totally vulnerable presence of a sleeping child produces in most people an attitude of tenderness and respect, even of reverence. So it is not that, in sleeping, one is most human, but that the sight of a sleeping human brings out what is most human in ourselves. But other problems remained. What sense does it make to address a person who is asleep? And what sense does it make make to address that person as "my love," then promptly refer to oneself as "faithless?" These apparently self-contradictory or negative relationships, it seemed to me, balanced the positive or affirmative one between sleeping and being human, and contributed to the incredibly tough, sinuous, and multi-significant texture of what superficially had seemed a quite innocuous couplet. I wouldn't be surprised if, underlying each work of art were a complex relational *system,* just as, underlying the human skin, within the human body, there is a complex musculature. When I spoke to A. about all this, she smiled. She is completely enchanting. . . ."

Even as Prometheus pursued his inquiries into the relational substance of the work of art, he came to rediscover his media. Previously he had thrilled to the glorious, blended colors of nature; now he thrilled to the pure colors of his palette, and to their pure relationships. He became absorbed in his media as if he were in a trance, from which from time to time he would awaken, look around, rub his eyes, drink in the world, and return to his trance. Yet, when one is entranced, Prometheus

* W. H. Auden, *Collected Shorter Poems* (New York: Random House and London, Faber and Faber, 1966). Reprinted by permission of the publishers.

was later to reflect, one is estranged. Much as he loved Titans and humans alike, he had come to recognize that the fascination which the media of art held for him in no way brought him closer to his friends. Indeed, he concluded, the alienation which art sometimes overcomes is an alienation it has just as often helped to create.

One after another, the foundational aspects of art were taken up by Prometheus; yet, even as he did so, he found he could not put the others down. So from self-expression—giving utterance to the world as viewed from his own perspective—he rose to the expression of nature—giving utterance to the inarticulate world about him. And from the expression of nature he rose to the expression of the medium, and from the expression of the medium he rose, still without sacrificing the rich values he had discovered in the earlier phases, to the exploration of possibilities. Once he had thought of possibilities as remote, spectral and unnatural, separated from actuality by an unfathomable abyss. Now suddenly, as if dreamily floated by magic powers, he found himself transported across to the other side where, ecstatically, he discovered possibilities to be as actual and as natural as anything else. He came to look upon music as the investigation and enunciation of audibilities, photography as the disclosure of visibilities, painting as the enunciation of the visualizable, dance as the exploration of the possibilities of mobility and immobility. He found himself enunciating possible meanings, not necessarily because he meant them, although often he did, but simply in grateful celebration of the brute fact that they were there, much as scholars love ideas of all sorts, regardless of their credibility. The vast universe of possibilities in nature—of meanings, of ideas, of things, of feelings, of sensations—chorused its welcome to Prometheus, and to it he addressed himself, under countless pseudonyms, both hungrily and happily.

If Zeus was great and powerful, Prometheus was sublime.

And art, at long last, could claim a deity.